PAINTING AND SCULPTURE IN THE MUSEUM OF MODERN ART

PAINTING AND SCULPTURE
IN THE MUSEUM OF MODERN ART

WITH SELECTED WORKS ON PAPER

CATALOG OF THE COLLECTION
JANUARY 1, 1977

Edited by Alicia Legg

The Museum of Modern Art, New York

TRUSTEES OF THE MUSEUM OF MODERN ART

Copyright © 1977 The Museum of Modern Art. All rights reserved
Library of Congress Catalog Card Number 77-81324. ISBN 0-87070-544-X
Type set by Black Dot, Inc., Crystal Lake, Ill. Printed by Halliday Lithograph, West Hanover, Mass.

The Museum of Modern Art, 11 West 53 Street, New York, N.Y. 10019
Printed in the United States of America

CONTENTS

INTRODUCTION 7

CATALOG 9

MUSEUM PUBLICATIONS CITED IN THE CATALOG 100

DONORS 103

GIFTS, THE DONORS RETAINING LIFE INTEREST 109

COMMITTEE ON PAINTING AND SCULPTURE 110

COMMITTEE ON DRAWINGS 110

INTRODUCTION

This catalog of 3400 entries represents The Museum of Modern Art's holdings of paintings and sculpture at the beginning of 1977. A companion to *Painting and Sculpture in The Museum of Modern Art, 1929–1967,* edited by Alfred H. Barr, Jr., this listing incorporates some 550 works acquired between 1967 and 1977. A separate list of gifts that are being retained by the donors during their lifetimes is also included.

The paintings cataloged here are works in oil or synthetic mediums on canvas, composition board, and wood. The sculptures are three-dimensional works in plaster, bronze, stone, wood, assembled and welded metals, and synthetic materials. Also included are certain works in oil, watercolor, gouache, pastel, and collage on paper or cardboard. Works in the traditional drawing mediums of pencil, charcoal, and pen and ink have been excluded.

William Rubin, Director of the Department of Painting and Sculpture, with the collaboration of Trustee and Staff Committees, has been responsible for that department's acquisitions. William S. Lieberman, Director of the Department of Drawings, is comparably responsible for acquiring works on paper. A few works on paper in large format, however, have entered the collection under the aegis of the Department of Painting and Sculpture.

The catalog is arranged alphabetically by artist and chronologically for the works of each artist. The date of a work is enclosed in parentheses if it is not inscribed by the artist on the work itself. The date for a sculpture in bronze refers to the original version in plaster or clay; wherever possible, the date of casting is also supplied. Certain works that have been replicated after earlier maquettes are listed according to the date of the replication. Dimensions are given in feet and inches and in centimeters, height preceding width, and followed by depth in the case of sculptures and constructions. Measurements are also given for bases made or designed by the sculptor. Sheet sizes are given for watercolors, gouaches, temperas, caseins, pastels, and collages, unless otherwise specified.

The Museum accession number indicates the year in which a work was acquired; for example, 396.41 is the number assigned to the three-hundred-ninety-sixth work acquired in 1941.

The words "by exchange" in the credit line indicate that the work was acquired in exchange for one previously owned by the Museum. The credit line for the work previously owned is retained for the newly acquired work.

References to reproductions in other Museum publications appear in abbreviated form following the entry. The key to these abbreviations appears on page 100. References to illustrations in Alfred H. Barr's *Painting and Sculpture in The Museum of Modern Art, 1929–1967,* appear to the left of a title.

Alicia Legg, Associate Curator
Department of Painting and Sculpture

ACKNOWLEDGMENTS

On behalf of the Trustees and Staff of The Museum of Modern Art I should like to express our respectful gratitude to the artists represented in the Museum collection. We are also deeply indebted to the donors whose gifts have helped to make this one of the foremost collections of modern and contemporary art. Without their respective talent and generosity this collection could not exist. Among the many members of the Museum staff who gave assistance in the preparation of this catalog are Monawee Richards of the Department of Drawings and Nancy Karumba of the Department of Painting and Sculpture. Each provided invaluable information on acquisitions. Emily Walter and Vera Elizabeth Kalmykow of the Department of Painting and Sculpture ably prepared the checklist. Jane Fluegel of the Department of Publications provided skilled editorial supervision of this project.

A.L.

CATALOG

AS OF JANUARY 1, 1977

ABE, Shiro (pen name: Suichiku). Japanese, born 1900.

DELIGHT OF A PEACEFUL LIFE. (c.1953) Two-panel screen, brush and ink, each sheet 53⅝ x 26¾″ (136.2 x 68 cm). Japanese House Fund. 278.54. Repr. *Suppl. V*, p. 29.

ADLER, Jankel. Polish, 1895–1949. Worked in Germany and Great Britain.

199 TWO RABBIS. 1942. Oil on canvas, 33⅞ x 44⅛″ (86 x 112.1 cm). Gift of Sam Salz. 1.49. Repr. *Suppl. I*, p. 16.

ADZAK, Roy (Royston Wright Adzak). British, born 1927.

478 FIVE SPLIT BOTTLES: WHITE ON WHITE. 1965. Construction of oil on canvas with recessed plaster molds, 28¾ x 45⅝ x 2⅞″ (73 x 115.8 x 7.2 cm). Gift of Mr. and Mrs. A. M. Sachs. 93.67.

AFRO (Afro Basaldella). Italian, born 1912.

THE YELLOW BOOK. 1952. Oil and tempera on canvas, 50 x 59¾″ (127 x 151.7 cm). Gift of Mr. and Mrs. Joseph Pulitzer, Jr. 251.57. Repr. *Suppl. VII*, p. 17.

350 BOY WITH TURKEY. 1954. Oil on canvas, 49⅛ x 59″ (124.5 x 149.8 cm). Gift of Mr. and Mrs. Gordon Bunshaft. 321.60. Repr. *Suppl. X*, p. 38.

AGAM (Yaacov Agam). Israeli, born 1928. Works in Israel and Paris.

506– DOUBLE METAMORPHOSIS, II. 1964. Oil on corrugated aluminum,
507 in eleven parts, 8′10″ x 13′2¼″ (269.2 x 401.8 cm). Gift of Mr. and Mrs. George M. Jaffin. 104.65a–k. Repr. in color, *Responsive Eye*, p. 28.

AGOSTINI, Peter. American, born 1913.

PRESS, I. (1968) Plaster, 8⅛ x 16¾ x 10¼″ (20.4 x 42.4 x 25.8 cm). Larry Aldrich Foundation Fund. 712.68.

ALBERS, Josef. American, born Germany. 1888–1976. To U.S.A. 1933.

Study for HOMAGE TO THE SQUARE: NIGHT SHADES. 1956. Oil on composition board, 23⅞ x 23⅞″ (60.7 x 60.7 cm). Gift of Mrs. Bliss Parkinson. 275.61. Repr. *Suppl. XI*, p. 22.

141 Study for HOMAGE TO THE SQUARE: EARLY RISING A. 1961. Oil on composition board, 24 x 24″ (60.9 x 60.9 cm). Gift of Mrs. Bliss Parkinson. 276.61. Repr. *Suppl. XI*, p. 22.

141 HOMAGE TO THE SQUARE: SILENT HALL. 1961. Oil on composition board, 40 x 40″ (101.8 x 101.8 cm). Dr. and Mrs. Frank Stanton Fund. 293.61. Repr. *Suppl. XI*, p. 23.

HOMAGE TO THE SQUARE: BROAD CALL. 1967, fall. Oil on composition board, 48 x 48″ (121.9 x 121.9 cm). The Sidney and Harriet Janis Collection (fractional gift). 664.67. Repr. *Janis*, p. 137; in color, *Invitation*, p. 34.

ALBRIGHT, Ivan Le Lorraine. American, born 1897.

244 WOMAN. (1928) Oil on canvas, 33 x 22″ (83.8 x 55.9 cm). Given anonymously. 228.48. Repr. *Suppl. I*, p. 24.

244 THE ARTIST'S FATHER. (1935) Bronze (cast 1952), 15″ (38.1 cm) high. Gift of Earle Ludgin. 172.52. *Note*: the subject is Adam Emory Albright.

ALCOPLEY, L. (Alfred Lewin Copley). American, born Germany 1910. To U.S.A. 1937.

314 "SPIRITUS UBI VULT SPIRAT," 24 [*"The Wind Bloweth Where It Listeth"*]. 1962. Watercolor and ink, 26¾ x 22⅞″ (67.9 x 58 cm). Larry Aldrich Foundation Fund. 225.62. Repr. *Suppl. XII*, p. 22.

ALECHINSKY, Pierre. Belgian, born 1927. Lives in Paris.

355 VANISHED IN SMOKE [*Parti en fumée*]. 1962. Distemper and India ink on paper mounted on canvas, 59⅝ x 58¼″ (151.5 x 147.7 cm). Gertrud A. Mellon Fund. 70.63.

THE COMPLEX OF THE SPHINX. 1967. Synthetic polymer paint and ink on canvas and Japanese paper, 63 x 59¾″ (160 x 151.5 cm). Gift of Mary A. Gordon. 588.76.

ALEXANDER, Peter. American, born 1939.

SCULPTURE: ORANGE-BLUE. (1970) Cast polyester resin, 8′8¾″ x 4½″ x 2⅜″ (266 x 11.4 x 6 cm). Larry Aldrich Foundation Fund. 206.70.

ALFARO SIQUEIROS. See SIQUEIROS.

AL-KAZI, Munira. Kuwaiti, born 1939. To England 1957–58.

465 CONCEPTION. 1962. Gouache and gold spray paint, 30½ x 20½″ (77.5 x 51.9 cm). Frances Keech Fund. 119.65.

ALVIANI, Getulio. Italian, born 1939.

503 SURFACE WITH VIBRATING TEXTURE [*Superficie a testura vibratile LL 36 Q 14 x 14 inv.*] (1964) Brushed aluminum on composition board, 33 x 33″ (83.6 x 83.6 cm). Larry Aldrich Foundation Fund. 105.65.

ANDERSON, John S. American, born 1928.

SHELTER. (1962) Wood, 50½ x 25¼″ (128.3 x 63.8 cm). Larry Aldrich Foundation Fund. 308.62. Repr. *Suppl. XII*, p. 25.

ANDRE, Carl. American, born 1935.

SQUAW ROCK. (1964) Six stacked, glazed, cast-concrete bricks, each 2 x 8⅜ x 1¾″ (5.1 x 21.2 x 4.4 cm); overall, 5½ x 8⅜ x 8⅜″ (14 x 21.2 x 21.2 cm), irregular. Gift of Mr. and Mrs. Michael Chapman. 296.75a–f.

TIMBER SPINDLE EXERCISE. (1964) Wood, 33 x 8 x 8″ (84 x 20.3 x 20.3 cm). Gift of Mr. and Mrs. Michael Chapman. 295.75.

IMPULSE DRIVER. (1965) Collage, 5¼ x 7⅞″ (13.4 x 19.9 cm). Acquired with matching funds from the National Endowment for the Arts and the Lydia and Harry L. Winston Art Collection. 478.76.

Untitled. (1965) Collage, 11¼ x 5⅝″ (28.5 x 14.3 cm). Acquired with matching funds from the National Endowment for the Arts and Mrs. Richard L. Selle. 700.76.

LEAD PIECE (144 LEAD PLATES 12″ x 12″ x ⅜″). (1969) 144 lead plates, each approximately ⅜ x 12 x 12″ (.9 x 30.5 x 30.5 cm); overall, ⅜″ x 12′7⅛″ x 12′1½″ (9 x 367.8 x 369.2 cm). Advisory Committee Fund. 494.69.

ANDREWS, Benny. American, born 1930.

NO MORE GAMES. 1970. Oil on canvas with collage of cloth and canvas; diptych, (a) 8′4⅞″ x 49⅞″ (256.2 x 126.7 cm), (b) 8′4⅞″ x 51″ (256.2 x 129.3 cm). Blanchette Rockefeller Fund. 35.71a–b.

ANGUIANO, Raúl. Mexican, born 1915.

210 LA LLORONA. 1942. Oil on canvas, 23⅝ x 29⅝″ (60 x 75.2 cm). Inter-American Fund. 622.42. Repr. *Ptg. & Sc.*, p. 182.

ANNESLEY, David. British, born 1936.

Untitled. (1967) Painted aluminum, 6′2¼″ x 9′3⅜″ x 20″ (188.6 x 282.8 x 50.8 cm). Harry J. Rudick Fund. 1306.68.

ANUSZKIEWICZ, Richard J. American, born 1930.

373　FLUORESCENT COMPLEMENT. 1960. Oil on canvas, 36 x 32¼″ (91.5 x 82 cm). Larry Aldrich Foundation Fund. 355.60. Repr. *Suppl. X*, p. 54; *Amer. 1963*, p. 8.

　　RADIANT GREEN. 1965. Synthetic polymer paint on composition board, 16 x 16″ (40.4 x 40.5 cm). The Sidney and Harriet Janis Collection (fractional gift). 1770.67. Repr. *Janis*, p. 139.

APPEL, Karel. Dutch, born 1921. To Paris 1950.

355　CHILD WITH BIRDS. 1950. Oil on canvas, 39½ x 39¾″ (100.4 x 101 cm). Mr. and Mrs. William B. Jaffe Fund. 327.55. Repr. *Suppl. V*, p. 23.

433　ÉTIENNE-MARTIN. 1956. Oil on canvas, 6′4⅞″ x 51¼″ (195.1 x 130.1 cm). Purchase. 183.66. Repr. in color, *Invitation*, p. 65. *Note*: Henri Étienne-Martin is the French sculptor.

　　TRAGIC SPACE. 1959. Oil on canvas, 45⅛ x 59⅛″ (114.6 x 150.2 cm). Gift of Mr. and Mrs. Edward J. Mathews. 110.75.

ARAKAWA, Shusaku. Japanese, born 1936. To U.S.A. 1961.

　　BACK AND FRONT OF TIME: S.A. EQUATION. 1965. Oil, pencil, and colored pencil on canvas, 7′5″ x 63¾″ (225.8 x 161.9 cm). Gift of Mrs. Bliss Parkinson. 2307.67.

ARCHIPENKO, Alexander. American, born Ukraine. 1887–1964. Worked in Paris 1908–21. To U.S.A. 1923.

　　MADONNA OF THE ROCKS. 1912. Painted plaster, 21 x 13 x 14″ (53.2 x 32.8 x 35.3 cm). Gift of Frances Archipenko and The Perls Galleries. 1073.69.

　　FIGURE IN MOVEMENT. 1913. Crayon, pencil, and collage of cut-and-pasted papers, 18¾ x 12⅜″ (47.6 x 31.4 cm). Gift of The Perls Galleries. 806.69. Repr. *Seurat to Matisse*, p. 47.

418　BOXING. 1914. Bronze (cast 1966), 23¼ x 18¼ x 15⅞″ (59.1 x 46.3 x 40.3 cm). Given anonymously. 567.66. Repr. *What Is Mod. Sc.*, p. 51; *Archipenko*, back cover.

　　GONDOLIER. 1914. Bronze, 33 x 11⅞ x 10⅛″ (83.8 x 30.1 x 25.5 cm), including bronze base 2 x 9¾ x 8⅛″ (5 x 24.8 x 20.4 cm). Gift of Frances Archipenko in honor of Alfred H. Barr, Jr. 1052.69.

　　STATUE ON A TRIANGULAR BASE. 1914. Bronze (cast 1955), 30⅛ x 7⅞ x 6¼″ (76.4 x 19.8 x 15.7 cm). Given anonymously. 1074.69.

104　WOMAN COMBING HER HAIR. (1915) Bronze, 13¾″ (35 cm) high. Acquired through the Lillie P. Bliss Bequest. 581.43. Repr. *Ptg. & Sc.*, p. 267; *What Is Mod. Sc.*, p. 43.

104　GLASS ON A TABLE. (1920) Wood and plaster relief, painted, 16⅛ x 13″ (41 x 33 cm). Katherine S. Dreier Bequest. 141.53.

104　WHITE TORSO. (c. 1920, after a marble of 1916) Silvered bronze, 18½″ (47.1 cm) high. Gift of Mr. and Mrs. Murray Thompson. 277.61. Repr. *Suppl. XI*, p. 16.

ARDON (Ardon-Bronstein), Mordecai. Israeli, born Poland 1896. Worked in Germany. To Israel 1933.

290　THE TENTS OF JUDEA. (1950) Oil and tempera on composition board, 31⅞ x 39⅜″ (80.9 x 100 cm). Gift of Miss Belle Kogan. 37.52.

449　AMULET FOR A YELLOW LANDSCAPE. 1966. Oil and tempera on canvas, 38⅛ x 50¾″ (96.8 x 128.7 cm). Gift of Mr. and Mrs. George M. Jaffin. 173.67.

ARIZA, Gonzalo. Colombian, born 1912.

217　SAVANNA. (1942) Oil on canvas, 19⅜ x 19¼″ (49.2 x 48.9 cm). Inter-American Fund. 633.42. Repr. *Ptg. & Sc.*, p. 176.

ARMAN, Armand P. American, born France 1928. To U.S.A. 1963.

　　BOOM! BOOM! (1960) Assemblage of plastic water pistols in a plexiglass case, 8¼ x 23¼ x 4½″ (21 x 59 x 11.2 cm). Gift of Philip Johnson. 495.70.

　　VALETUDINARIAN. (1960) Assemblage of pill bottles in a white painted wooden box with glass top, 16 x 23¾ x 3⅛″ (40.4 x 60.2 x 7.9 cm). Gift of Philip Johnson. 494.70.

477　COLLECTION. (1964) Assemblage: split toy automobiles and matchboxes embedded in polyester in a case, 16⅞ x 27¾ x 2⅞″ (42.8 x 70.5 x 7.3 cm). Promised gift and extended loan from Mr. and Mrs. William N. Copley. E.L.65.391.

ARMITAGE, Kenneth. British, born 1916.

296　FAMILY GOING FOR A WALK. (1951) Bronze, 29 x 31″ (73.7 x 78.8 cm). Acquired through the Lillie P. Bliss Bequest. 1.53. Repr. *Suppl. IV*, p. 40.

ARP, Jean (originally, Hans). French, born Alsace. 1887–1966. Lived in Switzerland 1959–66.

166　COLLAGE WITH SQUARES ARRANGED ACCORDING TO THE LAW OF CHANCE. (1916–17) Collage of colored papers, 19⅛ x 13⅝″ (48.6 x 34.6 cm). Purchase. 457.37. Repr. *Arp*, p. 37; *Assemblage*, p. 35.

　　SQUARES ARRANGED ACCORDING TO THE LAW OF CHANCE. (1917) Collage, gouache, ink, and bronze paint, 13⅛ x 10¼″ (33.2 x 25.9 cm). Gift of Philip Johnson. 496.70.

166　BIRDS IN AN AQUARIUM. (c. 1920) Painted wood relief, 9⅞ x 8″ (25.1 x 20.3 cm). Purchase. 232.37. Repr. *Ptg. & Sc.*, p. 277; *Masters*, p. 140; *Arp*, p. 38.

166　MOUNTAIN, TABLE, ANCHORS, NAVEL. (1925) Oil on cardboard with cutouts, 29⅝ x 23½″ (75.2 x 59.7 cm). Purchase. 77.36. Repr. *Ptg. & Sc.*, p. 214; in color, *Fantastic Art* (3rd), opp. p. 146; *Arp*, p. 43; in color, *Invitation*, p. 88.

167　TWO HEADS. (1927) Oil and string on canvas, 13¾ x 10⅝″ (35 x 27 cm). Purchase. 74.36. Repr. *Fantastic Art* (3rd), p. 146.

167　LEAVES AND NAVELS. (1929) Oil and string on canvas, 13¾ x 10¾″ (35 x 27.3 cm). Purchase. 1647.40. Repr. *Arp*, p. 51.

167　TWO HEADS. (1929) Painted wood relief, 47¼ x 39¼″ (120 x 99.7 cm). Purchase. 82.36. Repr. *Fantastic Art* (3rd), p. 148; *Arp*, p. 53; *Sc. of 20th C.*, p. 122.

168　LEAVES AND NAVELS, I. (1930) Painted wood relief, 39¾ x 31¾″ (100.9 x 80.6 cm). Purchase. 75.36. Repr. *Fantastic Art* (3rd), p. 147; *Arp*, p. 56.

　　MAN AT A WINDOW. (1930) Oil and cord on canvas, 31¾ x 27¼″ (80.5 x 69.2 cm). The Sidney and Harriet Janis Collection (fractional gift). 575.67. Repr. *Janis*, p. 59. *Note*: also called *Head of a Man*.

168　OBJECTS ARRANGED ACCORDING TO THE LAW OF CHANCE or NAVELS. (1930) Varnished wood relief, 10⅜ x 11⅛″ (26.3 x 28.3 cm). Purchase. 79.36. Repr. *Fantastic Art* (3rd), p. 146; *Arp*, p. 51.

　　BELL AND NAVELS. (1931) Painted wood, 10″ (25.4 cm) high, including wood base 1⅝″ high x 19⅜″ diameter (4.2 x 49.3 cm). Kay Sage Tanguy Fund. 219.68.

　　CONSTELLATION. (1932) Painted wood relief, 11¾ x 13⅛ x 2⅜″ (29.6 x 33.1 x 6 cm). The Sidney and Harriet Janis Collection (fractional gift). 576.67. Repr. *Janis*, p. 60.

　　CONSTELLATION WITH FIVE WHITE AND TWO BLACK FORMS: VARIATION 2. (1932) Painted wood relief, 27⅝ x 33½ x 1½″ (70.1 x 85.1 x 3.6 cm). The Sidney and Harriet Janis Collection (fractional gift). 577.67. Repr. *Janis*, p. 61.

HUMAN CONCRETION. (1935) Original plaster, 19½ x 18¾″ (49.5 x 47.6 cm). Gift of the Advisory Committee. 4.37. Repr. *Ptg. & Sc.*, p. 279; *Masters*, p. 140; *Arp*, p. 65; *What Is Mod. Sc.*, p. 60.

168 HUMAN CONCRETION. Replica of above (4.37), cast stone, 1949. Cast authorized and approved by artist. Purchase. 328.49.

169 RELIEF. (1938–39, after a relief of 1934–35) Wood, 19½ x 19⅝″ (49.5 x 49.8 cm). Gift of the Advisory Committee (by exchange). 336.39. Repr. *Ptg. & Sc.*, p. 278; *What Is Mod. Sc.*, p. 117. *Note*: the original relief (which warped) was in wood, painted white.

HAND. (1941–42) Marble relief, 6⅝ x 7⅞ x 1⅜″ (16.7 x 20 x 3.5 cm). Gift of Mme Jean Arp in memory of René d'Harnoncourt. 118.69.

169 FLORAL NUDE. (1957) Marble, 47¼″ (120 cm) high, 10½″ (26.5 cm) diameter at base. Mrs. Simon Guggenheim Fund. 129.61. Repr. *Suppl. XI*, cover.

PRE-ADAMITE DOLL [*Poupée préadamite*]. (1964) Marble, 19¼ x 13 x 13″ (48.7 x 32.9 x 32.9 cm), on marble base, 4⅜″ high x 11⅛″ diameter (11 x 28 cm). The Sidney and Harriet Janis Collection (fractional gift). 578.67. Repr. *Janis*, p. 63.

ARTSCHWAGER, Richard. American, born 1924.

TOWER. (1964) Painted formica and wood, 6′6″ x 24⅛″ x 39″ (198.1 x 61.1 x 99 cm). Gift of Philip Johnson. 671.71.

KEY MEMBER. (1967) Formica veneer and felt on wood, 11⅞ x 29⅛ x 8⅝″ (30.1 x 74 x 21.9 cm). Gift of Philip Johnson. 220.68.

ASSETTO, Franco. Italian, born 1911.

DARK SEAL. 1958. Oil, partly in low relief, on canvas, 35½ x 39⅜″ (90.1 x 100 cm). G. David Thompson Fund. 1.59. Repr. *Suppl. IX*, p. 17.

ATHERTON, John. American, 1900–1952.

288 CHRISTMAS EVE. 1941. Oil on canvas, 30¼ x 35″ (76.8 x 88.9 cm). Purchase. 136.42. Repr. *Ptg. & Sc.*, p. 173.

CONSTRUCTION. (1942) Gouache on cardboard, 9 x 11⅞″ (22.9 x 30.2 cm). Abby Aldrich Rockefeller Fund. 137.42.

ATLAN, Jean-Michel. French, born Algeria. 1913–1960.

REALM. (1957) Pastel, 9⅞ x 12¾″ (25 x 32.3 cm). Benjamin Scharps and David Scharps Fund. 81.58. Repr. *Suppl. VIII*, p. 19.

AULT, George. American, 1891–1949.

228 NEW MOON, NEW YORK. 1945. Oil on canvas, 28 x 20″ (71.1 x 50.8 cm). Gift of Mr. and Mrs. Leslie Ault. 132.57. Repr. *Suppl. VII*, p. 12.

AUSTIN, Darrel. American, born 1907.

CATAMOUNT. (1940) Oil on canvas, 20 x 24″ (50.8 x 61 cm). Abby Aldrich Rockefeller Fund. 312.41. Repr. *Ptg. & Sc.*, p. 174.

AVERY, Milton. American, 1893–1965.

239 THE DESSERT. (1939) Oil on canvas, 28⅛ x 36⅛″ (71.4 x 91.8 cm). Gift of Mr. and Mrs. Roy R. Neuberger. 130.51. Repr. *Suppl. III*, p. 20. *Note*: at the table, upper left, are David Burliuk with wine glass in hand, his wife Marussia beside him; to her left, Wallace Putnam, in whose studio the gathering took place; in right foreground, the wife of the artist. The man at the left has not been identified.

MORNING DUNES. 1958. Oil on canvas, 36⅛ x 56⅛″ (91.7 x 142.5 cm). Eve Clendenin Bequest. 418.74.

239 SEA GRASSES AND BLUE SEA. 1958. Oil on canvas, 60⅛″ x 6′3⅜″ (152.7 x 183.7 cm). Gift of friends of the artist. 649.59. Repr. *Suppl. IX*, p. 20; in color, *Invitation*, p. 117.

AWA TSIREH (Alfonso Roybal). American Indian, Pueblo of San Ildefonso, New Mexico. 1900–1955.

235 GREEN CORN CEREMONY. (c. 1935) Gouache, 19¼ x 27¾″ (48.9 x 70.5 cm). Abby Aldrich Rockefeller Fund. 330.39. Repr. *Ptg. & Sc.*, p. 158; in color, *Indian Art* (2nd), p. 194.

BACCI, Edmondo. Italian, born 1913.

350 INCIDENT 13R. (1953) Tempera on canvas, 32¾ x 56¼″ (83.1 x 142.9 cm). Purchase. 253.56. Repr. *Suppl. VI*, p. 30.

BACON, Francis. British, born 1909.

266 PAINTING. (1946) Oil and tempera on canvas, 6′5⅞″ x 52″ (197.8 x 132.1 cm). Purchase. 229.48. Repr. *Suppl. I*, p. 17; in color, *Masters*, p. 169; in color, *Invitation*, p. 107.

267 DOG. (1952) Oil on canvas, 6′6¼″ x 54¼″ (198.7 x 137.8 cm). William A. M. Burden Fund. 408.53. Repr. *New Decade*, p. 62.

267 NUMBER VII FROM EIGHT STUDIES FOR A PORTRAIT. (1953) Oil on canvas, 60 x 46⅛″ (152.3 x 117 cm). Gift of Mr. and Mrs. William A. M. Burden. 254.56. Repr. *Suppl. VI*, p. 29. *Note*: a variation on the painting *Innocent X* by Velázquez.

BADEN, Mowry Thacher. American, born 1936.

282 THE GATE. 1960. Oil on canvas, 6′6″ x 6′3″ (198.2 x 190.5 cm). Larry Aldrich Foundation Fund. 356.60. Repr. *Suppl. X*, p. 29.

BADI, Aquiles. Argentine, born 1894.

SCHOOL TABLEAU, SAN MARTÍN'S BIRTHDAY. (1935) Tempera, 15 x 19½″ (38.1 x 49.5 cm). Inter-American Fund. 636.42. Repr. *Latin-Amer. Coll.*, p. 30.

BAER, Jo. American, born 1929.

PRIMARY LIGHT GROUP: RED, GREEN, BLUE. 1964–65. Oil and synthetic polymer paint on canvas; triptych, (*a*) 60⅜ x 60¼″ (153.1 x 153 cm) (red); (*b*) 60⅜ x 60⅜″ (153.1 x 153.2 cm) (green); (*c*) 60¼ x 60⅛″ (153 x 152.6 cm) (blue). Philip Johnson Fund. 495.69a–c. Repr. *Amer. Art*, p. 72.

BAER, Martin. American, 1894–1961.

PARROT TULIPS. 1939. Oil and tempera on canvas, 16 x 13″ (40.7 x 33 cm). Gift of Mrs. Simon Guggenheim. 467.41.

BAERTLING, Olle. Swedish, born 1911.

491 AGRIAKI. 1959. Oil on canvas, 6′5″ x 38½″ (195.4 x 97 cm). Gift of Galerie Denise René. 495.64.

491 SIRUR. (1959) Welded steel, painted, 9′2½″ x 12′4″ x 58″ (280.6 x 375.5 x 147.3 cm); iron base 19⅜ x 14″ (49.1 x 35.4 cm). Gift of Mr. and Mrs. Leif Sjöberg. 496.64a–d.

BAILEY, Malcolm. American, born 1947.

HOLD, SEPARATE BUT EQUAL. (1969) Synthetic polymer paint, presstype, watercolor, and enamel on composition board, 7′ x 48″ (213.2 x 121.9 cm). Mr. and Mrs. John R. Jakobson Fund. 386.70. Repr. *Amer. Art*, p. 60.

BAIZERMAN, Eugenie. American, born Poland. 1899–1949. To U.S.A. 1913.

ACTRESS DRESSING. 1945. Oil on canvas, 45⅝ x 34″ (115.7 x 86.3 cm). Gift of Mr. and Mrs. Ralph F. Colin. 108.61. Repr. *Suppl. XI*, p. 20. *Note*: the subject is said to be the actress Irene Worth.

BAKER, George P. American, born 1931.

478 644. 1963. Bronze (cast 1964), 4½ x 8¾ x 4″ (11.4 x 22.1 x 9.9 cm). Larry Aldrich Foundation Fund. 114.66.

BALLA, Giacomo. Italian, 1871–1958.

116 STREET LIGHT [*Lampada—Studio di luce*]. 1909. Oil on canvas, 68³/₄ x 45¹/₄″ (174.7 x 114.7 cm). Hillman Periodicals Fund. 7.54. Repr. *Suppl. V*, p. 14; in color, *Futurism*, p. 26; in color, *Invitation*, p. 96.

116 SPEEDING AUTOMOBILE. 1912. Oil on wood, 21⁷/₈ x 27¹/₈″ (55.6 x 68.9 cm). Purchase. 271.49. Repr. *20th-C. Italian Art*, pl. 29; *The Machine*, p. 54.

116 SWIFTS: PATHS OF MOVEMENT + DYNAMIC SEQUENCES. 1913. Oil on canvas, 38¹/₈ x 47¹/₄″ (96.8 x 120 cm). Purchase. 272.49. Repr. *20th-C. Italian Art*, pl. 27; *Futurism*, p. 63.

117 COMPOSITION. (c.1914?) Distemper on canvas, 32 x 26³/₈″ (81.3 x 67 cm) (sight). Gift of Mr. and Mrs. Arnold H. Maremont. 357.60b. On reverse: *Spring*. 357.60a. Repr. *Suppl. X*, p. 20.

117 SPRING. (c. 1916) Oil on canvas, 32 x 26³/₈″ (81.3 x 67 cm) (sight). Gift of Mr. and Mrs. Arnold H. Maremont. 357.60a. On reverse: *Composition*. 357.60b. Repr. *Suppl. X*, p. 20.

BALTHUS (Baltusz Klossowski de Rola). French, born 1908.

193 ANDRÉ DERAIN. 1936. Oil on wood, 44³/₈ x 28¹/₂″ (112.7 x 72.4 cm). Acquired through the Lillie P. Bliss Bequest. 67.44. Repr. *Ptg. & Sc.*, p. 188.

193 JOAN MIRÓ AND HIS DAUGHTER DOLORES. 1937–38. Oil on canvas, 51¹/₄ x 35″ (130.2 x 88.9 cm). Abby Aldrich Rockefeller Fund. 398.38. Repr. *Ptg. & Sc.*, p. 189; in color, *20th-C. Portraits*, opp. p. 102; *Balthus*, p. 15; in color, *Invitation*, p. 63.

BANGERT, Colette. American, born 1934.

FLATLAND FIELDS. 1961. Synthetic polymer paint on paper, 22¹/₄ x 30¹/₂″ (56.3 x 77.4 cm). Gift of Harold W. Bangert. 278.61. Repr. *Suppl. XI*, p. 33.

BANNARD, Walter Darby. American, born 1931.

MANDRAGORA NUMBER 3. (1969) Synthetic polymer paint on canvas, 66¹/₈″ x 8′2¹/₈″ (167.7 x 251.7 cm). Given anonymously. 1075.69. Repr. *Amer. Art*, p. 76.

BARANIK, Rudolf. American, born Lithuania 1920. To U.S.A. 1938.

NAPALM ELEGY TA 3. 1973. Oil and collage on composition board, 48 x 47³/₄″ (121.9 x 121.3 cm). Gift of Mr. and Mrs. David Stulberg. 111.75.

BARANOFF-ROSSINÉ, Vladimir. Russian, 1888–1942. To Paris 1925.

SYMPHONY NUMBER 1. (1913) Polychrome wood, cardboard, and crushed eggshells, 63¹/₄ x 28¹/₂ x 25″ (161.1 x 72.2 x 63.4 cm). Katia Granoff Fund. 35.72.

BARELA, Patrocino. American, 1908–1964.

CORONATION OF THE VIRGIN. (1936) Wood relief, 20¹/₂ x 11″ (52.1 x 27.9 cm). Extended loan from the United States WPA Art Program. E.L.38.3051. Repr. *New Horizons*, no. 241.

11 THE TWELVE APOSTLES. (1936) Wood relief, 11¹/₂ x 61″ (29.2 x 154.9 cm). Extended loan from the United States WPA Art Program. E.L.44.1992.

BARKER, Walter William. American, born Germany 1921.

I-CHING SERIES. 1962. Watercolor, ink, and gouache, 19⁵/₈ x 13¹/₄″ (49.8 x 33.7 cm). Gift of Mr. and Mrs. Joseph Pulitzer, Jr. 396.63.

340 I-CHING SERIES, 5. 1963. Oil and chalk on canvas, 7′1¹/₈″ x 64¹/₈″ (213.8 x 163 cm). Gift of Mr. and Mrs. Morton D. May. 395.63.

BARLACH, Ernst. German, 1870–1938.

43 HEAD (DETAIL, WAR MONUMENT, GÜSTROW CATHEDRAL). (1927) Bronze, 13¹/₂″ (34.3 cm) high. Gift of Edward M. M. Warburg. 521.41. Repr. *Ptg. & Sc.*, p. 248.

43 SINGING MAN. (1928) Bronze, 19¹/₂ x 21⁷/₈ x 14¹/₈″ (49.5 x 55.3 x 35.9 cm). Abby Aldrich Rockefeller Fund. 656.39. Repr. *Ptg. & Sc.*, p. 249.

BARNES, Matthew Rackham. American, born Scotland. 1880–1951. To U.S.A. 1904.

243 HIGH PEAK. 1936. Oil on canvas, 36¹/₄ x 42¹/₈″ (92.1 x 107 cm). Acquired through the Lillie P. Bliss Bequest. 745.43. Repr. *Romantic Ptg.*, p. 111.

BARNET, Will. American, born 1911.

368 GOLDEN TENSION. 1959–60. Oil and gold leaf on canvas, 64 x 39⁷/₈″ (162.5 x 101.2 cm). Gift of Dr. Jack M. Greenbaum. 22.60. Repr. *Suppl. X*, p. 43.

BART, Robert. American, born Canada 1923. To U.S.A. 1928.

Untitled. 1964. Aluminum, 66¹/₂ x 28³/₄ x 28³/₄″ (168.7 x 73 x 73 cm). Gift of Philip Johnson. 766.69.

BARUCHELLO, Gianfranco. Italian, born 1924.

395 EXIT FROM THE GREAT ACCOLADE [*Uscita dalla grande accolade*]. 1963. Oil on canvas, 25 x 24³/₄″ (63.3 x 62.9 cm). Gift of Cordier & Ekstrom, Inc. 588.63.

BASALDÚA, Héctor. Argentine, born 1895.

EXPRESO VILLALONGA (EL CALLE). 1937. Tempera on cardboard, 12¹/₄ x 18³/₄″ (31.1 x 47.6 cm). Inter-American Fund. 641.42. Repr. *Latin-Amer. Coll.*, p. 30.

BASCHET, Bernard, born 1917, and François, born 1920, French.

488 GLASS TROMBONE. (1958) Steel, glass and metal rods, aluminum, brass, and cord, 65 x 36 x 23³/₈″ (165 x 91.4 x 59.2 cm). Gift of Daphne Hellman Shih. 115.66. *Note*: Bernard Baschet is the sound engineer and François the sculptor.

BASKIN, Leonard. American, born 1922.

302 MAN WITH A DEAD BIRD. (1951–56) Walnut, 64 x 18¹/₂″ (162.5 x 46.9 cm). A. Conger Goodyear Fund. 25.57. Repr. *Suppl. VII*, p. 24; *New Images*, p. 34.

302 SEATED BIRDMAN. (1961) Bronze, 35³/₄ x 15⁷/₈ x 20¹/₂″ (90.5 x 40.3 x 52 cm). Gift of Mr. and Mrs. Herman D. Shickman. 112.62. Repr. *Suppl. XII*, p. 16.

BAUCHANT, André. French, 1873–1958.

8 THE PROCLAMATION OF AMERICAN INDEPENDENCE. 1926. Oil on canvas, 30 x 46⁵/₈″ (76.2 x 118.4 cm). Inscribed: *Washington Procured Independence for the United States 4 Juili 1776. Libertas Americana. Lexington April, 19th 1775. Comitia Americana 17 Mars 1776*. Gift of Mme Ève Daniel and Mme Sibylle Cournand in memory of their mother, Mme Jeanne Bucher. 301.47. Repr. *Masters Pop. Ptg.*, no. 3. *Note*: represented, left to right, are Rochambeau, Franklin, Washington, and Lafayette.

8 CLEOPATRA'S BARGE [*Cléopatre allant trouver Antoine à Tarse*]. 1939. Oil on canvas, 32 x 39³/₈″ (81.3 x 100 cm). Abby Aldrich Rockefeller Fund. 649.39. Repr. *Ptg. & Sc.*, p. 17.

BAUERMEISTER, Mary. American, born Germany 1934. To U.S.A. 1962. Works in U.S.A. and Germany.

486 PROGRESSIONS. 1963. Pebbles and sand on four plywood panels, 51¼ x 47⅜ x 4¾″ (130.1 x 120.4 x 12 cm). Matthew T. Mellon Foundation Fund. 254.64.

BAUMEISTER, Willi. German, 1889–1955.

139 COMPOSITION. (1922) Gouache and crayon, 12¾ x 8⅝″ (32.4 x 21.9 cm). Katherine S. Dreier Bequest. 142.53.

410 AFRICAN PLAY, IV. 1942. Oil on composition board, 14⅛ x 18⅛″ (35.7 x 45.9 cm). Gift of Mr. and Mrs. F. Taylor Ostrander. 568.66.

139 ARU 6. 1955. Oil on composition board, 51¼ x 39¼″ (129.9 x 99.5 cm). Given anonymously. 9.56. Repr. *Suppl. VI*, p. 17.

BAYER, Herbert. American, born Austria 1900. To U.S.A. 1938.

141 IMAGE WITH GREEN MOON. 1961. Synthetic polymer paint on canvas, 16¼ x 16¼″ (41 x 41 cm). Given anonymously. 267.63.

BAZAINE, Jean. French, born 1904.

345 THE FLAME AND THE DIVER. 1953. Oil on canvas, 6′4¾″ x 51″ (194.8 x 129.5 cm). Given anonymously. 1.57. Repr. *Suppl. VII*, p. 19.

BAZIOTES, William. American, 1912–1963.

332 DWARF. 1947. Oil on canvas, 42 x 36⅛″ (106.7 x 91.8 cm). A. Conger Goodyear Fund. 229.47. Repr. *Ptg. & Sc.*, p. 227; in color, *New Amer. Ptg.*, p. 21.

332 POMPEII. 1955. Oil on canvas, 60 x 48″ (152.4 x 121.9 cm). Mrs. Bertram Smith Fund. 189.55. Repr. *Suppl. VI*, p. 23; *New Amer. Ptg.*, p. 23.

BEARDEN, Romare. American, born 1914.

HE IS ARISEN. (1945) Watercolor and India ink, 26 x 19⅜″ (66 x 49.2 cm). Advisory Committee Fund. 158.45.

338 THE SILENT VALLEY OF SUNRISE. (1959) Oil and casein on canvas, 58⅛ x 42″ (147.5 x 106.5 cm). Given anonymously. 113.60. Repr. *Suppl. X*, p. 37.

THE CONJUR WOMAN. (1964) Collage and gouache on cardboard, 12⅛ x 9⅜″ (30.6 x 23.7 cm). Blanchette Rockefeller Fund. 376.71. Repr. *Bearden*, p. 8.

THE DOVE. (1964) Collage, gouache, pencil, and colored pencil on cardboard, 13⅜ x 18¾″ (33.8 x 47.5 cm). Blanchette Rockefeller Fund. 377.71. Repr. *Bearden*, p. 9.

PATCHWORK QUILT. (1970) Collage of cloth and paper with synthetic polymer paint on composition board, 35¾ x 47⅞″ (90.9 x 121.6 cm). Blanchette Rockefeller Fund. 573.70. Repr. in color, *Bearden*, cover; in color, *Invitation*, p. 79.

BEASLEY, Bruce. American, born 1939.

CHORUS. (1960) Welded iron, 10½ x 14¾ x 9¾″ (26.6 x 37.5 x 24.7 cm). Gift of Mr. and Mrs. Frederick R. Weisman. 1.62. Repr. *Suppl. XII*, p. 22.

BEAUCHAMP, Robert. American, born 1923.

283 Untitled. 1962. Oil on canvas, 67″ x 6′10″ (170.2 x 208.2 cm). Larry Aldrich Foundation Fund. 226.62. Repr. *Suppl. XII*, p. 26.

BECHER, Bernhard, born 1931, and Hilla, born 1934. German.

ANONYMOUS SCULPTURE. (1970) Thirty photographs and text panel with reproduction. Photographs each 15⅞ x 11¾″ (40.1 x 29.9 cm); overall, 6′11⅝″ x 6′2¼″ (207.3 x 188.4 cm); text panel, 30⅞ x 12″ (78.4 x 30.2 cm). Gertrud A. Mellon Fund. 387.70a–ff.

BECKLEY, Bill. American, born 1946.

HOT AND COLD FAUCETS WITH DRAIN. 1975. Three Cibachrome color photographs mounted on composition board, each approximately 39⅞ x 30″ (101.2 x 76 cm). Purchased with the aid of funds from the National Endowment for the Arts and an anonymous donor. 589.76.1–3.

BECKMANN, Max. German, 1884–1950. Worked in Amsterdam 1936–47; in U.S.A. 1947–50.

72 THE DESCENT FROM THE CROSS. 1917. Oil on canvas, 59½ x 50¾″ (151.2 x 128.9 cm). Curt Valentin Bequest. 328.55. Repr. *Suppl. V*, p. 12; *Beckmann*, p. 28; *Modern Masters*, p. 127.

72 FAMILY PICTURE. 1920. Oil on canvas, 25⅝ x 39¾″ (65.1 x 100.9 cm). Gift of Abby Aldrich Rockefeller. 26.35. Repr. *Ptg. & Sc.*, p. 83; in color, *Beckmann*, p. 34. *Note*: represented, left to right, are the artist, his first wife, Minna Beckmann-Tube, his mother-in-law, Frau Tube, his wife's sister, Anne Marie Tube, a servant (reading newspaper); in foreground, his son, Peter Beckmann.

72 THE PRODIGAL SON. (1921) Series of four paintings: THE PRODIGAL SON AMONG COURTESANS, THE PRODIGAL SON AMONG SWINE, THE RETURN OF THE PRODIGAL, THE FEAST OF THE PRODIGAL. Gouache and watercolor with pencil underdrawing on parchment, 14¼ to 14½ x 11¾″ (36.1 to 36.9 x 29.9 cm). Purchase. 263–266.39.

72 SELF-PORTRAIT WITH A CIGARETTE. 1923. Oil on canvas, 23¾ x 15⅞″ (60.2 x 40.3 cm). Gift of Dr. and Mrs. F. H. Hirschland. 255.56. Repr. *Suppl. VI*, p. 16; *Beckmann*, p. 37.

73 DEPARTURE. (1932–33) Oil on canvas; triptych, center panel 7′3¾″ x 45⅜″ (215.3 x 115.2 cm); side panels each 7′3¾″ x 39¼″ (215.3 x 99.7 cm). Given anonymously (by exchange). 6.42.1–.3. Repr. *Ptg. & Sc.*, p. 82; in color, *Masters*, p. 63; *Beckmann*, pp. 59–60; in color, *Invitation*, pp. 104–05. *Note*: in his studio notebook the artist recorded the titles and dates of the three panels. All were begun in Frankfort about May 1932 and finished in Berlin late in 1933. See *Beckmann*, p. 55. Left panel: THE CASTLE [*Das Schloss*] finished 31 Dec. 1933. Center panel: THE HOMECOMING [*Die Heimkehr*] finished 15 Nov. 1933. Right panel: THE STAIRCASE [*Die Treppe*] finished 4 Nov. 1933.

73 SELF-PORTRAIT. (1936) Bronze (cast 1951), 14½″ (36.8 cm) high. Gift of Curt Valentin. 506.51.

BELL, Larry. American, born 1939.

508 GLASS SCULPTURE NUMBER 10. (1964) Partially silvered glass with chromium frame, 10⅜″ (26.2 cm) cube. Promised gift and extended loan from Mr. and Mrs. William N. Copley. E.L.65.392.

508 SHADOWS. (1967) Partially silvered glass with chromium frame, 14¼″ (36.1 cm) cube. Gift of the artist. 116.67.

BELLING, Rudolf. German, 1886–1972. In Istanbul 1937–65.

139 SCULPTURE. (1923) Bronze, partly silvered, 18⅞ x 7¾ x 8½″ (48 x 19.7 x 21.5 cm). A. Conger Goodyear Fund. 246.56. Repr. *Suppl. VI*, p. 16; *German Art of 20th C.*, p. 174; *What Is Mod. Sc.*, p. 46.

ALFRED FLECHTHEIM. (1927) Bronze, 7½″ (19 cm) high, at base, 4¾″ (12 cm) diameter. Gift of Curt Valentin. 3.50.

BELLMER, Hans. German, born Upper Silesia (now Poland). 1902–1975. To France 1938.

DOLL. (1936) Painted aluminum (cast 1965), 19⅛ x 10⅝ x 14⅞″ (48.5 x 26.9 x 37.6 cm), on bronze base, 7½ x 8 x 8″ (18.8 x 20.3 x 20.1 cm). The Sidney and Harriet Janis Collection (fractional gift). 579.67. Repr. *Janis*, p. 69.

THE MACHINE-GUNNERESS IN A STATE OF GRACE. (1937) Construction of wood and metal, 30⅞ x 29¾ x 13⅝″ (78.5 x 75.5 x 34.5 cm), on wood base 4¾ x 15¾ x 11⅞″ (12 x 40 x 29.9 cm). Advisory Committee Fund. 713.68. Repr. *Dada, Surrealism*, p. 151; *The Machine*, p. 160.

BELLOWS, George Wesley. American, 1882–1925.

234 UNDER THE ELEVATED. Watercolor, 5¾ x 8⅞″ (14.6 x 22.5 cm). Gift of Abby Aldrich Rockefeller. 27.35.

BEMAN, Roff. American, 1891–1940.

CORNFIELD AFTER RAIN. 1938. Oil on canvas, 30 x 40″ (76.2 x 101.6 cm). Extended loan from the United States WPA Art Program. E.L.39.1781.

234 BRUMMITT'S CORNFIELD. 1939. Oil on canvas, 24¼ x 36¼″ (61.6 x 92.1 cm). Extended loan from the United States WPA Art Program. E.L.39.1780. Repr. *Romantic Ptg.*, p. 116.

BENDER, C. Whitney. American, born 1929.

HUMID DAY. (1946) Gouache on cardboard, 15⅝ x 21⅝″ (39.7 x 54.9 cm). Purchase. 1.48.

BENEDIT, Luis Fernando. Argentine, born 1937.

442 PULLET. 1963. Oil and enamel on canvas, 31½ x 23¾″ (80 x 60.2 cm). Inter-American Fund. 255.64.

BENGLIS, Lynda. American, born 1941.

VICTOR. (1974) Aluminum screen, cotton bunting, plaster, sprayed zinc, steel, and tin, 66⅞ x 20½ x 13⅛″ (169.8 x 52 x 33.3 cm). Purchased with the aid of funds from the National Endowment for the Arts and an anonymous donor. 372.75.

BENGSTON, Billy Al. American, born 1934.

500 GREGORY. 1961. Lacquer and synthetic enamel on composition board, 48⅛ x 48⅛″ (122 x 122 cm). Larry Aldrich Foundation Fund. 628.65.

BENNETT, Rainey. American, born 1907.

FARM FIELDS. 1938. Watercolor, 21¾ x 30″ (55.2 x 76.2 cm). Purchase. 567.39.

BEN-SHMUEL, Ahron. American, born 1903.

256 PUGILIST. (1929) Black granite, 21″ (53.3 cm) high. Gift of Nelson A. Rockefeller. 172.34. Repr. *Ptg. & Sc.*, p. 262.

TORSO OF A BOY. 1930. Stone (diabase), 28¾″ (73 cm) high. Given anonymously. 314.41. Repr. *Ptg. & Sc. (I)*, p. 24.

SEATED WOMAN. 1932. Granite, 14¾″ (37.5 cm) high. Gift of Edward M. M. Warburg. 150.34. Repr. *Modern Works*, no. 158.

BENTON, Thomas Hart. American, 1889–1975.

234 HOMESTEAD. (1934) Tempera and oil on composition board, 25 x 34″ (63.5 x 86.4 cm). Gift of Marshall Field (by exchange). 6.38. Repr. *Ptg. & Sc.*, p. 157.

BEN-ZION. American, born Ukraine 1897. To U.S.A. 1920.

DE PROFUNDIS: IN MEMORY OF THE MASSACRED JEWS OF NAZI EUROPE (from a series of 14). (1943) Gouache and ink, 24 x 19″ (61 x 48.3 cm). Given anonymously. 2.44.

BÉRARD, Christian. French, 1902–1949.

194 JEAN COCTEAU. 1928. Oil on canvas, 25⅝ x 21¼″ (65.1 x 54 cm). Abby Aldrich Rockefeller Fund. 25.40. Repr. *Ptg. & Sc.*, p. 185.

194 PROMENADE. 1928. Oil on canvas, 16⅛ x 10⅝″ (41 x 27 cm). Purchase. 194.42. Repr. *Ptg. & Sc.*, p. 185.

194 ON THE BEACH (DOUBLE SELF-PORTRAIT). 1933. Oil on canvas, 31⅞ x 46″ (80.8 x 116.7 cm). Gift of James Thrall Soby. 23.60. Repr. *Suppl. X*, p. 23; *Soby Collection*, p. 27.

BERDECIO, Roberto. Bolivian, born 1913. Has worked in Mexico and U.S.A.

214 THE CUBE AND THE PERSPECTIVE. 1935. Duco airbrushed on steel panel mounted on wood, 30 x 26″ (76.2 x 66 cm). Gift of Leigh Athearn. 315.41. Repr. *Latin-Amer. Coll.*, p. 33.

BERMAN, Eugene. American, born Russia. 1899–1972. In France 1919–39; in U.S.A. 1939–56; in Italy 1956–72.

194 WINTER. 1929. Oil on canvas, 36⅛ x 28¾″ (91.8 x 73 cm). Gift of Richard Blow. 209.37. Repr. *Ptg. & Sc.*, p. 186.

194 THE GOOD SAMARITAN. 1930. Oil on canvas, 36¼ x 28⅞″ (92.1 x 73.3 cm). Gift of Mr. and Mrs. Edward M. M. Warburg. 256.56. Repr. *Suppl. VI*, p. 21.

195 SLEEPING FIGURES, STATUE, CAMPANILE. 1932. Oil on canvas, 36¼ x 28¾″ (92.1 x 73 cm). Gift of Philip L. Goodwin. 120.45. Repr. *Ptg. & Sc.*, p. 186.

195 THE GATES OF THE CITY, NIGHTFALL. 1937. Oil on canvas, 30¼ x 40¼″ (76.8 x 102.2 cm). Gift of James Thrall Soby. 224.47. Repr. *Ptg. & Sc.*, p. 187.

ICARE. Three designs for scenery for the ballet produced by the Ballets Russes de Monte Carlo, London, 1938. Gouache, 8½ x 11⅛″; 7⅞ x 10¾″; 10⅛ x 17⅞″ (21.6 x 28.3 cm; 20 x 27.2 cm; 25.6 x 45.3 cm). Gift of the artist. 61.42.1–.3. Theatre Arts Collection.

DEVIL'S HOLIDAY. Twelve gouache designs for the ballet produced by the Ballets Russes de Monte Carlo, New York, 1939. Six designs for costumes, 11⅞ x 15⅞″ to 8 x 5″ (30.2 x 40.3 to 20.3 x 12.7 cm); six designs for scenery, 12⅝ x 14⅞″ to 9⅜ x 12½″ (32.1 x 37.8 to 23.8 x 31.7 cm). 59.42.1–.11, gift of Paul Magriel; 109.46, gift of Briggs W. Buchanan. Theatre Arts Collection. Design for scenery (59.42.8) repr. *Masters*, p. 182.

GISELLE. Six designs for scenery for the ballet, 1940, unproduced. Gouache, various sizes, 14½ x 22″ to 4⅞ x 7⅜″ (36.8 x 55.9 to 12.4 x 18.7 cm). Gift of Paul Magriel. 60.42.1–.6. Theatre Arts Collection.

NUAGES. Design for costume for the ballet, 1940, not used. Gouache, 8⅞ x 11″ (22.5 x 27.9 cm). Gift of Paul Magriel. 62.42. Theatre Arts Collection.

BERMAN, Leonid. See LEONID.

BERMÚDEZ, Cundo. Cuban, born 1914.

THE BALCONY. (1941) Oil on canvas, 29 x 23⅛″ (73.7 x 58.7 cm). Gift of Edgar Kaufmann, Jr. 644.42. Repr. *Latin-Amer. Coll.*, p. 53. *Note*: the Museum owns one watercolor and eleven ink studies for this painting.

287 BARBER SHOP. 1942. Oil on canvas, 25⅛ x 21⅛″ (63.8 x 53.7 cm). Inter-American Fund. 68.44. Repr. *Bulletin*, vol. XI, no. 5, 1944, p. 10.

BERMÚDEZ, José Ygnacio. Cuban, born 1922.

382 MICROFLORA. 1956. Collage of paper with charcoal, pencil, tempera, 19¾ x 25½″ (50.2 x 64.7 cm). Inter-American Fund. 557.56. Repr. *Suppl. VI*, p. 35.

BERNARD, Émile. French, 1868–1941.

29 BRIDGE AT ASNIÈRES. 1887. Oil on canvas, 18⅛ x 21⅜″ (45.9 x 54.2 cm). Grace Rainey Rogers Fund. 113.62. Repr. *Suppl. XII*, p. 5; in color, *Post-Impress.* (2nd), p. 61.

BERROCAL, Miguel Ortiz. Spanish, born 1933. Lives in France and Italy.

478 MARIA OF THE O. (1964) Bronze, in seven demountable parts, 4¹/₈ x 6¹/₄ x 3″ (10.3 x 15.8 x 7.5 cm). Purchase. 126.65a–g.

BERTHOT, Jake. American, born 1939.

WALKEN'S RIDGE. 1975–76. Oil on canvas mounted on wood, two panels, each 59⁷/₈″ x 7′ (152.1 x 213.4 cm); overall, 60¹/₈″ x 14′¹/₈″ (152.5 x 427 cm). Louis and Bessie Adler Foundation Fund. 97.76a–b.

BEUYS, Joseph. German, born 1921.

THE SLED. 1969. Sled of wood and metal with felt, cloth straps, flashlight, wax, and cord, 13⁷/₈ x 35⁵/₈ x 13⁵/₈″ (35.2 x 90.5 x 34.5 cm). Gertrud A. Mellon Fund. 498.70. Note: Multiple edition, 45/50.

BIANCO, Pamela. American, born Great Britain 1906. To U.S.A. 1921.

315 POMEGRANATE. 1957–59. Oil and gold leaf on canvas, 30¹/₈ x 24″ (76.3 x 60.9 cm). Larry Aldrich Foundation Fund. 109.61. Repr. Suppl. XI, p. 44.

BIEDERMAN, Charles. American, born 1906.

417 RELIEF, NEW YORK. (1936) Casein on wood with metal, nails, and string, 33³/₈ x 6³/₄ x 5⁷/₈″ (84.7 x 17.1 x 14.9 cm). Gift of A. Conger Goodyear. 70.36.

BIGAUD, Wilson. Haitian, born 1931.

9 MURDER IN THE JUNGLE. (1950) Oil on composition board, 23⁷/₈ x 29³/₄″ (60.6 x 75.6 cm). Inter-American Fund. 2.51. Repr. Suppl. III, p. 24.

BISCHOFF, Elmer. American, born 1916.

280 GIRL WADING. 1959. Oil on canvas, 6′10⁵/₈″ x 67³/₄″ (209.8 x 172 cm). Blanchette Rockefeller Fund. 1.60. Repr. Suppl. X, p. 26.

BISHOP, James. American, born 1927.

UNTITLED NUMBER 2. (1973) Oil on canvas, 6′4″ x 6′4¹/₈″ (193.1 x 193.3 cm). Purchased with the aid of funds from the National Endowment for the Arts and an anonymous donor. 1396.75.

BISSIER, Julius. German, 1893–1965. Lived in Switzerland.

395 6 JULY 1959. 1959. Oil and tempera on canvas, 8¹/₄ x 11¹/₄″ (21 x 28.5 cm). Gertrud A. Mellon Fund. 397.63.

BISSIÈRE, Roger. French, 1888–1964.

193 RED AND BLACK. 1952. Oil and egg tempera on canvas, 42¹/₂ x 26³/₄″ (107.9 x 67.8 cm). Gift of Miss Darthea Speyer. 515.61. Repr. Suppl. XI, p. 16.

192 RED BIRD ON BLACK. 1953. Oil and egg tempera on canvas, 40 x 19⁵/₈″ (101.4 x 49.7 cm). Gift of Mr. and Mrs. Werner E. Josten. 713.59. Repr. Suppl. IX, p. 16.

BITTLEMAN, Arnold. American, born 1933.

COLLAGE WITH A LEAF. (1957) Oil with collage of leaves on paper, 30¹/₈ x 22⁷/₈″ (76.2 x 58.2 cm). Purchase. 108.58.

BLACKWELL, Tom. American, born 1938.

JAFFREY. 1976. Oil on canvas, 7′7⁷/₈″ x 6′1⁷/₈″ (212.8 x 187.3 cm). Mr. and Mrs. Stuart M. Speiser Fund. 590.76.

BLADEN, Ronald. American, born Canada 1918. To U.S.A. 1939.

Untitled. (1965–66) Painted wood, 36¹/₈ x 19¹/₄ x 24⁵/₈″ (92.7 x 48.7 x 62.5 cm). Gift of Donald Droll. 673.71.

496 Untitled. (1966–67; first made in wood, 1965) Painted and burnished aluminum in three identical parts, each 10′ x 48″ x 24″ (305 x 122 x 61 cm), spaced 9′4″ (284 cm) apart; overall length 28′4″ (864 cm). James Thrall Soby Fund. 69.67a–c. Repr. What Is Mod. Sc., p. 108.

BLANCO. See RAMOS BLANCO.

BLATAS, Arbit. American, born Lithuania 1908. Worked in Paris. To U.S.A. 1940.

THREE CHILDREN. (1938) Oil on canvas, 39¹/₄ x 13⁵/₈″ (99.7 x 34.6 cm). Gift of the French Art Galleries, Inc. 12.40.

BLOOM, Hyman. American, born Latvia 1913. To U.S.A. 1920.

CHRISTMAS TREE. 1939. Oil on canvas, 52 x 31″ (132.1 x 78.8 cm). Extended loan from the United States WPA Art Program. E.L.41.2312.

273 THE SYNAGOGUE. (c. 1940) Oil on canvas, 65¹/₄ x 46³/₄″ (165.7 x 118.7 cm). Acquired through the Lillie P. Bliss Bequest. 611.43. Repr. Ptg. & Sc., p. 171.

273 THE BRIDE. (1941) Oil on canvas, 20¹/₈ x 49⁷/₈″ (51.1 x 126.7 cm). Purchase. 7.42. Repr. Romantic Ptg., p. 99.

BLOSUM, Vern. American, born 1936.

392 TIME EXPIRED. 1962. Oil on canvas, 37¹/₂ x 27⁷/₈″ (95.1 x 70.7 cm). Larry Aldrich Foundation Fund. 71.63.

BLOW, Sandra. British, born 1925.

WINTER. (1956) Oil, sawdust, gauze on composition board, 36 x 60¹/₈″ (91.5 x 152.6 cm). Purchase. 257.56. Repr. Suppl. VI, p. 30.

BLUEMNER, Oscar Florianus. American, 1867–1938.

223 THE EYE OF FATE. (1927) Watercolor, 13³/₈ x 10″ (33.8 x 25.3 cm). Gift of James Graham and Sons. 78.60. Repr. Suppl. X, p. 21.

223 SUN STORM. (1927) Watercolor, 10 x 13¹/₄″ (25.3 x 33.5 cm). Gift of James Graham and Sons. 79.60. Repr. Suppl. X, p. 21.

BLUHM, Norman. American, born 1920.

VOLOS. 1971. Oil on canvas; triptych, each panel 38¹/₈ x 48¹/₈″ (96.7 x 122.1 cm); overall, 38¹/₈″ x 12′3³/₄″ (96.7 x 367.6 cm). Gift of Mr. and Mrs. Eliot C. Clarke. 261.72a–c.

BLUME, Peter. American, born Russia 1906. To U.S.A. 1911.

245 THE BOAT. (1929) Oil on canvas, 20¹/₈ x 24¹/₈″ (51.1 x 61.3 cm). Gift of Mrs. Sam A. Lewisohn. 39.52. Repr. Suppl. IV, p. 30.

Study for PARADE. 1929. Oil on cardboard, 20¹/₄ x 14″ (51.4 x 35.6 cm). Gift of Abby Aldrich Rockefeller. 30.35. Repr. La Pintura, p. 109.

244 PARADE. 1930. Oil on canvas, 49¹/₄ x 56³/₈″ (125.1 x 143.2 cm). Gift of Abby Aldrich Rockefeller. 29.35. Repr. Ptg. & Sc., p. 133.

MONK. Study for THE ETERNAL CITY. (1937) Oil on paper, 9⁷/₈ x 9¹/₂″ (25.1 x 24.1 cm). Given anonymously. 121.45.

245 THE ETERNAL CITY. 1937 (1934–37. Dated on painting 1937). Oil on composition board, 34 x 47⁷/₈″ (86.4 x 121.6 cm). Mrs. Simon Guggenheim Fund. 574.42. Repr. Ptg. & Sc., p. 152; in color, Masters, p. 161; in color, Invitation, p. 106. Note: the Museum also owns four pencil studies for this painting.

245 LANDSCAPE WITH POPPIES. (1939) Oil on canvas, 18 x 25¹/₈″ (45.7 x 63.8 cm). Gift of Abby Aldrich Rockefeller. 391.41. Repr. *Ptg. & Sc.*, p. 162.

BLUMENSCHEIN, Ernest Leonard. American, 1874–1960.

235 JURY FOR TRIAL OF A SHEEPHERDER FOR MURDER. (1936) Oil on canvas, 46¹/₄ x 30″ (117.5 x 76.2 cm). Abby Aldrich Rockefeller Fund. 300.38. Repr. *Art in Our Time*, no. 142.

BOCCACCI, Marcello. Italian, born 1914.

COMPOSITION—FIGURES AND LANDSCAPE. (1952) Gouache and pastel, 8⁵/₈ x 33¹/₄″ (21.9 x 84.5 cm). Gift of Mr. and Mrs. David M. Solinger. 29.53.

BOCCIONI, Umberto. Italian, 1882–1916.

118 THE CITY RISES. (1910) Oil on canvas, 6′6¹/₂″ x 9′10¹/₂″ (199.3 x 301 cm). Mrs. Simon Guggenheim Fund. 507.51. Repr. *Suppl. IV*, p. 20; in color, *Masters*, p. 99; *Futurism*, p. 37. *Note*: the left-hand third of *The City Rises* was damaged by fire in 1958 and has been partially repainted with pigment in a vinyl medium over discolored original oil paint. The Museum owns the final composition study, in black crayon, for this painting.

118 THE LAUGH. (1911) Oil on canvas, 43³/₈ x 57¹/₄″ (110.2 x 145.4 cm). Gift of Herbert and Nannette Rothschild. 656.59. Repr. *Suppl. IX*, p. 11; in color, *Futurism*, p. 40; *Modern Masters*, p. 149. *Note*: the Museum owns a pencil drawing related to this painting but probably a study for an earlier version of the same subject.

119 THE RIOT. (1911 or after) Oil on canvas, 19⁷/₈ x 19⁷/₈″ (50.5 x 50.5 cm). Gift of Herbert and Nannette Rothschild. 252.57. Repr. *Suppl. VII*, p. 7; *Futurism*, p. 34. *Note*: two ink drawings, dated 18 April 1911, are apparently studies for this painting and are reproduced in *Futurism*, p. 34.

119 DEVELOPMENT OF A BOTTLE IN SPACE. (1912) Silvered bronze (cast 1931), 15 x 12⁷/₈ x 23³/₄″ (38.1 x 32.7 x 60.3 cm). Aristide Maillol Fund. 230.48. Repr. *20th-C. Italian Art*, pl. 12; *Futurism*, p. 92; *Rosso*, p. 62. *Note*: variously titled by the artist *Sviluppo di una bottiglia nello spazio mediante la forma (Natura morta)*, and *Sviluppo di una bottiglia nello spazio (Natura morta)*.

DYNAMISM OF A SOCCER PLAYER [*Dinamismo di un footballer*]. (1913) Oil on canvas, 6′4¹/₈″ x 6′7¹/₈″ (193.2 x 201 cm). The Sidney and Harriet Janis Collection (fractional gift). 580.67. Repr. *Futurism*, p. 89; in color, *Janis*, p. 23; in color, *Invitation*, p. 55.

119 UNIQUE FORMS OF CONTINUITY IN SPACE. (1913) Bronze (cast 1931), 43⁷/₈ x 34⁷/₈ x 15³/₄″ (111.2 x 88.5 x 40 cm). Acquired through the Lillie P. Bliss Bequest. 231.48. Repr. *Sc. of 20th C.*, pp. 134, 135; *Masters*, p. 101; *Futurism*, p. 95; *What Is Mod. Sc.*, p. 49. *Note*: the Museum owns a large charcoal study for this sculpture, entitled by the artist *Muscular Dynamism*, and a pencil study.

BOICE, Bruce. American, born 1941.

Untitled. 1974. Synthetic polymer paint on three joined canvases with wood, overall, 31¹/₂″ x 7′8″ (80 x 233.7 cm). Purchased with the aid of funds from the National Endowment for the Arts and the Robert Rosenblum Fund. 39.75.

BOLOMEY, Roger. American, born 1918.

482 OCEAN GAME. 1964. Construction of polyurethane and aluminum on a wood frame, 52¹/₂″ x 6′1¹/₄″ x 28¹/₄″ (133.2 183.4 x 71.7 cm). Gift of Dr. Rosemary Lenel. 382.66.

BOLOTOWSKY, Ilya. American, born Russia 1907. To U.S.A. 1923.

364 WHITE CIRCLE. (1958) Oil on canvas, about 60³/₄″ (154.3 cm) diameter. Gift of N. E. Waldman. 24.60. Repr. *Suppl. X*, p. 51.

BOLUS, Michael. British, born South Africa 1934.

SEPTEMBER 64. (1964) Painted aluminum, 16¹/₈″ x 7′4⁵/₈″ x 48¹/₄″ (41 x 225.1 x 122.6 cm). Purchase. 768.69.

BOMBOIS, Camille. French, 1883–1970.

9 BEFORE ENTERING THE RING. (1930–35) Oil on canvas, 23⁵/₈ x 28³/₄″ (60 x 73 cm). Abby Aldrich Rockefeller Fund. 662.39. Repr. *Ptg. & Sc.*, p. 18.

BONEVARDI, Marcelo. Argentine, born 1929. To U.S.A. 1958.

480 FIGURE, I. 1964. Synthetic polymer paint on joined canvas, with construction of wood and string, 25¹/₈ x 21³/₄ x 2¹/₈″ (63.7 x 55 x 5.2 cm). Inter-American Fund. 650.64.

BONNARD, Pierre. French, 1867–1947.

32 THREE PANELS OF A SCREEN. (1894–96) Oil on brown twill lined with canvas, each panel about 65³/₄ x 20″ (167 x 50.8 cm). Gift of Mr. and Mrs. Allan D. Emil. 2.55.1–.3. Repr. *Suppl. V*, p. 6. *Note*: the screen originally had four panels.

33 THE BREAKFAST ROOM. (c. 1930–31) Oil on canvas, 62⁷/₈ x 44⁷/₈″ (159.6 x 113.8 cm). Given anonymously. 392.41. Repr. *Ptg. & Sc.*, p. 39; *Bonnard* (1948), p. 109; in color, *Masters*, p. 39; *Bonnard*, p. 81; in color, *Invitation*, p. 27.

BONTECOU, Lee. American, born 1931.

Untitled. 1959. Relief construction of welded steel, wire, cloth, 58¹/₈ x 58¹/₂ x 17³/₈″ (147.5 x 148.5 x 44 cm). Gift of Mr. and Mrs. Arnold H. Maremont. 2.60. Repr. *Suppl. X*, p. 42; *Amer. 1963*, p. 13.

363 Untitled. 1961. Relief construction of welded steel, wire, canvas, 6′8¹/₄″ x 7′5″ x 34³/₄″ (203.6 x 226 x 88 cm). Kay Sage Tanguy Fund. 398.63. Repr. *Amer. 1963*, p. 16.

BOOTH, Cameron. American, born 1892.

STREET IN STILLWATER. (1936) Gouache, 15³/₄ x 22³/₄″ (40 x 57.8 cm). Extended loan from the United States WPA Art Program. E.L.39.1865. Repr. *New Horizons*, no. 124.

BORDUAS, Paul-Émile. Canadian, 1905–1960. Worked in Paris from 1955.

349 MORNING CANDELABRA [*Lampadaires du matin*]. 1948. Oil on canvas, 32¹/₄ x 43″ (81.9 x 109.2 cm). Gift of the Passedoit Gallery. 263.54. Repr. *Suppl. V*, p. 27.

LA GUIGNOLÉE. 1954. Watercolor, 22 x 30¹/₄″ (55.9 x 76.8 cm). Purchase. 3.55.

BORÈS, Francisco. Spanish, born 1898. Lives in Paris.

192 THE FITTING [*L'Essayage—Souvenir imaginaire*]. 1934. Oil on canvas, 6′3¹/₄″ x 7′2³/₄″ (184.8 x 220.4 cm). Purchase. 2.49. Repr. *Suppl. I*, p. 12.

BORIANI, Davide. Italian, born 1936.

509 MAGNETIC SURFACE. (1959) Construction with iron filings and foam rubber on plastic background, with magnets and motor, in a glass-covered cylinder, 22³/₄″ diameter, 2⁷/₈″ deep (57.6 x 7.2 cm). Gift of the Olivetti Company of Italy. 1231.64.

BOTERF, Check. American, born 1934.

RED AND BLUE. (1968) Synthetic polymer paint on shaped canvas in three parts, overall, 7′3″ x 46¹/₂″ x 38¹/₈″ (220.9 x 118 x 96.8 cm). Gift of Tibor de Nagy Gallery. 2.69.

BOTERO, Fernando. Colombian, born 1932. In U.S.A. since 1961.

284 MONA LISA, AGE TWELVE. 1959. Oil and tempera on canvas, 6′11¹/₈″ x 6′5″ (211 x 195.5 cm). Inter-American Fund. 279.61. Repr. *Suppl. XI*, p. 52; in color, *Invitation*, p. 61.

THE PRESIDENTIAL FAMILY. 1967. Oil on canvas, 6′8¹/₈″ x 6′ 5¹/₄″ (203.5 x 196.2 cm). Gift of Warren D. Benedek. 2667.67.

BOTKIN, Henry. American, born 1896.

PALMA. (1963) Cloth collage and chalk on composition board, 14³/₄ x 18¹/₂″ (37.2 x 46.9 cm). Gift of Carroll Carstairs (by exchange). 256.64.

BOUCHÉ, René Robert. American, born Czechoslovakia. 1905–1963. Worked in Western Europe. To U.S.A. 1941.

262 GEORGES BRAQUE. 1957. Oil on canvas, 45¹/₈ x 34″ (114.5 x 86.4 cm). Gift of Mrs. Albert D. Lasker. 60.61. Repr. *Suppl. X*, p. 25.

BOURDELLE, Émile-Antoine. French, 1861–1929.

39 BEETHOVEN. (1901) Bronze, head, 15⁵/₈″ (39.6 cm) high, cast with base, 11³/₈″ (28.9 cm) high. Inscribed on base: *Moi je suis Bacchus qui pressure pour les hommes le nectar délicieux—Beethoven*. Gift of Mrs. Maurice L. Stone in memory of her husband. 714.59. Repr. *Suppl. IX*, p. 7.

39 BEETHOVEN, TRAGIC MASK. 1901. Bronze, 30¹/₂″ (77.4 cm) high. Grace Rainey Rogers Fund. 280.61. Repr. *Suppl. XI*, p. 10; *What Is Mod. Sc.*, p. 36.

BOURGEOIS, Louise. American, born France 1911. To U.S.A. 1938.

QUARANTANIA, I. (1948–53) Painted wood on wood base, 6′9¹/₄″ (206.4 cm) high, including base 6 x 27¹/₄ x 27″ (15.2 x 69.1 x 68.6 cm). Gift of Ruth Stephan Franklin. 1076.69.

QUARANTANIA, III. (1949–50) Unpainted wood, 59⁵/₈ x 11³/₄ x 2″ (151.3 x 29.8 x 5 cm), on wood base 3 x 13⁵/₈ x 14³/₈″ (7.6 x 34.5 x 36.4 cm). Gift of Mr. and Mrs. Cuthbert Daniel. 497.69.

303 SLEEPING FIGURE. (1950) Balsa wood, 6′2¹/₂″ (189.2 cm) high. Katharine Cornell Fund. 3.51. Repr. *Suppl. III*, p. 7.

SLEEPING FIGURE, II. (1959) Bronze (cast 1963), 6′3¹/₄″ (191.1 cm) high. Purchase. 153.62. Variant of *Sleeping Figure*, 1950, listed above, 3.51.

THE QUARTERED ONE. (1964–65) Bronze (cast 1969), 58³/₄ x 28³/₈ x 21³/₈″ (149 x 72 x 54.1 cm). Gift of Henriette Bonnotte in memory of Georges Bonnotte. 1047.69.

BOWERS, Lynn. American, born Canada 1932.

RHYTHMS IN BARBARA. 1970. Synthetic polymer paint on canvas; triptych, overall, 6′ x 6′3⁷/₈″ (182.9 x 192.8 cm). Blanchette Rockefeller Fund. 499.70a–c.

BOWLING, Frank. Guyanese, born 1936.

GIVING BIRTH ASTRIDE A GRAVE. 1973. Synthetic polymer paint on canvas, 6′1¹/₄″ x 48¹/₄″ (183.5 x 122.7 cm). Inter-American Fund. 128.74.

BRAINARD, Joe. American, born 1942.

Untitled. (1966) Collage of cut-and-pasted paper, thread, cloth, sequins, and enamel, 14 x 11″ (35.6 x 27.9 cm). Gift of the Fischbach Gallery. 95.71.

BRANCUSI, Constantin. French, born Rumania. 1876–1957. To Paris 1904.

Dating and other difficult details depend largely on the definitive catalog *Brancusi*, New York, 1968, by Sidney Geist; his catalog number is included in each entry. Athena Tacha Spear has also been of generous assistance. A group of the Museum's Brancusi sculptures is reproduced in color in *Masters*, p. 125.

108 DOUBLE CARYATID. (1908?) Limestone, 29⁵/₈″ (75.2 cm) high. Middle section of pedestal of *Magic Bird*, 144.53a. Katherine S. Dreier Bequest. 144.53c. *Geist* 41. Repr. *Suppl. IV*, p. 8.

108 MAGIC BIRD [*Pasarea Maiastra*]. Version I (1910) White marble, 22″ (55.9 cm) high; on three-part limestone pedestal, 70″ (177.8 cm) high, of which the middle section is the *Double Caryatid*, listed above (144.53c). Katherine S. Dreier Bequest. 144.53a–d. *Geist* 61. Repr. *Suppl. IV*, p. 8. *Note*: in the Rumanian title, *pasarea* means bird, *maiastra* means magic (or master). Geist quotes Brancusi's reference to a Rumanian folk tale: "Prince Charming was in search of Ilena Cosinzene. The master bird is the bird that spoke and showed the way to Prince Charming."

108 MLLE POGANY. Version I (1913) after a marble of 1912. Bronze, 17¹/₄″ (43.8 cm) high. Acquired through the Lillie P. Bliss Bequest. 2.53. *Geist* 74a. Repr. *Suppl. IV*, p. 21. *Note*: this first bronze cast was purchased in 1953 from the subject, Mlle Margit Pogany, who commissioned it in 1910.

108 THE NEWBORN. Version I (1915) close to the marble of 1915. Bronze, 5³/₄ x 8¹/₄″ (14.6 x 21 cm). Acquired through the Lillie P. Bliss Bequest. 605.43. *Geist* 87a. Repr. *Sc. of 20th C.*, p. 112.

110 SOCRATES. (1923) Wood, 51¹/₄″ (130 cm) high. Mrs. Simon Guggenheim Fund. 187.56. *Geist* 143. Repr. *Suppl. VI*, p. 1.

110 THE COCK. Version I (1924) Walnut, 47⁵/₈″ (121 cm) high, including cylindrical base 11¹/₂″ (29.2 cm) high. Inscribed: *A Audrey Chadwick. C. Brancusi Paris*. Gift of LeRay W. Berdeau. 620.59. *Geist* 151. Repr. *Bulletin*, Fall 1958, p. 15.

108 BIRD IN SPACE. (1928?) Bronze (unique cast), 54″ (137.2 cm) high. Given anonymously. 153.34. *Geist* 171, tenth of sixteen variations from 1923 to 1941 and depending on *Geist* 162, 1925. Repr. *Ptg. & Sc.*, p. 275; *Sc. of 20th C.*, pp. 110, 111.

109 FISH. 1930. Gray marble, 21 x 71″ (53.3 x 180.3 cm); on three-part pedestal of one marble and two limestone cylinders, 29¹/₈″ (74 cm) high. (Similar to much smaller marble *Fish*, 1922.) Acquired through the Lillie P. Bliss Bequest. 695.49. *Geist* 177. Repr. *Suppl. II*, p. 31; *Sc. of 20th C.*, p. 113.

110 BLOND NEGRESS. 1933. Version II, after a marble of 1928. Bronze, 15³/₄″ (40 cm) high; on four-part pedestal of marble, limestone, and two wood sections (carved by the artist), 55¹/₂″ (141 cm) high. The Philip L. Goodwin Collection. 97.58a–e. *Geist* 182a. Repr. *Bulletin*, Fall 1958, on cover and p. 5.

BRAQUE, Georges. French, 1882–1963.

LANDSCAPE AT LA CIOTAT. (1907) Oil on canvas, 28¹/₄ x 23³/₈″ (71.7 x 59.4 cm). Purchase. 373.75. Repr. in color, *Fauvism*, p. 126.

92 ROAD NEAR L'ESTAQUE. (1908) Oil on canvas, 23³/₄ x 19³/₄″ (60.3 x 50.2 cm). Given anonymously (by exchange). 103.43. Repr. *Ptg. & Sc.*, p. 86.

92 MAN WITH A GUITAR. (1911) Oil on canvas, 45³/₄ x 31⁷/₈″ (116.2 x 80.9 cm). Acquired through the Lillie P. Bliss Bequest. 175.45. Repr. *Ptg. & Sc.*, p. 87; *Gris*, p. 22; in color, *Masters*, p. 72.

92 SODA. (1911) Oil on canvas, 14¹/₄″ (36.2 cm) diameter. Acquired through the Lillie P. Bliss Bequest. 8.42. Repr. *Ptg. & Sc.*, p. 86.

93 GUITAR. (1913–14) Gesso on canvas with pasted paper, pencil, charcoal, and chalk, 39¼ x 25⅝" (99.7 x 65.1 cm). Acquired through the Lillie P. Bliss Bequest. 304.47. Repr. *Braque*, p. 61.

93 OVAL STILL LIFE [*Le Violon*]. (1914) Oil on canvas, 36⅜ x 25¾" (92.4 x 65.4 cm). Gift of the Advisory Committee. 210.35. Repr. *Ptg. & Sc.*, p. 96.

93 THE TABLE. 1928. Oil on canvas, 70¾ x 28¾" (179.7 x 73 cm). Acquired through the Lillie P. Bliss Bequest. 520.41. Repr. *Ptg. & Sc.*, p. 103; in color, *Braque*, p. 109; in color, *Invitation*, p. 51.

94 WOMAN WITH A MANDOLIN. 1937. Oil on canvas, 51¼ x 38¼" (130.2 x 97.2 cm). Mrs. Simon Guggenheim Fund. 2.48. Repr. *Suppl. I*, p. 9; in color, *Masters*, p. 94; *Braque*, p. 129; in color, *Invitation*, p. 73.

UNDER THE AWNING. 1948. Oil on canvas, 51 x 35⅛" (129.6 x 89.1 cm). The Adele R. Levy Fund. 227.62. Repr. *Levy Collection*, p. 29.

BRATBY, John Randall. British, born 1928.

269 NELL AND JEREMY SANDFORD. 1957. Oil on composition board, 6'5⅞" x 7'8⅛" (197.7 x 234 cm). Gift of Mr. and Mrs. Robert W. Dowling. 2.59. Repr. *Suppl. IX*, p. 29.

BRAUNER, Victor. Rumanian, 1903–1966. To Paris 1930.

NUDE AND SPECTRAL STILL LIFE [*La Vie intérieure*]. (1939) Oil on canvas, 36⅛ x 28⅝" (91.7 x 72.6 cm). The Sidney and Harriet Janis Collection (fractional gift). 581.67. Repr. *Janis*, p. 73.

THE SNAKE CHARMER [*La Psylle miraculeuse*]. 1943. Encaustic on canvas, 25⅝ x 21¼" (65.1 x 54 cm). Gift of Mr. and Mrs. Nathan L. Halpern. 1398.74.

TALISMAN. 1943. Tallow on wood, 6⅜ x 10⅞" (15.9 x 27.4 cm). The Sidney and Harriet Janis Collection (fractional gift). 582.67. Repr. *Dada, Surrealism*, p. 136; *Janis*, p. 73.

182 PROGRESSION PANTACULAIRE. 1948. Encaustic on cardboard, 19¾ x 27½" (50.2 x 69.8 cm). Gift of D. and J. de Menil. 331.49. Repr. *Suppl. II*, p. 14.

BRECHT, George. American, born 1926.

386 REPOSITORY. (1961) Assemblage: wall cabinet containing pocket watch, tennis ball, thermometer, plastic and rubber balls, baseball, plastic persimmon, "Liberty" statuette, wood puzzle, tooth brushes, bottle caps, house number, pencils, preserved worm, pocket mirror, light bulbs, keys, hardware, coins, photographs, playing cards, postcard, dollar bill, page from Thesaurus, 40⅜ x 10½ x 3⅛" (102.6 x 26.7 x 7.7 cm). Larry Aldrich Foundation Fund. 281.61. Repr. *Assemblage*, p. 155.

BREER, Robert. American, born 1926.

OSAKA I. (1970) Self-propelled sculpture with fiberglass shell, steel frame, battery-driven motor, and rubber-tire wheels, 6'1" high x 6'1⅛" diameter (185.3 x 185.6 cm). Gift of PepsiCo, Inc. 378.71.

BREININ, Raymond. American, born Russia 1909. To U.S.A. 1924.

DESERTED FARM. 1936. Gouache, 18 x 26¼" (45.7 x 66.7 cm). Extended loan from the United States WPA Art Program. E.L.39.1832. Repr. *New Horizons*, no. 126.

LONESOME FARM. 1936. Gouache, 20⅛ x 30" (50.9 x 76.2 cm). Extended loan from the United States WPA Art Program. E.L.39.1834. Repr. *Ptg. & Sc.*, p. 172.

WHITE HOUSE. 1938. Oil on canvas, 30 x 40⅛" (76.2 x 101.9 cm). Extended loan from the United States WPA Art Program. E.L.39.1856. Repr. *Amer. 1942*, p. 27.

ONE MORNING. (c. 1939) Gouache, 16⅝ x 27⅝" (42.2 x 70.2 cm). Abby Aldrich Rockefeller Fund. 568.39. Repr. *Amer. 1942*, p. 26.

BRETON, André. French, 1896–1966.

Untitled. 1935. Ink transfer (decalcomania), 10 x 12¾" (25.3 x 32.3 cm), irregular. Purchase. 7.69.

182 POEM-OBJECT. 1941. Assemblage mounted on drawing board: carved wood bust of man, oil lantern, framed photograph, toy boxing gloves, 18 x 21 x 4⅜" (45.8 x 53.2 x 10.9 cm). Inscribed in gouache and oil: *ces terrains vagues/où j'erre/vaincu par l'ombre/et la lune/accrochée à la maison de mon coeur.* Kay Sage Tanguy Bequest. 197.63. Repr. *Assemblage*, p. 67.

BRÔ, René (René Brault). French, born 1930.

291 SPRING BLOSSOMS. (1962) Oil and egg tempera on canvas, 25½ x 31⅞" (64.7 x 81 cm). Acquired through the Lillie P. Bliss Bequest. 228.62. Repr. *Suppl. XII*, p. 27.

BRÖCKMANN, Gottfried. German, born 1903.

CRIPPLED LIVES, I [*Krüppeldesein, I*]. (1922) Tempera on cardboard, 7⅛ x 8⅝" (17.9 x 21.9 cm). Gift of Mrs. Gertrud A. Mellon. 136.73.

CRIPPLED LIVES, IV [*Krüppeldesein, IV*[. (1922) Tempera on cardboard, 8½ x 7⅛" (21.5 x 18.1 cm). Gift of Mr. and Mrs. Ronald S. Lauder. 135.73.

BRODIE, Gandy. American, 1925–1975.

289 BROKEN BLOSSOM. (1960) Oil on canvas, 25⅝ x 36⅜" (65.1 x 92.3 cm). Purchase and exchange. 110.61. Repr. *Suppl. XI*, p. 46.

BROEGGER, Stig. Danish, born 1941.

PLACING PLATFORMS. 1970. Painted wood, photograph panels, and text panel. Platform, 12 x 41⅜ x 41⅜" (30.5 x 105 x 105 cm); panel with twenty photographs, 45⅛ x 51¾" (114.7 x 131.5 cm); panel with thirty-five photographs, 52⅝ x 47⅞" (133.6 x 121.6 cm); text panel, 18⅝ x 15" (47.1 x 38.1 cm). Mrs. Ruth Dunbar Cushing Fund. 388.70.1-4. Repr. *Information*, p. 26.

BROOK, Alexander. American, born 1898.

240 GEORGE BIDDLE PLAYING THE FLUTE. (1929) Oil on canvas, 40⅜ x 30¼" (102.6 x 76.8 cm). Gift of Abby Aldrich Rockefeller. 38.35. Repr. *20th-C. Portraits*, p. 96.

BROOKS, James. American, born 1906.

332 QUALM. 1954. Oil on canvas, 61 x 57⅛" (154.9 x 144.9 cm). Gift of Mrs. Bliss Parkinson. 247.56. Repr. *12 Amer.*, p. 17; *New Amer. Ptg.*, p. 25.

BROWN, Joan. American, born 1938.

THANKSGIVING TURKEY. 1959. Oil on canvas, 47⅞ x 47⅞" (121.5 x 121.5 cm). Larry Aldrich Foundation Fund. 80.60. Repr. *Suppl. X*, p. 35.

BRZOZOWSKI, Tadeusz. Polish, born 1918.

PRETZELS. (1959) Oil on canvas, 51¼ x 50" (130.1 x 127 cm). Gift of Mr. and Mrs. Arthur S. Freeman. 116.62. Repr. *Suppl. XII*, p. 20.

BUCHHEISTER, Carl. German, born 1890.

COMPOSITION. (c. 1933) Tempera, gouache, and cut-and-pasted cardboard, 20½ x 15″ (52.1 x 38 cm). Gift of Mr. and Mrs. Walter Bareiss. 242.76.

BUCHHOLZ, Erich. German, 1891–1972.

139 FORCES [*Kräfte*]. 1921. Oil on canvas, 7′7¼″ x 53¼″ (231.6 x 135.2 cm). Gift of Herbert and Nannette Rothschild. 261.56. Repr. *Suppl. VI*, p. 17.

BUFFET, Bernard. French, born 1928.

289 STILL LIFE WITH FISH, II. 1949. Oil on canvas, 16⅜ x 33½″ (41.6 x 85.1 cm). Mrs. Cornelius J. Sullivan Fund. 85.50. Repr. *Suppl. II*, p. 16.

BURCHFIELD, Charles. American, 1893–1967.

THE CITY. 1916. Watercolor, 13⅜ x 19⅜″ (34 x 49.2 cm). Gift of Abby Aldrich Rockefeller. 42.35.

ROGUES' GALLERY. 1916. Watercolor, 13½ x 19⅝″ (34.3 x 49.9 cm). Gift of Abby Aldrich Rockefeller. 44.35. Repr. *Burchfield*, no. 4.

242 GARDEN OF MEMORIES. 1917. Crayon and watercolor, 25¾ x 22½″ (65.4 x 57.1 cm). Gift of Abby Aldrich Rockefeller (by exchange). 2.36. Repr. *Burchfield*, no. 25.

INSECTS AT TWILIGHT. 1917. Watercolor, 14 x 19¾″ (35.6 x 50.2 cm). Gift of Abby Aldrich Rockefeller (by exchange). 3.36.

242 THE FIRST HEPATICAS. 1917–18. Watercolor, 21½ x 27½″ (54.6 x 69.8 cm). Gift of Abby Aldrich Rockefeller. 43.35. Repr. *Ptg. & Sc.*, p. 163; *Natural Paradise*, p. 109.

242 THE NIGHT WIND. 1918. Watercolor and gouache, 21½ x 21⅞″ (54.4 x 55.5 cm). Gift of A. Conger Goodyear. 359.60. Repr. *Burchfield*, no. 26; *Suppl. X*, p. 21; *Natural Paradise*, p. 120.

242 THE INTERURBAN LINE. 1920. Watercolor, 14¾ x 20¾″ (37.5 x 52.7 cm). Gift of Abby Aldrich Rockefeller (by exchange). 4.36. Repr. *Ptg. & Sc.*, p. 159.

242 PIPPIN HOUSE, EAST LIVERPOOL, OHIO. (1920) Watercolor, 26 x 19⅜″ (66 x 49.2 cm). Gift of Mr. and Mrs. Alex L. Hillman. 235.50. Repr. *Suppl. II*, p. 24.

242 RAILROAD GANTRY. (1920) Watercolor, 18 x 24⅝″ (45.7 x 62.6 cm). Given anonymously. 2.30. Repr. *Ptg. & Sc.*, p. 159.

BURLE MARX, Roberto. Brazilian, born 1909.

Detail 5 of Plan for Quadricentennial Gardens, Ibirapuera Park, São Paulo, Brazil. 1953. Gouache, 43 x 52⅛″ (109.2 x 132.4 cm). Inter-American Fund. 243.54. Repr. *Suppl. V*, p. 35.

BURLIN, Paul. American, 1886–1969.

236 FALLEN ANGEL. (1943) Oil on canvas, 13 x 16⅛″ (32.8 x 40.8 cm). Purchase. 104.43. Repr. *Ptg. & Sc.*, p. 234.

SERIES OF 9, NUMBER 2. 1969. Oil, casein, and synthetic polymer paint on canvas, 54⅞ x 48⅞″ (139.3 x 124 cm). Mrs. W. Murray Crane Fund. 39.71.

BURRA, Edward John. British, born 1905.

196 BAL DES PENDUS. (1937) Watercolor, 61⅛ x 44⅞″ (155.2 x 114 cm). Purchase. 233.48. Repr. *Suppl. I*, p. 15.

BURRI, Alberto. Italian, born 1915.

376 SACKCLOTH 1953. (1953) Burlap, sewn, patched, and glued, over canvas, 33⅞ x 39⅜″ (86 x 100 cm). Mr. and Mrs. David M. Solinger Fund. 542.54. Repr. *Suppl. V*, p. 23.

BURT, Michael. Paraguayan, born 1931.

437 THE OLD HOUSE ENDURES [*La Vieja casona permanece*]. 1966. Synthetic polymer paint, with collage of corrugated cardboard and cloth on canvas, 47⅜ x 47⅜″ (120.3 x 120.3 cm). Inter-American Fund. 2099.67.

BURY, Pol. Belgian, born 1922. To France 1961.

ERECTILE ENTITY (RED AND WHITE). 1962. Motor-driven construction of metal wires in wood panel, painted, 36 x 35¾ x 13½″ (91.2 x 90.6 x 34.2 cm). Gift of Philip Johnson. 770.69.

511 1,914 WHITE POINTS. 1964. Motor-driven construction of plastic-tipped nylon wires in wood panel, 39¼ x 19⅝ x 4¾″ (99.6 x 49.7 x 12.1 cm). Philip Johnson Fund. 566.64.

511 31 RODS EACH WITH A BALL. 1964. Motor-driven wood construction with cork and nylon wire, 39¾″ (100.9 cm) high, including wood box, 29¾ x 19½ x 6½″ (75.4 x 49.5 x 16.4 cm). Elizabeth Bliss Parkinson Fund. 565.64.

BUTLER, Horacio A. Argentine, born 1897.

EL CAMELOTE: TIGRE. (1941) Oil on canvas, 32 x 39″ (81.3 x 99.1 cm). Inter-American Fund. 653.42. Repr. *Latin-Amer. Coll.*, p. 26.

BUTLER, Reg (Reginald Cotterell Butler). British, born 1913.

295 THE UNKNOWN POLITICAL PRISONER (PROJECT FOR A MONUMENT). (1951–53) Welded bronze, brass wire and sheet, 17⅜″ (44.1 cm) high, on limestone base, 2¾ x 7½ x 7¼″ (7 x 19 x 18.4 cm). Saidie A. May Fund. 410.53. Repr. *Masters*, p. 159; *New Images*, p. 42; *What Is Mod. Sc.*, p. 124. *Note*: replica made by the artist to replace the original, damaged after winning first prize in international competition for a monument to The Unknown Political Prisoner, London, 1953.

295 ORACLE. (1952) Cast shell bronze welded to forged bronze armature, 33½″ x 6′1″ (85.1 x 185.4 cm). Purchase. 409.53. Repr. *Suppl. IV*, p. 41; *New Decade*, p. 67.

295 WOMAN STANDING. (1952) Welded bronze and brass sheet and wire, 18½″ (47 cm) high. Acquired through the Lillie P. Bliss Bequest. 3.53. *Note*: the Museum owns a sheet of studies for this sculpture.

477 THE BOX. (1953) Iron, welded and painted, 47⅛ x 17¼ x 16¾″ (119.5 x 43.6 x 42.4 cm). William P. Jones O'Connor Fund. 184.66.

295 GIRL. (1953–54) Cast shell bronze (cast 1955), 68⅜″ (173.7 cm) high. A. Conger Goodyear Fund. 558.56. Repr. *Suppl. VI*, p. 27.

BYARS, James Lee. American, born 1932. Worked in Japan.

When the four works below were given, the artist wished to be anonymous and to have the works remain untitled. He has since titled the works and given permission for his name to be used.

453 UNTITLED OBJECT. (1962–64) Crayon on Japanese handmade white flax paper, hinged and folded; unfolded, 12″ x 210′9″ (30.3 cm x 64.23 m); folded, 12 x 12 x 3¾″ (30.3 x 30.3 x 9.5 cm). Given anonymously. 47.65.

452 UNTITLED OBJECT (A MILE-LONG PAPER WALK). (1962–64) Japanese handmade white flax paper, hinged and folded; unfolded, 36″ x 300′ (91.4 cm x 91.44 m), ending in a circle, 9′ (274 cm) in diameter; folded, 36 x 36 x 3″ (91 x 91 x 7.6 cm). Given anonymously. 255.66.

452 UNTITLED OBJECT (RIVET CONTINUITY). (1962–64) Japanese handmade white flax paper, in seventy-five sections, ends of each section rounded, overlapped, and joined with rivets; un-

folded, 12″ x 500′ (30.4 cm x 152.4 m); folded, 12 x 70³/₄ x 4″ (30.4 x 179.7 x 10.1 cm). Given anonymously. 380.66. *Note*: the artist says that this object can form various shapes, such as a circle, star, or triangle.

453 UNTITLED OBJECT (RUNCIBLE). (1962–64) Japanese handmade white flax paper; a 50′ (15.24 m) square, divided into thirty-two parallel strips, attached by paper hinges to a single strip at right angles, forming a comb shape; each strip reverse-folds in 18″ (45.6 cm) squares, the whole object stacking into an 18″ (45.6 cm) cube. Given anonymously. 381.66.

CADMUS, Paul. American, born 1904.

248 GREENWICH VILLAGE CAFETERIA. (1934) Oil on canvas, 25¹/₂ x 39¹/₂″ (64.8 x 100.3 cm). Extended loan from the United States Public Works of Art Project. E.L.34.1508. Repr. *Ptg. & Sc.*, p. 144.

CALCAGNO, Lawrence. American, born 1916.

TIMELESS WHITE WITH RED AND GRAY. (1968) Synthetic polymer paint on canvas in two sections spaced 2″ apart; top, 25″ x 8′2″ (63.4 x 248.9 cm); bottom, 6″ x 8′1¹/₂″ (15.1 x 247.6 cm). Gift of Mr. and Mrs. William Unger (by exchange). 500.70a–b.

CALDER, Alexander. American, 1898–1976. Lived in France and U.S.A.

420 JOSEPHINE BAKER. (1927–29) Iron-wire construction, 39 x 22³/₈ x 9³/₄″ (99 x 56.6 x 24.5 cm). Gift of the artist. 841.66. Repr. *Salute to Calder*, p. 9. *Note*: the sculptor made five or six versions, inspired by the American dancer popular in Paris.

421 CAT LAMP. (1928) Iron-wire and paper construction, 8³/₄ x 10¹/₈ x 3¹/₈″ (22 x 25.6 x 7.7 cm). Gift of the artist. 846.66. Repr. *Salute to Calder*, p. 11.

421 ELEPHANT CHAIR WITH LAMP. (1928) Galvanized sheet steel, iron wire, lead, cloth, and painted-paper construction, 7⁷/₈ x 3¹/₂ x 4¹/₈″ (19.7 x 8.9 x 10.3 cm). Gift of the artist. 845.66. Repr. *Salute to Calder*, p. 11.

257 THE HORSE. (1928) Walnut, 15¹/₂ x 34³/₄″ (39.4 x 88.3 cm). Acquired through the Lillie P. Bliss Bequest. 747.43. Repr. *Ptg. & Sc.*, p. 264; *Salute to Calder*, p. 6.

257 THE HOSTESS. (1928) Wire construction, 11¹/₂″ (29.2 cm) high. Gift of Edward M. M. Warburg. 319.41. Repr. *Salute to Calder*, p. 7.

420 SODA FOUNTAIN. (1928) Iron-wire construction, 10³/₄″ (27.3 cm) high, on wood base, 1⁵/₈ x 5¹/₂ x 3¹/₂″ (4 x 13.9 x 8.7 cm). Gift of the artist. 844.66. Repr. *Salute to Calder*, p. 7.

257 Sow. (1928) Wire construction, 7¹/₂ x 17″ (19.5 x 43.2 cm). Gift of the artist. 5.44. Repr. *Ptg. & Sc.*, p. 264; *Salute to Calder*, p. 8.

257 Cow. (1929) Wire construction, 6¹/₂ x 16″ (16.5 x 40.7 cm). Gift of Edward M. M. Warburg. 318.41a–d. Repr. *Salute to Calder*, p. 6.

420 Cow. (1929) Wire and wood construction, 3¹/₂ x 8¹/₈ x 4″ (8.9 x 20.5 x 9.9 cm), on wood base, 2 x 6 x 5³/₄″ (5.2 x 15 x 14.5 cm). Gift of Edward M. M. Warburg. 499.41. Repr. *Salute to Calder*, p. 8.

421 MARION GREENWOOD. (1929–30) Brass-wire construction, 12⁵/₈ x 11¹/₈ x 11³/₈″ (31.9 x 28.1 x 28.8 cm). Gift of the artist. 842.66. Repr. *Salute to Calder*, p. 10. *Note*: the subject was an American painter.

421 PORTRAIT OF A MAN. (1929–30) Brass-wire construction, 12⁷/₈ x 8³/₄ x 13¹/₂″ (32.5 x 22.2 x 34.2 cm). Gift of the artist. 843.66.

422 SHARK SUCKER. (1930) Wood, 10³/₄ x 30⁷/₈ x 10¹/₄″ (27.1 x 78.3 x 25.9 cm). Gift of the artist. 389.66. Repr. *Calder* (2nd), p. 20; *Salute to Calder*, p. 26.

Brooch. (Early 1930s) Brass, 3⁵/₈ x 4³/₄″ (9.2 x 12.1 cm). Gift of Mrs. Katharine Kuh. 382.55.

258 A UNIVERSE. (1934) Motor-driven mobile: painted iron pipe, wire, and wood with string, 40¹/₂″ (102.9 cm) high. Gift of Abby Aldrich Rockefeller (by exchange). 163.34. Repr. *Calder* (2nd), p. 31; *The Machine*, p. 150; *Salute to Calder*, p. 12.

422 GIBRALTAR. (1936) Construction of lignum vitae, walnut, steel rods, and painted wood, 51⁷/₈ x 24¹/₄ x 11³/₈″ (131.7 x 61.3 x 28.7 cm). Gift of the artist. 847.66a–b. Repr. *Calder* (2nd), p. 36; *Salute to Calder*, p. 14.

259 WHALE. (1937) Standing stabile: painted sheet steel, supported by a log of wood, 68 x 69¹/₂ x 45³/₈″ (172.8 x 176.5 x 115 cm). Gift of the artist. 319.50. Repr. *Suppl. III*, p. 6; *Masters*, p. 146; *Sc. of 20th C.*, p. 169. *Note*: replaced by the artist; see *Whale, II*, 1.65.

258 LOBSTER TRAP AND FISH TAIL. (1939) Hanging mobile: painted steel wire and sheet aluminum, about 8′6″ x 9′6″ (260 x 290 cm). Commissioned by the Advisory Committee for the stairwell of the Museum. 590.39a–d. Repr. *Ptg. & Sc.*, p. 290; *Masters*, p. 147; *Salute to Calder*, p. 4; *What Is Mod. Sc.*, p. 76.

424 SPIDER. (1939) Standing mobile: sheet aluminum, steel rod, and steel wire, painted, 6′8¹/₂″ x 7′4¹/₂″ x 36¹/₂″ (203.5 x 224.5 x 92.6 cm). Gift of the artist. 391.66a–c. Repr. *Salute to Calder*, p. 18.

Buckle. (1930s or '40s) Hammered brass, 3¹/₈ x 4⁷/₁₆ x ³/₈″ (8 x 11.2 x 1 cm). Gift of the artist. 748.66.

Brooch. (1930s or '40s) Hammered silver, 12³/₈ x 9¹/₂″ (31.4 x 24.1 cm). Gift of the artist. 747.66. Repr. *Salute to Calder*, p. 28.

Brooch. (1930s or '40s) Hammered silver, 12¹/₄ x 11⁷/₈″ (31.1 x 30.1 cm). Gift of the artist. 746.66. Repr. *Salute to Calder*, p. 28.

Necklace. (1930s or '40s) Hammered brass, inner circumference 32″ (81.3 cm), outer circumference 56³/₈″ (143.1 cm). Purchase. 334.67.

Bracelet. (1930s or '40s) Hammered silver, 4³/₄ x 4 x 2″ (12.1 x 10.2 x 5.1 cm). Purchase. 338.67. Repr. *Salute to Calder*, p. 29.

424 Untitled. (Early 1940s) Standing mobile: sheet aluminum and steel wire, painted, 14⁵/₈ x 9 x 10⁷/₈″ (37.1 x 22.8 x 27.5 cm). Kay Sage Tanguy Bequest. 1122.64. Repr. *Salute to Calder*, p. 31.

Necklace. (1941) Hammered silver, inner circumference 26″ (66 cm), outer circumference 34″ (86.3 cm). James Thrall Soby Fund. 748.43. Repr. *Salute to Calder*, p. 30.

Buckle. (Before 1943) Hammered brass, 5³/₈ x 4⁷/₈″ (13.6 x 12.4 cm). Gift of the artist. 749.66. Repr. *Salute to Calder*, p. 29.

Comb. (Before 1943) Hammered brass, 6¹/₂ x 3⁷/₈″ (16.5 x 9.8 cm). Gift of the artist. 745.66. Repr. *Salute to Calder*, p. 27.

258 CONSTELLATION WITH RED OBJECT. (1943) Painted wood and steel wire construction, 25¹/₂ x 12¹/₂″ (31.8 x 64.8 cm). James Thrall Soby Fund. 746.43. Repr. *Ptg. & Sc.*, p. 291; *Salute to Calder*, p. 20.

423 MORNING STAR. (1943) Stabile: painted sheet steel and steel wire, painted and unpainted wood, 6′4³/₄″ x 48³/₈″ x 45³/₄″ (194.8 x 122.8 x 116 cm). Gift of the artist. 848.66. Repr. *Calder* (2nd), p. 57; *Salute to Calder*, p. 15.

MOBILE WITH 14 FLAGS (MODEL FOR MAN-EATER WITH PENNANTS). (1945) Sheet aluminum and copper rods, painted, 53″ high x c. 50″ diameter (134.6 x 127 cm). Gift of the artist. 40.71. Repr. *Salute to Calder*, p. 13.

259 MAN-EATER WITH PENNANTS. (1945) Standing mobile: painted steel rods and sheet iron, 14′ x about 30′ (425 x 915 cm). Commissioned for the Sculpture Garden. Purchase. 150.45. Repr. *Ptg. & Sc.*, p. 291; *Salute to Calder*, p. 19.

426 SNOW FLURRY, I. 1948. Hanging mobile: sheet steel and steel wire, painted, 7′10″ x 6′10¼″ (238.7 x 208.8 cm). Gift of the artist. 390.66a–c. Repr. *Salute to Calder*, p. 17; *Amer. Art*, p. 18.

260 BLACK WIDOW. 1959. Standing stabile: painted sheet steel, 7′8″ x 14′3″ x 7′5″ (233.3 x 434.1 x 226.2 cm). Mrs. Simon Guggenheim Fund. 557.63. *Salute to Calder*, p. 23.

424 Model for TEODELAPIO. (1962) Standing stabile: painted sheet aluminum, 23¾″ x 15¼ x 15¾″ (60.3 x 38.7 x 39.8 cm). Gift of the artist. 392.66. Repr. *Salute to Calder*, cover. *Note*: the final work, standing over 60 feet high, was made for the Festival of Two Worlds, Spoleto, Italy, 1962. Teodelapio, A.D., 601–653 was a Duke of Spoleto.

425 SANDY'S BUTTERFLY. 1964. Standing mobile: stainless sheet steel and iron rods, painted, 12′8″ x 9′2″ x 8′7″ (386 x 279 x 261 cm), at base 9′3″ x 7′6″ x 7′2″ (282 x 229 x 218 cm). Gift of the artist. 849.66a–b. Repr. *Salute to Calder*, p. 21.

423 WHALE, II. (1964. Replica of 1937 original) Standing stabile: painted sheet steel, supported by a log of wood, 68 x 69½ x 45⅜″ (172.8 x 176.5 x 115 cm). Gift of the artist (by exchange). 1.65. Repr. *Salute to Calder*, p. 5; *What Is Mod. Sc.*, p. 62. *Note*: the original version was on view in the Sculpture Garden from 1941 to 1963. It suffered damage from the weather, and Calder replaced it in 1964 with a replica in heavier steel.

THE BICYCLE. (1968. Free reconstruction of "*The motorized mobile that Duchamp liked*" of c. 1932) Motor-driven mobile of wood, metal, cord, and wire, 61½ x 59 x 26⅛″ (156 x 149.7 x 66.2 cm), including base 4¾ x 59 x 25″ (11.9 x 149.7 x 63.3 cm). Gift of the artist. 1002.69. Repr. *The Machine*, p. 148; *Salute to Calder*, p. 13.

CALLERY, Mary. American, 1903–1977. Lived in Paris.

304 HORSE. (1942) Bronze, 49⅛ x 34⅜″ (124.6 x 87.2 cm), base 37¼″ (94.4 cm) diameter. Purchase. 256.44. Repr. *Ptg. & Sc.*, p. 265.

CAMPBELL, Jewett. American, born 1912.

243 REFLECTED GLORY. (1939) Oil on canvas, 16⅛ x 20″ (41 x 50.8 cm). Purchase. 139.42.

THE SKATERS. (1940) Oil on canvas, 17 x 14″ (43.2 x 35.6 cm). Abby Aldrich Rockefeller Fund. 140.42.

CAMPENDONK, Heinrich. German, 1889–1957. To the Netherlands 1933.

71 MYSTICAL CRUCIFIXION. (1926–28?) Oil on glass, 17½ x 15″ (44.5 x 38.1 cm). Katherine S. Dreier Bequest. 146.53. Repr. *Suppl. IV*, p. 17.

CAMPIGLI, Massimo. Italian, 1895–1971. In Paris 1919–39.

198 Design for mosaic floor of Teatro Metropolitano, Rome. (1943) Gouache and oil on paper, 32¼ x 33⅛″ (81.9 x 84.3 cm). Gift of Eric Estorick. 471.53. Repr. *Suppl. V*, p. 19.

CAMPOLI, Cosmo. American, born 1922.

303 BIRTH. (1958) Bronze, 37¼ x 49¾″ (94.5 x 126.3 cm). Purchase. 715.59. Plaster model for bronze repr. *New Images*, p. 47.

CANADÉ, Vincent. American, born Italy 1879–1961. To U.S.A. 1892.

10 SELF-PORTRAIT. (c. 1926) Oil on canvas, 18⅝ x 14″ (47.3 x 35.6 cm). Gift of Abby Aldrich Rockefeller (by exchange). 5.36.

CANE, Louis. French, born 1943.

PAINTING. (1975) Oil on unstretched and adhered canvas pieces, 7′11⅞″ x 10′10⅝″ (243.4 x 331.9 cm). Dorothy and Sidney Singer Foundation Fund. 98.76.

CAPOGROSSI, Giuseppe. Italian, 1900–1972.

COMPOSITION. (1953) Gouache, 13¾ x 19⅝″ (35 x 49.9 cm). Alfred Flechtheim Fund. 8.54.

368 SECTION 4. 1953. Oil on canvas, 7′1⅞″ x 38⅝″ (218.1 x 98.1 cm). Blanchette Rockefeller Fund. 149.55. Repr. *New Decade*, p. 88.

CARDENAS, Santiago. Colombian, born 1937. In U.S.A. 1947–60, 1962–65. In Germany 1960–62.

LARGE BLACK BLACKBOARD WITH SHELF. (1976) Oil on canvas, 50½″ x 7′10½″ (128.4 x 240.1 cm). Mrs. John C. Duncan Fund. 591.76.

CARDOSO JUNIOR, José Bernardo. Brazilian, born Portugal. 1861–1947.

STILL LIFE WITH VIEW OF THE BAY OF GUANABARA. 1937. Oil on paper, 21¼ x 29½″ (54 x 74.9 cm). Inter-American Fund. 656.42. Repr. *Latin-Amer. Coll.*, p. 40.

CARLES, Arthur B. American, 1882–1952.

229 COMPOSITION, III. (1931–32) Oil on canvas, 51⅜ x 38¾″ (130.5 x 98.4 cm). Gift of Leopold Stokowski. 393.41.

CARO, Anthony. British, born 1924. In U.S.A. 1963–65.

MIDDAY. (1960) Steel, painted yellow, 7′7¾″ x 37⅜″ x 12′1¾″ (233.1 x 95 x 370.2 cm). Purchase. 419.74a–g. Repr. in color, *Caro*, p. 25.

FROGNAL. (1965) Steel, painted green, 12′1⅛″ x 10⅛″ x 35¼″ (368.8 x 305.3 x 89.5 cm). Given anonymously. 1345.74a–e. Repr. *Caro*, p. 62.

SOURCE. (1967) Steel and aluminum, painted, 6′1″ x 10′ x 11′9″ (185.5 x 305 x 358.3 cm). Blanchette Rockefeller Fund (by exchange). 99.76. Repr. in color, *Caro*, p. 88.

CARRÀ, Carlo. Italian, 1881–1966.

120 FUNERAL OF THE ANARCHIST GALLI. (1911) Oil on canvas, 6′6¼″ x 8′6″ (198.7 x 259.1 cm). Acquired through the Lillie P. Bliss Bequest. 235.48. Repr. *Masters*, p. 98; in color, *Futurism*, p. 31.

403 JOLTS OF A CAB [*Sobbalzi di fiacre*]. (1911) Oil on canvas, 20⅝ x 26½″ (52.3 x 67.1 cm). Gift of Herbert and Nannette Rothschild. 1007.65. Repr. *Futurism*, p. 53.

CARREÑO, Mario. Chilean, born Cuba 1913. Worked in U.S.A. 1939–41, 1944–51.

287 TORNADO. 1941. Oil on canvas, 31 x 41″ (78.8 x 104.1 cm). Inter-American Fund. 657.42. Repr. *Ptg. & Sc.*, p. 181.

VASE OF FLOWERS. 1943. Duco on composition board, 41 x 31″ (104.1 x 78.8 cm). Inter-American Fund. 70.44.

CARRIÈRE, Eugène. French, 1849–1906.

28 MATERNITY. (c. 1892) Oil on canvas, 37¾ x 45¾″ (95.9 x 116.2 cm). Given anonymously. 580.42.

CARTER, Clarence H. American, born 1904.

235 JANE REED AND DORA HUNT. 1941. Oil on canvas, 36 x 45″ (91.4 x 114.3 cm). Purchase. 334.42. Repr. *Ptg. & Sc.*, p. 160.

CARVALHO, Flavio de R. Brazilian, born 1899.

215 THE POET PABLO NERUDA. 1947. Oil over gesso on canvas, 39⅜ x 30⅞″ (100 x 78.3 cm). Inter-American Fund. 134.57. Repr. *Suppl. VII*, p. 13.

CASHWAN, Samuel. American, born Ukraine 1900. To U.S.A. c. 1907.

TORSO. (1936) Limestone, 23³/₄ x 15 x 6³/₄″ (60.3 x 38 x 17.2 cm). Extended loan from the United States WPA Art Program. E.L.41.2386. Repr. *Amer. 1942*, pp. 32–33.

CASSINARI, Bruno. Italian, born 1912.

262 THE MOTHER. 1948. Oil on canvas, 47¹/₂ x 29³/₄″ (120.6 x 75.6 cm). Mrs. Cornelius J. Sullivan Fund. 274.49. Repr. *20th-C. Italian Art*, pl. 97.

CASTEL, Moshe Elazar. Israeli, born 1909.

318 POETRY OF CANAAN, I. 1963. Mixed mediums on canvas, 64 x 51³/₈″ (162.4 x 130.4 cm). Gift of Mr. and Mrs. David Kluger. 1008.65. Repr. *Art Israel*, p. 28.

CASTELLANOS, Julio. Mexican, 1905–1947.

210 THE AUNTS. (1933) Oil on canvas, 60⁷/₈ x 48³/₄″ (154.6 x 123.8 cm). Inter-American Fund. 1.43. Repr. *Latin-Amer. Coll.*, p. 74.

210 THE ANGEL KIDNAPPERS [*Los Robachicos*]. (1943) Oil on canvas, 22⁵/₈ x 37³/₈″ (57.5 x 94.9 cm). Inter-American Fund. 6.44. Repr. *Ptg. & Sc.*, p. 182.

CAVALLON, Giorgio. American, born Italy. To U.S.A. 1920.

PAINTING 2. 1954. Oil on canvas, 48 x 60″ (121.9 x 152.4 cm). Mr. and Mrs. William H. Weintraub Fund. 491.69.

CELENTANO, Francis. American, born 1928.

502 FLOWING PHALANX. 1965. Synthetic polymer paint on canvas, 34¹/₈ x 46¹/₈″ (86.5 x 117.1 cm). Larry Aldrich Foundation Fund. 112.66.

CERVANTEZ, Pedro L. American, born 1915.

CROQUET GROUND. (1936) Oil on composition board, 19³/₄ x 28³/₄″ (50.2 x 73 cm). Extended loan from the United States WPA Art Program. E.L.39.1858. Repr. *Masters Pop. Ptg.*, no. 104.

PANHANDLE LUMBER COMPANY. 1937. Oil on composition board, 17¹/₂ x 24″ (44.5 x 61 cm). Extended loan from the United States WPA Art Program. E.L.39.1859. Repr. *Masters Pop. Ptg.*, no. 106.

CÉSAR (César Baldaccini). French, born 1921.

377 TORSO. (1954) Welded iron, 30³/₈ x 23³/₈ x 27¹/₈″ (77.1 x 59.4 x 68.8 cm). Blanchette Rockefeller Fund. 25.60. Repr. *Suppl. X*, p. 31; *New Images*, p. 51; *What Is Mod. Sc.*, p. 16.

377 GALACTIC INSECT. 1956. Welded iron, 19⁷/₈ x 37″ (50.5 x 94 cm). Gift of G. David Thompson. 3.59. Repr. *Suppl. IX*, p. 30.

377 SCULPTURE PICTURE. (1956) Welded iron relief, 30¹/₈ x 39³/₄ x 8″ (76.3 x 100.8 x 20.2 cm). Gift of G. David Thompson. 114.60. Repr. *Suppl. X*, p. 32.

377 THE YELLOW BUICK. (1961) Compressed automobile, 59¹/₂ x 30³/₄ x 24⁷/₈″ (151.1 x 77.7 x 63.5 cm). Gift of Mr. and Mrs. John Rewald. 294.61. Repr. *Suppl. XI*, p. 37; *The Machine*, p. 185.

CÉZANNE, Paul. French, 1839–1906.

Dating and titles of the following works have been checked with John Rewald, who is preparing a new catalog of Cézanne's paintings, and, in collaboration with Adrien Chappuis, of his watercolors. *Venturi* refers to *Cézanne: Son art—son oeuvre* by Lionello Venturi, Paris, 1936.

400 MELTING SNOW, FONTAINEBLEAU. (c. 1879–80) Oil on canvas, 29 x 39⁵/₈″ (73.5 x 100.7 cm), irregular. Gift of André Meyer. 373.61. *Venturi* 336. Repr. *Suppl. XI*, p. 9.

12 THE BATHER. (c. 1885) Oil on canvas, 50 x 38¹/₈″ (127 x 96.8 cm). Lillie P. Bliss Collection. 1.34. *Venturi* 548. Repr. *Ptg. & Sc.*, p. 27; in color, *Masters*, p. 23; in color, *Invitation*, p. 29.

13 THE BRIDGE AT GARDANNE. (1885–86) Watercolor, 8¹/₈ x 12¹/₄″ (20.6 x 31.1 cm). Lillie P. Bliss Collection. 6.34a. *Venturi* 912. Repr. *Ptg. & Sc.*, p. 23. On reverse: *View of Gardanne*, pencil, 6.34b.

13 BATHERS. (1885–90) Watercolor and pencil, 5 x 8¹/₈″ (12.7 x 20.6 cm). Lillie P. Bliss Collection. 2.34. *Venturi* 1114. Repr. *Bliss, 1934*, no. 12; *Seurat to Matisse*, p. 18.

14 STILL LIFE WITH APPLES. (1895–98) Oil on canvas, 27 x 36¹/₂″ (68.6 x 92.7 cm). Lillie P. Bliss Collection. 22.34. *Venturi* 736. Repr. *Ptg. & Sc.*, p. 25; in color, *Masters*, p. 20; in color, *Invitation*, p. 30.

13 ROCKY RIDGE ABOVE LE CHÂTEAU NOIR. (1895–1900) Watercolor and pencil, 12¹/₂ x 18³/₄″ (31.7 x 47.6 cm). Lillie P. Bliss Collection. 21.34. *Venturi* 1043. Repr. *Ptg. & Sc.*, p. 26; *Seurat to Matisse*, p. 20. *Note:* also called *Rocky Ridge* and *Rocks near the Caves above Château Noir*.

13 FOLIAGE. (1895–1900) Watercolor and pencil, 17⁵/₈ x 22³/₈″ (44.8 x 56.8 cm). Lillie P. Bliss Collection. 9.34a. *Venturi* 1128 (recto). Repr. *Bliss, 1934*, no. 21a; *Seurat to Matisse*, p. 21. On reverse: *Study of Trees*, watercolor, 9.34b.

13 STUDY OF TREES. (1895–1900) Watercolor, 17⁵/₈ x 22³/₈″ (44.8 x 56.8 cm). Lillie P. Bliss Collection. 9.34b. *Venturi* 1128 (verso). On reverse: *Foliage*, watercolor, 9.34a.

14 PINES AND ROCKS (FONTAINEBLEAU?). (1896–99) Oil on canvas, 32 x 25³/₄″ (81.3 x 65.4 cm). Lillie P. Bliss Collection. 16.34. *Venturi* 774. Repr. *Ptg. & Sc.*, p. 29; in color, *Masters*, p. 21; in color, *Invitation*, p. 31.

13 HOUSE AMONG TREES. (c. 1900) Watercolor and pencil, 11 x 17¹/₈″ (27.9 x 43.5 cm). Lillie P. Bliss Collection. 15.34. *Venturi* 977. Repr. *Ptg. & Sc.*, p. 26.

15 STILL LIFE WITH GINGER JAR, SUGAR BOWL, AND ORANGES. (1902–06) Oil on canvas, 23⁷/₈ x 28⁷/₈″ (60.6 x 73.3 cm). Lillie P. Bliss Collection. 18.34. *Venturi* 738. Repr. *Ptg. & Sc.*, p. 28. *Note:* formerly called *Oranges*.

15 LE CHÂTEAU NOIR. (1904–06) Oil on canvas, 29 x 36³/₄″ (73.6 x 93.2 cm). Gift of Mrs. David M. Levy. 137.57. *Venturi* 794. Repr. *Suppl. X*, p. 7; in color, *Levy Collection*, cover.

CHADWICK, Lynn. British, born 1914.

360 BALANCED SCULPTURE. (1952) Wrought iron, 19¹/₂ x 11⁷/₈ x 7³/₄″ (49.5 x 30 x 19.6 cm). Purchase. 7.53. Repr. *Suppl. IV*, p. 40. *Note*: the Museum owns a sheet of studies for this sculpture.

361 INNER EYE. (1952) Wrought iron with glass cullet, 7′6¹/₂″ x 42¹/₂″ x 30¹/₄″ (230 x 107.9 x 76.7 cm). A. Conger Goodyear Fund. 150.55. Repr. *New Decade*, p. 72.

CHAGALL, Marc. French, born Russia 1887. To France 1923. In U.S.A. 1941–48.

150 I AND THE VILLAGE. 1911. Oil on canvas, 6′3⁵/₈″ x 59⁵/₈″ (192.1 x 151.4 cm). Mrs. Simon Guggenheim Fund. 146.45. Repr. *Ptg. & Sc.*, p. 210; in color, *Masters*, p. 132; in color, *Invitation*, p. 53. *Note*: at right is a profile of the artist, facing left.

VASLAW NIJINSKY. Study of the dancer in the ballet *Spectre de la Rose*. (1911) Watercolor, oval 8³/₈ x 5¹/₄″ (21.3 x 13.3 cm). Gift of Edward M. M. Warburg. 507.41. Theatre Arts Collection.

151 CALVARY. 1912. Oil on canvas, 68³/₄″ x 6′3³/₄″ (174.6 x 192.4 cm). Acquired through the Lillie P. Bliss Bequest. 276.49. Repr. *Suppl. I*, p. 4.

152 BIRTHDAY [*L'Anniversaire*]. (1915) Oil on cardboard, 31³/₄ x 39¹/₄″ (80.6 x 99.7 cm). Acquired through the Lillie P. Bliss Bequest. 275.49. Repr. *Suppl. I*, p. 7; in color, *Masters*, p. 133; *Paintings from MoMA*, p. 67; in color, *Modern Masters*, p. 29. *Note*: this is the original version. A second version, 31⁷/₈ x 39³/₈″, painted in Paris about 1923, is in The Solomon R. Guggenheim Museum, New York. The artist and Bella Rosenfeld, his betrothed, are the subjects. The birthday was the artist's. The Museum owns a pencil study for this painting.

153 HOMAGE TO GOGOL. Design for curtain (not executed) for Gogol festival, Hermitage Theater, Petrograd (Leningrad). 1917. Watercolor, 15¹/₂ x 19³/₄″ (39.4 x 50.2 cm). Acquired through the Lillie P. Bliss Bequest. 71.44.

152 OVER VITEBSK. 1915–20 (after a painting of 1914). Oil on canvas, 26³/₈ x 36¹/₂″ (67 x 92.7 cm). Acquired through the Lillie P. Bliss Bequest. 277.49. Repr. *Suppl. I*, p. 5. *Note*: this is the second version. The first, painted in 1914, 27¹/₂ x 35¹/₂″, is in the Ayala and Sam Zacks Collection, Toronto.

153 TIME IS A RIVER WITHOUT BANKS [*Le Temps n'a point de rives*]. 1930–39. Oil on canvas, 39³/₈ x 32″ (100 x 81.3 cm). Given anonymously. 612.43. Repr. *Ptg. & Sc.*, p. 211; in color, *Chagall*, opp. p. 64.

ALEKO. Sixty-seven gouache, watercolor, and pencil designs for the ballet produced by the Ballet Theatre, Mexico City and New York. (1942) Four designs for scenery, 15¹/₄ x 22¹/₂″ to 15 x 20⁷/₈″ (38.7 x 57.1 to 38.1 x 53 cm); forty-eight designs for costumes, 14³/₄ x 22¹/₈″ to 10¹/₂ x 8¹/₂″ (37.5 x 56.2 to 26.7 x 21.6 cm); fifteen designs for choreography, 16 x 11⁷/₈″ to 7⁵/₈ x 10³/₈″ (40.7 x 30.2 to 19.4 x 26.3 cm). Acquired through the Lillie P. Bliss Bequest. 137.45.1–.67. Theatre Arts Collection. Design for scenery (137.45.3) repr. *Masters*, p. 182.

CHAMBERLAIN, John. American, born 1927.

388 ESSEX. (1960) Automobile body parts and other metal, relief, 9′ 6′8″ x 43″ (274.3 x 203.2 x 109.2 cm). Gift of Mr. and Mrs. Robert C. Scull and Purchase. 282.61. Repr. in color, *Assemblage*, p. 138.

TOMAHAWK NOLAN. (1965) Assemblage: welded and painted metal automobile parts, 43³/₄ x 52¹/₈ x 36¹/₄″ (111.1 x 132.2 x 92 cm). Gift of Philip Johnson. 677.71. Repr. *Amer. Art*, p. 48.

CHANG DAI-CHIEN. Chinese, born 1899.

316 LOTUS. 1961. Brush and ink on paper, 70³/₄ x 38¹/₄″ (179.6 x 96.9 cm) mounted on a silk scroll. Gift of Dr. Kuo Yu-Shou. 295.61. Repr. *Suppl. XI*, p. 17.

CHARLOT, Jean. American, born France 1898. To U.S.A. 1929. Worked in Mexico. Lives in Hawaii.

LANDSCAPE, MILPA ALTA. 1924. Oil on canvas, 11 x 14″ (27.9 x 35.6 cm). Gift of Abby Aldrich Rockefeller (by exchange). 217.37.

WOMAN LIFTING REBOZO. 1935. Oil on canvas, 25¹/₈ x 30″ (63.8 x 76.2 cm). Given anonymously (by exchange). 468.41. Repr. *Ptg. & Sc.*, p. 176.

CHAVEZ, Edward. American, born 1917.

COLT. (c. 1939) Gouache, 17⁷/₈ x 21¹/₂″ (45.4 x 54.6 cm). Abby Aldrich Rockefeller Fund. 569.39.

CHIMES, Thomas. American, born 1921.

314 CRUCIFIX. (1961) Oil on canvas, 36 x 36″ (91.5 x 91.5 cm). Larry Aldrich Foundation Fund. 198.63.

Study for THE INNER WORLD. (1961) Oil on canvas, 9¹/₄ x 10⁵/₈″ (23.6 x 26.9 cm). Larry Aldrich Foundation Fund. 283.61. Repr. *Suppl. XI*, p. 51.

DE CHIRICO, Giorgio. Italian, born Greece 1888. Worked in Paris 1911–15, 1925–39.

154 THE ANXIOUS JOURNEY. 1913. Oil on canvas, 29¹/₄ x 42″ (74.3 x 106.7 cm). Acquired through the Lillie P. Bliss Bequest. 86.50. Repr. *Suppl. II*, p. 6; *de Chirico*, p. 181; *The Machine*, p. 64.

154 THE NOSTALGIA OF THE INFINITE. (1913–14? Dated on painting 1911) Oil on canvas, 53¹/₄ x 25¹/₂″ (135.2 x 64.8 cm). Purchase. 87.36. Repr. *Ptg. & Sc.*, p. 191; in color, *Masters*, p. 134; *de Chirico*, p. 53; in color, *Invitation*, p. 85.

GARE MONTPARNASSE (THE MELANCHOLY OF DEPARTURE). 1914. Oil on canvas, 55¹/₈″ x 6′5/₈″ (140 x 184.5 cm). Fractional gift of James Thrall Soby. 1077.69. Repr. *Soby Collection*, p. 32.

155 THE EVIL GENIUS OF A KING. (1914–15) Oil on canvas, 24 x 19³/₄″ (61 x 50.2 cm). Purchase. 112.36. Repr. *Ptg. & Sc.*, p. 193; in color, *Fantastic Art* (3rd), opp. p. 120; *de Chirico*, p. 99; *Modern Masters*, p. 181.

155 THE DOUBLE DREAM OF SPRING. 1915. Oil on canvas, 22¹/₈ x 21³/₈″ (56.2 x 54.3 cm). Gift of James Thrall Soby. 138.57. Repr. *de Chirico*, p. 212; *Suppl. VII*, p. 7; *Soby Collection*, p. 36; *Dada, Surrealism*, p. 79.

EVANGELICAL STILL LIFE. 1916. Oil on canvas, 31³/₄ x 28¹/₈″ (80.5 x 71.4 cm), irregular. The Sidney and Harriet Janis Collection (fractional gift). 583.67. Repr. *Modern Works*, no. 57; *Cubism*, p. 175; *de Chirico*, p. 221; in color, *Janis*, p. 51.

GRAND METAPHYSICAL INTERIOR. 1917. Oil on canvas, 37³/₄ x 27³/₄″ (95.9 x 70.5 cm). Fractional gift of James Thrall Soby. 1078.69. Repr. *Soby Collection*, p. 39.

155 THE GREAT METAPHYSICIAN. 1917. Oil on canvas, 41¹/₈ x 27¹/₂″ (104.5 x 69.8 cm). The Philip L. Goodwin Collection. 98.58. Repr. in color, *de Chirico*, p. 133; *Bulletin*, Fall 1958, p. 7.

155 THE SACRED FISH. (1919) Oil on canvas, 29¹/₂ x 24³/₈″ (74.9 x 61.9 cm). Acquired through the Lillie P. Bliss Bequest. 333.49. Repr. *Suppl. II*, p. 7; in color, *de Chirico*, p. 155.

CHOKAI, Seiji. Japanese, born 1902.

289 GOURDS. (1950) Oil on canvas, 25⁵/₈ x 21″ (65.1 x 53.4 cm). Blanchette Rockefeller Fund. 110.58. Repr. *Suppl. VIII*, p. 19.

CHRISTO (Christo Javacheff). American, born Bulgaria 1935. In Paris 1958–64. In New York since 1964.

PACKAGE ON WHEELBARROW. (1963) Cloth, metal, wood, rope, and twine, 35¹/₈ x 59¹/₂ x 20¹/₄″ (89.1 x 151 x 51.4 cm). Blanchette Rockefeller Fund. 867.68.

TEMPORARY VOLUME—PACKAGE—FOR MINNEAPOLIS SCHOOL OF ART. 1966. Model: stuffed plastic sheet wrapped with twine, plastic figure, and paint and pencil on composition board on wood base; overall, 11⁷/₈ x 27 x 27³/₄″ (30.1 x 68.5 x 70.5 cm). Gift of Mr. and Mrs. Armand P. Bartos. 389.70.

The four works below are projects for an event to have been held at The Museum of Modern Art on June 9, 1968; because of technical problems, the event did not take place:

441 BARRELS STRUCTURE—THE WALL (53RD STREET BETWEEN FIFTH AND SIXTH AVENUES). 1968. Photomontage and enamel paint on cardboard, 22¹/₈ x 28¹/₈″ (56 x 71.2 cm). Inscribed: as above, with *Project for June 9, 1968—Museum of Modern Art N.Y.* Gift of Miss Louise Ferrari. 1652.68.

THE MUSEUM OF MODERN ART PACKAGED. (1968) Scale model: painted wood, cloth, twine, and polyethylene, 16″ (40.3 cm) high, on painted wood base 2 x 48¹/₈ x 24¹/₈″ (5 x 122 x 61 cm). Gift of D. and J. de Menil. 868.68.

"THE MUSEUM OF MODERN ART PACKED" PROJECT. 1968. Photomontage and drawing with oil, pencil, and pastel mounted

on cardboard; overall, 15⅝ x 21¾" (39.5 x 55.2 cm). Inscribed: *"The Museum of Modern Art Packed"* Project. Gift of D. and J. de Menil. 869.68.

PACKED TREE (PROJECT). 1968. Polyethylene, cloth, twine, cardboard, colored pencil, wash, and staples on matboard, mounted on composition board, 28 x 22⅛ x ¾" (71.1 x 56.1 x 1.8 cm). Inscribed: *Packed Tree (Project for the Museum of Modern Art New York—30 feet long by 4–6 feet diameter)*. Gift of the artist. 870.68.

CHRYSSA (Chryssa Vardea Mavromichali). American, born Greece 1933. To U.S.A. 1954.

391 PROJECTION LETTER F. (1958–60) Welded and cast aluminum relief, 68⅜ x 46⅛ x 2½" (173.7 x 117 x 6.3 cm). Gift of Joseph H. Konigsberg. 97.61. Repr. *Suppl. XI*, p. 51; *Amer. 1963*, p. 23.

513 FIVE VARIATIONS ON THE AMPERSAND. (1966) Neon-light constructions in tinted-plexiglass vitrines; one, 30¾ x 14¼ x 12⅜" (78.1 x 36.2 x 31.3 cm); four, 29½ x 14¼ x 12⅜" (74.8 x 36.2 x 31.3 cm). Gift of D. and J. de Menil. 393.66.1–.5.

CLARKE, John Clem. American, born 1937.

PLYWOOD WITH ROLLER MARKS NUMBER 2. 1974. Oil on canvas, 7'1¼" x 60¼" (214 x 152.7 cm). Mr. and Mrs. Stuart M. Speiser Fund. 592.76.

CLERK, Pierre. Canadian, born U.S.A. 1928.

PAINTING, II. 1955. Oil on canvas, 31½ x 37⅜" (79.8 x 94.9 cm). Purchase. 234.56. Repr. *Suppl. VI*, p. 31.

CLOAR, Carroll. American, born 1913.

276 AUTUMN CONVERSION. (1953) Tempera on composition board, 20⅛ x 26⅛" (51.1 x 66.4 cm). Gift of Mr. and Mrs. Edward F. Kook. 502.53. Repr. *Suppl. V*, p. 32.

CLOSE, Chuck. American, born 1940.

ROBERT/104,072. (1973–74) Synthetic polymer paint and ink with graphite on gessoed canvas, 9 x 7' (274.4 x 213.4 cm). Fractional gift of J. Frederic Byers III and promised gift of an anonymous donor. 286.76.

COHEN, Bernard. British, born 1933.

372 MUTATION WHITSUN SERIES 2. (1960) Oil and enamel on canvas, 54⅜ x 66¼" (138 x 168 cm). Philip Johnson Fund. 360.60. Repr. *Suppl. X*, p. 47.

COHEN, George. American, born 1919.

386 ANYBODY'S SELF-PORTRAIT. (1953) Assemblage: framed square mirror mounted on painted composition board, 9⅝" (24.3 cm) diameter, with two oval mirrors, plastic doll's torso, legs, and arms, painted doll's eyes with fiber lashes in anchovy tin can, small metal hand, nail heads, screw eyes, hooks, string, and cloth. Larry Aldrich Foundation Fund. 284.61. Repr. *Assemblage*, p. 112.

COLEMAN, Glenn O. American, 1887–1932.

234 JEFFERSON MARKET COURTHOUSE. (1929 or before) Gouache, 12½ x 15" (31.5 x 38 cm) (composition). Given anonymously. 123.40.

ANGELO'S PLACE. (1929) Oil on canvas, 25¼ x 34¼" (64.1 x 87 cm). Gift of Abby Aldrich Rockefeller. 47.35.

Study for CHERRY HILL. (Before 1931) Gouache, 10⅝ x 7⅞" (27 x 20 cm). Given anonymously (by exchange). 7.36.

COLLA, Ettore. Italian, 1899–1968.

378 CONTINUITY. (1951) Welded construction of five iron wheels, 7'11⅝" x 56" (242.8 x 142.2 cm). Purchase. 285.61. Repr. *Assemblage*, p. 148.

COLOMBO, Gianni. Italian, born 1937.

510 PULSATING STRUCTURALIZATION. (1959) Motor-driven relief construction of 174 plastic-foam blocks in a wood box, 36½ x 36½ x 9¼" (92.5 x 92.5 x 23.5 cm). Gift of the Olivetti Company of Italy. 1232.64.

COLQUHOUN, Robert. British, 1914–1962.

268 TWO SCOTSWOMEN. (1946) Oil on canvas, 48⅜ x 36" (122.9 x 91.4 cm). Mrs. Wendell T. Bush Fund. 236.48. Repr. *Suppl. I*, p. 14.

COLVILLE, Alex. Canadian, born 1920.

435 SKATER. 1964. Synthetic polymer paint on composition board, 44½ x 27½" (113 x 69.8 cm). Gift of R. H. Donnelley Erdman (by exchange). 372.65.

COMTOIS, Ulysses. Canadian, born 1931.

291 FROM EAST TO WEST. 1961. Oil on canvas, 24 x 30" (60.9 x 76.4 cm). Gift of the Women's Committee of the Art Gallery of Toronto. 374.61. Repr. *Suppl. XI*, p. 54.

488 COLUMN NUMBER 4. (1967) Aluminum, 24⅜" (61.6 cm) high, at base 3¾" (9.3 cm) diameter. Gift of Mrs. Bernard F. Gimbel. 2100.67.

CONGDON, William. American, born 1912. Works in Italy.

290 PIAZZA, VENICE, 12. 1952. Oil on composition board, 49 x 56" (124.5 x 142.2 cm). Gift of Peggy Guggenheim. 334.52. Repr. *Suppl. IV*, p. 33.

CONNER, Bruce. American, born 1933.

CHILD. 1959–60. Assemblage: wax figure with nylon, cloth, metal, and twine in a high chair, 34⅝ x 17 x 16½" (87.7 x 43.1 x 41.7 cm). Gift of Philip Johnson. 501.70.

387 THE BOX. (1960) Assemblage: wax figure, suitcase, tin cans, shredded nylon, etc., in wooden box, 32¼ x 20⅜ x 35¼" (81.7 x 51.7 x 89.3 cm). Larry Aldrich Foundation Fund. 112.61. Repr. *Suppl. XI*, p. 40.

CONSAGRA, Pietro. Italian, born 1920.

360 CONVERSATION BEFORE THE MIRROR. 1957. Bronze relief, 56 x 40⅞" (142.2 x 103.8 cm), attached to wood base. Gift of G. David Thompson. 81.60. Repr. *Suppl. X*, p. 33; *What Is Mod. Sc.*, p. 121.

CONSTABLE, William H. Australian, born 1906.

DESIGN FOR AN ABORIGINAL BALLET, II. (1939) Gouache, 15⅝ x 20¾" (39.7 x 52.7 cm). Purchase. 526.41. Theatre Arts Collection.

COOK, Howard. American, born 1901.

MORNING AT HONDO. (1941) Watercolor, 13½ x 27¼" (34.3 x 69.3 cm). Abby Aldrich Rockefeller Fund. 141.42.

COPLEY, William N. American, born 1919.

THE COMMON MARKET. 1961. Oil on canvas, 31⅞ x 51¼" (81 x 130.1 cm). Gift of Philip Johnson. 772.69.

442 THINK. 1964. Oil on canvas, 25⅝ x 32" (65.1 x 81 cm). Gift of Miss Jeanne Reynal. 1233.64.

CORBETT, Edward. American, 1919–1971.

NUMBER 11. 1951. Chalk, 36 x 24¹/₈″ (91.4 x 61.3 cm). Katharine Cornell Fund. 44.52. Repr. *15 Amer.*, p. 7.

NUMBER 15. 1951. Chalk and casein, 28 x 15″ (71.1 x 38.1 cm). Purchase. 43.52. Repr. *15 Amer.*, p. 6.

LEJOS DE SOCORRO. 1957. Oil, enamel and bronze paint on canvas, 48 x 50″ (122.1 x 127.1 cm). Gift of Philip Johnson. 255.57. Repr. *Suppl. VII*, p. 16.

CORINTH, Lovis. German, 1858–1925.

35 SELF-PORTRAIT. 1924. Oil on canvas, 39³/₈ x 31⁵/₈″ (100 x 80.3 cm). Gift of Curt Valentin. 320.50. Repr. *Suppl. III*, p. 8; in color, *German Art of 20th C.*, p. 72; *Modern Masters*, p. 129.

CORNELL, Joseph. American, 1903–1972.

417 OBJECT "BEEHIVE." 1934. Cylindrical, covered wood box painted red, 3⁵/₈″ (9.2 cm) high, 7³/₄″ (19.7 cm) diameter, containing on bottom a printed diagram, cut from a book, of Heaven, Hell, the stars, and planets; seven pins protrude through bottom of box, six in a circle, one in center, each supporting a brass thimble; around each of six outer pins is a cutout cardboard circle in a different color; all covered by a circular piece of copper screen supported on brads driven through the side of the box and by a cardboard disk covered with a photoengraving and pierced by seven octagonal holes. Gift of James Thrall Soby. 473.53.

312 TAGLIONI'S JEWEL CASKET. 1940. Wood box containing glass ice cubes, jewelry, etc., 4³/₄ x 11⁷/₈ x 8¹/₄″ (12 x 30.2 x 21 cm). Gift of James Thrall Soby. 474.53. Repr. *Masters*, p. 145; *Soby Collection*, p. 40.

OBJECT [*Roses des vents*]. 1942–53. Wooden box with twenty-one compasses set into a wooden tray resting on plexiglass-topped and partitioned section, divided into seventeen compartments containing small miscellaneous objects and three-part hinged lid covered inside with parts of maps of New Guinea and Australia, 2⁵/₈ x 21¹/₄ x 10³/₈″ (6.7 x 53.7 x 26.2 cm). Mr. and Mrs. Gerald Murphy Fund. 621.73.

312 CENTRAL PARK CARROUSEL, IN MEMORIAM. (1950) Construction in wood, mirror, wire netting, and paper, 20¹/₄ x 14¹/₂ x 6³/₄″ (51.4 x 36.8 x 17.1 cm). Katharine Cornell Fund. 5.51. Repr. *Suppl. III*, p. 21.

CORONEL, Pedro. Mexican, born 1923.

IMAGINARY LANDSCAPE, II. (1965) Colored ink, brush, and metallic paint, 9¹/₄ x 15³/₄″ (23.3 x 40 cm), irregular. Purchase. 1580.68.

CORPORA, Antonio. Italian, born Tunis 1909.

350 DIVIDED HOUR. 1958. Oil on canvas, 57¹/₂ x 44⁷/₈″ (145.9 x 113.8 cm). Given anonymously. 4.60. Repr. *Suppl. X*, p. 38.

COSTA, Toni. Italian, born 1935.

498 VISUAL DYNAMICS. 1963. Polyethylene on wood, diagonal measurements, 56⁵/₈ x 56⁵/₈″ (143.7 x 143.7 cm). Larry Aldrich Foundation Fund. 45.65. Repr. *Responsive Eye*, p. 51.

COUGHTRY, Graham. Canadian, born 1931.

280 RECLINING FIGURE. (1961) Oil on canvas, 52³/₄ x 51″ (134.3 x 129.7 cm). Gift of Emilio del Junco. 375.61. Repr. *Suppl. XI*, p. 56.

COVERT, John. American, 1882–1960.

225 EX ACT. 1919. Oil on relief of plywood and cardboard, 23¹/₄ x 25¹/₄″ (59 x 64.1 cm). Katherine S. Dreier Bequest. 147.53. Repr. *Suppl. IV*, p. 15.

CRAMPTON, Rollin. American. 1886–1970.

PREMISE. (c. 1950–51) Oil on canvas, 50¹/₈ x 36″ (127.1 x 91.4 cm). Larry Aldrich Foundation Fund. 2519.67. Repr. *Amer. Art*, p. 26.

GROWING LINE SERIES: NUMBER 2. (1969) Oil on canvas, 36¹/₈ x 49¹/₈″ (91.5 x 124.7 cm). Gift of J. C. Van Rijn. 1003.69.

DE CREEFT, José. American, born Spain 1884. To U.S.A. 1929.

256 SATURNIA. (1939) Hammered lead relief, 61 x 38″ (154.9 x 96.5 cm). Gift of Mrs. George E. Barstow. 591.39. Repr. *Ptg. & Sc.*, p. 258.

CREMONINI, Leonardo. Italian, born 1925.

ENAMORED TOMCAT. 1952. Oil on canvas, 23¹/₈ x 17³/₄″ (58.7 x 45.1 cm). Purchase. 5.55.

CRIPPA, Roberto. Italian, born 1921.

376 COMPOSITION. 1959. Bark mounted on plywood coated with paint, sawdust, and plastic glue, 6'6⁷/₈″ x 6'6⁷/₈″ (200.3 x 200.3 cm). Gift of Alexandre Iolas. 376.61. Repr. *Suppl. XI*, p. 38.

CRISTIANO, Renato. Italian, born 1926.

314 REASON AND INSTINCT—SUN AND MOON. (1958) Oil on canvas, applied with feet and hands, 36³/₈ x 32⁷/₈″ (92.3 x 83.5 cm). Purchase. 667.59. Repr. *Suppl. IX*, p. 17.

CROSS, Henri Edmond. French, 1856–1910.

23 LANDSCAPE WITH FIGURES. (c. 1905) Watercolor, 9⁵/₈ x 13³/₈″ (24.4 x 34 cm). Gift of Abby Aldrich Rockefeller. 234.40.

CRUZ-DIEZ, Carlos. Venezuelan, born 1923. In Paris since 1960.

505 PHYSICHROMIE, 114. 1964. Synthetic polymer paint on wood panel and on parallel cardboard strips interleaved with projecting plastic strips (or blades), 28 x 56¹/₄″ (71.1 x 142.8 cm). Inter-American Fund. 284.65.

CUIXART, Modest. Spanish, born 1925.

353 PAINTING. 1958. Latex and synthetic polymer paint with metallic powders on canvas, 7'4⁵/₈″ x 51¹/₄″ (225 x 130.1 cm). Gift of Mr. and Mrs. Alex L. Hillman. 26.60. Repr. *New Spanish Ptg. & Sc.*, p. 20; *Suppl. X*, p. 34.

CULWELL, Ben L. American, born 1918.

DEATH BY BURNING. (c. 1942) Watercolor and gouache, 12¹/₈ x 9⁵/₈″ (30.8 x 24.4 cm). Purchase. 4.47. Repr. *14 Amer.*, p. 19.

310 MEN FIGHTING AND STARS IN THE SOLOMONS. (1942) Watercolor and gouache, 8 x 8″ (20.3 x 20.3 cm). Purchase. 5.47. Repr. *14 Amer.*, p. 18.

CUNNINGHAM, Ben (Benjamin Frazier Cunningham). American, 1904–1975.

501 EQUIVOCATION. 1964. Synthetic polymer paint on composition board, 26 x 26″ (65.9 x 65.9 cm). Larry Aldrich Foundation Fund. 106.65. Repr. *Responsive Eye*, p. 27.

CUSHING, Lily. American, 1909–1969.

MAIN STREET, SAUGERTIES. (1938) Gouache on cardboard, 18¹/₂ x 26¹/₈″ (47 x 66.4 cm). Given anonymously. 319.39.

DALI, Salvador. Spanish, born 1904. Active in Paris and New York.

ILLUMINED PLEASURES. (1929) Oil and collage on composition board, 9³/₈ x 13³/₄″ (23.8 x 34.7 cm). The Sidney and Harriet Janis Collection (fractional gift). 584.67. Repr. *Modern Works*, no. 60; *Fantastic Art*, p. 156; *Dali*, p. 34; *Dada, Surrealism*, p. 109; in color, *Janis*, p. 53.

183 THE PERSISTENCE OF MEMORY [*Persistance de la mémoire*]. 1931. Oil on canvas, 9¹/₂ x 13″ (24.1 x 33 cm). Given anonymously. 162.34. Repr. *Ptg. & Sc.*, p. 200; in color, *Masters*, p. 145; *Dali* (2nd), opp. p. 38; *Dada, Surrealism*, p. 111; in color, *Invitation*, p. 86.

183 PORTRAIT OF GALA [*L'Angélus de Gala*]. 1935. Oil on wood, 12³/₄ x 10¹/₂″ (32.4 x 26.7 cm). Gift of Abby Aldrich Rockefeller. 298.37. Repr. *Ptg. & Sc.*, p. 201. *Note*: Gala is the wife of the artist.

DALSTROM, Gustaf Oscar. American, born Sweden 1893. To U.S.A. 1900.

CITY BUILDINGS. 1935. Oil on composition board, 26³/₄ x 32¹/₄″ (68 x 81.9 cm). Purchase. 570.39.

DALWOOD, Hubert. British, born 1924.

362 LARGE OBJECT. (1959) Cast aluminum, welded, 28⁷/₈ x 34¹/₈ x 27⁷/₈″ (73.2 x 86.5 x 70.8 cm). Gift of G. David Thompson. 61.61. Repr. *Suppl. XI*, p. 49.

DAMIAN, Horia. French, born Rumania 1922.

354 RED FORM ON RED BACKGROUND. 1960. Mixed mediums on canvas, 57¹/₂ x 51¹/₈″ (145.9 x 129.8 cm). Given anonymously. 113.61. Repr. *Suppl. XI*, p. 49.

DAMIANI, Jorge. Uruguayan, born Italy 1931.

284 AGONY. 1956. Oil on canvas, 6′4¹/₂″ x 47¹/₄″ (194.3 x 120 cm). Inter-American Fund. 114.58. Repr. *Suppl. VIII*, p. 14.

NUMBER XIV. 1960. Plastic cement with sand on composition board, 40 x 24″ (101.5 x 60.8 cm). Inter-American Fund. 62.61. Repr. *Suppl. XI*, p. 30.

DAPHNIS, Nassos. American, born Greece 1914. To U.S.A. 1930.

NUMBER 5–58. 1958. Synthetic polymer paint on canvas, 64¹/₈ x 43″ (162.7 x 109.2 cm). Blanchette Rockefeller Fund. 4.59. Repr. *Suppl. IX*, p. 19.

D'ARCANGELO, Allan. American, born 1930.

441 HIGHWAY U.S. 1, NUMBER 5. 1962. Synthetic polymer paint on canvas, 70″ x 6′9¹/₂″ (177.6 x 207 cm). Gift of Mr. and Mrs. Herbert Fischbach. 383.66.

PROPOSITION NUMBER I. 1966. Synthetic polymer paint on canvas, 6′8¹/₈″ x 6′8¹/₈″ (203.4 x 203.4 cm). Gift of Mr. and Mrs. Armand P. Bartos. 41.71.

DARIÉ, Sandú. Cuban, born Rumania 1908.

COMPOSITION IN RED. (1946) Gouache, ink, and wax, 11¹/₄ x 14¹/₄″ (28.6 x 36.2 cm). Gift of Miss Renée Spodheim. 5.50.

DAUGHERTY, James Henry. American. 1889–1974.

SIMULTANEOUS CONTRASTS. 1918. Oil on canvas, 35³/₄ x 40¹/₂″ (90.8 x 102.6 cm). Gift of Mr. and Mrs. Henry M. Reed. 119.69.

DAVIDSON, Jo. American, 1883–1952.

251 LA PASIONARIA (DOLORES IBARRURI). 1938. Bronze, 20¹/₂ x 21³/₈″ (52.1 x 54.1 cm). The purchase money, subscribed by Trustees and friends of the Museum, was given by the artist to a fund for assisting European refugee artists in 1941. 320.41. Repr. *Ptg. & Sc.*, p. 260.

DAVIE, Alan. British, born 1920.

348 PAINTING. (1955) Oil on composition board, 60 x 48¹/₈″ (152.2 x 122 cm). Gift of Mr. and Mrs. Allan D. Emil. 188.56. Repr. *Suppl. VI*, p. 31.

DAVIES, Arthur B. American, 1862–1928.

THE WINE PRESS. (1918) Oil on canvas, 32¹/₄ x 24¹/₄″ (81.9 x 61.6 cm). Lillie P. Bliss Collection. 31.34. Repr. *Bliss, 1934*, pl. 23.

36 ITALIAN LANDSCAPE. (1925) Oil on canvas, 26¹/₈ x 40¹/₈″ (66.4 x 101.9 cm). Lillie P. Bliss Collection. 30.34. Repr. *Ptg. & Sc.*, p. 164.

DAVIS, Emma Lu. American, born 1905.

257 COSMIC PRESENCE. (1934) Wood, painted, 8 x 66¹/₄ x 15¹/₄″ (23 x 168.3 x 38.7 cm). Purchase. 9.42. Repr. *Ptg. & Sc.*, p. 288.

CHINESE RED ARMY SOLDIER. (1936) Walnut, 9³/₄″ (24.8 cm) high. Abby Aldrich Rockefeller Fund. 142.42. Repr. *Ptg. & Sc.*, p. 261; *Amer. 1942*, p. 48.

DAVIS, Gene. American, born 1920.

459 ANTHRACITE MINUET. (1966) Synthetic polymer paint on canvas, 7′9¹/₈″ x 7′7¹/₈″ (236.4 x 231.3 cm). Purchase and Larry Aldrich Foundation Fund. 94.67.

DAVIS, James Edward. American, born 1901.

TRANSPARENCY. 1944. Translucent pigment on two sheets of cellulose acetate, 14 x 20¹/₈″ (35.6 x 51.1 cm) each, attached to plywood panel 20 x 30″ (50.8 x 76.2 cm). Purchase. 2.45.

DAVIS, Ron (Ronald W.). American, born 1937.

RING. (1968) Fiberglass and pigment impregnated in polyester resin, 56¹/₂″ x 11′4″ (143.4 x 345.6 cm). Mr. and Mrs. Samuel C. Dretzin Fund. 242.69.

DAVIS, Stuart. American, 1894–1964.

230 THE FRONT PAGE. 1912. Watercolor, 11 x 15″ (27.9 x 38.1 cm). Purchase. 116.46.

230 LUCKY STRIKE. (1921) Oil on canvas, 33¹/₄ x 18″ (84.5 x 45.7 cm). Gift of The American Tobacco Company, Inc. 132.51. Repr. *Suppl. III*, p. 16.

230 EGG BEATER, V. 1930. Oil on canvas, 50¹/₈ x 32¹/₄″ (127.3 x 81.9 cm). Abby Aldrich Rockefeller Fund. 122.45. Repr. *Ptg. & Sc.*, p. 127; in color, *Davis*, opp. p. 22.

230 SUMMER LANDSCAPE. 1930. Oil on canvas, 29 x 42″ (73.7 x 106.7 cm). Purchase. 30.40. Repr. *Davis*, p. 21.

430 SALT SHAKER. (1931) Oil on canvas, 49⁷/₈ x 32″ (126.5 x 81.2 cm). Gift of Edith Gregor Halpert. 543.54. Repr. *Davis*, p. 25; *Abstract Ptg. & Sc.*, p. 104.

MURAL. 1932. Oil on canvas, 16′11⁷/₈″ x 10′8⁷/₈″ (518 x 327.2 cm). Gift of Radio City Music Hall Corporation. 1399.74.

NEW YORK WATERFRONT. (1938) Gouache, 12 x 15⁷/₈″ (30.5 x 40.3 cm). Given anonymously. 583.42.

Study for HOT STILL-SCAPE. 1940. Oil on canvas, 9 x 12″ (22.9 x 30.5 cm). Given anonymously. 469.41.

230 VISA. 1951. Oil on canvas, 40 x 52″ (101.6 x 132.1 cm). Gift of Mrs. Gertrud A. Mellon. 9.53. Repr. *Suppl. IV*, p. 32; *Lettering*, p. 20; in color, *Masters*, p. 117; *Paintings from MoMA*, p. 50; in color, *Invitation*, p. 126.

DAY, John. American, born 1932.

463 ACROSS THE LETHE. 1962. Oil and collage of photographs and playbills on canvas, 60 x 50⅛" (152.4 x 127.3 cm). Gift of the artist through the Ford Foundation Purchase Program. 567.64.

DECHAR, Peter. American, born 1942.

438 PEARS. (1966) Oil on canvas, 54⅛" x 6'1¼" (137.5 x 183.4 cm). Larry Aldrich Foundation Fund. 728.66.

DEGAS, Hilaire-Germain-Edgar. French, 1834–1917.

18 AT THE MILLINER'S. (c. 1882) Pastel, 27⅝ x 27¾" (70.2 x 70.5 cm). Gift of Mrs. David M. Levy. 141.57. Repr. *Bulletin*, Fall 1958, p. 22; *Suppl. X*, p. 8; *Levy Collection*, p. 17; in color, *Impress.* (4th), p. 446; in color, *Invitation*, p. 14. *Note*: the young woman trying on the hat is the American painter Mary Cassatt.

DEHN, Adolf. American, 1895–1968.

FLORIDA SYMPHONY. 1939. Watercolor, 19⅜ x 28⅜" (49.2 x 72.1 cm). Abby Aldrich Rockefeller Fund. 571.39. Repr. *Ptg. & Sc.*, p. 158.

BUTTE, UTAH. 1940. Watercolor, 18⅜ x 26½" (46.7 x 67.3 cm). Abby Aldrich Rockefeller Fund (by exchange). 245.40.

DEHNER, Dorothy. American, born 1908.

FROM JAPAN. 1951. Watercolor, pen and ink, 18⅛ x 22⅞" (46 x 58.1 cm). Purchase. 10.53.

305 DECISION AT KNOSSOS. (1957) Bronze, 3⅛ x 4⅞ x 3" (7.8 x 12.3 x 7.6 cm). Purchase. 5.59. Repr. *Suppl. IX*, p. 37.

DeLAP, Tony. American, born 1927.

496 TANGO TANGLES, II. 1966. Lacquered plastic in two identical L-shaped movable parts; each, 13 x 3½ x ½" (32.9 x 8.7 x 1.1 cm). Larry Aldrich Foundation Fund. 2.67a–b.

DELAUNAY, Robert. French, 1885–1941.

WINDOWS [*Les Fenêtres*]. 1912. Encaustic on canvas, 31½ x 27⅝" (79.9 x 70 cm). The Sidney and Harriet Janis Collection (fractional gift). 586.67. Repr. in color, *Janis*, p. 19.

126 SIMULTANEOUS CONTRASTS: SUN AND MOON [*Soleils, lune, simultané 2*]. (1913. Dated on painting 1912) Oil on canvas, 53" (134.5 cm) diameter. Mrs. Simon Guggenheim Fund. 1.54. Repr. in color, *Masters*, p. 77; *Paintings from MoMA*, p. 53; in color, *Invitation*, p. 33. *Note*: also called *Sun Disks*.

126 DISKS. (1930–33) Oil on cardboard, 23⅝ x 23½" (60 x 59.8 cm). Gift of Judge and Mrs. Henry Epstein. 256.57. Repr. *Suppl. VII*, p. 11.

126 RHYTHM WITHOUT END. (1935) Gouache, brush and ink, 10⅝ x 8¼" (27 x 21 cm). Given anonymously. 34.36.

DELAUNAY-TERK, Sonia. French, born Ukraine 1885.

126 Decoration for *La Prose du Transsibérien et de la Petite Jehanne de France*, by Blaise Cendrars. 1913. Gouache and ink on printed text, scroll, 6'9½" x 13⅞" (207 x 35.3 cm). Purchase. 133.51.

126 PORTUGUESE MARKET. 1915. Oil and wax on canvas, 35⅝ x 35⅝" (90.5 x 90.5 cm). Gift of Theodore R. Racoosin. 191.55. Repr. *Suppl. VI*, p. 20.

DELVAUX, Paul. Belgian, born 1897.

181 THE ENCOUNTER [*La Rencontre*]. 1938. Oil on canvas, 35⅝ x 47½" (90.5 x 120.5 cm). Kay Sage Tanguy Bequest. 326.63.

181 PHASES OF THE MOON [*Les Phases de la lune*]. 1939. Oil on canvas, 55 x 63" (139.7 x 160 cm). Purchase. 504.51. Repr. *Suppl. IV*, p. 31; in color, *Invitation*, p. 93; *Modern Masters*, p. 195.

DE MARIA, Walter. American, born 1935.

HIGH ENERGY BAR AND CERTIFICATE. 1966. Stainless steel and paper. Steel bar, 1½ x 14 x 1½" (3.9 x 35.5 x 3.9 cm); certificate, 8½ x 13½" (21.7 x 34.2 cm). Purchase. 38.72a–b. *Note*: the artist states that this work is to be made in an infinite edition throughout his life. This cast is Number 151. The certificate states that it "will be incorporated as part of the whole work of art, to be known as The High Energy Unit."

DEMUTH, Charles. American, 1883–1935.

226 STROLLING. 1912. Watercolor and pencil, 8½ x 5⅛" (21.6 x 13 cm). Gift of Abby Aldrich Rockefeller. 60.35. Repr. *Demuth*, p. 22.

226 FLOWERS. 1915. Watercolor and pencil, 8½ x 11" (21.6 x 27.9 cm). Gift of Abby Aldrich Rockefeller. 55.35.

227 NANA, SEATED LEFT, AND SATIN AT LAURE'S RESTAURANT. Illustration for *Nana* by Zola. 1916. Watercolor and pencil, 8½ x 11" (21.6 x 27.9 cm). Gift of Abby Aldrich Rockefeller. 52.35. Repr. *Demuth*, p. 38.

THE SHINE. 1916. Watercolor and pencil, 7¾ x 10¼" (19.7 x 26 cm). Gift of James W. Barney. 165.34.

226 EIGHT O'CLOCK. 1917. Watercolor and pencil, 7⅞ x 10⅛" (20 x 25.7 cm). Gift of Abby Aldrich Rockefeller. 54.35.

226 VAUDEVILLE. 1917. Watercolor and pencil, 8 x 10½" (20.3 x 26.7 cm). Katharine Cornell Fund. 87.50. Repr. *Demuth*, p. 29.

226 VAUDEVILLE MUSICIANS. 1917. Watercolor and pencil, 13 x 8" (33 x 20.3 cm). Abby Aldrich Rockefeller Fund. 148.45. Repr. *Ptg. & Sc.*, p. 73.

227 "AT A HOUSE IN HARLEY STREET." One of five illustrations for *The Turn of the Screw* by Henry James. 1918. Watercolor and pencil, 8 x 11" (20.3 x 27.9 cm). Gift of Abby Aldrich Rockefeller. 56.35. Repr. *Ptg. & Sc.*, p. 72.

226 DANCING SAILORS. 1918. Watercolor and pencil, 7⅞ x 9⅞" (20 x 25.1 cm) (sight). Abby Aldrich Rockefeller Fund. 147.45. Repr. *Ptg. & Sc.*, p. 72.

226 EARLY HOUSES, PROVINCETOWN. 1918. Watercolor and pencil, 14 x 10" (35.6 x 25.4 cm). Gift of Philip L. Goodwin. 3.49. Repr. *Demuth*, p. 64.

226 VAUDEVILLE DANCERS. 1918. Watercolor and pencil, 8 x 11½" (20.3 x 29.2 cm). Purchase. 149.45.

226 ACROBATS. 1919. Watercolor and pencil, 13 x 7⅞" (33 x 20 cm). Gift of Abby Aldrich Rockefeller. 51.35. Repr. *Bulletin*, vol. II, no. 8, 1935, p. 2; in color, *Masters*, p. 115; *Demuth*, frontispiece. *Note*: the Museum owns a pencil study for this watercolor.

227 STAIRS, PROVINCETOWN. 1920. Gouache and pencil on cardboard, 23½ x 19½" (59.7 x 49.5 cm). Gift of Abby Aldrich Rockefeller. 59.35. Repr. *Ptg. & Sc.*, p. 109.

227 IN THE KEY OF BLUE. (c. 1920) Gouache, pencil, and crayon, 19½ x 15½" (49.5 x 39.4 cm). Gift of Abby Aldrich Rockefeller. 57.35.

EGGPLANT AND TOMATOES. 1926. Watercolor and pencil, 14⅛ x 20" (35.8 x 50.9 cm). The Philip L. Goodwin Collection. 99.58. Repr. *Bulletin*, Fall 1958, p. 6.

227 CORN AND PEACHES. 1929. Watercolor and pencil, 13¾ x 19¾" (35 x 50.2 cm). Gift of Abby Aldrich Rockefeller. 53.35.

DENIS, Maurice. French, 1870–1943.

28 THE PITCHER. (1890–95?) Oil and sand on paper mounted on canvas, 17³/4 x 9¹/2″ (45.1 x 24.1 cm). Gift of A. M. Adler and Norman Hirschl. 282.58. Repr. *Suppl. VIII*, p. 6. *Note*: attribution to Denis seems probable but has been questioned.

28 ON THE BEACH OF TRESTRIGNEL. 1898. Oil on cardboard, 27⁵/8 x 39³/8″ (70 x 99.8 cm). Grace Rainey Rogers Fund. 1.64.

AFTERNOON IN THE WOODS. 1900. Oil on canvas, 28³/4 x 39¹/2″ (73 x 100.3 cm). Gift of Mr. and Mrs. Arthur G. Altschul. 679.71.

DENNY, Robyn. British, born 1930.

457 FOLDED. 1965. Oil on canvas, 6′11⁷/8″ x 6′ (213 x 182.8 cm). Blanchette Rockefeller Fund. 116.66.

DERAIN, André. French, 1880–1954.

Several titles and dates have been revised in consultation with Mme Derain (1964) and D.-H. Kahnweiler (1965).

60 POPLARS. (c. 1900) Oil on canvas, 16¹/4 x 12⁷/8″ (41.3 x 32.7 cm). Bequest of Anna Erickson Levene in memory of her husband, Dr. Phoebus Aaron Theodor Levene. 128.47.

60 FISHING BOATS, COLLIOURE. (1905) Oil on canvas, 15¹/8 x 18¹/4″ (38.2 x 46.3 cm). The Philip L. Goodwin Collection. 100.58. Repr. *Bulletin*, Fall 1958, p. 6.

BACCHIC DANCE. (1906) Watercolor and pencil, 19¹/2 x 25¹/2″ (49.5 x 64.8 cm). Gift of Abby Aldrich Rockefeller. 61.35.

60 L'ESTAQUE. (1906) Oil on canvas, 13⁷/8 x 17³/4″ (35.3 x 45.1 cm). Acquired through the Lillie P. Bliss Bequest. 6.51. Repr. *Suppl. III*, p. 10.

60 LONDON BRIDGE. (1906) Oil on canvas, 26 x 39″ (66 x 99.1 cm). Gift of Mr. and Mrs. Charles Zadok. 195.52. Repr. *Suppl. IV*, p. 18; in color, *Masters*, p. 46; in color, *Invitation*, p. 114.

61 LANDSCAPE NEAR CASSIS. (1907) Oil on canvas, 18¹/8 x 21⁵/8″ (46 x 54.9 cm). Mrs. Wendell T. Bush Fund. 278.49. Repr. *Suppl. I*, p. 5.

60 MME DERAIN IN GREEN. (Previous title: *Woman in a Green Dress*.) (1907) Oil on canvas, 28³/4 x 23⁵/8″ (73 x 60 cm). Given anonymously. 143.42.

404 MARTIGUES. (1908–09) Oil on canvas, 32 x 25⁵/8″ (81.2 x 65.1 cm). Mrs. George Hamlin Shaw and Loula D. Lasker Funds. 1234.64.

404 STILL LIFE WITH A BLUE HAT. (1912) Oil on canvas, 28³/8 x 35⁷/8″ (72 x 91.1 cm). Gift of Mr. and Mrs. Justin K. Thannhauser in honor of Alfred H. Barr, Jr. 174.67.

61 VALLEY OF THE LOT AT VERS. (1912) Oil on canvas, 28⁷/8 x 36¹/4″ (73.3 x 92.1 cm). Abby Aldrich Rockefeller Fund. 262.39. Repr. *Ptg. & Sc.*, p. 50.

61 WINDOW AT VERS. (Previous title: *The Window on the Park*.) (1912) Oil on canvas, 51¹/2 x 35¹/4″ (130.8 x 89.5 cm). Abby Aldrich Rockefeller Fund, purchased in memory of Mrs. Cornelius J. Sullivan. 631.39. Repr. *Ptg. & Sc.*, p. 51.

61 ITALIAN WOMAN. (Previous title: *Mourning Woman*.) (1913) Oil on canvas, 35⁷/8 x 28³/4″ (91.1 x 73 cm). Gift of Dr. Alfred Gold. 31.47.

HEAD OF A WOMAN. (1920) Oil on wood, 8³/4 x 6¹/4″ (22 x 15.7 cm). Gift of Mr. and Mrs. Arthur Wiesenberger. 2520.67.

62 TORSO. (c. 1921) Oil on cardboard, 30 x 21³/8″ (76.2 x 54.3 cm). Purchase (by exchange). 1638.40.

62 THREE TREES. (1923?) Oil on canvas, 36 x 32¹/8″ (91.4 x 81.6 cm). Gift of Mr. and Mrs. Sam A. Lewisohn. 302.47. Repr. *Ptg. & Sc.*,

p. 53. *Note*: according to Mme Derain, subject is near Les Lecques or St.-Cyr-sur-Mer, Côte d'Azur.

62 LANDSCAPE, PROVENCE. (Previous title: *Landscape*.) (c. 1926) Oil on canvas, 23¹/2 x 28⁵/8″ (59.7 x 72.7 cm). Given anonymously. 454.37.

DESPIAU, Charles. French, 1874–1946.

42 YOUNG PEASANT GIRL. (1909) Pewter (cast 1929), 11¹/2″ (29.2 cm) high. Gift of Abby Aldrich Rockefeller. 618.39. Repr. *Bulletin*, vol. XI, no. 4, 1944, p. 9.

DOMINIQUE. (1926) Original plaster, 21³/4″ (55.2 cm) high. Gift of Abby Aldrich Rockefeller. 617.39. Repr. *Ptg. & Sc.*, p. 241. *Note*: the subject is Mlle Dominique Jeanès.

42 ADOLESCENCE. (1921–28?) Bronze, 25¹/8″ (63.8 cm) high. Gift of Frank Crowninshield. 615.43. Repr. *Bulletin*, vol. XI, no. 4, 1944, p. 6. *Note*: alternate title, *Diana*.

42 PORTRAIT HEAD. Original plaster, 18¹/4 x 17″ (46.3 x 43 cm). Gift of Abby Aldrich Rockefeller. 620.39. Repr. *Ptg. & Sc.*, p. 241.

42 ANTOINETTE SCHULTE. (1934) Bronze, 19″ (48.2 cm) high. Gift of Miss Antoinette Schulte. 394.62. Repr. *Suppl. XII*, p. 12.

42 ASSIA. (1938) Bronze, 6′3³/4″ (184.8 cm) high. Gift of Mrs. Simon Guggenheim. 334.39. Repr. *Ptg. & Sc.*, p. 243; *Masters*, p. 45; *What Is Mod. Sc.*, p. 10.

42 ANNE MORROW LINDBERGH. (1939) Bronze, 15¹/2″ (39.4 cm) high. Gift of Colonel and Mrs. Charles A. Lindbergh. 1654.40. Repr. *20th-C. Portraits*, p. 109.

DESVALLIÈRES, Georges. French, 1861–1950.

28 NOTRE DAME. (c. 1905?) Oil and charcoal on cardboard, 40¹/2 x 28¹/2″ (102.9 x 72.4 cm). Gift of John Hay Whitney. 18.49.

DIAS, Antonio. Brazilian, born 1944. Lives in New York.

Untitled. 1967, August. Watercolor, brush, pen and ink, 18¹/2 x 12⁵/8″ (46.9 x 31.9 cm). Inter-American Fund. 817.69.

Untitled. 1967, August. Watercolor, brush, pen and ink, 18¹/2 x 12⁵/8″ (47 x 31.9 cm). Inter-American Fund. 818.69.

DIBBETS, Jan. Dutch, born 1941.

DUTCH MOUNTAIN—BIG SEA "A" AND STUDY FOR THE WORK. 1971. Eleven color photographs mounted on aluminum panels, overall, 33⁷/8″ x 14′10¹/8″ (86 x 454.4 cm); eleven color photographs and pencil on paper, 29⁵/8 x 39³/8″ (75.2 x 99.8 cm). Purchase. 150.73a–f.

DICKINSON, Edwin. American, born 1891.

239 COTTAGE PORCH, PEAKED HILL. 1932. Oil on canvas, 26¹/8 x 30¹/8″ (66.4 x 76.3 cm). Grace Rainey Rogers Fund. 98.61. Repr. *Suppl. XI*, p. 18.

238 COMPOSITION WITH STILL LIFE. 1933–37. Oil on canvas, 8′1″ x 6′5³/4″ (246.4 x 197.5 cm). Gift of Mr. and Mrs. Ansley W. Sawyer. 173.52. Repr. *Romantic Ptg.*, p. 123; in color, *Invitation*, p. 102.

DICKINSON, Preston. American, 1891–1930.

229 PLUMS ON A PLATE. (1926) Oil on canvas, 14 x 20″ (35.6 x 50.8 cm). Gift of Abby Aldrich Rockefeller. 2.31. Repr. *Ptg. & Sc.*, p. 132.

STILL LIFE. 1926. Pastel, 21 x 14″ (53.3 x 35.6 cm). Gift of Abby Aldrich Rockefeller. 63.35.

229 HARLEM RIVER. (Before 1928) Oil on canvas, 16⅛ x 20¼″ (41 x 51.4 cm). Gift of Abby Aldrich Rockefeller. 62.35.

DIEBENKORN, Richard. American, born 1922.

BERKELEY, 46. 1955. Oil on canvas, 58⅞ x 61⅞″ (149.6 x 157.2 cm). Gift of Mr. and Mrs. Gifford Phillips. 188.73.

DILL, Guy. American, born 1946.

Untitled. (1969) Cast concrete pigmented with black iron oxide, aluminum, and stainless steel wire, 7⅜″ x 11′11″ x 8½″ (19 x 363.5 x 21.5 cm). Gift of Mr. and Mrs. E. Brooke Alexander. 297.75.

DILLER, Burgoyne. American, 1906–1965.

CONSTRUCTION. 1938. Painted wood construction, 14⅝ x 12½ x 2⅝″ (37 x 31.9 x 6.7 cm). Gift of Mr. and Mrs. Armand P. Bartos. 4.58. Repr. *Suppl. VIII*, p. 18.

364 FIRST THEME. (1942) Oil on canvas, 42 x 42″ (106.6 x 106.6 cm). Gift of Silvia Pizitz. 6.59. Repr. *Suppl. IX*, p. 18. *Note*: the title *First Theme* supersedes the previous title *Composition.*

DINE, Jim. American, born 1935.

HOUSEHOLD PIECE. (1959) Assemblage: wood, canvas, cloth, iron springs, oil and bronze paint, sheet copper, brown paper bag, mattress stuffing, and plastic, 54¼ x 44¼ x 9¼″ (137.7 x 112.4 x 23.5 cm). Gift of John W. Weber. 660.70.

FIVE FEET OF COLORFUL TOOLS. 1962. Oil on canvas surmounted by a board on which thirty-two tools hang from hooks; overall, 55⅝ x 60¼ x 4⅜″ (141.2 x 152.9 x 11 cm). The Sidney and Harriet Janis Collection (fractional gift). 587.67a–gg. Repr. *Janis*, p. 151.

STILL LIFE PAINTING. 1962. Oil on canvas with twelve partly painted toothbrushes in plastic glass on metal holder, 35⅞ x 24¼ x 4¼″ (91.2 x 61.7 x 10.8 cm). Gift of Philip Johnson. 504.70. Repr. *Amer. Art*, p. 52.

DIX, Otto. German, 1891–1969.

201 CAFÉ COUPLE. 1921. Watercolor and pencil, 20 x 16⅛″ (50.8 x 41 cm). Purchase. 124.45. Repr. *Ptg. & Sc.*, p. 142.

201 CAFÉ. 1922. Watercolor, pen and ink, 19¼ x 14⅜″ (48.9 x 36.5 cm). Gift of Samuel A. Berger. 7.55.

201 SELF-PORTRAIT. 1922. Watercolor and pencil, 19⅜ x 15½″ (49.2 x 39.3 cm). Gift of Richard L. Feigen. 142.57. Repr. *Suppl. VII*, p. 21.

201 DR. MAYER-HERMANN. 1926. Oil and tempera on wood, 58¾ x 39″ (149.2 x 99.1 cm). Gift of Philip Johnson. 3.32. Repr. *Ptg. & Sc.*, p. 190; in color, *Invitation*, p. 60. *Note*: the subject is Dr. Wilhelm Mayer-Hermann, a prominent Berlin throat specialist who died in New York in 1945.

201 CHILD WITH DOLL. 1928. Oil and tempera on wood, 29¼ x 15¼″ (74.3 x 38.7 cm). Gift of Abby Aldrich Rockefeller. 65.35. Repr. *German Art of 20th C.*, p. 89. *Note*: the child is Nelly Thaesler-Dix, daughter of the artist.

DLUGOSZ, Louis. American, born 1916.

HENRY. (1938) Terra cotta, 12½″ (31.7 cm) high. Purchase. 247.40. *Note*: the subject is a brother of the artist.

DMITRIENKO, Pierre. French, 1925–1974.

THE COUPLE. 1965. Oil on paper, 22 x 28⅞″ (55.7 x 73.2 cm). Gift of Carl van der Voort. 185.66.

VAN DOESBURG, Theo (C. E. M. Küpper). Dutch, 1883–1931.

138 COMPOSITION (THE COW). 1916. Gouache, 15⅝ x 22¾″ (39.7 x 57.8 cm). Purchase. 226.48. A study for the oil, no. 225.48. Repr. *Cubism*, pl. 144.

138 COMPOSITION (THE COW). (1916–17) Oil on canvas, 14¾ x 25″ (37.5 x 63.5 cm). Purchase. 225.48. Repr. *Cubism*, pl. 144; *Suppl. I*, p. 18; *de Stijl*, pp. 6 (detail), 9; in color, *Masters*, p. 217. *Note*: the Museum owns eight pencil studies for this painting.

138 RHYTHM OF A RUSSIAN DANCE. 1918. Oil on canvas, 53½ x 24¼″ (135.9 x 61.6 cm). Acquired through the Lillie P. Bliss Bequest. 135.46. Repr. *Ptg. & Sc.*, p. 116; *de Stijl*, pp. 6 (detail), 10; in color, *Masters*, p. 217; in color, *Invitation*, p. 38.

138 COLOR CONSTRUCTION: PROJECT FOR A PRIVATE HOUSE (in collaboration with Cornelis van Eesteren). (1922) Gouache and ink, 22½ x 22½″ (57.1 x 57.1 cm). Edgar Kaufmann, Jr., Fund. 149.47. Architecture Collection. Repr. *de Stijl*, p. 6 (detail), cover; in color, *Masters*, p. 217.

SIMULTANEOUS COUNTER-COMPOSITION. (1929–30) Oil on canvas, 19¾ x 19⅝″ (50.1 x 49.8 cm). The Sidney and Harriet Janis Collection (fractional gift). 588.67. Repr. *Cubism*, pl. 156; in color, *Janis*, p. 35.

DOMINGUEZ, Oscar. French, born Spain. 1906–1957. To Paris 1927.

Untitled. 1936. Gouache (decalcomania), 14⅛ x 11½″ (35.9 x 29.2 cm). Purchase. 458.37.

Untitled. (1937) Ink transfer (decalcomania), 6⅝ x 9⅞″ (16.6 x 24.9 cm), irregular. Given anonymously. 465.67.

Untitled. (1937) Ink transfer (decalcomania), 6⅛ x 8⅝″ (15.4 x 21.8 cm), irregular. Given anonymously. 466.67. Repr. *Dada, Surrealism*, p. 139; *Seurat to Matisse*, p. 73.

182 NOSTALGIA OF SPACE [*Nostalgie de l'espace*]. 1939. Oil on canvas, 28¾ x 36⅛″ (73 x 91.8 cm). Gift of Peggy Guggenheim. 174.52. *Note*: also called *La Formule.*

DOMOTO, Hisao. Japanese, born 1928. In Paris 1955–67.

470 SOLUTION OF CONTINUITY, 24. 1964. Oil on canvas, 63⅝ x 51⅛″ (161.6 x 129.8 cm). Promised gift and extended loan from Mr. and Mrs. David Kluger. E.L.70.1281. Repr. *New Jap. Ptg. & Sc.*, p. 75.

DONATI, Enrico. American, born Italy 1909. Worked in France. To U.S.A. 1934.

311 ST. ELMO'S FIRE. 1944. Oil on canvas, 36½ x 28½″ (92.7 x 72.4 cm). Given anonymously. 129.47. Repr. *Ptg. & Sc.*, p. 230.

INSCRIPTION 4062 B.C. (1962) Oil and sand on canvas, 60 x 50″ (152.5 x 126.9 cm). Gift of Mr. and Mrs. Gilbert W. Kahn. 73.62. Repr. *Suppl. XII*, p. 21.

VAN DONGEN, Kees (Cornelis T. M. van Dongen). French, born the Netherlands. 1877–1968. To France 1897.

63 MODJESKO, SOPRANO SINGER. (1908) Oil on canvas, 39⅜ x 32″ (100 x 81.3 cm). Gift of Mr. and Mrs. Peter A. Rübel. 192.55. Repr. *Suppl. VI*, p. 10; in color, *Invitation*, p. 19; in color, *Fauvism*, p. 59. *Note*: Modjesko was a female impersonator well known in Paris *cafés concerts.*

WOMAN WITH PLUMED HAT. (1910) Oil on canvas, 29 x 21½″ (73.7 x 54.6 cm). Gift of Mrs. Rita Silver in memory of her husband, Leo Silver. 1400.74.

DORAZIO, Piero. Italian, born 1927.

374 RELIEF. 1953. Painted wood and celluloid in frame, 17 x 21½ x 5⅛″ (43 x 54.8 x 13 cm). Given anonymously. 286.61. Repr. *Suppl. XI*, p. 25.

461 HAND OF MERCY [*Mano della clemenza*]. 1963. Oil on canvas, 64⅛ x 51⅜″ (162.6 x 130.3 cm). Bertram F. and Susie Brummer Foundation Fund. 107.65.

DORCÉLY, Roland. Haitian, born 1930. Works in Paris.

289 WHEN TO RELAX? [*A Quand la détente?*]. 1958. Tempera on composition board, 36 x 49¼″ (91.5 x 125 cm). Gift of Edna and Keith Warner. 115.58. Repr. *Suppl. VIII*, p. 20.

DORIANI, William. American, born 1891.

FLAG DAY. (1935) Oil on canvas, 12¼ x 38⅝″ (31.1 x 98 cm). The Sidney and Harriet Janis Collection (fractional gift). 589.67. Repr. *Janis*, p. 87.

DOS PRAZERES, Heitor. Brazilian, 1902–1966.

ST. JOHN'S DAY. 1942. Oil on oilcloth, 25½ x 31¾″ (64.8 x 80.6 cm). Inter-American Fund. 773.42. Repr. *Latin-Amer. Coll.*, p. 40.

DOUAIHY, Saliba. American, born Lebanon 1915. To U.S.A. 1955.

456 MAJESTIC. 1965. Synthetic polymer paint on canvas, 46¼ x 54″ (117.3 x 137.1 cm). Gift of Y. K. Bedas. 384.66.

DOVE, Arthur G. American, 1880–1946.

223 GRANDMOTHER. (1925) Collage of shingles, needlepoint, page from the Concordance, pressed flowers, and ferns, 20 x 21¼″ (50.8 x 54 cm). Gift of Philip L. Goodwin (by exchange). 636.39. Repr. *Ptg. & Sc.*, p. 222; *Assemblage*, p. 43; in color, *Invitation*, p. 59.

223 THE INTELLECTUAL. (1925) Assemblage: magnifying glass, bone, moss, bark, and a scale glued or nailed on varnished cloth, mounted on wood panel, 17 x 7⅛″ (43 x 18.2 cm). The Philip L. Goodwin Collection. 101.58. Repr. *Bulletin*, Fall 1958, p. 8.

223 PORTRAIT OF ALFRED STIEGLITZ. (1925) Assemblage: camera lens, photographic plate, clock and watch springs, and steel wool, on cardboard, 15⅞ x 12⅛″ (40.3 x 30.8 cm). Purchase. 193.55. Repr. *Suppl. VI*, p. 21.

223 WILLOWS. (1940) Oil on gesso on canvas, 25 x 35″ (63.5 x 88.9 cm). Gift of Duncan Phillips. 471.41. Repr. *Ptg. & Sc.*, p. 222; *Natural Paradise*, p. 109.

DREIER, Katherine S. American, 1877–1952.

225 ABSTRACT PORTRAIT OF MARCEL DUCHAMP. 1918. Oil on canvas, 18 x 32″ (45.7 x 81.3 cm). Abby Aldrich Rockefeller Fund. 279.49. Repr. *Suppl. I*, p. 20.

DROSTE, Karl-Heinz. German, born 1931.

362 RELIEF XIII/60 VADASA II. (1960) Bronze, 23½ x 18¼″ (59.6 x 46.2 cm). Gift of Mr. and Mrs. Clarence C. Franklin. 268.63.

DRUMMOND, Sally Hazelet. American, born 1924.

HUMMINGBIRD. 1961. Oil on canvas, 12 x 12″ (30.4 x 30.4 cm). Larry Aldrich Foundation Fund. 229.62 Repr. *Amer. 1963*, p. 29.

DU BOIS, Guy Pène. American, 1884–1958.

234 AMERICANS IN PARIS. 1927. Oil on canvas, 28¾ x 36⅜″ (73 x 92.4 cm). Given anonymously. 66.35. Repr. *Ptg. & Sc.*, p. 157.

DUBUFFET, Jean. French, born 1901.

Loreau refers to the definitive *Catalogue des travaux de Jean Dubuffet*, edited by Max Loreau, Paris; 27 volumes published to date (1976).

GRAND JAZZ BAND (NEW ORLEANS). 1944, December. Oil and tempera on canvas, 45⅛ x 57¾″ (114.6 x 146.7 cm). From the Marionettes of the City and the Country series. Gift of Mr. and Mrs. Gordon Bunshaft. 1515.68. *Loreau I*, 379. Repr. in color, *Dubuffet*, p. 23; *Modern Masters*, p. 135.

263 SNACK FOR TWO [*Casse-croûte à deux*]. (1945) Oil on canvas, 29⅛ x 24⅛″ (74 x 61.2 cm). From the Mirobolus, Macadam et Cie/Hautes Pâtes series. Gift of Mrs. Saidie A. May. 280.49. *Loreau II*, 31. Repr. *Suppl. I*, p. 13.

433 WALL WITH INSCRIPTIONS. 1945. Oil on canvas, 39⅜ x 31⅞″ (99.7 x 81 cm). From the Walls series. Mr. and Mrs. Gordon Bunshaft Fund. 186.66. *Loreau I*, 445.

263 HENRI MICHAUX, JAPANESE ACTOR. 1946. Mixed mediums on canvas, 51½ x 38⅜″ (130.8 x 97.3 cm). From the More Beautiful Than They Think: Portraits series. Gift of Mr. and Mrs. Gordon Bunshaft. 309.62. Repr. *Suppl. XII*, p. 16.

HIGH HEELS. 1946. Oil and sand on canvas, 25⅝ x 21½″ (65.1 x 54.3 cm). From the Mirobolus, Macadam et Cie/Hautes Pâtes series. The Sidney and Harriet Janis Collection (fractional gift). 590.67. *Loreau II*, 152. Repr. *Janis*, p. 101.

JOË BOUSQUET IN BED. 1947 (January). Gouache and ink over gesso incised with pen on cardboard, 19½ x 12¾″ (49.4 x 32.3 cm). From the More Beautiful Than They Think: Portraits series. Mrs. Simon Guggenheim Fund. 15.69. *Loreau III*, 114. *Note*: the subject is a French poet who was paralyzed in World War I and lived bedridden for over three decades in Narbonne. He died in 1950.

263 JOË BOUSQUET IN BED. (1947) Oil emulsion in water on canvas, 57⅝ x 44⅞″ (146.3 x 114 cm). From the More Beautiful Than They Think: Portraits series. Mrs. Simon Guggenheim Fund. 114.61. *Loreau III*, 116. Repr. *Suppl. XI*, p. 42; *Dubuffet*, p. 33.

PORTRAIT OF HENRI MICHAUX. 1947. Oil on canvas, 51½ x 38⅜″ (130.7 x 97.3 cm). Inscribed on reverse: *Portrait of Henri Michaux*; on stretcher: *Michaux gros cerne crême*. From the More Beautiful Than They Think: Portraits series. The Sidney and Harriet Janis Collection (fractional gift). 591.67. *Loreau III*, 112. Repr. *Janis*, p. 101.

CORPS DE DAME: LA JUIVE. 1950 (October). Oil on canvas, 45¾ x 35″ (116.2 x 88.7 cm). From the Corps de Dame series. Gift of the Pierre Matisse Gallery. 1512.68. *Loreau VI*, 109.

CORPS DE DAME: BLUE SHORT CIRCUIT [*Court-circuit bleu*]. 1951 (February). Oil on canvas, 46⅛ x 35¼″ (117 x 89.4 cm). From the Corps de Dames series. The Sidney and Harriet Janis Collection (fractional gift). 593.67. *Loreau VI*, 118. Repr. in color, *Janis*, p. 103; in color, *Invitation*, p. 130.

TABLE AUX SOUVENIRS. 1951 (March). Oil and sand on canvas, 32⅛ x 39½″ (81.5 x 100.2 cm). From the Landscaped Tables series. The Sidney and Harriet Janis Collection (fractional gift). 592.67. *Loreau VII*, 20. Repr. *Janis*, p. 107.

FAÇADE. 1951 (June). Watercolor on gesso on paper, 9⅞ x 13″ (25 x 32.9 cm). From the Barren Landscapes series. The Sidney and Harriet Janis Collection (fractional gift). 1772.67. Repr. *Janis*, p. 105.

264 WORK TABLE WITH LETTER. 1952. Oil paint in Swedish putty on composition board, 35⅝ x 47⅞″ (90.5 x 121.6 cm). From the

264 THE COW WITH THE SUBTILE NOSE. 1954. Oil and enamel on canvas, 35 x 45¾″ (88.9 x 116.1 cm). From the Cows, Grass, Foliage series. Benjamin Scharps and David Scharps Fund. 288.56. *Loreau X*, 109. Repr. *Suppl. VI*, p. 24; *Dubuffet*, p. 99.

CURSED GOSSIP [*Maudite commère*]. (1954) Charcoal on cast stone base, 13″ (33.2 cm) high, including base 2³⁄₈ x 3¹⁄₂ x 3¹⁄₂″ (6.1 x 9 x 9 cm). From the Petites statues de la vie précaire series. Gift of Henry Slesar. 298.75. *Loreau X*, 29. Repr. *Dubuffet*, p. 89.

THE MAGICIAN. 1954, September. Slag and roots, 43¹⁄₂″ (109.8 cm) high, including slag base 2³⁄₄ x 12³⁄₄ x 8″ (6.8 x 32.2 x 20.2 cm). From the Petites statues de la vie précaire series. Gift of Mr. and Mrs. N. Richard Miller and Mr. and Mrs. Alex L. Hillman and Samuel Girard Funds. 871.68. *Loreau X*, 38. Repr. *Dubuffet*, p. 91.

263 BLACK COUNTRYSIDE [*Terres noires*]. (1955) Assemblage: cut-and-pasted paper with ink transfer on paper, 25¹⁄₂ x 23¹⁄₈″ (64.8 x 58.7 cm). From the Second Series of Imprint Assemblages. Gift of Mr. and Mrs. Donald H. Peters. 12.56.

MARRIAGE VOWS [*Les Voeux de mariage*]. 1955, August. Oil on canvas, 39¹⁄₂ x 32″ (100.3 x 81.1 cm). From the Monolithic Figures series. Gift of William H. Weintraub. 499.64. *Loreau XI*, 154.

GEORGES DUBUFFET IN THE GARDEN. (1955. Dated on painting 1955 and 1956). Collage of cut-up oil paintings with wood chips and newspaper on canvas, 61¹⁄₄ x 36¹⁄₈″ (155.5 x 91.7 cm). From the Painting Assemblages series. Gift of William H. Weintraub. 500.64. *Loreau XII*, 11. Repr. in color, *Assemblage*, p. 95.

264 BEARD OF UNCERTAIN RETURNS. 1959. Oil on canvas, 45³⁄₄ x 35¹⁄₈″ (116.1 x 89.2 cm). From the Beards series. Mrs. Sam A. Lewisohn Fund. 63.61. *Loreau XV*, 85. Repr. *Suppl. XI*, p. 43; *Dubuffet*, p. 147.

BOTANICAL ELEMENT: BAPTISM OF FIRE [*Baptême du feu*]. 1959 (September). Assemblage of leaves on paper, 21⁵⁄₈ x 27¹⁄₈″ (54.9 x 68.9 cm). From the Botanical Elements series. The Sidney and Harriet Janis Collection (fractional gift). 594.67. Repr. *Janis*, p. 109.

PLACE FOR AWAKENINGS [*Site aux éveils*]. 1960. Pebbles, sand, and plastic paste on composition board, 34⁷⁄₈ x 45³⁄₈″ (88.4 x 115.2 cm). From the Matériologies series. Gift of Mr. and Mrs. Ralph F. Colin. 1293.68. *Loreau XVII*, 139.

265 BUSINESS PROSPERS. 1961. Oil on canvas, 65″ x 7′2⁵⁄₈″ (165.1 x 220 cm). From the Paris Circus series. Mrs. Simon Guggenheim Fund. 115.62. *Loreau XIX*, 55. Repr. *Dubuffet*, p. 161; *Suppl. XII*, p. 17; in color, *Invitation*, p. 125.

Design for jacket of *The Work of Jean Dubuffet* by Peter Selz, The Museum of Modern Art, New York, 1962. (1961) Gouache, 9⁵⁄₈ x 27¹⁄₈″ (24.5 x 68.9 cm). Commissioned by the Museum. Gift of the artist. 117.62. Repr. in color, *Dubuffet* jacket.

FIGURE: BUST [*Personnage: Buste*]. 1962 (March 13) Gouache, 10³⁄₈ x 8¹⁄₈″ (26.2 x 20.5 cm). From the Legends series. Gift of the artist in honor of Mr. and Mrs. Ralph F. Colin. 1324.68. *Loreau XIX*, 310.

ALGEBRA OF UNCERTAINTY [*L'Algèbre des incertitudes*]. 1964 (March 20) Synthetic polymer paint on paper, 19³⁄₄ x 26¹⁄₂″ (50 x 67.3 cm). From the Hourloupe series. Gift of the artist in honor of Mr. and Mrs. Ralph F. Colin. 1327.68. *Loreau XX*, 282.

CUP OF TEA, II [*Tasse de thé, II*]. 1966. Cast polyester resin and cloth with synthetic polymer paint, 6′5⁷⁄₈″ x 46¹⁄₄″ x 3³⁄₄″ (197.8 x

117.3 x 9.5 cm). From the Hourloupe series. Gift of Mr. and Mrs. Lester Avnet. 720.68.

STUDY FOR TOWER WITH FIGURES [*Tour aux figures*]. (1968, summer) Cast polyester resin and synthetic polymer paint, 9′9³⁄₄″ x 6′ diameter (299 x 183 cm). From the Tower with Figures series. Gift of Mr. and Mrs. M. Riklis. 1137.69. *Loreau XXIV*, 6.

CUCKOO BAZAAR: THE HOURLOUPE BALL. 1972, September 6. Design for costume; collage and colored felt pens, 21¹⁄₄ x 10¹⁄₄″ (34 x 26 cm). From the Coucou Bazar series. Gift of Ernst Beyeler. 606.73. Theatre Arts Collection. *Loreau XXVII*, 132. *Note:* first performed at The Solomon R. Guggenheim Museum, New York, May 16, 1973.

DUCHAMP, Marcel. American, born France. 1887–1968. In U.S.A. 1915–18, 1920–23, 1942–68.

LANDSCAPE. (1908) Oil on canvas, 18¹⁄₈ x 24″ (46 x 60.9 cm). Gift of Mr. and Mrs. Samuel Dorsky. 703.71.

156 LANDSCAPE. 1911. Oil on canvas, 18¹⁄₄ x 24¹⁄₈″ (46.3 x 61.3 cm). Katherine S. Dreier Bequest. 148.53. Repr. *Suppl. IV*, p. 10; *Duchamp*, p. 248.

156 THE PASSAGE FROM VIRGIN TO BRIDE. Munich, 1912 (July–August). Oil on canvas, 23³⁄₈ x 21¹⁄₄″ (59.4 x 54 cm). Inscribed, lower left: *Le Passage de la vierge à la mariée*. Purchase. 174.45. Repr. *Ptg. & Sc.*, p. 91; in color, *Masters*, p. 136; *Dada, Surrealism*, p. 13; in color, *Invitation*, p. 56; *Duchamp*, p. 262.

156 3 STOPPAGES ÉTALON. 1913–14. Assemblage: three threads glued to three painted canvas strips, 5¹⁄₄ x 47¹⁄₄″ (13.3 x 120 cm), each mounted on a glass panel, 7¹⁄₄ x 49³⁄₈ x ¹⁄₄″ (18.4 x 125.4 x .6 cm); three wood slats, 2¹⁄₂ x 43 x ¹⁄₈″ (6.2 x 109.2 x .2 cm), 2¹⁄₂ x 47 x ¹⁄₈″ (6.1 x 119.4 x .2 cm), 2¹⁄₂ x 43¹⁄₄ x ¹⁄₈″ (6.3 x 109.7 x .2 cm), shaped along one edge to match the curves of the threads; the whole fitted into a wood box, 11¹⁄₈ x 50⁷⁄₈ x 9″ (28.2 x 129.2 x 22.7 cm). Inscribed on reverse: *Un mètre de fil droit, horizontal, tombé d'un mètre de haut. 3 Stoppages étalon; appartenant à Marcel Duchamp. 1913–14.* Katherine S. Dreier Bequest. 149.53. Repr. *Suppl. IV*, p. 10; *Masters*, p. 137; *Duchamp*, p. 273. *Note: stoppages étalon* may be translated "standard stoppages" but *stoppage* in French means both the action of "stopping" and the action of sewing together a torn or cut cloth with a thread.

NETWORK OF STOPPAGES. [*Réseaux des stoppages*]. Paris (1914) Oil and pencil on canvas, 58⁵⁄₈″ x 6′5⁵⁄₈″ (148.9 x 197.7 cm). Abby Aldrich Rockefeller Fund and gift of Mrs. William Sisler. 390.70. Repr. in color, *Duchamp*, facing page 273.

157 TO BE LOOKED AT (FROM THE OTHER SIDE OF THE GLASS) WITH ONE EYE, CLOSE TO, FOR ALMOST AN HOUR. Buenos Aires, 1918. Oil paint, silver leaf, lead wire, and magnifying lens on glass (cracked), 19¹⁄₂ x 15⁵⁄₈″ (49.5 x 39.7 cm), mounted between two panes of glass in a standing metal frame, 20¹⁄₈ x 16¹⁄₄ x 1¹⁄₂″ (51 x 41.2 x 3.7 cm), on painted wood base 1⁷⁄₈ x 17⁷⁄₈ x 4¹⁄₂″ (4.8 x 45.3 x 11.4 cm); overall height 22″ (55.8 cm). Inscribed: *A regarder (l'autre côté du verre) d'un oeil, de près, pendant presque une heure.* Katherine S. Dreier Bequest. 150.53. Repr. *Suppl. IV*, p. 11; *Cubism*, p. 175; in color, *Invitation*, p. 147; *Duchamp*, p. 287 (also called *Disturbed Balance*).

157 FRESH WIDOW. New York, 1920. Miniature French window, painted wood frame and eight panes of glass covered with black leather, 30¹⁄₂ x 17⁵⁄₈″ (77.5 x 44.8 cm), on wood sill, ³⁄₄ x 21 x 4″ (1.9 x 53.4 x 10.2 cm). Inscribed: *Fresh Widow Copyright Rose Selavy 1920*. Katherine S. Dreier Bequest. 151.53. Repr. *Suppl. IV*, p. 11; *Assemblage*, p. 44; *Duchamp*, p. 290. *Note: Fresh Widow* is, of course, a pun and so is *Sélavy* if pronounced *c'est la vie*.

157 MONTE CARLO BOND. Paris, 1924. Photocollage on colored lithograph (no. 12/30), 12¹⁄₄ x 7³⁄₄″ (31.1 x 19.7 cm). Gift of the artist. 3.39. Repr. *Duchamp*, p. 297; *Seurat to Matisse*, p. 66.

DUCHAMP-VILLON

Note: framed in the roulette wheel, above the center, is a cutout photograph of the artist, his face wreathed in soapsuds. Man Ray took the photograph.

ROTARY DEMISPHERE (PRECISION OPTICS). Paris, 1925. Motor-driven construction: painted wood demisphere, fitted on black velvet disk, copper collar with plexiglass dome, motor, pulley, and metal stand, 58½ x 25¼ x 24″ (148.6 x 64.2 x 60.9 cm). Gift of Mrs. William Sisler and Edward James Fund. 391.70a–c. Repr. *Duchamp*, p. 298.

BOX IN A VALISE [*Boîte-en-valise*]. (1935–41) Leather valise containing miniature replicas, photographs, and color reproductions of works by Duchamp, 16 x 15 x 4″ (40.7 x 38.1 x 10.2 cm). Inscribed at time of acquisition: *Marcel Duchamp New York Jan. 1943* and stamped with the Museum's name in gold. James Thrall Soby Fund. 67.43.1–70. Repr. of another replica *Duchamp*, p. 304. *Note*: Number IX of a deluxe edition of twenty, completed in 1941. The artist assembled the contents of this "portable museum" between 1935 and 1940.

BICYCLE WHEEL. New York (1951. Third version, after lost original of 1913). Assemblage: metal wheel, 25½″ (63.8 cm) diameter, mounted on painted wood stool, 23¾″ (60.2 cm) high; overall, 50½″ (128.3 cm) high. The Sidney and Harriet Janis Collection (fractional gift). 595.67. Repr. *Assemblage*, p. 46; *Janis*, p. 49; *Duchamp*, p. 270.

WEDGE OF CHASTITY [*Coin de chasteté*]. 1954. Plaster in two sections, partly painted, 2¾ x 3⅞ x 2½″ (6.9 x 10 x 6.1 cm). Inscribed: *Pour Sacha Maruchess très cordialement*. Gift of Mr. and Mrs. Solomon Ethe. 154.62a–b. Repr. of sculpture is galvanized plaster and dental plastic, *Duchamp*, p. 309.

416 WHY NOT SNEEZE ROSE SÉLAVY? 1964. Replica of 1921 original. Painted metal birdcage containing 151 white marble blocks, thermometer, and piece of cuttlebone; cage, 4⅞ x 8¾ x 6⅜″ (12.3 x 22.1 x 16 cm). Inscribed lower edge: *For the Museum of Modern Art New York Marcel Duchamp/1964*; on bottom: *Why/not/sneeze/Rose/Sélavy?/1921*. Gift of Galleria Schwarz. 1123.64a–e. Repr. *Dada, Surrealism*, p. 16; *Duchamp* (original version), p. 295.

L.H.O.O.Q./SHAVED. (1965) Playing card pasted on folded note paper, 8¼ x 5½″ (21 x 13.8 cm). Gift of Philip Johnson. 506.70. Repr. *Duchamp*, p. 315.

DUCHAMP-VILLON, Raymond. French, 1876–1918.

102 BAUDELAIRE. 1911. Bronze, 15¾″ (40 cm) high. Alexander M. Bing Bequest. 5.60. Repr. *Suppl. X*, p. 18.

102 THE LOVERS. (1913) Original plaster relief, 27½ x 46 x 6½″ (69.8 x 116.8 x 16.3 cm). Purchase. 258.39. Repr. *Ptg. & Sc.*, p. 268; *What Is Mod. Sc.*, p. 114.

102 THE HORSE. 1914. Bronze (cast c. 1930–31), 40 x 39½ x 22⅜″ (101.6 x 100.1 x 56.7 cm). Van Gogh Purchase Fund. 456.37. This cast was made after the sculptor's death by his brother Jacques Villon and the sculptor Albert Pommier, who enlarged the original model according to the artist's instructions. Repr. *Ptg. & Sc.*, p. 269; *Masters*, p. 79; *What Is Mod. Sc.*, p. 50.

DUFF, John. American, born 1943.

WHITE DIVIDE. (1971) Fiberglass and resin with white paint, 70⅞ x 32 x 4⅝″ (179.7 x 81.3 x 11.7 cm). Gift of Joseph Helman. 593.76.

DUFFAUT, Préfète. Haitian, born 1923.

SIN [*Le Péché*]. 1953. Oil on composition board, 15½ x 20″ (39.2 x 50.8 cm). Given anonymously. 574.70.

DUFY, Raoul. French, 1877–1953.

M.L. refers to *Raoul Dufy*, volume 1, by Maurice Laffaille, Geneva, 1972.

64 SAILBOAT AT SAINTE-ADRESSE. (1912) Oil on canvas, 34⅞ x 45⅝″ (88.6 x 115.9 cm). Gift of Mr. and Mrs. Peter A. Rübel. 476.53. *M.L.* 320 (*Le Casino de Sainte-Adresse au Pêcheur*). Repr. in color, *Masters*, p. 48.

65 THE PALM. 1923. Watercolor and gouache, 19¾ x 25″ (50.2 x 63.5 cm). Gift of Mrs. Saidie A. May. 140.34. Repr. *Ptg. & Sc.*, p. 54.

64 THE POET FRANÇOIS BERTHAULT. (1925) Oil on paper over canvas, 32 x 25⅝″ (81.3 x 65.1 cm). Gift of Mr. and Mrs. Peter A. Rübel. 544.54. Repr. *Suppl. V*, p. 8.

64 WINDOW AT NICE. (c. 1929) Oil on canvas, 21⅝ x 18⅛″ (54.9 x 46 cm). Gift of Mrs. Gilbert W. Chapman. 267.54. Repr. *Suppl. V*, p. 8.

DURCHANEK, Ludvik. American, born Austria 1902, of Czech parentage. To U.S.A. 1927.

302 FURY. (1958) Welded sheet bronze, 30¾″ (78 cm) high. Blanchette Rockefeller Fund. 116.58. Repr. *Suppl. VIII*, p. 16.

DŽAMONJA, Dušan. Yugoslavian, born 1928.

379 METALLIC SCULPTURE. (1959) Welded iron nails with charred wood core, 16⅜″ high, 10″ diameter (41.5 x 25.4 cm). Philip Johnson Fund. 2.61. Repr. *Suppl. XI*, p. 41.

EBERZ, Josef. German, 1880–1942.

403 STAGE [*Bühne*]. 1916. Oil on cardboard, 9¼ x 11⅞″ (23.4 x 30.1 cm). Gift of Richard L. Feigen. 729.66.

VAN EESTEREN, Cornelis. See VAN DOESBURG.

EGAS, Camilo. Ecuadorian, 1899–1962. To U.S.A. 1930.

217 DREAM OF ECUADOR. 1939. Oil on canvas, 20 x 25″ (50.8 x 63.5 cm). Inter-American Fund. 3.45. Repr. *Ptg. & Sc.*, p. 141.

EGUCHI, Shyu. Japanese, born 1932.

474 MONUMENT, NUMBER 4 [*Kuwagata*]. (1964) Cherry wood, 17¾ x 21¾ x 13½″ (44.9 x 55.1 x 34.1 cm). Purchase. 602.65. Repr. *New Jap. Ptg. & Sc.*, p. 83.

EIELSON, Jorge. Peruvian, born 1924. In Italy since 1952.

488 WHITE QUIPUS. (1964) Knotted cloth and tempera on canvas, 37½ x 59⅛″ (95 x 150.2 cm). Inter-American Fund. 108.65. *Note*: quipus were knotted cords used by the Inca Indians to record facts and events. Color and knots had specific meanings.

EILSHEMIUS, Louis Michel. American, 1864–1941.

36 AFTERNOON WIND. 1899. Oil on canvas, 20 x 36″ (50.8 x 91.4 cm). Given anonymously. 394.41. Repr. *Ptg. & Sc.*, p. 164.

402 THE DEMON OF THE ROCKS. 1901. Oil on cardboard, 20 x 15⅛″ (50.6 x 38.3 cm). Gift of Fania Marinoff Van Vechten in memory of Carl Van Vechten. 285.65.

402 THE HUDSON AT YONKERS. (1911?) Oil on cardboard, 15 x 20″ (37.9 x 50.8 cm). Gift of Fania Marinoff Van Vechten in memory of Carl Van Vechten. 286.65.

36 IN THE STUDIO. (c. 1911) Oil on cardboard, 22⅛ x 13¾″ (56.2 x 35 cm). Gift of Abby Aldrich Rockefeller. 67.35.

SAMOA. 1911. Oil on cardboard, 10 x 8″ (25.4 x 20.3 cm). The Sidney and Harriet Janis Collection (fractional gift). 596.67. Repr. *Janis*, p. 81.

DANCING NYMPHS. (1914) Oil on composition board, 20¹/₈ x 20¹/₄″ (51 x 51.2 cm). The Sidney and Harriet Janis Collection (fractional gift). 597.67. Repr. *Janis*, p. 81. *Note*: the canvas is signed "Elshemus"; the artist signed his name variously as Elshemus, Eilshemius, and Eilsemus.

NYMPH. (1914) Oil on composition board, 20¹/₈ x 19³/₄″ (51 x 50.2 cm). The Sidney and Harriet Janis Collection (fractional gift). 598.67. Repr. *Janis*, p. 81. *Note*: signed "Elshemus."

402 MOSQUE NEAR BISKRA. (c. 1915?) Oil on cardboard, 30¹/₂ x 20¹/₄″ (77.4 x 51.3 cm). Gift of Fania Marinoff Van Vechten in memory of Carl Van Vechten. 287.65.

VAN ELK, Ger. Dutch, born 1941.

THE ADIEU, III. 1974. Oil and ink on color photograph framed under nonreflective glass, 39¹/₈ x 36³/₈″ (99.2 x 92.3 cm), including artist's trapezoidal frame. Hedwig van Amerigen Foundation Fund. 112.75.

ENGMAN, Robert. American, born 1927.

371 A STUDY IN GROWTH. (1958) Plastic-coated stainless steel, 19¹/₂″ (49.3 cm) high. Larry Aldrich Foundation Fund. 27.60. Repr. *Suppl. X*, p. 51.

ENRÍQUEZ, Carlos. Cuban, 1901–1957.

LANDSCAPE WITH WILD HORSES. 1941. Oil on composition board, 17¹/₂ x 23⁵/₈″ (44.5 x 60 cm). Gift of Dr. C. M. Ramírez Corría. 604.42. Repr. *Latin-Amer. Coll.*, p. 50.

ENSOR, James. Belgian, 1860–1949.

27 TRIBULATIONS OF ST. ANTHONY [*Les Tribulations de St. Antoine*]. 1887. Oil on canvas, 46³/₈ x 66″ (117.8 x 167.6 cm). Purchase. 1642.40. Repr. *Ptg. & Sc.*, p. 34; in color, *Masters*, p. 35.

27 MASKS CONFRONTING DEATH [*Masques devant la mort*]. 1888. Oil on canvas, 32 x 39¹/₂″ (81.3 x 100.3 cm). Mrs. Simon Guggenheim Fund. 505.51. Repr. *Suppl. IV*, p. 19; in color, *Invitation*, p. 20.

EPSTEIN, Jacob. British, born U.S.A. 1880–1959. To England 1905.

114 NAN SEATED. (1911) Bronze, 18¹/₂″ (47 cm) high, at base, 13 x 5⁷/₈″ (33 x 14.9 cm). Gift of Mrs. Frank Altschul in memory of her father, Philip J. Goodhart. 4.49. Repr. *Suppl. I*, p. 28. *Note*: Nan Condron, a gypsy, was a professional model.

114 MOTHER AND CHILD. (1913) Marble, 17¹/₄ x 17″ (43.8 x 43.1 cm). Gift of A. Conger Goodyear. 5.38. Repr. *Ptg. & Sc.*, p. 270.

114 THE ROCK DRILL. (1913–14) Bronze (cast 1962), 28 x 26″ (71 x 66 cm) on wood base, 12″ (30.5 cm) diameter. Mrs. Simon Guggenheim Fund. 155.62. Repr. *Suppl. XII*, p. 1; *The Machine*, p. 65. *Note*: the original plaster version of this sculpture was mounted on an actual rock drill and so exhibited.

413 PAUL ROBESON. (1928) Bronze, 13¹/₂″ (34.2 cm) high. Gift of Fania Marinoff Van Vechten in memory of Carl Van Vechten. 288.65. *Note*: the subject of this unfinished portrait is the singer.

115 ORIEL ROSS. (1932) Bronze, 26¹/₄ x 17″ (66.7 x 43 cm). Gift of Edward M. M. Warburg. 2.33. Repr. *Ptg. & Sc.*, p. 252; *What Is Mod. Sc.*, p. 28. *Note*: Epstein's third portrait of this model who was an actress and later married Earl Paulett.

412 ISOBEL. (1933) Tinted plaster, 27⁷/₈ x 26¹/₂ x 18″ (70.6 x 67.1 x 45.6 cm). Gift of Lady Kathleen Epstein on behalf of the artist's estate. 188.66. *Note*: Epstein's second portrait of Isobel Nicholas, an art student, later a painter and ballet set designer.

413 ROBERT FLAHERTY. (1933) Tinted plaster, 12¹/₂ x 8³/₈ x 11¹/₈″ (31.7 x 21.1 x 28 cm). Gift of Lady Kathleen Epstein on behalf of the artist's estate. 187.66. *Note*: the subject is the American documentary-film master.

412 HAILE SELASSIE. (1936) Tinted plaster, 46¹/₄ x 27³/₄ x 17″ (117.5 x 70.5 x 43.1 cm). Gift of Lady Kathleen Epstein on behalf of the artist's estate. 189.66. *Note*: the subject is the deposed Emperor of Ethiopia.

412 LEDA (WITH COXCOMB). (1940) Tinted plaster, 8¹/₈ x 7¹/₄ x 7¹/₄″ (20.5 x 18.3 x 18.3 cm). Gift of Lady Kathleen Epstein on behalf of the artist's estate. 190.66. *Note*: Epstein's fourth portrait of his granddaughter, Leda Hornstein.

413 PANDIT NEHRU. (1946) Tinted plaster, 11⁵/₈ x 7¹/₈ x 9¹/₈″ (29.5 x 18 x 23.1 cm). Gift of Lady Kathleen Epstein on behalf of the artist's estate. 191.66. *Note*: study for a bust completed in 1949. Jawaharlal Nehru was Prime Minister of India.

115 RECLINING NUDE STRETCHING. (1946) Bronze, 4 x 28¹/₄ x 7″ (10.1 x 71.6 x 17.6 cm). Gift of Dr. and Mrs. Arthur Lejwa in memory of Leon Chalette. 603.59. Repr. *Suppl. IX*, p. 10. *Note*: the model for this and the preceding sculpture was Betty Peters who kept a lodging house in the East End of London.

115 RECLINING NUDE TURNING. (1946) Bronze, 5¹/₂ x 21³/₄ x 12³/₄″ (14 x 55.3 x 32.4 cm). Gift of Dr. and Mrs. Arthur Lejwa in memory of Leon Chalette. 82.58. Repr. *Suppl. VIII*, p. 6.

413 ROSALYN TURECK. (1956) Tinted plaster, 12¹/₂ x 10¹/₈ x 10⁷/₈″ (31.6 x 25.6 x 27.6 cm). Gift of Lady Kathleen Epstein on behalf of the artist's estate. 192.66. *Note*: the subject is the well-known concert pianist.

ERNST, Jimmy. American, born Germany 1920. To U.S.A. 1938.

311 THE FLYING DUTCHMAN. 1942. Oil on canvas, 20 x 18¹/₈″ (50.8 x 46 cm). Purchase. 68.43. Repr. *Ptg. & Sc.*, p. 230.

311 A TIME FOR FEAR. 1949. Oil on canvas, 23⁷/₈ x 20″ (60.6 x 50.8 cm). Katharine Cornell Fund. 73.50. Repr. *Abstract Ptg. & Sc.*, p. 121.

ERNST, Max. French, born Germany. 1891–1976. To France 1922; in U.S.A. 1941–50.

162 THE GRAMINEOUS BICYCLE GARNISHED WITH BELLS THE DAPPLED FIRE DAMPS AND THE ECHINODERMS BENDING THE SPINE TO LOOK FOR CARESSES. (Cologne, 1920 or 1921) Botanical chart altered with gouache, 29¹/₄ x 39¹/₄″ (74.3 x 99.7 cm). Inscribed: *la biciclette graminée garnie de grelots les grisous grivelés et les échinodermes courbants l'échine pour quêter des caresses.* Purchase. 279.37. Repr. *Fantastic Art* (3rd), p. 163.

162 THE HAT MAKES THE MAN. (Cologne, 1920) Collage, pencil, ink, and watercolor, 14 x 18″ (35.6 x 45.7 cm). Inscribed: *bedecktsamiger stapelmensch nacktsamiger wasserformer ("edelformer") Kleidsame nervatur. auch! umpressnerven! (c'est le chapeau qui fait l'homme) (le style c'est le tailleur).* Purchase. 242.35. Repr. *Ptg. & Sc.*, p. 213; *Fantastic Art*, p. 163.

162 THE LITTLE TEAR GLAND THAT SAYS TIC TAC. 1920. Gouache on wallpaper, 14¹/₄ x 10″ (36.2 x 25.4 cm). Inscribed: *la petite fistule lacrimale qui dit tic tac.* Purchase. 238.35. Repr. *Masters*, p. 138; *The Machine*, p. 125.

162 STRATIFIED ROCKS, NATURE'S GIFT OF GNEISS LAVA ICELAND MOSS 2 KINDS OF LUNGWORT 2 KINDS OF RUPTURES OF THE PERINEUM GROWTHS OF THE HEART (B) THE SAME THING IN A WELL-POLISHED BOX SOMEWHAT MORE EXPENSIVE. (1920) Anatomical engraving altered with gouache and pencil, 6 x 8¹/₈″ (15.2 x 20.6 cm). Inscribed: *schichtgestein naturgabe aus gneis lava isländisch moos 2 sorten lungenkraut 2 sorten dammriss herzge-*

wächse (b) dasselbe in fein poliertem kästchen etwas teurer. Purchase. 280.37.

162 WOMAN, OLD MAN AND FLOWER [*Weib, Greis und Blume*]. (1923–24) Oil on canvas, 38 x 51¼″ (96.5 x 130.2 cm). Purchase. 264.37. Repr. *Ptg. & Sc.*, p. 194; *Ernst*, p. 27.

162 TWO CHILDREN ARE THREATENED BY A NIGHTINGALE. (1924) Oil on wood with wood construction, 27½ x 22½ x 4½″ (69.8 x 57.1 x 11.4 cm). Inscribed: *2 enfants sont menacés par un rossignol.* Purchase. 256.37. Repr. *Fantastic Art* (3rd), p. 165; in color, *Ernst*, frontispiece; in color, *Invitation*, p. 87.

RENDEZVOUS OF FRIENDS—THE FRIENDS BECOME FLOWERS. 1928. Oil on canvas, 51⅛ x 63¾″ (129.8 x 161.9 cm). Purchase. 189.73.

163 THE SEA. (1928) Painted plaster on canvas, 22 x 18½″ (55.9 x 47 cm). Purchase. 85.36. Repr. *Ernst*, p. 36.

163 BIRDS ABOVE THE FOREST. (1929) Oil on canvas, 31¾ x 25¼″ (80.6 x 64.1 cm). Katherine S. Dreier Bequest. 154.53. Repr. *Suppl. IV*, p. 13; *Ernst*, p. 35.

LOPLOP INTRODUCES MEMBERS OF THE SURREALIST GROUP. (1931) Cut-and-pasted photographs, pencil, and pencil frottage, 19¾ x 13¼″ (50.1 x 33.6 cm). Purchase. 267.35. Repr. *Seurat to Matisse*, p. 66.

BUTTERFLIES. (1931 or 1933) Collage, oil, gouache, and pencil, 19¾ x 25¾″ (50.2 x 65.4 cm). Purchase. 240.35.

THE BLIND SWIMMER. 1934. Oil on canvas, 36⅜ x 29″ (92.3 x 73.5 cm). Gift of Mrs. Pierre Matisse and the Helena Rubinstein Fund. 228.68. Repr. *Dada, Surrealism*, p. 130.

Untitled. (1934) Painted stone, 2⅜ x 4¼ x 4¾″ (5.8 x 10.7 x 11.7 cm). Gift of Mrs. Bliss Parkinson. 221.68.

164 LES ASPERGES DE LA LUNE [*Lunar Asparagus*]. (1935) Plaster, 65¼″ (165.7 cm) high. Purchase. 273.37. Repr. *Ptg. & Sc.*, p. 292; *What Is Mod. Sc.*, p. 55.

LES ASPERGES DE LA LUNE [*Lunar Asparagus*]. 1935. Bronze (cast 1972), 64⅜″ (163.4 cm) high, including bronze base 4⅝ x 8⅛ x 4⅝″ (11.6 x 23 x 11.6 cm). Gift of the artist. 584.73.

164 THE NYMPH ECHO [*La Nymphe Écho*]. 1936. Oil on canvas, 18¼ x 21¾″ (46.3 x 55.2 cm). Purchase. 262.37. Repr. in color, *Fantastic Art* (3rd), opp. p. 168.

165 NAPOLEON IN THE WILDERNESS. (1941) Oil on canvas, 18¼ x 15″ (46.3 x 38.1 cm). Acquired by exchange. 12.42. Repr. *Ptg. & Sc.*, p. 195; *Ernst*, p. 42.

AN ANXIOUS FRIEND. 1944. Bronze (cast 1973), 26⅜ x 14 x 16″ (67 x 35.5 x 40.4 cm), including bronze base 2½ x 13⅝ x 10⅜″ (6.3 x 34.5 x 26.3 cm). Gift of the artist. 583.73. Repr. *Ernst*, p. 50 (another cast).

164 THE KING PLAYING WITH THE QUEEN. (1944) Bronze (cast 1954, from original plaster), 38½″ (97.8 cm) high, at base 18¾ x 20½″ (47.7 x 52.1 cm). Gift of D. and J. de Menil. 330.55. Repr. *Suppl. VI*, p. 19; *Ernst*, p. 50.

MOONMAD. 1944. Bronze (cast 1973), 36⅞ x 13⅞ x 13¾″ (93.7 x 35.3 x 34.9 cm), including bronze base 2¾ x 12¼ x 10⅝″ (5.9 x 31 x 26.8 cm). Gift of the artist. 585.73. Repr. *Ernst*, p. 50 (another cast).

165 MUNDUS EST FABULA. 1959. Oil on canvas, 51¼ x 64″ (130.1 x 162.5 cm). Gift of the artist. 116.61. Repr. *Ernst*, p. 49; *Suppl. XI*, p. 14.

EROL (Erol Akyavash). Turkish, born 1932. In U.S.A. 1950–60.

318 THE GLORY OF THE KINGS. (1959?) Oil on canvas, 48″ x 7′1¼″ (121.8 x 214 cm). Gift of Mr. and Mrs. L. M. Angeleski. 130.61. Repr. *Suppl. XI*, p. 35.

ESTES, Richard. American, born 1936.

DOUBLE SELF-PORTRAIT. (1976) Oil on canvas, 24 x 36″ (60.8 x 91.5 cm). Mr. and Mrs. Stuart M. Speiser Fund. 594.76.

ETROG, Sorel. Israeli, born Rumania 1933. Lives in Canada.

297 RITUAL DANCER. (1960–62) Bronze, 56¼″ (142.6 cm) high. Gift of Mr. and Mrs. Samuel J. Zacks. 327.63. *Note:* the Museum owns a pencil study for this sculpture.

EURICH, Richard. British, born 1903.

THE NEW FOREST. 1939. Oil on canvas, 25 x 30⅛″ (63.5 x 76.5 cm). Gift of the American Academy and National Institute of Arts and Letters Fund, through the American British Art Center. 584.42.

ÈVE, Jean. French, born 1900.

THE CATHEDRAL AT MANTES. 1930. Oil on canvas, 18⅛ x 21½″ (46 x 54.6 cm). Gift of Mr. and Mrs. Peter A. Rübel. 615.51.

EVERGOOD, Philip. American, 1901–1973.

248 DON'T CRY, MOTHER. (1938–44) Oil on canvas, 26 x 18″ (66 x 45.7 cm). Purchase. 120.44. Repr. *Ptg. & Sc.*, p. 146.

EYÜBOĞLU. See RAHMI.

FAHLSTRÖM, Öyvind. Swedish, born Brazil. 1928–1976. In Sweden 1939–61; to U.S.A. 1961.

EDDIE (SYLVIE'S BROTHER) IN THE DESERT. (1966) Variable collage: fifteen movable serigraphed paper cutouts over serigraphed cutouts pasted on painted wood panel, 35¼ x 50½″ (89.5 x 128.1 cm). The Sidney and Harriet Janis Collection (fractional gift). 600.67. Repr. *Janis*, p. 147.

FANGOR, Wojciech. Polish, born 1922. Worked in Great Britain, Germany, France; to U.S.A. 1966.

500 NUMBER 17. 1963. Oil on burlap, 39½ x 39½″ (100.1 x 100.1 cm). Gift of Beatrice Perry, Inc. 46.65. Repr. *Responsive Eye*, p. 29.

FARRERAS, Francisco. Spanish, born 1927.

463 COLLAGE NUMBER 242. 1965. Collage of tempera-tinted and burned papers over wood, 60 x 70⅛″ (152.4 x 178.1 cm). Gift of Dr. Andres J. Escoruela. 503.65.

FAUSETT, Dean. American, born 1913.

291 DERBY VIEW. (1939) Oil tempera on canvas, 24⅛ x 40″ (61.3 x 101.6 cm). Purchased from the Southern Vermont Artists' Exhibition at Manchester with a fund given anonymously. 1643.40. Repr. *What Is Mod. Ptg.* (9th), p. 6.

FAUTRIER, Jean. French, 1898–1964.

192 FLOWERS. (c. 1927) Oil on canvas, 25⅝ x 21¼″ (65.1 x 54 cm). Gift of A. Conger Goodyear. 530.41.

FAZZINI, Pericle. Italian, born 1913.

292 THE SIBYL. 1947. Bronze, 37¼″ (94.6 cm) high, at base 24⅝ x 11⅝″ (62.6 x 29.5 cm). Gift of D. and J. de Menil. 333.52. Repr. *Suppl. IV*, p. 37; *Masters*, p. 172; *Sc. of 20th C.*, p. 184.

FEELEY, Paul. American, 1910–1966.

ALNIAM. (1964) Synthetic polymer paint on canvas, 59⅜ x 59⅜″ (150.6 x 150.7 cm). Gift of Philip Johnson. 507.70.

487 ERRAI (MODEL FOR A PARK STRUCTURE). (1965) Construction of enamel on composition board, 24³/₈ x 25¹/₂ x 25¹/₂″ (61.8 x 64.7 x 64.7 cm). Larry Aldrich Foundation Fund. 587.66.

FEININGER, Lyonel. American, 1871–1956. In Germany 1887–1936; returned to U.S.A. 1937.

428 UPRISING [*Émeute*]. 1910. Oil on canvas, 41¹/₈ x 37⁵/₈″ (104.4 x 95.4 cm). Gift of Julia Feininger. 257.64.

THE DISPARAGERS. 1911. Watercolor, pen and ink, 9¹/₂ x 12³/₈″ (24.1 x 31.4 cm). Acquired through the Lillie P. Bliss Bequest. 477.53. Repr. *Feininger-Hartley*, p. 21.

220 VIADUCT. 1920. Oil on canvas, 39³/₄ x 33³/₄″ (100.9 x 85.7 cm). Acquired through the Lillie P. Bliss Bequest. 259.44. Repr. *Ptg. & Sc.*, p. 108; in color, *Invitation*, p. 115.

220 THE STEAMER ODIN, II. 1927. Oil on canvas, 26¹/₂ x 39¹/₂″ (67.3 x 100.3 cm). Acquired through the Lillie P. Bliss Bequest. 751.43. Repr. *Ptg. & Sc.*, p. 109; in color, *Feininger-Hartley*, opp. p. 32; *Masters*, p. 113; *German Art of 20th C.*, p. 110.

428 RUIN BY THE SEA. 1930. Oil on canvas, 27 x 43³/₈″ (68.4 x 110 cm). Inscribed on stretcher: *Ruine am Meere I* (*Kirche bei Hoff, Ostsee*). Purchased with funds provided by Julia Feininger, Mr. and Mrs. Richard K. Weil, and Mr. and Mrs. Ralph F. Colin. 593.66. Repr. in color, *Feininger-Ruin*, cover; p. 17. *Note*: the Museum also has twenty-three watercolors and drawings of the same subject dating from 1928 to 1935, gift of Julia Feininger, and two drawings of 1953, one a gift and one an extended loan from Mr. and Mrs. Walter Bareiss.

220 GLASSY SEA. 1934. Watercolor, pen and ink, charcoal, 13³/₈ x 19″ (34 x 48.3 cm). Given anonymously (by exchange). 258.44.

220 RUIN BY THE SEA, II. 1934. Watercolor, pen and ink, 12 x 18¹/₂″ (30.2 x 47 cm). Gift of Julia Feininger. 99.63.

220 DAWN. 1938. Watercolor, pen and ink, 12¹/₂ x 19″ (31.7 x 48.3 cm). Purchase. 501.41. Repr. *Feininger-Hartley*, p. 36.

429 MANHATTAN, I. 1940. Oil on canvas, 39⁵/₈ x 31⁷/₈″ (100.5 x 80.9 cm). Gift of Julia Feininger. 259.64.

220 CHURCH ON THE CLIFF, I. 1953. Charcoal, wash, pen and ink, 12⁵/₈ x 19¹/₄″ (32 x 48.8 cm). Gift of Mr. and Mrs. Walter Bareiss. 344.63.

CHURCH ON THE CLIFF, III. 1953. Charcoal, wash, pen and ink, 12⁵/₈ x 19¹/₈″ (32 x 48.5 cm). Extended loan from Mr. and Mrs. Walter Bareiss, E.L.63.607.

FEININGER, Theodore Lux. American, born Germany 1910. To U.S.A. 1936.

288 GHOSTS OF ENGINES. 1946. Oil on canvas, 20¹/₈ x 24″ (51.1 x 61 cm). Gift of the Griffis Foundation. 309.47.

FEITELSON, Lorser. American, born 1898.

369 MAGICAL SPACE FORMS. 1955. Oil on canvas, 6′ x 60″ (183 x 152.4 cm). Inscribed: *Homage to Piero della Francesca and Michelangelo*. Gift of Thomas McCray. 156.62. Repr. *Suppl. XII*, p. 23.

456 Untitled. 1964. Oil and enamel on canvas, 60¹/₄ x 50¹/₄″ (152.9 x 127.5 cm). Gift of Craig Ellwood. 766.65.

FERBER, Herbert. American, born 1906.

356 JACKSON POLLOCK. 1949. Lead, 17⁵/₈ x 30″ (44.8 x 76.2 cm). Purchase. 51.49. Repr. *Suppl. I*, p. 20.

THE BOW. 1950. Bronze (cast 1969 from original in lead, brass, and copper), 47 x 30¹/₈ x 24¹/₈″ (119.3 x 76.5 x 61 cm), including bronze base 1 x 11³/₈ x 13⁷/₈″ (2.5 x 28.9 x 35.2 cm). Given anonymously. 1079.69. Repr. *Amer. Art*, p. 34.

HE IS NOT A MAN. 1950. Bronze with welded metal rods (unique cast, from original in lead), 67¹/₄ x 19¹/₂ x 13³/₈″ (170.9 x 49.4 x 33.9 cm), set in concrete base 18 x 12 x 12″ (45.7 x 30.4 x 30.4 cm). Gift of William Rubin. 680.71.

ROOF SCULPTURE WITH S CURVE, II. 1954. Bronze (cast 1969), 49³/₈ x 60 x 26³/₄″ (125.4 x 152.4 x 67.8 cm); at base, 45³/₈ x 21³/₄″ (115.1 x 55.1 cm). Given anonymously. 1080.69.

356 HOMAGE TO PIRANESI, I. 1962–63. Welded and brazed sheet copper and brass tubing, 7′7¹/₄″ x 48³/₄″ x 48″ (231.8 x 123.8 x 121.7 cm). Given anonymously. 594.63.

FERGUSON, Duncan. American, born Shanghai 1901.

CAT. (1928) Bronze, 7³/₈ x 13¹/₂ x 8″ (18.7 x 34.3 x 20.1 cm). Gift of Abby Aldrich Rockefeller. 613.39.

FERNÁNDEZ, Agustín. Cuban, born 1928. In Paris 1960–68. Lives in Puerto Rico.

288 STILL LIFE AND LANDSCAPE. (1956) Oil on canvas, 48 x 55¹/₈″ (122 x 140 cm). Inter-American Fund. 118.58. Repr. *Suppl. VIII*, p. 17.

467 Untitled. 1964. Oil on canvas, 49 x 48⁵/₈″ (124.2 x 123.4 cm). Inter-American Fund. 504.65.

FERNÁNDEZ-MURO, José Antonio. Argentine, born Spain 1920. To U.S.A. 1962.

341 SILVERED CIRCLE [*Círculo azogado*]. 1962. Oil on aluminum paper over canvas, 68¹/₈ x 50″ (173 x 126.8 cm). Gift of Emilio del Junco. 174.63.

FERREIRA. See REYES FERREIRA.

FERREN, John. American, 1905–1970.

365 COMPOSITION. 1937. Etched and colored plaster with intaglio, 11⁷/₈ x 9¹/₈″ (30.2 x 23.2 cm). Gift of the Advisory Committee (by exchange). 498.41. Repr. *Ptg. & Sc.*, p. 119.

FERRER, Rafael. American, born Puerto Rico 1933.

DEFLECTED FOUNTAIN 1970, FOR MARCEL DUCHAMP. Documentation of a piece executed by the artist on May 14, 1970, in the fountain of the Philadelphia Museum of Art courtyard, the aim of which was to deflect the vertical flow of water into a path of approximately 45° by the simplest possible means. Eight photographs, each approximately 9³/₈ x 13³/₄″ (23.6 x 34.7 cm); overall, 23 x 54¹/₂″ (58.3 x 138.4 cm). Gift of M. E. Thelen Gallery. 43.71a–h.

MUSEUM OF MODERN ART ICE PIECE. 1970. The bridge over the east pool of The Museum of Modern Art garden was stacked with 8 tons of ice in blocks and photographed periodically during the evening of June 30, 1970. Three photographs, each 9⁷/₈ x 13⁵/₈″ (24.9 x 34.6 cm); overall, 9⁷/₈ x 41″ (24.9 x 104.1 cm). Gift of M. E. Thelen Gallery. 42.71.

FESENMAIER, Helene. American, born 1937.

FROM THE CONSTRUCTION "SQUASH." 1975. Oil, synthetic polymer paint, crayon, pencil, cut-and-pasted papers, and pastel, 38 x 29″ (96.5 x 73.7 cm). Gift of the Adelaide Ross Foundation. 243.76.

FETT, William. American, born 1918.

LANDSCAPE OF MICHOACAN. 1942. Watercolor, 13³/₄ x 19⁷/₈″ (35 x 50.5 cm). Gift of James Thrall Soby. 69.43.

FIENE, Ernest. American, born Germany. 1894–1965. To U.S.A. 1912.

VENICE, I. (1932) Oil on wood, 7³/₄ x 11¹/₄″ (19.7 x 28.6 cm). Given anonymously. 130.40.

FIGARI, Pedro. Uruguayan, 1861–1938.

212 CREOLE DANCE. (1925?) Oil on cardboard, 20¹/₂ x 32″ (52.1 x 81.3 cm). Gift of the Honorable and Mrs. Robert Woods Bliss. 8.43. Repr. *Ptg. & Sc.*, p. 175.

FISCHER, Ida E. American, born Austria. 1883–1956. To U.S.A. 1892.

381 FLORIDA BARK. (1951) Assemblage: plaster and cement on composition board, with bark, shells, corks, etc., 16 x 12″ (40.7 x 30.5 cm). Gift of the American Abstract Artists. 9.55.

FIUME, Salvatore. Italian, born 1915.

291 ISLAND OF STATUES. 1948. Oil on canvas, 28 x 36¹/₄″ (71.1 x 92.1 cm). Purchase. 281.49. Repr. *20th-C. Italian Art*, pl. 105.

FLACK, Audrey. American, born 1931.

LEONARDO'S LADY. 1974. Oil over synthetic polymer paint on canvas, 6′2″ x 6′8″ (188 x 203.2 cm). Purchased with the aid of funds from the National Endowment for the Arts and an anonymous donor. 113.75.

FLANAGAN, Barry. British, born 1941.

Untitled. 1967. Fiberglass and burlap construction in two parts, 32³/₈ x 14³/₄ x 12³/₄″ (82.1 x 37.3 x 32.2 cm) and 7¹/₂ x 14¹/₂ x 12³/₈″ (18.9 x 36.8 x 31.2 cm). Gift of Donald Droll. 151.70a–b.

FLANNAGAN, John B. American, 1898–1942.

254 TRIUMPH OF THE EGG, I. (1937) Granite, 12 x 16″ (35 x 40.7 cm). Purchase. 296.38. Repr. *Flannagan*, frontispiece; *Ptg. & Sc.*, p. 266; *Sc. of 20th C.*, p. 120.

FLAVIN, Dan. American, born 1933.

Untitled. (1968) Fluorescent light bulbs and metal fixtures, 25 x 25 x 5³/₄″ (63.5 x 63.5 x 14.6 cm). Gift of Philip Johnson. 114.75.

UNTITLED (TO THE "INNOVATOR" OF WHEELING PEACHBLOW). 1968. Fluorescent lights and metal fixtures, 8¹/₂″ x 8¹/₄″ x 5³/₄″ (245 x 244.3 x 14.5 cm). Helena Rubinstein Fund. 3.69a–b.

FOLLETT, Jean. American, born 1917.

387 MANY-HEADED CREATURE. (1958) Assemblage: light switch, cooling coils, window screen, nails, faucet knob, mirror, twine, cinders, etc., on wood panel, 24 x 24″ (61 x 61 cm). Larry Aldrich Foundation Fund. 296.61. Repr. *Assemblage*, p. 124.

FONTANA, Lucio. Italian, born Argentina. 1899–1968.

360 CRUCIFIXION. 1948. Ceramic, 19¹/₈″ (48.6 cm) high. Purchase. 335.49.

SPATIAL CONCEPT. (1957) Pen and ink on paper mounted on canvas, with punctures and scrapes, 6′6⁷/₈″ x 55″ (200.3 x 139.3 cm). Gift of Morton G. Neumann. 701.76.

360 SPATIAL CONCEPT: EXPECTATIONS. (1959) Synthetic polymer paint on burlap, slashed, 39³/₈ x 32¹/₈″ (100 x 81.5 cm). Philip Johnson Fund. 413.60. Repr. *Suppl. X*, p. 46.

SPATIAL CONCEPT: EXPECTATIONS NUMBER 2. (1960) Slashed canvas and gauze, unpainted, 39¹/₂ x 31⁵/₈″ (100.3 x 80.3 cm). Gift of Philip Johnson. 508.70.

FORBES, Donald. American, 1905–1951.

MILLSTONE. (1936) Oil on canvas, 26¹/₄ x 36″ (66.7 x 91.4 cm). Extended loan from the United States WPA Art Program. E.L.39.1771. Repr. *Romantic Ptg.*, p. 99.

FORNER, Raquel. Argentine, born 1902.

213 DESOLATION. 1942. Oil on canvas, 36⁷/₈ x 28⁷/₈″ (93.7 x 72.7 cm). Inter-American Fund. 697.42. Repr. *Latin-Amer. Coll.*, p. 25.

MOONS. (1957) Brush, pen and colored inks, 15⁷/₈ x 21⁷/₈″ (40.3 x 55.7 cm). Inter-American Fund. 257.57. Repr. *Suppl. VII*, p. 23.

FOULKES, Llyn. American, born 1934.

POSTCARD. 1964. Oil on canvas, 68³/₈ x 64″ (173.5 x 162.5 cm). Fractional gift of Charles Cowles. 431.72.

FRANCIS, Sam (Samuel Lewis Francis). American, born 1923. Worked chiefly in France, 1950–60.

337 BIG RED. (1953) Oil on canvas, 10′ x 6′4¹/₄″ (303.2 x 194 cm). Gift of Mr. and Mrs. David Rockefeller. 5.58. Repr. in color, *12 Amer.*, p. 22; *New Amer. Ptg.*, p. 29.

336 PAINTING. (1958) Watercolor, 27¹/₈ x 40¹/₈″ (68.7 x 101.7 cm). Udo M. Reinach Estate. 28.60. Repr. *Suppl. X*, p. 36.

TOWARDS DISAPPEARANCE, II. (1958) Oil on canvas, 9′1¹/₂″ x 10′5⁷/₈″ (275.6 x 319.7 cm). Purchase. 100.76.

FRANCISCO, Richard. American, born 1942.

ZEBRA. 1973. Collage with tracing paper, balsa wood, synthetic polymer paint, and pencil on paper, 12¹/₄ x 16¹/₈″ (31.2 x 41 cm). Gift of Jock Truman. 99.74.

FRANKENTHALER, Helen. American, born 1928.

TROJAN GATES. (1955) Duco on canvas, 6′ x 48⁷/₈″ (182.9 x 124.1 cm). Gift of Mr. and Mrs. Allan D. Emil. 189.56. Repr. *Suppl. VI*, p. 34.

337 JACOB'S LADDER. 1957. Oil on canvas, 9′5³/₈″ x 69⁷/₈″ (287.9 x 177.5 cm). Gift of Hyman N. Glickstein. 82.60. Repr. *Suppl. X*, p. 36; in color, *Invitation*, p. 140.

MAUVE DISTRICT. (1966) Synthetic polymer paint on canvas, 8′7″ x 7′11″ (261.5 x 241.2 cm). Mrs. Donald B. Straus Fund. 2668.67.

COMMUNE. 1969. Synthetic polymer paint on canvas, 9′3¹/₂″ x 8′9¹/₄″ (282.5 x 267.2 cm). Gift of the artist. 1081.69.

FRAZIER, Dyyon (LeRoy Dyyon). American, born 1946.

TRACES OF LOVE, 23. 1970. Synthetic polymer paint, collage, pen and ink, metallic paint on paper, 23³/₄ x 18″ (60.1 x 45.6 cm). Larry Aldrich Foundation Fund. 152.70.

FRENCH, Leonard. Australian, born 1928.

434 THE PRINCESS. (1965) Enamel and gold leaf, copper panels, and burlap collage on burlap mounted on composition board, 48¹/₄ x 60″ (122.4 x 152.2 cm). Gift of Mr. and Mrs. David Rockefeller. 104.66.

FREUD, Lucian. British, born Germany 1922.

269 WOMAN WITH A DAFFODIL. 1945. Oil on canvas, 9³/₈ x 5⁵/₈″ (23.8 x 14.3 cm). Purchase. 12.53. Repr. *Suppl. IV*, p. 31.

269 GIRL WITH LEAVES. (1948) Pastel, 18⁷/₈ x 16¹/₂″ (47.9 x 41.9 cm). Purchase. 240.48. Repr. *Suppl. I*, p. 15. *Note*: the subject is Kitty, the daughter of Sir Jacob Epstein and the former wife of the painter.

269 PORTRAIT OF A WOMAN. (1949) Oil on canvas, 16⅛ x 12″ (41 x 30.5 cm). Gift of Lincoln Kirstein. 546.54. Repr. *Suppl. V*, p. 32. *Note*: the subject is a London neighbor who had been bombed out during the war.

DEAD MONKEY. (1950) Pastel, 8⅜ x 14¼″ (21.3 x 36.2 cm). Gift of Lincoln Kirstein. 547.54.

FRIEDMAN, Arnold. American, 1879–1946.

SNOWSCAPE. 1926. Oil on canvas, 36¼ x 42″ (92.1 x 106.7 cm). Gift of Mr. and Mrs. Sam A. Lewisohn. 320.39. Repr. *Amer. Ptg. & Sc.*, no. 35.

222 SAWTOOTH FALLS. (1945) Oil on canvas, 36⅛ x 29⅞″ (91.8 x 75.9 cm). Purchase Fund and gift of Dr. Nathaniel S. Wollf (by exchange). 119.46. Repr. *Ptg. & Sc.*, p. 223.

FRIESZ, Othon. French, 1879–1949.

65 LANDSCAPE WITH FIGURES (BATHERS). 1909. Oil on canvas, 25⅝ x 32″ (65.1 x 81.3 cm). Gift of Mrs. Saidie A. May. 5.35. Repr. *Ptg. & Sc.*, p. 56.

STANDING NUDE. 1929. Watercolor, 20⅛ x 17⅞″ (51 x 32.5 cm). Gift of Mrs. Saidie A. May. 17.32.

THE GARDEN. 1930. Oil on canvas, 23⅝ x 28¾″ (60 x 73 cm). Gift of Mrs. Saidie A. May. 16.32.

GABO, Naum. American, born Russia. 1890–1977. Worked in Germany, France, and England. To U.S.A. 1946.

133 HEAD OF A WOMAN. (c. 1917–20, after a work of 1916) Construction in celluloid and metal, 24½ x 19¼″ (62.2 x 48.9 cm). Purchase. 397.38. Repr. *Ptg. & Sc.*, p. 272.

133 SPIRAL THEME. (1941) Construction in plastic, 5½ x 13¼ x 9⅜″ (14 x 33.6 x 23.7 cm), on base 24″ (61 cm) square. Advisory Committee Fund. 7.47. Repr. *Ptg. & Sc.*, p. 273; *Masters*, p. 127; *What Is Mod. Sc.*, p. 67; *Sc. of 20th C.*, p. 153. *Note*: an earlier version, 5⅜″ (13.7 cm) high, is in the Tate Gallery, London.

133 Project for sculptures (never executed) for lobby of the Esso Building, Rockefeller Center, New York, N.Y. (1949) Four plastic and metal sculpture maquettes installed in two architectural models: 51st Street entrance, one wall sculpture, 8¾ x 7¼″ (22.2 x 18.4 cm); 52nd Street entrance, one wall sculpture, 6½ x 9″ (16.5 x 22.9 cm); two sculptures over revolving doors, each 3″ (7.6 cm) high. Gift of the artist. 13.53.1, 14.53.1–.3. Repr. *Suppl. IV*, p. 43.

GAITONDE, Vasudeo S. Indian, born 1924.

351 PAINTING, 4. 1962. Oil on canvas, 40 x 49⅞″ (101.6 x 126.6 cm). Gift of Mrs. Joseph James Akston. 1.63.

GALI, Zvi. Israeli, 1924–1961.

THE BAKER'S DREAM. (1956) Encaustic on plywood, 52⅝ x 17½″ (133.6 x 44.4 cm). Purchase. 119.58. Repr. *Suppl. VIII*, p. 23.

GALLATIN, A. E. American, 1881–1952.

364 FORMS AND RED. 1949. Oil on canvas, 30 x 23″ (76.2 x 58.4 cm). Purchase (by exchange). 134.51. Repr. *Abstract Ptg. & Sc.*, p. 80.

GALLO, Frank. American, born 1933.

478 GIRL IN SLING CHAIR. 1964. Polyester resin, 36¾ x 23 x 33¾″ (93.1 x 58.3 x 85.6 cm), at base 13⅝ x 24″ (34.4 x 60.8 cm). Purchase. 1235.64.

GALVÁN. See GUERRERO GALVÁN.

GARGALLO, Pablo. Spanish, 1881–1934. Worked in Paris.

104 PICADOR. (1928) Wrought iron, 9⅜ x 13½″ (24.7 x 34.2 cm). Gift of A. Conger Goodyear. 151.34. Repr. *Art in Our Time*, no. 309.

GASPARO, Oronzo. American, born Italy. 1903–1969. To U.S.A. 1916.

ITALIOPA. 1936. Gouache, 19½ x 14½″ (49.5 x 36.8 cm). Purchase. 76.39. Repr. *La Pintura*, p. 127.

GATCH, Lee. American, 1902–1968.

BATTLE WAGON. (1946) Oil on canvas, 14⅛ x 28⅛″ (35.9 x 71.4 cm). Gift of Mrs. Charles Suydam Cutting. 336.49. Repr. *Suppl. II*, p. 22

241 RAINBOW RAMPAGE. (1950) Oil on canvas, 28 x 40″ (71.1 x 101.6 cm). Gift of Mr. and Mrs. Roy R. Neuberger. 7.51.

GAUDIER-BRZESKA, Henri. French, 1891–1915. Worked in England.

115 BIRDS ERECT. (1914) Limestone, 26⅝ x 10¼ x 12⅜″ (67.6 x 26 x 31.4 cm). Gift of Mrs. W. Murray Crane. 127.45. Repr. *Ptg. & Sc.*, p. 270.

GAUGUIN, Paul. French, 1848–1903. In Tahiti and the Marquesas Islands, 1891–93, 1895–1903.

24 STILL LIFE WITH THREE PUPPIES. 1888. Oil on wood, 36⅛ x 24⅝″ (91.8 x 62.6 cm). Mrs. Simon Guggenheim Fund. 48.52. Repr. *Suppl. IV*, p. 1; *Art Nouveau*, p. 48; in color, *Masters*, p. 31; *Post-Impress.* (2nd), p. 199; in color, *Invitation*, p. 15.

MEYER DE HAAN. (1889) Watercolor, 6⅜ x 4½″ (16.4 x 11.5 cm). Gift of Arthur G. Altschul. 699.76.

24 THE MOON AND THE EARTH [*Hina Te Fatou*]. 1893. Oil on burlap, 45 x 24½″ (114.3 x 62.2 cm). Lillie P. Bliss Collection. 50.34. Repr. *Ptg. & Sc.*, p. 32; *Post-Impress.* (2nd), p. 531.

GEGO (Gertrude Goldschmidt). Venezuelan, born Germany 1912.

371 SPHERE. (1959) Welded brass and steel, painted, 22″ (55.7 cm) diameter, on three points, 8⅝ x 7½ x 7⅛″ (21.8 x 19 x 18 cm) apart. Inter-American Fund. 115.60. Repr. *Suppl. X*, p. 50.

GENOVÉS, Juan. Spanish, born 1930.

445 MICROGRAPHY. 1966. Oil on canvas, 10⅛ x 9⅜″ (25.6 x 23.6 cm). Purchase. 594.66.

GENTILS, Vic. Belgian, born Great Britain 1919.

476 BERLIN-LEIPZIG. 1963. Assemblage: piano parts, piano stool, velvet, felt, and metal, in a frame with folding doors, 53½ x 44⅜ x 16¾″ (135.8 x 112.5 x 42.5 cm). Advisory Committee Fund. 1236.64. *Note*: the title and material for this work came from two pianos, one made in Berlin and the other in Leipzig.

GERSTEIN, Noemí. Argentine, born 1910.

YOUNG GIRL. (1959) Brass rods soldered with silver, 25¾″ (65.4 cm) high. Inter-American Fund. 3.61. Repr. *Suppl. XI*, p. 26.

GIACOMETTI, Alberto. Swiss, 1901–1966. To Paris 1922.

WOMAN. (1928) Plaster, 15¾ x 6¾″ (39.8 x 17 cm); at base, 4 x 3¼″ (10.1 x 8.1 cm). Purchase. 418.71.

WOMAN. (1929) Bronze (cast 1970–71), 15½ x 6⅝″ (39.2 x 16.7 cm); at base, 3⅞ x 3⅛″ (9.8 x 7.8 cm). Courtesy Mme Alberto Giacometti. 419.71.

184 WOMAN WITH HER THROAT CUT [*Femme égorgée*]. 1932. Bronze (cast 1949), 8 x 34½ x 25″ (20.3 x 87.6 x 63.5 cm). Purchase.

696.49. Repr. *Suppl. I*, p. 27; *Giacometti*, p. 38; *Dada, Surrealism*, p. 118.

184 THE PALACE AT 4 A.M. (1932–33) Construction in wood, glass, wire, string, 25 x 28¼ x 15¾″ (63.5 x 71.8 x 40 cm). Purchase. 90.36. Repr. *Ptg. & Sc.*, p. 294; *Masters*, p. 150; *Giacometti*, p. 45; *Dada, Surrealism*, p. 119; *What Is Mod. Sc.*, p. 75.

414 Six untitled miniature figures in plaster held upright by metal pins inserted in plaster bases. (c. 1945) Gift of Mr. and Mrs. Thomas B. Hess. 730.66–735.66.

Figure I. 1″ (2.5 cm) high, on base 3½ x 2 x 2⅛″ (8.9 x 5 x 5.2 cm). 730.66.

Figure II. 1½″ (3.9 cm) high, on base 2¼ x 1¾ x 1¾″ (5.6 x 4.3 x 4.2 cm). 731.66.

Figure III. ¾″ (2.1 cm) high, on base 1⅜ x 1½ x 1⅝″ (3.3 x 3.8 x 4.1 cm). 732.66.

Figure IV. ⅞″ (2.2 cm) high, on base ⅞ x 1½ x 1⅛″ (2.1 x 3.6 x 2.9 cm). 733.66.

Figure V. 1¼″ (3.2 cm) high, on base 1 x 1½ x 1¼″ (2.5 x 3.7 x 3.1 cm). 734.66.

Figure VI. 1″ (2.4 cm) high, on base ⅝ x ½ x ½″ (1.6 x 1.2 x 1.2 cm). 735.66. Repr. *Giacometti*, p. 47 (Figures I and II). *Note*: bronze casts of these figures are in the Study Collection.

HEAD OF A MAN ON A ROD. (1947) Bronze, 23½″ (59.7 cm) high, including bronze base 6⅜ x 5⅞ x 6″ (16 x 14.9 x 15.1 cm). Gift of Mrs. George Acheson. 595.76. Repr. in color *Giacometti*, p. 51 (detail).

185 MAN POINTING. 1947. Bronze, 70½″ (179 cm) high, at base 12 x 13¼″ (30.5 x 33.7 cm). Gift of Mrs. John D. Rockefeller 3rd. 678.54. Repr. *Sc. of 20th C.*, p. 210; *New Images*, pp. 69, 72; *Giacometti*, p. 49, detail in color, p. 41; *What Is Mod. Sc.*, p. 11.

184 CITY SQUARE [*La Place*]. (1948) Bronze, 8½ x 25⅜ x 17¼″ (21.6 x 64.5 x 43.8 cm). Purchase. 337.49. Repr. *Suppl. II*, p. 26; *Giacometti*, p. 56; *Sc. of 20th C.*, p. 211.

THREE MEN WALKING, I. (1948–49) Bronze, 28½ x 16 x 16⅜″ (72.2 x 40.5 x 41.5 cm) including base, 10⅝ x 7¾ x 7¾″ (27 x 19.6 x 19.6). The Sidney and Harriet Janis Collection (fractional gift). 601.67. Repr. *Janis*, p. 111.

STANDING FIGURE. (c. 1949) Unique bronze, 9⅜ x 2⅜ x 2¼″ (23.8 x 6 x 5.6 cm). Gift of Mr. and Mrs. Eli Wallach. 1082.69.

184 THE ARTIST'S MOTHER. 1950. Oil on canvas, 35⅜ x 24″ (89.9 x 61 cm). Acquired through the Lillie P. Bliss Bequest. 15.53. Repr. *Suppl. IV*, p. 29; *New Images*, p. 74; *Giacometti*, p. 80. *Note*: the sitter is Annetta Giacometti.

185 CHARIOT. (1950) Bronze, 57 x 26 x 26⅛″ (144.8 x 65.8 x 66.2 cm). Purchase. 8.51. Repr. *Suppl. III*, p. 5; *Masters*, p. 151; *Giacometti*, p. 61; *Sc. of 20th C.*, p. 212.

185 DOG. (1951) Bronze (cast 1957), 18″ (45.7 cm) high, at base 39 x 6⅛″ (99 x 15.5 cm). A. Conger Goodyear Fund. 120.58. Repr. *Suppl. VIII*, p. 1; *Giacometti*, p. 62.

TALL FIGURE, III. 1960. Bronze, 7′9″ (236.2 cm) high. Fractional gift of Nina and Gordon Bunshaft in honor of the artist. 1083.69. Repr. *Giacometti*, p. 72.

ANNETTE. 1962. Oil on canvas, 36⅜ x 28⅞″ (92.3 x 73.2 cm). The Sidney and Harriet Janis Collection (fractional gift). 603.67. Repr. *Janis*, p. 113.

GIACOMETTI, Augusto. Swiss, 1877–1947.

127 COLOR ABSTRACTION. (1903?) Pastel cutout mounted on paper, 5⅞ x 5½″ (14.7 x 14 cm) irregular. Gift of Ernst Beyeler. 414.60. Repr. *Suppl. X*, p. 14.

SUMMER NIGHT. 1917. Oil on canvas, 26½ x 25⅝″ (67.2 x 65 cm). Mrs. Bertram Smith Fund. 2518.67.

COLOR ABSTRACTION, II [*Farbige Abstraktion, II*]. (1919) Gouache on paper, 8⅜ x 8½″ (21.2 x 21.4 cm), irregular. Gift of Kasmin, Ltd. 1296.68.

COLORED MOSS, IV [*Farbiges Moos, IV*]. 1919. Gouache on paper, 8⅝ x 8⅜″ (21.8 x 21.3 cm), irregular. Gift of William Rubin. 1295.68.

GILBERT & GEORGE. British. Gilbert Proesch, born 1943; George Passmore, born 1942.

TO BE WITH ART IS ALL WE ASK. 1970. Triptych: charcoal and wash on partially charred sheets of paper, overall 9′2⅜″ x 22′11″ (280.3 x 718.9 cm). Elizabeth Bliss Parkinson Fund. 379.71.

GILIOLI, Emile. French, 1911–1977.

374 SKY AND SEA. (1956) Crystal, 10½″ (26.6 cm) high. Gift of Louis Carré. 121.58. Repr. *Suppl. VIII*, p. 18.

GILL, James F. American, born 1934.

393 MARILYN. 1962. Oil on composition board, triptych, each panel 48 x 35⅞″ (122 x 91 cm). Gift of D. and J. de Menil. 72.63a–c. *Note*: the subject is the actress, Marilyn Monroe.

WOMAN IN STRIPED DRESS. 1962. Color crayon on gesso on composition board, 40 x 30″ (101.4 x 76.2 cm). Larry Aldrich Foundation Fund. 2.63.

GILLIAM, Sam. American, born 1933

Untitled. 1971. Dye stain on paper, 20¼ x 25½″ (51.9 x 64.8 cm). Acquired with matching funds from the National Endowment for the Arts and The Lily Auchincloss Foundation, Inc. 607.73

GLARNER, Fritz. American, born Switzerland. 1899–1972. In U.S.A. 1936–71. To Switzerland 1971.

364 RELATIONAL PAINTING. 1947–48. Oil on canvas, 43⅛ x 42¼″ (109.5 x 107.3 cm). Purchase. 52.49. Repr. *Suppl. I*, p. 19.

364 RELATIONAL PAINTING, TONDO 37. 1955. Oil on composition board, 19″ (48 cm) diameter. Gift of Mr. and Mrs. Armand P. Bartos. 264.56. Repr. *Suppl. VI*, p. 22.

432 RELATIONAL PAINTING, 85. 1957. Oil on canvas, 48 x 46⅛″ (121.8 x 116.9 cm). Given anonymously. 736.66.

GLASCO, Joseph. American, born, 1925.

303 MAN WALKING. (1955) Bronze, 17½″ (44.4 cm) high. Purchase (by exchange). 190.56. Repr. *Suppl. VI*, p. 32.

GLEIZES, Albert. French, 1881–1953.

100 COMPOSITION. 1922. Gouache, 3½ x 2¾″ (8.9 x 7 cm) (sight). Gift of A. E. Gallatin. 461.37.

GLENNY, Anna. American, born 1888.

MRS. WOLCOTT. (1930) Bronze, 15½″ (39.4 cm) high. Gift of A. Conger Goodyear. 25.35. Repr. *Amer. Ptg. & Sc.*, no. 130. *Note*: Frances Wolcott is the wife of Josiah Oliver Wolcott, Senator from Delaware.

GOERITZ, Mathias. Born Germany 1915. In Mexico since 1949.

MESSAGE NUMBER 7B, ECCLESIASTES VII. 1959. Assemblage of nails, metal foils, oil, and iron on wood panel, 17⅞ x 13⅝ x 3⅜″ (45.1 x 34.5 x 8.4 cm). Gift of Philip Johnson. 779.69.

VAN GOETHEM, Jan L. A. Dutch, born 1929. Lives in Curaçao, Netherlands Antilles.

Untitled. 1966. Collage of burnt paper, watercolor, crayon, and pencil, 25³/₄ x 19³/₄″ (65.4 x 50.1 cm), irregular. Purchase. 2318.67.

VAN GOGH, Vincent. Dutch, 1853–1890. To France 1886.

25 HOSPITAL CORRIDOR AT SAINT RÉMY. (1889) Gouache and watercolor, 24¹/₈ x 18⁵/₈″ (61.3 x 47.3 cm). Abby Aldrich Rockefeller Bequest. 242.48. Repr. *Suppl. I*, p. 2; in color, *Masters*, p. 27; *Post-Impress.* (2nd), p. 325; *Modern Masters*, p 73; *Seurat to Matisse*, p. 23.

25 THE STARRY NIGHT. (1889) Oil on canvas, 29 x 36¹/₄″ (73.7 x 92.1 cm). Acquired through the Lillie P. Bliss Bequest. 472.41. Repr. *Ptg. & Sc.*, p. 33; in color, *Masters*, p. 29; *Post-Impress.* (2nd), p. 345; *Paintings from MoMA*, frontispiece; in color, *Invitation*, p. 16.

GOINGS, Ralph. American, born 1928.

SHERWIN WILLIAMS CHEVY. 1975. Oil on canvas, 43⁷/₈x 62″ (111.5 x 157.5 cm). Purchased with the aid of funds from the National Endowment for the Arts and an anonymous donor. 101.76.

GOLUB, Leon. American, born 1922.

282 TORSO, III. 1960. Oil and lacquer on canvas, 63¹/₈ x 39¹/₄″ (160.2 x 99.6 cm). Edward Joseph Gallagher 3rd Memorial Collection. 117.61. Repr. *Suppl. XI*, p. 48.

GONTCHAROVA, Natalie. Russian, 1881–1962. To Paris 1915.

131 LANDSCAPE, 47. 1912. Oil on canvas, 21¹/₂ x 18³/₈″ (54.6 x 46.7 cm). Gift of the artist. 84.36.

LE COQ D'OR. Design for scenery for the ballet produced by the Ballets Russes, Paris, 1914. Gouache, watercolor, touches of pencil on cardboard, 18³/₈ x 24¹/₄″ (46.7 x 61.6 cm). Acquired through the Lillie P. Bliss Bequest. 305.47. Theatre Arts Collection. Repr. *Masters*, p. 182.

THE FLIGHT INTO EGYPT. Design for the ballet *Liturgy*, not produced. (1915) Watercolor, gouache heightened with gelatin, and pencil 12 x 8¹/₈″ (30.5 x 20.6 cm). Gift of Mr. and Mrs. Sidney Elliott Cohn. 101.74.

THE NATIVITY. Design for the ballet *Liturgy*, not produced. (1915) Watercolor, gouache, and pencil, 12 x 8¹/₈″ (30.5 x 20.6 cm). Gift of Mr. and Mrs. Sidney Elliott Cohn. 100.74.

COMPOSITION. 1920. Watercolor, 11¹/₈ x 7⁷/₈″ (28.3 x 20 cm). Gift of the artist. 91.36.

COMPOSITION. (1920?) Watercolor, 11 x 7⁷/₈″ (27.9 x 20 cm). Gift of the artist. 73.36.

COMPOSITION. (1920?) Watercolor, 11 x 7⁷/₈″ (27.9 x 20 cm). Gift of the artist. 103.36.

GONZALEZ, Julio. Spanish, 1876–1942. To Paris 1900.

111 HEAD. (1935?) Wrought iron, 17³/₄ x 15¹/₄″ (45.1 x 38.7 cm). Purchase. 266.37. Repr. *Ptg. & Sc.*, p. 284; *Masters*, p. 90; *What Is Mod. Sc.*, p. 24; *Sc. of 20th C.*, p. 166.

HEAD (Study for sculpture). 1936. Gouache, crayon, pen and ink on pasted paper, 11 x 7¹/₂″ (27.9 x 18.9 cm). Gift of Dr. and Mrs. Arthur Lejwa. 787.63. *Note*: related to *Head*, 266.37.

111 TORSO. (c. 1936) Hammered and welded iron, 24³/₈″ (61.9 cm) high. Gift of Mr. and Mrs. Samuel A. Marx. 191.56. Repr. *Suppl. VI*, p. 18; *Gonzalez*, p. 38.

111 WOMAN COMBING HER HAIR. (1936) Wrought iron, 52 x 23¹/₂ x 24⁵/₈″ (132.1 x 59.7 x 62.4 cm). Mrs. Simon Guggenheim Fund. 16.53. Repr. *Suppl. IV*, p. 27; *Masters*, p. 91; *What Is Mod. Sc.*, p. 83.

111 STANDING WOMAN. (c. 1941) Watercolor, brush, pen and ink, 12¹/₂ x 9⁵/₈″ (31.8 x 24.3 cm) (irregular). Gift of the James S. and Marvelle W. Adams Foundation. 235.56. Repr. *Suppl. VI*, p. 19.

414 HEAD OF THE MONTSERRAT, II. (1942) Bronze, 12³/₈ x 7³/₄ x 11¹/₈″ (31.3 x 19.6 x 28.1 cm). Gift of Mrs. Harry Lynde Bradley. 937.65. Repr. *Gonzalez*, p. 41 (another cast).

GONZÁLEZ GOYRI, Roberto. Guatemalan, born 1924.

305 WOLF'S HEAD. (1950) Bronze, 11″ (28 cm) high. Inter-American Fund. 331.55. Repr. *Suppl. VI*, p. 32.

GOODE, Joe. American, born 1937.

SHOES, SHOES, SHOES. (1966) Wood stairs with wool carpet, 41 x 36 x 54¹/₂″ (103.8 x 91.2 x 138.9 cm). Fractional gift of Charles Cowles. 663.70.

GOODMAN, Sidney. American, born 1936.

285 FIND A WAY. (1961) Oil on canvas, 37³/₄ x 61″ (95.7 x 154.7 cm). Gift of Dr. Abraham Melamed. 157.62. Repr. *Figure U.S.A.*

GOODNOUGH, Robert. American, born 1917.

338 LAOCOÖN. 1958. Oil and charcoal on canvas, 66³/₈ x 54¹/₈″ (168.4 x 137.5 cm). Given anonymously. 9.59. Repr. *Suppl. IX*, p. 27.

STRUGGLE. 1967. Synthetic polymer paint, oil, and charcoal on canvas, 59″ x 9′8¹/₈″ (149.8 x 294.8 cm). Given anonymously. 1084.69.

104. 1968. Pasted paper on cardboard, 22 x 30¹/₄″ (55.8 x 76.7 cm). Joseph M. and Dorothy B. Edinburg Charitable Trust Fund. 165.70.

GORKY, Arshile (Vosdanig Manoog Adoian). American, born Turkish Armenia. 1904–1948. To U.S.A. 1920.

308 COMPOSITION: HORSE AND FIGURES. 1928. Oil on canvas, 34¹/₄ x 43³/₈″ (87 x 110.2 cm). Gift of Bernard Davis in memory of the artist. 237.50.

308 Study for a mural for Administration Building, Newark Airport, New Jersey. (1935–36) Gouache, 13⁵/₈ x 29⁷/₈″ (34.6 x 75.9 cm). Extended loan from the United States WPA Art Program. E.L.39.1811. *Note*: the ten mural panels called *Aviation: Evolution of Forms under Aerodynamic Limitations*, oil on canvas, 1530 square feet, were installed at Newark Airport but later were painted over. Although two of the ten panels were rescued, cleaned, and placed in the custody of the Newark Museum in 1976, the panel to which this study relates was on an outside wall and was irreparable.

308 ARGULA. (1938) Oil on canvas, 15 x 24″ (38.1 x 61 cm). Gift of Bernard Davis. 323.41. Repr. *Ptg. & Sc. (I)*, p. 42.

309 GARDEN IN SOCHI. (1941) Oil on canvas, 44¹/₄ x 62¹/₄″ (112.4 x 158.1 cm). Purchase Fund and gift of Mr. and Mrs. Wolfgang S. Schwabacher (by exchange). 335.42. Repr. *14 Amer.*, p. 20; *Ptg. & Sc.*, p. 225; *Gorky*, p. 27.

308 BULL IN THE SUN. (1942) Gouache, 18¹/₂ x 24³/₄″ (47 x 62.9 cm). Gift of George B. Locke. 4.57. Design for a rug in the collection of The Museum of Modern Art. Repr. *Suppl. VII*, p. 20.

GARDEN IN SOCHI. (c. 1943) Oil on canvas, 31 x 39″ (78.7 x 99 cm). Acquired through the Lillie P. Bliss Bequest. 492.69.

GOOD HOPE ROAD, II. 1945. Oil on canvas, 25¹/₂ x 32⁵/₈″ (64.7 x 82.7 cm). The Sidney and Harriet Janis Collection (fractional gift). 604.67. Repr. *Janis*, p. 115. *Note*: also called *Pastoral*.

Study for SUMMATION. 1946. Pencil and colored crayon on paper, 18¹/₂ x 24³/₈″ (47 x 61.8 cm). The Sidney and Harriet Janis Collection (fractional gift). 605.67. Repr. *Janis*, p. 115.

309 AGONY. 1947. Oil on canvas, 40 x 50½" (101.6 x 128.3 cm). A. Conger Goodyear Fund. 88.50. Repr. *Suppl. II*, p. 21; *Gorky*, p. 41; in color, *Masters*, p. 175; *New Amer. Ptg.*, p. 35; *Paintings from MoMA*, p. 75; in color, *Invitation*, p. 41.

SUMMATION. (1947) Pencil, pastel, and charcoal on buff paper mounted on composition board, 6'7⅝" x 8'5¾" (202.1 x 258.2 cm). Mr. and Mrs. Gordon Bunshaft Fund. 234.69. Repr. *Gorky*, p. 39.

GOSTOMSKI, Zbigniew. Polish, born 1932.

COMPOSITION WITH A CIRCLE. 1964. Oil on ten joined strips of composition board forming three areas by the incision of a half-inch circular space spanning the two panels; diptych, overall, 29½ x 61½" (75 x 156.2 cm) including 2" (5 cm) space between panels. Gift of Jean and Howard Lipman. 2309.67a–b.

GOTO, Joseph. American, born Hawaii of Japanese parents, 1920. To U.S.A. 1947.

359 ORGANIC FORM, I. (1951) Welded steel in two parts, 11'4¼" (346.1 cm) high, two-part base, 3 x 15⅜ x 12" (7.6 x 39.1 x 35 cm). Purchase. 175.52. Repr. *Suppl. IV*, p. 39.

GOTTLIEB, Adolph. American, 1903–1974.

333 VOYAGER'S RETURN. 1946. Oil on canvas, 37⅞ x 29⅞" (96.2 x 75.9 cm). Gift of Mr. and Mrs. Roy R. Neuberger. 175.46. Repr. *Ptg. & Sc.*, p. 226.

MAN LOOKING AT WOMAN. 1949. Oil on canvas, 42 x 54" (106.6 x 137.1 cm). Gift of the artist. 1088.69.

FLOTSAM AT NOON (IMAGINARY LANDSCAPE). 1952. Oil on canvas, 36⅛ x 48" (91.7 x 121.7 cm). Gift of Samuel A. Berger. 378.61. Repr. *Natural Paradise*, p. 61.

333 UNSTILL LIFE, III. (1954–56) Oil on canvas, 6'8" x 15'5¼" (203 x 470.5 cm). Given anonymously. 415.60. Repr. *Suppl. X*, p. 40.

COMPOSITION. 1955. Oil on canvas, 6'1⅛" x 60⅛" (183.3 x 152.5 cm). Gift of the artist. 1086.69.

DESCENDING ARROW. 1956. Oil on canvas, 8 x 6' (243.5 x 182.4 cm). Gift of the artist. 1087.69.

333 BLAST, I. (1957) Oil on canvas, 7'6" x 45⅛" (228.7 x 114.4 cm). Philip Johnson Fund. 6.58. Repr. *Suppl. VIII*, p. 11; in color, *Invitation*, p. 143.

ABOVE AND BELOW, I. 1964–65. Oil on canvas, 7'6" x 9' (220.5 x 274.3 cm). Gift of the artist. 1085.69. Repr. *Amer. Art*, p. 43.

GOURGUE, Enguérrand. Haitian, born 1930.

9 MAGIC TABLE. (1947) Oil on cardboard, 17 x 20¾" (43.2 x 52.7 cm). Inter-American Fund. 244.48.

GOYRI. See GONZÁLEZ GOYRI.

GRAHAM, John (Ivan Dabrowsky). American, born Ukraine. 1886–1961. To U.S.A. 1920.

SELF-PORTRAIT. 1943. Oil on canvas, 20 x 16" (50.7 x 40.6 cm). Gift of S. Herman Klarsfeld. 780.69.

HARLEQUIN (SELF-PORTRAIT). (c. 1944) Oil and pencil on canvas, 24⅛ x 20¼" (61.2 x 51.3 cm). Gift of Margery and Harry Kahn. 622.73.

TWO SISTERS [*Les Mamelles d'outre-mer*]. 1944. Oil, enamel, pencil, charcoal, and casein on composition board, 47⅞ x 48" (121.4 x 121.8 cm). Alexander M. Bing Fund. 873.68.

GRAHAM, Robert. American, born Mexico 1938.

Untitled. (1968) Three miniature figures of pigmented wax, fur, and paper; two beds, platform, ramp, and pole of balsa wood with foam and paper bedding, pole fixtures of metal, plastic, glass, and wire in plexiglass vitrine; vitrine, 10 x 20 x 20" (25.4 x 50.8 x 50.8 cm), including base 1 x 20 x 20" (2.6 x 50.8 x 50.8 cm). Gift of Philip Johnson. 115.75.

GRANELL, Eugene F. Spanish, born 1912. To U.S.A. 1950.

310 THE LAST HAITIAN NIGHT OF KING CHRISTOPHE. 1960. Oil on canvas, 30⅛ x 42⅛" (76.3 x 107 cm). Gift of Mr. and Mrs. Raymond J. Braun. 100.62. Repr. *Suppl. XII*, p. 30.

GRAVES, Morris. American, born 1910.

274 MESSAGE III, MESSAGE IV, MESSAGE VI, MESSAGE VII. (1937) Tempera and wax on paper; III and IV, 12 x 15½" (30.5 x 39.4 cm); VI and VII, 12 x 16½" (30.5 x 41.9 cm). Extended loans from the United States WPA Art Program. E.L.39.1813–.1816. VI, repr. *Amer. 1942*, p. 52. *Note: Message IV* is illustrated.

274 BIRD SINGING IN THE MOONLIGHT. (1938–39) Gouache, 26¾ x 30⅛" (68 x 76.5 cm). Purchase. 14.42. Repr. *Ptg. & Sc.*, p. 229.

IN THE MOONLIGHT. (1938–39) Gouache and watercolor, 25 x 30⅛" (63.5 x 76.5 cm). Purchase. 20.42.

274 SNAKE AND MOON. (1938–39) Gouache and watercolor, 25½ x 30¼" (64.8 x 76.8 cm). Purchase. 25.42. Repr. *Amer. 1942*, p. 55; *Natural Paradise*, p. 36.

275 BLIND BIRD. (1940) Gouache, 30⅛ x 27" (76.5 x 68.6 cm). Purchase. 15.42. Repr. in color, *Masters*, p. 164; *Romantic Ptg.*, frontispiece.

NESTLING. (1940) Gouache and watercolor, 26¾ x 30" (68 x 76.2 cm). Purchase. 22.42.

FLEDGLING. (1940) Gouache and watercolor, 10⅜ x 21¾" (26.3 x 55.2 cm). Purchase. 145.42.

274 LITTLE-KNOWN BIRD OF THE INNER EYE. (1941) Gouache, 20¾ x 36⅝" (52.7 x 93 cm). Purchase. 21.42. Repr. *Amer. 1942*, p. 56; *Natural Paradise*, p. 108.

274 OWL OF THE INNER EYE. (1941) Gouache, 20¾ x 36⅝" (52.7 x 93 cm). Purchase. 23.42. Repr. *Ptg. & Sc.*, p. 229.

274 UNNAMED BIRD OF THE INNER EYE. (1941) Gouache, 22 x 39" (55.9 x 99.1 cm). Purchase. 26.42.

WOODPECKERS. (1941) Gouache and watercolor, 31 x 26" (78.8 x 66 cm). Purchase. 27.42.

BAT DANCING FOR A SLUG. (1943) Watercolor, 24 x 29⅞" (61 x 75.9 cm). Given anonymously. 83.50.

275 JOYOUS YOUNG PINE. (1944) Watercolor and gouache, 53⅝ x 27" (136.2 x 68.6 cm). Purchase (by exchange). 138.45. Repr. *Natural Paradise*, p. 161.

275 THE INDIVIDUAL STATE OF THE WORLD. 1947. Gouache, 30¼ x 24⅞" (76.8 x 63.2 cm). A. Conger Goodyear Fund. 3.48. Repr. *Suppl. I*, p. 23.

GREENE, Balcomb. American, born 1904.

365 THE ANCIENT FORM. (1940) Oil on canvas, 20 x 30" (50.8 x 76.2 cm). Purchase. 326.41. Repr. *Ptg. & Sc.*, p. 120.

272 EXECUTION (FIRST VERSION). (1948) Oil on canvas, 39⅞ x 29⅞" (101.3 x 75.9 cm). Katharine Cornell Fund. 6.50. Repr. *Suppl. II*, p. 23.

GREENE, Gertrude. American, 1911–1956.

364 WHITE ANXIETY. 1943–44. Painted wood relief construction on composition board, 41¾ x 32⅞" (105.8 x 83.3 cm). Gift of Balcomb Greene. 658.59. Repr. *Suppl. IX*, p. 18.

GREENE, Stephen. American, born 1918.

BIOGRAPH. (1967–68) Gouache, watercolor, collage, and pencil, 21³/₈ x 28⁷/₈″ (54.3 x 73.3 cm). John S. Newberry Fund. 13.68.

GRIGORIAN, Marcos. Iranian, born Russia 1924. To U.S.A. 1962.

450 Untitled. 1963. Dried earth on canvas, 33¹/₂ x 31⁷/₈″ (84.9 x 80.9 cm). Gift of Dr. and Mrs. Alex J. Gray. 48.65.

GRIPPE, Peter. American, born 1912.

305 THE CITY. (1942) Terra cotta, 9¹/₂ x 11¹/₈ x 16″ (24.1 x 28.3 x 40.7 cm). Given anonymously. 20.43. Repr. *Ptg. & Sc.*, p. 289.

CITY WITH SPACE FIGURES, I. 1945. Terra cotta, 12 x 14³/₄ x 11⁷/₈″ (30.4 x 37.4 x 30.1 cm). Given anonymously. 1065.69.

GRIS, Juan (José Victoriano González). Spanish, 1887–1927. To France 1906.

90 STILL LIFE. 1911. Oil on canvas, 23¹/₂ x 19³/₄″ (59.7 x 50.2 cm). Acquired through the Lillie P. Bliss Bequest. 502.41. Repr. *Gris*, p. 16.

90 GUITAR AND FLOWERS. (1912) Oil on canvas, 44¹/₈ x 27⁵/₈″ (112.1 x 70.2 cm). Bequest of Anna Erickson Levene in memory of her husband, Dr. Phoebus Aaron Theodor Levene. 131.47. Repr. *Ptg. & Sc.*, p. 90; *Gris*, p. 19; in color, *Masters*, p. 73.

90 GRAPES AND WINE. 1913, October. Oil on canvas, 36¹/₄ x 23⁵/₈″ (92.1 x 60 cm). Bequest of Anna Erickson Levene in memory of her husband, Dr. Phoebus Aaron Theodor Levene. 132.47. Repr. *Ptg. & Sc.*, p. 93.

91 BREAKFAST. (1914) Pasted paper, crayon, and oil on canvas, 31⁷/₈ x 23¹/₂″ (80.9 x 59.7 cm). Acquired through the Lillie P. Bliss Bequest. 248.48. Repr. *Suppl. I*, p. 8; *Assemblage*, p. 20; in color, *Masters*, p. 76; *Gris*, p. 40; in color, *Invitation*, p. 50.

91 THE CHESSBOARD. 1917, March. Oil on wood, 28³/₄ x 39³/₈″ (73 x 100 cm). Purchase. 5.39. Repr. *Ptg. & Sc.*, p. 99; *Gris*, p. 75.

GROPPER, William. American, 1897–1977.

248 THE SENATE. (1935) Oil on canvas, 25¹/₈ x 33¹/₈″ (63.8 x 84.2 cm). Gift of A. Conger Goodyear. 108.36. Repr. *Ptg. & Sc.*, p. 150.

GROSS, Chaim. American, born Austria 1904. To U.S.A. 1921.

254 HANDLEBAR RIDERS. (1935) Lignum vitae, 41¹/₄″ (104.7 cm) high, at base 10¹/₂ x 11¹/₂″ (26.7 x 29.2 cm). Gift of A. Conger Goodyear. 156.37. Repr. *Ptg. & Sc.*, p. 261. *Note*: the Museum owns an ink study for this sculpture.

GROSS, Michael. Israeli, born 1920.

SMALL FIGURE ON BLUE. (1964) Casein on composition board, 19³/₄ x 15⁷/₈″ (50.1 x 40.3 cm). Gift of Mr. and Mrs. George M. Jaffin. 2.65. Repr. *Art Israel*, p. 37.

GROSSER, Maurice. American, born 1903.

THE PUSHCART. 1942. Oil on canvas, 19¹/₈ x 26¹/₈″ (48.6 x 66.4 cm). Gift of Briggs W. Buchanan. 575.43.

GROSZ, George. American, 1893–1959. Born and died in Germany. In U.S.A. 1932–59.

395 EXPLOSION. (1917) Oil on composition board, 18⁷/₈ x 26⁷/₈″ (47.8 x 68.2 cm). Gift of Mr. and Mrs. Irving Moskovitz. 780.63.

200 METROPOLIS. 1917. Oil on cardboard, 26³/₄ x 18³/₄″ (68 x 47.6 cm). Purchase. 136.46. Repr. *Ptg. & Sc.*, p. 142.

200 THE ENGINEER HEARTFIELD. (1920) Watercolor and collage of pasted postcard and halftone, 16¹/₂ x 12″ (41.9 x 30.5 cm). Gift of A. Conger Goodyear. 176.52. Repr. *Suppl. IV*, p. 28; *Masters*, p. 139; *The Machine*, p. 114; in color, *Invitation*, p. 57. *Note*: John Heartfield was a close friend of the artist and a fellow-dadaist in Berlin just after World War I. He died in 1968.

200 REPUBLICAN AUTOMATONS. (1920) Watercolor, 23⁵/₈ x 18⁵/₈″ (60 x 47.3 cm). Advisory Committee Fund. 120.46. Repr. *Ptg. & Sc.*, p. 213.

METHUSELAH. (1922) Watercolor, bronze paint, pen and ink, 20³/₄ x 16¹/₄″ (52.6 x 41.1 cm). Mr. and Mrs. Werner E. Josten Fund. 143.57. Repr. *Suppl. VII*, p. 7. *Note*: costume design for the title role in the play, *Methusalem*, by Ivan Goll. Apparently Grosz's designs were not used. The play was produced by William Dieterle, Dramatisches Theater, Berlin, 1924, with décor and costumes by Hannes Boht.

200 THE POET MAX HERRMANN-NEISSE. 1927. Oil on canvas, 23³/₈ x 29¹/₈″ (59.4 x 74 cm). Purchase. 49.52. Repr. *Suppl. IV*, p. 28; *Modern Masters*, p. 223. *Note*: the Museum owns an ink study for this painting.

200 SELF-PORTRAIT WITH A MODEL. 1928. Oil on canvas, 45¹/₂ x 29³/₄″ (115.6 x 75.6 cm). Gift of Mr. and Mrs. Leo Lionni. 548.54.

200 PUNISHMENT. (1934) Watercolor, 27¹/₂ x 20¹/₂″ (69.8 x 52.1 cm). Gift of Mr. and Mrs. Erich Cohn. 169.34. Repr. *Ptg. & Sc.*, p. 143.

GROUP N. An Italian group, located in Padua and exhibiting anonymously, comprising Alberto Biasi, Ennio Chiggio, Toni Costa, Edoardo Landi, and Manfredo Massironi; disbanded in 1964.

503 UNSTABLE PERCEPTION. (1963) Metal rods and eighteen metal cylinders on wood mount, 17⁷/₈ x 18 x 3¹/₄″ (45.3 x 45.5 x 8.2 cm). Gift of the Olivetti Company of Italy. 1238.64. Repr. *Responsive Eye*, p. 4.

GUAYASAMÍN (Oswaldo Guayasamín Calero). Ecuadorian, born 1919.

MY BROTHER. 1942. Oil on wood, 15⁷/₈ x 12³/₄″ (40.3 x 32.4 cm). Inter-American Fund. 699.42. Repr. *Latin-Amer. Coll.*, p. 55.

GUDNASON. See SVAVAR GUDNASON.

GUERRERO GALVÁN, Jesús. Mexican, born 1910.

211 THE CHILDREN. 1939. Oil on canvas, 53³/₄ x 43¹/₄″ (136.5 x 109.8 cm). Inter-American Fund. 2.43. Repr. *Latin-Amer. Coll.*, p. 73. *Note*: the Museum owns a pencil study for this painting.

GUERRESCHI, Giuseppe. Italian, born 1929.

THE SHUTTERS. 1956. Oil on canvas, 70⁷/₈ x 43″ (179.9 x 109.2 cm). Gift of Mrs. Saul S. Sherman. 26.57. Repr. *Suppl. VII*, p. 19.

GUEVARA. See HERRERA GUEVARA.

GUGLIELMI, O. Louis. American, born Cairo, of Italian parents. 1906–1956. To U.S.A. 1914.

244 WEDDING IN SOUTH STREET. (1936) Oil on canvas, 30 x 24″ (76.2 x 61 cm). Extended loan from the United States WPA Art Program. E.L.38.3041. Repr. *Ptg. & Sc.*, p. 161.

ISAAC WALTON IN BROOKLYN. (1937) Oil on composition board, 29³/₄ x 23⁷/₈″ (75.6 x 60.6 cm). Extended loan from the United States WPA Art Program. E.L.39.1792.

GUIDO, Alfredo. Argentine, born 1892.

213 STEVEDORES RESTING. (1938) Tempera on wood, 21¹⁄₈ x 18¹⁄₈″ (53.7 x 46 cm) (sight). Inter-American Fund. 702.42. Repr. *Ptg. & Sc.*, p. 175.

GUIGNARD, Alberto da Veiga. Brazilian, 1895–1962.

215 OURO PRETO: ST. JOHN'S EVE. 1942. Oil on plywood, 31¹⁄₂ x 23⁵⁄₈″ (80 x 60 cm). Commissioned through the Inter-American Fund. 10.43. Repr. *Latin-Amer. Coll.*, p. 38. *Note*: the Museum owns an ink study for this painting.

GUJRAL, Satish. Indian, born 1925.

436 OUTPOST. 1962. Oil and mixed mediums on canvas, 33¹⁄₈ x 44³⁄₈″ (83.9 x 112.6 cm). Gift of Dr. and Mrs. Samuel Rosen. 452.64.

GUSTON, Philip. American, born 1913.

334 PAINTING. 1954. Oil on canvas, 63¹⁄₄ x 60¹⁄₈″ (160.6 x 152.7 cm). Gift of Philip Johnson. 7.56. Repr. *Suppl. V*, p. 21; *New Amer. Ptg.*, p. 41.

334 THE CLOCK. 1956–57. Oil on canvas, 6′4″ x 64¹⁄₈″ (193.1 x 163 cm). Gift of Mrs. Bliss Parkinson. 659.59. Repr. *New Amer. Ptg.*, p. 42.

GUTTUSO, Renato. Italian, born 1912.

279 MELON EATERS. 1948. Oil on canvas, 35 x 45⁵⁄₈″ (88.9 x 115.9 cm). Purchase (by exchange). 689.49. Repr. *Suppl. II*, p. 16.

279 LAVA QUARRY. 1957. Oil on canvas, 57⁵⁄₈ x 45″ (146.8 x 114.3 cm). Gift of Mrs. Joseph James Akston. 310.62. Repr. *Suppl. XII*, p. 14.

279 ORANGE GROVE AT NIGHT. (1957) Oil on canvas, 55³⁄₈″ x 7′6⁵⁄₈″ (140.6 x 230.2 cm). Blanchette Rockefeller Fund. 85.58. Repr. *Suppl. VIII*, p. 13.

GYSIN, Brion. American, born Great Britain 1916. Lives in Paris.

A TRIP FROM HERE TO THERE. (1958) Ink and gouache, 31′6⁵⁄₈″ (961.7 cm) long, folded to fit between covers, 11¹⁄₂ x 8″ (29.1 x 20.3 cm). Larry Aldrich Foundation Fund. 230.62. Detail repr. *Suppl. XII*, p. 36.

HADZI, Dimitri. American, born 1921.

362 HELMET, I. 1958. Bronze, 13¹⁄₈″ (33.2 cm) high. Mr. and Mrs. William B. Jaffe Fund. 604.59. Repr. *Suppl. IX*, p. 33.

HAESE, Günter. German, born 1924.

487 IN TIBET. (1964) Construction of clockwork parts, brass screening, and wire, 19¹⁄₂ x 9¹⁄₄ x 4¹⁄₄″ (49.5 x 23.5 x 10.3 cm). Blanchette Rockefeller Fund. 1125.64.

487 CARAVAN. (1965) Construction of clockwork parts, brass screening, and wire, 11¹⁄₈ x 15¹⁄₂ x 11¹⁄₂″ (28.2 x 39.4 x 29 cm). Gift of Mr. and Mrs. C. Gerald Goldsmith. 595.66.

HAGUE, Raoul. American, born Constantinople of Armenian parents, 1905. To U.S.A. 1921.

OHAYO WORMY BUTTERNUT. (1947–48) Butternut, 66¹⁄₂″ (168.9 cm) high, attached to base 3¹⁄₂ x 18 x 11⁷⁄₈″ (8.9 x 45.7 x 30.2 cm). Katharine Cornell Fund. 248.56. Repr. *12 Amer.*, p. 47; *What Is Mod. Sc.*, p. 17.

358 PLATTEKILL WALNUT. (1952) Walnut, 35⁵⁄₈ x 27³⁄₄ x 22⁵⁄₈″ (90.5 x 70.4 x 57.4 cm). Elizabeth Bliss Parkinson Fund. 249.56. Repr. *12 Amer.*, p. 50.

HAINS, Raymond. French, born 1926. Lives in Venice.

SAFFA SUPER MATCH BOX. (1965) Synthetic polymer paint on plywood, 45¹⁄₂ x 34¹⁄₄ x 3″ (115.5 x 86.9 x 7.5 cm). Gift of Philip Johnson. 782.69.

HAJDU, Étienne. French, born Rumanian Transylvania, of Hungarian parents, 1907.

299 SOLDIERS IN ARMOR. (1953) Sheet copper relief, repoussé, 38¹⁄₂″ x 6′5¹⁄₄″ (97.8 x 196.2 cm). A. Conger Goodyear Fund. 152.55. Repr. *New Decade*, p. 23.

298 WHITE HEAD. 1958. Marble, 30¹⁄₂ x 13⁷⁄₈″ (77.3 x 35.2 cm). Gift of The Four Seasons. 122.58. Repr. *Suppl. IX*, p. 30.

HALLER, Hermann. Swiss, 1880–1950.

STANDING GIRL. (c. 1926) Bronze, 14″ (35.6 cm) high. Gift of Mrs. Saidie A. May. 13.30. Repr. *Modern Works*, no. 169.

HAMBLETT, Theora. American, 1895–1977.

10 THE VISION. (1954) Oil on composition board, 17⁷⁄₈ x 48″ (45.4 x 121.9 cm). Gift of Albert Dorne. 10.55. Repr. *Suppl. V*, p. 33.

HANSEN, Robert. American, born 1924.

314 MAN-MEN: MIRROR. 1959. Lacquer on composition board, 46¹⁄₈″ x 6′ (116.7 x 182.7 cm). Larry Aldrich Foundation Fund. 74.62. Repr. *Figure U.S.A.*

HANSON, Joseph Mellor. British, 1900–1963. To U.S.A. 1939.

NOCTURNAL ENCOUNTERS. 1949. Oil on canvas, 35¹⁄₈ x 45³⁄₈″ (89.2 x 115.2 cm). Given anonymously. 89.50. Repr. *Suppl. II*, p. 22.

HARE, David. American, born 1917.

MAGICIAN'S GAME. (1944) Bronze (cast 1946), 40¹⁄₄ x 18¹⁄₂ x 25¹⁄₄″ (102.2 x 47 x 64.1 cm). Given anonymously. 244.69. Repr. *Dada, Surrealism*, p. 179.

305 CRAB. (1951) Welded bronze, 23¹⁄₄″ (59 cm) high, on three points, 9 x 7¹⁄₂ x 7¹⁄₄″ (22.9 x 19 x 18.4 cm) apart. Purchase. 136.51. Repr. *Suppl. III*, p. 7.

FIGURE WAITING IN COLD. (1951) Bronze and iron on stone base, 71⁷⁄₈ x 10¹⁄₂ x 11″ (182.5 x 26.5 x 27.8 cm); at base, 14³⁄₄ x 7¹⁄₂ x 9¹⁄₈″ (37.4 x 19 x 23.1 cm). Given anonymously. 1089.69.

305 SUNSET, I. (1953) Stone and painted wire, 19¹⁄₄″ (48.8 cm) high. Fund given in memory of Philip L. Goodwin. 669.59. Repr. *Suppl. IX*, p. 34.

SUNSET, II. (1953) Bronze and steel, 62 x 50 x 6¹⁄₄″ (157.5 x 127 x 15.7 cm). Given anonymously. 1090.69.

HARKAVY, Minna R. American, born Estonia 1895.

255 AMERICAN MINER'S FAMILY. 1931. Bronze, 27″ (68.6 cm) high, at base 23 x 19³⁄₄″ (58.4 x 50.2 cm). Abby Aldrich Rockefeller Fund. 303.38. Repr. *Ptg. & Sc.*, p. 263.

HART, George Overbury ("Pop"). American, 1868–1933.

THE HUDSON. 1925. Watercolor and ink, 17¹⁄₄ x 23¹⁄₄″ (43.8 x 59 cm). Given anonymously. 73.35.

FRUIT PACKERS, TEHUANTEPEC. 1927. Watercolor and ink, 17¹⁄₄ x 23¹⁄₄″ (43.8 x 59 cm). Gift of Abby Aldrich Rockefeller. 71.35.

236 THE MERRY-GO-ROUND, OAXACA. 1927. Watercolor, 17¹⁄₄ x 23¹⁄₄″ (43.8 x 59 cm). Gift of Abby Aldrich Rockefeller. 75.35. Repr. *Art in Our Time*, no. 209.

ORCHESTRA AT COCK FIGHT, MEXICO. 1928. Watercolor and pastel, 17⁵/₈ x 23⁵/₈″ (44.8 x 60 cm). Given anonymously. 76.35. Repr. *Ptg. & Sc.*, p. 165.

HORSE SALE, FEZ: TRYING THE HORSES. 1929. Watercolor, 17¼ x 23½″ (43.8 x 59.7 cm). Given anonymously. 72.35.

THE SULTAN'S MESSENGER, FEZ. 1929. Watercolor and pastel, 16³/₈ x 22³/₈″ (41.6 x 56.8 cm). Given anonymously. 79.35.

HARTIGAN, Grace. American, born 1922.

THE PERSIAN JACKET. 1952. Oil on canvas, 57½ x 48″ (146 x 121.9 cm). Gift of George Poindexter. 413.53. Repr. *12 Amer.*, p. 54.

RIVER BATHERS. 1953. Oil on canvas, 69³/₈″ x 7′4³/₄″ (176.2 x 225.5 cm). Given anonymously. 11.54. Repr. *Suppl. V*, p. 26; in color, *12 Amer.*, opp. p. 53.

336 SHINNECOCK CANAL. 1957. Oil on canvas, 7′6½″ x 6′4″ (229.8 x 193 cm). Gift of James Thrall Soby. 6.60. Repr. *Soby Collection*, p. 46.

HARTLEY, Marsden. American, 1877–1943.

BIRCH GROVE, AUTUMN. (c. 1909) Oil on cardboard, 12¹/₈ x 12¹/₈″ (30.6 x 30.6 cm). Lee Simonson Bequest. 335.67.

427 MAINE MOUNTAINS, AUTUMN. (c. 1909) Oil on cardboard, 12¹/₈ x 12¹/₈″ (30.6 x 30.6 cm). Lee Simonson Bequest. 448.67.

222 BOOTS. (1941) Oil on gesso composition board, 28¹/₈ x 22¹/₄″ (71.4 x 56.5 cm). Purchase. 146.42. Repr. *Ptg. & Sc.*, p. 166; *Masters*, p. 118.

222 EVENING STORM, SCHOODIC, MAINE. 1942. Oil on composition board, 30 x 40″ (76.2 x 101.6 cm). Acquired through the Lillie P. Bliss Bequest. 66.43. Repr. *Ptg. & Sc.*, p. 167; in color, *Natural Paradise*, p. 111.

HARTUNG, Hans. French, born Germany 1904. In Paris since 1935.

344 PAINTING. 1948. Oil on canvas, 38¹/₄ x 57¹/₂″ (97.2 x 146 cm). Gift of John L. Senior, Jr. 50.52. Repr. *Suppl. IV*, p. 35.

HAUBENSAK, Pierre. Swiss, born 1935. Lives in Ibiza.

447 Study for MAURESQUE. 1965. Synthetic polymer paint on paper, 24³/₈ x 19⁵/₈″ (61.9 x 49.9 cm). Gift of Carl van der Voort. 193.66.

HAYDEN, Henri. French, born Poland. 1883–1970. To Paris 1907.

100 STILL LIFE. (1917) Gouache and charcoal, 16³/₄ x 14″ (42.4 x 35.5 cm). Gift of Mr. and Mrs. Sidney Elliott Cohn. 361.60. Repr. *Suppl. X*, p. 17.

HAYES, David V. American, born 1931.

304 BEAST. (1957) Forged steel, 20³/₈ x 21¹/₈″ (53.6 x 51.7 cm). Blanchette Rockefeller Fund. 605.59. Repr. *Recent Sc. U.S.A.* *Note*: the Museum owns an ink study for this sculpture.

HAYTER, Stanley William. British, born 1901. In Paris 1926–39; U.S.A. 1939–50; Paris since 1950.

HAND SCULPTURE. (1940) Plaster, 15¹/₄″ (38.8 cm) high. Given anonymously. 519.41.

HECKEL, Erich. German, 1883–1970.

70 SEATED MAN (SELF-PORTRAIT). 1909. Oil on canvas, 27³/₄ x 23⁷/₈″ (70.4 x 60.5 cm). Gift of G. David Thompson. 10.59. Repr. *Suppl. IX*, p. 10.

TWO NUDES ON THE BEACH. 1912. Watercolor, ink, and char-

coal, 10³/₄ x 12″ (27.3 x 30.5 cm) (irregular). Gift of Samuel A. Berger. 11.55.

AUTUMN DAY. 1922. Watercolor, 18¹/₄ x 23¹/₄″ (46.3 x 59 cm). Given anonymously. 82.35.

HEDRICK, Wally. American, born 1928.

AROUND PAINTING. 1957. Oil on circular canvas, about 69³/₄″ (177 cm) diameter. Larry Aldrich Foundation Fund. 717.59. Repr. *16 Amer.*, p. 15.

HEILIGER, Bernhard. German, born 1915.

298 ERNST REUTER. (1954) Bronze (cast 1958), 15⁷/₈″ (40.1 cm) high. Matthew T. Mellon Foundation Fund. 123.58. Repr. *Suppl. VIII*, p. 16. *Note*: Dr. Ernst Reuter was first postwar Mayor of Berlin in 1946, Western Sector Mayor, 1948. He died in 1953.

HELD, Al. American, born 1928.

THE BIG N. (1965) Synthetic polymer paint on canvas, 9′3/₈″ x 9′ (275.2 x 274.3 cm). Purchase. 104.73.

HÉLION, Jean. French, born 1904.

142 EQUILIBRIUM. 1934. Oil on canvas, 10³/₄ x 13³/₄″ (27.3 x 35 cm). Acquired through the Lillie P. Bliss Bequest. 389.42. Repr. *Ptg. & Sc.*, p. 119.

COMPOSITION. 1936. Oil on canvas, 39¹/₄ x 31⁷/₈″ (99.7 x 80.9 cm). Gift of the Advisory Committee. 76.36. Repr. *Ptg. & Sc. (I)*, p. 46.

410 COMPOSITION. (1938) Oil on canvas, 13¹/₈ x 16″ (33.2 x 40.4 cm). Kay Sage Tanguy Bequest. 1126.64.

HEPWORTH, Barbara. British, 1903–1975.

143 DISKS IN ECHELON. (1935) Padouk wood, 12¹/₄″ (31.1 cm) high, attached to base 19³/₈ x 8⁷/₈″ (49.1 x 22.5 cm). Gift of W. B. Bennet. 80.36. Repr. *Ptg. & Sc.*, p. 274.

143 HELIKON. (1948) Portland stone, 24¹/₄″ (61.6 cm) high, attached to base 12¹/₈″ (30.8 cm) square. Gift of Curt Valentin. 155.53. Repr. *Suppl. IV*, p. 39.

143 HOLLOW FORM (PENWITH). (1955–56) Lagos wood, partly painted, 35³/₈ x 25⁷/₈ x 25⁵/₈″ (89.8 x 65.7 x 64.8 cm) attached to base 35⁷/₈ x 23¹/₂″ (91.1 x 59.7 cm). Gift of Dr. and Mrs. Arthur Lejwa. 7.60. Repr. *Suppl. X*, p. 45.

HERBIN, Auguste. French, 1882–1960.

DESSERT. (1912–13?) Oil on canvas, 45⁷/₈ x 35¹/₈″ (116.3 x 89.2 cm). Gift of Miss May E. Walter. 420.71.

STILL LIFE. 1915. Oil on canvas, 25 x 17¹/₂″ (63.5 x 44.5 cm). Gift of Mrs. Rita Silver in memory of her son, Stanley R. Silver. 1401.74.

STREET FAIR [*Fête foraine*]. 1918. Oil on canvas, 46 x 35″ (106.8 x 88.9 cm). Gift of Mrs. Rita Silver in memory of her son, Stanley R. Silver. 1402.74.

COMPOSITION ON THE WORD "VIE," 2. 1950. Oil on canvas, 57¹/₂ x 38¹/₄″ (145.8 x 97.1 cm). The Sidney and Harriet Janis Collection (fractional gift). 606.67. Repr. in color, *Janis*, p. 135.

HERRERA GUEVARA, Luis. Chilean, 1891–1945.

214 SNOW STORM AT THE UNIVERSITY. 1941. Oil on canvas, 24 x 27⁵/₈″ (61 x 70.2 cm). Inter-American Fund. 707.42. Repr. *Latin-Amer. Coll.*, p. 41.

HESSE, Eva. American, born Germany. 1936–1970.

REPETITION 19, III. (1968) Nineteen tubular fiberglass units, 19 to 20¼″ high x 11 to 12¾″ diameter (48 to 51.1 cm high x 27.8 to 32.3 cm diameter). Gift of Charles and Anita Blatt. 1004.69a–s.

VINCULUM, II. (1969) Twenty-three rubberized wire-mesh plaques stapled to shielded wire, 19′5″ x 3″ (591.7 x 7.6 cm), with twenty-three hanging extruded rubber wires, knotted, ranging in size from 7″ (17.9 cm) to 62″ (157.6 cm). Size installed, 9′9″ x 2½″ x 9′7½″ (297.2 x 5.8 x 293.5 cm). The Gilman Foundation Fund. 374.75.

HIDAI, Nankoku. Japanese, born 1912.

WORK 59–42. 1959. Brush and ink on paper, 9 x 6⅞″ (22.8 x 17.2 cm), mounted on silk scroll, 29⅞″ x 10¾″ (75.9 x 27.3 cm). Elizabeth Bliss Parkinson Fund. 6.61. Repr. *Suppl. XI*, p. 35.

WORK 60 B. 1960. Brush and ink on paper mounted on plywood, 6⅞ x 9″ (17.3 x 22.8 cm). Mr. and Mrs. Donald B. Straus Fund. 4.61.

WORK 60 C. 1960. Brush and ink on paper mounted on plywood, 9 x 6⅝″ (22.9 x 16.8 cm). Mr. and Mrs. Donald B. Straus Fund. 5.61.

WORK 60 D. 1960. Brush and ink on paper mounted on plywood, 9 x 6⅝″ (22.9 x 16.8 cm). Mr. and Mrs. Donald B. Straus Fund. 118.61. Repr. *Suppl. XI*, p. 35.

317 WORK 63–14–3. 1963. Brush and ink on paper mounted on cardboard, 59⅝ x 47⅜″ (151.2 x 120.2 cm). Gift of Dr. Frederick Baekeland. 196.64.

HIGGINS, Edward. American, born 1930.

THE OUTSIDE OF A SOLDIER. 1958. Welded steel and plaster, 24⅜ x 21⅝ x 15⅜″ (61.8 x 54.9 x 38.9 cm). Larry Aldrich Foundation Fund. 11.59. Repr. *Recent Sc. U.S.A.*

363 DOUBLE PORTRAIT—TORSOS. (1960) Steel and epoxy, 16¼ x 17 x 7¾″ (41.2 x 43.1 x 19.6 cm). Larry Aldrich Foundation Fund. 116.60. Repr. *Suppl. X*, p. 43; *Amer. 1963*, p. 35. *Note*: the subjects are the artist and his wife.

Untitled. 1962. Steel and epoxy, 56 x 28 x 15″ (142.2 x 71.1 x 138.1 cm). Gift of Juan M. and Roderick W. Cameron. 2661.67.

HILER, Hilaire. American, 1898–1966.

POUTER PIGEONS. 1930. Gouache, 14¾ x 18″ (37.5 x 45.7 cm). Gift of Abby Aldrich Rockefeller. 83.35. Repr. *La Pintura*, p. 131.

HILLSMITH, Fannie. American, born 1911.

288 LIQUOR STORE WINDOW. 1946. Oil tempera and sand on canvas, 32 x 34⅛″ (81.3 x 86.7 cm). Purchase. 307.47.

HINMAN, Charles. American, born 1932.

490 POLTERGEIST. 1964. Synthetic polymer paint on shaped canvas over wood framework, 8′2¾″ x 61⅞″ x 16⅜″ (250.7 x 156.9 x 41.5 cm). Larry Aldrich Foundation Fund. 3.65.

HINTERREITER, Hans. Swiss, born 1902. Lives in Ibiza.

501 OP. 134. 1961. Mixed mediums, 15⅜ x 13⅞″ (39 x 35.1 cm). Gift of the artist. 251.66.

HIRAGA, Key. Japanese, born 1936.

THE WINDOW. 1964. Oil on canvas, 57¼ x 44⅜″ (145.3 x 112.5 cm). Given anonymously. 2310.67. Repr. *New Jap. Ptg. & Sc.*, p. 106.

HIRSCH, Joseph. American, born 1910.

248 TWO MEN. 1937. Oil on canvas, 18⅛ x 48¼″ (46 x 122.5 cm). Abby Aldrich Rockefeller Fund. 572.39. Repr. *Ptg. & Sc.*, p. 150.

439 DAYBREAK. (1962) Oil on canvas, 57¼ x 6′1¼″ (145.4 x 183.5 cm). Purchase and anonymous gift. 1261.64.

HIRSHFIELD, Morris. American, born Russian Poland. 1872–1946. To U.S.A. 1890.

ANGORA CAT. (1937–39. Dated on canvas 1937). Oil on canvas, 22⅛ x 27¼″ (56.1 x 69.1 cm). The Sidney and Harriet Janis Collection (fractional gift). 607.67. Repr. *Janis*, p. 90.

BEACH GIRL. (1937–39. Dated on canvas 1937) Oil on canvas, 36¼ x 22¼″ (91.8 x 56.3 cm). The Sidney and Harriet Janis Collection (fractional gift). 2097.67. Repr. *Janis*, p. 89.

LION. 1939. Oil on canvas, 28¼ x 40¼″ (71.5 x 102 cm). The Sidney and Harriet Janis Collection (fractional gift). 608.67. Repr. *Janis*, p. 90.

10 GIRL IN A MIRROR. 1940. Oil on canvas, 40⅛ x 22¼″ (101.9 x 56.5 cm). Purchase. 327.41. Repr. *Bulletin*, vol. IX, no. 2, 1941, p. 6.

10 TIGER. 1940. Oil on canvas, 28 x 39⅞″ (71.1 x 101.3 cm). Abby Aldrich Rockefeller Fund. 328.41. Repr. *Ptg. & Sc.*, p. 22.

INSEPARABLE FRIENDS. 1941. Oil on canvas, 60⅛ x 40⅛″ (152.6 x 101.9 cm). The Sidney and Harriet Janis Collection (fractional gift). 609.67. Repr. in color, *Janis*, p. 91; in color, *Invitation*, p. 77.

GIRL WITH PIGEONS. 1942. Oil on canvas, 30 x 40⅛″ (76.1 x 101.7 cm). The Sidney and Harriet Janis Collection (fractional gift). 610.67. Repr. *Janis*, p. 92.

PARLIAMENTARY BUILDINGS. 1946. Oil on canvas, 36⅛ x 28″ (91.7 x 71.1 cm). The Sidney and Harriet Janis Collection (fractional gift). 611.67. Repr. *Janis*, p. 92. *Note*: also called *Sacré Coeur*.

HÖCH, Hannah. German, born 1889.

159 Untitled. 1925. Collage, 9¾ x 7⅝″ (24.5 x 19.2 cm). Gift of Miss Rose Fried. 3.63.

410 WATCHED. 1925. Collage, 10⅞ x 7⅜″ (27.5 x 18.5 cm). Joseph G. Mayer Foundation Fund, in memory of René d'Harnoncourt. 2634.67.

410 INDIAN DANCER (FROM AN ETHNOGRAPHIC MUSEUM). 1930. Collage, 10⅛ x 8⅞″ (25.7 x 22.4 cm). Frances Keech Fund. 569.64. *Note*: the principal element is a photograph of the actress, Marie Falconetti, from the film of 1928, *The Passion of Joan of Arc*.

159 Untitled. 1945. Collage, 13½ x 12⅛″ (34 x 30.7 cm). Gift of Miss Rose Fried. 4.63.

WITH SEAWEED. (1950) Collage, 13⅝ x 9⅞″ (34.6 x 25 cm). Gift of Miss Rose Fried. 5.63.

VAN HOEYDONCK, Paul. Belgian, born 1925.

Untitled. 1960. Synthetic polymer paint on composition board, 23⅝ x 23¼″ (60 x 59 cm). Purchase. 416.60.

HOFER, Carl. German, 1878–1955.

71 MAN WITH A MELON. (1926) Oil on canvas, 42¼ x 28⅞″ (107.3 x 73.3 cm). Purchase. 284.49. Repr. *Suppl. I*, p. 11.

HOFMANN, Hans. American, born Germany. 1880–1966. To U.S.A. 1932.

SPRING. 1940. Oil on wood panel, 11¼ x 14⅛″ (28.5 x 35.7 cm). Gift of Mr. and Mrs. Peter A. Rübel. 1516.68. Repr. *Hofmann*, p. 24.

321 AMBUSH. 1944. Oil on paper, 24 x 19″ (61 x 48.3 cm). Purchase. 51.52.

321 DELIGHT. 1947. Gesso and oil on canvas, 50 x 40″ (126.9 x 101.6 cm). Gift of Mr. and Mrs. Theodore S. Gary. 2.56. Repr. *Suppl. VI*, p. 23.

 FLOWERING DESERT. 1953. Oil on canvas, 23³/₄ x 27″ (60.5 x 68.6 cm). Eve Clendenin Bequest. 422.74. Repr. in color, *Amer. Art*, p. 9; in b. & w. p. 27.

321 MEMORIA IN AETERNUM. 1962. Oil on canvas, 7′ x 6′¹/₈″ (213.3 x 183.2 cm). Gift of the artist. 399.63. Dedicated to Arthur Carles, Arshile Gorky, Jackson Pollock, Bradley Walker Tomlin, Franz Kline. Repr. *Hofmann*, p. 55; in color, *Invitation*, p. 133.

HOLLAND, Tom. American, born 1936.

 Untitled (Malibu Series). 1969. Synthetic polymer paint on fiberglass with copper rivets, 5′9¹/₄″ x 9′2¹/₄″ (176 x 280 cm). Fractional gift of Charles Cowles. 664.70.

HONEGGER, Gottfried. Swiss, born 1917.

370 HENCEFORTH. 1959. Oil over cardboard collage on canvas, 25 x 25″ (63.5 x 63.5 cm). Gift of Mr. and Mrs. Peter A. Rübel. 29.60. Repr. *Suppl. X*, p. 54.

HOPPER, Edward. American, 1882–1967.

232 CORNER SALOON. (1913) Oil on canvas, 24 x 29″ (61 x 73.7 cm). Abby Aldrich Rockefeller Fund. 329.41. Repr. *Ptg. & Sc.*, p. 154.

232 HOUSE BY THE RAILROAD. (1925) Oil on canvas, 24 x 29″ (61 x 73.7 cm). Given anonymously. 3.30. Repr. *Ptg. & Sc.*, p. 155; in color, *Masters*, p. 111.

232 MRS. ACORN'S PARLOR. (1926) Watercolor, 14 x 20″ (35.6 x 50.8 cm). Gift of Abby Aldrich Rockefeller. 87.35.

232 BOX FACTORY, GLOUCESTER. (1928) Watercolor, 14 x 20″ (35.6 x 50.8 cm). Gift of Abby Aldrich Rockefeller. 85.35. Repr. *Hopper*, no. 47.

232 NIGHT WINDOWS. (1928) Oil on canvas, 29 x 34″ (73.7 x 86.4 cm). Gift of John Hay Whitney. 248.40. Repr. *Ptg. & Sc.*, p. 156.

233 NEW YORK MOVIE. (1939) Oil on canvas, 32¹/₄ x 40¹/₈″ (81.9 x 101.9 cm). Given anonymously. 396.41. Repr. *Ptg. & Sc.*, p. 155.

233 GAS. (1940) Oil on canvas, 26¹/₄ x 40¹/₄″ (66.7 x 102.2 cm). Mrs. Simon Guggenheim Fund. 577.43. Repr. *Ptg. & Sc.*, p. 156; in color, *Romantic Ptg.*, opp. p. 38; in color, *Invitation*, p. 121.

HORD, Donal. American, born 1902.

 MEXICAN BEGGAR. (1938) Columbia marble, 12⁵/₈ x 7⁷/₈ x 6¹/₄″ (31.9 x 19.9 x 15.8 cm). Extended loan from the United States WPA Art Program. E.L.41.2383. Repr. *Amer. 1942*, p. 73.

HOSIASSON, Philippe. French, born Ukraine 1898.

347 RED AND BLACK. 1956. Oil on canvas, 57⁷/₈ x 45¹/₄″ (146.8 x 114.9 cm). Benjamin Scharps and David Scharps Fund. 289.56. Repr. *Suppl. VI*, p. 25.

HOYER, Thorvald Arenst. American, born Denmark. 1872–1949. To U.S.A. c. 1915.

 INSIDE A BARN. 1937. Oil on canvas, 30¹/₈ x 24¹/₈″ (76.5 x 61.3 cm). Extended loan from the United States WPA Art Program. E.L.39.1775. Repr. *Masters Pop. Ptg.*, no. 128.

HUDSON, Robert. American, born 1938.

 FAT KNAT. 1964. Painted metal construction, 55¹/₈ x 17¹/₂ x 53⁷/₈″ (139.9 x 44.5 x 136.7 cm). Fractional gift of Charles Cowles. 623.73.

HUEBLER, Douglas. American, born 1924.

 LOCATION PIECE, 6—NATIONAL. 1970. Seventeen photographs with captions, variable from 6³/₈ x 8³/₈″ (16.2 x 21.2 cm) to 9⁷/₈ x 8″ (25.1 x 20.3 cm), and text panel with three mounted sheets; overall, 12 x 26¹/₂″ (30.5 x 67.3 cm). Larry Aldrich Foundation Fund. 44.71a–t. *Note:* the artist asked one newspaper in each of the fifty states to contribute one photograph from any recently published local news item. Seventeen newspapers participated.

HUGHES, Toni. American, born 1907.

 CHILDREN ON THE BEACH. 1940. Construction in plumber's hanger iron, galvanized wire cloth, screening, with various ornaments, 24¹/₂″ (62.2 cm) high, on base 24¹/₈ x 7¹/₂″ (61.3 x 9.1 cm). Purchase. 397.41.

HULTBERG, John. American, born 1922.

315 TILTED HORIZON. 1955. Oil on canvas, 54¹/₈″ x 6′4¹/₈″ (137.4 x 193.2 cm). Gift of Dr. and Mrs. Daniel E. Schneider. 286.58. Repr. *Suppl. VIII*, p. 13.

HUMPHREY, Ralph. American, born 1932.

 HUDSON. (1968) Synthetic polymer paint on canvas, 6′7³/₄″ x 6′8³/₈″ (202.5 x 204.2 cm). Gift of Carter Burden. 245.69.

HUNDERTWASSER (Friedrich Stowasser). Austrian, born 1928.

 LIGHTNING [*La Foudre*]. 1959. Oil, egg tempera, and chalk on paper over canvas, 38¹/₈ x 57¹/₂″ (96.7 x 45.9 cm). Joachim Jean Aberbach and Mrs. John Barry Ryan Funds. 714.68.

HUNT, Edward C. ("Pa"). American, 1870–1934.

 PETER HUNT'S ANTIQUE SHOP. (1930–34) Oil on canvas, 20 x 30¹/₈″ (50.8 x 76.5 cm). Abby Aldrich Rockefeller Fund. 645.39. Repr. *Masters Pop. Ptg.*, no. 134.

HUNT, Richard. American, born 1935.

363 ARACHNE. (1956) Welded steel, 30″ (76 cm) high, base, 18¹/₂″ (45.9 cm) diameter. Purchase. 5.57. Repr. *Suppl. VII*, p. 15; *Hunt*, front cover.

HUOT, Robert. American, born 1935.

 COMRIE. 1964. Synthetic polymer paint on canvas, 6′8¹/₈″ x 7′6″ (203.5 x 228.6 cm). Given anonymously. 423.74.

HUTCHINSON, Peter. British, born 1930.

 ARC. 1969. Three photographs and photocopy of map on cardboard mount; overall, 50¹/₄ x 40¹/₈″ (127.7 x 101.9 cm). Larry Aldrich Foundation Fund. 1066.69a–d.

IKEDA, Fumio (pen name: Suijō). Japanese, born 1912.

317 WHITE PATH. (c. 1953) Brush and ink, 25³/₄ x 54³/₈″ (65.4 x 138.1 cm). Japanese House Fund. 279.54.

INDIANA, Robert. American, born 1928.

477 FRENCH ATOMIC BOMB. 1959–60. Assemblage: polychromed wood beam and metal, 38⁵/₈ x 11⁵/₈ x 4⁷/₈″ (98 x 29.5 x 12.3 cm). Gift of Arne Ekstrom. 1127.64.

391 MOON. 1960. Assemblage: wood beam with iron-rimmed wheels and white paint, 6′6″ (198.1 cm) high, on base 5 x 17¹/₈ x 10¹/₄″ (12.7 x 43.5 x 26 cm). Philip Johnson Fund. 288.61. Repr. *Assemblage*, p. 141; *Amer. 1963*, p. 41.

391 THE AMERICAN DREAM, I. 1961. Oil on canvas, 6′ x 60¹/₈″ (183 x 152.7 cm). Larry Aldrich Foundation Fund. 287.61. Repr. *Suppl. XI*, p. 50; *Amer. 1963*, p. 39.

LAW. (1961) Painted wood and metal, 44$^{1}/_{8}$ x 10$^{7}/_{8}$ x 3$^{1}/_{8}$" (111.9 x 27.6 x 7.8 cm), including wood base 3$^{1}/_{4}$ x 10$^{3}/_{4}$ x 10$^{5}/_{8}$" (8 x 27.2 x 26.7 cm). Gift of Philip Johnson. 783.69.

INOKUMA, Genichiro. Japanese, born 1902. To U.S.A. 1955.

472 SUBWAY. 1966. Oil on canvas, 6'8$^{1}/_{4}$" x 50$^{3}/_{8}$" (203.8 x 127.8 cm). Blanchette Rockefeller Fund. 95.67.

IPOUSTEGUY, Jean. French, born 1920.

299 DAVID AND GOLIATH. 1959. Bronze, two figures in four parts: *David*, 47$^{7}/_{8}$ x 24$^{1}/_{4}$ x 25" (121.4 x 61.4 x 63.3 cm); *Goliath* (in three sections), 30$^{3}/_{8}$ x 53$^{3}/_{4}$ x 29$^{1}/_{2}$" (76.9 x 136.5 x 74.8 cm). Matthew T. Mellon Foundation Fund. 6.63.1–.2a–c.

IRWIN, Robert. American, born 1928.

Untitled. (1968) Synthetic polymer paint on metal, 60$^{3}/_{8}$" (153.2 cm), diameter. Mrs. Sam. A. Lewisohn Fund. 235.69.

ISENBURGER, Eric. American, born Germany 1902. To U.S.A. 1941.

GIRL WITH A CAT. 1939. Oil on canvas, 39$^{5}/_{8}$ x 32" (100.6 x 81.3 cm). Gift of Albert D. Lasker. 538.41.

ISOBE, Yukihisa. Japanese, born 1936.

WORK 64, 3, 4. 1964. Two-part assemblage of varnished wood, sacking, felt, plaster, string, paper, labels, ribbon, paint, pen and ink, 71$^{1}/_{2}$ x 71$^{1}/_{2}$ x 2$^{1}/_{8}$" (181.6 x 181.6 x 5.4 cm), and 71$^{7}/_{8}$ x 71$^{1}/_{2}$ x 2$^{1}/_{4}$" (182.4 x 181.6 x 5.6 cm). Given anonymously (by exchange). 214.68a–b.

ISRAEL, Marvin. American, born 1924.

467 Untitled. 1964. Oil on paper, 30$^{1}/_{8}$ x 22$^{1}/_{4}$" (76.3 x 56.5 cm). Larry Aldrich Foundation Fund. 194.66.

JACOB, Max. French, 1876–1944.

THREE FIGURES. 1928. Gouache, 13$^{7}/_{8}$ x 12$^{1}/_{4}$" (35.3 x 31.1 cm). Given anonymously. 88.35.

JACOBSEN, Robert. Danish, born 1912.

Untitled. (c. 1956) Iron and bronze, 15$^{1}/_{4}$ x 10$^{3}/_{8}$ x 4$^{3}/_{4}$" (38.5 x 26.3 x 12 cm), at base 7$^{1}/_{2}$ x 2$^{5}/_{8}$" (9.1 x 6.6 cm). Gift of Mr. and Mrs. Eli Wallach. 1091.69.

JARVAISE, James. American, born 1925.

338 HUDSON RIVER SCHOOL SERIES, 32. 1957. Oil on composition board, 60$^{1}/_{8}$ x 48" (152.5 x 121.9 cm). Larry Aldrich Foundation Fund. 8.60. Repr. *Suppl. X*, p. 35.

JAWLENSKY, Alexey. Russian, 1864–1941. Worked in Germany and Switzerland.

66 HEAD. (c. 1910?) Oil on canvas over cardboard, 16$^{1}/_{8}$ x 12$^{7}/_{8}$" (41 x 32.7 cm). Acquired through the Lillie P. Bliss Bequest. 415.53. Repr. *Suppl. V*, p. 36.

MEDITATION: YELLOW HEAD. 1936. Oil on cloth-textured paper, 9$^{3}/_{4}$ x 7$^{3}/_{8}$" (24.8 x 18.5 cm). The Sidney and Harriet Janis Collection (fractional gift). 612.67. Repr. *Janis*, p. 45.

JEAN, Marcel. French, born 1900.

SPECTER OF THE GARDENIA. (1936) Painted black cloth over plaster, zippers, and strip of film on velvet-covered wood base, 13$^{7}/_{8}$ x 7 x 9$^{7}/_{8}$" (35 x 17.6 x 25 cm), including base 3" high x 7" diameter (7.5 x 17.8 cm). D. and J. de Menil Fund. 229.68. Repr. *Fantastic Art* (3rd), p. 176; *Assemblage*, p. 64.

WOMAN'S PROFILE. 1936. Ink transfer (decalcomania), 19$^{3}/_{4}$ x 12$^{7}/_{8}$" (50 x 32.7 cm). Saidie A. May Fund. 10.69.

JEANNERET. See LE CORBUSIER.

JENKINS, Paul. American, born 1923.

PHENOMENA: JUNCTION RED. 1963. Synthetic polymer paint on canvas, 67 x 47$^{1}/_{4}$" (170.3 x 120 cm). Gift of Mr. and Mrs. David Kluger. 1536.68.

342 PHENOMENA: YELLOW STRIKE. 1963–64. Synthetic polymer paint on canvas, 60$^{1}/_{8}$ x 39$^{7}/_{8}$" (152.6 x 101.3 cm). Gift of Mr. and Mrs. David Kluger. 1297.68.

JENSEN, Alfred J. American, born Guatemala of Danish parents, 1903. To U.S.A. 1934.

372 CLOCKWORK IN THE SKY. 1959. Oil on canvas, 6' x 46$^{1}/_{8}$" (182.7 x 117 cm). Gift of Henry Luce III. 117.60. Repr. *Suppl. X*, p. 48.

HERE—THEN—THERE! 1959. Oil on canvas, 25$^{1}/_{8}$ x 36$^{1}/_{8}$" (63.9 x 91.8 cm). Gift of Mr. and Mrs. E. C. Kip Finch. 290.76.

JESPERS, Oscar. Belgian, born 1887.

202 TEMPTATION OF ST. ANTHONY. (1934) Limestone, 17$^{1}/_{2}$ x 56$^{1}/_{4}$" (44.5 x 142.8 cm). A. Conger Goodyear Fund. 121.46. Repr. *Ptg. & Sc.*, p. 250.

JESS (Jess Collins). American, born 1923.

EX. 4—TRINITY'S TRINE. 1964. Oil on canvas over wood, 45$^{7}/_{8}$ x 48$^{1}/_{8}$" (116.5 x 122.3 cm). Purchased with the aid of funds from the National Endowment for the Arts and an anonymous donor. 424.74.

JOHN, Gwen. British, 1876–1939.

34 GIRL WITH BARE SHOULDERS. (1909–10?) Oil on canvas, 17$^{1}/_{8}$ x 10$^{1}/_{4}$" (43.4 x 26 cm). A. Conger Goodyear Fund. 124.58. Repr. *Suppl. VIII*, p. 6. *Note*: Fenella Lovell, who posed for Gwen John in Paris before 1911, was probably the model for this painting as well as for the *Nude Girl* in the Tate Gallery, London.

WOMAN READING AT A WINDOW. (1911) Oil on canvas, 16$^{1}/_{8}$ x 10" (40.9 x 25.3 cm). Mary Anderson Conroy Bequest in memory of her mother, Julia Quinn Anderson. 421.71.

GIRL WITH A BLUE SCARF. (c. 1915–20) Oil on canvas, 16$^{1}/_{4}$ x 13" (41.1 x 33 cm). Gift of Nelson A. Sears in memory of Mrs. Millicent A. Rogers. 400.63.

JOHNS, Jasper. American, born 1930.

FLAG. 1954–55. Encaustic, oil, and collage on fabric mounted on plywood, 42$^{1}/_{4}$ x 60$^{5}/_{8}$" (107.3 x 153.8 cm). Gift of Philip Johnson in honor of Alfred H. Barr, Jr. 106.73. Repr. *Art of the Real*, p. 21.

390 GREEN TARGET. 1955. Encaustic on newspaper over canvas, 60 x 60" (152.4 x 152.4 cm). Richard S. Zeisler Fund. 9.58. Repr. *Suppl. VIII*, p. 20; *16 Amer.*, p. 27.

390 TARGET WITH FOUR FACES. (1955) Encaustic on newspaper over canvas, 26 x 26" (66 x 66 cm) surmounted by four tinted plaster faces in wood box with hinged front. Box, closed, 3$^{3}/_{4}$ x 26 x 3$^{1}/_{2}$" (9.5 x 66 x 8.9 cm). Overall dimensions with box open, 33$^{5}/_{8}$ x 26 x 3" (85.3 x 66 x 7.6 cm). Gift of Mr. and Mrs. Robert C. Scull. 8.58. Repr. *Suppl. VIII*, p. 20; *16 Amer.*, p. 26; in color, *Invitation*, p. 101.

391 WHITE NUMBERS. 1957. Encaustic on canvas, 34 x 28$^{1}/_{8}$" (86.5 x 71.3 cm). Elizabeth Bliss Parkinson Fund. 10.58. Repr. *Suppl. VIII*, p. 20; *16 Amer.*, p. 24; *Art of the Real*, p. 20.

390 MAP. (1961) Oil on canvas, 6'6" x 10'3¹⁄₈" (198.2 x 307.7 cm). Fractional gift of Mr. and Mrs. Robert C. Scull. 277.63.

0 THROUGH 9. 1961. Aluminum relief (cast 1966), 26 x 19⁷⁄₈ x ⁷⁄₈" (66 x 50.2 x 2.2 cm), irregular. The Sidney and Harriet Janis Collection (fractional gift). 613.67. Repr. *Janis*, p. 149.

JOHNSON, Daniel LaRue. American, born 1938.

444 FREEDOM NOW, NUMBER 1. 1963–64. Pitch on canvas with assemblage including "Freedom Now" button, broken doll, hacksaw, mousetrap, flexible tube, wood, 53⁷⁄₈ x 55³⁄₈ x 7¹⁄₂" (136.6 x 140.5 x 18.9 cm). Given anonymously. 4.65.

JOHNSON, Lester F. American, born 1919.

282 THREE HEADS WITH THE WORD "BLACK." 1962. Oil on canvas, 60¹⁄₄" x 6'6¹⁄₈" (153 x 198.5 cm). Larry Aldrich Foundation Fund. 73.63.

JOHNSON, Ray. American, born 1927.

462 CAGED. (1959) Collage with gouache and watercolor, 10¹⁄₂ x 7³⁄₈" (26.6 x 18.7 cm). Larry Aldrich Foundation Fund. 289.65.

JOHNSTON, Ynez. American, born 1920.

DARK JUNGLE. (1950) Casein on cardboard, 23⁷⁄₈ x 18¹⁄₂" (60.6 x 47 cm). Katharine Cornell Fund. 10.51.

JONSON, Sven. Swedish, born 1902.

THEME AND VARIATIONS, II. 1954. Watercolor, 16 x 13" (40.7 x 32.8 cm). Gift of Carl Magnus Berger. 13.56. Repr. *Suppl. VI*, p. 36.

JUDD, Donald. American, born 1928.

RELIEF. (1961) Asphaltum and gesso on composition board mounted on wood, with aluminum-pan inset, 48¹⁄₈ x 36¹⁄₈ x 4" (122.2 x 91.8 x 10.2 cm). Gift of Barbara Rose. 630.73.

Untitled. (1967) Stainless steel, 6¹⁄₈ x 36¹⁄₈ x 26¹⁄₈" (15.5 x 91.6 x 66.2 cm). Gift of Philip Johnson. 682.71.

Untitled. (1968) Five open rectangles of painted steel spaced approximately 5¹⁄₈" (13 cm) apart, each 48³⁄₈" x 10' x 20¹⁄₄" (122.8 x 305 x 51.4 cm); overall, 48³⁄₈" x 10' x 10'1" (122.8 x 305 x 307.6 cm). Mr. and Mrs. Simon Askin Fund. 715.68a–e.

Untitled. (1969) Brass and plexiglass, 6¹⁄₈ x 27¹⁄₈ x 24¹⁄₈" (15.4 x 68.8 x 61.1 cm). Gift of Philip Johnson. 681.71. Repr. *Amer. Art*, p. 67.

Untitled. (1973–75, refabricated after 1967 version) Painted galvanized iron, 25⁵⁄₈" x 6'4³⁄₄" x 14³⁄₄" (65.1 x 194.6 x 37.2 cm). Gift of Philip Johnson (by exchange). 375.75.

JULES, Mervin. American, born 1912.

THE LITTLE PRESSER. (1943) Oil on composition board, 11¹⁄₂ x 11⁵⁄₈" (29.2 x 29.5 cm). Purchase. 617.43.

JUNYER, Joan. American, born Spain (Catalonia) 1904. To U.S.A. 1941.

THREE PAINTINGS IN SCULPTURE. (1954) Enameled steel, 6³⁄₈" (16.2 cm), 5¹⁄₂" (13.9 cm), and 6¹⁄₂" (16.6 cm) high. Blanchette Rockefeller Fund. 6.57, 7.57, 8.57. Repr. *Suppl. VII*, p. 15.

KABAK, Robert. American, born 1930.

FIRES. (1956) Casein on gesso on composition board, 11³⁄₄ x 36" (29.8 x 91.3 cm). Purchase. 236.56. Repr. *Suppl. VI*, p. 30.

KADISHMAN, Menashe. Israeli, born 1932.

SEGMENTS. (1969) Five painted aluminum sections on glass sheet; overall, 62¹⁄₄" x 14'4¹⁄₄" x 12" (158 x 437.4 x 30.5 cm). Gift of Mr. and Mrs. George M. Jaffin. 509.70a–f.

KAHLO, Frida. Mexican, 1910–1954.

MY GRANDPARENTS, MY PARENTS, AND I (FAMILY TREE). (1936) Oil and tempera on metal panel, 12¹⁄₈ x 13⁵⁄₈" (30.7 x 34.5 cm). Gift of Allan Roos, M.D., and B. Mathieu Roos. 102.76.

210 SELF-PORTRAIT WITH CROPPED HAIR. 1940. Oil on canvas, 15³⁄₄ x 11" (40 x 27.9 cm). Gift of Edgar Kaufmann, Jr. 3.43. Repr. *Ptg. & Sc.*, p. 181.

KAHN, Wolf. American, born Germany 1927. To U.S.A. 1940.

IN THE HARBOR OF PROVINCETOWN. (1956) Pastel, 10⁷⁄₈ x 13⁷⁄₈" (27.6 x 35.2 cm). Purchase. 560.56. Repr. *Suppl. VI*, p. 33.

KALINOWSKI, Horst Egon. German, born 1924. To Paris 1952.

MAY NIGHT. 1961. Collage of gouache, velvet, metal thread, 12¹⁄₂ x 22¹⁄₈" (32 x 56.2 cm). Philip Johnson Fund. 297.61. Repr. *Suppl. XI*, p. 39.

480 THE GATE OF THE EXECUTED [*La Porte des suppliciés*]. 1963. Assemblage: leather over wood with a chain and other metal and wood parts, 6'6³⁄₄" x 58¹⁄₂" x 11⁵⁄₈" (200 x 148.6 x 29.5 cm). Philip Johnson Fund. 1129.64.

KANDINSKY, Wassily. Russian, 1866–1944. Worked in Germany and France.

122 CHURCH AT MURNAU. (1909) Oil on cardboard, 19¹⁄₈ x 27¹⁄₂" (48.6 x 69.8 cm). Purchase. 321.50. Repr. *Suppl. II*, p. 10.

121 PICTURE WITH AN ARCHER. (1909) Oil on canvas, 69 x 57" (175.2 x 144.7 cm). Fractional gift of Mrs. Bertram Smith. 619.59. Repr. *Suppl. VIII*, p. 5.

122 SKETCH, 14. 1913. Watercolor, 9¹⁄₂ x 12¹⁄₂" (24.1 x 31.7 cm). Katherine S. Dreier Bequest. 159.53. *Note*: according to Will Grohmann in *Kandinsky: Life and Work*, this watercolor is a study for one of several works in oil on glass of 1911 entitled *The Last Judgment*.

122 Study for PAINTING WITH WHITE FORM. 1913. Watercolor and ink, 10⁷⁄₈ x 15" (27.6 x 38.1 cm). Katherine S. Dreier Bequest. 157.53. Repr. *Suppl. IV*, p. 12.

122 WATERCOLOR (NUMBER 13). 1913. Watercolor, 12⁵⁄₈ x 16¹⁄₈" (32.1 x 41 cm). Katherine S. Dreier Bequest. 158.53.

123 PANEL (3). 1914. Oil on canvas, 64 x 36¹⁄₄" (162.5 x 92.1 cm). Mrs. Simon Guggenheim Fund. 2.54. Repr. in color, *Masters*, p. 120; *German Art of 20th C.*, p. 71; *Paintings from MoMA*, p. 52; in color, *Invitation*, p. 40. *Note*: this and the following, 3.54, are two of four canvases commissioned as a mural ensemble for a New York apartment. The other two canvases are in the collection of the Solomon R. Guggenheim Museum, New York. *Panel (3)* is sometimes called *Summer*.

123 PANEL (4). 1914. Oil on canvas, 64 x 31¹⁄₂" (162.5 x 80 cm). Mrs. Simon Guggenheim Fund. 3.54. Repr. in color, *Masters*, p. 120; *Paintings from MoMA*, p. 52; in color, *Invitation*, p. 40. *Note*: see note to *Panel (3)*, above. *Panel (4)* is sometimes called *Spring*.

122 Untitled. 1915. Watercolor, 13¹⁄₄ x 9" (33.7 x 22.9 cm). Gift of Abby Aldrich Rockefeller. 89.35. Repr. *Ptg. & Sc.*, p. 203.

123 BLACK RELATIONSHIP [*Schwarze Beziehung*]. 1924. Watercolor, 14¹⁄₂ x 14¹⁄₄" (36.8 x 36.2 cm). Acquired through the Lillie P. Bliss Bequest. 341.49. Repr. *Suppl. II*, p. 10. *Note*: formerly listed as *The Black Circle*.

133 BLUE (NUMBER 393). 1927. Oil on cardboard, 19½ x 14½″ (49.5 x 36.8 cm). Katherine S. Dreier Bequest. 160.53.

LIGHTLY TOUCHING [*Leicht berührt*]. 1931. Oil on cardboard, 27⅝ x 19¼″ (69.9 x 48.8 cm). The Sidney and Harriet Janis Collection (fractional gift). 614.67. Repr. *Janis*, p. 43. *Note*: also called *Leicht gebunden*.

ROUND POETRY [*Runde Dichtung*]. 1933. Watercolor and gouache on paper, 17⅜ x 17⅜″ (44.1 x 44.1 cm). John S. Newberry Fund. 1518.68. Repr. *Seurat to Matisse*, p.75, as *Blue Circle*.

KANE, John. American, born Scotland. 1860–1934. To U.S.A. 1880.

HOMESTEAD. (c. 1929?) Oil on canvas, 24 x 27″ (61 x 68.6 cm). Gift of Abby Aldrich Rockefeller. 90.35. Repr. *Masters Pop. Ptg.*, no. 148.

7 SELF-PORTRAIT. (1929) Oil on canvas over composition board, 36⅛ x 27⅛″ (91.8 x 68.9 cm). Abby Aldrich Rockefeller Fund. 6.39. Repr. *Ptg. & Sc.*, p. 21; in color, *Masters*, p. 17; in color, *Invitation*, p. 64.

THE CAMPBELLS ARE COMING. (1932) Oil and gold paint on paper over composition board, 20 x 16⅛″ (50.8 x 40.8 cm). Inscribed: *Cambells are/comeing/John Kane*, over previous inscription, *Scotch Piper/by/John Kane*. The Sidney and Harriet Janis Collection (fractional gift). 615.67. Repr. *Janis*, p. 83.

7 SCOTCH DAY AT KENNYWOOD. 1933. Oil on canvas, 19⅞ x 27⅛″ (50.5 x 68.9 cm). Gift of Mr. and Mrs. Albert Lewin. 504.53. Repr. *Suppl. V*, p. 33.

7 THROUGH COLEMAN HOLLOW UP THE ALLEGHENY VALLEY. Oil on canvas, 30 x 38⅝″ (76.2 x 98.1 cm). Given anonymously. 400.41. Repr. *Ptg. & Sc.*, p. 20.

KANTOR, Morris. American, born Russia. 1896–1974. To U.S.A. 1911.

241 SOUTH TRURO CHURCH. 1934. Oil on canvas, 24⅛ x 27″ (61.3 x 68.6 cm). Gift of Abby Aldrich Rockefeller (by exchange). 11.36.

KARFIOL, Bernard. American, born Hungary. 1886–1952.

236 SEATED NUDE. (1929) Oil on canvas, 40 x 30″ (101.6 x 76.2 cm). Gift of Abby Aldrich Rockefeller. 4.30. Repr. *Ptg. & Sc.*, p. 75.

FISHING VILLAGE. (1932) Watercolor, 10 x 14¾″ (25.4 x 37.5 cm). Given anonymously (by exchange). 12.36.

KATZMAN, Herbert. American, born 1923.

THE SEINE. (1949) Oil on canvas, 37¼ x 63″ (94.6 x 160 cm). Gift of Mr. and Mrs. Hugo Kastor. 52.52. Repr. *Suppl. IV*, p. 33.

KAUFFER, E. McKnight. American, born 1891. Lived in England 1914–41.

Untitled. 1939. Gouache, 13 x 9⅞″ (33 x 25.2 cm). Gift of Monroe Wheeler. 434.74.

KAUFFMAN, Craig (Robert Craig Kauffman). American, born 1932.

489 RED-BLUE. 1964. Synthetic polymer paint on vacuum-formed plexiglass, 7'5⅝″ x 45½″ x 5⅛″ (227.4 x 115.4 x 13 cm). Larry Aldrich Foundation Fund. 603.65.

Untitled. 1968. Molded plexiglass, painted, 43″ x 7'5⅛″ x 16¼″ (109.1 x 226.2 x 41.2 cm). Given anonymously. 508.69.

KAUFMAN, Donald. American, born 1935.

TRIBALLOON. (1968) Synthetic polymer paint on canvas, 8' x 8'⅛″ (243.8 x 244 cm). Larry Aldrich Foundation Fund. 1517.68.

KAWASHIMA, Takeshi. Japanese, born 1930. To U.S.A. 1963.

473 UNTITLED 1964, NEW YORK. 1964. Oil on canvas, center panel of a triptych, 8'4½″ x 6'6⅛″ (255.1 x 203.3 cm). Junior Council Fund. 604.65. Repr. in color, *New Jap. Ptg. & Sc.*, p. 20.

KELDER, Toon. Dutch, born 1894.

MASKER. (1952–53) Iron wire, 23½″ (59.6 cm) high, at base 12¼ x 9″ (30.9 x 22.8 cm). Gift of Dr. H. B. G. Casimir. 145.57. Repr. *Suppl. VII*, p. 15.

KELLY, Ellsworth. American, born 1923.

COLORS FOR A LARGE WALL. 1951. Oil on canvas, mounted on sixty-four wood panels; overall, 7'10¼″ x 7'10½″ (239.3 x 239.9 cm). Gift of the artist. 1067.69a–b. Repr. *Art of the Real*, p. 24; in color, *Kelly*, p. 44.

369 RUNNING WHITE. 1959. Oil on canvas, 7'4″ x 68″ (223.6 x 172.7 cm). Purchase. 9.60. Repr. *Suppl. X*, p. 53.

SPECTRUM, III. 1967. Oil on canvas in thirteen parts; overall, 33¼″ x 9'5⅝″ (84.3 x 275.7 cm). The Sidney and Harriet Janis Collection (fractional gift). 336.67. Repr. in color, *Janis*, p. 141; *Amer. Art*, p. 70.

GREEN-BLUE. (1968) Painted aluminum, 8'7½″ x 9'4½″ x 68½″ (262.7 x 285.5 x 173.7 cm). Susan Morse Hilles Fund. 1513.68. Repr. in color, *Kelly*, p. 100.

KELPE, Paul. American, born 1902.

COMPOSITION, NUMBER 160. 1928. Watercolor, collage, and pencil, 15¾ x 12⅛″ (40.1 x 30.6 cm). The Joseph G. Mayer Foundation Fund in honor of René d'Harnoncourt. 359.75.

COMPOSITION, NUMBER 337. 1933. Watercolor and pencil, 17¼ x 11⅜″ (43.7 x 29.1 cm), irregular. Given anonymously. 360.75.

KEMENY, Zoltan. Swiss, born Hungary. 1907–1965. Lived in Paris and Zurich.

376 SHADOW OF THE MIRACLE. (1957) Copper T-sections mounted on wood, 33⅝ x 21⅞″ (85.3 x 55.5 cm). Gift of G. David Thompson. 12.59. Repr. *Suppl. IX*, p. 32.

KHAKHAR, Bhupen P. Indian, born 1934.

466 KALI. 1965. Enamel and metallic papers on plywood, 68¼ x 60″ (173.3 x 152.2 cm). Grace M. Mayer Fund. 2311.67.

KIENBUSCH, William. American, born 1914.

381 NEW ENGLAND COLLAGE, II. (1947) Cedar shingles, asphalt roofing, tar paper, etc., nailed to painted board, 21⅛ x 26⅝″ (53.7 x 67.6 cm). Purchase. 249.48. Repr. *Suppl. I*, p. 22.

LOW TIDE. 1950. Casein and ink, 22½ x 31″ (57.1 x 78.8 cm). Katharine Cornell Fund. 137.51. Repr. *Abstract Ptg. & Sc.*, p. 99.

KIENHOLZ, Edward. American, born 1927.

476 THE FRIENDLY GREY COMPUTER—STAR GAUGE MODEL #54. (1965) Motor-driven assemblage: aluminum painted rocking chair, metal case, two instrument boxes with dials, plastic case containing yellow and blue lights, panel with numbers, bell, "rocker switch," pack of index cards, directions for operation, light switch, telephone receiver, doll's legs, 40 x 39⅛ x 24½″ (101.3 x 99.2 x 62.1 cm) on aluminum sheet 48⅛ x 36″ (122 x 91.5 cm). Gift of Jean and Howard Lipman. 605.65. Repr. *The Machine*, p. 190. *Note*: computer should answer one question at a time.

KIERZKOWSKI, Bronislaw. Polish, born 1924.

376 TEXTURED COMPOSITION, 150. 1958. Cement and perforated metal strips on board, 20³/₈ x 26¹/₄" (51.8 x 66.7 cm). Purchase. 272.61. Repr. *15 Polish Ptrs.*, p. 30.

KIESLER, Frederick J. American, born Austria. 1890–1965. To U.S.A. 1926.

 TOTEM FOR ALL RELIGIONS. (1947) Wood and rope, 9′4¹/₄" x 34¹/₈" x 30⁷/₈" (285.1 x 86.6 x 78.4 cm); upper rope extensions: left, 34¹/₄" (87 cm), and right, 33¹/₄" (84.4 cm). Gift of Mr. and Mrs. Armand P. Bartos. 45.71a–b.

 Study for GALAXY (HORSE). 1954. Oil and enamel on wood panels, left, 23¹/₈ x 29" (58.4 x 73.6 cm); center, 24³/₈ x 17³/₄" (61.6 x 44.8 cm); right, 24¹/₄ x 17⁵/₈" (61.6 x 44.7 cm). Gift of Mr. and Mrs. Thomas B. Hess. 499.69a–c.

484 LANDSCAPE—MARRIAGE OF HEAVEN AND EARTH. (1961–62) Bronze and silver plate (cast 1964), 6′1¹/₂" x 63¹/₈" x 27" (184 x 160.1 x 68.5 cm). Kay Sage Tanguy Fund. 675.65a–f.

KIKUHATA, Mokuma. Japanese, born 1935.

475 ROULETTE: NUMBER FIVE. (1964) Assemblage: wood boards, sheet metal with circular cutouts, cans, iron pipe, baseball, pencil, enamel paint, etc., 42¹/₈ x 25³/₈ x 8¹/₂" (107 x 64.5 x 21.6 cm). Daphne Hellman Shih Fund. 606.65. Repr. in color, *New Jap. Ptg. & Sc.*, p. 18.

KING, Phillip. British, born Tunisia 1934.

 ROSEBUD. (1962) Fiberglass and wood, painted, in three parts; overall, 58¹/₂ x 65³/₄ x 62¹/₂" (148.5 x 167 x 158.7 cm). Susan Morse Hilles Fund. 223.68a–c.

KINGMAN, Dong. American, born 1911.

 FROM MY ROOF. 1941. Watercolor, 18³/₄ x 28¹/₂" (47.6 x 72.4 cm). Gift of Albert M. Bender. 401.41. Repr. *La Pintura*, p. 136.

KIRCHNER, Ernst Ludwig. German, 1880–1938.

 Donald E. Gordon has corrected some dates and titles.

68 STREET, DRESDEN. (1908. Dated on painting 1907) Oil on canvas, 59¹/₄" x 6′6⁷/₈" (150.5 x 200.4 cm). Purchase. 12.51. Repr. *Suppl. III*, p. 9; in color, *Invitation*, p. 124; *Modern Masters*, p. 123. *Note*: on the reverse, a painting of a group of women bathers done about 1912. In 1960 when the canvas was damaged in shipment and it was necessary to line it, fiberglass was used instead of linen in order to avoid obliterating the painting on the back. It is somewhat dimmed but remains visible. Will Grohmann (1954) identified the street as König-Johannstrasse, Dresden.

69 STREET, BERLIN. (1913) Oil on canvas, 47¹/₂ x 35⁷/₈" (120.6 x 91.1 cm). Purchase. 274.39. Repr. *Ptg. & Sc.*, p. 79; in color, *German Art of 20th C.*, p. 40. *Note*: Will Grohmann (1954) identified the street as Friedrichstrasse, Berlin.

69 ARTILLERYMEN. (1915) Oil on canvas, 55¹/₄ x 59³/₈" (140.3 x 150.8 cm). Gift of Mr. and Mrs. Morton D. May. 15.56. Repr. *German Art of 20th C.*, p. 43.

68 SAND HILLS IN ENGADINE. (1917–18) Oil on canvas, 33³/₄ x 37¹/₂" (85.7 x 95.2 cm). Purchase. 285.49. Repr. *Suppl. I*, p. 10.

KITAJ, R. B. (Ronald Brooks Kitaj). American, born 1932. Lives in London.

444 THE OHIO GANG. (1964) Oil and crayon on canvas, 6′1¹/₈" x 6¹/₄" (183.1 x 183.5 cm). Philip Johnson Fund. 109.65.

KJARVAL, Jóhannes Sveinsson. Icelandic, born 1885.

199 LAVA AT BESSASTADIR. (1947–54) Oil on canvas, 29⁵/₈ x 37⁵/₈" (75.2 x 95.4 cm). Given in memory of Holger Cahill. 289.61. Repr. *Suppl. XI*, p. 19.

KLEE, Paul. German, 1879–1940. Born and died in Switzerland.

144 STILL LIFE WITH FOUR APPLES. (1909) Oil on paper mounted on composition board, 13¹/₂ x 11¹/₈" (34.3 x 28.2 cm). Gift of Mr. and Mrs. Peter A. Rübel. 27.57. Repr. *Suppl. VII*, p. 3.

144 WITH THE RED X [*Mit dem roten X*]. 1914. Watercolor, 6¹/₄ x 4¹/₄" (15.9 x 10.8 cm). Katherine S. Dreier Bequest. 162.53.

144 LAUGHING GOTHIC [*Lachende Gotik*]. 1915. Watercolor, 10¹/₄ x 5³/₈" (26 x 13.6 cm). Purchase. 91.50. Repr. *Suppl. II*, p. 14.

144 DEMON ABOVE THE SHIPS [*Dämon über den Schiffen*]. 1916. Watercolor, pen and ink, 9 x 7⁷/₈" (22.9 x 20 cm). Acquired through the Lillie P. Bliss Bequest. 122.44. Repr. *Ptg. & Sc.*, p. 204; in color, *Klee*, 1945, opp. p. 24.

144 INTRODUCING THE MIRACLE [*Vorführung des Wunders*]. 1916. Tempera, pen and ink on canvas, 10³/₈ x 8⁷/₈" (26.4 x 22.4 cm). Fractional gift of Allan Roos, M.D., and B. Mathieu Roos. 395.62. Repr. *Suppl. XII*, p. 11.

144 CHRISTIAN SECTARIAN [*Christlicher Sectierer*]. 1920. Watercolor on transfer drawing, 10¹/₈ x 6⁵/₈" (25.7 x 16.8 cm). James Thrall Soby Fund. 121.44. Repr. *Ptg. & Sc.*, p. 205. *Note*: *Sectierer* for *Sektierer* is the artist's spelling.

145 THE END OF THE LAST ACT OF A DRAMA [*Schluss des letzten Aktes eines Dramas*]. 1920. Watercolor on transfer drawing, 8¹/₈ x 11³/₈" (20.6 x 28.8 cm). Promised gift and extended loan from Allan Roos, M.D., and B. Mathieu Roos. E.L.62.1390. Repr. *Suppl. XII*, p. 11.

146 THE ANGLER [*Der Angler*]. 1921. Watercolor, pen and ink, 18⁷/₈ x 12³/₈" (47.6 x 31.2 cm). John S. Newberry Collection. 64.61. Repr. *Suppl. XI*, p. 14.

147 THE ARROW BEFORE THE TARGET [*Der Pfeil vor dem Ziel*]. 1921. Watercolor on transfer drawing, 8³/₄ x 12³/₈" (22.2 x 31.3 cm). John S. Newberry Collection. 376.60. Repr. *Suppl. X*, p. 16.

146 DYING PLANTS [*Sterbende Pflanzen*]. 1922. Watercolor, pen and ink, 19¹/₈ x 12⁵/₈" (48.5 x 32.2 cm) (composition). The Philip L. Goodwin Collection. 102.58. Repr. *Bulletin*, Fall 1958, p. 8.

145 FLOWERS IN THE WIND [*Blumen im Wind*]. 1922. Watercolor, pen and ink, 6⁵/₈ x 5³/₈" (16.8 x 13.6 cm). Katherine S. Dreier Bequest. 164.53.

148 GOOD FISHING PLACE [*Guter Fischplatz*]. 1922. Watercolor, pen and ink, 10¹/₂ x 16¹/₈" (26.7 x 41 cm) (without margins). Katherine S. Dreier Bequest. 165.53.

147 SCHERZO WITH THIRTEEN [*Das Scherzo mit der Dreizehn*]. 1922. Watercolor, pen and ink, 8³/₄ x 11⁷/₈" (22.2 x 30.2 cm). Purchase. 139.51. Repr. *Suppl. III*, p. 14.

146 TWITTERING MACHINE [*Zwitscher-Maschine*]. 1922. Watercolor, pen and ink, 16¹/₄ x 12" (41.3 x 30.5 cm) (without margins). Purchase. 564.39. Repr. *Ptg. & Sc.*, p. 207; in color, *Masters*, p. 129; *Klee*, 1945, frontispiece; *The Machine*, p. 127.

145 URN COLLECTION [*Urnensammlung*]. 1922. Watercolor on transfer drawing, 10⁷/₈ x 8¹/₂" (27.6 x 21.6 cm). Katherine S. Dreier Bequest. 163.53. Repr. *Suppl. IV*, p. 16.

145 VOCAL FABRIC OF THE SINGER ROSA SILBER [*Das Vokaltuch der Kammersängerin Rosa Silber*]. (1922) Gouache and gesso on canvas, 20¹/₄ x 16³/₈" (51.4 x 41.6 cm) (irregular). Gift of Mr. and Mrs. Stanley Resor. 13.55. Repr. *Private Colls.*, p. 8.

146 GIRL WITH DOLL CARRIAGE [*Mädchen mit Puppenwagen*]. 1923. Watercolor, pen and ink, 15³/₈ x 8³/₈" (39 x 21.3 cm) (without margins). Purchase. 13.51. Repr. *Suppl. III*, p. 14.

ACTOR'S MASK [*Schauspielermaske*]. 1924. Oil on canvas mounted on board, 14¹/₂ x 13³/₈" (36.7 x 33.8 cm). The Sidney and Harriet Janis Collection (fractional gift). 616.67. Repr. *Klee*, 1930, no. 12; *Klee*, 1945, p. 41; in color, *Janis*, p. 39; in color, *Invitation*, p. 21.

147 FLOWER GARDEN [*Blumengarten*]. 1924. Watercolor and gouache, 14⁷/₈ x 8³/₈" (37.8 x 21.3 cm) (without margins). Katherine S. Dreier Bequest. 166.53. Repr. *Suppl. IV*, p. 16.

147 HERON [*Reiher*]. 1924. Mixed mediums, waxed, on paper, 13⁵/₈ x 7¹/₄" (34.6 x 18.4 cm) (without margins). Katherine S. Dreier Bequest. 167.53.

147 OLD CITY ARCHITECTURE [*Alte Stadtarchitektur*]. 1924. Watercolor, pen and ink, 9⁷/₈ x 7¹/₄" (25.1 x 18.4 cm) (without margins). Katherine S. Dreier Bequest. 168.53.

408 EARLY MORNING IN RO . . . [*Früher Morgen in Ro . . .*]. 1925. Watercolor, 14⁵/₈ x 20¹/₈" (37 x 50.9 cm). Gift of Mrs. Gertrud A. Mellon. 1262.64.

148 SLAVERY [*Sklaverei*]. 1925. Gouache and printing ink, 10 x 14" (25.4 x 35.6 cm). Gift of Abby Aldrich Rockefeller. 96.35. Repr. *Ptg. & Sc.*, p. 206.

148 AROUND THE FISH [*Um den Fisch*]. 1926. Oil on canvas, 18³/₈ x 25¹/₈" (46.7 x 63.8 cm). Abby Aldrich Rockefeller Fund. 271.39. Repr. *Ptg. & Sc.*, p. 209.

148 PASTORALE [*Pastorale, K10*]. 1927. Tempera on canvas mounted on wood, 27¹/₄ x 20⁵/₈" (69.3 x 52.4 cm). Abby Aldrich Rockefeller Fund and exchange. 157.45. Repr. *Ptg. & Sc.*, p. 208.

408 PORTRAIT OF AN EQUILIBRIST [*Artistenbildnis*]. 1927. Oil and collage on cardboard over wood with painted plaster border, 24⁷/₈ x 15³/₄" (63.2 x 40 cm). Mrs. Simon Guggenheim Fund. 195.66. Repr. *Klee*, 1930, cover (simplified zinc cut).

CAT AND BIRD. 1928. Oil and ink on gesso on canvas, mounted on wood, 15 x 21" (38.1 x 53.2 cm). Gift of Sidney Janis; and gift of Suzy Prudden Sussman and Joan H. Meijer in memory of F. H. Hirschland. 300.75. Repr. *Modern Works*, no. 94; *Klee*, 1945, p. 47.

GIFTS FOR I. 1928. Tempera on gesso on canvas mounted on wood, 15³/₄ x 22" (40 x 55.9 cm). Fractional gift of James Thrall Soby. 1092.69. Repr. *Soby Collection*, p. 48.

FIRE IN THE EVENING [*Feuer Abends*]. 1929. Oil on cardboard, 13³/₈ x 13¹/₄" (33.8 x 33.4 cm). Mr. and Mrs. Joachim Jean Aberbach Fund. 153.70.

IN THE GRASS [*Im Gras*]. (1930) Oil on canvas, 16⁵/₈ x 20³/₄" (42.1 x 52.5 cm). The Sidney and Harriet Janis Collection (fractional gift). 617.67. Repr. *Cubism*, p. 181; *Klee*, 1945, p. 46; *Janis*, p. 41.

149 THE MOCKER MOCKED [*Oder der verspottete Spötter*]. (1930) Oil on canvas, 17 x 20⁵/₈" (43.2 x 52.4 cm). Gift of J. B. Neumann. 637.39. Repr. *Ptg. & Sc.*, p. 209.

149 EQUALS INFINITY [*Gleich Unendlich*]. 1932. Oil on canvas mounted on wood, 20¹/₄ x 26⁷/₈" (51.4 x 68.3 cm). Acquired through the Lillie P. Bliss Bequest. 90.50. Repr. *Suppl. II*, p. 13; in color, *Masters*, p. 131; in color, *Invitation*, p. 99.

FEAR [*Angst*]. (1934) Oil on burlap, 20 x 21⁷/₈" (50.7 x 55.6 cm). Gift of Nelson A. Rockefeller. 683.71. Repr. *20th-C. Art from NAR Coll.*, p. 76.

149 LETTER GHOST [*Geist eines Briefes*]. (1937) Watercolor, gouache,

and ink on newspaper, 13 x 19¹/₄" (33 x 48.9 cm). Purchase. 8.39. Repr. *Ptg. & Sc.*, p. 205.

KLEEMANN, Ron. American, born 1937.

HOBBS' TUB NUMBER 2. 1974. Synthetic polymer paint on canvas, 42 x 60" (106.7 x 152.4 cm). Mr. and Mrs. Stuart M. Speiser Fund. 596.76.

KLEIN, Yves. French, 1928–1962.

Untitled. (1957) Sponge, painted blue, on brass-rod stand, 22⁵/₈ x 12¹/₂ x 4⁵/₈" (57.3 x 31.7 x 11.5 cm), including brass rod, 15" high x ³/₄" diameter (37.9 x 1.8 cm), and brass base, ¹/₈ x 5¹/₄ x 6" (.4 x 13.1 x 15.2 cm). Gift of Philip Johnson. 786.69.

ANTHROPOMETRY: PRINCESS HELENA. 1960. Oil on wood, 6'6" x 50¹/₂" (198 x 128.2 cm). Gift of Mr. and Mrs. Arthur Wiesenberger. 1068.69.

BLUE MONOCHROME. 1961. Oil on cotton cloth over plywood, 6'4⁷/₈" x 55¹/₈" (195.1 x 140 cm). The Sidney and Harriet Janis Collection (fractional gift). 618.67. Repr. in color, *Janis*, p. 133.

KLEINSCHMIDT, Paul. German, 1883–1949.

HEAD OF A WOMAN. 1935. Watercolor and pencil, 18⁵/₈ x 15³/₈" (47.2 x 38.9 cm). Gift of Richard A. Cohn. 166.70.

KLIMT, Gustav. Austrian, 1862–1918.

35 THE PARK. (1910 or earlier) Oil on canvas, 43¹/₂ x 43¹/₂" (110.4 x 110.4 cm). Gertrud A. Mellon Fund. 10.57. Repr. *Suppl. VII*, p. 5. *Note*: has also been dated 1903.

KLINE, Franz. American, 1910–1962.

330 CHIEF. (1950) Oil on canvas, 58³/₈" x 6'1¹/₂" (148.3 x 186.7 cm). Gift of Mr. and Mrs. David M. Solinger. 2.52. Repr. *Suppl. IV*, p. 35.

PAINTING NUMBER 2. 1954. Oil on canvas, 6'8¹/₂" x 8'9" (204.3 x 271.6 cm). Mr. and Mrs. Joseph H. Hazen and Mr. and Mrs. Francis F. Rosenbaum Funds. 236.69.

TWO HORIZONTALS. 1954. Oil on canvas, 31¹/₈ x 39¹/₄" (79.1 x 99.5 cm). The Sidney and Harriet Janis Collection (fractional gift). 619.67. Repr. *Janis*, p. 125.

LE GROS. 1961. Oil on canvas, 41³/₈ x 52⁵/₈" (105 x 133.8 cm). The Sidney and Harriet Janis Collection (fractional gift). 620.67. Repr. *Janis*, p. 125.

KNAPP, Stefan. British, born Poland 1921.

VERDURE. (1950) Vitreous enamel on steel, 61⁷/₈ x 35³/₈ x ⁷/₈" (150.7 x 89.6 x 2.3 cm). Gift of Harold Kovner. 258.57. Repr. *Suppl. VII*, p. 18.

KNATHS, Karl. American, 1891–1971.

229 GIORGIONE BOOK. (1941) Oil on canvas, 40 x 20" (101.6 x 50.8 cm). Gift of John S. Newberry. 140.44. Repr. *Art in Prog.*, p. 83.

KOBZDEJ, Aleksander. Polish, 1920–1972.

352 CONFLICT. 1959. Casein and oil on paper mounted on canvas, 39¹/₄ x 28³/₄" (99.4 x 73 cm). Blanchette Rockefeller Fund. 83.60. Repr. *15 Polish Ptrs.*, p. 35; *Suppl. X*, p. 39.

KOENIG, Fritz. German, born 1924.

297 CAMARGUE, X. (1958) Bronze, 3 x 17¹/₄ x 15³/₈" (7.6 x 43.8 x 39 cm). Matthew T. Mellon Foundation Fund. 119.61. Repr. *Suppl.*

XI, p. 46. *Note*: the Museum owns an ink study for this sculpture.

KOERNER, Henry. American, born Austria 1915. To U.S.A. 1938.

276 ROSE ARBOR. (1947) Oil on composition board, 27³/₄ x 35″ (70.5 x 88.9 cm). Gift of John Hay Whitney. 5.48. Repr. *Bulletin*, vol. XV, no. 4, 1948, p. 10. *Note*: the Museum owns an ink study for this painting.

KOHN, Gabriel. American, 1910–1975.

TILTED CONSTRUCTION. (1959) Laminated wood, 27¹/₈″ (68.8 cm) high, at base 18¹/₂ x 12⁵/₈″ (46.7 x 31.9 cm). Philip Johnson Fund. 606.59. Repr. *Suppl. IX*, p. 33; *Amer. 1963*, p. 49.

369 ACROTERE. (1960) Laminated wood, 35¹/₄ x 31 x 22¹/₄″ (90.3 x 80.7 x 56.4 cm). Given anonymously (by exchange). 559.63. Repr. *Amer. 1963*, p. 51.

KOJIMA, Nobuaki. Japanese, born 1935.

Untitled. 1964. Construction of painted plaster and strips of red-and-white cloth coated with polyethyline resin, 67⁵/₈ x 35¹/₂ x 19³/₈″ (171.7 x 90 x 49 cm). Given anonymously. 2312.67. Repr. in color, *New Jap. Ptg. & Sc.*, p. 19 (also in group, front left, p. 97).

KOKOSCHKA, Oskar. British subject, born Austria of Austrian-Czech parents, 1886. Worked in Germany and Czechoslovakia. To England 1938. Lives in Switzerland.

74 NUDE BENDING FORWARD. (c. 1907) Watercolor, chalk, pen and ink, pencil, 17³/₄ x 12¹/₄″ (45.1 x 31.1 cm) (irregular). Rose Gershwin Fund. 549.54.

DR. EMMA VERONIKA SANDERS. (1909) Oil on canvas, 32⁵/₈ x 22³/₈″ (82.7 x 56.7 cm). Gift of Mr. and Mrs. William Mazer. 2414.67.

74 HANS TIETZE AND ERICA TIETZE-CONRAT. (1909) Oil on canvas, 30¹/₈ x 53⁵/₈″ (76.5 x 136.2 cm). Abby Aldrich Rockefeller Fund. 651.39. Repr. *Ptg. & Sc.*, p. 80; in color, *Masters*, p. 66; *German Art of 20th C.*, p. 74; in color, *Invitation*, p. 62.

74 SELF-PORTRAIT. (1913) Oil on canvas, 32¹/₈ x 19¹/₂″ (81.6 x 49.5 cm). Purchase. 26.40. Repr. *Ptg. & Sc.*, p. 81.

75 SEATED WOMAN. 1921. Watercolor, 27³/₄ x 20³/₈″ (70.5 x 51.7 cm). Gift of Myrtil Frank. 53.52.

74 TIGLON. (1926) Oil on canvas, 38 x 51″ (96.5 x 129.6 cm). Benjamin Scharps and David Scharps Fund. 237.56. Repr. *Suppl. VI*, p. 15.

75 PORT OF HAMBURG. (1951) Oil on canvas, 35³/₄ x 47¹/₂″ (90.8 x 120.5 cm). Rose Gershwin Fund. 14.56. Repr. *Suppl. VI*, p. 15; *Modern Masters*, p. 133.

KOLÁŘ, Jiří. Czechoslovakian, born 1914.

Untitled. (early 1950's) Collage, 14³/₄ x 20¹/₄″ (37.4 x 51.4 cm). Gift of Mr. and Mrs. Sidney Elliott Cohn. 707.71.

KOLBE, Georg. German, 1877–1947.

STANDING GIRL. (c. 1920) Bronze, 16¹/₄″ (41.3 cm) high. Gift of Abby Aldrich Rockefeller. 612.39.

43 GRIEF. (1921) Bronze, 15³/₄ x 22″ (40 x 55.9 cm). Gift of Edward M. M. Warburg. 9.39. Repr. *Ptg. & Sc.*, p. 245.

KOMAN, Ilhan. Turkish, born 1921. Lives in Sweden.

378 MY COUNTRY'S SUN [*Le Soleil de mon pays*]. (1957) Antique wrought iron, reconstructed, 66¹/₈″ x 6′4¹/₈″ (168 x 193.2 cm). Philip Johnson Fund. 13.59. Repr. *Suppl. IX*, p. 35.

DE KOONING, Elaine. American, born 1920.

BULLFIGHT. (1960) Gouache, 19³/₈ x 24⁵/₈″ (49.2 x 62.6 cm). Larry Aldrich Foundation Fund. 120.61. Repr. *Suppl. XI*, p. 33.

DE KOONING, Willem. American, born the Netherlands 1904. To U.S.A. 1926.

VALENTINE. (1947) Oil and enamel on paper, mounted on composition board, 36³/₈ x 24¹/₄″ (92.4 x 61.6 cm). Fractional gift of Mr. and Mrs. Gifford Phillips. 1093.69.

331 PAINTING. (1948) Enamel and oil on canvas, 42⁵/₈ x 56¹/₈″ (108.3 x 142.5 cm). Purchase. 238.48. Repr. *Suppl. I*, p. 21; *New Amer. Ptg.*, p. 54; *de Kooning*, p. 57.

331 WOMAN, I. (1950–52) Oil on canvas, 6′3⁷/₈″ x 58″ (192.7 x 147.3 cm). Purchase. 478.53. Repr. *New Images*, p. 91; in color, *Masters*, p. 177; *New Amer. Ptg.*, p. 53; *de Kooning*, p. 91, detail in color, p. 90; in color, *Invitation*, p. 131.

331 WOMAN, II. (1952) Oil on canvas, 59 x 43″ (149.9 x 109.3 cm). Gift of Mrs. John D. Rockefeller 3rd. 332.55. Repr. *Suppl. VI*, p. 29; *de Kooning*, p. 92.

SEPTEMBER MORN. (1958) Oil on canvas, 62⁷/₈ x 49³/₈″ (159.5 x 125.7 cm). The Sidney and Harriet Janis Collection (fractional gift). 621.67. Repr. *Janis*, p. 121.

A TREE IN NAPLES. (1960) Oil on canvas, 6′8¹/₄″ x 70¹/₈″ (203.7 x 178.1 cm). The Sidney and Harriet Janis Collection (fractional gift). 622.67. Repr. *Janis*, p. 121. *Note*: also called *A Tree Grows in Naples*.

WOMAN, XI. (1961) Oil and pastel on paper mounted on canvas, 29 x 22³/₈″ (73.5 x 56.6 cm). The Sidney and Harriet Janis Collection (fractional gift). 623.67. Repr. *Janis*, p. 123.

KOPMAN, Benjamin. American, born Russia. 1887–1965. To U.S.A. 1903.

236 HEAD. 1929. Oil on canvas, 22⁷/₈ x 18¹/₈″ (58.1 x 46 cm). Given anonymously. 97.35.

THE RUIN. (1930) Oil on canvas, 25⁵/₈ x 36³/₈″ (65.1 x 92.4 cm). Given anonymously. 98.35. Repr. *Ptg. & Sc.*, p. 166.

LANDSCAPE WITH FIGURE. 1963. Oil on canvas, 42 x 50″ (106.5 x 126.9 cm). Gift of G. David Thompson. 589.63.

KOSUTH, Joseph. American, born 1945.

ONE AND THREE CHAIRS. (1965) Wood folding chair, photograph of chair, and photographic enlargement of dictionary definition of chair; chair, 32³/₈ x 14⁷/₈ x 20⁷/₈″ (82 x 37.8 x 53 cm); photo panel, 36 x 24¹/₈″ (91.5 x 61.1 cm); text panel, 24¹/₈ x 24¹/₂″ (91.5 x 61.1 cm). Larry Aldrich Foundation Fund. 393.70a–c. Repr. *Information*, p. 69.

KRAA, Kirsten. American, born Germany of Danish parents, 1941. To U.S.A. 1956.

442 Untitled. (1964) Oil on canvas, 15¹/₈ x 15″ (38.2 x 38.1 cm). Larry Aldrich Foundation Fund. 260.64.

KRAJCBERG, Frans. Brazilian, born Poland 1921.

352 PAINTING, I. 1957. Oil on canvas, 36¹/₈ x 28³/₄″ (91.6 x 73 cm). Inter-American Fund. 125.58. Repr. *Suppl. VIII*, p. 17.

KRASNER, Lee. American, born 1911.

Untitled. 1949. Oil on composition board, 48 x 37″ (121.9 x 93.9 cm). Gift of Alfonso A. Ossorio. 500.69.

Untitled. 1951. Oil on canvas, 6′10¹/₂″ x 57⁷/₈″ (209.5 x 146.8 cm). Mrs. Ruth Dunbar Cushing Fund. 237.69.

KRASNOPEVTSEV, Dimitri Mikhailovich. Russian, born 1925.

BOTTLES PLANTED IN THE GROUND. 1966. Oil on composition board, 20⁷/₈ x 17³/₄″ (52.8 x 45.1 cm). Purchase. 2102.67.

KRICKE, Norbert. German, born 1922.

374 PLANE OF RODS [*Flächenbahn*]. (1960) Stainless steel welded with silver, 8³/₄ x 28¹/₈″ (22.1 x 71.4 cm). Purchase. 121.61. Repr. *Suppl. XI*, p. 26.

KRIESBERG, Irving. American, born 1919.

RED SHEEP. 1951. Tempera on composition board, 48 x 42″ (121.9 x 106.7 cm). Gift of Mr. and Mrs. Hugo Kastor. 140.51.

KROHG, Per. Norwegian, born 1889. Works in Paris.

RAIN. (Before 1933) Gouache, 11¹/₄ x 15¹/₂″ (28.6 x 39.4 cm). Given anonymously. 99.35.

KRUSHENICK, Nicholas. American, born 1929.

458 THE RED BARON. 1967. Synthetic polymer paint on shaped canvas, 8′1¹/₈″ x 6′3¹/₄″ at top, 65¹/₄″ at bottom (244.2 x 191.1, 165.7 cm). Larry Aldrich Foundation Fund. 117.67.

KUBIN, Alfred. Austrian, 1877–1959.

402 AS DAY FLIES SO GOES THE NIGHT. (c. 1900–03) Gouache, wash, brush and ink, 13 x 10³/₄″ (32.9 x 27.2 cm). John S. Newberry Collection. 599.64.

THE LAST KING. (c. 1900–03) Wash, brush, pen and ink, 14⁵/₈ x 11¹/₈″ (37.1 x 28.2 cm). John S. Newberry Collection. 603.64.

KUHN, Walt. American, 1880–1949.

236 APPLES IN THE HAY. 1932. Oil on canvas, 30 x 40″ (76.2 x 101.6 cm). Given anonymously (by exchange). 14.36. Repr. *Ptg. & Sc.*, p. 65.

KUNIYOSHI, Yasuo. American, born Japan. 1889–1953. To U.S.A. 1906.

240 SELF-PORTRAIT AS A GOLF PLAYER. (1927) Oil on canvas, 50¹/₄ x 40¹/₄″ (127.6 x 102.2 cm). Abby Aldrich Rockefeller Fund. 293.38. Repr. *Ptg. & Sc.*, p. 76.

240 UPSIDE DOWN TABLE AND MASK. 1940. Oil on canvas, 60¹/₈ x 35¹/₂″ (152.7 x 90.2 cm). Acquired through the Lillie P. Bliss Bequest. 125.44. Repr. *Ptg. & Sc.*, p. 77.

KUNO, Shin. Japanese, born 1921.

Untitled. 1961. Relief of lacquered steel and tar on wood, 50¹/₈ x 35⁷/₈ x 2¹/₄″ (127.2 x 90.9 x 5.5 cm). Given anonymously. 2313.67. Repr. *New Jap. Ptg. & Sc.*, p. 53.

KUPFERMAN, Lawrence. American, born 1909.

LOW TIDE SEASCAPE. 1947. Gouache, 23¹/₄ x 29″ (59 x 73.7 cm). Purchase. 308.47.

KUPKA, František (*or* Frank). Czech, 1871–1957. To France 1895.

124 GIRL WITH A BALL. (c. 1908) Pastel, 24¹/₂ x 18³/₄″ (62.2 x 47.5 cm). Gift of Mr. and Mrs. František Kupka. 567.56.

124 MME KUPKA AMONG VERTICALS. (1910–11) Oil on canvas, 53³/₈ x 33⁵/₈″ (135.5 x 85.3 cm). Hillman Periodicals Fund. 563.56. Repr. *Modern Masters*, p. 147. *Note*: the subject is Eugénie Kupka, the wife of the artist.

124 THE FIRST STEP. (1910–13? Dated on painting 1909) Oil on canvas, 32³/₄ x 51″ (83.2 x 129.6 cm). Hillman Periodicals Fund. 562.56. Repr. in color, *Invitation*, p. 32.

125 THE MUSICIAN FOLLOT. (1911? Dated on painting 1910) Oil on canvas, 28¹/₂ x 26¹/₈″ (72.4 x 66.3 cm). Hillman Periodicals Fund. 564.56.

124 OVAL MIRROR. (1911? Dated on painting 1910) Oil on canvas, 42⁵/₈ x 34⁷/₈″ (108.3 x 88.6 cm). Hillman Periodicals Fund. 565.56. *Note*: titled and dated by Kupka for his retrospective exhibition, Prague, in 1946: *Oval Mirror, 1911*. Previous title: *The Mirror*.

125 RED AND BLUE DISKS. (1911? Dated on painting 1911–12) Oil on canvas, 39³/₈ x 28³/₄″ (100 x 73 cm). Purchase. 141.51. Repr. *Suppl. IV*, p. 21. *Note*: titled and dated by Kupka for his retrospective exhibition, Prague, in 1946: *Red and Blue Disks (Origin of the Fugue), 1911*.

125 FUGUE IN TWO COLORS: AMORPHA. (1912) Twenty-seven studies for the large painting exhibited in the Salon d'Automne, Paris, 1912, and now in the National Gallery, Prague. Tempera, brush and ink, largest 16³/₈ x 18⁵/₈″ (41.6 x 47.3 cm), smallest 4³/₈ x 4⁷/₈″ (11.1 x 12.2 cm). Gift of Mr. and Mrs. František Kupka. 569.56.1–.10; 569.56.13–.29. Repr. *Seurat to Matisse*, p. 43. *Note*: although these studies are reproduced as a group, one, no. 569.56.1, is also shown separately.

125 VERTICAL PLANES (STUDY). (1912? Dated on painting 1911). Oil on canvas, 25⁵/₈ x 18¹/₄″ (65.1 x 46.2 cm). Gift of Alfred H. Barr, Jr. 566.56. *Note*: titled and dated by Kupka for his retrospective exhibition, Prague, in 1946: *Preliminary Study for the Vertical Planes, 1911*. The final composition was completed in 1913. Previous title: *Curving Verticals*.

125 Replica (1946) of FUGUE IN TWO COLORS: AMORPHA, 1912. Gouache, India ink, and pencil, 9 x 9⁵/₈″ (22.9 x 24.3 cm). Gift of the artist. 147.57.

125 Replica (1946) of VERTICAL PLANES, 1912–13. Watercolor, gouache, and pencil, 11¹/₄ x 6⁵/₈″ (28.5 x 16.8 cm). Gift of the artist. 149.57.

125 Replica (1946) of SOLO OF A BROWN STROKE, 1913. Watercolor, gouache, and pencil, 5¹/₄ x 8¹/₂″ (13.2 x 21.4 cm). Gift of the artist. 148.57.

KURELEK, William. Canadian, born 1927.

286 HAILSTORM IN ALBERTA. (1961) Oil on composition board, 27¹/₄ x 19″ (69.3 x 48.2 cm). Gift of the Women's Committee of the Art Gallery of Toronto. 380.61. Repr. *Suppl. XI*, p. 54.

KUSAMA, Yayoi. Japanese, born 1929. To U.S.A. 1957.

ACCUMULATION OF STAMPS, 63. 1962. Collage of pasted labels with watercolor, 23³/₄ x 29″ (60.3 x 73.6 cm). Gift of Philip Johnson. 510.70.

LACHAISE, Gaston. American, born France. 1882–1935. To U.S.A. 1906.

419 WOMAN ARRANGING HER HAIR. (1910–12) Bronze (cast 1963), 10¹/₂ x 5¹/₈ x 2³/₄″ (26.4 x 13 x 6.8 cm). Given anonymously (by exchange). 253.66.

HEAD. (After 1920?) Granite, 8¹/₂″ (21.6 cm) high. Given anonymously. 608.39.

252 WOMAN WALKING. 1922. Bronze, 18¹/₂″ (47 cm) high, at base 6¹/₂ x 5³/₈″ (16.5 x 13.7 cm). Gift of Abby Aldrich Rockefeller. 635.39. Repr. *20th-C. Portraits*, p. 86.

252 EGYPTIAN HEAD. 1923. Bronze, 13″ (33 cm) high. Gift of Abby Aldrich Rockefeller. 606.39. Another cast repr. *Living Amer.*, no. 105.

419 THE MOUNTAIN. (1924) Bronze (cast 1964), 7¹/₂ x 19³/₈ x 9¹/₂″ (19 x 49.2 x 24 cm). Given anonymously (by exchange). 252.66.

252 FLOATING FIGURE. (1927) Bronze (cast 1935), 51³/₄″ x 8′ (131.4 x

243.9 cm). Given anonymously in memory of the artist. 3.37. Repr. *Ptg. & Sc.*, p. 254; *Masters*, p. 108; *Sc. of 20th C.*, p. 99.

DANCER. 1928. Bronze, 10³⁄₄ x 9¹⁄₄″ (27.3 x 23.3 cm). Gift of Abby Aldrich Rockefeller. 605.39.

252 JOHN MARIN. 1928. Bronze, 12¹⁄₂″ (31.7 cm) high. Gift of Abby Aldrich Rockefeller. 154.34. Repr. *Ptg. & Sc.*, p. 253.

419 HENRY McBRIDE. 1928. Bronze, 13⁵⁄₈ x 10¹⁄₈ x 11¹⁄₈″ (34.5 x 25.6 x 28.1 cm). Gift of Maximilian H. Miltzlaff. 246.66. *Note*: the subject was for thirty-seven years the knowledgeable and genial art critic for the *New York Sun*.

WOMAN STANDING. (1932) Plaster, 22¹⁄₂ x 12″ (57.1 x 30.5 cm). Gift of Abby Aldrich Rockefeller. 603.39. Original plaster of 604.39.

WOMAN STANDING. 1932. Bronze, 22¹⁄₄ x 11⁷⁄₈″ (56.5 x 30.1 cm). Gift of Abby Aldrich Rockefeller. 604.39. Bronze cast of 603.39.

253 STANDING WOMAN. 1932. Bronze, 7′4″ x 41¹⁄₈″ x 19¹⁄₈″ (223.6 x 104.3 x 48.4 cm). Mrs. Simon Guggenheim Fund. 251.48. Repr. *Ptg. & Sc.*, p. 255; *Masters*, p. 109; *Sc of 20th C.*, pp. 100, 101.

DYNAMO MOTHER. 1933. Bronze, 11¹⁄₈ x 17³⁄₄ x 7¹⁄₂″ (28.3 x 45.1 x 19 cm). Gift of Edward M. M. Warburg. 406.41.

253 KNEES. (1933) Marble, 19″ (48.3 cm) high, at base 13¹⁄₄ x 9¹⁄₂″ (33.6 x 24 cm). Gift of Mr. and Mrs. Edward M. M. Warburg. 3.56. Repr. *Suppl. VI*, p. 18; *Lachaise*, no. 54.

EDWARD M. M. WARBURG. (1933) Plaster, 14¹⁄₂″ (36.8 cm) high. Gift of Edward M. M. Warburg. 239.50. Alabaster version repr. *Lachaise*, no. 52.

253 TORSO. 1934. Plaster, 45 x 41¹⁄₄″ (114.3 x 104.7 cm). Gift of Edward M. M. Warburg. 160.34. Repr. *Lachaise*, no. 40. *Note*: torso of the *Standing Woman* of 1932, 251.48.

LA FRESNAYE, Roger de. French, 1885–1925.

101 THE CONQUEST OF THE AIR. 1913. Oil on canvas, 7′8⁷⁄₈″ x 6′5″ (235.9 x 195.6 cm). Mrs. Simon Guggenheim Fund. 222.47. Repr. *Ptg. & Sc.*, p. 95; in color, *Masters*, p. 75; in color, *Invitation*, p. 52. *Note*: the two figures are said to be the artist and his brother Henri, director of the Nieuport airplane factory.

LAING, Gerald. British, born 1936. Lives in U.S.A.

NUMBER 15. 1965. Metallic paint, painted wood, and pencil on cardboard, 22 x 15″ (55.8 x 38 cm). Joseph G. Mayer Foundation Fund. 831.69.

R.I. 1967. Metallic tape and plastic-coated paper on cardboard, 14³⁄₈ x 19⁷⁄₈″ (36.4 x 50.4 cm). Joseph G. Mayer Foundation Fund. 832.69.

LAM, Wifredo. Cuban, born 1902. Worked in France, Spain, and Italy from 1923. Lives in France.

MOTHER AND CHILD. 1939. Gouache, 41 x 29¹⁄₄″ (104.1 x 74.3 cm). Purchase. 652.39.

306 SATAN. 1942. Gouache, 41⁷⁄₈ x 34″ (106.4 x 86.4 cm). Inter-American Fund. 710.42. Repr. *Latin-Amer. Coll.*, p. 52.

306 THE JUNGLE. 1943. Gouache on paper mounted on canvas, 7′10¹⁄₄″ x 7′6¹⁄₂″ (239.4 x 229.9 cm). Inter-American Fund. 140.45. Repr. *Ptg. & Sc.*, p. 235; in color, *Masters*, p. 167; in color, *Invitation*, p. 81.

LANDAU, Jacob. American, born 1917.

284 CINNA THE POET. (1959) Watercolor, 27¹⁄₄ x 40³⁄₈″ (69.1 x 102.5 cm). Larry Aldrich Foundation Fund. 158.62. Repr. *Figure U.S.A.*

LANDFIELD, Ronnie. American, born 1947.

DIAMOND LAKE. (1969) Synthetic polymer paint on canvas, 9′1¹⁄₄″ x 9′1¹⁄₄″ (274.8 x 427.3 cm). Gift of Philip Johnson. 301.75.

LANDI, Edoardo. Italian, born 1937.

512 GEOMETRICAL KINETIC VARIATIONS. (1963) Motor-driven construction of water-filled plexiglass tubes, painted metal rollers with strips of colored cloth tape, in a box, 19³⁄₄ x 19³⁄₄ x 5³⁄₄″ (50 x 50 x 14.5 cm). Gift of the Olivetti Company of Italy. 1237.64. *Note*: made while the artist was a member of Group N, Padua.

LANDSMAN, Stanley. American, born 1930.

512 Untitled. (1967) Construction of coated glass with electric light bulb, 37¹⁄₈ x 6³⁄₄ x 6³⁄₄″ (94.2 x 16.9 x 16.9 cm). Larry Aldrich Foundation Fund. 96.67.

LANDUYT, Octave. Belgian, born 1922.

271 PURIFICATION BY FIRE. 1957. Oil on composition board, 47⁷⁄₈ x 35⁷⁄₈″ (121.7 x 91 cm). Philip Johnson Fund. 128.58. Repr. *Suppl. VIII*, p. 14.

271 ESSENTIAL SURFACE, EYE. (1960) Oil on canvas, 51³⁄₈ x 63¹⁄₈″ (130.5 x 160.3 cm). Philip Johnson Fund. 122.61. Repr. *Suppl. XI*, p. 45.

LANSKOY, André. French, born Russia. 1902–1976. To Paris 1921.

346 EXPLOSION. 1958. Oil on canvas, 57¹⁄₂ x 38¹⁄₄″ (146 x 97.2 cm). Gift of Louis Carré. 362.60. Repr. *Suppl. X*, p. 37.

LARCHE, Raoul François. French, 1860–1912.

38 LOÏE FULLER, THE DANCER. (c. 1900) Bronze, 18¹⁄₈″ (45.7 cm) high (wired for use as a table lamp). Gift of Anthony Russo. 266.63. Repr. *Suppl. XII*, p. 36.

LARIONOV, Michael. Russian, 1881–1964. To Paris 1915.

STILL LIFE. (c. 1906) Gouache and watercolor, 10¹⁄₄ x 16″ (26 x 40.6 cm). Gift of Mrs. Alfred P. Shaw. 293.74.

131 RAYONIST COMPOSITION: DOMINATION OF RED. (1912–13. Dated on painting 1911) Oil on canvas, 20³⁄₄ x 28¹⁄₂″ (52.7 x 72.4 cm). Gift of the artist. 36.36.

131 RAYONIST COMPOSITION: HEADS. (1912–13. Dated on painting 1911) Oil on paper, 27¹⁄₄ x 20¹⁄₂″ (69.3 x 52.1 cm). Gift of the artist. 37.36.

131 RAYONIST COMPOSITION NUMBER 8. (1912–13) Tempera, 20 x 14³⁄₄″ (50.8 x 37.5 cm). Gift of the artist. 40.36.

131 RAYONIST COMPOSITION NUMBER 9. (1913) Tempera, 10³⁄₈ x 18″ (26.3 x 45.7 cm). Gift of the artist. 41.36.

131 SPIRAL. 1915. Tempera, 30⁵⁄₈ x 21¹⁄₄″ (77.8 x 54 cm). Gift of the artist. 38.36.

RÉNARD. Three watercolor designs made in 1921 for the ballet produced by Ballets Russes de Monte Carlo, 1922. Two designs for costumes, 20 x 13³⁄₄″ (50.8 x 35 cm), one for scenery, 20¹⁄₂ x 25¹⁄₄″ (52.1 x 64.1 cm). Gift of the artist. 42.36.1–.3. Theatre Arts Collection.

LASSAW, Ibram. American, born Egypt, of Russian parents, 1913. To U.S.A. 1921.

NEBULA IN ORION. (1951) Welded bronze, 28³⁄₄ x 34 x 20″ (73 x 86.1 x 50.7 cm). Gift of Mrs. John D. Rockefeller 3rd. 238.69.

357 KWANNON. 1952. Welded bronze with silver, 6′ x 43″ (182.9 x 109.2 cm). Katharine Cornell Fund. 196.52. Repr. *Suppl. IV*, p. 38; *What Is Mod. Sc.*, p. 79.

LATASTER, Ger. Dutch, born 1920.

355 THREATENED GAME. 1956. Oil on composition board, 48 x 68″ (121.9 x 172.7 cm). Gift of G. David Thompson. 14.59. Repr. *Suppl. IX*, p. 21.

LATHAM, John. British, born Rhodesia (modern-day Zambia) 1921.

380 SHEM. 1958. Assemblage: hessian-covered door, with books, scrap metals, various paints, plasters, and cements, 8′4¹/₂″ x 46″ x 12¹/₂″ (255.2 x 116.8 x 31.7 cm). Philip Johnson Fund. 298.61. Repr. *Assemblage*, p. 123.

ART AND CULTURE. 1966–69. Assemblage: book, labeled vials filled with powders and liquids, letters, photostats, etc., in a leather case, 3¹/₈ x 11¹/₈ x 10″ (7.9 x 28.2 x 25.3 cm). Blanchette Rockefeller Fund. 511.70a–t.

LAUFMAN, Sidney. American, born 1891.

THE WOODYARD. (1932) Oil on canvas, 25³/₄ x 32″ (65.4 x 81.3 cm). Given anonymously. 336.41. Repr. *Ptg. & Sc.*, p. 74.

LAURENCIN, Marie. French, 1883–1956.

THE BLUE PLUME. (c. 1914) Pastel, pencil, watercolor, 9⁵/₈ x 7⁵/₈″ (24.5 x 19.4 cm). Gift of Mrs. Meredith Hare. 137.34.

TWO WOMEN [*Deux filles*]. (c. 1935) Oil on canvas, 18 x 21¹/₂″ (45.8 x 54.6 cm). Gift of Mrs. Rita Silver in memory of her husband, Leo Silver. 1403.74.

LAURENS, Henri. French, 1885–1954.

103 HEAD. (1918) Wood construction, painted, 20 x 18¹/₄″ (50.8 x 46.3 cm). Van Gogh Purchase Fund. 263.37. Repr. *Ptg. & Sc.*, p. 271; *Masters*, p. 78; *What Is Mod. Sc.*, p. 45; *Sc. of 20th C.*, p. 145.

103 GUITAR. (1920) Terra cotta, 14¹/₄″ (36.2 cm) high, at base 4³/₄ x 3⁵/₈″ (10.2 x 9.2 cm). Gift of Curt Valentin. 303.47.

HEAD OF A BOXER. (1920) Stone relief, polychrome, 9³/₄ x 9⁷/₈″ (24.8 x 25.1 cm). Gift of Mrs. Marie L. Feldhaeusser. 240.50.

103 SEATED WOMAN. (1926) Terra cotta, 14¹/₂″ (36.8 cm) high, at base 8 x 7¹/₄″ (20.3 x 18.4 cm). Gift of Lucien Lefebvre-Foinet. 258.37.

103 MERMAID. (1937) Bronze, 10″ (25.5 cm) high. Gift of Mr. and Mrs. Walter Bareiss. 571.56. Repr. *Suppl. VI*, p. 19.

LAURENT, Robert. American, born France. 1890–1970. To U.S.A. 1902.

254 AMERICAN BEAUTY. (c. 1933) Alabaster, 12¹/₄″ (31.1 cm) high, at base 6³/₄ x 7³/₈″ (17.1 x 18.7 cm). Abby Aldrich Rockefeller Fund. 124.46. Repr. *Ptg. & Sc.*, p. 259.

LAWRENCE, Jacob. American, born 1917.

278 THE MIGRATION OF THE NEGRO. (1940–41) Series of thirty temperas on gesso on composition board, 18 x 12″ (45.7 x 30.5 cm) and 12 x 18″ (30.5 x 45.7 cm). Gift of Mrs. David M. Levy. 28.42.1–.30. There are in all sixty panels in this series: the thirty odd numbers in the Phillips Collection, Washington, D.C., the thirty even numbers in The Museum of Modern Art. Nos. 28.42.5 and 28.42.6 are reproduced here. Nos. 28.42.11, 28.42.26, and 28.42.29 are repr. *Ptg. & Sc.*, p. 151. Nos. 28.42.24 and 28.42.29 are repr. in color, *Invitation*, p. 113.

A FAMILY. 1943. Gouache on paper, 22¹/₂ x 15¹/₂″ (57 x 39.3 cm). Gift of Mrs. Maurice Blin. 684.71.

278 SEDATION. 1950. Casein, 31 x 22⁷/₈″ (78.8 x 58.1 cm). Gift of Mr. and Mrs. Hugo Kastor. 15.51. Repr. *Suppl. III*, p. 22.

LEBDUSKA, Lawrence. American, 1894–1966.

MONASTERY FARM, RHODE ISLAND. (1936) Oil on rubberized cloth, 28¹/₄ x 38″ (71.8 x 96.5 cm). Abby Aldrich Rockefeller Fund. 632.39. Repr. *Masters Pop. Ptg.*, no. 157.

JUNGLE SCENE. (c. 1936) Oil on composition board, 23¹/₂ x 30″ (59.5 x 75.9 cm). Gift of Emil J. Arnold. 1519.68.

LEBENSTEIN, Jan. Polish, born 1930. To Paris 1959.

352 AXIAL FIGURE, 110. 1961. Oil on canvas, trapezoid, 7′1¹/₂″ x 46³/₄″ at top, 31¹/₂″ at bottom (217.2 x 118.8 x 80 cm). Blanchette Rockefeller Fund. 273.61. Repr. *15 Polish Ptrs.*, p. 41.

FIGURE. 1962. Gouache, watercolor, pen and ink, 17¹/₄ x 10¹/₄″ (43.9 x 42.2 cm). Gift of Mrs. Robert Benjamin. 706.76.

LEBRUN, Rico. American, born Italy. 1900–1964. To U.S.A. 1924.

272 FIGURE IN RAIN. 1949. Duco on canvas over composition board, 48 x 30¹/₈″ (121.9 x 76.5 cm). Gift of Mrs. Robert Woods Bliss. 102.50. Repr. *Suppl. II*, p. 25.

DOBLE DISPARATE. 1958. Oil and casein on plywood, 7′5/₈″ x 45¹/₈″ (214.7 x 114.5 cm). Extended loan from Mr. and Mrs. Frank S. Wyle. E.L.61.92. Repr. *New Images*, p. 98.

VAN DER LECK, Bart. Dutch, 1876–1958.

Untitled. (1917) Gouache and pencil, 18⁵/₈ x 22¹/₂″ (44.7 x 57.1 cm), irregular. Gift of Constance B. Cartwright. 149.73.

LE CORBUSIER (Charles-Édouard Jeanneret). French, born Switzerland. 1887–1965. To Paris 1917.

142 STILL LIFE. 1920. Oil on canvas, 31⁷/₈ x 39¹/₄″ (80.9 x 99.7 cm). Van Gogh Purchase Fund. 261.37. Repr. *Ptg. & Sc.*, p. 123; *Masters*, p. 219.

LEE, Ung-no. Korean, born 1904.

MOUNTAINS. (1957) Brush and colored inks, 18³/₄ x 22⁵/₈″ (47.5 x 57.3 cm) mounted on cloth scroll, 39³/₄ x 28¹/₂″ (101 x 72.4 cm). Blanchette Rockefeller Fund. 96.58.

316 SAILING. (1957) Brush and colored inks, 50 x 12⁵/₈″ (127 x 32 cm) mounted on cloth scroll, 71⁵/₈ x 17⁷/₈″ (182 x 45.3 cm). Blanchette Rockefeller Fund. 95.58. Repr. *Suppl. VIII*, p. 23.

COMPOSITION. (1959?) Brush and colored inks, 13³/₄ x 18″ (34.8 x 45.6 cm). Gift of the artist. 119.60.

LE FAUCONNIER, Henri Victor Gabriel. French, 1881–1946.

100 THE HUNTSMAN. (1912) Oil on canvas, 62¹/₄ x 46³/₈″ (158.1 x 117.8 cm). Gift of Mr. and Mrs. Leo Lionni. 505.53. Repr. *Suppl. V*, p. 16.

LÉGER, Fernand. French, 1881–1955. In U.S.A. 1940–45.

BRIDGE. (1908?) Oil on canvas, 36¹/₂ x 28⁵/₈″ (92.7 x 72.6 cm). The Sidney and Harriet Janis Collection (fractional gift). 624.67. Repr. *Janis*, p. 5. *Note*: also called *Paysage* and *Composition # 1*.

95 CONTRAST OF FORMS. 1913. Oil on canvas, 39¹/₂ x 32″ (100.3 x 81.1 cm). The Philip L. Goodwin Collection. 103.58. Repr. *Bulletin*, Fall 1958, p. 9.

95 EXIT THE BALLETS RUSSES. 1914. Oil on canvas, 53³/₄ x 39¹/₂″ (136.5 x 100.3 cm). Gift of Mr. and Mrs. Peter A. Rübel (partly by exchange). 11.58. Repr. *Bulletin*, Fall 1958, p. 26; in color, *Invitation*, p. 66. *Note*: according to the former owner, Leonid Massine, the title of the picture was given by the artist.

97 Verdun: The Trench Diggers. 1916. Watercolor, 14$^1/_8$ x 10$^3/_8$″ (35.9 x 26.3 cm). Frank Crowninshield Fund. 142.44.

Bargeman. (1918) Oil on canvas, 18$^1/_8$ x 21$^7/_8$″ (45.8 x 55.5 cm). The Sidney and Harriet Janis Collection (fractional gift). 625.67. Repr. *Janis*, p. 7.

95 Propellers. 1918. Oil on canvas, 31$^7/_8$ x 25$^3/_4$″ (80.9 x 65.4 cm). Katherine S. Dreier Bequest. 171.53. Repr. *Suppl. IV*, p. 9; *The Machine*, p. 140.

95 The City (study). 1919. Oil on canvas, 36$^1/_4$ x 28$^3/_8$″ (92.1 x 72.1 cm). Acquired through the Lillie P. Bliss Bequest. 178.52. Repr. *Suppl. IV*, p. 23; *Léger*, p. 28. *Note*: study for *The City*, 1919, Philadelphia Museum of Art, A. E. Gallatin Collection.

Animated Landscape [*Paysage animé, Ier état*]. 1921. Oil on canvas, 19$^7/_8$ x 25$^3/_8$″ (50.4 x 64.4 cm). The Sidney and Harriet Janis Collection (fractional gift). 626.67. Repr. *Janis*, p. 7.

96 Three Women [*Le Grand déjeuner*]. 1921. Oil on canvas, 6$^{′1}/_4$″ x 8′3″ (183.5 x 251.5 cm). Mrs. Simon Guggenheim Fund. 189.42. Repr. *Ptg. & Sc.*, p. 124; *Léger*, p. 31; in color, *Masters*, p. 85; *Art in Prog.*, opp. p. 74; *Paintings from MoMA*, p. 44; in color, *Invitation*, p. 71.

Skating Rink. Costume design for the ballet produced by Ballet Suédois, Paris. (1922) Watercolor and pencil, 12$^3/_8$ x 9$^1/_2$″ (31.4 x 24.1 cm). W. Alton Jones Foundation Fund. 270.54. Theatre Arts Collection.

405 Mural Painting. 1924. Oil on canvas, 71 x 31$^1/_4$″ (180.3 x 79.2 cm). Given anonymously. 49.65. Repr. *Léger*, p. 39.

97 The Baluster. 1925. Oil on canvas, 51 x 38$^1/_4$″ (129.5 x 97.2 cm). Mrs. Simon Guggenheim Fund. 179.52. Repr. *Suppl. IV*, p. 24.

97 Compass and Paint Tubes. 1926. Gouache, 10$^1/_2$ x 14$^1/_4$″ (26.7 x 36.2 cm). Gift of Edward M. M. Warburg. 407.41. Repr. *Mod. Art in Your Life*, p. 24.

97 Umbrella and Bowler. 1926. Oil on canvas, 50$^1/_4$ x 38$^3/_4$″ (130.1 x 98.2 cm). A. Conger Goodyear Fund. 650.59. Repr. *Suppl. IX*, p. 13.

Design for a mural. (1938) Gouache and watercolor, 4$^1/_4$ x 7$^1/_4$″ (10.7 x 18.2 cm). Gift of the Advisory Committee. 135.47. *Note*: a miniature mural painting for the model of the *Suspended House* designed by Paul Nelson.

405 Project for a cinematic mural (never executed) for the lobby of the International Building, Rockefeller Center, New York. (1939–40) Seven paintings, key studies for a proposed moving mural, to be projected on a marble wall. Gouache, pencil, pen and ink on cardboard; five, 20 x 15″ (50.7 x 38 cm); two, 20 x 16″ (50.7 x 40.5 cm). Given anonymously. 737–743.66. Nos. 737.66, 741.66, and 742.66 are reproduced here.

98 The Divers, II [*Les Plongeurs*]. 1941–42. Oil on canvas, 7′6″ x 68″ (228.6 x 172.8 cm). Mrs. Simon Guggenheim Fund. 333.55. Repr. *Suppl. VI*, p. 12.

99 Three Musicians. 1944 (after a drawing of 1924–25; dated on canvas 24–44). Oil on canvas, 68$^1/_2$ x 57$^1/_4$″ (174 x 145.4 cm). Mrs. Simon Guggenheim Fund. 334.55. Repr. *Léger*, p. 65; *Suppl. VI*, p. 13.

99 Big Julie [*La Grande Julie*]. 1945. Oil on canvas, 44 x 50$^1/_8$″ (111.8 x 127.3 cm). Acquired through the Lillie P. Bliss Bequest. 141.45. Repr. *Ptg. & Sc.*, p. 131; *Léger*, p. 67; in color, *Masters*, p. 96; in color, *Invitation*, p. 129; *Modern Masters*, p. 253.

99 Landscape with Yellow Hat. 1952. Oil on canvas, 36$^1/_4$ x 28$^7/_8$″ (92.2 x 73.4 cm). Gift of Mr. and Mrs. David M. Solinger. 292.58. Repr. *Suppl. VIII*, p. 8.

LEHMBRUCK, Wilhelm. German, 1881–1919.

44 Standing Woman. (1910) Bronze (cast in New York, 1916–17, from an original plaster), 6′3$^1/_8$″ (190.8 cm) high, base 20$^1/_2$″ (52 cm) diameter. Given anonymously. 6.30. Repr. *Ptg. & Sc.*, p. 244.

45 Kneeling Woman. (1911) Cast stone, 69$^1/_2$″ (176.5 cm) high, at base 56 x 27″ (142.2 x 68.6 cm). Abby Aldrich Rockefeller Fund. 268.39. Repr. *Ptg. & Sc.*, p. 246; *Masters*, p. 65; *Sc. of 20th C.*, pp. 84–87.

45 Standing Youth. (1913) Cast stone, 7′8″ (233.7 cm) high, at base 36 x 26$^3/_4$″ (91.5 x 68 cm). Gift of Abby Aldrich Rockefeller. 68.36. Repr. *Ptg. & Sc.*, p. 247; *Masters*, p. 65; *What Is Mod. Sc.*, p. 37; *Sc. of 20th C.*, pp. 88, 89.

LEKAKIS, Michael. American, born 1907.

358 Ptisis (Soaring). (1957–62) Oak, 34$^7/_8$ x 25$^1/_2$ x 15$^3/_4$″ (88.4 x 64.6 x 40 cm), on pine base 12 x 11$^3/_8$ x 11″ (30.3 x 28.7 x 27.8 cm) and mahogany pedestal, 41$^7/_8$ x 10$^5/_8$ x 10$^1/_8$″ (106.2 x 27 x 25.6 cm). Gift of the artist through the Ford Foundation Purchase Program. 74.63. Repr. *Amer. 1963*, p. 57.

LENCH, Stanley. British, born 1934.

Pola Negri. (1958) Gouache, 30 x 21$^7/_8$″ (76 x 55.5 cm). Purchase. 129.58.

LENK, Thomas (Kaspar-Thomas Lenk). German, born 1933.

491 Stratification 44D, II [*Schichtung*]. 1969. Construction of plexiglass disks, 32$^1/_4$ x 12$^1/_4$ x 13$^1/_2$″ (81.9 x 31.1 x 34.1 cm). Gertrud A. Mellon Fund (by exchange). 506.69. *Note*: original sculpture of 1966, acquired in 1967, was damaged beyond repair. The artist made this piece, differing slightly from the original, to replace it.

LEONID (Leonid Berman). American, born Russia. 1896–1976. Worked in France. To U.S.A. 1946.

195 Shrimp Fishermen. 1937. Oil on canvas, 21$^1/_4$ x 31$^3/_4$″ (54 x 80.6 cm). Gift of James Thrall Soby. 578.43. Repr. *Ptg. & Sc.*, p. 184.

195 Malamocco. 1948. Oil on canvas, 36 x 28″ (91.4 x 71.1 cm). Purchase. 10.50. Repr. *Suppl. II*, p. 25.

LE PARC, Julio. Argentine, born 1928. To Paris 1958.

375 Double Concurrence—Continuous Light, 2. (1961) Black wood box, 21 x 19$^3/_4$ x 5$^5/_8$″ (53.4 x 50 x 14.1 cm) with illuminated aperture 7$^7/_8$ x 8″ (20 x 20.2 cm) in which fifty-four plastic squares, 1$^1/_2$ x 1$^1/_2$″ (3.6 x 3.6 cm), are suspended from eighteen nylon threads; mirror backing, 11$^7/_8$ x 16″ (30.1 x 40.4 cm), two reflectors, three sets of interchangeable pierced metal screens, two glass filters. Philip Johnson Fund. 199.63a–l.

375 Continuous Instability—Light. (1962) Two-part construction: painted wood screen, 43$^1/_2$″ (110.5 cm) diameter, recessed in cylinder, 15″ (38 cm) deep; projection apparatus in wood box, 19$^5/_8$ x 9 x 9″ (49.9 x 23 x 23 cm), including electric bulb, dangling aluminum blades, and four interchangeable pierced metal screens. Heat of bulb sets apparatus in motion. Inter-American Fund. 312.62. Repr. *Suppl. XII*, p. 34.

502 Instability through Movement of the Spectator. 1962–64. Synthetic polymer paint on wood and polished aluminum in painted wood box, 28$^5/_8$ x 57$^1/_8$ x 36$^1/_2$″ (72.6 x 145 x 92.8 cm). Inter-American Fund. 110.65.

LEPPER, Robert. American, born 1906.

Orb and Instrument. 1961. Iron and other metals, 50$^7/_8$″ (129.2 cm) high, wood base 2$^5/_8$ x 16$^7/_8$ x 9$^1/_2$″ (6.6 x 42.9 x 24.1 cm). Gift of the artist. 571.64.

LEPRI, Stanislao. Italian, born 1910.

BANQUET. 1945. Tempera on plywood, 18¹/₂ x 23⁵/₈″ (47 x 60 cm). Gift of D. and J. de Menil. 343.49. Repr. *20th-C. Italian Art*, pl. 104.

LESLIE, Alfred. American, born 1927.

THE SECOND TWO-PANEL HORIZONTAL. 1958. Oil on canvas, each panel, 66″ x 6′ (167.6 x 182.8 cm). Larry Aldrich Foundation Fund. 718.59a–b. Repr. *16 Amer.*, p. 36.

NOTAN STUDY FOR THE KILLING OF FRANK O'HARA. (1966) Watercolor and wash, 18¹/₈ x 24″ (45.8 x 60.7 cm). Gift of Mr. and Mrs. Richard L. Selle. 14.68.

NOTAN STUDY FOR THE KILLING OF FRANK O'HARA. (1966) Wash and brush, 18¹/₈ x 24″ (45.8 x 60.7 cm). Larry Aldrich Foundation Fund. 15.68.

LE VA, Barry. American, born 1941.

STRIPS, SHEETS, AND PARTICLES. 1967–68. Pencil, pen and ink, pasted photograph on graph paper, 17 x 22″ (43.2 x 55.9 cm). Philip Johnson Fund. 101.71.

LEVEE, John. American, born 1924. Lives in Paris.

PAINTING. 1954. Oil on canvas, 63⁷/₈ x 51¹/₈″ (162 x 129.8 cm). Gift of Mr. and Mrs. Jack I. Poses. 192.56. Repr. *Suppl. VI*, p. 31.

OCTOBER 1, 1958. 1958. Oil on canvas, 28³/₄ x 39³/₈″ (73 x 100 cm). Gift of Joseph H. Hazen. 671.59. Repr. *Suppl. IX*, p. 38.

LEVI, Josef. American, born 1938.

512 BINAL LANTANA. 1965. White formica box with painted perforated metal screens and fluorescent lights, 36³/₄ x 39⁵/₈ x 8¹/₂″ (93.1 x 100.5 x 21.4 cm). Larry Aldrich Foundation Fund. 105.66.

LEVI, Julian E. American, born 1900.

237 PORTRAIT OF SUBA. 1944. Oil on canvas, 28¹/₈ x 19⁷/₈″ (71.4 x 50.5 cm). Purchase and exchange. 262.44. Repr. *Ptg. & Sc.*, p. 74. *Note*: the subject is the artist, Miklos Suba.

LEVINE, Jack. American, born 1915.

248 THE FEAST OF PURE REASON. (1937) Oil on canvas, 42 x 48″ (106.7 x 121.9 cm). Extended loan from the United States WPA Art Program. E.L.38.2926. Repr. *Ptg. & Sc.*, p. 145.

249 THE STREET. (1938) Oil tempera and oil on canvas, 59¹/₂″ x 6′11″ (151.1 x 210.8 cm). Extended loan from the United States WPA Art Program. E.L.41.2378. Repr. *Amer. 1942*, p. 88.

249 THE PASSING SCENE. (1941) Oil on composition board, 48 x 29³/₄″ (121.9 x 75.6 cm). Purchase. 133.42. Repr. *Ptg. & Sc. (I)*, p. 55.

249 ELECTION NIGHT. (1954) Oil on canvas, 63¹/₈″ x 6′1/₂″ (160.3 x 184.1 cm). Gift of Joseph H. Hirshhorn. 153.55. Repr. *Private Colls.*, p. 8; in color, *Invitation*, p. 109.

LEWIS, Wyndham. British, born U.S.A. 1884–1957.

FIGURE. 1912. Watercolor and ink, 10³/₄ x 6³/₄″ (27.3 x 17.1 cm). Gift of Victor S. Riesenfeld. 197.55.

142 ROMAN ACTORS. (1934) Watercolor, gouache, and ink, 15¹/₈ x 22¹/₈″ (38.4 x 56.2 cm). Francis E. Brennan Fund. 14.54. Repr. *Fantastic Art* (3rd), p. 215.

A HAND OF BANANAS. (c. 1938) Gouache, watercolor, pencil, ink, 8 x 7¹/₈″ (20.3 x 18.1 cm). Purchase. 408.41.

LEWITIN, Landès. American, born Cairo, of Rumanian parents. 1892–1966. To U.S.A. 1916. In Paris 1928–39.

381 INNOCENCE IN A LABYRINTH. (1940) Collage of colored photoengravings, 8¹/₂ x 17¹/₂″ (21.6 x 44.5 cm). Purchase. 6.48. Repr. *Assemblage*, p. 160.

310 KNOCKOUT. (1955–59) Oil and ground glass on composition board, 23⁷/₈ x 17⁷/₈″ (60.6 x 45.4 cm). Promised gift and extended loan from Royal S. Marks. E.L.63.1108. Repr. *16 Amer.*, p. 39.

LEWITT, Sol. American, born 1928.

B258. (1966) Baked enamel on aluminum, in six parts, overall, 6′9″ x 24′ 2¹/₄″ x 6′9″ (205.6 x 637.2 x 205.7 cm). Elizabeth Bliss Parkinson Fund. 716.68a–f.

STRAIGHT LINES IN FOUR DIRECTIONS SUPERIMPOSED. (1969, September) (Vertical, horizontal, 45° diagonal left and right lines drawn as close together as possible, approximately ¹/₁₆″ apart.) Graphite on white wall, size variable. Purchase. 1347.74. Repr. of one version, *Amer. Art*, p. 73.

LIAUTAUD, Georges. Haitian, born 1899.

THE GOAT WITH TWO HEADS. (1961) Wrought iron, 16¹/₈ x 9¹/₄ x 8¹/₂″ (40.9 x 23.3 x 21.5 cm). Inter-American Fund. 76.62. Repr. *Suppl. XII*, p. 37.

LIBERMAN, Alexander. American, born Russia 1912. To U.S.A. 1941.

MINIMUM. 1949. Enamel on composition board, 48 x 48″ (121.9 x 121.9 cm). Gift of the Samuel I. Newhouse Foundation, Inc. 501.69. Repr. *Art of the Real*, p. 22.

373 CONTINUOUS ON RED. 1960. Oil on circular canvas, approximately 6′8″ (203 cm) diameter. Gift of Mr. and Mrs. Fernand Leval. 381.61. Repr. *Suppl. X*, p. 52; in color, *Responsive Eye*, p. 25.

373 PASSAGE. (1960) Enamel on metal with marble base, 9¹/₄ x 6¹/₄ x 5¹/₂″ (23.4 x 15.8 x 14 cm). Gift of Mr. and Mrs. Jan Mitchell. 84.60. Repr. *Suppl. X*, p. 52.

SIGMA, I. (1961) Polished aluminum, 8′6″ (259.1 cm) high, including aluminum base 12 x 20 x 14″ (30.4 x 50.8 x 35.4 cm). Gift of Mr. and Mrs. Edouard Cournand. 661.70.

497 TEMPLE, I. 1963–64. Burnished aluminum, 9′2³/₈″ (279.9 cm) high, base ³/₈ x 60 x 60″ (.9 x 152.4 x 152.4 cm). Given in memory of Fernand Leval by his wife and children. 449.67a–e.

ABOVE. (1970) Painted steel, 12′10⁵/₈″ x 11′7¹/₄″ x 9′1¹/₈″ (394.6 x 353.6 x 277.2 cm). A. Conger Goodyear Fund. 422.71.

LICHTENSTEIN, Roy. American, born 1923.

DROWNING GIRL. 1963. Oil and synthetic polymer paint on canvas, 67⁵/₈ x 66³/₄″ (171.6 x 169.5 cm). Philip Johnson Fund (by exchange) and gift of Mr. and Mrs. Bagley Wright. 685.71.

MODERN PAINTING WITH BOLT. (1966) Synthetic polymer paint and oil partly silkscreened on canvas, 68¹/₄ x 68³/₈″ (173.2 x 173.5 cm). The Sidney and Harriet Janis Collection (fractional gift). 666.67. Repr. *Janis*, p. 153.

MODERN SCULPTURE WITH GLASS WAVE. (1967) Brass and glass, 7′7¹/₄″ x 29″ x 28″ (231.8 x 73.8 x 70.1 cm). Gift of Mr. and Mrs. Richard L. Selle. 597.76a–i.

ENTABLATURE. (1976) Oil and synthetic polymer paint on canvas, 54″ x 16′ (137.1 x 484.1 cm). Fractional gift of an anonymous donor. 291.76.

LINDNER, Richard. American, born Germany 1901. To U.S.A. 1941.

312 THE MEETING. 1953. Oil on canvas, 60″ x 6′ (152.4 x 182.9 cm). Given anonymously. 75.62. Repr. *Amer. 1963*, p. 61. *Note*: an

assembly of characters from the artist's childhood in Munich and later life in New York. Foreground: left to right, the photographer Evelyn Hofer, King Ludwig II of Bavaria, the family cook, the cat Florian, the artist Saul Steinberg. Background: the artist's sister Lizzi as a child, the artist with his aunt Else Bornstein, and the painter Hedda Sterne (then Mrs. Steinberg).

312 THE MIRROR. 1958. Oil and encaustic on canvas, 39³/₈ x 25⁵/₈″ (100 x 65 cm). Given in memory of Dr. Hermann Vollmer. 65.61. Repr. *Suppl. XI*, p. 44; *Amer. 1963*, p. 63.

CONSTRUCTION. (1962) Assemblage: plastic mask, printed paper and cloth on painted wood panel, 11⁷/₈ x 13 x 3³/₄″ (29.9 x 33 x 9.5 cm). Philip Johnson Fund. 7.63.

464 CHECKMATE. 1966. Collage with watercolor, pencil, crayon, pastel, brush and ink, 23⁷/₈ x 18″ (60.6 x 45.7 cm). John S. Newberry Fund. 370.66. *Note*: the man in the photograph is Marcel Duchamp, to whom the watercolor is dedicated.

LIPCHITZ, Jacques. American, born Lithuania. 1891–1973. In France 1909–41. To U.S.A. 1941.

105 MAN WITH A GUITAR. 1915. Limestone, 38¹/₄″ (97.2 cm) high, at base 7³/₄ x 7³/₄″ (19.7 x 19.7 cm). Mrs. Simon Guggenheim Fund (by exchange). 509.51. Repr. *Masters*, p. 78; *What Is Mod. Sc.*, p. 44; *Sc. of 20th C.*, p. 139.

105 GERTRUDE STEIN. (1920) Bronze, 13³/₈″ (34 cm) high. Fund given by friends of the artist. 9.63. Repr. *Four Amer. in Paris*, p. 158.

105 SEATED MAN. (1925) Bronze, 13¹/₂ x 12″ (34.3 x 30.2 cm). Purchase. 658.39. Repr. *Ptg. & Sc.*, p. 280; *Lipchitz*, p. 46.

106 FIGURE. 1926–30. Bronze (cast 1937), 7′1¹/₄″ x 38⁵/₈″ (216.6 x 98.1 cm). Van Gogh Purchase Fund. 214.37. Repr. *Ptg. & Sc.*, p. 281; *Masters*, p. 86; *Sc. of 20th C.*, p. 141.

105 RECLINING NUDE WITH GUITAR. (1928) Black limestone, 16³/₈″ (41.6 cm) high, at base 27⁵/₈ x 13¹/₂″ (70.3 x 34.3 cm). Promised gift and extended loan from Mrs. John D. Rockefeller 3rd. E.L.55.1865. Repr. *Lipchitz*, pp. 50–51; *Sc. of 20th C.*, p. 140; *What Is Mod. Sc.*, p. 21.

106 SONG OF THE VOWELS. 1931. Terra cotta, 14¹/₂ x 10¹/₂″ (36.8 x 26.4 cm). Gift of the artist. 257.37. Repr. *Ptg. & Sc.*, p. 280.

SONG OF THE VOWELS. (1931) Bronze (cast 1962, from terra cotta original), 14⁵/₈ x 10″ (37 x 25.2 cm). Gift of the artist. 8.63.

107 THE RAPE OF EUROPA, II. (1938) Bronze, 15¹/₄ x 23¹/₈″ (38.7 x 58.7 cm). Given anonymously. 193.42. Repr. *Ptg. & Sc.*, p. 282.

THE RAPE OF EUROPA, IV. 1941. Chalk, gouache, brush and ink, 26 x 20″ (66 x 50.8 cm). Purchase. 154.42. Repr. *Lipchitz*, p. 63. *Note*: study for the sculpture *Rape of Europa, IV*.

107 THE RAPE OF EUROPA, IV. 1941. Gouache, watercolor, brush and ink, 18³/₄ x 13⁵/₈″ (47.6 x 34.6 cm). Gift of Philip L. Goodwin. 6.49. Repr. *Seurat to Matisse*, p. 80. *Note*: study for the sculpture *Rape of Europa, IV*.

106 BLOSSOMING. (1941–42) Bronze, 21¹/₂ x 16¹/₂″ (54.6 x 41.8 cm). Given anonymously. 619.43. Repr. *Ptg. & Sc.*, p. 282.

107 MOTHER AND CHILD, II. (1941–45) Bronze, 50 x 51″ (127 x 129.5 cm). Mrs. Simon Guggenheim Fund (by exchange). 508.51. Repr. *Suppl. III*, p. 4; *Masters*, p. 95; *Sc. of 20th C.*, pp. 178, 179.

LIPPOLD, Richard. American, born 1915.

367 VARIATION NUMBER 7: FULL MOON. (1949–50) Brass rods, nickel-chromium and stainless steel wire, 10 x 6′ (305 x 183 cm). Mrs. Simon Guggenheim Fund. 241.50. Repr. *Suppl. II*, p. 1; *Masters*, p. 181; *What Is Mod. Sc.*, p. 78.

LIPTON, Seymour. American, born 1903.

IMPRISONED FIGURE. 1948. Wood and sheet-lead construction, 7′3¹/₄″ x 30⁷/₈″ x 23⁵/₈″ (215.2 x 78.3 x 59.9 cm), including wood base 6¹/₈ x 23¹/₈ x 20¹/₈″ (15.3 x 58.6 x 51 cm). Gift of the artist. 507.69. Repr. *Dada, Surrealism*, p. 117.

357 SANCTUARY. (1953) Nickel-silver over steel, 29¹/₄ x 25″ (74.3 x 63.5 cm). Blanchette Rockefeller Fund. 550.54. Repr. *Suppl. V*, p. 31. *Note*: the Museum owns a crayon study for this sculpture.

482 MANUSCRIPT. (1961) Brazed bronze on monel metal, 60³/₈″ x 7′1/₈″ x 37¹/₈″ (153.3 x 213.7 x 94.2 cm). Mrs. Simon Guggenheim Fund. 530.65.

LISSITZKY, El (Lazar Markovich Lissitzky). Russian, 1890–1941. In Germany 1921–23, 1925–28.

130 PROUN 19D. (1922?) Gesso, oil, collage, etc., on plywood, 38³/₈ x 38¹/₄″ (97.5 x 97.2 cm). Katherine S. Dreier Bequest. 172.53. Repr. *Suppl. IV*, p. 15.

130 PROUN COMPOSITION. (c. 1922) Gouache and ink, 19³/₄ x 15³/₄″ (50.2 x 40 cm). Gift of Curt Valentin. 338.41. Repr. *Ptg. & Sc.*, p. 115.

PROUN GK. (c. 1922–23) Gouache, 26 x 19³/₄″ (66 x 50.2 cm). Extended loan. E.L.35.780.

LITWAK, Israel. American, born Ukraine. 1867–? To U.S.A. 1903.

6 DOVER, NEW JERSEY. 1947. Oil on canvas, 22 x 32″ (55.9 x 81.3 cm). Gift of Dr. F. H. Hirschland. 53.49.

LONG, Richard. British, born 1945.

WALKING A STRAIGHT LINE BY NIGHT, DARTMOOR, ENGLAND. 1970. Photograph, map, and typewritten statement on cardboard mounted on composition board, 8⁷/₈ x 39¹/₂″ (22.5 x 100.3 cm). Charles Simon Fund. 394.70.

LOPEZ, José Dolores. American, c. 1880–c. 1939.

11 ADAM AND EVE AND THE SERPENT. (c. 1930) Cottonwood; tree 24⁷/₈″ (63.2 cm) high; figures 13″ and 14″ (33 and 35.6 cm) high; garden 8¹/₂ x 21¹/₄″ (21.6 x 54 cm). Gift of Mrs. Meredith Hare. 106.43a–d. Repr. *Ptg. & Sc.*, p. 296.

LÓPEZ GARCÍA, Antonio. Spanish, born 1936.

435 THE APPARITION. 1963. Oil on wood relief, 21¹/₂ x 31⁵/₈ x 5³/₈″ (54.5 x 80.2 x 13.6 cm). Gift of the Staempfli Gallery. 290.65.

LOUIS, Morris. American, 1912–1962.

343 Untitled. (1958) Synthetic polymer paint on canvas, 11′7¹/₄″ x 7′7¹/₄″ (353.7 x 231.5 cm). Grace Rainey Rogers Fund. 560.63.

BETA IOTA. (1961) Synthetic polymer paint on canvas, 8′6¹/₈″ x 23′7¹/₄″ (259.3 x 719.7 cm). Gift of Mrs. Abner Brenner. 1531.68.

343 THIRD ELEMENT. 1962. Synthetic polymer paint on canvas, 7′1³/₄″ x 51″ (207.5 x 129.5 cm). Blanchette Rockefeller Fund. 200.63. Repr. in color, *Invitation*, p. 141; in color, *Amer. Art*, p. 11.

LOVE, Jim. American, born 1927.

379 FIGURE. (1959) Assemblage: welded steel and cast iron with brush, 16″ (40.6 cm) high. Larry Aldrich Foundation Fund. 299.61. Repr. *Suppl. XI*, p. 39.

LOWRY, L. S. (Laurence Stephen Lowry). British, 1887–1976.

437 SHIPS NEAR CUMBERLAND COAST. 1963. Oil on composition board, 11⁷/₈ x 19¹/₄″ (30.1 x 48.7 cm). Blanchette Rockefeller Fund. 572.64.

LOZANO. See RODRÍGUEZ LOZANO.

LUNDQUIST, Evert. Swedish, born 1904.

199 POTTERY, NUMBER 9. (1949) Oil on canvas, 46¹⁄₈ x 41³⁄₈″ (117 x 105 cm). Gift of Mrs. G. P. Raymond. 123.61. Repr. *Suppl. XI*, p. 21.

LURÇAT, Jean. French, 1892–1966.

192 ENCHANTED ISLE. (c. 1928) Oil on canvas, 15¹⁄₄ x 24¹⁄₈″ (38.7 x 61.3 cm). Gift of Bernard Davis. 339.41.

LYTLE, Richard. American, born 1935.

ICARUS DESCENDED. (1958) Oil on canvas, 62³⁄₈ x 70¹⁄₄″ (158.4 x 178.3 cm). Elizabeth Bliss Parkinson Fund. 130.58. Repr. *Suppl. VIII*, p. 10; *16 Amer.*, p. 45.

MacBRYDE, Robert. British, born 1913.

268 WOMAN IN A RED HAT. (1947) Oil on canvas, 50 x 28¹⁄₂″ (127 x 72.4 cm). Acquired through the Lillie P. Bliss Bequest. 253.48. Repr. *Suppl. I*, p. 14.

McCRACKEN, John. American, born 1934.

THE ABSOLUTELY NAKED FRAGRANCE. 1967. Plywood covered with fiberglass and resin, sanded and polished, 10′¹⁄₄″ x 20³⁄₈″ x 3¹⁄₄″ (305.3 x 51.5 x 8.2 cm). D. and J. de Menil Fund. 4.69.

MACDONALD-WRIGHT, Stanton. American, 1890–1973. In France 1907–16.

STILL LIFE SYNCHROMY. 1913. Oil on canvas, 20 x 20″ (50.8 x 50.8 cm). Given anonymously. 347.49.

224 SYNCHROMY. (1917) Oil on canvas, 31 x 24″ (78.8 x 61 cm). Given anonymously. 346.49. Repr. *Suppl. II*, p. 11.

SYNCHROMY IN BLUE. (c. 1917–18) Oil on canvas, 26¹⁄₄ x 20¹⁄₈″ (66.4 x 51.1 cm). The Sidney and Harriet Janis Collection (fractional gift). 629.67. Repr. *Janis*, p. 21.

TRUMPET FLOWERS. 1919. Oil on canvas, 18¹⁄₈ x 13¹⁄₈″ (45.8 x 33.2 cm). The Sidney and Harriet Janis Collection (fractional gift). 630.67. Repr. *Janis*, p. 21.

431 EMBARKATION. 1962. Oil on plywood, 48¹⁄₄ x 36¹⁄₈″ (122.3 x 91.5 cm). Gift of Mr. and Mrs. Walter Nelson Pharr. 120.65.

MacENTYRE, Eduardo A. Argentine, born 1929.

505 GENERATIVE PAINTING: BLACK, RED, ORANGE. 1965. Oil on canvas, 64³⁄₄ x 59″ (164.9 x 150.4 cm). Inter-American Fund. 3.67.

McEWEN, Jean. Canadian, born 1923.

OCHRE CELL. 1961. Oil on canvas, 30 x 30″ (76.2 x 76.2 cm). Gift of the Women's Committee of the Art Gallery of Toronto. 383.61. Repr. *Suppl. XI*, p. 55.

349 PLUMB LINE IN YELLOW. 1961. Oil on canvas, 60¹⁄₄ x 60¹⁄₈″ (152.8 x 152.7 cm). Gift of Mr. and Mrs. Samuel J. Zacks. 2.62. Repr. *Suppl. XII*, p. 21.

McFADDEN, Elizabeth. American, born 1912.

BANNERS OF THE SUN. 1955. Collage of fabric and paper on corrugated cardboard, 18¹⁄₄ x 16¹⁄₈″ (46.4 x 40.7 cm). Purchase. 576.56. Repr. *Suppl. VI*, p. 22.

McGARRELL, James. American, born 1930.

285 REST IN AIR. 1958. Oil on composition board, 47⁷⁄₈ x 59⁵⁄₈″ (121.5 x 151.4 cm). Larry Aldrich Foundation Fund. 12.60. Repr. *New Images*, p. 105; *Suppl. X*, p. 27.

MACHLIN, Sheldon. American, 1918–1975.

509 SPACE BOX. (1963) Painted aluminum, 6 x 17⁵⁄₈ x 5″ (15.2 x 44.6 x 12.7 cm). Larry Aldrich Foundation Fund. 111.65.

MacIVER, Loren. American, born 1909.

243 SHACK. (1934) Oil on canvas, 20¹⁄₈ x 24″ (51.1 x 61 cm). Gift of Abby Aldrich Rockefeller. 399.38. Repr. *Art in Our Time*, no. 136.

YELLOW SEASON. (1938) Oil on canvas, 30¹⁄₈ x 36¹⁄₈″ (76.5 x 91.8 cm). Extended loan from the United States WPA Art Program. E.L.39.1777.

243 HOPSCOTCH. (1940) Oil on canvas, 27 x 35⁷⁄₈″ (68.6 x 91.1 cm). Purchase. 1649.40. Repr. *Masters*, p. 160.

243 RED VOTIVE LIGHTS. (1943) Oil on wood, 20 x 25⁵⁄₈″ (50.8 x 65.1 cm). James Thrall Soby Fund. 4.45. Repr. *Ptg. & Sc.*, p. 170.

JIMMY SAVO'S SHOES. 1944. Oil on canvas, 22¹⁄₈ x 30¹⁄₈″ (56.1 x 76.4 cm). Gift of Mr. and Mrs. Harry G. Liese in memory of Dr. Morton Singer. 1520.68.

MACK, Heinz. German, born 1931.

510 SILVER DYNAMO. 1964. Motor-driven wheel covered with sheet aluminum in a glass-covered, aluminum-lined box, 60 x 60 x 7″ (152.4 x 152.4 x 17.4 cm). Elizabeth Bliss Parkinson Fund. 1239.64.

MACKE, August. German, 1887–1914.

71 SUSANNA AND THE ELDERS. 1913. Colored inks, 9¹⁄₈ x 9⁷⁄₈″ (23.2 x 25 cm). Gift of Mr. and Mrs. Walter Bareiss. 573.56. Repr. *Suppl. VI*, p. 14.

71 LADY IN A PARK. 1914. Oil on canvas, 38¹⁄₂ x 23¹⁄₄″ (97.8 x 58.9 cm). Gift of the Henry Pearlman Foundation. 16.56. Repr. *Suppl. VI*, p. 14.

McNEIL, George. American, born 1908.

334 CONSTANZA. 1958. Oil on composition board, 47⁷⁄₈ x 47⁷⁄₈″ (121.6 x 121.6 cm). Larry Aldrich Foundation Fund. 17.59. Repr. *Suppl. IX*, p. 20.

McWILLIAM, Frederick Edward. British, born 1909.

296 LAZARUS, II. (1955) Bronze, 38⁵⁄₈″ (98 cm) high, at base 7¹⁄₂″ (18.9 cm) diameter. Gift of Dr. and Mrs. Arthur Lejwa. 557.56. Repr. *Suppl. VI*, p. 27.

MAGALHÃES, Aloisio. Brazilian, born 1927.

LANDSCAPE. 1956. Gouache, pen and ink, 12⁷⁄₈ x 19⁵⁄₈″ (32.6 x 49.8 cm). Inter-American Fund. 13.57. Repr. *Suppl. VII*, p. 22.

MAGARIÑOS D., Victor. Argentine, born 1924.

Untitled. (c. 1964) Felt pen with colored inks on paper, 10¹⁄₄ x 12¹⁄₂″ (25.8 x 31.7 cm). Given anonymously. 588.66.

Untitled. (c. 1964) Watercolor, felt pens with colored inks on paper, 10¹⁄₈ x 12¹⁄₂″ (25.7 x 31.7 cm). Inter-American Fund. 589.66.

Untitled. (c. 1964) Felt pens with colored inks and gouache on paper, 10¹⁄₈ x 12⁵⁄₈″ (25.7 x 31.8 cm). Inter-American Fund. 590.66.

Untitled. (c. 1964) Felt pens with colored inks and oil on paper, 10¹⁄₈ x 12¹⁄₂″ (25.6 x 31.7 cm). Inter-American Fund. 591.66.

Untitled. (c. 1964) Felt pens with colored inks on paper, 10¹⁄₈ x 12¹⁄₂″ (25.7 x 31.7 cm). Inter-American Fund. 592.66.

503 OBJECT: LIGHT-FORM VARIATIONS. 1965. Synthetic polymer paint on thirty-six glass squares projecting at right angles from painted composition board, 11⅝ x 11½ x 1¾" (29.3 x 29.1 x 4.4 cm). Inter-American Fund. 4.67.

MAGRITTE, René. Belgian, 1898–1967.

411 THE MENACED ASSASSIN [L'Assassin menacé]. (1926) Oil on canvas, 59¼ x 6'4⅞" (150.4 x 195.2 cm). Kay Sage Tanguy Fund. 247.66. Repr. Magritte, p. 10.

180 THE FALSE MIRROR [Le Faux Miroir]. (1928) Oil on canvas, 21¼ x 31⅞" (54 x 80.9 cm). Purchase. 133.36. Repr. Ptg. & Sc., p. 199; Magritte, p. 25; in color, Invitation, p. 95.

THE PALACE OF CURTAINS, III [Le Palais des rideaux]. (1928–29) Oil on canvas, 32 x 45⅞" (81.2 x 116.4 cm). The Sidney and Harriet Janis Collection (fractional gift). 631.67. Repr. Magritte, p. 24; Janis, p. 57.

ETERNITY. 1935. Oil on canvas, 25⅝ x 31⅞" (65 x 80.9 cm). Gift of Harry Torczyner. 432.72.

180 PORTRAIT [Le Portrait]. (1935) Oil on canvas, 28⅞ x 19⅞" (73.3 x 50.2 cm). Gift of Kay Sage Tanguy. 574.56. Repr. Suppl. VI, p. 20; in color, Magritte, frontispiece.

180 THE EMPIRE OF LIGHT, II [L'Empire des lumières, II]. 1950. Oil on canvas, 31 x 39" (78.8 x 99.1 cm). Gift of D. and J. de Menil. 16.51. Repr. Suppl. III, p. 15; in color, Magritte, p. 50.

180 MEMORY OF A VOYAGE [Souvenir de voyage]. 1955. Oil on canvas, 63⅞ x 51¼" (162.2 x 130.2 cm). Gift of D. and J. de Menil. 607.59. Repr. Suppl. IX, p. 14; Magritte, p. 53. Note: the subject is Marcel Lecomte, the Belgian poet.

MAILLOL, Aristide. French, 1861–1944.

40 THE MEDITERRANEAN. (1902–05) Bronze, 41" (104.1 cm) high, at base 45 x 29¾" (114.3 x 75.6 cm). Gift of Stephen C. Clark. 173.53. Repr. Masters, p. 43; Sc. of 20th C., pp. 72–74; What Is Mod. Sc., p. 39.

40 DESIRE. (1906–08) Tinted plaster relief, 46⅞ x 45" (119.1 x 114.3 cm). Gift of the artist. 7.30. Repr. Ptg. & Sc., p. 238; Sc. of 20th C., p. 79; What Is Mod. Sc., p. 115. Note: plaster made from the original mold in 1925 and approved by the sculptor.

HEAD OF FLORA. (1910–11) Bronze, 14¾" (37.5 cm) high. Given anonymously. 599.39.

SPRING. (1910–11) Bronze, 66⅛ x 21 x 13" (168 x 53.5 x 33 cm), including bronze base 1¾ x 10¾ x 10½" (4.5 x 27.5 x 26.6 cm). Gift of Mr. and Mrs. Alexandre P. Rosenberg. 1404.74. Note: one of four figures of the Seasons commissioned by the Russian collector Ivan A. Morosoff in 1910. Three casts were executed during Maillol's lifetime. The first, by Godard in 1911, is in the Pushkin Museum, Moscow. Another, later cast is in a Swiss collection. This cast by Valsuani in natural patina was finished after foundry in the artist's studio, as shown by the marks of chiselling, hammering, and filing visible on the entire surface.

40 SUMMER. (1910–11) Tinted plaster, 64" (162.5 cm) high, at base 13¼ x 11¾" (33.6 x 29.8 cm). Gift of the artist. 9.30. Repr. Ptg. & Sc., p. 237. Note: plaster made from the original mold in 1925 and approved by the sculptor.

41 TORSO OF A WOMAN. (c. 1925) Bronze, 40" (101.6 cm) high, at base 10½ x 10½" (26.7 x 26.7 cm). Sam A. Lewisohn Bequest. 3.52. Repr. Suppl. IV, p. 6.

40 SEATED FIGURE. (c. 1930?) Terra cotta, 9" (22.9 cm) high, at base 2⅜ x 5⅜" (6 x 13.7 cm). Gift of Mrs. Saidie A. May. 391.42. Repr. Ptg. & Sc., p. 241; Sc. of 20th C., p. 82.

41 THE RIVER. (Begun 1938–39, completed 1943) Lead, 53¾ x 7'6" (136.5 x 228.6 cm), at base 67 x 27¾" (170.1 x 70.4 cm). Mrs.

Simon Guggenheim Fund. 697.49. Repr. Suppl. I, p. 26; Masters, p. 44; Sc. of 20th C., pp. 80, 81.

MAKOWSKI, Zbigniew. Polish, born 1930.

465 SEPARATE OBJECTS. 1963. Oil on canvas, 32 x 39⅜" (81.3 x 100 cm). Gift of Mr. and Mrs. Maurice A. Lipschultz. 112.65.

Untitled. 1964. Watercolor and ink, 4¼ x 3¾" (10.8 x 9.5 cm). Gift of Mr. and Mrs. Irwin Hersey. 630.65.

MALEVICH, Kasimir. Russian, 1878–1935. In Germany 1927.

Exact dating of Malevich's Suprematist paintings is difficult to determine, as is the precise way they should be hung and reproduced; the same painting may appear in photographs of Malevich exhibitions during his lifetime right side up, upside down, or sideways.

128 WOMAN WITH WATER PAILS: DYNAMIC ARRANGEMENT. 1912. Oil on canvas, 31⅝ x 31⅝" (80.3 x 80.3 cm). 815.35. Repr. Ptg. & Sc., p. 107.

128 PRIVATE OF THE FIRST DIVISION. 1914. Oil on canvas with collage of postage stamp, thermometer, etc., 21⅛ x 17⅝" (53.7 x 44.8 cm). 814.35.

128 SUPREMATIST COMPOSITION: AIRPLANE FLYING. 1914. Oil on canvas, 22⅞ x 19" (58.1 x 48.3 cm). Purchase. 248.35. Repr. Ptg. & Sc., p. 113; Mod. Art in Your Life, p. 20. Note: dated 1914 on back of canvas. Exhibited Petrograd, December 1915. There is documentary evidence that the ill., p. 128, is right side up and somewhat less evidence that it is upside down.

128 SUPREMATIST COMPOSITION: RED SQUARE AND BLACK SQUARE. (1914 or 1915?) Oil on canvas, 28 x 17½" (71.1 x 44.5 cm). 816.35. Repr. Cubism, fig. 113; in color, Invitation, p. 36. Note: exhibited in Petrograd, December 1915, as shown on p. 128. Early editions of Cubism show large black square below.

129 SUPREMATIST COMPOSITION. Oil on canvas, 31⅝ x 31⅝" (80.3 x 80.3 cm). 818.35. Note: a related pencil drawing by the artist is dated 1914–15 but the painting may date from a year or two later.

129 SUPREMATIST COMPOSITION. (1916–17?) Oil on canvas, 38½ x 26⅛" (97.8 x 66.4 cm). 819.35. Repr. Ptg. & Sc., p. 114.

129 SUPREMATIST COMPOSITION: WHITE ON WHITE. (1918?) Oil on canvas, 31¼ x 31¼" (79.4 x 79.4 cm). 817.35. Repr. Ptg. & Sc., p. 113. Note: just how this painting should be hung and reproduced is problematic: a photograph of a Malevich exhibition, probably Moscow, 1920, shows the painting hung with the square near the lower left-hand corner. It is hung in the Museum galleries with the square near the upper right-hand corner.

MALLARY, Robert. American, born 1917.

389 IN FLIGHT. 1957. Relief of wood, dust, sand, synthetic polymer resin on painted plywood, 43½" x 6'7⅝" x 4⅜" (110.4 x 202.2 x 11.1 cm). Larry Aldrich Foundation Fund. 15.59. Repr. Recent Sc. U.S.A.; 16 Amer., p. 49.

EARTH MOTHER. 1958. Relief of composition stone in resin base over wooden supports, 6'5⅛" x 48" (195.8 x 121.8 cm). Gift of Philip Johnson. 524.71. Repr. 16 Amer., p. 51, with title Nambe.

389 PHOENIX. 1960. Relief of cardboard and synthetic resins with sand over wood supports, 7'10½" x 6'7½" (240 x 202 cm). Gift of Allan Stone. 269.63.

MALLORY, Ronald. American, born 1935.

508 Untitled. 1966. Motor-driven construction with mercury sealed in plastic, 19¾ x 19¾ x 8" (50.2 x 50.2 x 20.3 cm). Larry Aldrich Foundation Fund. 196.66. Note: one clockwise revolution occurs every two minutes.

MANESSIER, Alfred. French, born 1911.

395 FIGURE OF PITY [*Grande figure de pitié*]. 1944–45. Oil on canvas, 57³/₄ x 38¹/₄″ (146.7 x 97.2 cm). Gift of Mr. and Mrs. Charles Zadok. 590.63. Repr. *New Decade*, p. 27.

EVOCATION OF THE ENTOMBMENT. 1948. Watercolor, 3¹/₈ x 11″ (8 x 27.9 cm). Mrs. Cornelius J. Sullivan Fund. 255.48.

446 FOR THE FEAST OF CHRIST THE KING. 1952. Oil on canvas, 6′7″ x 59¹/₈″ (200.5 x 150 cm). Abby Aldrich Rockefeller Fund. 197.66. Repr. *New Decade*, p. 30.

MANGOLD, Robert. American, born 1937.

¹/₂ W SERIES. 1968. Synthetic polymer paint on composition board, in two parts, each 48¹/₄ x 48¹/₄″ (122.5 x 122.4 cm); overall, 48¹/₄″ x 8′1/₂″ (122.5 x 245.1 cm). Larry Aldrich Foundation Fund. 239.69a–b.

MANOLO (Manuel Martínez Hugué). Spanish, 1872–1945. Worked in Paris.

43 STANDING NUDE. (1912) Bronze, 9³/₈″ (23.8 cm) high, at base 4¹/₂ x 4″ (11.4 x 10.2 cm) (irregular). Given anonymously. 597.39.

43 GRAPE HARVESTER. (1913) Bronze, 17³/₄″ (45 cm) high, at base 7 x 6″ (17.8 x 15.3 cm). Gift of Dr. and Mrs. Arthur Lejwa. 260.57. Repr. *Suppl. VII*, p. 8.

MAN RAY. American, 1890–1976. Lived in Paris.

225 THE ROPE DANCER ACCOMPANIES HERSELF WITH HER SHADOWS. 1916. Oil on canvas, 52″ x 6′1³/₈″ (132.1 x 186.4 cm). Gift of G. David Thompson. 33.54. Repr. *Abstract Ptg. & Sc.*, p. 57; in color, *Invitation*, p. 45.

225 ADMIRATION OF THE ORCHESTRELLE FOR THE CINEMATOGRAPH. 1919. Gouache, wash, and ink, airbrushed, 26 x 21¹/₂″ (66 x 54.6 cm). Gift of A. Conger Goodyear. 231.37. Repr. *Ptg. & Sc.*, p. 212.

417 CADEAU [*Gift*]. (c. 1958. Replica of 1921 original) Painted flatiron with row of thirteen tacks, heads glued to bottom, 6¹/₈ x 3⁵/₈ x 4¹/₂″ (15.3 x 9 x 11.4 cm). James Thrall Soby Fund. 249.66. Repr. *Dada, Surrealism*, p. 35 (original); *Object Transformed*, p. 28. *Note*: one of five or six replicas made before 1963. In 1963, the artist produced, signed, and numbered ten additional copies.

417 EMAK BAKIA. 1962. Replica of 1926 original. Cello fingerboard and scroll with horsehair, 29¹/₄ x 5³/₄ x 10³/₄″ (74.2 x 14.5 x 27.1 cm) on wood base in two parts, 1⁵/₈ x 11 x 11¹/₈″ (4.2 x 27.9 x 28.2 cm). Kay Sage Tanguy Fund. 5.67. *Note*: Emak Bakia is the name of the Basque villa where the artist worked on the film of the same name, 1927.

417 INDESTRUCTIBLE OBJECT (or OBJECT TO BE DESTROYED). 1964. Replica of 1923 original. Metronome with cutout photograph of eye on pendulum, 8⁷/₈ x 4³/₈ x 4⁵/₈″ (22.5 x 11 x 11.6 cm). James Thrall Soby Fund. 248.66a–e. Repr. *Assemblage*, p. 49; *The Machine*, p. 153 (other replicas). *Note*: the original *Object to Be Destroyed* was destroyed in 1957, then remade in 1958 with the title *Indestructible Object*. "Since 1940, I made a replica from time to time, in all about five examples. These including the one you have I consider originals bearing the original eye." One hundred replicas were produced in 1965.

MANSO, Leo. American, born 1914.

381 ASCENT 3. (1962) Collage of painted fabric on cardboard, 26 x 12⁵/₈″ (65.9 x 32.1 cm) (composition). Gift of Mr. and Mrs. Sidney Elliott Cohn. 12.63.

EARTH 2. (1962) Collage of painted fabric and paper on cardboard, 23 x 20″ (58.3 x 50.6 cm). Gift of Dr. and Mrs. Ronald Neschis. 13.63.

MANZONI, Piero. Italian, 1933–1963.

LINE 1000 METERS LONG. 1961. Chrome-plated metal drum containing a roll of paper with an ink line drawn along its 1000-meter length, 20¹/₄″ high x 15³/₈″ diameter (51.2 x 38.8 cm). Inscribed: *CONTIENE UNA LINEA LUNGA 1000 METRI/ ESEGUITA DA PIERO MANZONI/IL 24 LUGLIO 1961*. Gift of Fratelli Fabbri Editori and Purchase. 110.73.

MANZÙ, Giacomo. Italian, born 1908.

MRS. MUSSO. 1941. Bronze, 23¹/₄ x 16¹/₄ x 14³/₄″ (59.2 x 41.3 x 37.5 cm) on marble base, 3⁷/₈ x 12 x 11″ (10 x 30.6 x 28.1 cm). Gift of Mrs. Jacob M. Kaplan. 721.76.

292 PORTRAIT OF A LADY. (1946) Bronze (cast 1955), 59¹/₄ x 23¹/₄ x 44³/₈″ (150.5 x 59 x 112.5 cm). A. Conger Goodyear Fund. 193.56. Repr. *Suppl. VI*, p. 26; another cast, *20th-C. Italian Art*, pl. 125. *Note*: the subject is Mrs. Alice Lampugnani.

MAPANDA, Kumberai. Rhodesian, Shona tribe, born c. 1940.

478 LITTLE MASK. (1964) Stone (steatite), 4³/₄ x 3⁵/₈ x 2⁵/₈″ (11.8 x 9.2 x 6.4 cm). Katherine S. Dreier Fund. 2103.67.

MARC, Franz. German, 1880–1916.

403 BLUE HORSE WITH RAINBOW. (1913) Watercolor, gouache, and pencil, 6³/₈ x 10¹/₈″ (16.2 x 25.7 cm). John S. Newberry Collection. 2.64.

MARCA-RELLI, Conrad. American, born 1913.

382 SLEEPING FIGURE. 1953–54. Collage of painted canvas, 52¹/₈″ x 6′5⁵/₈″ (132.4 x 197.3 cm). Mr. and Mrs. Walter Bareiss Fund. 337.55. Repr. *Suppl. VI*, p. 23.

MARCHAND, André. French, born 1907.

THE KNIFE. Oil on canvas, 18¹/₈ x 21⁵/₈″ (46 x 54.9 cm). Gift of Mrs. Sam A. Lewisohn. 55.52.

MARCKS, Gerhard. German, born 1889.

203 THE RUNNERS. (1924) Bronze, 7³/₄″ (19.6 cm) high, at base 7⁷/₈ x 2¹/₄″ (20 x 5.7 cm). Gift of Abby Aldrich Rockefeller. 625.39. Repr. *Ptg. & Sc.*, p. 248.

203 CRUCIFIX. (1948) Bronze, 23 x 18⁵/₈″ (58.5 x 47.1 cm), on wood cross 27⁵/₈ x 21⁷/₈″ (72 x 55.5 cm). Gift of Mrs. John D. Rockefeller 3rd. 338.55. Repr. *Suppl. VI*, p. 18.

203 FREYA. (1949) Bronze, 66⁵/₈″ (169.2 cm) high, at base 19¹/₂ x 16⁷/₈″ (49.5 x 42.9 cm). Gift of Curt Valentin. 271.54. Repr. *Suppl. V*, p. 13.

203 AMAZON. (1949–50) Bronze, 26″ (66 cm) high, at base 5¹/₄ x 5¹/₄″ (13.4 x 13.4 cm). Gift of Curt Valentin. 17.51. Repr. *Suppl. III*, p. 21.

MARCOUSSIS, Louis. Polish, 1883–1941. To France 1903.

100 STILL LIFE WITH ZITHER. 1919. Watercolor, oil, ink, and pencil on paper, 16³/₄ x 9¹/₂″ (42.5 x 24.1 cm). Katherine S. Dreier Bequest. 174.53.

MARDEN, Brice. American, born 1938.

GROVE GROUP, I. 1973. Oil and wax on canvas, 6′ x 9′1/₈″ (182.8 x 274.5 cm). Treadwell Corporation Fund. 151.73.

MARGULES, De Hirsh. American, born Rumania. 1899–1965. To U.S.A. 1899.

PORTUGUESE DOCK, GLOUCESTER. 1936. Watercolor, 14⁵/₈ x

22⁷/₈" (37.2 x 58.1 cm). Gift of A. Conger Goodyear (by exchange). 107.36. Repr. *La Pintura*, p. 138.

MARI, Enzo. Italian, born 1932.

509 DYNAMIC OPTICAL DEFORMATION OF A CUBE IN A SPHERE. (1958–63) Transparent polyester resin, 4" (10.1 cm) diameter. Larry Aldrich Foundation Fund. 501.65. Repr. *Responsive Eye*, p. 50.

MARIA (Maria Martins). Brazilian, 1910–1973. In U.S.A. 1939–1948.

313 CHRIST. (1941) Jacaranda wood, 7'10¹/₂" (240 cm) high, base 20" (50.8 cm) diameter. Gift of Nelson A. Rockefeller. 558.41. Repr. *Ptg. & Sc. (I)*, p. 58.

313 THE IMPOSSIBLE, III. (1946) Bronze, 31¹/₂ x 32¹/₂" (80 x 82.5 cm). Purchase. 138.46. Repr. *Ptg. & Sc.*, p. 293.

313 THE ROAD; THE SHADOW; TOO LONG, TOO NARROW. (1946) Bronze, 56¹/₂ x 71³/₄ x 23³/₈" (143.4 x 179.7 x 59.4 cm). Brazil Fund. 573.64.

MARIANO (Mariano Rodríguez). Cuban, born 1912.

THE COCK. 1941. Oil on canvas, 29¹/₄ x 25¹/₈" (74.3 x 63.8 cm). Gift of the Comisión Cubana de Cooperación Intelectual. 30.42. Repr. *Latin-Amer. Coll.*, p. 52.

FIGURES IN A LANDSCAPE. 1942. Watercolor, 23 x 28" (58.4 x 71.1 cm). Inter-American Fund. 718.42.

MARIN, John. American, 1870–1953. In Paris 1905–10.

221 LOWER MANHATTAN. 1920. Watercolor, 21⁷/₈ x 26³/₄" (55.4 x 68 cm). The Philip L. Goodwin Collection. 104.58. Repr. in color, *Art in Prog.*, opp. p. 52; *Bulletin*, Fall 1958, p. 10.

221 CAMDEN MOUNTAIN ACROSS THE BAY. 1922. Watercolor, 17¹/₄ x 20¹/₂" (43.8 x 52.1 cm). Gift of Abby Aldrich Rockefeller (by exchange). 16.36. Repr. *Ptg. & Sc.*, p. 70; *Natural Paradise*, p. 114.

221 LOWER MANHATTAN (COMPOSING DERIVED FROM TOP OF WOOLWORTH). 1922. Watercolor and charcoal with paper cutout attached with thread, 21⁵/₈ x 26⁷/₈" (54.9 x 68.3 cm). Acquired through the Lillie P. Bliss Bequest. 143.45. Repr. *Ptg. & Sc.*, p. 71; in color, *Masters*, p. 114; in color, *Invitation*, p. 123.

221 BUOY, MAINE. 1931. Watercolor, 14³/₄ x 19¹/₄" (37.5 x 48.9 cm). Gift of Philip L. Goodwin. 170.34. Repr. *Ptg. & Sc.*, p. 70; *Natural Paradise*, p. 31.

MARINI, Marino. Italian, born 1901.

293 LAMBERTO VITALI. (1945) Bronze (cast 1949), 9" (22.9 cm) high. Acquired through the Lillie P. Bliss Bequest. 694.49. Repr. *Suppl. II*, p. 28. *Note*: the subject is a Milanese businessman, art critic, and collector.

293 HORSE AND RIDER. (1947) Bronze, 64 x 62" (162.6 x 157.5 cm), at base 29 x 16³/₄" (73.7 x 42.6 cm). Promised gift and extended loan from Mrs. John D. Rockefeller 3rd. E.L.55.1867. Repr. *20th-C. Italian Art*, pl. 119.

293 MIRACLE. (1953–54) Bronze, 7'11¹/₂" x 6'1" x 54⁷/₈" (242.5 x 185.2 x 139.2 cm). Mrs. Simon Guggenheim Fund. 77.62. Repr. *Suppl. XII*, p. 40.

293 CURT VALENTIN. (1954) Bronze, 9¹/₈" (23.2 cm) high. Gift of the artist. 17.55. Repr. *Suppl. V*, p. 13.

MARISOL (Marisol Escobar). Venezuelan, born Paris 1930. To U.S.A. 1950.

394 THE FAMILY. (1962) Painted wood and other materials in three

sections, 6'10⁵/₈" x 65¹/₂" (209.8 x 166.3 cm). Advisory Committee Fund. 231.62a–c. Repr. *Amer. 1963*, p. 71. *Note*: The Family is based on a castoff photograph found among wastepaper near the artist's studio. Names are unknown.

LOVE. 1962. Plaster and glass (Coca Cola bottle), 6¹/₄ x 4¹/₈ x 8¹/₈" (15.8 x 10.5 x 20.6 cm). Gift of Claire and Tom Wesselmann. 1405.74.

LBJ. (1967) Synthetic polymer paint and pencil on wood construction, 6'8" x 27⁷/₈" x 24⁵/₈" (203.1 x 70.9 x 62.4 cm). Gift of Mr. and Mrs. Lester Avnet. 776.68.

PORTRAIT OF SIDNEY JANIS SELLING PORTRAIT OF SIDNEY JANIS BY MARISOL, BY MARISOL. (1967–68) Mixed mediums on wood, 69 x 61¹/₂ x 21⁵/₈" (175.2 x 156.2 x 54.8 cm). The Sidney and Harriet Janis Collection (fractional gift). 2356.67. Repr. *Janis*, p. 169.

MARKMAN, Ronald. American, born 1931.

443 FAMILY CIRCLE. (1965) Synthetic polymer paint on canvas, 48⁷/₈ x 56¹/₂" (124 x 143.4 cm). Larry Aldrich Foundation Fund. 107.66.

MARSH, Reginald. American, 1898–1954.

234 IN FOURTEENTH STREET. 1934. Egg tempera on composition board, 35⁷/₈ x 39³/₄" (91.1 x 101 cm). Gift of Mrs. Reginald Marsh. 262.57. Repr. *Suppl. VII*, p. 12.

MARSICANO, Nicholas. American, born 1914.

466 SHE. (1959) Oil on canvas, 60⁵/₈ x 52¹/₈" (153.8 x 132.2 cm). Gift of Larry Aldrich. 938.65.

MARTIN, Agnes. American, born Canada 1912. To U.S.A. 1933.

RED BIRD. 1964. Synthetic polymer paint and colored pencil on canvas, 71¹/₈ x 71¹/₈" (180.5 x 180.5 cm). Gift of Philip Johnson. 514.70.

454 THE TREE. 1964. Oil and pencil on canvas, 6 x 6' (182.8 x 182.8 cm). Larry Aldrich Foundation Fund. 5.65.

UNTITLED NUMBER 5. 1975. Synthetic polymer paint and pencil on synthetic polymer gesso on canvas, 71⁷/₈" x 6'1/₄" (182.6 x 183.2 cm). Gift of the American Art Foundation. 287.76.

MARTIN, Fletcher. American, born 1904.

TROUBLE IN FRISCO. 1938. Oil on canvas, 30 x 36" (76.2 x 91.4 cm). Abby Aldrich Rockefeller Fund. 10.39. Repr. *Amer. 1942*, p. 99.

MARTIN, Phillip John. British, born 1927.

348 PAINTING, POSITANO. 1953. Enamel on paper, mounted on canvas, 59 x 39" (149.9 x 99.1 cm). Given anonymously. 247.54. Repr. *Suppl. V*, p. 27.

MARTÍNEZ, Ricardo. Argentine, born 1923.

442 COLORED INCOMPREHENSION. 1964. Pen and colored inks, and colored pencils on newspaper, 11³/₈ x 16³/₈" (28.9 x 41.4 cm). Inter-American Fund. 261.64.

MARTÍNEZ PEDRO, Luis. Cuban, born 1910.

AT THE BEACH OF JIBACOA. 1946. Watercolor and gouache on cardboard, 12¹/₂ x 9³/₈" (31.7 x 23.8 cm). Inter-American Fund. 14.47.

368 COMPOSITION 13. 1957. Oil on canvas, 58¹/₈ x 38" (147.5 x 96.5 cm). Gift of Mr. and Mrs. Joseph Cantor. 672.59. Repr. *Suppl. IX*, p. 19.

MARTINI, Arturo. Italian, 1889–1947.

202　DAEDALUS AND ICARUS. (1934–35) Bronze, 24 x 9⅝″ (61 x 24.3 cm). Aristide Maillol Fund. 345.49. Repr. *20th-C. Italian Art*, pl. 116; *Sc. of 20th C.*, p. 69.

MARX. See BURLE MARX.

MASON, Raymond. British, born 1922.

LANDSCAPE (THE LUBÉRON). 1973 (spring). Watercolor and pencil, 18⅝ x 24¼″ (47.3 x 61.5 cm). Mr. and Mrs. Milton J. Petrie Fund. 619.73.

MASSON, André. French, born 1896. In U.S.A. 1941–45.

CARD TRICK [*Le Tour de cartes*]. (1923) Oil on canvas, 28¾ x 19¾″ (73 x 50.2 cm). Gift of Mr. and Mrs. Archibald MacLeish. 1348.74. Repr. *Masson*, p. 99.

176　BATTLE OF FISHES. (1926) Sand, gesso, oil, pencil, and charcoal on canvas, 14¼ x 28¾″ (36.2 x 73 cm). Purchase 260.37. Repr. *Ptg. & Sc.*, p. 218; in color, *Masson*, p. 20.

FIGURE. (1926–27) Oil and sand on canvas, 18⅛ x 10½″ (46.1 x 26.9 cm). Gift of William Rubin. 111.73.

395　BATTLE OF A BIRD AND A FISH. (1927) Oil on canvas, 39⅜ x 25¾″ (100 x 65.2 cm). Gift of Richard L. Feigen. 591.63.

176　ANIMALS DEVOURING THEMSELVES. (1929) Pastel, 28¾ x 45¾″ (73 x 116.2 cm). Purchase. 256.35. Repr. *Fantastic Art* (3rd), p. 183; *Seurat to Matisse*, p. 68; *Masson*, p. 131.

LES POISSONIÈRES. 1930. Oil on canvas, 38⅜ x 51½″ (97.4 x 130.9 cm). Gift of Mr. and Mrs. William Mazer. 1406.74. Repr. *Masson*, p. 89.

176　STREET SINGER. 1941. Pastel and collage of paper, leaf, and dragonfly wings, 23½ x 17½″ (59.7 x 44.5 cm). Purchase. 158.42. Repr. *Ptg. & Sc.*, p. 218; *Masson*, p. 162.

177　LEONARDO DA VINCI AND ISABELLA D'ESTE. 1942. Oil on canvas, 39⅞ x 50″ (101.3 x 127 cm). Given anonymously. 72.43. Repr. *Ptg. & Sc.*, p. 219; *Masson*, p. 66.

177　MEDITATION ON AN OAK LEAF. 1942. Tempera, pastel, and sand on canvas, 40 x 33″ (101.6 x 83.8 cm). Given anonymously. 84.50. Repr. *Suppl. II*, p. 15; in color, *Masson*, p. 60.

ANDROMEDA. (1943) Tempera and sand on canvasboard, 12⅝ x 10″ (31.9 x 25.4 cm). Gift of Ruth Gilliland Hardman and William Kistler III. 376.75. Repr. *Masson*, p. 167.

THE KILL [*La Curée*]. (1944) Oil on canvas, 21¾ x 26¾″ (55.2 x 67.9 cm). Gift of the artist. 103.76. Repr. *Masson*, p. 65.

177　WEREWOLF. (1944) Pastel, brush and ink, 18 x 24″ (45.7 x 61 cm). Acquired through the Lillie P. Bliss Bequest. 126.44.

177　ATTACKED BY BIRDS. 1956. Oil and sand on canvas, 29⅝ x 35½″ (75 x 90.1 cm). Gift of Mr. and Mrs. Allan D. Emil. 270.63.

MASTROIANNI, Umberto. Italian, born 1910.

292　SOLOMON. 1958. Bronze, 26¾ x 21″ (67.9 x 53.2 cm). Given anonymously. 11.60. Repr. *Suppl. X*, p. 30.

MATARÉ, Ewald. German, 1887–1965.

202　COW. (1924) Bronze, 6⅞ x 13⅛″ (17.5 x 33.1 cm). Gift of Mrs. Heinz Schultz. 101.62. Repr. *Suppl. XII*, p. 12.

MATHIEU, Georges. French, born 1921.

PAINTING. 1947. Oil and gesso on plywood, 62⅞ x 47¼″ (159.7 x 120 cm). Gift of G. David Thompson. 660.59. Repr. *Suppl. IX*, p. 21.

347　MONTJOIE SAINT DENIS! 1954. Oil on canvas, 12′3⅝″ x 35½″ (375 x 90.2 cm). Gift of Mr. and Mrs. Harold Kaye. 198.55. Repr. *Suppl. V*, p. 27. *Note*: the title is a medieval French battle cry.

NUMBER 5. 1955. Oil on canvas, 38 x 64″ (96.5 x 162.5 cm). Gift of Samuel I. Rosenman. 505.64.

MATISSE, Henri. French, 1869–1954.

LEMONS AND BOTTLE OF DUTCH GIN. 1896. Oil on canvas, 12¼ x 11½″ (31.2 x 29.3 cm). Fractional gift of Mr. and Mrs. Warren Brandt. 722.76

48　STILL LIFE. (1899?) Oil on canvas, 18⅛ x 15″ (46 x 38.1 cm). Gift of A. Conger Goodyear. 7.49. Repr. *Matisse*, p. 301.

MALE MODEL [*L'Homme Nu; "Le Serf"; Académie bleue; Bevilacqua*]. (1900) Oil on canvas, 39⅛ x 28⅝″ (99.3 x 72.7 cm). Purchase. 377.75. Repr. *Matisse*, p. 304; *Matisse, 64 Paintings*, p. 23.

48　THE SERF. (1900–03) Bronze, 37⅜″ (92.3 cm) high, at base 12 x 13″ (30.3 x 33 cm). Mr. and Mrs. Sam Salz Fund. 553.56. Repr. *Suppl. VI*, p. 8; another cast, *Matisse*, p. 305; *Four Amer. in Paris*, pl. 13; *Sc. of Matisse*, p. 10.

MUSIC (SKETCH). (1907, summer) Oil on canvas, 29 x 24″ (73.4 x 60.8 cm). Gift of A. Conger Goodyear in honor of Alfred H. Barr, Jr. 78.62. Repr. *Suppl. XII*, p. 7; in color, *Matisse*, p. 79; *Four Amer. in Paris*, pl. 12. *Note*: study for the large composition now at the Hermitage, Leningrad.

48　RECLINING NUDE, I. (1907) Bronze, 13½ x 19¾″ (34.3 x 50.2 cm). Acquired through the Lillie P. Bliss Bequest. 143.51. Repr. *Suppl. III*, p. 5; *Matisse*, p. 337; *What Is Mod. Sc.*, p. 18; *Four Amer. in Paris*, pl. 16; *Sc. of Matisse*, p. 19.

48　SEATED FIGURE, RIGHT HAND ON GROUND. (1908) Bronze, 7½ x 5″ (19 x 12.6 cm). Abby Aldrich Rockefeller Fund. 198.52. Another cast repr. *Matisse*, p. 366; *Sc. of Matisse*, p. 21.

49　DANCE (FIRST VERSION). (1909, early) Oil on canvas, 8′6½″ x 12′9½″ (259.7 x 390.1 cm). Gift of Nelson A. Rockefeller in honor of Alfred H. Barr, Jr. 201.63. Repr. *Matisse*, p. 360; in color, *Invitation*, p. 42. *Note*: the second version, of 1910, is at the Hermitage, Leningrad.

50　BATHER. (1909, summer) Oil on canvas, 36½ x 29⅛″ (92.7 x 74 cm). Gift of Abby Aldrich Rockefeller. 17.36. Repr. *Ptg. & Sc.*, p. 40; in color, *Matisse*, p. 161.

48　LA SERPENTINE. (1909) Bronze, 22¼″ (56.5 cm) high, at base 11 x 7½″ (28 x 19 cm). Gift of Abby Aldrich Rockefeller. 624.39. Repr. *Ptg. & Sc.*, p. 250; *Matisse*, p. 367; *Sc. of Matisse*, p. 24, cover.

Series of four reliefs:

52　THE BACK, I. 1909. Bronze, 6′2⅜″ x 44½″ x 6½″ (188.9 x 113 x 16.5 cm). Mrs. Simon Guggenheim Fund. 4.52. Repr. *Masters*, p. 51; *Matisse*, p. 313 (with wrong date); *Sc. of Matisse*, p. 26.

52　THE BACK, II. (1913) Bronze, 6′2¼″ x 47⅝″ x 6″ (188.5 x 121 x 15.2 cm). Mrs. Simon Guggenheim Fund. 240.56. Repr. *Suppl. VI*, p. 8; *Sc. of Matisse*, p. 27.

53　THE BACK, III. (1916–17) Bronze, 6′2½″ x 44″ x 6″ (189.2 x 111.8 x 15.2 cm). Mrs. Simon Guggenheim Fund. 5.52. Repr. *Masters*, p. 51; *Matisse*, p. 458 (wrongly entitled *The Back, II*); *Sc. of Matisse*, p. 28.

53　THE BACK, IV. (1930) Bronze, 6′2″ x 44¼″ x 6″ (188 x 112.4 x 15.2 cm). Mrs. Simon Guggenheim Fund. 6.52. Repr. *Masters*, p. 51; plaster, *Matisse*, p. 459 (wrongly entitled *The Back, III*); *What Is Mod. Sc.*, p. 116; *Sc. of Matisse*, p. 29.

Series of five portraits of Jeannette (Jeanne Vaderin, a young woman who in 1910 was living in the Paris suburb of Clamart near Matisse's home):

52 JEANNETTE, I (Jeanne Vaderin, 1st state). (1910–13) Bronze, 13″ (33 cm) high. Acquired through the Lillie P. Bliss Bequest. 7.52. Repr. *Masters*, p. 50; another cast, *Matisse*, p. 368; *Sc. of Matisse*, p. 30.

52 JEANNETTE, II (Jeanne Vaderin, 2nd state). (1910–13) Bronze, 10³/₈″ (26.2 cm) high. Gift of Sidney Janis. 383.55. Repr. *Suppl. VI*, p. 9; another cast, *Matisse*, p. 369; *Sc. of Matisse*, p. 30.

53 JEANNETTE, III (Jeanne Vaderin, 3rd state). (1910–13) Bronze, 23³/₄″ (60.3 cm) high. Acquired through the Lillie P. Bliss Bequest. 8.52. Repr. *Masters*, p. 50; another cast, *Matisse*, p. 369; *Sc. of Matisse*, p. 30.

53 JEANNETTE, IV (Jeanne Vaderin, 4th state). (1910–13) Bronze, 24¹/₈″ (61.3 cm) high. Acquired through the Lillie P. Bliss Bequest. 9.52. Repr. *Masters*, p. 50; another cast, *Matisse*, p. 370; *Sc. of Matisse*, p. 31.

53 JEANNETTE, V (Jeanne Vaderin, 5th state). (1910–13) Bronze, 22⁷/₈″ (58.1 cm) high. Acquired through the Lillie P. Bliss Bequest. 10.52. Repr. *Sc. of 20th C.*, pp. 132, 133; *Masters*, p. 50; another cast, *Matisse*, p. 371; *Sc. of Matisse*, p. 31.

50 GOLDFISH AND SCULPTURE. (1911) Oil on canvas, 46 x 39⁵/₈″ (116.2 x 100.5 cm). Gift of Mr. and Mrs. John Hay Whitney. 199.55. Repr. *Private Colls.*, p. 7; in color, *Matisse*, p. 165.

51 THE RED STUDIO. (1911) Oil on canvas, 71¹/₄″ x 7′2¹/₄″ (181 x 219.1 cm). Mrs. Simon Guggenheim Fund. 8.49. Repr. *Suppl. I*, p. 6; in color, *Masters*, p. 49; *Matisse*, p. 162; in color, *Invitation*, p. 74.

50 THE BLUE WINDOW. (1911, autumn) Oil on canvas, 51¹/₂ x 35⁵/₈″ (130.8 x 90.5 cm). Abby Aldrich Rockefeller Fund. 273.39. Repr. *Ptg. & Sc.*, p. 41; in color, *Matisse*, p. 167.

VIEW OF NOTRE DAME. 1914. Oil on canvas, 58 x 37¹/₈″ (147.3 x 94.3 cm). Purchase. 116.75. Repr. *Matisse, 64 Paintings*, p. 35.

54 GOURDS. 1916 (summer). Oil on canvas, 25⁵/₈ x 31⁷/₈″ (65.1 x 80.9 cm). Mrs. Simon Guggenheim Fund. 109.35. Repr. *Ptg. & Sc.*, p. 42.

55 THE MOROCCANS. (1916) Oil on canvas, 71³/₈″ x 9′2″ (181.3 x 279.4 cm). Gift of Mr. and Mrs. Samuel A. Marx. 386.55. Repr. in color, *Matisse*, p. 172; *Paintings from MoMA*, p. 25; *School of Paris*, p. 15; in color, *Invitation*, p. 116.

56 PIANO LESSON. (1916) Oil on canvas, 8′1¹/₂″ x 6′11³/₄″ (245.1 x 212.7 cm). Mrs. Simon Guggenheim Fund. 125.46. Repr. *Ptg. & Sc.*, p. 43; in color, *Masters*, p. 52; *Matisse*, p. 175; in color, *Invitation*, p. 69.

54 THE ROSE MARBLE TABLE. (1917) Oil on canvas, 57¹/₂ x 38¹/₄″ (146 x 97 cm). Mrs. Simon Guggenheim Fund. 554.56. Repr. *Matisse*, p. 407; *Suppl. VI*, p. 9.

57 INTERIOR WITH A VIOLIN CASE. (1918–19, winter) Oil on canvas, 28³/₄ x 23⁵/₈″ (73 x 60 cm). Lillie P. Bliss Collection. 86.34. Repr. *Ptg. & Sc.*, p. 45; *Matisse*, p. 423.

57 TIARI. (1930) Bronze, 8″ (20.3 cm) high. A. Conger Goodyear Fund. 154.55. Repr. *Matisse*, p. 461; *What Is Mod Sc.*, p. 23; *Sc. of Matisse*, p. 40. *Note*: tiari (French, *tiaré*) is a Tahitian flower.

57 VENUS IN A SHELL, I. (1930) Bronze, 12¹/₄ x 7¹/₄ x 8¹/₈″ (31 x 18.3 x 20.6 cm). Gift of Pat and Charles Simon. 417.60. Repr. *Suppl. X*, p. 15; another cast, *Matisse*, p. 461; *Sc. of Matisse*, p. 40.

57 LEMONS AGAINST A FLEUR-DE-LIS BACKGROUND. 1943, March. Oil on canvas, 28⁷/₈ x 24¹/₄″ (73.4 x 61.3 cm). Loula D. Lasker Bequest. 382.61. Repr. *Matisse*, p. 489; *Suppl. XI*, p. 13.

58 Maquettes for a set of red and yellow liturgical vestments designed for the Chapel of the Rosary of the Dominican Nuns of Vence. (c. 1950) Gouache on cut-and-pasted paper. Chasuble, front: 52¹/₂″ x 6′1¹/₈″ (133.3 x 198.4 cm); back: 50¹/₂″ x 6′6¹/₂″ (128.2 x 199.4 cm).

Stole: 49 x 7¹/₂″ (124.5 x 19 cm) (design).
Maniple: 17 x 8³/₈″ (43.2 x 21.2 cm) (design).
Chalice Veil: 20¹/₄ x 20¹/₄″ (51.5 x 51.5 cm).
Burse: 10 x 8³/₄″ (25.4 x 22.2 cm).
Acquired through the Lillie P. Bliss Bequest. 176.53.1–.6. *Note*: the Museum also owns a set of silk vestments made after the above maquettes, and four other chasubles, green, black, violet, and red, without the minor vestments.

Design for cover of *Exhibition: H. Matisse*, introduction by Alfred H. Barr, Jr., The Museum of Modern Art, New York, 1951. (1951) Gouache on cut-and-pasted paper, 10⁵/₈ x 15³/₄″ (27 x 40 cm). Commissioned by the Museum. 419.53. Repr. in color, *Matisse*, cover.

59 Design for jacket of *Matisse: His Art and His Public* by Alfred H. Barr, Jr., The Museum of Modern Art, New York, 1951. (1951) Gouache on cut-and-pasted paper, 10⁵/₈ x 16⁷/₈″ (27 x 42.9 cm). Commissioned by the Museum. 418.53. Repr. in color, *Matisse*, jacket.

Maquette for NUIT DE NOËL. 1952. Gouache on cut-and-pasted paper, 10′7″ x 53¹/₂″ (312.8 x 135.9 cm). Gift of Time Inc. 421.53.1–.5. Repr. in color, *Last Works of Matisse*, pl. J. *Note*: the stained-glass window made after the above maquette is also owned by the Museum.

NUIT DE NOËL. 1952. Stained-glass window commissioned by *Life*, 1952. Metal framework, 11′3³/₄″ x 54³/₄″ x ⁵/₈″ (332.5 x 139 x 1 cm). Executed in workshop of Paul and Adeline Bony, Paris, under artist's supervision. Gift of Time Inc. 420.53.1–4.

THE SWIMMING POOL [*La Piscine*]. (1952) Nine-panel mural in two parts. Gouache on cut-and-pasted paper mounted on burlap, a–e, 7′6⁵/₈″ x 27′9¹/₂″ (230.1 x 847.8 cm); f–i, 7′6⁵/₈″ x 26′1¹/₂″ (230.1 x 796.1 cm). Mrs. Bernard F. Gimbel Fund. 302.75a–i.

MEMORY OF OCEANIA [*Souvenir d'Océanie*]. 1953. Gouache and crayon on cut-and-pasted paper over canvas, 9′4″ x 9′4⁷/₈″ (284.4 x 286.4 cm). Mrs. Simon Guggenheim Fund. 224.68.

MATTA (Sebastian Antonio Matta Echaurren). Chilean, born 1912. In U.S.A. 1939–48. Lives in Paris.

PAYSAGE FLAMMIFÈRE. (1940) Crayon and pencil on paper, 18¹/₈ x 22¹/₂″ (45.8 x 57.1 cm). The Sidney and Harriet Janis Collection (fractional gift). 632.67. Repr. *Janis*, p. 75.

306 LISTEN TO LIVING [*Écoutez vivre*]. 1941. Oil on canvas, 29¹/₂ x 37³/₈″ (74.9 x 94.9 cm). Inter-American Fund. 33.42. Repr. *Ptg. & Sc.*, p. 221; in color, *Masters*, p. 166.

307 LE VERTIGE D'ÉROS. (1944) Oil on canvas, 6′5″ x 8′3″ (195.6 x 251.5 cm). Given anonymously. 65.44. Repr. *Ptg. & Sc.*, p. 220; in color, *Matta*, p. 22; in color, *Invitation*, p. 91.

307 THE SPHERICAL ROOF AROUND OUR TRIBE (REVOLVERS). (1952) Tempera on canvas, 6′6⁵/₈″ x 9′7⁷/₈″ (199.7 x 294.5 cm). Gift of D. and J. de Menil. 16.54. Repr. *Suppl. V*, p. 22; *Matta*, p. 31.

MAUNY, Jacques. French, born 1892.

IN PORT. (Before 1932) Oil on cardboard, 11³/₄ x 11³/₄″ (29.8 x 29.8 cm). Given anonymously. 112.35.

PICASSO. (Before 1932) Gouache, 10³/₈ x 13⁷/₈″ (26.1 x 35.1 cm). Given anonymously. 114.35.

MAURER, Alfred. American, 1868–1932.

219 SELF-PORTRAIT. (c. 1927) Oil on composition board, 21¹/₂ x 18″ (54.6 x 45.7 cm). Bertram F. and Susie Brummer Foundation Fund. 290.61. Repr. *Suppl. XI*, p. 11.

MECHAU, Frank A. American, 1903–1946.

235 DANGERS OF THE MAIL. (1935) Study for mural in Post Office Department Building, Washington, D.C., 1937. Oil, tempera, and

pencil on paper, 25 x 54¹/₂″ (63.5 x 138.4 cm). Gift of A. Conger Goodyear. 101.36. Repr. *Ptg. & Sc.*, p. 165.

PONY EXPRESS. (1935) Study for mural in Post Office Department Building, Washington, D.C., 1937. Oil on paper, 25 x 54¹/₂″ (63.5 x 138.4 cm). Gift of A. Conger Goodyear. 100.36. Repr. *La Pintura*, p. 83.

MEHRING, Howard. American, born 1931.

457 NOVA. 1965. Synthetic polymer paint on canvas, 7′7⁷/₈″ x 70¹/₈″ (215.5 x 178 cm). Gift of Mr. and Mrs. Eugene M. Schwartz. 254.66.

MELOTTI, Fausto. Italian, born 1901.

SCULPTURE 17. (1935) Coated steel, 6′5¹/₂″ x 23³/₈″ x 9¹/₂″ (196.8 x 59.3 x 24 cm). Elizabeth Bliss Parkinson Fund. 207.70.

MÉRIDA, Carlos. Guatemalan, born 1891. Lives in Mexico.

214 TEMPO IN RED MAJOR. 1942. Wax crayon, 17⁷/₈ x 24″ (45.4 x 61 cm). Inter-American Fund. 738.42. Repr. *Ptg. & Sc.*, p. 224.

MERKIN, Richard. American, born 1938.

444 THE NIGHT THE NUT GOT LOOSE. (1965) Gouache and charcoal on paper over cardboard, 26 x 39³/₄″ (65.8 x 100.9 cm). Larry Aldrich Foundation Fund. 385.66.

MERRILD, Knud. American, born Denmark. 1894–1954. To U.S.A. 1921.

HERMA. 1935. Gesso-wax on paper, 10¹/₂ x 8¹/₂″ (26.7 x 21.6 cm). Purchase. 75.39. Repr. *Amer. 1942*, p. 110.

310 ARCHAIC FORM. 1936. Gesso-wax and pencil on paper, 10¹/₂ x 8³/₄″ (26.7 x 22.2 cm). Purchase. 73.39. Repr. *Amer. 1942*, p. 111; *Ptg. & Sc.*, p. 224.

SYNTHESIS. (c. 1936) Gesso-wax on paper, 10 x 9¹/₄″ (25.4 x 23.6 cm). Purchase. 74.39. Repr. *Amer. 1942*, p. 109.

310 PERPETUAL POSSIBILITY. 1942. Enamel on canvas over composition board, 20 x 16¹/₈″ (50.8 x 41.1 cm). Gift of Mrs. Knud Merrild. 85.60.

CHAIN REACTION. 1947. Oil on canvas over composition board, 17¹/₂ x 13¹/₂″ (44.5 x 34.3 cm). Gift of Alexander M. Bing. 144.51. Repr. *Suppl. III*, p. 17.

MERZ, Mario. Italian.

UNTITLED (A REAL SUM IS A SUM OF PEOPLE). (1972) Eleven framed photographs, spaced approximately 5¹/₂ inches apart, surmounted by ten argon numbers, a luminous tube transformer, and wires, overall, 24″ x 16′7¹/₄″ x 5¹/₈″ (60.9 x 506 x 13 cm). Mrs. Armand P. Bartos Fund. 129.74a–w.

MESSAGIER, Jean. French, born 1920.

448 JUNE CROSSING [*Traversée de juin*]. 1956. Oil on canvas, 58⁷/₈″ x 6′4³/₈″ (149.5 x 193.9 cm). Promised gift and extended loan from Mr. and Mrs. David Kluger. E.L.64.272.

METZINGER, Jean. French, 1883–1956.

100 LANDSCAPE. (1912–14?) Oil on canvas, 28³/₄ x 36¹/₄″ (73 x 92.1 cm). Gift of T. Catesby Jones. 410.41.

100 STILL LIFE WITH LAMP. (1916) Oil on canvas mounted on composition board, 32 x 23⁷/₈″ (81.2 x 60.5 cm). Gift of Mr. and Mrs. Harry Lewis Winston. 412.60. Repr. *Suppl. X*, p. 19.

403 COMPOSITION. (1919?) Oil on canvas, 31⁷/₈ x 25⁵/₈″ (81 x 64.9 cm). Gift of Mr. and Mrs. A. M. Adler. 1240.64.

MEZA, Guillermo. Mexican, born 1917.

287 DEMONSTRATION. (1942) Oil on canvas, 19³/₄ x 39³/₈″ (50.2 x 100 cm). Gift of Sam A. Lewisohn (by exchange). 739.42. Repr. *Ptg. & Sc.*, p. 179.

MIKI, Tomio. Japanese, born 1937.

475 UNTITLED (EARS). (1964) Cast aluminum relief, 21³/₈ x 19 x 1¹/₂″ (54.3 x 48.2 x 3.7 cm). Philip Johnson Fund. 607.65. Repr. *New Jap. Ptg. & Sc.*, p. 108.

MIKUS, Eleanore. American, born 1927.

TABLET NUMBER 84. 1964. Synthetic polymer paint on composition-board sections, 51⁵/₈ x 35⁷/₈″ (131.1 x 90.9 cm). Gift of Louise Nevelson. 505.65.

MILIÁN, Raúl. Cuban, born 1914.

COMPOSITION. (1951) Colored inks, 15 x 11″ (38 x 27.9 cm). Gift of Emilio del Junco. 183.52.

Untitled. 1959. Watercolor and ink, 14⁷/₈ x 11″ (37.7 x 27.9 cm). Gift of Emilio del Junco. 86.60.

Untitled. 1959. Watercolor and ink, 15 x 11″ (38 x 27.9 cm). Gift of Emilio del Junco. 87.60.

Untitled. 1960. Watercolor and ink, 15 x 11″ (38 x 27.9 cm). Gift of Emilio del Junco. 88.60. Repr. *Suppl. X*, p. 57.

MILLARES, Manolo. Spanish, born 1926.

378 COMPOSITION 9. (1957) Whiting and lampblack on burlap and string, 27⁵/₈ x 53¹/₄″ (70.2 x 135.3 cm). Blanchette Rockefeller Fund. 134.58. Repr. *Suppl. VIII*, p. 15.

MILLER, Earl. American, born 1930.

AMERICAN FLYER. 1965. Tempera and collage of paper and foil mounted on cardboard, 17³/₄ x 18⁷/₈″ (45 x 47.7 cm). Larry Aldrich Foundation Fund. 790.69.

MILNE, David Brown. Canadian, 1882–1953.

217 SUNBURST OVER THE CATSKILLS. 1917. Watercolor, 15¹/₈ x 21³/₄″ (38.4 x 55.2 cm). Gift of Douglas M. Duncan. 384.61. Repr. *Suppl. XI*, p. 53.

MINGUZZI, Luciano. Italian, born 1911.

304 DOG AMONG REEDS. (1951) Bronze, 27¹/₈ x 21″ (68.9 x 53.3 cm). Aristide Maillol Fund. 20.53. Repr. *Suppl. IV*, p. 37.

MINNE, George. Belgian, 1867–1941.

38 KNEELING YOUTH. (1898) Original plaster, 31³/₈″ (79.6 cm) high, at base 6³/₄ x 12⁵/₈″ (17.1 x 32 cm). Gift of Mr. and Mrs. Samuel Josefowitz. 232.62. Repr. *Suppl. XII*, p. 4; bronze cast, *Art Nouveau*, p. 72. *Note*: five replicas in marble were commissioned about 1902 by the architect Henry van de Velde for a fountain in Karl Osthaus's Folkwang Museum at Hagen, later moved to Essen.

MIRÓ, Joan. Spanish, born 1893. In Paris 1919–40.

Dupin refers to the catalog *Joan Miró: Life and Work*, by Jacques Dupin, New York, 1962.

170 TABLE WITH GLOVE. 1921. Oil on canvas, 46 x 35¹/₄″ (116.8 x 89.5 cm). Gift of Armand G. Erpf. 18.55. *Dupin* 72. Repr. *Private Colls.*, p. 7; *Miró* (1959), p. 30; in color, *Miró* (1973), p. 17. *Note*: former title, *Glove and Newspaper*.

170 THE CARBIDE LAMP. 1922–23. Oil on canvas, 15 x 18″ (38.1 x 45.7

cm). Purchase. 12.39. *Dupin* 80. Repr. *Ptg. & Sc.*, p. 126; *Miró* (1973), p. 18.

170 THE EAR OF GRAIN. 1922–23. Oil on canvas, 14⁷/₈ x 18¹/₈″ (37.8 x 46 cm). Purchase. 11.39. *Dupin* 81. Repr. *Ptg. & Sc.*, p. 126; *Miró* (1959), p. 34; *Miró* (1973), p. 19.

170 THE HUNTER (CATALAN LANDSCAPE). 1923–24. Oil on canvas, 25¹/₂ x 39¹/₂″ (64.8 x 100.3 cm). Purchase. 95.36. *Dupin* 84. Repr. *Ptg. & Sc.*, p. 215; in color, *Masters*, p. 142; *Miró* (1959), p. 39; in color, *Miró* (1973), p. 23; in color, *Invitation*, p. 90.

THE BIRTH OF THE WORLD. Montroig, 1925 (summer). Oil on canvas, 8′2³/₄″ x 6′6³/₄″ (250.8 x 200 cm). Acquired through an anonymous fund, the Mr. and Mrs. Joseph Slifka and Armand G. Erpf Funds, and by gift of the artist. 262.72. Repr. *Dada, Surrealism*, p. 69; in color, *Miró* (1973), p. 31.

170 PERSON THROWING A STONE AT A BIRD. 1926. Oil on canvas, 29 x 36¹/₄″ (73.7 x 92.1 cm). Purchase. 271.37. *Dupin* 172. Repr. *Ptg. & Sc.*, p. 215; in color, *Fantastic Art* (3rd), opp. p. 184; in color, *Miró* (1973), p. 36.

171 DUTCH INTERIOR, I. 1928. Oil on canvas, 36¹/₈ x 28³/₄″ (91.8 x 73 cm). Mrs. Simon Guggenheim Fund. 163.45. *Dupin* 234. Repr. *Ptg. & Sc.*, p. 216; in color, *Miró* (1959), p. 57; in color, *Miró* (1973), p. 42, foldout; in color, *Invitation*, p. 72. *Note*: as basis for this painting the artist, according to Walter Erben in *Joan Miró*, New York, 1959, used a picture postcard of *The Lute Player* by H. M. Sorgh (Dutch painter, 1611?–1670), which he had bought at the Rijksmuseum in Amsterdam in 1928.

COLLAGE. Montroig, 1929, summer. Pastel, ink, watercolor, crayon, and pasted papers, 28⁵/₈ x 42³/₄″ (72.7 x 108.4 cm). James Thrall Soby Fund. 1307.68.

172 RELIEF CONSTRUCTION. 1930. Wood and metal, 35⁷/₈ x 27⁵/₈″ (91.1 x 70.2 cm). Purchase. 259.37. *Dupin*, p. 232. Repr. *Ptg. & Sc.*, p. 278; *Miró* (1959), p. 64; *Miró* (1973), p. 53.

171 OBJECT. 1931. Assemblage: painted wood, steel, string, bone, and a bead, 15³/₄″ (40 cm) high, at base 8¹/₄ x 4³/₄″ (21 x 12 cm). Gift of Mr. and Mrs. Harold X. Weinstein. 7.61. Repr. *Suppl. XI*, p. 36; *Miró* (1973), p. 55.

172 DRAWING-COLLAGE. 1933. Collage and charcoal drawing on green paper with three postcards, sandpaper, and four engravings, 42¹/₂ x 28³/₈″ (107.8 x 72.1 cm). Kay Sage Tanguy Bequest. 328.63. Repr. *Miró* (1973), p. 61.

COLLAGE (STUDY FOR "PAINTING," 1933). Barcelona, 1933, February 11. Cut-and-pasted photomechanical reproductions and pencil, 18¹/₂ x 24⁷/₈″ (46.8 x 63 cm). Gift of the artist. 131.73. Repr. *Miró* (1973), p. 58.

173 PAINTING. 1933. Oil on canvas, 68¹/₂″ x 6′5¹/₄″ (174 x 196.2 cm). Gift of the Advisory Committee (by exchange). 229.37. *Dupin* 336. Repr. *Ptg. & Sc.*, p. 217; in color, *Masters*, p. 143; *Miró* (1959), p. 73; in color, *Miró* (1973), p. 59; in color, *Invitation*, p. 89; *Modern Masters*, p. 187. *Note:* formerly titled *Composition*.

HIRONDELLE/AMOUR. (1933–34, winter) Oil on canvas, 6′6¹/₂″ x 8′1¹/₂″ (199.3 x 247.6 cm). Gift of Nelson A. Rockefeller. 723.76. Repr. in color, *Miró*, p. 81; in color, *20th-C. Art from NAR Coll.*, p. 81; in color, *Miró* (1973), p. 65.

OPERA SINGER. 1934. Pastel and pencil on brown emery paper, 41³/₈ x 29¹/₈″ (105.1 x 74.2 cm). Gift of William H. Weintraub. 509.64. Repr. *Miró* (1973), p. 68.

172 ROPE AND PEOPLE, I. 1935. Oil on cardboard mounted on wood, with coil of rope, 41¹/₄ x 29³/₈″ (104.7 x 74.6 cm). Gift of the Pierre Matisse Gallery. 71.36. *Dupin* 408. Repr. *Fantastic Art* (3rd), p. 187; *Miró* (1959), p. 76; in color, *Miró* (1973), p. 69.

416 OBJECT. (1936) Assemblage: stuffed parrot on wood perch,

stuffed silk stocking with velvet garter and doll's paper shoe suspended in a hollow wood frame, derby hat, hanging cork ball, celluloid fish, and engraved map, 31⁷/₈ x 11⁷/₈ x 10¹/₄″ (81 x 30.1 x 26 cm). Gift of Mr. and Mrs. Pierre Matisse. 940.65a–c. Repr. *Miró*, p. 77; *Assemblage*, p. 63; *Dada*, p. 147; *What Is Mod. Sc.*, p. 95; in color, *Miró* (1973), p. 71. *Note*: the original map disintegrated and the fish disappeared; both have been replaced. Also called *Poetic Object*.

STILL LIFE WITH OLD SHOE. Paris, 1937, January 24–May 29. Oil on canvas, 32 x 46″ (81.3 x 116.8 cm). Fractional gift of James Thrall Soby. 1094.69. Repr. *Bulletin*, Fall, 1958, p. 30; in color, *Miró*, p. 89; in color, *Miró* (1973), p. 73.

SEATED WOMAN, I [*Femme assise, I*]. 1938. Oil on canvas, 64³/₈ x 51⁵/₈″ (163.4 x 131 cm). Fractional gift of Mr. and Mrs. William H. Weintraub. 1532.68. Repr. in color, *Miró* (1973), p. 79.

172 THE BEAUTIFUL BIRD REVEALING THE UNKNOWN TO A PAIR OF LOVERS. 1941. Gouache and oil wash, 18 x 15″ (45.7 x 38.1 cm). Acquired through the Lillie P. Bliss Bequest. 7.45. *Dupin* 558. Repr. *Ptg. & Sc.*, p. 218; *Miró* (1959), p. 105; in color, *Miró* (1973), p. 80.

PORTRAIT OF A MAN IN A LATE NINETEENTH-CENTURY FRAME. 1950. Oil on canvas with ornamented wood frame; painting, 37⁷/₈ x 31¹/₂″ (96 x 80 cm); overall, including frame, 57¹/₂ x 49¹/₄″ (146 x 125 cm). Gift of Mr. and Mrs. Pierre Matisse. 210.72. Repr. in color, *Miró* (1973), p. 84.

174– MURAL PAINTING. (1950–51) Oil on canvas, 6′2³/₄″ x 19′5³/₄″
175 (188.8 x 593.8 cm). Mrs. Simon Guggenheim Fund. 592.63. *Dupin* 775. Repr. *Miró* (1959), pp. 130–131; in color, *Miró* (1973), p. 86, foldout. *Note*: commissioned by Harvard University for Harkness Commons Dining Room, Graduate Center, and later replaced by a ceramic replica.

PERSONAGE. (1956) Ceramic, 31¹/₄ x 9⁷/₈ x 8¹/₂″ (79.4 x 25.1 x 21.6 cm); at base, 11¹/₂ x 11¹/₄″ (29.3 x 28.6 cm). Gift of Mr. and Mrs. Edwin A. Bergman. 1408.74. *Note*: sculpture executed in collaboration with Llorens Artigas.

Design for jacket of *Joan Miró* by James Thrall Soby, The Museum of Modern Art, New York, 1959. (1958) Watercolor, brush and ink, 9⁵/₈ x 17³/₄″ (24.4 x 45 cm). Commissioned by the Museum. Gift of the artist. 721.59. Repr. *Suppl. IX*, p. 15; in color, *Miró* (1959), jacket.

MOONBIRD. (1966) Bronze, 7′8¹/₈″ x 6′9¹/₄″ x 59¹/₈″ (228.8 x 206.4 x 150.1 cm). Acquired through the Lillie P. Bliss Bequest. 515.70. Repr. *Miró* (1973), p. 99.

THE SONG OF THE VOWELS. Palma, 1966, April 24. Oil on canvas, 12′1¹/₈″ x 45¹/₄″ (366 x 114.8 cm). Mrs. Simon Guggenheim Fund, special contribution in honor of Dorothy C. Miller. 57.70. Repr. in color, *Miró* (1973), p. 97.

WOMAN WITH THREE HAIRS SURROUNDED BY BIRDS IN THE NIGHT. Palma, 1972, September 2. Oil on canvas, 7′11⁷/₈″ x 66¹/₂″ (243.5 x 168.9 cm). Gift of the artist in honor of James Thrall Soby. 116.73. Repr. in color, *Miró* (1973), p. 103.

THE EYE ATTRACTS DIAMONDS [*L'Oeil attire les diamants*]. 1974. Open umbrella, partially painted wood, wire, paper, and plastic and cloth flowers; size overall, excluding open umbrella, 71³/₄ x 47¹/₄ x 24³/₄″ (182.2 x 120 x 62.9 cm). Gift of the artist. 1407.74a–g.

MISHAAN, Rodolfo (Rodolfo Mishaan Pinto). Guatemalan, born 1924. Lives in U.S.A.

438 MAYA. (1965) Collage of casein-painted newspaper and synthetic polymer paint on matboard, 40¹/₄ x 60″ (102.2 x 152.4 cm). Larry Aldrich Foundation Fund. 199.66

MITCHELL, Joan. American, born 1926.

336 LADYBUG. (1957) Oil on canvas, 6'5⅞" x 9' (197.9 x 274 cm). Purchase. 385.61. Repr. *Suppl. XI*, p. 31.

MODEL, Evsa. American, born Russia 1900. Worked in France. To U.S.A. 1938.

OPEN DOOR. (1942) Oil on canvas, 65⅛ x 43" (165.4 x 109.2 cm). Purchase. 390.42.

MODIGLIANI, Amedeo. Italian, 1884–1920. To France 1906.

112 CARYATID. (c. 1914) Limestone, 36¼" (92.1 cm) high, at base 16⅜ x 16⅞" (41.6 x 42.9 cm). Mrs. Simon Guggenheim Fund. 145.51. Repr. *Suppl. III*, p. 3; *Masters*, p. 104; *Modigliani* (3rd), p. 20; *Sc. of 20th C.*, p. 116.

113 HEAD. (1915?) Limestone, 22¼ x 5 x 14¾" (56.5 x 12.7 x 37.4 cm). Gift of Abby Aldrich Rockefeller in memory of Mrs. Cornelius J. Sullivan. 593.39. Repr. *Ptg. & Sc.*, p. 251; *Sc. of 20th C.*, p. 115.

113 BRIDE AND GROOM. (1915–16) Oil on canvas, 21¾ x 18¼" (55.2 x 46.3 cm). Gift of Frederic Clay Bartlett. 339.42. Repr. *Ptg. & Sc.*, p. 60; in color, *Modigliani* (3rd), p. 25.

112 ANNA ZBOROWSKA. (1917) Oil on canvas, 51¼ x 32" (130.2 x 81.3 cm). Lillie P. Bliss Collection. 87.34. Repr. *Ptg. & Sc.*, p. 61; *Modigliani* (3rd), p. 51.

113 RECLINING NUDE [*Le Grand nu*]. (c. 1919) Oil on canvas, 28½ x 45⅞" (72.4 x 116.5 cm). Mrs. Simon Guggenheim Fund. 13.50. Repr. *Suppl. II*, p. 3; in color, *Masters*, p. 105; *Modigliani* (3rd), p. 49; *Paintings from MoMA*, p. 31; in color, *Invitation*, p. 78.

MOGENSEN, Paul. American, born 1941.

NO TITLE. (1973, after earlier version of 1967) Synthetic polymer paint on fiberglass-reinforced polyester, in sixteen parts; overall, 8' x 8' x 1⅝" (243.9 x 243.9 x 4.2 cm). Larry Aldrich Foundation Fund. 1349.74.

MOHOLY-NAGY, László. American, born Hungary. 1895–1946. In Germany 1921–34; U.S.A. 1937–46.

140 NICKEL CONSTRUCTION. (1921) Nickel-plated iron, welded, 14⅛" (35.6 cm) high, base 6⅞ x 9⅜" (17.5 x 23.8 cm). Gift of Mrs. Sibyl Moholy-Nagy. 17.56. Repr. *Suppl. VI*, p. 17; *The Machine*, p. 136.

TELEPHONE PICTURE EM 2 [*Telephonbild*]. (1922) Porcelain enamel on steel, 9½ x 6" (24 x 15 cm). Gift of Philip Johnson in memory of Sibyl Moholy-Nagy. 92.71.

TELEPHONE PICTURE EM 3 [*Telephonbild*]. (1922) Porcelain enamel on steel, 18⅜ x 11⅞" (47.5 x 30.1 cm). Gift of Philip Johnson in memory of Sibyl Moholy-Nagy. 91.71.

140 Z II. 1925. Oil on canvas, 37⅝ x 29⅝" (95.4 x 75.1 cm). Gift of Mrs. Sibyl Moholy-Nagy. 18.56. Repr. *Suppl. VI*, p. 16.

SPACE MODULATOR L3. (1936) Oil on perforated zinc and composition board, with glass-headed pins, 17¼ x 19⅛" (43.8 x 48.6 cm). Purchase. 223.47. Repr. *Ptg. & Sc.*, p. 115.

Untitled. 1942. Oil on clear plastic, 23⅛ x 18⅛" (58.7 x 46 cm). Gift of Mrs. Katharine Kuh. 526.61. Repr. *Suppl. XI*, p. 22.

141 DOUBLE LOOP. 1946. Plexiglass, 16¼ x 22¼ x 17½" (41.1 x 56.5 x 44.5 cm). Purchase. 195.56. Repr. *Suppl. VI*, p. 17.

MOLINARI, Guido. Canadian, born 1933.

372 YELLOW ASYMMETRY. 1959. Synthetic polymer paint on canvas, 48 x 60" (122 x 152.1 cm). Gift of Mr. and Mrs. Monroe Geller. 75.63.

MONDRIAN, Piet. Dutch, 1872–1944. Worked in Paris 1912–14, 1919–38; in New York 1940–44.

134 MILL BY THE WATER. (c. 1905) Oil on canvas mounted on cardboard, 11⅞ x 15" (30.2 x 38.1 cm). Purchase. 243.50. Repr. *Suppl. II*, p. 8. *Note*: formerly titled and dated *Landscape with Mill* (before 1905).

RED AMARYLLIS WITH BLUE BACKGROUND. (c. 1907) Watercolor, 18⅜ x 13" (46.5 x 33 cm). The Sidney and Harriet Janis Collection (fractional gift). 1773.67. Repr. *Janis*, p. 25.

134 BLUE FAÇADE (COMPOSITION 9). (1913–14) Oil on canvas, 37½ x 26⅝" (95.2 x 67.6 cm). Gift of Mr. and Mrs. Armand P. Bartos. 153.57. Repr. *Suppl. VII*, p. 10.

134 COMPOSITION IN BROWN AND GRAY. (1913–14) Oil on canvas, 33¾ x 29¾" (85.7 x 75.6 cm). Purchase. 242.50. Repr. *Suppl. II*, p. 8.

134 COLOR PLANES IN OVAL. (1914?) Oil on canvas, 42⅜ x 31" (107.6 x 78.8 cm). Purchase. 14.50. Repr. *Suppl. II*, p. 9; *de Stijl*, pp. 6 (detail), 7.

COMPOSITION, V. 1914. Oil on canvas, 21⅝ x 33⅝" (54.8 x 85.3 cm). The Sidney and Harriet Janis Collection (fractional gift). 633.67. Repr. in color, *Janis*, p. 27; in color, *Invitation*, p. 49. *Note*: also called *Façade, 5*.

135 PIER AND OCEAN. 1914. Charcoal and white watercolor on buff paper, 34⅝ x 44" (87.9 x 111.2 cm); oval composition 33 x 40" (83.8 x 101.6 cm). Mrs. Simon Guggenheim Fund. 34.42. Repr. *Mondrian*, p. 6.

COMPOSITION WITH COLOR PLANES, V. 1917. Oil on canvas, 19⅜ x 24⅛" (49 x 61.2 cm). The Sidney and Harriet Janis Collection (fractional gift). 1774.67. Repr. *Janis*, p. 28.

135 COMPOSITION C. 1920. Oil on canvas, 23¾ x 24" (60.3 x 61 cm). Acquired through the Lillie P. Bliss Bequest. 257.48. Repr. *Suppl. I*, p. 18; in color, *Masters*, p. 217.

135 COMPOSITION. 1921. Oil on canvas, 29⅞ x 20⅝" (76 x 52.4 cm). Gift of John L. Senior, Jr. 154.57. Repr. *Suppl. VII*, p. 10.

136 COMPOSITION. 1925. Oil on canvas, 15⅞ x 12⅝" (40.3 x 32.1 cm). Gift of Philip Johnson. 486.41. Repr. *Mod. Art in Your Life*, p. 10.

136 PAINTING, I. 1926. Oil on canvas; diagonal measurements, 44¾ x 44" (113.7 x 111.8 cm). Katherine S. Dreier Bequest. 179.53. Repr. *Suppl. IV*, p. 14; *Mondrian*, p. 10; *Masters*, p. 122.

COMPOSITION. 1933. Oil on canvas, 16¼ x 13⅛" (41.2 x 33.3 cm). The Sidney and Harriet Janis Collection (fractional gift). 635.67. Repr. *Modern Works*, no. 118; *Mondrian*, p. 11; *Janis*, p. 31. *Note*: also called *Composition in White, Blue and Red; Composition (Red and Blue); Composition with Blue and Red*. The painting appears on the easel of George Segal's sculpture *Portrait of Sidney Janis with Mondrian Painting*, 653.67.

136 COMPOSITION IN WHITE, BLACK, AND RED. 1936. Oil on canvas, 40¼ x 41" (102.2 x 104.1 cm). Gift of the Advisory Committee. 2.37. Repr. *Ptg. & Sc.*, p. 117; *Mondrian*, cover.

COMPOSITION IN YELLOW, BLUE, AND WHITE, I. 1937. Oil on canvas, 22½ x 21¾" (57.1 x 55.2 cm). The Sidney and Harriet Janis Collection (fractional gift). 637.67. Repr. *Janis*, p. 32.

COMPOSITION IN RED, BLUE, AND YELLOW. 1937–42. Oil on canvas, 23¾ x 21⅞" (60.3 x 55.4 cm). The Sidney and Harriet Janis Collection (fractional gift). 638.67. Repr. *Janis*, p. 33.

137 BROADWAY BOOGIE WOOGIE. 1942–43. Oil on canvas, 50 x 50" (127 x 127 cm). Given anonymously. 73.43. Repr. *Ptg. & Sc.*, p. 118; *Mondrian*, p. 14; in color, *Masters*, p. 123; in color, *Invitation*, p. 39.

MONET, Claude. French, 1840–1926.

19 POPLARS AT GIVERNY, SUNRISE. (1888) Oil on canvas, 29$^{1}/_{8}$ x 36$^{1}/_{2}$″ (74 x 92.7 cm). The William B. Jaffe and Evelyn A. J. Hall Collection. 617.51. Repr. *Suppl. IV*, p. 18; in color, *Masters*, p. 19; *Post-Impress.* (2nd), p. 17.

20– WATER LILIES. (c. 1920) Oil on canvas; triptych, each section
21 6′6″ x 14′ (200 x 425 cm). Mrs. Simon Guggenheim Fund. 666.59.1–.3. Repr. *Monet*, pp. 44–45; *Suppl. IX*, pp. 4–5, 40 (detail); two panels in color, *Invitation*, pp. 24–25.

21 WATER LILIES. (c. 1920) Oil on canvas, 6′6$^{1}/_{2}$″ x 19′7$^{1}/_{2}$″ (199.5 x 599 cm). Mrs. Simon Guggenheim Fund. 712.59.

19 THE JAPANESE FOOTBRIDGE. (c. 1920–22) Oil on canvas, 35$^{1}/_{4}$ x 45$^{7}/_{8}$″ (89.5 x 116.3 cm). Grace Rainey Rogers Fund. 242.56. Repr. *Suppl. VI*, p. 7.

MONTANEZ-ORTIZ, Rafael. American, born 1934.

389 ARCHEOLOGICAL FIND, 3. (1961) Burnt mattress, 6′2$^{7}/_{8}$″ x 41$^{1}/_{4}$″ x 9$^{3}/_{8}$″ (190 x 104.5 x 23.7 cm). Gift of Constance Kane. 76.63. Repr. *Object Transformed*, p. 23.

MONTENEGRO, Roberto. Mexican, born 1885.

 MAYA WOMEN. (1926) Oil on canvas, 31$^{1}/_{2}$ x 27$^{1}/_{2}$″ (80 x 69.8 cm). Gift of Nelson A. Rockefeller. 560.41. Repr. *Latin-Amer. Coll.*, p. 68.

MOORE, Henry. British, born 1898.

 H.M. refers to the catalog *Henry Moore, Sculpture and Drawings*, London; vol. 1, 1921–48, 4th ed., 1957, edited by David Sylvester; vol. 2, 1949–54, 2nd ed., 1965, and vol. 3, 1955–64, 1965, both edited by Alan Bowness.

186 TWO FORMS. (1934) Pynkado wood, 11 x 17$^{3}/_{4}$″ (27.9 x 45.1 cm) on irregular oak base, 21 x 12$^{1}/_{2}$″ (53.3 x 31.7 cm). Sir Michael Sadler Fund. 207.37. *H.M.* 153. Repr. *Ptg. & Sc.*, p. 285; *Moore*, p. 36; *Cubism*, fig. 223; *What Is Mod. Sc.*, p. 60.

186 MOTHER AND CHILD. (1938) Elmwood, 30$^{3}/_{8}$ x 13$^{7}/_{8}$ x 15$^{1}/_{2}$″ (77.2 x 35.2 x 39.2 cm). Acquired through the Lillie P. Bliss Bequest. 21.53. *H.M.* 194. Repr. *Suppl. IV*, p. 36.

186 RECLINING FIGURE. (1938) Cast lead, 5$^{3}/_{4}$ x 13″ (14.6 x 33 cm). Purchase. 630.39. *H.M.* 192. Repr. *Ptg. & Sc.*, p. 287; *Moore*, p. 49.

186 THE BRIDE. (1939–40) Cast lead and copper wire, 9$^{3}/_{8}$ x 4$^{1}/_{8}$″ (23.8 x 10.3 cm). Acquired through the Lillie P. Bliss Bequest. 15.47. *H.M.* 213. Repr. *Ptg. & Sc.*, p. 287; *Sc. of 20th C.*, p. 129.

188 SCULPTURE AND RED ROCKS. 1942. Crayon, wash, pen and ink, 19$^{1}/_{8}$ x 14$^{1}/_{4}$″ (48.6 x 36.2 cm). Gift of Philip L. Goodwin. 9.49.

188 SEATED FIGURES, II. 1942. Crayon, wash, pen and ink, 22$^{5}/_{8}$ x 18$^{1}/_{8}$″ (57.5 x 46 cm). Acquired through the Lillie P. Bliss Bequest. 74.43. *H.M.* 245. Repr. *Ptg. & Sc. (I) Suppl.*, p. 11.

 IDEAS FOR TWO-FIGURE SCULPTURE. 1944. Crayon, pen and ink, pencil, watercolor, 8$^{7}/_{8}$ x 6$^{7}/_{8}$″ (22.5 x 17.5 cm). Purchase. 176.46. Repr. in color, *Moore*, frontispiece.

186 FAMILY GROUP. (1945) Bronze, 9$^{3}/_{8}$″ (23.8 cm) high, at base 8$^{1}/_{2}$ x 5$^{1}/_{8}$″ (21.6 x 13 cm). Acquired through the Lillie P. Bliss Bequest. 16.47. *H.M.* 259. Repr. *Ptg. & Sc.*, p. 286. *Note:* working model for large *Family Group*, *H.M.* 269.

187 FAMILY GROUP. (1948–49) Bronze (cast 1950), 59$^{1}/_{4}$ x 46$^{1}/_{2}$″ (150.5 x 118 cm), at base 45 x 29$^{7}/_{8}$″ (114.3 x 75.9 cm). A. Conger Goodyear Fund. 146.51. *H.M.* 269. Repr. *Suppl. III*, p. 1.

188 Study for sculpture on Time-Life Building, London. (1952–53) Bronze, 15 x 38$^{7}/_{8}$″ (38.1 x 98.7 cm). Gift of Time Inc. 18.54. Repr.

Suppl. V, p. 30. *Note*: cast of working model for "screen," c. 10 x 26′, *H.M.* 344.

189 RECLINING FIGURE, II. (1960) Bronze, in two parts, a) 50 x 34$^{5}/_{8}$ x 29$^{1}/_{4}$″ (127 x 87.7 x 74.2 cm); b) 36$^{5}/_{8}$ x 55$^{1}/_{4}$ x 41$^{1}/_{8}$″ (93 x 140.2 x 104.4 cm); overall length 8′3″ (251.6 cm). Given in memory of G. David Thompson, Jr., by his father. 131.61a-b. *H.M.* 458. Repr. *Suppl. XI*, p. 15.

415 LARGE TORSO: ARCH. (1962–63) Bronze, 6′6$^{1}/_{8}$″ x 59$^{1}/_{8}$″ x 51$^{1}/_{4}$″ (198.4 x 150.2 x 130.2 cm). Mrs. Simon Guggenheim Fund. 608.65. *H.M.* 159–62.

 ANIMAL FORM. (1969–70) Roman travertine marble, 6′1$^{5}/_{8}$″ x 8′9$^{3}/_{8}$″ x 38$^{5}/_{8}$″ (156.5 x 267.6 x 98.1 cm), including separate travertine base 12″ x 9′4$^{1}/_{8}$″ x 53″ (30.4 x 284.6 x 134.6 cm). Gift of Mr. and Mrs. Gordon Bunshaft in honor of Henry Moore. 705.71a-b.

MOPP, Maximilian (Max Oppenheimer). American, born Austria. 1885–1954. To U.S.A. 1939.

159 THE WORLD WAR. (1916) Oil on canvas, 21 x 17$^{5}/_{8}$″ (53.3 x 44.8 cm). Given anonymously. 504.41.

MORALES SEQUEIRA, Armando. Nicaraguan, born 1927. In New York since 1960.

 SPOOK TREE. (1956) Oil on canvas, 51$^{1}/_{4}$ x 22$^{5}/_{8}$″ (130 x 57.9 cm). Inter-American Fund. 14.57. Repr. *Suppl. VII*, p. 16.

MORANDI, Giorgio. Italian, 1890–1964.

198 STILL LIFE. 1916. Oil on canvas, 32$^{1}/_{2}$ x 22$^{5}/_{8}$″ (82.5 x 57.5 cm). Acquired through the Lillie P. Bliss Bequest. 286.49. Repr. *Masters*, p. 103.

198 STILL LIFE. 1938. Oil on canvas, 9$^{1}/_{2}$ x 15$^{5}/_{8}$″ (24.1 x 39.7 cm). Purchase. 688.49. Repr. *Suppl. II*, p. 17.

MORENO, Rafael. Cuban, born Spain. 1887–1955.

 THE FARM. (1943) Oil on canvas, 39″ x 6′6$^{1}/_{8}$″ (99.1 x 198.4 cm). Inter-American Fund. 12.44.

MORGAN, Maud. American, born 1903.

 MUSICAL SQUASH. (1942) Oil on canvas, 15$^{7}/_{8}$ x 26$^{1}/_{8}$″ (40.3 x 66.4 cm). Gift of Mrs. Kenneth Simpson. 593.42.

MORITA, Yasuji. Japanese, 1912–1960.

 THE WIND MAN. (c. 1953) Brush and ink, 53$^{1}/_{2}$ x 27$^{1}/_{2}$″ (135.9 x 69.8 cm). Japanese House Fund. 272.54.

MORRIS, Robert. American, born 1931.

 The two objects following relate to Marcel Duchamp's "Litanies for the Chariot," an element in the design of his *Large Glass*:

 LITANIES. 1963. Lead over wood with steel key ring, twenty-seven keys, and brass lock, 12 x 7$^{1}/_{8}$ x 2$^{1}/_{2}$″ (30.4 x 18 x 6.3 cm). Gift of Philip Johnson. 517.70. Repr. *Amer. Art*, p. 59. *Note:* The twenty-seven keys are each inscribed with individual words from the *Green Box*, facsimile notes for the *Large Glass*.

 DOCUMENT. 1963. Typed and notarized statement on paper and sheet of lead over wood mounted in imitation leather mat, overall, 17$^{5}/_{8}$ x 23$^{3}/_{4}$″ (44.8 x 60.4 cm) (sight). Inscribed: . . . *The undersigned ROBERT MORRIS, being the maker of the metal construction entitled LITANIES, described in the annexed Exhibit A, hereby withdraws from said construction all esthetic quality and content.* . . Gift of Philip Johnson. 516.70.

 MAGNIFIED AND REDUCED INCHES. (1963) Stamped and incised lead over wood painted with metallic powder in synthetic

polymer, $5/8$ x $11^{1/4}$ x $4^{7/8}''$ (1.6 x 28.6 x 12.4 cm). Gift of Philip Johnson. 518.70.

Untitled. (1963) Lead over wood panel painted with metallic powder in synthetic polymer, $1^{1/8}$ x $8^{1/8}$ x $5''$ (2.8 x 20.5 x 12.6 cm). Gift of Philip Johnson. 522.70.

Untitled. (1963) Knotted rope on tin box covered with encaustic, on wood base painted with metallic powder in synthetic polymer; overall, $7^{1/2}$ x $10^{1/4}$ x $5^{3/4}''$ (19 x 26 x 14.6 cm). Gift of Philip Johnson. 521.70a-b.

Untitled. 1963–64. Glass case on wood base painted with metallic powder in synthetic polymer containing cracked glass case on painted wood base, stamped lead, mirror, and two metal rulers, $3^{3/4}$ x $16^{1/8}$ x $4^{5/8}''$ (9.5 x 41 x 11.8 cm). Inscribed: *REJECTED 9-23-63 11:35 AM; BREAKAGE ACCEPTED 6-24-64 2:20 PM.* Gift of Philip Johnson. 519.70.

Untitled. 1964. Molded lead sheet over wood with painted wood pieces and steel wire, $10^{1/2}$ x $12^{3/8}$ x $2''$ (26.6 x 31.4 x 4.9 cm). Gift of Philip Johnson. 520.70.

Untitled. (1969) Draped $1''$ (2.5 cm) thick, gray-green felt, $15'3/4''$ x $6'^{1/2}''$ x $1''$ (459.2 x 184.1 x 2.5 cm). The Gilman Foundation Fund. 387.75.

MOSES, Ed. American, born 1926.

CHAP. BEAN SEC. (1973–74) Laminated tissue paper with synthetic polymer resin, $6'7/8''$ x $7'2^{7/8}''$ (185.2 x 220.7 cm). The Gilman Foundation Fund. 1350.74.

MOSKOWITZ, Robert. American, born 1935.

387 Untitled. 1961. Oil on canvas, with part of window shade, 24 x 30'' (61 x 76 cm). Larry Aldrich Foundation Fund. 300.61. Repr. *Assemblage*, p. 161.

MOSKOWITZ, Shalom. See SHALOM OF SAFED.

MOTHERWELL, Robert. American, born 1915.

329 PANCHO VILLA, DEAD AND ALIVE. 1943. Gouache and oil with collage on cardboard, 28 x $35^{7/8}''$ (71.1 x 91.1 cm). Purchase. 77.44. Repr. *Ptg. & Sc.*, p. 231; in color, *Motherwell*, p. 14.

328 WESTERN AIR. 1946–47. Oil on canvas, 6' x 54'' (182.9 x 137.2 cm). Purchase (by exchange). 75.50. Repr. *Contemp. Ptrs.*, p. 72; *Motherwell*, p. 13.

328 PERSONAGE, WITH YELLOW OCHRE AND WHITE. 1947. Oil on canvas, 6' x 54'' (182.8 x 137 cm). Gift of Mr. and Mrs. Samuel M. Kootz. 15.57. Repr. *Suppl. VII*, p. 20; *New Amer. Ptg.*, p. 57; *Motherwell*, p. 24.

328 THE VOYAGE. (1949) Oil and tempera on paper mounted on composition board, 48'' x 7'10'' (122 x 238.8 cm). Gift of Mrs. John D. Rockefeller 3rd. 339.55. Repr. *Suppl. VI*, p. 40; in color, *New Amer. Ptg.*, p. 69; *Motherwell*, p. 27.

329 ELEGY TO THE SPANISH REPUBLIC, 54. (1957–61) Oil on canvas, 70'' x 7'6^{1/4}'' (178 x 229 cm). Given anonymously. 132.61. Repr. *Suppl. XI*, p. 64; *Motherwell*, p. 44; *Amer. Art*, p. 42.

NEW ENGLAND ELEGY 2. 1965–66. Synthetic polymer paint on canvas, 6'10'' x 11'7'' (208.3 x 351.1 cm). Gift of S. I. Newhouse, Jr. 1308.68.

ELEGY TO THE SPANISH REPUBLIC, 108. (1965–67) Oil on canvas, 6'10'' x 11'6^{1/4}'' (208.2 x 351.1 cm). Purchase. 155.70. Repr. in color, *Invitation*, p. 142.

BESIDE THE SEA. 1968. Synthetic polymer paint on paper, $30^{3/8}$ x 22'' (77 x 55.7 cm). Gift of the artist. 1095.69.

IN BEIGE WITH WHITE 3. 1968. Collage of brown and white paper, $30^{1/4}$ x 22'' (76.8 x 55.8 cm). Gift of the artist. 1096.69.

OPEN NUMBER 17 (BLUE). 1968. Synthetic polymer paint and charcoal on canvas, 8'3'' x 16'9'' (251.4 x 510.3 cm). Gift of the artist. 1254.69.

OPEN NUMBER 24 IN VARIATIONS OF ORANGE. 1968. Synthetic polymer paint and charcoal on canvas, 6'9'' x 9'7^{1/8}'' (205.6 x 292.3 cm). Gift of the artist. 1097.69.

DE MOULPIED, Deborah. American, born 1933.

371 FORM 7. (1960) Polystyrene, $12^{1/4}$ x $14^{1/4}$ x $11^{1/2}''$ (31 x 36.2 x 29 cm). Larry Aldrich Foundation Fund. 66.61. Repr. *Suppl. XI*, p. 27.

MUCCINI, Marcello. Italian, born 1926.

287 BULL. (1948) Duco on plywood, 13 x $28^{1/4}''$ (33 x 71.8 cm). Purchase. 287.49. Repr. *20th-C. Italian Art*, pl. 98.

MUELLER, Otto. German, 1874–1930.

71 BATHERS. (c. 1920) Oil on burlap, $27^{5/8}$ x $35^{3/4}''$ (70.2 x 90.8 cm). Gift of Samuel A. Berger. 19.55. Repr. *Suppl. V*, p. 10.

MUKAI, Shuji. Japanese, born 1939.

472 Untitled. (1963) Oil, string, and canvas on wood, $6'^{3/8}''$ x $53^{7/8}''$ (183.6 x 136.8 cm). Purchase. 609.65. Repr. *New Jap. Ptg. & Sc.*, p. 111.

MUKAROBGWA, Thomas. Rhodesian, born 1924.

DYING PEOPLE IN THE BUSH. (1962) Oil on cardboard mounted on composition board, $23^{1/4}$ x $36^{1/4}''$ (59 x 91.9 cm). Gift of Mr. and Mrs. Walter Hochschild. 331.63. Repr. *Suppl. XII*, p. 33.

RIVER COMING IN THE MIDDLE OF THE BUSH. (1962) Oil on cardboard mounted on composition board, $23^{3/8}$ x $36^{1/8}''$ (59.3 x 91.7 cm). Gift of Mr. and Mrs. Walter Hochschild. 330.63. Repr. *Suppl. XII*, p. 33.

9 VERY IMPORTANT BUSH. (1962) Oil on cardboard mounted on composition board, $23^{1/2}$ x $36^{1/4}''$ (59.6 x 92 cm). Gift of Mr. and Mrs. Walter Hochschild. 329.63.

VIEW YOU SEE IN THE MIDDLE OF A TREE. (1962) Oil on composition board, $23^{7/8}$ x $23^{7/8}''$ (60.4 x 60.4 cm). Gift of Mr. and Mrs. Walter Hochschild. 332.63. Repr. *Suppl. XII*, p. 33.

MÜLLER, Jan. American, born Germany. 1922–1958.

283 FAUST, I. (1956) Oil on canvas, $68^{1/8}''$ x 10' (173 x 304.7 cm). Purchase. 16.57. Repr. *Suppl. VII*, p. 16.

MÜLLER, Robert. Swiss, born 1920. To Paris 1950.

361 EX-VOTO. (1957) Forged iron, $6'11^{7/8}''$ (213 cm) high, at base $13^{7/8}$ x $14^{3/4}''$ (33.8 x 37.9 cm). Philip Johnson Fund. 18.59. (Purchased in 1957.) Repr. *Suppl. IX*, p. 31.

MULLICAN, Lee (Alva Lee Mullican). American, born 1919.

312 PRESENCE. (1955) Painted wood construction, $36^{1/8}$ x $17^{3/8}''$ (91.5 x 44.1 cm). Mr. and Mrs. Roy R. Neuberger Fund. 19.56. Repr. *Suppl. VI*, p. 32.

MUNCH, Edvard. Norwegian, 1863–1944.

THE STORM. 1893. Oil on canvas, $36^{1/8}$ x $51^{1/2}''$ (91.8 x 130.8 cm). Gift of Mr. and Mrs. H. Irgens Larsen and Purchase. 1351.74.

MUNSELL, Richard. American, born 1909.

POSING FOR THE FIRST TIME. (1939) Oil and tempera on canvas, 17¹/₂ x 8¹/₄" (44.5 x 21 cm). Purchase. 340.41.

MÜNTER, Gabrielle. German, 1877–1962.

INTERIOR. 1908. Oil on cardboard, 20¹/₈ x 26¹/₄" (51 x 66.4 cm), irregular. Gift of the Glickstein Foundation. 1006.69.

MURCH, Walter Tandy. American, born Canada. 1907–1967. To U.S.A. 1929.

CLOCK. 1965. Mixed mediums on cardboard, 28¹/₈ x 22¹/₄" (71.4 x 56.3 cm). Larry Aldrich Foundation Fund. 250.66.

MÜRITOĞLU, Zühtü. Turkish, born 1906.

379 THE UNKNOWN POLITICAL PRISONER. (1956) Wood and iron, 53³/₄" (136.4 cm) high, at base 15¹/₄ x 11³/₈" (38.6 x 28.9 cm). Purchase. 135.58. Repr. *Suppl. VIII*, p. 18. *Note*: variant of the model submitted by the artist to the international competition for a monument to The Unknown Political Prisoner, London, 1953.

MURPHY, Gerald. American, 1888–1964.

430 WASP AND PEAR. (1927) Oil on canvas, 36³/₄ x 38⁵/₈" (93.3 x 97.9 cm). Gift of Archibald MacLeish. 1130.64. Repr. *Murphy*, p. 43.

MUSE, Isaac Lane. American, born 1906.

COMPOSITION WITH BIRD AND SHELLS. 1941. Watercolor, 13 x 20¹/₄" (33 x 51.4 cm). Gift of Mrs. Wallace M. Scudder. 77.43.

MUSIC, Antonio Zoran. Italian, born Gorizia 1909.

DALMATIAN SCENE. 1951. Oil on canvas, 21³/₈ x 28³/₄" (54.3 x 73 cm). Purchase. 22.53.

NADELMAN, Elie. American, born Poland. 1882–1946. Worked in Paris 1904–14. To U.S.A. 1914.

250 STANDING FEMALE NUDE. (c. 1909) Bronze, 21³/₄" (55.2 cm) high, at base 5³/₄ x 5¹/₂" (14.6 x 14 cm). Aristide Maillol Fund. 261.48. Repr. *Nadelman*, p. 13.

250 MAN IN THE OPEN AIR. (c. 1915) Bronze, 54¹/₂" (138.4 cm) high, at base 11³/₄ x 21¹/₂" (29.9 x 54.6 cm). Gift of William S. Paley (by exchange). 259.48. Repr. *Masters*, p. 106; *Nadelman*, p. 25. *Note*: the Museum owns a watercolor and ink study for this sculpture.

250 STANDING BULL. (1915) Bronze, 6⁵/₈ x 11¹/₄" (16.8 x 28.6 cm). Gift of Mrs. Elie Nadelman. 225.47. Repr. *Nadelman*, p. 23.

250 WOUNDED BULL. (1915) Bronze, 5⁷/₈ x 11¹/₂" (14.7 x 29.2 cm). Gift of Mrs. Elie Nadelman. 226.47. Repr. *Ptg. & Sc.*, p. 253; *Nadelman*, p. 22.

250 WOMAN AT THE PIANO. (c. 1917) Wood, stained and painted, 35¹/₈" (89.2 cm) high, at base including piano, 21¹/₂ x 8¹/₄" (54.5 x 21.5 cm). The Philip L. Goodwin Collection. 105.58. Repr. *Nadelman*, p. 30; *Bulletin*, Fall 1958, p. 11.

251 MAN IN A TOP HAT. (c. 1927) Painted bronze, 26 x 14⁷/₈" (66 x 37.6 cm). Abby Aldrich Rockefeller Fund. 260.48. Repr. *Nadelman*, p. 43.

251 WOMAN WITH A POODLE. (c. 1934) Terra cotta, 11³/₄ x 21¹/₂" (29.8 x 54.5 cm). Purchase. 263.48.

STANDING FEMALE NUDE. (c. 1940) Papier maché, 12¹/₈ x 5³/₄ x 4¹/₂" (31 x 14.7 x 11.3 cm). Gift of Andy Warhol. 632.73.

251 HEAD OF A WOMAN. (c. 1942) Rose marble, 15⁵/₈" (39.7 cm) high. Gift of William S. Paley (by exchange). 262.48. Repr. *Nadelman*, p. 41.

251 FIGURE. (c. 1945) Plaster, 11" (27.9 cm) high. Aristide Maillol Fund. 264.48.

NAGARE, Masayuki. Japanese, born 1923.

358 RECEIVING. (1959–60) Stone (gabbro), 9³/₄ x 28³/₄" (24.7 x 73 cm). Gift of Mrs. John D. Rockefeller 3rd. 121.60. Repr. *Suppl. X*, p. 46.

NAGWARABA. Australian contemporary. Headman of the Labara clan, west coast of Groote Eylandt, northeast Australia.

11 TWO SNAKES. (1955) Colored clays over charcoal on eucalyptus bark, about 22 x 36³/₈" (55.9 x 92.3 cm). Purchase. 290.58. Repr. *Suppl. IX*, p. 15.

NAKAMURA, Kazuo. Canadian, born 1926.

368 INNER CORE 2. 1960–61. Oil on canvas, 42 x 31" (106.6 x 78.7 cm). Blanchette Rockefeller Fund. 386.61. Repr. *Suppl. XI*, p. 55.

NAKANISHI, Natsuyuki. Japanese, born 1935.

COMPACT OBJECT. (1961) Oil and sand on plaster, 9⁵/₈ high x 6¹/₈" diameter (24.4 x 15.4 cm). Given anonymously. 2314.67.

475 COMPACT OBJECT. (1962) Assemblage: bones, watch and clock parts, bead necklace, hair, eggshell, lens, and other manufactured objects embedded in polyester, egg-shaped, 5⁵/₈ x 8³/₈" (14.3 x 21.2 cm). Frank Crowninshield Fund. 610.65. Repr. *New Jap. Ptg. & Sc.*, p. 99; in color, p. 18.

NAKIAN, Reuben. American, born 1897.

256 YOUNG CALF. (1927) Georgia pink marble, 15 x 11¹/₂" (38.1 x 29.2 cm). Purchase. 297.38. Repr. *Art in Our Time*, no. 298; *Nakian*, p. 40.

256 "POP" HART. (1932) Tinted plaster, 17" (43.2 cm) high. Gift of Abby Aldrich Rockefeller. 3.33. Repr. *Ptg. & Sc.*, p. 260; *Nakian*, p. 41.

256 HARRY L. HOPKINS. 1934. Tinted plaster, 17¹/₂" (44.4 cm) high, on two bases 9¹/₂" (24.1 cm) high. Gift of Charles Abrams. 401.63. Repr. *Nakian*, p. 41.

HARRY L. HOPKINS. 1934. Bronze (cast 1963), 26³/₈" (67 cm) high including bases cast together with head. Gift of Charles Abrams. 202.63.

484 THE BURNING WALLS OF TROY. (1957) Terra cotta, 8¹/₈ x 11⁵/₈ x 5³/₈" (20.6 x 29.5 x 13.6 cm). Gift of Wilder Green in memory of Frank O'Hara. 394.66. Repr. *Nakian*, p. 19.

357 ROCK DRAWING. (1957) Terra cotta, 10 x 14¹/₄ x 6" (25.3 x 36.1 x 15.2 cm). Fund given in memory of Philip L. Goodwin. 19.59. Repr. *Suppl. IX*, p. 15; *Nakian*, p. 27.

357 Study for THE RAPE OF LUCRECE. (1958) Terra cotta, 9¹/₄ x 16 x 4¹/₄" (23.5 x 40.6 x 10.6 cm) (irregular). Gift of the artist in memory of Holger Cahill. 363.60. Repr. *Suppl. X*, p. 30; *Nakian*, p. 27.

485 HIROSHIMA. 1965–66. Bronze (cast 1967–68), 9'3³/₄" x 6'2³/₄" x 45¹/₄" (283.8 x 189.8 x 114.3 cm). Mrs. Simon Guggenheim Fund. 1514.68. Repr. *Nakian*, p. 46 (work in progress).

NATKIN, Robert. American, born 1930.

INTIMATE LIGHTING: LATE OCTOBER, FIVE O'CLOCK. (1972) Synthetic polymer paint on canvas, 8' x 7'4¹/₈" (243.8 x 223.8 cm). Gift of Nancy Hanks. 191.73.

NDANDARIKA, Joseph. Rhodesian, born 1944.

286 BUSHMEN RUNNING FROM THE RAIN. (1962) Oil on composition board, 48¼ x 48″ (122.5 x 121.8 cm). Gift of Mr. and Mrs. Walter Hochschild. 333.63. Repr. *Suppl. XII*, p. 32.

NEDO, Mion Ferrario. Venezuelan, born Milan 1926.

 PROGRESSION 49. 1970. Relief: strips of layered matboard on painted wood, 46⅝ x 27 x 2¼″ (118.4 x 68.5 x 5.7 cm). Gift of Estudio Actual. 211.72.

NEEL, Alice. American, born 1900.

262 DAVID. (1963) Oil on canvas, 34 x 20⅛″ (86.4 x 51 cm). Larry Aldrich Foundation Fund. 561.63. *Note*: portrait of David Brody, the son of an old friend of the artist.

NEGRET, Edgar. Colombian, born 1920.

374 SIGN FOR AN AQUARIUM (MODEL). (1954) Painted iron, 4⅜ x 13½″ (11.2 x 34 cm), 3½″ (8.8 cm) diameter at base. Inter-American Fund. 551.54. Repr. *Suppl. V*, p. 37.

NEMUKHIN, Vladimir Nikolaevich. Russian, born 1925.

469 CARDS ON A MARQUETRY TABLE. 1966. Oil, tempera, and collage of playing cards on canvas, 43⅜ x 35⅛″ (110 x 89 cm). Purchase. 2104.67.

NEVELSON, Louise. American, born Ukraine 1900. To U.S.A. 1905.

385 SKY CATHEDRAL. (1958) Assemblage: wood construction painted black, 11′3½″ x 10′1¼″ x 18″ (343.9 x 305.4 x 45.7 cm). Gift of Mr. and Mrs. Ben Mildwoff. 136.58. Repr. *Suppl. VIII*, p. 24; *16 Amer.*, p. 57; *What Is Mod. Sc.*, p. 119.

384 HANGING COLUMN (from *Dawn's Wedding Feast*). (1959) Assemblage: wood construction painted white, 6′ x 6⅝″ (182.8 x 16.7 cm). Blanchette Rockefeller Fund. 14.60. Repr. *Suppl. X*, p. 60.

384 HANGING COLUMN (from *Dawn's Wedding Feast*). (1959) Assemblage: wood construction painted white, 6′ x 10⅛″ (182.8 x 25.7 cm). Blanchette Rockefeller Fund. 15.60. Repr. *Suppl. X*, p. 60.

494 ATMOSPHERE AND ENVIRONMENT, I. (1966) Construction of enameled aluminum, 6′6¼″ x 12′3⅜″ x 48½″ (198.6 x 366.7 x 123 cm). Mrs. Simon Guggenheim Fund. 386.66.

NEWALL, Albert. British, born 1920. Lives in South Africa.

 MARINE OBJECT. 1955. Ink and pastel, 13¼ x 18¼″ (33.6 x 46.2 cm). Gift of the artist. 20.56. Repr. *Suppl. VI*, p. 33.

NEWMAN, Barnett. American, 1905–1970.

366 ABRAHAM. 1949. Oil on canvas, 6′10¾″ x 34½″ (210.2 x 87.7 cm). Philip Johnson Fund. 651.59. Repr. *New Amer. Ptg.*, p. 62; *Newman*, p. 59.

 ONEMENT, III. 1949. Oil on canvas, 71⅞ x 33½″ (182.5 x 84.9 cm). Gift of Mr. and Mrs. Joseph Slifka. 527.71.

 THE VOICE. (1950) Egg tempera and enamel on canvas, 8′1⅛″ x 8′9½″ (244.1 x 268 cm). The Sidney and Harriet Janis Collection (fractional gift). 1.68. Repr. *Newman*, p. 68; *Janis*, p. 131; *Natural Paradise*, p. 122.

455 THE WILD. (1950) Oil on canvas, 7′11¾″ x 1⅝″ (243 x 4.1 cm). Gift of The Kulicke Family. 1139.69. Repr. *Newman*, pp. 72, 74.

 VIR HEROICUS SUBLIMIS. 1950–51. Oil on canvas, 7′11⅜″ x 17′9¼″ (242.2 x 513.6 cm). Gift of Mr. and Mrs. Ben Heller. 240.69. Repr. in color, *Newman*, opp. p. 72; in color, *Invitation*, p. 144; *Natural Paradise*, p. 54.

 BROKEN OBELISK. 1963–67. Cor-ten steel, in two parts, overall, 25′5″ x 10′6″ x 10′6″ (774.5 x 320 x 320 cm). Given anonymously. 526.71. Repr. *Newman*, p. 120.

NICHOLSON, Ben. British, born 1894.

143 PAINTED RELIEF. 1939. Synthetic board mounted on plywood, painted, 32⅞ x 45″ (83.5 x 114.3 cm). Gift of H. S. Ede and the artist (by exchange). 1645.40. Repr. *Ptg. & Sc.*, p. 274; *What Is Mod. Sc.*, p. 118.

NICOLAO, Tereza. Brazilian, born 1928.

290 SHANTY TOWN, I [*Favela, I*]. 1957. Oil on plywood, 26⅞ x 38⅞″ (68.1 x 98.5 cm). Inter-American Fund. 137.58. Repr. *Suppl. VIII*, p. 15.

NIIZUMA, Minoru. Japanese, born 1930. To U.S.A. 1959.

474 CASTLE OF THE EYE. 1964. Marble, 18½ x 15¾ x 8″ (47.1 x 39.9 x 20.1 cm). Blanchette Rockefeller Fund. 611.65a-b. Repr. *New Jap. Ptg. & Sc.*, p. 78.

NILSSON, Gladys. American, born 1940.

443 THE PINK SUIT. (1965) Watercolor, 9⅞ x 9⅛″ (24.9 x 23.2 cm). Larry Aldrich Foundation Fund. 676.65.

 PEOPLE HOUSES. (1967) Watercolor and pencil on paper, 16 x 22⅛″ (40.4 x 56 cm). Larry Aldrich Foundation Fund. 4.68.

NOGUCHI, Isamu. American, born 1904. Works principally in U.S.A., Japan, and Italy.

300 PORTRAIT OF MY UNCLE. 1931. Terra cotta, 12½″ (31.7 cm) high. Gift of Edward M. M. Warburg. 244.50. Repr. *Amer. Ptg. & Sc.*

300 CAPITAL. (1939) Georgia marble, 16 x 24 x 24″ (40.7 x 61 x 61 cm). Gift of Miss Jeanne Reynal. 561.41. Repr. *Ptg. & Sc.*, p. 289.

 BIG BOY. 1952. Karatsu ware, 7⅞ x 6⅞″ (18.7 x 17.4 cm). A. Conger Goodyear Fund. 20.55.

300 EVEN THE CENTIPEDE. (1952) Kasama ware in eleven pieces, each approximately 18″ (46 cm) wide, mounted on wood pole 14′ (425 cm) high. A. Conger Goodyear Fund. 1.55a-k. Repr. *Suppl. V*, p. 31.

300 BIRD C (MU). (1952–58) Greek marble, 22¾ x 8⅛″ (57.8 x 20.5 cm). In memory of Robert Carson, architect (given anonymously). 418.60. Repr. *Suppl. X*, p. 44.

300 WOMAN. (1957) Iron, 14⅜ x 18¼ x 8⅝″ (36.5 x 46.3 x 21.9 cm). Purchase. 419.60. Repr. *Suppl. X*, p. 44.

483 STONE OF SPIRITUAL UNDERSTANDING. 1962. Bronze suspended on square wood bar set on metal supports, 52¼ x 48 x 16″ (132.6 x 121.9 x 40.4 cm). Gift of the artist. 574.64a-c.

NOLAN, Sidney. Australian, born 1917.

268 AFTER GLENROWAN SIEGE (Second Ned Kelly series). (1955) Enamel on composition board, 48 x 36″ (121.9 x 91.5 cm). Benjamin Scharps and David Scharps Fund. 340.55. Repr. *Suppl. VI*, p. 28.

 FIGURES AND FOREST. (1958) Alizarin dye on paper, 12 x 10″ (30.4 x 25.4 cm). Blanchette Rockefeller Fund. 138.58. Repr. *Suppl. VIII*, p. 17.

NOLAND, Kenneth. American, born 1924.

 TURNSOLE. 1961. Synthetic polymer paint on canvas, 7′10⅛″ x 7′10⅛″ (239 x 239 cm). Blanchette Rockefeller Fund. 5.68. Repr. in color, *Invitation*, p. 37.

NOLDE, Emil (Emil Hansen). Danish, born North Schleswig, Germany, later part of Denmark. 1867–1956. Worked in Germany.

Dr. Martin Urban, Director of the Ada and Emil Nolde Foundation, has corrected some dates.

67 CHRIST AMONG THE CHILDREN. (1910) Oil on canvas, 34$^{1}/_{8}$ x 41$^{7}/_{8}$" (86.8 x 106.4 cm). Gift of Dr. W. R. Valentiner. 341.55. Repr. *Art in Our Time*, no. 125; *Nolde*, p. 20; in color, *German Art of 20th C.*, p. 33; in color, *Invitation*, p. 22.

PAPUAN HEAD. 1914. Watercolor, 19$^{7}/_{8}$ x 14$^{3}/_{4}$" (50.4 x 37.5 cm). Gift of Mr. and Mrs. Eugene Victor Thaw. 279.58.

67 RUSSIAN PEASANTS. (1915) Oil on canvas, 29 x 35$^{1}/_{2}$" (73.4 x 90 cm). Matthew T. Mellon Foundation Fund. 19.54. Repr. *Suppl. V*, p. 10.

67 FLOWERS. (c. 1915?) Oil on burlap, 26$^{1}/_{4}$ x 33$^{1}/_{4}$" (66.6 x 84.5 cm). Gift of Mr. and Mrs. Werner E. Josten. 555.56. Repr. in color, *German Art of 20th C.*, p. 36.

66 ISLANDER. (1920–21) Watercolor, 18$^{1}/_{2}$ x 13$^{3}/_{4}$" (47 x 34.9 cm). Gertrud A. Mellon Fund. 21.55.

66 AMARYLLIS AND ANEMONE. (c. 1930) Watercolor, 13$^{3}/_{4}$ x 18$^{3}/_{8}$" (35 x 46.7 cm). Gift of Philip L. Goodwin. 10.49. Repr. *Suppl. I*, p. 11.

66 MAGICIANS. (1931–35) Watercolor, 20$^{1}/_{8}$ x 14$^{3}/_{8}$" (51.1 x 36.5 cm). Purchase. 654.39. Repr. *Ptg. & Sc.*, p. 78.

NOVELLI, Gastone. Italian, born Austria. 1925–1968.

CIENFUEGOS. 1968. Oil, oil with pumice, ink, charcoal, and pencil on canvas, 12'6$^{1}/_{4}$" x 6'7$^{1}/_{8}$" (351.1 x 201.2 cm). Gift of Sra. Giovanola Ripandelli. 112.73.

NOVROS, David. American, born 1941.

VI: XXXII. (1966) Vinyl lacquer paint on shaped canvases in six parts, overall, 14'7$^{1}/_{4}$" x 6'9$^{3}/_{4}$" (445.1 x 207.6 cm). Gift of Charles Cowles. 528.71a–f.

NTIRO, Sam Joseph. Tanzanian, born 1923. Lives in Uganda.

286 MEN TAKING BANANA BEER TO BRIDE BY NIGHT. 1956. Oil on canvas, 16$^{1}/_{8}$ x 20" (40.9 x 50.8 cm). Elizabeth Bliss Parkinson Fund. 122.60. Repr. *Suppl. X*, p. 24.

OBIN, Philomé. Haitian, born 1892.

9 INSPECTION OF THE STREETS. 1948. Oil on composition board, 24 x 24" (61 x 61 cm). Inter-American Fund. 268.48.

OBREGÓN, Alejandro. Colombian, born Spain 1920.

290 SOUVENIR OF VENICE. (1953) Oil on canvas, 51$^{1}/_{4}$ x 38$^{1}/_{8}$" (130.2 x 96.8 cm). Inter-American Fund. 22.55. Repr. *Suppl. V*, p. 25.

OCAMPO, Miguel. Argentine, born 1922.

NUMBER 166. 1957. Gouache, 17$^{1}/_{4}$ x 12$^{1}/_{8}$" (43.6 x 30.8 cm), composition. Inter-American Fund. 90.58.

373 NUMBER 172. 1957. Oil on canvas, 21$^{1}/_{4}$ x 31$^{7}/_{8}$" (54 x 81 cm). Inter-American Fund. 89.58. Repr. *Suppl. VIII*, p. 22.

O'CONOR, Roderic. Irish, 1860–1940. Worked in France.

34 THE GLADE. 1892. Oil on canvas, 36$^{1}/_{4}$ x 23$^{1}/_{2}$" (92 x 59.6 cm). Acquired through the Lillie P. Bliss Bequest. 270.56. Repr. *Suppl. VI*, p. 6.

OELZE, Richard. German, born 1900.

182 EXPECTATION [*Erwartung*]. 1935–36. Oil on canvas, 32$^{1}/_{8}$ x 39$^{5}/_{8}$" (81.6 x 100.6 cm). Purchase. 27.40. Repr. *Ptg. & Sc.*, p. 202.

O'GORMAN, Juan. Mexican, born 1905.

211 THE SAND MINES OF TETELPA. 1942. Tempera on composition board, 22$^{1}/_{4}$ x 18" (56.5 x 45.7 cm). Gift of Edgar Kaufmann, Jr. 751.42. Repr. *Ptg. & Sc.*, p. 178.

OKADA, Kenzo. American, born Japan 1902. To U.S.A. 1950.

368 NUMBER 3. 1953. Oil on canvas, 65$^{1}/_{8}$ x 57$^{7}/_{8}$" (165.4 x 147 cm). Given anonymously. 248.54. Repr. *Suppl. V*, p. 28.

O'KEEFFE, Georgia. American, born 1887.

228 EVENING STAR, III. (1917) Watercolor, 9 x 11$^{7}/_{8}$" (22.7 x 30.2 cm). Mr. and Mrs. Donald B. Straus Fund. 91.58. Repr. *Suppl. VIII*, p. 8; *Natural Paradise*, p. 36.

228 LAKE GEORGE WINDOW. 1929. Oil on canvas, 40 x 30" (101.6 x 76.2 cm). Acquired through the Richard D. Brixey Bequest. 144.45. Repr. *Ptg. & Sc.*, p. 129; *Art of the Real*, p. 12; in color, *Invitation*, p. 97.

OLDENBURG, Claes. American, born Sweden 1929. To U.S.A. 1936.

"EMPIRE" ("PAPA") RAY GUN. (1959) Casein on newspaper over wire, 35$^{7}/_{8}$ x 44$^{7}/_{8}$ x 14$^{5}/_{8}$" (90.9 x 113.8 x 36.9 cm). Gift of the artist. 791.69. Repr. *Oldenburg*, p. 58.

392 RED TIGHTS WITH FRAGMENT 9. (1961) Muslin soaked in plaster over wire frame, painted with enamel, 69$^{5}/_{8}$ x 34$^{1}/_{4}$ x 8$^{3}/_{8}$" (176.7 x 87 x 22.2 cm). Gift of G. David Thompson. 387.61. Repr. *Suppl. XI*, p. 48; *Amer. 1963*, p. 77; in color, *Oldenburg*, p. 78.

PASTRY CASE, I. 1961–62. Enamel paint on nine plaster sculptures in glass showcase, 20$^{3}/_{4}$ x 30$^{1}/_{8}$ x 14$^{3}/_{4}$" (52.7 x 76.5 x 37.3 cm). The Sidney and Harriet Janis Collection (fractional gift). 639.67a–dd. Repr. in color, *Oldenburg*, p. 89; in color, *Janis*, p. 159. *Note*: also called *Case of Pastries and Sundaes*.

FLOOR CAKE (GIANT PIECE OF CAKE). (1962) Synthetic polymer paint and latex on canvas filled with foam rubber and cardboard, 58$^{3}/_{8}$" x 9'6$^{1}/_{4}$" x 58$^{3}/_{8}$" (148.2 x 290.2 x 148.2 cm). Gift of Philip Johnson. 414.75. Repr. *Oldenburg*, p. 152; in color, *Amer. Art*, p. 12, in b. & w., p. 53.

392 TWO CHEESEBURGERS, WITH EVERYTHING (DUAL HAMBURGERS). 1962. Burlap soaked in plaster, painted with enamel, 7 x 14$^{3}/_{4}$ x 8$^{5}/_{8}$" (17.8 x 37.5 x 21.8 cm). Philip Johnson Fund. 233.62. Repr. *Amer. 1963*, p. 78; in color, *Oldenburg*, p. 84.

GIANT SOFT FAN. (1966–67) Construction of vinyl filled with foam rubber, wood, metal, and plastic tubing; fan, 10' x 58$^{7}/_{8}$" x 61$^{7}/_{8}$" (305 x 149.5 x 157.1 cm), variable; plus cord and plug, 24'3$^{1}/_{4}$" (739.6 cm). The Sidney and Harriet Janis Collection (fractional gift). 2098.67. Repr. *Oldenburg*, p. 134; *Janis*, pp. 160–161. *Note*: also called *Giant Black Vinyl Soft Fan*.

OLITSKI, Jules. American, born Russia 1922. To U.S.A. 1924.

342 CLEOPATRA FLESH. 1962. Synthetic polymer paint on canvas, 8'8" x 7'6" (264.2 x 228.3 cm). Gift of G. David Thompson (by exchange). 262.64.

WILLEMITE'S VISION. 1972. Synthetic polymer paint on canvas, 8'2$^{1}/_{2}$" x 17'5$^{1}/_{8}$" (250.2 x 531.1 cm). Blanchette Rockefeller Fund (by exchange). 113.73.

JEHOVAH COVER—2. 1975. Synthetic polymer paint on canvas, 7'1" x 40" (216 x 101.6 cm). The Gilman Foundation Fund. 104.76.

OLIVEIRA, Nathan. American, born 1928.

280 STANDING MAN WITH STICK. 1959. Oil on canvas, 68$^{7}/_{8}$ x 60$^{1}/_{4}$" (174.8 x 153 cm). Gift of Joseph H. Hirshhorn. 609.59. Repr. in color, *New Images*, p. 112.

OLSON, Eric H. Swedish, born 1909.

508 OPTOCHROMI H 12-4. 1965. Glass with polarization and birefringence sheets, 16⁵/₈ x 6³/₄ x 4″ (42 x 17.2 x 10 cm). Gift of Mr. and Mrs. Leif Sjöberg (by exchange). 182.66. *Note*: the artist states: "Each glass plane is made into a lamellar glass, which contains polarizing film and a double refractive film."

OPPENHEIM, Dennis. American, born 1938.

TIME POCKET. 1968. Collage of topographical map, scale plan, typewritten sheet, transfer type, gouache, crayon, felt-tipped pen, ink, and pencil on cardboard, 28 x 22″ (71.1 x 55.8 cm). Gift of Charles Cowles. 529.71.

TIME POCKET—PROJECT FOR FROZEN LAKE. 1968. Putty, marble dust, plexiglass, and spray paint, 2⁷/₈ x 14¹/₈ x 16¹/₄″ (7.2 x 36.1 x 41.2 cm). Gift of Charles Cowles. 530.71.

HIGHWAY 20. 1969. Three color photographs and two photocopies of air and road maps, 48¹/₂ x 45″ (123 x 114.1 cm). Larry Aldrich Foundation Fund. 1070.69.

OPPENHEIM, Meret. Swiss, born Berlin 1913.

182 OBJECT [*Le Déjeuner en fourrure*]. (1936) Fur-covered cup, saucer, and spoon; cup, 4³/₈″ (10.9 cm) diameter; saucer, 9³/₈″ (23.7 cm) diameter; spoon, 8″ (20.2 cm) long; overall height 2⁷/₈″ (7.3 cm). Purchase. 130.46a–c. Repr. *Fantastic Art* (3rd), p. 192; *Assemblage*, p. 60; *Dada, Surrealism*, p. 143.

OPPER, John. American, born 1908.

PAINTING. (1960) Oil on canvas, 69¹/₄ x 42″ (175.8 x 106.7 cm). Gift of Mrs. Leo Simon. 388.61. Repr. *Suppl. XI*, p. 24.

ORION, Ezra. Israeli, born 1934.

481 HIGH NIGHT, II. (1963) Welded iron, 6′2″ (187.9 cm) high, at base 14 x 13³/₈″ (35.5 x 34.2 cm). Gift of Mr. and Mrs. George M. Jaffin. 6.65. Repr. *Art Israel*, p. 60.

ORLANDO, Felipe. Cuban, born 1911.

WOMAN WASHING. (1943) Gouache, 15³/₈ x 11¹/₄″ (39 x 28.6 cm). Inter-American Fund. 78.44.

OROZCO, José Clemente. Mexican, 1883–1949. In U.S.A. 1917–18, 1927–34, 1940, 1945–46.

204 THE SUBWAY. (1928) Oil on canvas, 16¹/₈ x 22¹/₈″ (41 x 56.2 cm). Gift of Abby Aldrich Rockefeller. 203.35. Repr. *Latin-Amer. Coll.*, p. 58.

204 PEACE. (1930) Oil on canvas, 30¹/₄ x 48¹/₄″ (76.8 x 122.5 cm). Given anonymously. 467.37.

204 BARRICADE. (1931) Oil on canvas, 55 x 45″ (139.7 x 114.3 cm). Given anonymously. 468.37. Repr. *Ptg. & Sc.*, p. 136. *Note*: variant of the fresco (1924) in the National Preparatory School, Mexico City.

204 THE CEMETERY. (1931) Oil on canvas, 27 x 39⁷/₈″ (68.6 x 101.3 cm). Given anonymously. 469.37. Repr. *Latin-Amer. Coll.*, p. 58.

205 ZAPATISTAS. 1931. Oil on canvas, 45 x 55″ (114.3 x 139.7 cm). Given anonymously. 470.37. Repr. *Ptg. & Sc.*, p. 137; in color, *Invitation*, p. 111.

205 DIVE BOMBER AND TANK. 1940. Fresco, 9 x 18′ (275 x 550 cm), on six panels, 9 x 3′ (275 x 91.4 cm) each. Commissioned through the Abby Aldrich Rockefeller Fund. 1630.40.1–.6. Repr. *Ptg. & Sc.*, p. 135.

205 SELF-PORTRAIT. 1940. Oil and gouache on cardboard, 20¹/₄ x 23³/₄″ (51.4 x 60.3 cm). Inter-American Fund. 605.42. Repr. *Latin-Amer. Coll.*, p. 61.

ORTIZ. See MONTANEZ-ORTIZ.

ORTMAN, George. American, born 1926.

372 TRIANGLE. (1959) Collage of painted canvas on composition board with nine plaster inserts, 49⁵/₈ x 49⁷/₈ x 3³/₄″ (126 x 126.6 x 9.5 cm). Larry Aldrich Foundation Fund. 364.60. Repr. *Suppl. X*, p. 47.

ORTVAD, Erik. Danish, born 1917.

Untitled. 1945. Watercolor, 13 x 15⁷/₈″ (33 x 40.3 cm). Gift of the artist. 64.47.

OSAWA, Gakyù. Japanese, 1890–1953.

317 THE DEEP POOL. (c. 1953) Brush and ink, 26⁷/₈ x 54³/₈″ (68.3 x 138.1 cm). Japanese House Fund. 273.54. Repr. *Suppl. V*, p. 28.

OSSAYE, Roberto. Guatemalan, 1927–1954.

289 PITAHAYA. 1953. Oil on canvas, 12⁷/₈ x 18³/₄″ (32.7 x 47.5 cm). Given in memory of the artist by Mrs. Roberto Ossaye and her daughter Maria del Carmen Ossaye. 17.57. Repr. *Suppl. VII*, p. 20.

OSSORIO, Alfonso. American, born the Philippines 1916. To U.S.A. 1929.

ANIMULAE. (1950) Wax and watercolor on paper, 30¹/₄ x 22″ (76.6 x 55.8 cm) (sight). Gift of the artist. 1098.69.

IMPREGNATE. (1951) Wax, watercolor, pen and ink on paper, 29¹/₂ x 22¹/₂″ (74.8 x 56.9 cm). Gift of the artist in memory of his brother, Miguel N. Ossorio. 502.69.

SUM, 2. 1959. Assemblage: synthetic resin with miscellaneous materials on composition board, 7′11³/₄″ x 48″ (243.2 x 121.8 cm). Given anonymously. 3.62. Repr. *Suppl. XII*, p. 18.

EMPTY CHAIR OR THE LAST COLONIAL. 1969. Assemblage: miscellaneous materials including glass, wood, plastic, bone, shell, stone, and metal on plastic sheets mounted on wood, 46³/₈ x 39¹/₄ x 15⁷/₈″ (117.7 x 99.7 x 40.3 cm). Gift of the artist. 688.71.

OSVER, Arthur. American, born 1912.

MELANCHOLY OF A ROOFTOP. (1942) Oil on canvas, 48 x 24″ (121.9 x 61 cm). Purchase. 340.42. Repr. *Ptg. & Sc.*, p. 172.

OTERO, Alejandro. Venezuelan, born 1921. Worked in Paris 1945–52, 1960–64.

371 COLOR-RHYTHM, I [*Coloritmo I*]. 1955. Duco on plywood, 6′6³/₄″ x 19″ (200.1 x 48.2 cm). Inter-American Fund. 21.56. Repr. *Suppl. VI*, p. 33.

OUDOT, Roland. French, born 1897.

LOISETTE. 1929. Oil on canvas, 28³/₄ x 23⁵/₈″ (73 x 60 cm). Gift of A. Conger Goodyear. 563.41.

OZENFANT, Amédée. French, 1886–1966. In U.S.A. 1938–55.

142 THE VASES [*Les Vases; Dorique*]. 1925. Oil on canvas, 51³/₈ x 38³/₈″ (130.5 x 97.5 cm). Acquired through the Lillie P. Bliss Bequest. 164.45. Repr. *Ptg. & Sc.*, p. 125.

PAALEN, Wolfgang. Austrian, 1905–1959. Worked in Paris and Mexico.

410 Study for TOTEM LANDSCAPE OF MY CHILDHOOD. 1937. Oil on canvas, 21⁷/₈ x 15¹/₈″ (55.3 x 38.3 cm). Kay Sage Tanguy Bequest. 1131.64.

182 Untitled. 1938. Colored inks, 21³/₄ x 28¹/₂″ (55.1 x 72.2 cm). Gift of Mrs. Milton Weill. 80.62. Repr. *Suppl. XII*, p. 22.

FUMAGE. (1944–45?) Oil and candle soot on paper, 18³/₄ x 10¹/₄″ (47.6 x 26 cm) (irregular). Gift of Samuel A. Berger. 23.55.

PACENZA, Onofrio A. Argentine, born 1902.

213 END OF THE STREET. 1936. Oil on canvas, 33³/₈ x 41³/₈″ (84.8 x 105.1 cm). Inter-American Fund. 212.42.

PANCETTI, José. Brazilian, born 1903.

SELF-PORTRAIT. 1941. Oil on canvas, 32 x 24″ (81.3 x 60.8 cm). Inter-American Fund. 765.42. Repr. *Latin-Amer. Coll.*, p. 39.

PANNAGGI, Ivo. Italian, born 1901. Lives in Norway.

198 MY MOTHER READING THE NEWSPAPER. (c. 1922) Oil on canvas on composition board, 11¹/₈ x 10¹/₄″ (28.3 x 26 cm). Gift of Mario da Silva. 510.51.

PAOLOZZI, Eduardo. British, born 1924.

STUDY FOR SCULPTURE. 1950. Watercolor, 22 x 30″ (55.9 x 76.2 cm). Mrs. Wendell T. Bush Fund. 182.53.

COMPOSITION. 1951. Collage of cut-and-pasted serigraphs printed in dye, 20¹/₂ x 26⁷/₈″ (52.1 x 68.3 cm). Purchase. 183.53.

296 SCULPTURE. (1951) Cast concrete, 9³/₈ x 18¹/₄ x 11¹/₄″ (23.8 x 46.3 x 28.6 cm). Purchase. 181.53. Repr. *Suppl. IV*, p. 41.

296 JASON. (1956) Bronze, 66¹/₈″ (167.8 cm) high, at base 14³/₄ x 11¹/₄″ (37.5 x 28.6 cm). Blanchette Rockefeller Fund. 661.59. (Purchased in 1957.) Repr. *New Images*, p. 119.

489 LOTUS. (1964) Welded aluminum, 7′5¹/₈″ (226.1 cm) high, at base 36³/₈ x 36¹/₈″ (92.3 x 91.6 cm). Gift of G. David Thompson. 291.65.

The thirteen works listed below are studies for the portfolio of serigraphs *As Is When*, published in 1965. All are composed of cut-and-pasted paper, a few with the addition of tracing paper, gouache, pencil, or ballpoint pen. With the exception of *Assembling Reminders for a Particular Purpose*, 477.71, a gift of the artist, all are the gifts of Mrs. Alexander Keiller.

ARTIFICIAL SUN. 1964, May 13. 28¹/₈ x 22¹/₈″ (71.2 x 56.1 cm). 2401.67.

EXPERIENCE. 1964, July. 35¹/₈ x 25¹/₄″ (89.1 x 64.0 cm). 2391.67.

REALITY. 1964, July. 30⁵/₈ x 21¹/₈″ (77.6 x 53.4 cm). 2400.67.

WITTGENSTEIN AS SOLDIER. 1964, August. 30¹/₂ x 21¹/₈″ (77.4 x 53.4 cm). 2397.67.

WITTGENSTEIN IN NEW YORK. 1964, August. 30⁵/₈ x 21″ (77.6 x 53.3 cm). 2395.67.

FUTURISM AT LENABO. 1964, November. 29³/₄ x 23⁵/₈″ (75.5 x 59.9 cm). 2396.67.

PARROT. 1964, November. 30³/₈ x 21⁷/₈″ (77.1 x 55.5 cm). 2392.67.

TORTURED LIFE. 1964. 33⁷/₈ x 23¹/₄″ (86.0 x 58.9 cm). 21.68.

ASSEMBLING REMINDERS FOR A PARTICULAR PURPOSE. 1965, January. 30⁷/₈ x 22¹/₂″ (78.4 x 57.1 cm). 477.71.

THE SPIRIT OF THE SNAKE. 1965, January. 32¹/₈ x 22¹/₈″ (81.4 x 56.0 cm). 2399.67.

HE MUST, SO TO SPEAK, THROW AWAY THE LADDER. 1965, February. 30³/₄ x 20¹/₄″ (78.1 x 51.3 cm). 2393.67.

TITLE PAGE. 1965, March. 31⁵/₈ x 20¹/₂″ (80.3 x 52.0 cm). 2398.67.

WITTGENSTEIN AT THE CINEMA ADMIRES BETTY HUTTON. 1965, March. 31¹/₄ x 20³/₈″ (79.3 x 51.6 cm). 2394.67.

The ten works listed below are studies for the portfolio of serigraphs *Universal Electronic Vacuum*, published in 1967. All are composed of cut-and-pasted paper on graph paper, dated 1967, the gift of Mrs. Alexander Keiller.

NUMBER 1: MEMORY MATRIX. 40⁷/₈ x 28″ (103.7 x 71.1 cm). 276.68.1.

NUMBER 2: A FORMULA THAT CAN SHATTER INTO A MILLION GLASS BULLETS. 36 x 26¹/₂″ (91.3 x 67.1 cm). 276.68.2

NUMBER 3: HORIZON OF EXPECTATIONS. 41 x 28″ (103.9 x 71.0 cm). 276.68.3.

NUMBER 4: PROTOCOL-SENTENCES. 41 x 28″ (104 x 71 cm). 276.68.4.

NUMBER 5: SPONTANEOUS DISCREMATION AND NON-SPONTANEOUS DISCREMINATION ALTERED TO POSTER FOR EDITIONS ALECTO. 41 x 28″ (103.9 x 71.1 cm). 276.68.5.

NUMBER 6: 7 PYRAMIDE IN FORM EINER ACHTELSKUGEL. 40⁷/₈ x 28″ (103.9 x 71 cm). 276.68.6.

NUMBER 7: SUN CITY. 40⁷/₈ x 28″ (103.8 x 71.7 cm). 276.68.7.

NUMBER 8: COMPUTER-EPOCH. 40⁷/₈ x 28″ (103.6 x 71.2 cm). 276.68.8.

NUMBER 9: 883 WHIPPED CREAM, A TASTE OF HONEY, PEANUTS, LEMON TREE AND OTHERS. 41 x 28″ (103.9 x 71 cm). 276.68.9.

NUMBER 10: WAR GAMES (REVISED). 41 x 28″ (104.0 x 71 cm). 276.68.10.

POSTER. 1967. Collage, 41 x 28″ (104.0 x 71.0 cm). Gift of Mrs. Alexander Keiller. 277.68.

PAPSDORF, Fred. American, born 1887.

FLOWERS IN A VASE. 1940. Oil on canvas, 18¹/₄ x 14¹/₄″ (46.3 x 36.2 cm). Purchase. 249.40. Repr. *Amer. Realists*, p. 48.

PAREDES, Diógenes. Ecuadorian, born 1910.

217 THRESHERS. 1942. Tempera on cardboard, 20¹/₂ x 19⁵/₈″ (52.1 x 49.9 cm). Inter-American Fund. 766.42. Repr. *Latin-Amer. Coll.*, p. 55.

PARK, David. American, 1911–1960.

280 GROUP OF FIGURES. 1960. Watercolor, 11¹/₂ x 14¹/₂″ (29.2 x 36.9 cm). Larry Aldrich Foundation Fund. 15.63.

RICHARD DIEBENKORN. 1960. Watercolor, 14⁵/₈ x 11³/₄″ (37.1 x 29.7 cm). Larry Aldrich Foundation Fund. 16.63.

PARKER, Raymond. American, born 1922.

341 Untitled. 1960. Oil on canvas, 71⁷/₈″ x 7′2″ (182.5 x 218.4 cm). Gift of Mr. and Mrs. Samuel M. Kootz. 31.60. Repr. *Suppl. X*, p. 41.

PARKER, Robert Andrew. American, born 1927.

BOSNIA 1911. 1954. Watercolor and ink, 18 x 11⁷/₈″ (45.7 x 30.2 cm). Katharine Cornell Fund. 21.54.

CAMILLE PISSARRO AS A YOUNG MAN. 1954. Watercolor and ink, 12¹/₄ x 17¹/₄″ (31.1 x 43.8 cm). Katharine Cornell Fund. 20.54.

PASCIN, Jules. American, born Bulgaria. 1885–1930. Worked in Europe and North Africa. In U.S.A., Cuba, and Mexico 1914–20. Died in Paris.

GIRLS ON BENCH. Watercolor, pen and ink, 9¹/₂ x 10¹/₈″ (23.5 x 25.6 cm). Given anonymously. 122.35.

SEATED GIRL. Watercolor and pencil, 12¹/₄ x 8¹/₂″ (31.1 x 21.6 cm). Gift of A. Conger Goodyear. 22.54.

PICNICKERS. (1914–15) Watercolor, pen and ink, 7³/₈ x 11¹/₈″ (18.6 x 28 cm). Given anonymously. 123.35.

CAB IN HAVANA. (1914–20) Watercolor, pen and ink, 7¹/₂ x 9⁵/₈″ (18.8 x 24.4 cm). Gift of Abby Aldrich Rockefeller. 121.35.

PORT OF HAVANA. (1914–20) Watercolor and pencil, $4^7/8$ x $7^1/2''$ (12.2 x 19 cm). Given anonymously. 124.35.

191 SOCRATES AND HIS DISCIPLES MOCKED BY COURTESANS. (c. 1921) Oil, gouache, and crayon on paper mounted on canvas, $61^1/4''$ x $7'2''$ (155.6 x 218.5 cm). Given anonymously in memory of the artist. 307.38. Repr. *Ptg. & Sc.*, p. 64; *Seurat to Matisse*, p. 77.

191 RECLINING MODEL. (c. 1925) Oil on canvas, $28^3/4$ x $36^1/4''$ (73 x 92.1 cm). Gift of A. Conger Goodyear. 564.41.

PASMORE, Victor. British, born 1908.

460 SQUARE MOTIF IN BROWN, WHITE, BLACK, BLUE, AND OCHRE. (1948–53) Collage and oil on canvas, 25 x 30'' (63.5 x 76.1 cm). Gift of Mr. and Mrs. Allan D. Emil. 1241.64.

PATERNOSTO, César. Argentine, born 1931. To U.S.A. 1967.

458 DUINO. 1966. Oil on shaped canvas in two parts, $6'6^3/4''$ x $51^3/8''$ (200 x 130.4 cm), and $6'6^1/8''$ x 51'' (198.4 x 129.5 cm). Inter-American Fund. 450.67a–b.

PAVLOS (Dionyssopoulos). Greek, born 1930. To Paris 1958.

HANGING COAT. (1974) Steel wool, $43^5/8$ x $16^5/8''$ (110.8 x 42.3 cm), irregular. Purchase. 1352.74.

PEARLSTEIN, Philip. American, born 1924.

TWO FEMALE MODELS IN THE STUDIO. 1967. Oil on canvas, $50^1/8$ x $60^1/4''$ (127.3 x 153.1 cm). Gift of Mr. and Mrs. Stephen B. Booke. 634.73.

PEARSON, Henry. American, born 1914.

BLACK ON WHITE. 1964. Oil on canvas, $6'6''$ x $6'6''$ (198 x 198 cm). Purchase. 1007.69.

PECHSTEIN, Max. German, 1881–1955.

MAX RAPHAEL. (c. 1910) Watercolor, $22^5/8$ x $18^3/8''$ (57.3 x 46.7 cm). Gift of Mr. and Mrs. Eugene Victor Thaw. 22.56.

PEDERSEN, Carl-Henning. Danish, born 1913.

THE HAPPY WORLD. 1943. Watercolor, pen and ink, $16^1/4$ x $11^3/4''$ (41.3 x 29.9 cm). Gift of the artist. 70.47.

WINGED MAN. 1944. Watercolor, pen and ink, $12^5/8$ x $15^5/8''$ (32.1 x 39.7 cm). Gift of the artist. 71.47.

LIGHT BLUE WORLD BIRD. 1945. Gouache, watercolor, pen and ink, $9^7/8$ x $8^1/2''$ (25 x 21.6 cm). Gift of the artist. 73.47.

TOWN AT NIGHT. 1945. Watercolor, $10^1/8$ x $6^5/8''$ (25.7 x 16.8 cm). Gift of the artist. 72.47.

354 THE YELLOW STAR. 1952. Oil and pencil on canvas, $48^7/8$ x $40^1/2''$ (124 x 102.8 cm). Gift of G. David Thompson. 8.61. Repr. *Suppl. XI*, p. 21.

PEDRO. See MARTÍNEZ PEDRO.

PELÁEZ DEL CASAL, Amelia. Cuban, 1897–1968.

216 STILL LIFE IN RED. 1938. Oil on canvas, $27^1/4$ x $33^1/2''$ (69.3 x 85.1 cm). Inter-American Fund. 162.42. Repr. *Latin-Amer. Coll.*, p. 49.

216 FISHES. 1943. Oil on canvas, $45^1/2$ x $35^1/8''$ (115.6 x 89.2 cm). Inter-American Fund. 80.44. Repr. *Ptg. & Sc.*, p. 130.

GIRLS. 1943. Watercolor, 25 x $27^5/8''$ (63.5 x 70.2 cm). Inter-American Fund. 81.44.

PEREIRA, Irene Rice. American, 1907–1971.

SHADOWS WITH PAINTING. (1940) Outer surface, oil on glass, $1^1/4''$ (3.2 cm) in front of inner surface, gouache on cardboard, 15 x $12^1/8''$ (38.1 x 30.8 cm). Gift of Mrs. Marjorie Falk. 348.41.

365 WHITE LINES. 1942. Oil on vellum with marble dust, sand, etc., $25^7/8$ x $21^7/8''$ (65.7 x 55.6 cm). Gift of Edgar Kaufmann, Jr. 341.42. Repr. *Ptg. & Sc.*, p. 122.

PÉRI, László. Hungarian, born 1889. Worked in Germany 1921–33. To London 1933.

139 IN FRONT OF THE TABLE. (1922) Tempera on cardboard, $25^1/4$ x 34'' (64.1 x 86.4 cm) (irregular). Katherine S. Dreier Bequest. 184.53.

PERLIN, Bernard. American, born 1918.

277 THE LOVERS. 1946. Gouache, 30 x $37^3/4''$ (76.2 x 95.9 cm). Purchase. 269.48. Repr. *Suppl. I*, p. 23.

PETITJEAN, Hippolyte. French, 1854–1929.

LANDSCAPE WITH ROAD. Watercolor, $12^1/2$ x $18^5/8''$ (31.6 x 47.2 cm). Gift of Mr. and Mrs. A. M. Adler. 782.63.

PETO, John Frederick. American, 1854–1907.

36 OLD TIME LETTER RACK. (Previous title: *Old Scraps*.) 1894. Oil on canvas, 30 x $25^1/8''$ (76.2 x 63.8 cm). Gift of Nelson A. Rockefeller. 29.40. Repr. *Art in Our Time*, no. 43. *Note:* formerly attributed to Harnett, titled *Old Scraps*, and dated 1879–80. Removal of the lining canvas in 1967 revealed the inscription "Old Time Letter Rack/11.94/John F. Peto/Artist/Island Heights/N.J."

PETTET, William. American, born 1942.

Untitled. (1968) Synthetic polymer paint on canvas, $7'8''$ x $17'5^1/8''$ (233.6 x 531.2 cm). Gift of Nicholas Wilder in memory of Jordan Hunter (1949–1968). 792.69.

PETTORUTI, Emilio. Argentine, born 1895. Lives in Paris.

213 THE VERDIGRIS GOBLET. 1934. Oil on canvas, $21^5/8$ x $18^1/8''$ (54.9 x 46 cm). Inter-American Fund. 4.43. Repr. *Latin-Amer. Coll.*, p. 24.

PEVSNER, Antoine. French, born Russia. 1886–1962. To Paris 1923.

132 ABSTRACT FORMS. 1913? (1923?) Encaustic on wood, $17^1/4$ x $13^1/2''$ (43.8 x 34.3 cm). Gift of the artist. 35.36. *Note:* dated 1913 by artist, 1923 by his brother, Alexei Pevsner.

132 BUST. (1923–24) Construction in metal and celluloid, $20^7/8$ x $23^3/8''$ (53 x 59.4 cm). Purchase. 396.38. Repr. *Ptg. & Sc.*, p. 272.

132 TORSO. (1924–26) Construction in plastic and copper, $29^1/2$ x $11^5/8''$ (74.9 x 29.4 cm). Katherine S. Dreier Bequest. 185.53. Repr. *Suppl. IV*, p. 12; *Sc. of 20th C.*, p. 148.

132 DEVELOPABLE COLUMN. 1942. Brass and oxidized bronze, $20^3/4''$ (52.7 cm) high, base $19^3/8''$ (49.2 cm) diameter. Purchase. 15.50. Repr. *Suppl. II*, p. 19; *Masters*, p. 126; *What Is Mod. Sc.*, p. 70.

PEYRONNET, Dominique-Paul. French, 1872–1943.

8 THE FERRYMAN OF THE MOSELLE. (c. 1934) Oil on canvas, 35 x $45^5/8''$ (88.9 x 115.9 cm). Abby Aldrich Rockefeller Fund. 664.39. Repr. *Ptg. & Sc.*, p. 19.

PFRIEM, Bernard. American, born 1916.

338 RED RISING UP. 1960. Oil on canvas, $57^1/2$ x 45'' (145.8 x 114.2 cm). Larry Aldrich Foundation Fund. 124.61. Repr. *Suppl. XI*, p. 32.

PICABIA, Francis. French, 1879–1953. Active in New York and Barcelona, 1913–17.

THE SPRING [La Source]. 1912 (June–September) Oil on canvas, 8'2¼" x 8'2⅛" (249. 6 x 249.3 cm). Gift of the children of Eugene and Agnes E. Meyer: Elizabeth Lorentz, Eugene Meyer III, Katharine Graham, and Ruth M. Epstein. 1411.74.

DANCES AT THE SPRING [Danses à la source]. 1912 (June–September) Oil on canvas, 8'3⅛" x 8'2" (251.8 x 248.9 cm). Gift of the children of Eugene and Agnes E. Meyer: Elizabeth Lorentz, Eugene Meyer III, Katharine Graham, and Ruth M. Epstein. 1412.74.

COMIC WEDLOCK [Mariage comique]. 1914 (c. June–July) Oil on canvas, 6'5⅜" x 6'6¾" (196.5 x 200 cm). Gift of the children of Eugene and Agnes E. Meyer: Elizabeth Lorentz, Eugene Meyer III, Katharine Graham, and Ruth M. Epstein. 1409.74.

THIS HAS TO DO WITH ME [C'est de moi qu'il s'agit]. 1914 (c. June–July) Oil on canvas, 6'6⅝" x 6'6⅜" (199.8 x 199.2 cm), irregular. Gift of the children of Eugene and Agnes E. Meyer: Elizabeth Lorentz, Eugene Meyer III, Katharine Graham, and Ruth M. Epstein. 1410.74.

158 I SEE AGAIN IN MEMORY MY DEAR UDNIE [Je revois en souvenir ma chère Udnie]. (1914, perhaps begun 1913) Oil on canvas, 8'2½" x 6'6¼" (250.2 x 198.8 cm). Hillman Periodicals Fund. 4.54. Repr. Suppl. V, p. 15; Dada, Surrealism, p. 25; in color, Invitation, p. 44.

M'AMENEZ-Y. (1919–20) Oil on cardboard, 50¾ x 35⅜" (129.2 x 89.8 cm). Helena Rubinstein Fund. 1309.68. Repr. Dada, Surrealism, p. 28.

PICASSO, Pablo. Spanish, 1881–1973. To France 1904.

Zervos refers to Pablo Picasso, volumes I through XXVIII by Christian Zervos, Editions "Cahiers d'Art," Paris, 1932–74.

76 BROODING WOMAN. (1904–05) Watercolor, 10⅝ x 14½" (26.7 x 36.6 cm). Gift of Mr. and Mrs. Werner E. Josten. 4.56a. Zervos, I, no. 231. Repr. Picasso 75th Anniv., p. 19; in color, Picasso in MoMA, p. 27. On reverse: THREE CHILDREN. (1903–04) Watercolor, 14½ x 10⅝" (36.6 x 26.7 cm). 4.56b. Zervos, I, no. 218. Repr. Suppl. VI, p. 11; Picasso in MoMA, p. 26.

76 TWO NUDES. (1906, late) Oil on canvas, 59⅝ x 36⅝" (151.3 x 93 cm). Gift of G. David Thompson in honor of Alfred H. Barr, Jr. 621.59. Zervos, I, no. 366. Repr. Picasso 50 (3rd), p. 52; Picasso 75th Anniv., p. 31; Bulletin, Fall 1958, p. 36; in color, Picasso in MoMA, p. 39.

HEAD (Study for Les Demoiselles d'Avignon). (1906, late) Watercolor, 8⅞ x 6⅞" (22.4 x 17.5 cm). John S. Newberry Collection. 383.60. Zervos, II*, no. 10. Repr. Suppl. X, p. 15; Picasso in MoMA, p. 42.

76 HEAD OF A MAN (Study for Les Demoiselles d'Avignon). (1907, early) Watercolor, 23¾ x 18½" (60.3 x 47 cm). A. Conger Goodyear Fund. 14.52. Zervos, VI, no. 977. Repr. Suppl. IV, p. 22; Picasso in MoMA, p. 43.

77 LES DEMOISELLES D'AVIGNON. (1907) Oil on canvas, 8' x 7'8" (243.9 x 233.7 cm). Acquired through the Lillie P. Bliss Bequest. 333.39. Zervos, II*, no. 18. Repr. Ptg. & Sc., p. 85; in color, Masters, p. 69; Picasso 50 (3rd), opp. p. 54; in color, Picasso in MoMA, p. 41; in color, Invitation, p. 47.

76 BATHERS IN A FOREST. 1908. Watercolor and pencil on paper over canvas, 18¾ x 23⅛" (47.5 x 58.7 cm) (sight). Hillman Periodicals Fund. 28.57. Repr. Picasso 75th Anniv., p. 36; Suppl. VII, p. 8; Picasso in MoMA, p. 46.

REPOSE. Paris (1908, spring or early summer) Oil on canvas, 32 x 25¾" (81.2 x 65.4 cm). Acquired by exchange through the

Katherine S. Dreier Bequest and the Hillman Periodicals, Philip Johnson, Miss Janice Loeb, and Mr. and Mrs. Norbert Schimmel Funds. 575.70. Zervos, XXVI, no. 303. Repr. Picasso in MoMA, p. 47.

LANDSCAPE. La Rue des Bois (1908, fall) Oil on canvas, 39⅝ x 32" (100.8 x 81.3 cm). Gift of David Rockefeller. 1413.74. Zervos, II*, no. 83. Repr. Picasso in MoMA, p. 50.

78 FRUIT DISH. (1909, early spring) Oil on canvas, 29¼ x 24" (74.3 x 61 cm). Acquired through the Lillie P. Bliss Bequest. 263.44. Zervos, II*, no. 121. Repr. Ptg. & Sc., p. 84; Picasso in MoMA, p. 55.

78 HEAD. (1909, spring) Gouache, 24 x 18" (61 x 45.7 cm). Gift of Mrs. Saidie A. May. 12.30. Zervos, II*, no. 148. Repr. Picasso 50 (3rd), p. 66; Picasso in MoMA, p. 59.

78 STILL LIFE WITH LIQUEUR BOTTLE. (1909, summer) Oil on canvas, 32⅛ x 25¾" (81.6 x 65.4 cm). Mrs. Simon Guggenheim Fund. 147.51. Zervos, II*, no. 173. Repr. Suppl. III, p. 12; in color, Picasso in MoMA, p. 63.

78 WOMAN'S HEAD. (1909, fall) Bronze, 16¼" (41.3 cm) high. Purchase. 1632.40. Zervos, II**, no. 573. Repr. Ptg. & Sc., p. 267; Picasso 50 (3rd), p. 69; Sc. of 20th C., pp. 130, 131; What Is Mod. Sc., p. 42; Sc. of Picasso, p. 56; Picasso in MoMA, p. 61. Note: the subject is Fernande Olivier, companion of the artist, 1904–12.

79 WOMAN IN A CHAIR. (1909, late) Oil on canvas, 28¾ x 23⅝" (73 x 60 cm). Gift of Mr. and Mrs. Alex L. Hillman. 23.53. Zervos, II*, no. 215. Repr. Suppl. IV, p. 22; Picasso in MoMA, p. 65.

79 "MA JOLIE." (1911–12, winter) Oil on canvas, 39⅜ x 25¾" (100 x 65.4 cm). Acquired through the Lillie P. Bliss Bequest. 176.45. Zervos, II*, no. 244. Repr. Ptg. & Sc., p. 88; Lettering, p. 24; in color, Picasso in MoMA, p. 69; in color, Invitation, p. 48. Note: also entitled Woman with a Zither or Woman with a Guitar.

GUITAR. Paris (1912, early) Sheet metal and wire, 30½ x 13⅛ x 7⅝" (77.5 x 35 x 19.3 cm). Gift of the artist. 94.71. Zervos, II**, no. 773. Repr. Sc. of Picasso, p. 58; Picasso in MoMA, p. 75.

THE ARCHITECT'S TABLE. Paris (1912, spring) Oil on canvas mounted on panel, 28⅝ x 23½" (72.6 x 59.7 cm). Gift of William S. Paley. 697.71. Zervos, II*, no. 321. Repr. Four Amer. in Paris, pl. 50; in color, Picasso in MoMA, p. 73.

79 VIOLIN AND GRAPES. (1912, summer or early fall) Oil on canvas, 20 x 24" (50.6 x 61 cm). Mrs. David M. Levy Bequest. 32.60. Zervos, II*, no. 350. Repr. Suppl. X, p. 11; Levy Collection, p. 28; in color, Picasso in MoMA, p. 77. Note: sometimes mistakenly reproduced vertically.

78 MAN WITH A HAT. (1912, December) Charcoal, ink, pasted paper, 24½ x 18⅝" (62.2 x 47.3 cm). Purchase. 274.37. Zervos, II**, no. 398. Repr. Ptg. & Sc., p. 97; in color, Picasso in MoMA, p. 78; Seurat to Matisse, p. 49.

HEAD. (1913, spring) Collage, pen and ink, pencil, and watercolor on paper, 17 x 11⅜" (43 x 28.8 cm) (irregular). The Sidney and Harriet Janis Collection (fractional gift). 640.67. Zervos, II**, no. 403. Repr. Picasso in MoMA, p. 80; Janis, p. 11.

GLASS, GUITAR, AND BOTTLE. (1913, spring) Oil, pasted paper, gesso, and pencil on canvas, 25¾ x 21⅛" (65.4 x 53.6 cm). The Sidney and Harriet Janis Collection (fractional gift). 641.67. Zervos, II**, no. 419. Repr. Cubism, p. 81; Picasso 50 (3rd), p. 82; Picasso in MoMA, p. 81; Janis, p. 12. Note: also called Still Life with a Guitar; La Table; Guitar and Glass.

80 CARD PLAYER. (1913–14, winter) Oil on canvas, 42½ x 35¼" (108 x 89.5 cm). Acquired through the Lillie P. Bliss Bequest. 177.45. Zervos, II**, no. 466. Repr. Ptg. & Sc., p. 89; in color, Picasso in MoMA, p. 87.

WOMAN WITH A MANDOLIN. Paris (1914, spring) Oil, sand, and charcoal on canvas, 45¹/₂ x 18⁵/₈" (115.5 x 47.5 cm). Gift of David Rockefeller. 415.75. Repr. *Four Amer. in Paris*, pl. 54; in color, *Picasso in MoMA*, p. 90.

79 PIPE, GLASS, BOTTLE OF RUM. 1914, March. Pasted paper, pencil, gouache, on cardboard, 15³/₄ x 20³/₄" (40 x 52.7 cm). Gift of Mr. and Mrs. Daniel Saidenberg. 287.56. Repr. *Picasso 75th Anniv.*, p. 43; *Picasso in MoMA*, p. 92.

80 GREEN STILL LIFE. 1914 (summer) Oil on canvas, 23¹/₂ x 31¹/₄" (59.7 x 79.4 cm). Lillie P. Bliss Collection. 92.34. *Zervos, II***, no. 485. Repr. *Ptg. & Sc.*, p. 97; in color, *Picasso in MoMA*, p. 94.

 GLASS, NEWSPAPER, AND BOTTLE. (1914, fall) Oil and sand on canvas, 14¹/₄ x 24¹/₈" (36 x 61.2 cm). The Sidney and Harriet Janis Collection (fractional gift). 642.67. *Zervos, II***, no. 531. Repr. *Picasso in MoMA*, p. 96; *Janis*, p. 12. *Note*: also called *Still Life*.

80 GLASS OF ABSINTH. (1914) Painted bronze with silver sugar strainer, 8¹/₂ x 6¹/₂" (21.6 x 16.4 cm); diameter at base, 2¹/₂" (6.4 cm). Gift of Mrs. Bertram Smith. 292.56. *Zervos, II***, no. 584. Repr. *Picasso 75th Anniv.*, p. 46; in color, *Sc. of Picasso*, frontispiece; in color, *Picasso in MoMA*, p. 95.

80 HARLEQUIN. 1915 (late) Oil on canvas, 6'1¹/₄" x 41³/₈" (183.5 x 105.1 cm). Acquired through the Lillie P. Bliss Bequest. 76.50. *Zervos, II***, no. 555. Repr. *Suppl. II*, p. 4; in color, *Picasso in MoMA*, p. 99.

81 PIERROT. 1918. Oil on canvas, 36¹/₂ x 28³/₄" (92.7 x 73 cm). Sam A. Lewisohn Bequest. 12.52. *Zervos, III*, no. 137. Repr. *Suppl. IV*, p. 6; in color, *Picasso in MoMA*, p. 102.

80 SEATED WOMAN. (1918) Gouache, 5¹/₂ x 4¹/₂" (14 x 11.4 cm). Gift of Abby Aldrich Rockefeller. 127.35. *Zervos, III*, no. 207; *Picasso in MoMA*, p. 106.

 GUITAR. (1919, early) Oil, charcoal, and pinned paper on canvas, 7'1" x 31" (216 x 78.8 cm). Gift of A. Conger Goodyear. 384.55. *Zervos, II***, no. 570. Repr. *Suppl. VI*, p. 11; *Picasso 50* (3rd), p. 93; in color, *Picasso in MoMA*, p. 105.

81 SLEEPING PEASANTS. 1919. Tempera, watercolor, and pencil, 12¹/₄ x 19¹/₄" (31.1 x 48.9 cm). Abby Aldrich Rockefeller Fund. 148.51. *Zervos, III*, no. 371. Repr. *Suppl. III*, p. 13; in color, *Masters*, p. 80; in color, *Picasso in MoMA*, p. 109; *Seurat to Matisse*, p. 58.

81 THE RAPE. 1920. Tempera on wood, 9³/₈ x 12⁷/₈" (23.8 x 32.6 cm). The Philip L. Goodwin Collection. 106.58. *Zervos, IV*, no. 109. Repr. *Picasso 50* (3rd), p. 117; *Picasso 75th Anniv.*, p. 55; *Bulletin*, Fall 1958, p. 10; in color, *Picasso in MoMA*, p. 111.

83 THREE MUSICIANS. 1921 (summer) Oil on canvas, 6'7" x 7'3³/₄" (200.7 x 222.9 cm). Mrs. Simon Guggenheim Fund. 55.49. *Zervos, IV*, no. 331. Repr. *Suppl. I*, p. 1; in color, *Masters*, p. 83; *Paintings from MoMA*, p. 37; in color, *Picasso in MoMA*, p. 113; in color, *Invitation*, p. 70.

82 THREE WOMEN AT THE SPRING. 1921 (summer) Oil on canvas, 6'8¹/₄" x 68¹/₂" (203.9 x 174 cm). Gift of Mr. and Mrs. Allan D. Emil. 332.52. *Zervos, IV*, no. 322. Repr. *Suppl. IV*, p. 25; in color, *Picasso in MoMA*, p. 115. *Note*: also titled *Fontainebleau* and *La Fontaine*.

407 STUDIO WITH PLASTER HEAD. 1925 (summer) Oil on canvas, 38⁵/₈ x 51⁵/₈" (97.9 x 131.1 cm). Purchase. 116.64. *Zervos, V*, no. 445. Repr. *Picasso 50* (3rd), p. 139; in color, *Picasso in MoMA*, p. 121; *Modern Masters*, p. 243.

 SEATED WOMAN. 1926, December. Oil on canvas, 8³/₄ x 5" (22.2 x 12.5 cm). The Sidney and Harriet Janis Collection (fractional gift). 643.67. *Zervos, VII*, no. 60. Repr. *Picasso in MoMA*, p. 124; *Janis*, p. 15.

85 SEATED WOMAN. 1927. Oil on wood, 51¹/₈ x 38¹/₄" (129.9 x 96.8 cm). Fractional gift of James Thrall Soby. 516.61. *Zervos, VII*,

no. 77. Repr. *Picasso 50* (3rd), p. 148; *Picasso 75th Anniv.*, p. 64; *Suppl. XI*, p. 12; in color, *Soby Collection*, frontispiece; in color, *Picasso in MoMA*, p. 125.

84 THE STUDIO. 1927–28. Oil on canvas, 59" x 7'7" (149.9 x 231.2 cm). Gift of Walter P. Chrysler, Jr. 213.35. *Zervos, VII*, no. 142. Repr. *Ptg. & Sc.*, p. 105; in color, *Masters*, p. 87; in color, *Picasso in MoMA*, p. 129; *Modern Masters*, p. 245.

 PAINTER AND MODEL. 1928. Oil on canvas, 51¹/₈ x 64¹/₄" (129.8 x 163 cm). The Sidney and Harriet Janis Collection (fractional gift). 644.67. *Zervos, VII*, no. 143. Repr. *Cubism*, pl. 88; *Picasso 50* (3rd), p. 156; in color, *Picasso in MoMA*, p. 131; in color, *Janis*, p. 17; in color, *Invitation*, p. 75. *Note*: also called *Artist and Model*; *The Painter with His Models*; *Abstraction*.

85 BATHER AND CABIN. 1928, August 9. Oil on canvas, 8¹/₂ x 6¹/₄" (21.5 x 15.8 cm) (painted area). Hillman Periodicals Fund. 342.55. *Zervos, VII*, no. 211. Repr. *Picasso 75th Anniv.*, p. 65; *Picasso in MoMA*, p. 132.

85 SEATED BATHER. (1930, early) Oil on canvas, 64¹/₄ x 51" (163.2 x 129.5 cm). Mrs. Simon Guggenheim Fund. 82.50. *Zervos, VII*, no. 306. Repr. *Suppl. II*, p. 5; in color, *Picasso in MoMA*, p. 133.

86 GIRL BEFORE A MIRROR. 1932, March 14. Oil on canvas, 64 x 51¹/₄" (162.3 x 130.2 cm). Gift of Mrs. Simon Guggenheim. 2.38. *Zervos, VII*, no. 379. Repr. *Ptg. & Sc.*, p. 106; in color, *Masters*, p. 89; *Picasso 50* (3rd), frontispiece; *Paintings from MoMA*, cover; in color, *Picasso in MoMA*, p. 139; in color, *Invitation*, p. 76.

 MINOTAURE. (1933) Collage of pencil on paper, corrugated cardboard, silver foil, ribbon, wallpaper painted with gold paint and gouache, paper doily, burnt linen leaves, tacks, and charcoal on paper, 19¹/₈ x 16¹/₈" (48.5 x 41 cm). Gift of Mr. and Mrs. Alexandre P. Rosenberg. 114.74. Repr. *Picasso 75th Anniv.*, p. 73; *Dada, Surrealism*, p. 127; *Seurat to Matisse*, p. 67. *Note*: cover design for the Surrealist review by that name.

396– GUERNICA. (1937, May–early June) Oil on canvas, 11'5¹/₂" x
397 25'5³/₄" (349.3 x 776.6 cm). Extended loan. E.L.39.1095. *Zervos, IX*, no. 65. Repr. *Picasso 50* (3rd), p. 207; *Picasso 75th Anniv.*, pp. 76–77; *Picasso in MoMA*, p. 237.

 Also on extended loan, fifty-eight studies for, and postscripts after, the *Guernica* in various mediums, including the following seven oil paintings:

398 HORSE'S HEAD. 1937, May 2. Oil on canvas, 25¹/₂ x 36¹/₄" (64.8 x 92 cm). E.L.39.1093.7. *Zervos, IX*, no. 11. Repr. *Picasso 75th Anniv.*, p. 75.

 WEEPING HEAD. 1937, June 15. Oil, color crayon, and pencil on canvas, 21⁵/₈ x 18¹/₈" (54.9 x 46 cm). E.L.39.1093.26. *Zervos, IX*, no. 54.

 WEEPING HEAD WITH HANDKERCHIEF. 1937, June 22. Oil on canvas, 21⁵/₈ x 18¹/₈" (54.9 x 46 cm). E.L.39.1093.38. *Zervos, IX*, no. 52.

 MOTHER WITH DEAD CHILD. 1937, June 22. Oil, color crayon, and pencil on canvas, 21⁵/₈ x 18¹/₈" (54.9 x 46 cm). E.L.39.1093.27. *Zervos, IX*, no. 49.

398 MOTHER WITH DEAD CHILD. 1937, September 26. Oil on canvas, 51¹/₄" x 6'4³/₄" (130.1 x 194.9 cm). E.L.39.1093.58. *Zervos, IX*, no. 69.

 WEEPING HEAD WITH HANDKERCHIEF. 1937, October 13. Oil and ink on canvas, 21⁵/₈ x 18¹/₈" (54.9 x 46 cm). E.L.39.1093.37.

398 WEEPING WOMAN WITH HANDKERCHIEF. 1937, October 17. Oil on canvas, 36¹/₄ x 28⁵/₈" (92 x 72.5 cm). E.L.39.1093.41. *Zervos, IX*, no. 77.

406 STILL LIFE WITH RED BULL'S HEAD. 1938, November 26. Oil and enamel on canvas, 38¹/₈ x 51" (96.7 x 129.6 cm). Promised gift

and extended loan from Mr. and Mrs. William A. M. Burden. E.L.63.292. *Zervos, IX*, no. 239. Repr. *Picasso 75th Anniv.*, p. 81; in color, *Picasso in MoMA*, p. 153.

87 NIGHT FISHING AT ANTIBES. (1939, August) Oil on canvas, 6'9" x 11'4" (205.8 x 345.4 cm). Mrs. Simon Guggenheim Fund. 13.52. *Zervos, IX*, no. 316. Repr. *Suppl. IV*, p. 26; in color, *Masters*, p. 93; in color, *Picasso in MoMA*, p. 157.

THE CHARNEL HOUSE. 1944–45. Oil and charcoal on canvas, 6'6⁵/₈" x 9'2¹/₂" (199.8 x 250.1 cm). Mrs. Sam A. Lewisohn Bequest (by exchange) and Purchase. 93.71. *Zervos, XIV*, no. 76. Repr. *Picasso in MoMA*, p. 167.

88 PREGNANT WOMAN. (1950) Bronze (cast 1955), 41¹/₄" (104.8 cm) high, at base 7⁵/₈ x 6¹/₄" (19.3 x 15.8 cm). Gift of Mrs. Bertram Smith. 271.56. Repr. *Picasso 75th Anniv.*, p. 102; *Sc. of Picasso*, p. 125; *Picasso in MoMA*, p. 173.

88 SHE-GOAT. (1950) Bronze (cast 1952), after found objects, 46³/₈ x 56³/₈" (117.7 x 143.1 cm), base 41¹/₈ x 28¹/₈" (104.4 x 71.4 cm). Mrs. Simon Guggenheim Fund. 611.59. Repr. *Suppl. IX*, p. 1; *Sc. of Picasso*, p. 126; *Picasso in MoMA*, p. 174.

88 BABOON AND YOUNG. 1951. Bronze (cast 1955), after found objects, 21" (53.3 cm) high, base 13¹/₄ x 6⁷/₈" (33.3 x 17.3 cm). Mrs. Simon Guggenheim Fund. 196.56. Repr. *Picasso 75th Anniv.*, p. 103; *Sc. of Picasso*, p. 134; *Picasso in MoMA*, p. 175.

87 HEAD OF A WOMAN. (1951) Bronze (cast 1955), 21¹/₈" (53.6 cm) high, at base 14¹/₈ x 7³/₈" (35.7 x 18.8 cm). Benjamin Scharps and David Scharps Fund. 273.56. Repr. *Picasso 75th Anniv.*, p. 102; *Sc. of Picasso*, p. 130; *Picasso in MoMA*, p. 175.

87 GOAT SKULL AND BOTTLE. (1951–52) Painted bronze (cast 1954), 31 x 37⁵/₈ x 21¹/₂" (78.8 x 95.3 x 54.5 cm). Mrs. Simon Guggenheim Fund. 272.56. Repr. *Picasso 75th Anniv.*, p. 103; *Sc. of Picasso*, p. 132; *Picasso in MoMA*, p. 177.

PLATE WITH STILL LIFE. (1954) Modeled polychrome glazed ceramic in relief, unique, 2⁷/₈ x 14³/₄ x 12¹/₂" (7.2 x 37.4 x 31.7 cm). Gift of R. Thornton Wilson. 2511.67. Repr. *Picasso in MoMA*, p. 178.

89 STUDIO IN A PAINTED FRAME. 1956, April 2. Oil on canvas, 35 x 45⁵/₈" (88.8 x 115.8 cm). Gift of Mr. and Mrs. Werner E. Josten. 29.57. *Zervos, XVII*, no. 58. Repr. *Picasso 75th Anniv.*, p. 113; *Suppl. VII*, p. 9; *Picasso in MoMA*, p. 179.

89 WOMAN BY A WINDOW. 1956, June 11. Oil on canvas, 63³/₄ x 51¹/₄" (162 x 130 cm). Mrs. Simon Guggenheim Fund. 30.57. *Zervos, XVII*, no. 120. Repr. *Picasso 75th Anniv.*, p. 114; *Suppl. VII*, p. 1; in color, *Picasso in MoMA*, p. 181. *Note*: the subject is Jacqueline Roque, subsequently Mme Picasso.

89 BEARDED FAUN. 1956. Painting on tile, 8 x 8" (20.3 x 20.3 cm). Philip Johnson Fund. 274.56. Repr. *Suppl. VI*, p. 10; *Picasso in MoMA*, p. 178.

89 HEAD OF A FAUN. 1956. Painting on tile, 8 x 8" (20.3 x 20.3 cm). Philip Johnson Fund. 275.56. Repr. *Suppl. VI*, p. 10; *Picasso in MoMA*, p. 178.

MONUMENT. (1972) Constructed after an enlargement, supervised by the artist, of a 20" (50 cm) wire maquette from 1928–29 of a monument to Guillaume Apollinaire. Cor-ten steel, 12'11⁵/₈" (395.3 cm) high, including base 1⁷/₈ x 58³/₄ x 10'5³/₄" (4.7 x 149.2 x 319.3 cm). Gift of the artist. 152.73.

PICKENS, Alton. American, born 1917.

278 THE BLUE DOLL. 1942. Oil on canvas, 42⁷/₈ x 35" (108.9 x 88.9 cm). James Thrall Soby Fund. 622.43. Repr. *Ptg. & Sc.*, p. 147.

278 CARNIVAL. 1949. Oil on canvas, 54⁵/₈ x 40³/₈" (138.7 x 102.6 cm). Gift of Lincoln Kirstein. 511.51. Repr. *Suppl. IV*, p. 30.

PICKETT, Joseph. American, 1848–1918.

6 MANCHESTER VALLEY. (1914–18?) Oil with sand on canvas, 45¹/₂ x 60⁵/₈" (115.4 x 153.7 cm). Gift of Abby Aldrich Rockefeller. 541.39. Repr. *Ptg. & Sc.*, p. 13; in color, *Masters*, p. 16; in color, *Invitation*, p. 118.

PIENE, Otto. German, born 1928.

PURE ENERGY [*La Force pure, 1*]. 1958. Oil on canvas, 39¹/₂ x 31¹/₂" (100.2 x 80 cm). Gertrud A. Mellon Fund. 420.60. Repr. *Suppl. X*, p. 59.

PIGNON, Édouard. French, born 1905.

270 OSTEND. 1948. Watercolor, 20¹/₂ x 27¹/₂" (52.1 x 69.8 cm). Mrs. Cornelius J. Sullivan Fund. 270.48. Repr. *Suppl. I*, p. 13.

PILARAME, Feramarze. Iranian, born 1936.

319 LAMINATIONS [*Les Lames*]. (1962) Gouache and metallic paint, 6'5⁷/₈" x 32⁵/₈" (197.7 x 82.7 cm). Elizabeth Bliss Parkinson Fund. 313.62. *Note*: *Lames* may also be translated as *Blades*.

PIPER, John. British, born 1903.

270 CWN TRYFAN ROCK. (1950) Oil on canvas, 25¹/₈ x 30" (63.8 x 76.2 cm). Purchase. 19.51. Repr. *Suppl. III*, p. 20.

END OF THE GLYDER MOUNTAIN. (1950) Gouache, 22⁵/₈ x 27⁵/₈" (57.5 x 70.2 cm). Gift of Curt Valentin. 322.50.

PIRANDELLO, Fausto. Italian, born 1899.

198 WOMEN'S QUARTERS [*Gineceo*]. (1950) Oil on cardboard, 28¹/₄ x 34¹/₈" (71.7 x 86.6 cm). Gift of Mrs. Joseph James Akston. 314.62. Repr. *Suppl. XII*, p. 13.

PISTOLETTO, Michelangelo. Italian, born 1933.

435 MAN WITH YELLOW PANTS. 1964. Collage with oil and pencil on polished stainless steel, 6'6⁷/₈" x 39³/₈" (200.3 x 100 cm). Blanchette Rockefeller Fund. 292.65. Repr. *Object Transformed*, p. 34. *Note*: the subject is Gian Enzo Sperone, of the galleries in New York and Turin.

PIZZINATO, Armando. Italian, born 1910.

MAY DAY. 1948. Oil on plywood, 31³/₈ x 45¹/₂" (79.7 x 115.6 cm). Gift of Peggy Guggenheim. 185.52.

PLAVINSKY, Dimitri Petrovich. Russian, born 1937.

468 VOICES OF SILENCE. (1962) Oil on canvas, 55¹/₄" x 6'7" (139.8 x 200.5 cm). Purchase. 2105.67.

469 COELACANTH. 1965. Oil and synthetic polymer paint on canvas with small pieces of cardboard and wood shavings beneath paint, 39³/₈ x 59¹/₈" (99.7 x 150.1 cm). Purchase. 2106.67.

POLAK, Marcel. Dutch, born 1902. To France 1948.

THE SHADOW. 1954. Collage of paper with watercolor and pastel, 8¹/₈ x 6⁷/₈" (20.5 x 17.5 cm) (irregular). Alfred Flechtheim Fund. 277.56.

CHRISTMAS. 1954–55. Collage of paper with watercolor, gouache, and ink, 8⁷/₈ x 6³/₄" (22.6 x 17 cm) (irregular). Purchase. 276.56. Repr. *Suppl. VI*, p. 22.

POLESELLO, Rogelio. Argentine, born 1939.

504 Untitled. 1966. Synthetic polymer paint airbrushed on paper, 39³/₈ x 25¹/₂" (99.9 x 64.8 cm). Gift of Emilio del Junco (by exchange). 6.67.

POLIAKOFF, Serge. French, born Russia. 1906–1969. To Paris 1923.

346 COMPOSITION. (1956) Oil on burlap, 38$^{1}/_{8}$ x 51$^{1}/_{4}$" (96.7 x 130.2 cm). Gift of M. Knoedler & Company. 579.56. Repr. *Suppl. VI,* p. 24.

POLLOCK, Jackson. American, 1912–1956.

322 THE SHE-WOLF. 1943. Oil, gouache, and plaster on canvas, 41$^{7}/_{8}$ x 67" (106.4 x 170.2 cm). Purchase. 82.44. Repr. *Ptg & Sc.,* p. 231; *Pollock, 1967,* p. 86; in color, *Invitation,* p. 83.

322 PAINTING. 1945. Mixed mediums on paper, 30$^{5}/_{8}$ × 22$^{3}/_{8}$" (77.7 x 57 cm). Blanchette Rockefeller Fund. 13.58. Repr. *Suppl. VIII,* p. 9.

322 PAINTING. (1945?) Gouache on plywood, 23 x 18$^{7}/_{8}$" (58.4 x 47.8 cm). Gift of Monroe Wheeler. 415.58. Repr. *Suppl. VIII,* p. 9; *Pollock, 1967,* p. 37.

 FREE FORM. 1946. Oil on canvas, 19$^{1}/_{4}$ x 14" (48.9 x 35.5 cm). The Sidney and Harriet Janis Collection (fractional gift). 645.67. Repr. *Janis,* p. 119.

 SOUNDS IN THE GRASS: SHIMMERING SUBSTANCE. (1946) Oil on canvas, 30$^{1}/_{8}$ x 24$^{1}/_{4}$" (76.3 x 61.6 cm). Mr. and Mrs. Albert Lewin and Mrs. Sam A. Lewisohn Funds. 6.68. Repr. *Pollock,* p. 16.

324 FULL FATHOM FIVE. 1947. Oil on canvas with nails, tacks, buttons, key, coins, cigarettes, matches, etc., 50$^{7}/_{8}$ x 30$^{1}/_{8}$" (129.2 x 76.5 cm). Gift of Peggy Guggenheim. 186.52. Repr. *Suppl. IV,* p. 34; *Pollock, 1967,* p. 96.

323 NUMBER 1, 1948. 1948. Oil on canvas, 68" x 8'8" (172.7 x 264.2 cm). Purchase. 77.50. Repr. *Suppl. II,* p. 20; *Pollock,* p. 22; in color, *Masters,* p. 178; *Pollock, 1967,* p. 47.

322 NUMBER 12. 1949. Oil on paper mounted on composition board, 31 x 22$^{1}/_{2}$" (78.8 x 57.1 cm). Gift of Edgar Kaufmann, Jr. 15.52. Repr. *Pollock, 1967,* p. 102.

324 NUMBER 5. (1950) Oil on canvas, 53$^{3}/_{4}$ x 39" (136.5 x 99.1 cm). Gift of Mr. and Mrs. Walter Bareiss. 155.57. Repr. *Suppl. VII,* p. 18.

 ONE (NUMBER 31, 1950). (1950) Oil and enamel paint on canvas, 8'10" x 17'5$^{5}/_{8}$" (269.5 x 530.8 cm). Gift of Sidney Janis. 7.68. Repr. in color, *Pollock,* pp. 18–19; *Pollock, 1967,* p. 106; *Janis,* p. 207; *Natural Paradise,* p. 168.

 ECHO (NUMBER 25, 1951). 1951. Enamel paint on canvas, 7'7$^{7}/_{8}$" x 7'2" (233.4 x 218.4 cm). Acquired through the Lillie P. Bliss Bequest and the Mr. and Mrs. David Rockefeller Fund. 241.69. Repr. *Pollock,* p. 32; *Pollock, 1967,* p. 114.

324 PAINTING. (1953–54) Oil and gouache on paper, 15$^{3}/_{4}$ x 20$^{1}/_{2}$" (40 x 52.1 cm). On reverse: brush drawing in black and red ink. Gift of Mr. and Mrs. Ira Haupt. 263.57a-b. Repr. *Suppl. VIII,* p. 9.

 WHITE LIGHT. 1954. Oil, enamel, and aluminum paint on canvas, 48$^{1}/_{4}$ x 38$^{1}/_{4}$" (122.4 x 96.9 cm). The Sidney and Harriet Janis Collection (fractional gift). 337.67. Repr. *Pollock, 1967,* p. 128; *Janis,* p. 119.

POMODORO, Arnaldo. Italian, born 1926.

481 SPHERE, I. (1963) Bronze, 44$^{3}/_{4}$ (113.5 cm) diameter, on base $^{1}/_{2}$" (1.2 cm) high, 7$^{3}/_{8}$" (18.5 cm) diameter. Mrs. Simon Guggenheim Fund. 1242.64.

PONCE DE LEÓN, Fidelio. Cuban, 1895–1949.

216 TWO WOMEN. 1934. Oil on canvas, 39$^{1}/_{4}$ x 39$^{3}/_{8}$" (99.7 x 100 cm). Gift of Dr. C. M. Ramírez Corría. 606.42. Repr. *Ptg. & Sc.,* p. 180.

POONS, Larry. American, born Japan 1937. To U.S.A. 1938.

373 NIGHT ON COLD MOUNTAIN. (1962) Synthetic polymer paint and dye on canvas, 6'8" x 6'8" (203.1 x 203.1 cm). Larry Aldrich Foundation Fund. 271.63.

POPOVA, Lyubov Sergeievna. Russian, 1889–1924.

131 ARCHITECTONIC PAINTING. 1917. Oil on canvas, 31$^{1}/_{2}$ x 38$^{5}/_{8}$" (80 x 98 cm). Philip Johnson Fund. 14.58. Repr. *Suppl. X,* p. 50.

PORTER, Fairfield. American, 1907–1975.

 SCHWENK. 1959. Oil on canvas, 22$^{5}/_{8}$ x 31" (57.3 x 78.7 cm). Gift of Arthur M. Bullowa. 212.72.

443 FLOWERS BY THE SEA. 1965. Oil on composition board, 20 x 19$^{1}/_{2}$" (50.6 x 49.5 cm). Larry Aldrich Foundation Fund. 200.66.

PORTINARI, Cândido. Brazilian, 1903–1962.

215 MORRO. (1933) Oil on canvas, 44$^{7}/_{8}$ x 57$^{3}/_{8}$" (114 x 145.7 cm). Abby Aldrich Rockefeller Fund. 663.39. Repr. *Art in Our Time,* no. 152a.

215 SCARECROW. 1940. Oil on canvas, 51$^{1}/_{2}$ x 64" (130.8 x 162.5 cm). Abby Aldrich Rockefeller Fund. 361.41. Repr. *Art in Prog.,* p. 104.

PORTOCARRERO, René. Cuban, born 1912.

 MYTHOLOGICAL PERSONAGE. 1945. Gouache, 37$^{1}/_{4}$ x 27$^{3}/_{4}$" (94.6 x 70.5 cm). Inter-American Fund. 166.45.

POUGNY, Jean (Ivan Puni). Russian, born Finland. 1892–1956. To Paris 1923.

 FLIGHT OF FORMS. (1919) Gouache on paper over canvas, 51$^{1}/_{8}$ x 51$^{1}/_{2}$" (129.7 x 130.8 cm). Abby Aldrich Rockefeller Fund. 39.72.

POUSETTE-DART, Richard. American, born 1916.

 DESERT. 1940. Oil on canvas, 43" x 6' (109 x 182.8 cm). Given anonymously. 1099.69.

 FUGUE NUMBER 2. 1943. Oil and sand on canvas, 41$^{1}/_{8}$" x 8'10$^{1}/_{2}$" (104.2 x 270.4 cm). Given anonymously. 1100.69. Repr. *Amer. Art,* p. 22.

330 NUMBER 11: A PRESENCE. (1949) Oil on canvas, 25$^{1}/_{8}$ x 21$^{1}/_{8}$" (63.8 x 53.7 cm). Katharine Cornell Fund. 100.50. Repr. *Abstract Ptg. & Sc.,* p. 137.

 CHAVADE. 1951. Oil and pencil on canvas, 53$^{3}/_{8}$" x 8'$^{1}/_{2}$" (135.6 x 245 cm). Philip Johnson Fund. 503.69.

451 RADIANCE. 1962–63. Oil and metallic paint on canvas, 6'$^{1}/_{8}$" x 8'$^{1}/_{4}$" (183.3 x 244.4 cm). Gift of Susan Morse Hilles. 453.64.

PRAZERES. See DOS PRAZERES.

PRENDERGAST, Maurice. American, born Newfoundland. 1859–1924.

 CAMPO VITTORIO EMANUELE, SIENA. (1898) Watercolor, 11$^{1}/_{4}$ x 13$^{3}/_{4}$" (28.6 x 35 cm). Gift of Abby Aldrich Rockefeller. 131.35.

37 FESTIVAL, VENICE. (1898) Watercolor, 16$^{5}/_{8}$ x 14" (42.2 x 35.6 cm). Gift of Abby Aldrich Rockefeller. 133.35.

37 THE LAGOON, VENICE. 1898. Watercolor, 11$^{1}/_{8}$ x 15$^{3}/_{8}$" (28.3 x 39 cm). Acquired through the Lillie P. Bliss Bequest. 168.45.

37 THE EAST RIVER. 1901. Watercolor, 13$^{3}/_{4}$ x 19$^{3}/_{4}$" (35 x 50.2 cm). Gift of Abby Aldrich Rockefeller. 132.35. Repr. *Ptg. & Sc.,* p. 66; in color, *La Pintura,* p. 144.

37 APRIL SNOW, SALEM. (1906–07) Watercolor, 14$^{3}/_{4}$ x 21$^{5}/_{8}$" (37.5 x 54.9 cm). Gift of Abby Aldrich Rockefeller. 129.35. Repr. *Ptg. & Sc.,* p. 66.

37 ACADIA. (1922) Oil on canvas, 31$^{3}/_{4}$ x 37$^{1}/_{2}$" (80.6 x 95.2 cm). Abby Aldrich Rockefeller Fund. 167.45. Repr. *Ptg. & Sc.,* p. 67; in color, *Masters,* p. 37.

PRENTICE, David. American, born 1943.

Untitled. (1967) Synthetic polymer paint on canvas in five parts, overall, 6' x 10'1/2" (182.9 x 306 cm). Gift of Charles Cowles. 532.71a–e.

PRÉVERT, Jacques. French, born 1900.

THE WINDOW OF ISIS. (1957) Collage on photograph, 14¼ x 11⅝" (36.3 x 29.6 cm). Gift of James Thrall Soby. 291.61. Repr. *Suppl. XI*, p. 36.

PRICE, Kenneth. American, born 1935.

BLIND SEA TURTLE CUP. (1968) Ceramic sculpture in tray with sand in glass vitrine on wood pedestal; ceramic, 2⅞ x 3⅞ x 5⅝" (7.2 x 9.8 x 14.2 cm); overall, 63½ x 29½ x 32" (161.3 x 74.9 x 81.3 cm). Fractional gift of Charles Cowles. 433.72.

PRINNER, Antoine. French, born Hungary 1902. To France 1927.

298 EVOCATION [*L'Appelée*]. (1952) Bronze, 48" (122 cm) high, at base 13⅝ x 18¾" (34.7 x 47.5 cm). Blanchette Rockefeller Fund. 31.57. Repr. *Suppl. VI*, p. 27.

PURVES-SMITH, Charles Roderick. Australian, 1913–1949.

KANGAROO HUNT. 1939. Oil on canvas, 25½ x 36½" (64.8 x 92.7 cm). Purchase. 567.41.

PUTNAM, Wallace. American, born 1899.

SHEEP ON A CLIFF. (1952) Oil on composition board, 16⅛ x 30⅜" (41 x 77.2 cm). Given anonymously. 552.54. Repr. *Suppl. V*, p. 32.

QUINTE, Lothar. German, born 1923.

461 BLUE FIELD, III. 1963. Oil on canvas, 51½ x 39⅝" (130.5 x 100.4 cm). Gertrud A. Mellon Fund. 50.65.

QUIRT, Walter. American, 1902–1968.

248 BURIAL. 1934. Oil on gesso on composition board, 6⅜ x 7¾" (16.2 x 19.7 cm). Given anonymously. 401.38. Repr. *Ptg. & Sc.*, p. 149.

THE TRANQUILLITY OF PREVIOUS EXISTENCE. (1941) Oil on canvas, 24⅛ x 32" (61.3 x 81.3 cm). Purchase. 163.42. Repr. *Art in Prog.*, p. 96.

RABKIN, Leo. American, born 1919.

THE RED VISIT. (1960) Watercolor, 38⅛ x 24⅞" (96.8 x 63.1 cm) (irregular). Larry Aldrich Foundation Fund. 365.60. Repr. *Suppl. X*, p. 34.

TRIANGLES OF THE FIELD. (1967) Motor-driven construction in plastic and metal, 48⅝" x 6'3¾" x 9½" (123.4 x 184.6 x 23.4 cm). Gift of Mrs. Charles G. Stachelberg. 1310.68.

RAHMI, Bedri (Bedri Rahmi Eyüboğlu). Turkish, born 1913.

318 THE CHAIN. 1962. Synthetic polymer paint on burlap, 14⅛ x 47⅝" (35.8 x 121 cm) (irregular). Gift of the Honorable Turgut Menemencioğlu. 234.62. Repr. *Suppl. XII*, p. 30.

RAMÍREZ, Eduardo (Eduardo Ramírez Villamizar). Colombian, born 1922.

BLACK AND WHITE. 1956. Gouache, 25⅞ x 32⅝" (65.6 x 82.9 cm). Inter-American Fund. 580.56. Repr. *Suppl. VI*, p. 33.

374 HORIZONTAL WHITE RELIEF. 1961. Synthetic polymer paint on cardboard, 11 x 24⅜ x 1¾" (28 x 61.8 x 4.5 cm). Gift of Silvia Pizitz. 562.63.

RAMOS BLANCO, Teodoro. Cuban, born 1902.

216 OLD NEGRO WOMAN. (1939) Acana wood, 11⅛" (28.3 cm) high. Inter-American Fund. 776.42. Repr. *Latin-Amer. Coll.*, p. 50.

RATTNER, Abraham. American, born 1893.

241 MOTHER AND CHILD. (1938) Oil on canvas, 28¾ x 39⅜" (73 x 100 cm). Given anonymously. 19.40.

RAUSCHENBERG, Robert. American, born 1925.

Untitled. (c. 1952) Collage of gold leaf on composition board, 12¼ x 12⅝" (31.2 x 32 cm). Joint bequest of Eve Clendenin to The Museum of Modern Art and The Solomon R. Guggenheim Museum. 441.74.

383 FIRST LANDING JUMP. 1961. "Combine painting": cloth, metal, leather, electric fixture, cable, and oil paint on composition board; overall, including automobile tire and wooden plank on floor, 7'5⅛" x 6' x 8⅞" (226.3 x 182.8 x 22.5 cm). Gift of Philip Johnson. 434.72. Repr. *Rauschenberg*, p. 113. *Note*: this piece is lit by a small blue light enclosed in a tin can. The electric cable connecting it to a socket is intended to be part of the work.

Also, thirty-four "combine drawings" for Dante's *Inferno*, 1959–60. Given anonymously.

RAY. See MAN RAY.

RAYNAUD, Jean Pierre. French, born 1939.

CORNER 806. 1967. Fiberglass, steel, and enamel, in two sections, overall, 13'2½" x 30⅞" x 30¾" (402.5 x 78.4 x 75 cm). Purchase. 209.70a–b.

REDER, Bernard. American, born Rumania. 1897–1963. Worked in Prague and Paris. To U.S.A. 1943.

255 TORSO. (1938) French limestone, 45" (114.3 cm) high, at base 23¾ x 17" (60.3 x 43.2 cm). Gift of J. van Straaten. 187.52. Repr. *Suppl. IV*, p. 36.

255 LADY WITH HOUSE OF CARDS. 1957. Cast bronze, 7'5½" (227.4 cm) high, at base 34⅜ x 35¼" (87.3 x 89.5 cm). Gift of Mr. and Mrs. Albert A. List. 783.63.

REDON, Odilon. French, 1840–1916.

401 BUTTERFLIES. (1910) Oil on canvas, 29⅛ x 21½" (73.9 x 54.6 cm). Gift of Mrs. Werner E. Josten in memory of her husband. 454.64.

26 ROGER AND ANGELICA. (c. 1910) Pastel, 36½ x 28¾" (92.7 x 73 cm). Lillie P. Bliss Collection. 111.34. Repr. *Ptg. & Sc.*, p. 35; in color, *Redon*, p. 85.

26 SILENCE. (c. 1911) Oil on gesso on paper, 21¼ x 21½" (54 x 54.6 cm). Lillie P. Bliss Collection. 113.34. Repr. *Ptg. & Sc.*, p. 36; *Redon*, p. 93; in color, *Invitation*, p. 94.

26 YELLOW FLOWERS. (1912?) Pastel, 25½ x 19½" (64.6 x 49.4 cm). Acquired through the Mary Flexner Bequest. 19.57. Repr. *Suppl. VII*, p. 3; *Seurat to Matisse*, p. 25.

26 VASE OF FLOWERS. (1914) Pastel, 28¾ x 21⅛" (73 x 53.7 cm). Gift of William S. Paley. 553.54. Repr. *Suppl. V*, p. 6.

REDWOOD, Junius. American, born 1917.

287 NIGHT SCENE. (1941) Oil on cardboard, 43⅜ x 33⅜" (110.2 x 84.8 cm). Purchase. 755.43.

REFREGIER, Anton. American, born Russia 1905. To U.S.A. 1920.

ACCIDENT IN THE AIR. (1939) Oil on composition board, 19 x 23" (48.3 x 58.4 cm). Gift of the New York World's Fair, 1939. 641.39.

REIMANN, William. American, born 1935.

371 ICON. (1957) Opaque plexiglass, 34¹/₄″ (87 cm) high, base, 18″ (45.5 cm) diameter. Larry Aldrich Foundation Fund. 67.61. Repr. *Suppl. XI*, p. 27.

REINHARDT, Ad. American, 1913–1967.

432 Untitled. 1938. Oil on canvas, 16 x 20″ (40.6 x 50.8 cm). Gift of the artist. 451.67.

The six works following are studies for paintings for the Easel Division, Federal Art Project, W.P.A., 1938–39. Gift of the artist.

Study for a painting. 1938. Collage of pasted and painted paper, brush and ink, 3⁷/₈ x 5″ (9.8 x 12.5 cm). 453.67.

Study for a painting. 1938. Collage of pasted and painted paper, 4 x 5″ (9.9 x 12.5 cm). 457.67.

432 Study for a painting. 1938. Gouache, 4 x 5″ (10.1 x 12.7 cm). 455.67.

Study for a painting. 1939. Gouache, 4 x 5″ (10 x 12.7 cm). 452.67.

Study for a painting. 1939. Gouache, 3⁷/₈ x 5″ (9.8 x 12.5 cm). 456.67.

432 Study for a painting. 1939. Gouache, 4 x 5″ (10 x 12.5 cm). 454.67.

432 COLLAGE, 1940. 1940. Collage on cardboard, 15³/₄ x 13¹/₈″ (39.8 x 33.2 cm). Gift of the artist. 458.67.

NEWSPRINT COLLAGE. Dated on work 1940 and 1943. Collage on cardboard, 16 x 20″ (40.6 x 50.8 cm). Gift of the artist. 459.67.

NUMBER 43 (ABSTRACT PAINTING, YELLOW). 1947. Oil on canvas, 40¹/₈ x 32″ (101.7 x 81.2 cm). Gift of Mrs. Ad Reinhardt. 1101.69.

NUMBER 22. 1949. Oil on canvas, 50 x 20″ (127 x 50.6 cm). Gift of Mrs. Ad Reinhardt. 1102.69.

NUMBER 111. (1949) Oil on canvas, 60 x 40¹/₈″ (152.3 x 101.8 cm). Gift of Mrs. Ad Reinhardt. 1103.69.

NUMBER 104. 1950. Oil on canvas, 60¹/₈ x 39″ (152.6 x 99 cm). Gift of Mrs. Ad Reinhardt. 1104.69.

NUMBER 114. (1950) Oil on canvas, 60 x 40¹/₈″ (152.2 x 101.7 cm). Gift of Mrs. Ad Reinhardt. 1105.69. Repr. *Amer. Art*, p. 24.

NUMBER 87. 1957. Oil on canvas, 9′ x 40″ (274.3 x 101.5 cm). Purchase. 246.69.

366 ABSTRACT PAINTING. 1960–61. Oil on canvas, 60 x 60″ (152.4 x 152.4 cm). Purchase (by exchange). 570.63. Repr. *Amer. 1963*, p. 81.

RENOIR, Pierre-Auguste. French, 1841–1919.

16 RECLINING NUDE. (1902) Oil on canvas, 26¹/₂ x 60⁵/₈″ (67.3 x 154 cm). Gift of Mr. and Mrs. Paul Rosenberg. 23.56. Repr. *Suppl. VI*, p. 3.

16 THE WASHERWOMAN. (1917) Bronze, 48″ (121.9 cm) high, at base 21³/₄ x 50″ (55.3 x 127 cm). A. Conger Goodyear Fund. 188.53. Repr. *Sc. of 20th C.*, p. 63; *Masters*, p. 41.

RESNICK, Milton. American, born Ukraine 1917. To U.S.A. 1922.

334 BURNING BUSH. 1959. Oil on canvas, 63 x 48″ (160 x 121.8 cm). Larry Aldrich Foundation Fund. 612.59. Repr. *Suppl. IX*, p. 26.

REUTERSWÄRD, Carl Fredrik. Swedish, born 1934.

352 BAM BAM. 1958. Enamel on paper, 24 x 17″ (61 x 43 cm). Gift of Theodor Ahrenberg. 662.59. Repr. *Suppl. IX*, p. 17.

REYES FERREIRA, Jesús. Mexican.

ANGEL. Tempera, 29¹/₂ x 19⁵/₈″ (74.9 x 49.9 cm). Gift of Mrs. Edgar J. Kaufmann. 607.42.

REYNAL, Jeanne. American, born 1903.

340 A GOOD CIRCULAR GOD. (1948–50) Mosaic, 37 x 24³/₈″ (94 x 61.9 cm). Katharine Cornell Fund. 20.51. Repr. *Suppl. III*, p. 17.

REYNOLDS, Alan. British, born 1926.

COMPOSITION JULY. 1952. Oil on composition board, 30 x 47³/₄″ (76.2 x 121.3 cm). Purchase. 188.52.

RIBEMONT-DESSAIGNES, Georges. French, born 1884.

159 SILENCE. (c. 1915) Oil on canvas, 36¹/₄ x 28⁷/₈″ (92.1 x 73.3 cm). Katherine S. Dreier Bequest. 189.53.

RICHENBURG, Robert. American, born 1917.

UPRISING. 1959. Oil on canvas, 6′4¹/₈″ x 56″ (193.2 x 142.2 cm). Given anonymously. 722.59. Repr. *Suppl. IX*, p. 26.

RICHIER, Germaine. French, 1904–1959.

294 THE DEVIL WITH CLAWS [*Le Griffu*]. (1952) Bronze, 34¹/₂ x 37¹/₄″ (87.5 x 94.5 cm). Wildenstein Foundation Fund. 18.57. Repr. *Suppl. VI*, p. 26.

294 SIX-HEADED HORSE. (1953?) Plaster over string and wire, 14 x 14⁷/₈″ (35.4 x 37.7 cm). Gift of Mrs. Katharine Kuh. 421.60. Repr. *Suppl. X*, p. 22.

294 SCULPTURE WITH BACKGROUND. (1955–56) Gilded bronze: figure, 8³/₄″ (22.2 cm) high; background, 9¹/₄ x 14³/₄ x 4⁵/₈″ (23.5 x 37.3 x 11.8 cm). Blanchette Rockefeller Fund. 293.56a–b. Repr. *Suppl. VI*, p. 25.

RICKEY, George. American, born 1907. In Great Britain 1913–30.

493 TWO LINES—TEMPORAL I. (1964–77) Two stainless steel mobile blades on stainless steel base, 35′4⁵/₈″ (10.79 m) high. Mrs. Simon Guggenheim Fund. 506.65a–c. Repr. *What Is Mod Sc.*, p. 104 (before modification of base).

RILEY, Bridget. British, born 1931.

FISSION. (1963) Tempera on composition board, 35 x 34″ (88.8 x 86.2 cm). Gift of Philip Johnson. 793.69.

499 CURRENT. 1964. Synthetic polymer paint on composition board, 58³/₈ x 58⁷/₈″ (148.1 x 149.3 cm). Philip Johnson Fund. 576.64. Repr. *Responsive Eye*, p. 34; background of cover, detail.

RIOPELLE, Jean-Paul. Canadian, born 1923. Works in Paris.

349 FOREST BLIZZARD. 1953. Oil on composition board, 67¹/₈″ x 8′4¹/₄″ (170.5 x 254.7 cm). Gift of Mr. and Mrs. Ralph F. Colin. 26.54. Repr. *Suppl. V*, p. 26.

RIVERA, Diego. Mexican, 1886–1957. Worked in Europe 1907–21. In U.S.A. 1930–33, 1940.

206 JACQUES LIPCHITZ (PORTRAIT OF A YOUNG MAN). 1914. Oil on canvas, 25⁵/₈ x 21⁵/₈″ (65.1 x 54.9 cm). Gift of T. Catesby Jones. 412.41. Repr. *Latin-Amer. Coll.*, p. 57.

STILL LIFE WITH VEGETABLES. 1918. Watercolor, 12¹/₂ x 19¹/₄″ (31.7 x 48.9 cm). Given anonymously. 199.40. Repr. *Rivera*, no. 56.

206 MAY DAY, MOSCOW. 1928. Sketchbook of forty-five watercolors; thirty-three, 4 x 6¹/₄″ (10.3 x 16 cm), and twelve, 6¹/₄ x 4″ (16 x 10.3 cm). Gift of Abby Aldrich Rockefeller. 137.35.1–45. Nos.

137.35.20 and 137.35.30 are reproduced here, and nos. 137.35.20, 137.35.24, and 137.35.30 are repr. *Ptg. & Sc.*, p. 140.

206 AGRARIAN LEADER ZAPATA. 1931. Fresco, 7'9³/4" x 6'2" (238.1 x 188 cm). Abby Aldrich Rockefeller Fund. 1631.40. Repr. *Ptg. & Sc.*, p. 134; in color, *Invitation*, p. 110. *Note*: the Museum invited the artist to New York to paint seven frescoes for an exhibition in 1931, under a grant from Abby Aldrich Rockefeller. *Agrarian Leader Zapata*, the only one of the seven in the Museum Collection, is a variant of the fresco in the Palace of Cortés, Cuernavaca, 1930.

206 FLOWER FESTIVAL: FEAST OF SANTA ANITA. 1931. Encaustic on canvas, 6'6¹/2" x 64" (199.3 x 162.5 cm). Variant of a section of the fresco in the Ministry of Education, Mexico City, 1923–27. Gift of Abby Aldrich Rockefeller. 23.36. Repr. *Rivera*, no. 47.

H.P. Twenty-four watercolor designs made in 1927 and 1931 for the ballet first produced by the Philadelphia Grand Opera Company, 1932. Seventeen designs for costumes, various sizes, 20⁵/8 x 28¹/2 to 5³/8 x 3⁷/8" (52.4 x 72.4 to 13.6 x 9.8 cm); seven designs for scenery, 17⁷/8 x 11³/8 to 5³/8 x 8¹/4" (45.4 x 28.9 to 13.6 x 21 cm). Gift of Abby Aldrich Rockefeller. 505.41.1–.24. Theatre Arts Collection.

DE RIVERA, José. American, born 1904.

374 CONSTRUCTION 8. (1954) Stainless steel forged rod, 9³/8" (23.8 cm) high. Gift of Mrs. Heinz Schultz in memory of her husband. 24.55. Repr. *Suppl. V*, p. 38; *What Is Mod. Sc.*, p. 81.

492 STEEL CENTURY TWO (CONSTRUCTION 73). 1960–65. Stainless steel, 54¹/8" x 10'5³/4" (137.3 x 319.4 cm) on painted steel base with motor, 47" (119.3 cm) high, 24¹/4" (61.6 cm) diameter. Gift of American Iron and Steel Institute. 677.65a–b. *Note*: the sculpture revolves once every 4 minutes, 45 seconds.

RIVERA, Manuel. Spanish, born 1927.

378 METAMORPHOSIS (HERALDRY). (1960) Relief of wire mesh on painted wood, 32¹/4 x 40" (81.8 x 101.5 cm). Gift of Mr. and Mrs. Richard Rodgers. 203.63.

RIVERS, Larry. American, born 1923.

281 WASHINGTON CROSSING THE DELAWARE. (1953) Oil on canvas, 6'11⁵/8" x 9'3⁵/8" (212.4 x 283.5 cm). Given anonymously. 25.55. Repr. *Suppl. V*, p. 24. *Notes*: damaged during fire, 1958; discolored by smoke, some charcoal drawing washed away by water, lower right-hand corner charred and partly restored. Exhibition approved by artist. The Museum owns thirteen pencil studies for this painting.

DOUBLE PORTRAIT OF FRANK O'HARA. (1955) Oil on canvas, 15¹/4 x 25¹/8" (38.4 x 63.6 cm). Gift of Stuart Preston. 288.76.

281 THE POOL. (1956) Oil, charcoal, and bronze paint on canvas, 8'7³/8" x 7'8⁵/8" (262.5 x 235.2 cm). Gift of Mr. and Mrs. Donald Weisberger. 139.58. Repr. *Suppl. VIII*, p. 12.

HEAD. (1957) Welded steel, 18¹/8" (46 cm) high, at base 14¹/4 x 8¹/4" (36.2 x 20.9 cm). Given anonymously. 20.59. Repr. *Recent Sc. U.S.A.*

281 THE LAST CIVIL WAR VETERAN. 1959. Oil and charcoal on canvas, 6'10¹/2" x 64¹/8" (209.6 x 162.9 cm). Blanchette Rockefeller Fund. 235.62. Repr. *Suppl. XII*, p. 15. *Note*: the subject is Walter Williams of Houston, Texas, who died December 19, 1959, shortly after this painting was finished.

ROA, Israel. Chilean, born 1909.

THE PAINTER'S BIRTHDAY. Oil on canvas, 27⁵/8 x 38" (70.2 x 96.5 cm). Inter-American Fund. 213.42. Repr. *Latin-Amer. Coll.*, p. 43.

ROBUS, Hugo. American, 1885–1964.

251 GIRL WASHING HER HAIR. (1940) After plaster of 1933. Marble, 17 x 30¹/2" (43.2 x 77.5 cm). Abby Aldrich Rockefeller Fund. 659.39. Repr. *Ptg. & Sc.*, p. 259.

ROCKBURNE, Dorothea. Canadian. To U.S.A. 1951.

A, C AND D FROM GROUP/AND. (1970) Paper, chip board, nails, and graphite, 13'10¹/2" x 21'1¹/2" x 44¹/8" (422.8 x 641.3 x 112 cm). Given anonymously. 36.71.

Untitled. 1972. Oil stain on paper, 17 x 13¹/4" (43.2 x 33.7 cm). Gift of Waldo Rasmussen. 714.76.

GOLDEN SECTION PAINTING: SQUARE SEPARATED BY PARALLELOGRAM. (1974, August) Gesso and blue pencil on sized, glued, and folded linen, 64³/8" x 8'8¹/2" (163.6 x 265.5 cm). Purchased with the aid of funds from the National Endowment for the Arts and an anonymous donor. 1353.74.

RODCHENKO, Alexander. Russian, 1891–1956.

130 COMPOSITION. 1918. Gouache, 13 x 6³/8" (33 x 16.2 cm). Gift of the artist. 28.36. Repr. *Ptg. & Sc.*, p. 115.

130 NON-OBJECTIVE PAINTING: BLACK ON BLACK. 1918. Oil on canvas, 32¹/4 x 31¹/4" (81.9 x 79.4 cm). Gift of the artist, through Jay Leyda. 114.36.

130 COMPOSITION. 1919. Gouache, 12¹/4 x 9" (31.1 x 22.9 cm). Gift of the artist. 29.36. Repr. *Cubism*, fig. 118.

403 COMPOSITION. 1919. Watercolor and ink, 14⁵/8 x 11¹/2" (37.1 x 9.2 cm). Gift of the artist. 30.36.

130 NON-OBJECTIVE PAINTING. 1919. Oil on canvas, 33¹/4 x 28" (84.5 x 71.1 cm). Gift of the artist, through Jay Leyda. 113.36.

LINE CONSTRUCTION. 1920. Colored inks, 12³/4 x 7³/4" (32.4 x 19.7 cm). Given anonymously. 11.40.

RODIN, Auguste. French, 1840–1917.

17 ST. JOHN THE BAPTIST PREACHING. (1878–80) Bronze, 6'6³/4" (200.1 cm) high, at base 37 x 22¹/2" (94 x 57.2 cm) (irregular). Mrs. Simon Guggenheim Fund. 27.55. Repr. *Suppl. V*, p. 7; *Rodin*, p. 29 and in color opp. p. 27.

THE MIGHTY HAND. (1884–86) Bronze, 18³/8 x 11⁵/8" (46.5 x 29.5 cm). Extended loan from Mrs. Jefferson Dickson. E.L.62.1100. Repr. *Rodin*, p. 80.

The ten bronzes that follow are studies for *Monument to Balzac* (1897–98):

BUST OF THE YOUNG BALZAC. (1891) Bronze, 17¹/4" (43.8 cm) high. Gift of The Cantor, Fitzgerald Collection. 430.75.

BALZAC IN A FROCK COAT. (1891–92) Bronze (cast 1971), 23⁷/8 x 8¹/2 x 10³/8" (60.5 x 21.6 x 26.5 cm); at base, 8¹/8 x 9¹/2" (21.6 x 24.2 cm). Gift of the B. G. Cantor Art Foundation. 636.73. Repr. *Rodin*, p. 92 (plaster).

BUST. (1891–92) Bronze (cast 1971), 12¹/8" (30.8 cm) high. Gift of The Cantor, Fitzgerald Collection. 434.75.

HEAD. (1891–92) Bronze (cast 1971), 6⁷/8" (17.5 cm) high. Gift of The Cantor, Fitzgerald Collection. 432.75.

MASK OF BALZAC SMILING. (1891–92) Bronze (cast 1970), 8¹/4" (21 cm) high. Gift of The Cantor, Fitzgerald Collection. 431.75.

STUDY FOR THE NAKED BALZAC. (1891–92) Bronze (cast 1971), 33³/4 x 19 x 11" (85.6 x 48.3 x 27.9 cm); at base, 19 x 11" (48.3 x 27.9 cm). Gift of The Cantor, Fitzgerald Collection. 433.75.

NAKED BALZAC WITH FOLDED ARMS. (1892–93) Bronze (cast 1966), 29³/4 x 12¹/8 x 13⁵/8" (75.5 x 30.8 x 34.6 cm); at base, 15¹/2 x

13³/₈″ (39.4 x 34.1 cm). Gift of the B. G. Cantor Art Foundation. 637.73.

HEAD. (1896–97) Bronze, 7¹/₂″ (19 cm) high. Gift of The Cantor, Fitzgerald Collection. 437.75. Repr. *Rodin*, p. 91 (plaster). *Note*: Albert E. Elsen has called this the "penultimate study(?)" for the *Monument*.

HEADLESS NAKED FIGURE STUDY FOR BALZAC. (1896–97) Bronze (cast 1970), 39 x 15¹/₄ x 12¹/₂″ (99 x 38.6 x 32 cm); at base, 15¹/₈ x 12¹/₈″ (38.5 x 30.8 cm). Gift of The Cantor, Fitzgerald Collection. 436.75. Repr. *Rodin*, p. 97 (plaster).

NAKED FIGURE STUDY FOR BALZAC. (1896–97) Bronze (cast 1965), 11¹/₂ x 3¹/₄ x 3¹/₄″ (29.3 x 8.4 x 8.4 cm); at base, 3¹/₄ x 3¹/₄″ (8.4 x 8.4 cm). Gift of The Cantor, Fitzgerald Collection. 435.75.

17 MONUMENT TO BALZAC. (1897–98) Bronze (cast 1954), 8′10″ (269 cm) high, at base 48¹/₄ x 41″ (122.5 x 104.2 cm). Presented in memory of Curt Valentin by his friends. 28.55. Repr. *Suppl. V*, p. 1; *Rodin*, pp. 88, 100; *Rosso*, pp. 53, 72; *What Is Mod. Sc.*, p. 35.

RODRÍGUEZ-LARRAIN, Emilio (Emilio Rodríguez-Larrain y Balta). Peruvian, born 1928. Lives in France.

467 BIRTH OF A PERSONAGE. (1965) Oil and tempera on composition board, 6′6³/₄″ x 56″ (200 x 142 cm). Given anonymously. 201.66.

RODRÍGUEZ LOZANO, Manuel. Mexican, born 1896.

211 BEYOND DESPAIR. 1940. Oil on canvas, 33¹/₈ x 27⁵/₈″ (84.2 x 70.2 cm). Inter-American Fund. 5.43. Repr. *Latin-Amer. Coll.*, p. 72.

ROESCH, Kurt. American, born Germany 1905. To U.S.A. 1933.

BONES ON THE TABLE. (1939) Oil on canvas, 28¹/₄ x 35⁷/₈″ (71.8 x 91.1 cm). Gift of Mr. and Mrs. Walter Hochschild. 488.41.

VAN ROGGER, Roger. Belgian, born 1914.

DESCENT FROM THE CROSS. 1946–48. Oil on canvas, 57¹/₈″ x 6′11″ (145.1 x 210.8 cm). Given anonymously. 78.50.

ROHLFS, Christian. German, 1849–1938.

66 MAN IN TOP HAT AND TAILS. (c. 1915–16) Gouache, watercolor, and graphite, 18¹/₈ x 12¹/₂″ (45.9 x 31.5 cm). Gift of Mr. and Mrs. Walter Bareiss. 581.56.

66 BLUE FAN DANCER. 1916. Gouache and watercolor, 19 x 13³/₄″ (48.2 x 34.9 cm). Gift of Mr. and Mrs. Eugene Victor Thaw. 582.56. Repr. *Suppl. VI*, p. 14.

MAN IN A TOP HAT. 1935. Watercolor with crayon, 19⁷/₈ x 13″ (50.5 x 32.8 cm). John S. Newberry Collection. 611.63.

ROJAS, Carlos. Colombian, born 1933.

STUDY FOR "MONUMENT TO EVITA PERON." (1972) Steel tubing painted black, 6′6⁷/₈″ x 62⁵/₈″ x 60¹/₄″ (200.4 x 159.1 x 153.1 cm). David Rockefeller Latin-American Fund. 130.74.

RONALD, William. American, born Canada 1926. To U.S.A. 1954.

348 SAINTPAULIA. 1956. Oil on canvas, 48 x 52³/₈″ (122 x 132.9 cm). Blanchette Rockefeller Fund. 32.57. Repr. *Suppl. VII*, p. 17.

ROSE, Herman. American, born 1909.

291 TOWER AND TANK. (1947) Oil on canvas, 15 x 13″ (38.1 x 33 cm). Purchase. 12.49. Repr. *Suppl. I*, p. 25.

ROSENQUIST, James. American, born 1933.

MARILYN MONROE, I. 1962. Oil and spray enamel on canvas, 7′9″ x 6′¹/₄″ (236.2 x 183.3 cm). The Sidney and Harriet Janis

Collection (fractional gift). 646.67. Repr. *Amer. 1963*, p. 92; in color, *Janis*, p. 155; in color, *Invitation*, p. 127.

ROSENTHAL, Bernard. American, born 1914.

THE ARK. 1958. Welded brass, 28″ (71 cm) high, at base 7³/₄ x 10¹/₂″ (19.8 x 26.8 cm). Gift of Mr. and Mrs. Victor M. Carter. 613.59. Repr. *Recent Sc. U.S.A.*

ROSSO, Medardo. Italian, 1858–1928. Lived in Paris 1889–1917.

38 THE CONCIERGE [*La Portinaia*]. (1883) Wax over plaster, 14¹/₂ x 12⁵/₈″ (36.8 x 32 cm). Mrs. Wendell T. Bush Fund. 614.59. Repr. *Suppl. IX*, p. 9; *Rosso*, p. 24. *Note*: the subject is the artist's doorkeeper, Orsola.

JEWISH BOY [*Bimbo Ebreo*]. (1892) Wax over plaster, 8⁷/₈″ (22.6 cm) high. Harriet H. Jonas Bequest. 425.74. Repr. *Rosso*, p. 38.

38 THE BOOKMAKER. (1894) Wax over plaster, 17¹/₂ x 13 x 14″ (44.3 x 33 x 35.5 cm) (irregular). Acquired through the Lillie P. Bliss Bequest. 673.59. Repr. *Suppl. IX*, p. 8; *Rosso*, pp. 44, 73; *What Is Mod. Sc.*, p. 31. *Note*: the subject is Eugène Marin, the son-in-law of the collector, Henri Rouart.

38 MAN READING. (1894) Bronze (cast 1960), 10 x 11¹/₄ x 11″ (25.3 x 28.5 x 27.9 cm) (irregular). Harry J. Rudick Fund. 89.60. Repr. *Suppl. X*, p. 13; *Rosso*, pp. 45, 73.

ROSZAK, Theodore J. American, born Poland 1907. To U.S.A. 1909.

356 SPECTRE OF KITTY HAWK. (1946–47) Welded and hammered steel brazed with bronze and brass, 40¹/₄″ (102.2 cm) high, at base 18 x 15″ (45.7 x 38.1 cm). Purchase. 16.50. Repr. *Suppl. II*, p. 18; *Masters*, p. 176; *Sc. of 20th C.*, p. 222. *Note*: the Museum owns two ink studies for this sculpture.

ROTHKO, Mark. American, born Latvia. 1903–1970. To U.S.A. 1913.

NUMBER 24. 1948. Oil on canvas, 34 x 50¹/₄″ (86.1 x 127.6 cm). Gift of the artist. 1106.69.

Untitled. (c. 1948) Oil on canvas, 8′10³/₈″ x 9′9¹/₄″ (270.2 x 297.8 cm). Gift of the artist. 1107.69.

NUMBER 22. 1949. Oil on canvas, 9′9″ x 8′11¹/₈″ (297 x 272 cm). Gift of the artist. 1108.69. Repr. in color, *Natural Paradise*, p. 55.

326 NUMBER 10. 1950. Oil on canvas, 7′6³/₈″ x 57¹/₈″ (229.6 x 145.1 cm). Gift of Philip Johnson. 38.52. Repr. *15 Amer.*, p. 19; in color, *New Amer. Ptg.*, p. 69; *Art of the Real*, p. 14.

YELLOW AND GOLD. 1956. Oil on canvas, 67¹/₈ x 62³/₄″ (170.5 x 159.4 cm). Gift of Philip Johnson. 576.70. Repr. in color, *Amer. Art*, p. 10; in b. & w., p. 33.

326 NUMBER 19. (1958) Oil on canvas, 7′11¹/₄″ x 7′6¹/₄″ (241.9 x 229 cm). Given anonymously. 389.61. Repr. *Rothko*, p. 31; *Suppl. XII*, p. 19.

327 RED, BROWN, AND BLACK. 1958. Oil on canvas, 8′10⁵/₈″ x 9′9¹/₄″ (270.8 x 297.8 cm). Mrs. Simon Guggenheim Fund. 21.59. Repr. *Suppl. IX*, p. 23; *Rothko*, p. 29; in color, *Invitation*, p. 35.

HORIZONTALS, WHITE OVER DARKS. 1961. Oil on canvas, 56¹/₂″ x 7′9³/₈″ (143.3 x 237 cm). The Sidney and Harriet Janis Collection (fractional gift). 647.67. Repr. in color, *Janis*, p. 129.

ROUAULT, Georges. French, 1871–1958.

46 WOMAN AT A TABLE (THE PROCURESS). 1906. Watercolor and pastel, 12¹/₈ x 9¹/₂″ (30.8 x 24.1 cm). Acquired through the Lillie P. Bliss Bequest. 503.41. Repr. *Rouault* (3rd), p. 49; *Ptg. & Sc.*, p. 46; *Seurat to Matisse*, p. 33.

46 CLOWN. (c. 1907) Oil on paper, 11½ x 12⅞″ (29.2 x 32.7 cm). Gift of Vladimir Horowitz. 692.49. Repr. *Suppl. II*, p. 3.

CLOWN. (1912) Oil on canvas, 35⅜ x 26⅞″ (89.8 x 68.2 cm). Gift of Nate B. and Frances Spingold. 79.58. Repr. *Bulletin*, Fall 1958, p. 43.

46 THE THREE JUDGES. 1913. Gouache and oil on cardboard, 29⅞ x 41⅝″ (75.9 x 105.7 cm). Sam A. Lewisohn Bequest. 17.52. Repr. *Suppl. IV*, p. 5; in color, *Rouault* (3rd), p. 67; in color, *Masters*, p. 57.

47 CIRCUS TRAINER. 1915. Gouache and crayon, 15⅝ x 10⅜″ (39.7 x 26.3 cm). Gift of Mr. and Mrs. Peter A. Rübel. 616.51. Repr. *Rouault* (3rd), p. 70.

47 MAN WITH SPECTACLES. 1917. Watercolor and crayon, 11¾ x 6½″ (29.8 x 16.5 cm). Gift of Abby Aldrich Rockefeller. 140.35. Repr. *Ptg. & Sc.*, p. 48; *Rouault* (3rd), p. 70.

47 CHRIST MOCKED BY SOLDIERS. (1932) Oil on canvas, 36¼ x 28½″ (92.1 x 72.4 cm). Given anonymously. 414.41. Repr. *Ptg. & Sc.*, p. 49; in color, *Rouault* (3rd), p. 89; in color, *Invitation*, p. 23.

47 LANDSCAPE WITH FIGURES. (c. 1937) Oil on canvas, 21⅜ x 27½″ (54.3 x 69.8 cm). Gift of Sam Salz. 427.53. Repr. *Suppl. V*, p. 9.

ROUSSEAU, Henri. French, 1844–1910.

4 THE SLEEPING GYPSY. 1897. Oil on canvas, 51″ x 6′7″ (129.5 x 200.7 cm). Gift of Mrs. Simon Guggenheim. 646.39. Repr. *Ptg. & Sc.*, p. 14; in color, *Masters*, p. 13; *Rousseau* (2nd), opp. p. 32; *Paintings from MoMA*, p. 9; in color, *Invitation*, p. 13.

5 THE DREAM. 1910. Oil on canvas, 6′8½″ x 9′9½″ (204.5 x 298.5 cm). Gift of Nelson A. Rockefeller. 252.54. Repr. in color, *Masters*, p. 15; in color, *Invitation*, p. 80.

ROY, Pierre. French, 1880–1950.

193 DANGER ON THE STAIRS [*Danger dans l'escalier*]. (1927 or 1928) Oil on canvas, 36 x 23⅝″ (91.4 x 60 cm). Gift of Abby Aldrich Rockefeller. 142.35. Repr. *Ptg. & Sc.*, p. 198.

193 DAYLIGHT SAVING TIME [*L'Heure d'été*]. (1929) Oil on canvas, 21½ x 15″ (54.6 x 38.1 cm). Gift of Mrs. Ray Slater Murphy. 1.31. Repr. *Ptg. & Sc.*, p. 198.

COUNTRY FAIR [*Comice agricole*]. (c. 1930) Oil on canvas, 16⅛ x 13″ (41 x 33 cm). Gift of Abby Aldrich Rockefeller. 128.40.

RUBIN, Reuven. Israeli, born Rumania. 1893–1974. To Israel 1912.

FLUTE PLAYER. (1938) Oil on canvas, 32 x 25⅝″ (81.3 x 65.1 cm). Gift of Mrs. Felix M. Warburg. 252.40.

RUIZ, Antonio. Mexican, born 1897.

211 THE NEW RICH. 1941. Oil on canvas, 12⅝ x 16⅝″ (32.1 x 42.2 cm). Inter-American Fund. 6.43. Repr. *Ptg. & Sc.*, p. 141.

RUSSELL, Morgan. American, 1886–1953.

William C. Agee has revised some dates and titles.

THREE APPLES. (1910) Oil on cardboard, 9¾ x 12⅞″ (24.6 x 32.4 cm). Given anonymously. 349.49.2.

224 CREAVIT DEUS HOMINEM (SYNCHROMY NUMBER 3: COLOR COUNTERPOINT). (1913) Oil on canvas mounted on cardboard, 11⅞ x 10¼″ (30.2 x 26 cm). Given anonymously. 149.51.

ARCHAIC COMPOSITION NUMBER 2. (1915–16) Oil on canvas, 12¾ x 9¾″ (32.4 x 24.7 cm). Given anonymously. 349.49.1.

STUDY IN TRANSPARENCY. (c. 1922) Oil on tissue paper, 18¾ x 13⅞″ (47.5 x 35.2 cm), irregular. Gift of Miss Rose Fried. 29.55.

224 COLOR FORM SYNCHROMY (EIDOS). (1922–23) Oil on canvas,

14½ x 10⅝″ (36.8 x 27 cm). Mrs. Wendell T. Bush Fund. 21.51. Repr. *Suppl. III*, p. 16.

RYAN, Anne. American, 1889–1954.

COLLAGE, 269. (1949) Pasted paper and cloth, 4½ x 4″ (11.4 x 10.2 cm) (irregular). Given anonymously. 159.55.

381 NUMBER 48. (1950) Collage of pasted paper, tinfoil, and cloth on cardboard, 15¾ x 12½″ (40 x 31.7 cm). Katharine Cornell Fund. 22.51. Repr. *Abstract Ptg. & Sc.*, p. 115; *Assemblage*, p. 99.

COLLAGE. (c. 1952) Pasted paper and cloth, 6½ x 5″ (16.5 x 12.7 cm). Given anonymously. 157.55.

COLLAGE. (c. 1953) Pasted paper and cloth, 7 x 5″ (17.8 x 12.7 cm). Given anonymously. 158.55.

RYMAN, Robert. American, born 1930.

TWIN. 1966. Oil on cotton, 6′3¾″ x 6′3⅞″ (192.4 x 192.6 cm). Charles and Anita Blatt Fund and Purchase. 691.71.

SAGE, Kay. American, 1898–1963.

315 HYPHEN. 1954. Oil on canvas, 30 x 20″ (76.2 x 50.9 cm). Purchase. 343.55. Repr. *Suppl. VI*, p. 21.

462 THE GREAT IMPOSSIBLE. 1961. Watercolor, ink, and collage with convex lenses, 12⅝ x 9⅜″ (32 x 23.6 cm). Kay Sage Tanguy Bequest. 1132.64.

SALAHI, Ibrahim. Sudanese, born 1930.

437 THE MOSQUE. (1964) Oil on canvas, 12⅛ x 18⅛″ (30.7 x 46 cm). Elizabeth Bliss Parkinson Fund. 7.65.

SALEMME, Attilio. American, 1911–1955.

THE FIRST COMMUNICATION. 1943. Oil on canvas, 13 x 19⅞″ (33 x 50.5 cm). Purchase. 171.45. Repr. *Ptg. & Sc.*, p. 225.

ASTRONOMICAL EXPERIMENT. 1945. Oil on canvas, 30 x 40″ (76.2 x 101.6 cm). Gift of Mrs. John D. Rockefeller 3rd. 190.52.

ANTECHAMBER TO INNER SANCTUM. 1950. Oil on canvas, 28 x 40″ (71.1 x 101.6 cm). Gift of Mrs. Gertrud A. Mellon. 191.52. Repr. *Suppl. IV*, p. 45.

SAMANT, Mohan B. Indian, born 1926. In U.S.A. 1959–64.

351 GREEN SQUARE. (1963) Synthetic polymer paint, sand, and oil on canvas, 69⅛ x 52″ (175.4 x 132.1 cm). Gift of George M. Jaffin. 334.63.

SAMARAS, Lucas. American, born Greece 1936. To U.S.A. 1948.

387 Untitled. (1960–61) Assemblage: wood panel with plaster-covered feathers, nails, screws, nuts, pins, razor blades, flashlight bulbs, buttons, bullets, aluminum foil, 23 x 19 x 4″ (59 x 48.2 x 10.2 cm). Larry Aldrich Foundation Fund. 301.61. Repr. *Suppl. XI*, p. 40.

BOOK 4. (1962) Assemblage: partly opened book with pins, razor blade, scissors, table knife, metal foil, piece of glass, and plastic rod, 5½ x 8⅞ x 11½″ (14 x 22.5 x 29.2 cm). Gift of Philip Johnson. 525.70.

SANDBACK, Fred. American, born 1943.

Untitled. (1967) Elastic rayon cord and metal sleeve clamps, stretched in installation to 69″ x 14′ x 24″ (175.2 x 426.7 x 60.9 cm). Gift of Philip Johnson. 692.71.

SANI, Alberto. Italian, born c. 1900.

10 SLAUGHTERING SWINE. (c. 1950) Gray marble relief, 11¾ x 12¼ x 4¾″ (29.8 x 31.1 x 12 cm). Purchase. 26.53. Repr. *Suppl. IV*, p. 47.

SANTO, Pasquale (Patsy). American, born Italy 1893. To U.S.A. 1913.

SPRING. 1940. Oil on canvas, 24¹/₈ x 18¹/₈" (61.3 x 46 cm). Abby Aldrich Rockefeller Fund. 1653.40. Repr. *Amer. Realists,* p. 51.

SARET, Alan. American, born 1944.

Untitled. (1969) Vinyl-coated hexagonal wire netting, 7'2³/₄" x 49" x 41⁵/₈" (220.3 x 124.5 x 105.5 cm), irregular. Purchase. 131.74.

SAURA, Antonio. Spanish, born 1930.

CRUCIFIXION. 1960. Cut-and-torn pasted papers, ink, and crayon on black paper, 27⁵/₈ x 19⁵/₈" (70 x 49.8 cm). John S. Newberry Fund. 24.68.

SCARAVAGLIONE, Concetta. American, 1900–1975.

VINCENT CANADÉ. (1927?) Bronze, 11" (27.9 cm) high. Given anonymously (by exchange). 18.43. Repr. *20th-C. Portraits,* p. 76.

SCARPITTA, Salvatore. American, born 1919.

363 COMPOSITION, I. (1959) Oil and casein on canvas strips stretched over armature, 45³/₄ x 35¹/₈" (116.2 x 89.1 cm). Gift of William S. Rubin. 615.59. Repr. *Suppl. IX,* p. 32.

SCHIELE, Egon. Austrian, 1890–1918.

75 GIRL PUTTING ON SHOE. 1910. Watercolor and charcoal, 14¹/₂ x 12¹/₂" (36.7 x 31.6 cm). Mr. and Mrs. Donald B. Straus Fund. 23.57. Repr. *Suppl. VII,* p. 4.

75 NUDE WITH VIOLET STOCKINGS. 1912. Watercolor, pencil, brush and ink, 12⁵/₈ x 18⁵/₈" (32 x 47.3 cm). Mr. and Mrs. Donald B. Straus Fund. 22.57. Repr. *Suppl. VII,* p. 4.

75 PROSTITUTE. 1912. Watercolor and pencil, 19 x 12³/₈" (48.1 x 31.3 cm). Mr. and Mrs. Donald B. Straus Fund. 21.57. Repr. *Suppl. VII,* p. 4.

SCHLEMMER, Oskar. German, 1888–1943.

STUDY FOR THE "TRIADIC BALLET." (1922) Gouache, ink, and collage of photographs, 22⁵/₈ x 14⁵/₈" (57.5 x 37.1 cm) (irregular). Gift of Mr. and Mrs. Douglas Auchincloss. 24.56. Repr. *Suppl. VI,* p. 16; *The Machine,* p. 135. *Note:* décor for the Third Part, with costume designs for "The Abstract/The Metaphysical," "Gold Sphere," and "Wire Costume." The ballet was first produced by Schlemmer at the Landestheater, Stuttgart, in 1922. It was subsequently produced in 1926 with music by Hindemith.

140 BAUHAUS STAIRWAY. (1932) Oil on canvas, 63⁷/₈ x 45" (162.3 x 114.3 cm). Gift of Philip Johnson. 597.42. Repr. *Ptg. & Sc.,* p. 128; in color, *German Art of 20th C.,* p. 114; in color, *Invitation,* p. 67.

SCHMID, Elsa. American, born Germany. 1897–1970.

241 FATHER D'ARCY. (1948–49) Mosaic and modeled fresco, 31¹/₄ x 17¹/₂" (79.4 x 44.5 cm). Gift of Mrs. Charles Suydam Cutting. 79.50. Repr. *Suppl. II,* p. 28. *Note:* the subject is The Very Reverend Martin C. D'Arcy, S.J., English scholar. The Museum owns a pencil and an ink study for this mosaic.

SCHMIDT, Arnold. American, born 1930.

499 Untitled. 1965. Synthetic polymer paint on canvas, 48¹/₈" x 8'¹/₈" (122.1 x 244.1 cm). Gift of Mr. and Mrs. Herbert C. Bernard. 113.66. Repr. *What Is Mod. Ptg.,* p. 45.

SCHMIDT, Julius. American, born 1923.

362 IRON SCULPTURE. (1960) Cast iron, 22¹/₂ x 38¹/₄ x 21³/₄" (57 x 97 x 55.2 cm). Gift of Mr. and Mrs. Samuel A. Marx. 123.60. Repr. *Suppl. X,* p. 42.

SCHMIDT-ROTTLUFF, Karl. German. 1884–1976.

70 HOUSES AT NIGHT. 1912. Oil on canvas, 37⁵/₈ x 34¹/₂" (95.6 x 87.4 cm). Gift of Mr. and Mrs. Walter Bareiss. 156.57. Repr. *Suppl. VII,* p. 6.

70 PHARISEES. 1912. Oil on canvas, 29⁷/₈ x 40¹/₂" (75.9 x 102.9 cm). Gertrud A. Mellon Fund. 160.55. Repr. *Suppl. V,* p. 11; in color, *German Art of 20th C.,* p. 50.

WASHERWOMEN BY THE SEA. (1921) Oil on burlap, 38⁵/₈ x 44¹/₄" (98 x 112.4 cm). Gift of Mr. and Mrs. Richard K. Weil. 265.57. Repr. *German Art of 20th C.,* p. 51; *Suppl. VII,* p. 6.

70 LANDSCAPE WITH LIGHTHOUSE. 1922. Watercolor, 18⁷/₈ x 23⁷/₈" (47.9 x 60.6 cm). Purchase. 17.50.

SCHMITHALS, Hans. German, 1878–1964.

127 THE GLACIER. (c. 1903) Mixed mediums on paper, 45¹/₄ x 29¹/₂" (114.8 x 74.7 cm). Matthew T. Mellon Foundation Fund. 90.60. Repr. *Suppl. X,* p. 14.

SCHNEIDER, Gérard. French, born Switzerland of French and Italian parents, 1896.

347 PAINTING 95 B. 1955. Oil on canvas, 57⁵/₈ x 45" (146.3 x 114.2 cm). Gift of Mr. and Mrs. Harold Kaye. 197.56. Repr. *Suppl. VI,* p. 25.

SCHNITZLER, Max. American, born Poland 1903.

365 NUMBER 1. (1955) Oil on canvas, 65⁷/₈ x 50" (167.3 x 126.8 cm). Given anonymously. 9.61. Repr. *Suppl. XI,* p. 28.

SCHÖFFER, Nicolas. French, born Hungary, 1912. To Paris 1936.

515 MICROTEMPS 11. (1965) Motor-driven construction of steel, duraluminum, and plexiglass, in illuminated wood stage, 24¹/₈ x 35¹/₄ x 23³/₄" (61.3 x 89.5 x 60.1 cm). Frank Crowninshield Fund. 108.66.

SCHOOLEY, Elmer. American, born 1916.

GERMAN LANDSCAPE. 1962. Oil on canvas, 30¹/₈ x 36¹/₄" (76.4 x 91.8 cm). Gift of the artist through the Ford Foundation Purchase Program. 175.63.

SCHWARTZ, Manfred. American, born Poland. 1909–1970. To U.S.A. 1920.

272 THE RING. 1962. Pastel, 22 x 18¹/₄" (55.9 x 46.2 cm). Gift of Mrs. H. Harris Jonas. 204.63.

SCHWITTERS, Kurt. British subject, born Germany. 1887–1948. In England 1940–48.

161 DRAWING A 2: HANSI-SCHOKOLADE [*Zeichnung A 2: Hansi*]. 1918. Collage of colored papers and wrapper, 7¹/₈ x 5³/₄" (18.1 x 14.6 cm) (sight). Purchase. 96.36. Repr. *German Art of 20th C.,* p. 93.

160 PICTURE WITH LIGHT CENTER [*Bild mit Heller Mitte*]. 1919. Collage of paper with oil on cardboard, 33¹/₄ x 25⁷/₈" (84.5 x 65.7 cm). Purchase. 18.50. Repr. *Suppl. II,* p. 12; in color, *German Art of 20th C.,* p. 95; in color, *Invitation,* p. 58.

REVOLVING [*Das Kreisen*]. 1919. Relief construction of wood, metal, cord, cardboard, wool, wire, leather, and oil on canvas, 48³/₈ x 35" (122.7 x 88.7 cm) (sight). Advisory Committee Fund. 231.68.

161 MERZ 22. 1920. Collage of railroad and bus tickets, wallpaper, ration stamps, 6⁵/₈ x 5³/₈" (16.8 x 13.6 cm) (sight). Katherine S. Dreier Bequest. 190.53.

161 MERZ 39: RUSSIAN PICTURE [*Russisches Bild*]. 1920. Collage of

colored papers, tickets, wrappers, $7^3/8$ x $5^5/8''$ (18.7 x 14.3 cm) (sight). Katherine S. Dreier Bequest. 191.53.

MERZ 83: DRAWING F [*Zeichnung F*]. 1920. Collage of cut paper wrappers, announcements, tickets, $5^3/4$ x $4^1/2''$ (14.6 x 11.4 cm) (sight). Katherine S. Dreier Bequest. 192.53. Repr. *Masters*, p. 139.

MERZ 88: RED STROKE [*Rotstrich*]. 1920. Collage of colored papers, tickets, labels, stamps, $5^1/4$ x $4^1/8''$ (13.2 x 10.3 cm). The Sidney and Harriet Janis Collection (fractional gift). 648.67. Repr. *Janis*, p. 65.

UNTITLED (FOR HOHLT ON THE OCCASION OF HIS WEDDING). 1920. Collage of printed papers, $9^7/8$ x $7^1/4''$ (25.1 x 18.2 cm). Gift of Marlborough-Gerson Gallery, Inc. 230.68.

MERZ 458. (c. 1920–22) Collage of streetcar tickets, wrappers, ration stamps, colored paper, etc., 7 x $5^5/8''$ (17.8 x 14.3 cm) (sight). Katherine S. Dreier Bequest. 193.53.

160 CHERRY PICTURE [*Das Kirschbild*]. 1921. Collage of colored papers, fabrics, printed labels and pictures, pieces of wood, etc., and gouache on cardboard background, $36^1/8$ x $27^3/4''$ (91.8 x 70.5 cm). Mr. and Mrs. A. Atwater Kent, Jr. Fund. 27.54. Repr. *Suppl. V*, p. 18.

MERZ 252: COLORED SQUARES [*Farbige Quadrate*]. 1921. Collage of colored papers, $7^1/8$ x $5^3/4''$ (18 x 14.4 cm). The Sidney and Harriet Janis Collection (fractional gift). 649.67. Repr. *Janis*, p. 66.

MERZ 460: TWO UNDERDRAWERS [*Twee Onderbroeken*]. 1921. Collage of colored cut papers, ribbon, printed cotton, candy wrapper, 8 x $6^3/4''$ (20.3 x 17.1 cm). Katherine S. Dreier Bequest. 194.53.

FAMIGLIA. 1922. Collage of colored and printed papers, $5^3/4$ x $4^1/4''$ (14.3 x 10.8 cm). The Sidney and Harriet Janis Collection (fractional gift). 650.67. Repr. *Janis*, p. 66.

160 MERZ (WITH EMERKA WRAPPER). (1922?) Collage of cut paper, carbon paper, mattress ticking, $13^3/4$ x $10^3/8''$ (35 x 26.3 cm) (sight). Katherine S. Dreier Bequest. 197.53.

161 MERZ: SANTA CLAUS [*Der Weihnachtsmann*]. 1922. Collage of papers and cloth, $11^1/4$ x $8^1/4''$ (28.4 x 20.8 cm). Purchase. 258.35. Repr. *Ptg. & Sc.*, p. 212.

MERZ 370: BLUE SPARK [*Blauer Funken*]. 1922. Collage of cut colored paper, $8^1/8$ x $6^3/4''$ (20.6 x 17.1 cm). Katherine S. Dreier Bequest. 195.53.

MERZ 379: POTSDAMER. 1922. Collage of papers and cloth, $7^1/8$ x $5^3/4''$ (18.1 x 14.6 cm). Purchase. 97.36.

161 MERZ 448: MOSCOW [*Moskau*]. 1922. Collage of cardboard and wood, 6 x $6^1/4''$ (15.2 x 15.9 cm). Katherine S. Dreier Bequest. 196.53. Repr. *Suppl. IV*, p. 13.

MERZ 704: BÜHLAU. 1923. Collage of cut papers, wrappers, tram ticket, linen, $5^1/4$ x $3^5/8''$ (13.3 x 9.2 cm). Katherine S. Dreier Bequest. 198.53.

MERZ DRAWING [*Merzzeichnung*]. 1924. Collage of cut colored papers and a button, $7^3/4$ x $6^1/8''$ (19.7 x 15.6 cm). Katherine S. Dreier Bequest. 202.53. Repr. *Assemblage*, p. 52.

MERZ 8. 1924. Collage of cut papers, $5^1/2$ x 4'' (14 x 10.2 cm). Katherine S. Dreier Bequest. 200.53.

161 MERZ 32. 1924. Collage of photographic paper, 5 x $3^3/4''$ (12.7 x 9.5 cm). Katherine S. Dreier Bequest. 201.53.

MERZ 2005: CONSTANTINOPLE [*Konstantinopel*]. 1924. Collage of cut paper, cardboard, tram tickets, pellet of wood, $5^1/8$ x $4^1/8''$ (13 x 10.5 cm). Katherine S. Dreier Bequest. 199.53. Repr. *German Art of 20th C.*, p. 94.

MERZ (WITH BLACK RECTANGLE). 1925. Collage of colored papers, $5^5/8$ x $4^1/2''$ (14.3 x 11.4 cm). Katherine S. Dreier Bequest. 204.53.

160 MERZ (WITH LETTERS "ELIKAN" REPEATED). (1925?) Collage of cut paper, candy wrappers, advertisement, $17^1/8$ x $14^1/4''$ (43.5 x 36.2 cm). Katherine S. Dreier Bequest. 208.53.

161 MERZ (WITH PAPER LACE). 1925. Collage of colored paper, paper lace, paper top of cigarette box, $4^3/8$ x $3^3/8''$ (11.1 x 8.6 cm). Katherine S. Dreier Bequest. 203.53. Repr. *Suppl. IV*, p. 13.

161 MERZ 17: LISSITZKY. 1926. Collage of colored papers, $5^1/4$ x $4^1/8''$ (13.3 x 10.5 cm). Katherine S. Dreier Bequest. 205.53.

MERZ 48: BERLIN. 1926. Collage of tickets, colored and painted papers, $4^3/4$ x $3^1/2''$ (11.8 x 8.7 cm). The Sidney and Harriet Janis Collection (fractional gift). 651.67. Repr. *Janis*, p. 67.

MERZ DRAWING E [*Merzzeichnung E*]. 1928. Collage of cut paper, $5^3/4$ x $4^1/8''$ (14.6 x 10.5 cm). Katherine S. Dreier Bequest. 206.53.

V-2. 1928. Collage of colored and printed papers with pen and ink and crayon, $5^1/8$ x $3^1/2''$ (12.8 x 8.9 cm) (irregular). The Sidney and Harriet Janis Collection (fractional gift). 652.67. Repr. *Janis*, p. 67.

161 MERZ (WITH BRITISH CENSOR'S SEAL). (1940–45) Collage of cut papers, envelopes, censorship forms, $7^3/8$ x $6^1/8''$ (18.7 x 15.6 cm). Katherine S. Dreier Bequest. 207.53.

SCLIAR, Carlos. Brazilian, born 1920.

462 PEAR AND CHERRY. 1965. Synthetic polymer paint and collage on paper over composition board, 11 x 7'' (27.7 x 17.8 cm). Gift of Mr. and Mrs. David Rockefeller. 631.65.

SCOTT, Patrick. Irish, born 1921.

286 WOMAN CARRYING GRASSES. (1958) Oil on canvas, 20 x 15'' (50.8 x 38.1 cm). Elizabeth Bliss Parkinson Fund. 140.58. Repr. *Suppl. VIII*, p. 17.

SCOTT, Tim. British, born 1937.

BIRD IN ARRAS, VI. (1969) Plexiglass and painted steel tubing, $8'7^7/8''$ x $7'1^5/8''$ x $9'7^1/8''$ (266.3 x 217.5 x 292.4 cm). Dr. and Mrs. Joseph A. Epstein and Benjamin Sturges Funds. 192.73a–j.

SEAWRIGHT, James L. American, born 1936.

512 EIGHT. (1966) Construction with sound: seven compartments containing an octagonal black-metal construction, silvered plastic spheres, a metal plate with translucent plastic panel, an oil on canvas, an oscilloscope tube, a cathode-ray tube, and a miniature speaker which repeats the word "eight" at 15-second intervals, in composition board box, $6^3/8$ x 44 x 6'' (16.2 x 111.7 x 15.2 cm). Adriane Reggie Fund. 596.66.

SEGAL, George. American, born 1924.

394 THE BUS DRIVER. (1962) Figure of plaster over cheesecloth; bus parts including coin box, steering wheel, driver's seat, railing, dashboard, etc. Figure, $53^1/2$ x $26^7/8$ x 45'' (136 x 68.2 x 114 cm); wood platform, $5^1/8''$ x $51^5/8''$ x $6'3^5/8''$ (13 x 131 x 191.9 cm); overall height, $6'3''$ (192 cm). Philip Johnson Fund. 337.63a–k. *Note*: the artist's brother-in-law, David Kutliroff, was the model.

PORTRAIT OF SIDNEY JANIS WITH MONDRIAN PAINTING. (1967) Plaster figure with Mondrian's *Composition*, 1933, on an easel; figure, 66'' (167.6 cm) high; easel, 67'' (170 cm) high. The Sidney and Harriet Janis Collection (fractional gift). 653.67. Repr. *Janis*, p. 167.

SEGONZAC, André Dunoyer de. French, 1884–1974.

65 LANDSCAPE. (c. 1928) Watercolor, 18⁷/₈ x 24³/₄" (47.9 x 62.9 cm). Lillie P. Bliss Collection. 119.34. Repr. *Bliss, 1934*, no. 55.

 ROAD AND CRANE (IRON CRANE AND BOAT AT MARSEILLES). Watercolor, 24⁷/₈ x 18⁷/₈" (63.2 x 47.9 cm). Gift of Frank Crowninshield. 625.43.

SEGUÍ, Antonio. Argentine, born 1934. Lives in Paris.

445 BOX OF GENTLEMEN. 1964. Oil on canvas, 6'4⁷/₈" x 51³/₈" (195 x 130.3 cm). Inter-American Fund. 293.65.

SELEY, Jason. American, born 1919.

388 MASCULINE PRESENCE. (1961) Assemblage: welded chromium-plated steel automobile bumpers and grill, 7'2⁷/₈" x 48" (220.6 x 121.9 cm). Gift of Dr. and Mrs. Leonard Kornblee. 302.61. Repr. *Assemblage*, p. 147.

 FLIP. (1963) Assemblage: welded chromium-plated steel automobile bumpers, 30⁵/₈ x 25¹/₄ x 14³/₈" (77.8 x 64 x 36.4 cm). Gift of Philip Johnson. 795.69. Repr. *Amer. 1963*, p. 99.

SELIGER, Charles. American, born 1926.

 NATURAL HISTORY: FORM WITHIN ROCK. 1946. Oil on canvas, 25 x 30" (63.5 x 76.2 cm). Gift of August Hanniball, Jr. 139.47.

SELIGMANN, Kurt. American, born Switzerland. 1900–1962. Worked in Paris. To U.S.A. 1939.

 EXORCISM. 1954. Pen and ink, tempera, and resin, 28¹/₄ x 34¹/₈" (71.7 x 86.8 cm). Abby Aldrich Rockefeller Fund (by exchange). 495.75.

182 THE KING. 1960. Oil on canvas, 24¹/₄ x 20" (61.4 x 50.7 cm). Gift of Stamo Papadaki (by exchange). 91.60. Repr. *Suppl. X*, p. 22.

SEQUEIRA. See MORALES SEQUEIRA.

SÉRAPHINE (Séraphine Louis). French, 1864–1934.

 TREE OF PARADISE. (c. 1920–25) Oil on canvas, 6'4³/₄" x 51³/₄" (194.9 x 130.5 cm). Purchase. 37.71.

SERPAN, Iaroslav. French, born Czechoslovakia 1922.

354 MURTSPHDE, 570. (1957) Oil on canvas, 57¹/₂ x 44⁷/₈" (146 x 113.7 cm). Gift of G. David Thompson. 22.59. Repr. *Suppl. IX*, p. 24.

SERRANO, Pablo (Pablo Serrano Aguilar). Spanish, born 1910.

414 HEAD OF ANTONIO MACHADO. 1965. Bronze, 26 x 20⁷/₈ x 24⁵/₈" (65.8 x 53 x 62.5 cm), iron base ³/₈ x 23³/₄ x 23³/₄" (.7 x 60.2 x 60.2 cm). Gift of the Organizing Committee of Homage, "Walk with Antonio Machado." 97.67. *Note:* the Spanish poet Antonio Machado died in exile in 1939. This portrait (of which the Museum's cast is the second) was commissioned as part of a larger monument to the poet in Baeza, the Andalusian city where he taught for many years. Dedication of the monument, planned for February 20, 1966, was prohibited by the Spanish government authorities.

SEURAT, Georges-Pierre. French, 1859–1891.

22 EVENING, HONFLEUR. (1886) Oil on canvas, 25³/₄ x 32" (65.4 x 81.1 cm). Gift of Mrs. David M. Levy. 266.57. Repr. *Bulletin*, Fall 1958, p. 46; *Levy Collection*, p. 23. *Note:* original title was *L'Embouchure de la Seine, un soir, Honfleur.* The flat frame, 2³/₄" (7 cm) wide, was painted by the artist.

22 PORT-EN-BESSIN, ENTRANCE TO THE HARBOR. (1888) Oil on canvas, 21⁵/₈ x 25⁵/₈" (54.9 x 65.1 cm). Lillie P. Bliss Collection.

126.34. Repr. *Ptg. & Sc.*, p. 31; *Seurat*, p. 89; in color, *Masters*, p. 25; *Impress.* (4th), p. 511; *Post-Impress.* (2nd), p. 115; *Paintings from MoMA*, p. 19; in color, *Invitation*, p. 17. *Note:* formerly listed by the Museum as *Fishing Fleet at Port-en-Bessin.* Seurat's second and final title, 1890, was *Port-en-Bessin, entrée de l'avant-port.* Border of canvas was painted by the artist.

SEVERINI, Gino. Italian, 1883–1966. Active chiefly in Paris.

117 DYNAMIC HIEROGLYPHIC OF THE BAL TABARIN. (1912) Oil on canvas, with sequins, 63⁵/₈ x 61¹/₂" (161.6 x 156.2 cm). Acquired through the Lillie P. Bliss Bequest. 288.49. Repr. in color, *Masters*, p. 102; *Futurism*, p. 68; in color, *Invitation*, p. 43.

SHAHN, Ben. American, born Lithuania. 1898–1969. To U.S.A. 1906.

246 BARTOLOMEO VANZETTI AND NICOLA SACCO. From the Sacco-Vanzetti series of twenty-three paintings. (1931–32) Tempera on paper over composition board, 10¹/₂ x 14¹/₂" (26.7 x 36.8 cm). Gift of Abby Aldrich Rockefeller. 144.35. Repr. *Ptg. & Sc.*, p. 148; in color, *Shahn*, pl. 3.

246 TWO WITNESSES, MELLIE EDEAU AND SADIE EDEAU. From the Tom Mooney series of fifteen paintings. (1932) Tempera on paper over composition board, 12 x 16" (30.5 x 40.7 cm). Purchase. 128.46. Repr. in color, *Shahn*, pl. 5.

246 HANDBALL. (1939) Tempera on paper over composition board, 22³/₄ x 31¹/₄" (57.8 x 79.4 cm). Abby Aldrich Rockefeller Fund. 28.40. Repr. *Ptg. & Sc.*, p. 148; in color, *Masters*, p. 162.

246 WILLIS AVENUE BRIDGE. (1940) Tempera on paper over composition board, 23 x 31³/₈" (58.4 x 79.7 cm). Gift of Lincoln Kirstein. 227.47. Repr. in color, *Shahn*, pl. 11; in color, *Invitation*, p. 112.

 FRENCH WORKERS. (1942–43) Gouache on cardboard, 14³/₄ x 20⁵/₈" (37.6 x 52.5 cm). Gift of Francis E. Brennan. 390.61. Repr. *Suppl. XI*, p. 20.

246 PORTRAIT OF MYSELF WHEN YOUNG. (1943) Tempera on cardboard, 20 x 27⁷/₈" (50.8 x 70.8 cm). Purchase. 273.48. Repr. in color, *Shahn*, pl. 21.

247 WELDERS. (1943) Tempera on cardboard mounted on composition board, 22 x 39³/₄" (55.9 x 100.9 cm). Purchase. 264.44. Repr. *Ptg. & Sc.*, p. 149; in color, *Shahn*, pl. 25.

247 PACIFIC LANDSCAPE. (1945) Tempera on paper over composition board, 25¹/₄ x 39" (64.1 x 99.1 cm). Gift of Philip L. Goodwin. 1.50. Repr. *Shahn*, pl. 30; *Suppl. II*, p. 27.

247 FATHER AND CHILD. (1946) Tempera on cardboard, 40 x 30" (101.5 x 76.1 cm). Gift of James Thrall Soby. 157.57. Repr. *Suppl. VII*, p. 13; *Soby Collection*, p. 64. *Note:* the Museum owns six charcoal studies for this painting.

246 MAN. (1946) Tempera on composition board, 22⁷/₈ x 16³/₈" (57.9 x 41.5 cm). Gift of Mr. and Mrs. E. Powis Jones. 141.58. Repr. *Suppl. VIII*, p. 14.

247 THE VIOLIN PLAYER. (1947) Tempera on plywood, 40 x 26" (101.6 x 66 cm). Sam A. Lewisohn Bequest. 18.52. Repr. *Suppl. IV*, p. 7.

 "A GOOD MAN IS HARD TO FIND." (1948) Gouache, 8' x 62" (243.9 x 157.5 cm). Gift of the artist. 23.51. Repr. *Suppl. III*, p. 22. *Note:* seated at the piano, Harry S. Truman, and above him, at right, Thomas E. Dewey, presidential candidates in 1948. Subsequently posters were made of this painting.

 Design for a poster. (1955) Gouache and watercolor, 38⁷/₈ x 25¹/₂" (98.7 x 64.8 cm). Gift of Henry H. Ploch. 376.65. *Note:* designed on the occasion of the 25th anniversary of the artist's association with the Downtown Gallery.

 Cartoon for mosaic mural for William E. Grady Vocational High School, Brooklyn, New York. (1956) Tempera, 7'8¹/₈" x 49'2¹/₄" (2.34 x 15 m). Gift of the artist. 674.59.

ARRANGEMENT OF LETTERS. (1963) Cast silver with gold wash, 3¼ x 2" (8.1 x 5 cm). Given anonymously. 403.63. Repr. *Lettering*, p. 34.

LETTERS IN A CUBE. (1963) Cast silver with gold wash, 2⅛ x 1⅞" (5.2 x 4.8 cm). Given anonymously. 402.63. Repr. *Lettering*, p.34.

SHALOM OF SAFED (Shalom Moskowitz). Israeli, born c. 1880.

437 NOAH'S ARK. (1965) Synthetic polymer paint on paper, 26½ x 18⅞" (67.3 x 47.8 cm). Gift of the Jerome L. and Jane Stern Foundation. 202.66. *Note*: Hebrew inscription, lower edge: "Shalom Moskowitz the Galilean/and here is the ark on the seventh month on the seventeenth day of the month on the mountains (sic) of Ararat."

SHAPIRO, Joel. American, born 1941.

Untitled (house on shelf). 1974. Bronze, 12⅞ x 2½ x 28⅛" (32.5 x 6.4 x 71.5 cm). Purchased with the aid of funds from the National Endowment for the Arts and an anonymous donor. 379.75.

SHARRER, Honoré. American, born 1920.

277 WORKERS AND PAINTINGS. 1943. Oil on composition board, 11⅝ x 37" (29.5 x 94 cm). Gift of Lincoln Kirstein. 17.44. Repr. *Ptg. & Sc.*, p. 153. *Note*: the Museum owns ten pencil and ink studies for this painting.

SHASHURIN, Dimitri M. Russian, born 1919.

352 ELEMENTS OF LIFE. 1962. Oil on cardboard, 13⅞ x 19⅝" (35 x 49.7 cm). Gift of Yevgeny Yevtushenko. 17.63.

SHAW, Charles. American, 1892–1974.

365 EDGE OF DUSK. 1956. Oil on canvas, 36¼ x 48¼" (92.1 x 122.4 cm). Given in memory of W.D.S.B. by his wife. 25.56. Repr. *Suppl. VI*, p. 22.

SHEELER, Charles. American, 1883–1965.

228 AMERICAN LANDSCAPE. 1930. Oil on canvas, 24 x 31" (61 x 78.8 cm). Gift of Abby Aldrich Rockefeller. 166.34. Repr. *Ptg. & Sc.*, p. 132; in color, *Invitation*, p. 119.

BUCKS COUNTY BARN. 1932. Oil on gesso on composition board, 23⅞ x 29⅞" (60.6 x 75.9 cm). Gift of Abby Aldrich Rockefeller. 145.35.

SHEMI, Yehiel. Israeli, born 1922.

305 BIRD. (1955) Welded iron, 22½" (57.1 cm) high, at base 11½ x 7⅛" (29.2 x 18.1 cm). Blanchette Rockefeller Fund. 142.58. Repr. *Suppl. VIII*, p. 16.

SHERMAN, Sarai. American, born 1922.

262 BEAR CAT. (1959) Casein and oil on canvas, 39½ x 27½" (100.3 x 69.8 cm). Gift of Joseph H. Hirshhorn. 35.60. Repr. *Suppl. X*, p. 25.

SHIELDS, Alan. American, born 1944.

G.U.—G.U. WELL. (1969–70) Synthetic polymer paint and thread on unstretched canvas, 9'8⅝" x 14'3⅛" (296 x 434.6 cm). William H. Weintraub Fund. 38.71.

SICKERT, Walter Richard. British, 1860–1942.

34 LA GAIETÉ MONTPARNASSE. (c. 1905) Oil on canvas, 24⅛ x 20" (61.2 x 50.8 cm). Mr. and Mrs. Allan D. Emil Fund. 422.60. Repr. *Suppl. X*, p. 13. *Note*: the head in the bowler hat at lower center is said to be a self-portrait.

34 SIR THOMAS BEECHAM CONDUCTING. (c. 1935) Oil on burlap, 38¾ x 41⅛" (98.5 x 104.5 cm). Bertram F. and Susie Brummer Foundation Fund. 344.55. Repr. *Masters Brit. Ptg.*, p. 99.

SIEVAN, Maurice. American, born Ukraine 1898. To U.S.A. 1907.

272 OOMPALIK. 1962. Oil on canvas, 69⅛ x 59¼" (175.4 x 150.4 cm). Larry Aldrich Foundation Fund. 77.63.

SIGNAC, Paul. French, 1863–1935.

23 ALBENGA. (c. 1896) Watercolor, 4⅜ x 7½" (11.1 x 19 cm). Acquired through the Lillie P. Bliss Bequest. 25.51.

23 LIGHTHOUSE. (c. 1896) Watercolor and charcoal, 5⅜ x 6½" (13.6 x 16.5 cm). Acquired through the Lillie P. Bliss Bequest. 26.51. Repr. *Suppl. III*, p. 10; *Seurat to Matisse*, p. 30.

23 LES ALYSCAMPS, ARLES. (1904) Watercolor and charcoal, 16 x 10½" (40.7 x 26.7 cm). Acquired through the Lillie P. Bliss Bequest. 24.51. Repr. *Suppl. III*, p. 10.

23 HARBOR OF LA ROCHELLE. 1922. Watercolor, 11 x 17⅝" (27.9 x 44.8 cm). Lillie P. Bliss Collection. 130.34. Repr. *Bliss, 1934*, no. 65.

SIHVONEN, Oli. American, born 1921.

505 DUPLEX. (1963) Oil on canvas, 56⅛ x 52" (142.4 x 132 cm). Larry Aldrich Foundation Fund. 113.65.

SILLS, Thomas. American, born 1914.

448 LANDLOCKED. (1960) Oil on canvas, 51¾ x 68¼" (131.3 x 173.3 cm). Gift of Mrs. Annie McMurray. 263.64.

SILVA, Carlos. Argentine, born 1930.

DEYBER. 1968. Gouache and pencil, 19⅝ x 18⅞" (49.7 x 47.8 cm). Given anonymously. 844.69.

SIMPSON, David. American, born 1928.

RED, BLUE, PURPLE CIRCLE. (1962) Oil on canvas, 48⅛" (122.2 cm) diameter. Larry Aldrich Foundation Fund. 78.63. Repr. *Amer. 1963*, p. 103.

SINTENIS, Renée. German, 1888–1965.

202 DAPHNE. (1930) Bronze, 56½" (143.5 cm) high. Abby Aldrich Rockefeller Fund. 337.39. Repr. *Ptg. & Sc.*, p. 248.

SIPORIN, Mitchell. American, 1910–1976.

THE REFUGEES. 1939. Oil on composition board, 30 x 36" (76.2 x 91.4 cm). Purchase. 573.39. Repr. *Amer. 1942*, p. 114.

SIQUEIROS, David Alfaro. Mexican, 1896–1974.

208 PROLETARIAN VICTIM. 1933. Duco on burlap, 6'9" x 47½" (205.8 x 120.6 cm). Gift of the Estate of George Gershwin. 4.38. Repr. *Latin-Amer. Coll.*, p. 64.

209 COLLECTIVE SUICIDE. 1936. Duco on wood with applied sections, 49" x 6' (124.5 x 182.9 cm). Gift of Dr. Gregory Zilboorg. 208.37. Repr. *Fantastic Art* (3rd), p. 220.

208 ECHO OF A SCREAM. 1937. Duco on wood, 48 x 36" (121.9 x 91.4 cm). Gift of Edward M. M. Warburg. 633.39. Repr. *Ptg. & Sc.*, p. 138; in color, *Invitation*, p. 108.

209 ETHNOGRAPHY. (1939) Duco on composition board, 48⅛ x 32⅜" (122.2 x 82.2 cm). Abby Aldrich Rockefeller Fund. 1657.40. Repr. *Ptg. & Sc.*, p. 139.

208 THE SOB. 1939. Duco on composition board, 48½ x 24¾" (123.2 x

62.9 cm). Given anonymously. 490.41. Repr. *Latin-Amer. Coll.*, p. 66.

209 HANDS. 1949. Duco on composition board, 48⅛ x 39⅜″ (122.2 x 100 cm). Gift of Henry R. Luce. 101.50.

SIRONI, Mario. Italian, 1885–1961.

SUSANNA AND THE ELDERS. (1935) Oil on canvas on composition board, 42¼ x 43½″ (107.3 x 110.3 cm). Gift of the Mr. and Mrs. Stanley Marcus Foundation. 693.71.

198 MULTIPLICATION. (c. 1941) Oil on canvas, 22⅛ x 31½″ (56.2 x 80 cm). Gift of Eric Estorick. 480.53. Repr. *Suppl. V*, p. 19.

SITNIKOV, Vasily Yakovlevich. Russian, born 1915.

SONG OF THE LARK. 1960. Oil and colored crayons on paper, 23⅝ x 33″ (59.8 x 83.7 cm). Gift of Jimmy Ernst. 120.62.

THE STEPPE. 1960. Oil and crayon on paper, 23½ x 32⅞″ (59.5 x 83.4 cm). Gift of Jimmy Ernst. 119.62. Repr. *Suppl. XII*, p. 27.

SUNSET. (1961) Colored crayons, 17 x 23½″ (43 x 59.6 cm). Gift of Jimmy Ernst. 176.63.

291 HILLOCK. 1962. Oil and colored crayons, 23⅝ x 32¾″ (59.8 x 83.2 cm). Given anonymously. 404.63.

SKUNDER (Skunder Boghossian). Ethiopian, born 1937.

434 JU-JU'S WEDDING. 1964. Tempera and metallic paint on cut and torn cardboard, 21⅛ x 20″ (53.6 x 50.7 cm). Blanchette Rockefeller Fund. 109.66.

SMITH, David. American, 1906–1965.

HEAD. 1938. Cast iron and steel, 19¾ x 9⅝″ (50.2 x 24.5 cm). Gift of Charles E. Merrill. 110.43. Repr. *Ptg. & Sc.*, p. 288.

301 DEATH BY GAS (from the Medals for Dishonor series). 1939–40. Bronze medallion, 11⅜″ (28.9 cm) diameter (irregular). Given anonymously. 267.57. Repr. *Suppl. VII*, p. 14.

301 TWENTY-FOUR GREEK Ys. 1950. Forged steel, painted, 42¾ x 29⅛″ (108.6 x 73.9 cm). Blanchette Rockefeller Fund. 294.56. Repr. *Suppl. VII*, p. 14; *Lettering*, p. 28.

AUSTRALIA. 1951. Painted steel, 6′7½″ x 8′11⅞″ x 16⅛″ (202 x 274 x 41 cm); at base, 14 x 14″ (35.6 x 35.6 cm). Gift of William Rubin. 1533.68. Repr. *Smith*, p. 25.

301 CHICAGO CIRCLE. 1955–56. Bronze medallion, 11″ (27.9 cm) diameter. Given anonymously. 268.57. Repr. *Suppl. VII*, p. 14.

301 HISTORY OF LEROY BORTON. 1956. Steel, 7′4¼″ x 26¾″ x 24½″ (224.1 x 67.9 x 62.2 cm). Mrs. Simon Guggenheim Fund. 159.57. Repr. *Smith*, p. 30; *Suppl. VII*, p. 24. *Note*: dedicated by the artist in homage and friendship to the blacksmith and craftsman who assisted him with the power-forging of the series *Forgings 1955*.

495 ZIG, III. 1961. Painted steel, 7′8¾″ (225.4 cm) high, including base 4″ x 8′2¼″ x 18⅛″ (10.1 x 249.5 x 45.9 cm). Mrs. Simon Guggenheim Fund. 387.66

CUBI X. 1963. Stainless steel, 10′1⅜″ x 6′6¾″ x 24″ (308.3 x 199.9 x 61 cm), including steel base 2⅞ x 25 x 23″ (7.3 x 63.4 x 58.3 cm). Robert O. Lord Fund. 717.68. Repr. *What Is Mod. Sc.*, p. 103; *Amer. Art*, p. 47.

SMITH, Leon Polk. American, born 1906.

ANITOU. 1958. Oil on canvas, 56⅝″ (143.6 cm) diameter. Gift of Dr. and Mrs. Arthur Lejwa. 1109.69. Repr. *Amer. Art*, p. 37.

SMITH, Richard. British, born 1931.

RING-A-LINGLING. 1966. Synthetic polymer paint on shaped canvas with sheet aluminum, in three parts, each approximately 7′ x 7′ x 17″ (213.4 x 213.4 x 43 cm); overall, 7′ x 20′11¾″ x 17″ (213.4 x 640.2 x 43 cm). Purchase. 46.71a–c.

WHITE ROPE. 1973. Synthetic polymer paint on canvas with metal rods, rope and string, 10′6″ x 57½″ (321.2 x 146.1 cm). Purchase. 598.76.

SMITH, Tony. American, born 1912.

CIGARETTE. (1961) Painted steel, 15′1″ x 25′6″ x 18′7″ (459.2 x 777.2 x 566.3 cm). Mrs. Simon Guggenheim Fund. 114.73.

SMITHSON, Robert. American, 1938–1973.

MIRROR WITH ROCK SALT (SALT MINE AND MUSEUM PROPOSAL). 1968. Pencil, pasted photograph, and pasted paper, 17¾ x 24″ (45.1 x 60.8 cm). Gift of Mrs. John de Cuevas. 622.71.

SOBEL, Janet. American, born Russia. 1894–1968. To U.S.A. 1908.

MILKY WAY. 1945. Enamel on canvas, 44⅞ x 29⅞″ (114 x 75.9 cm). Gift of the artist's family. 1311.68.

SOFU. See TAKESHI.

SOMAINI, Francesco. Italian, born 1926.

WOUNDED, II. (1960) Cast iron, partly painted, with painted iron base, 17½ x 18¼″ (44.5 x 46.3 cm). Blanchette Rockefeller Fund. 366.60a–b. Repr. *Suppl. X*, p. 32.

360 SANGUINARY MARTYRDOM [*Grande martirio sanguinante*]. (1960) Cast iron, 52⅛ x 26⅛″ (132.3 x 66.4 cm). Gift of Philip Johnson. 1534.68.

SONNIER, Keith. American, born 1941.

Untitled. (1967) Satin over foam rubber on wood with felt, 3⅜″ x 9′11″ x 3¾″ (8.4 x 302.3 x 9.3 cm). Gift of Philip Johnson. 526.70.

SØRENSEN, Jørgen Haugen. Danish, born 1934. Lives in France.

379 WOMAN. 1960. Stoneware, 43⅝ x 36⅜″ (110.8 x 92.3 cm). Purchase. 81.62. Repr. *Suppl. XII*, p. 25.

SORIANO, Juan. Mexican, born 1920.

CHILD WITH BIRD. 1941. Gouache, 25½ x 19⅝″ (64.8 x 49.9 cm). Inter-American Fund. 792.42. Repr. *Latin-Amer. Coll.*, p. 72.

SOTO, Jesús Rafael. Venezuelan, born 1923. To Paris 1950.

509 OLIVE AND BLACK. 1966. Horizontal, mobile, flexible metal strips suspended in front of two plywood panels painted with synthetic polymer paint and mounted on composition board, 61½ x 42¼ x 12½″ (156.1 x 107.1 x 31.7 cm). Inter-American Fund. 547.67.

SOULAGES, Pierre. French, born 1919.

346 JANUARY 10, 1951. 1951. Oil on burlap, 57½ x 38¼″ (146 x 97.2 cm). Acquired through the Lillie P. Bliss Bequest. 209.53. Repr. *Suppl. IV*, p. 34.

346 PAINTING. 1956. Oil on canvas, 59¼″ x 6′4¾″ (150.5 x 195 cm). Gift of Mr. and Mrs. Samuel M. Kootz. 23.59.

SOUTINE, Chaim. French, born Lithuania. 1893–1943. To France 1913.

190 THE OLD MILL. (c. 1922–23) Oil on canvas, 26⅛ x 32⅜″ (66.4 x

82.2 cm). Vladimir Horowitz and Bernard Davis Funds. 557.54. Repr. *Suppl. V*, p. 9; *Soutine*, p. 64; in color, *Invitation*, p. 122.

190 DEAD FOWL. (c. 1924) Oil on canvas, 43½ x 32″ (110.4 x 81.1 cm). Gift of Mr. and Mrs. Justin K. Thannhauser. 93.58. Repr. *Suppl. VI*, p. 10.

190 PORTRAIT OF MARIA LANI. (1929) Oil on canvas, 28⅞ x 23½″ (73.3 x 59.7 cm). Mrs. Sam A. Lewisohn Bequest. 275.54. Repr. *Suppl. V*, p. 5; *Soutine*, p. 94.

CHARTRES CATHEDRAL. (1933) Oil on wood, 36 x 19¾″ (91.4 x 50 cm). Gift of Mrs. Lloyd Bruce Wescott. 514.64. Repr. *Art in Our Time*, no. 105; in color, *Soutine*, p. 27.

SOYER, Moses. American, born Russia. 1899–1974. To U.S.A. 1912.

237 ARTIST AND MODEL. (1962) Oil on canvas, 16⅛ x 20⅛″ (41 x 51.2 cm). Gift of Mr. and Mrs. Herbert A. Goldstone. 315.62. Repr. *Suppl. XII*, p. 13.

SOYER, Raphael. American, born Russia 1899. To U.S.A. 1912.

237 SEAMSTRESS. (1956–60) Oil on canvas, 30 x 24⅛″ (76.2 x 61.2 cm). Gift of Mr. and Mrs. Sidney Elliott Cohn. 10.61. Repr. *Suppl. XI*, p. 20.

SPARHAWK-JONES, Elizabeth. American, born 1885.

427 STARTLED WOMAN. (c. 1956?) Oil on canvas, 19 x 26⅛″ (48.2 x 66.2 cm). Larry Aldrich Foundation Fund. 455.64.

SPENCER, Niles. American, 1893–1952.

231 CITY WALLS. 1921. Oil on canvas, 39⅜ x 28¾″ (100 x 73 cm). Given anonymously (by exchange). 25.36. Repr. *Ptg. & Sc.*, p. 112. *Note*: the Museum owns a pencil study for this painting.

231 ORDNANCE ISLAND, BERMUDA. (1928) Oil on canvas, 24 x 36″ (61 x 91.4 cm). Gift of Sam A. Lewisohn. 302.38. Repr. *Amer. Ptg. & Sc.*, no. 99.

231 NEAR AVENUE A. 1933. Oil on canvas, 30¼ x 40¼″ (76.8 x 102.2 cm). Gift of Nelson A. Rockefeller. 3.38. Repr. *Art in Our Time*, no. 120.

231 IN FAIRMONT. 1951. Oil on canvas, 65½ x 41½″ (166.3 x 105.4 cm). Edward Joseph Gallagher 3rd Memorial Collection. 6.56. Repr. *Suppl. V*, p. 17.

SPENCER, Stanley. British, 1891–1959.

199 THE NURSERY. 1936. Oil on canvas, 30⅛ x 36⅛″ (76.5 x 91.8 cm). Gift of the Contemporary Art Society, London. 22.40. Repr. *Ptg. & Sc.*, p. 183.

SPOERRI, Daniel. Swiss, born Rumania 1930.

380 KICHKA'S BREAKFAST, I. 1960. Assemblage: wood chair hung on wall with board across seat, coffee pot, tumbler, china, egg cups, eggshells, cigarette butts, spoons, tin cans, etc., 14⅜ x 27⅜ x 25¾″ (36.6 x 69.5 x 65.4 cm). Philip Johnson Fund. 391.61. Repr. *Assemblage*, p. 132.

SPRUCE, Everett. American, born 1908.

THE HAWK. 1939. Oil on composition board, 19⅜ x 23½″ (49.2 x 59.7 cm). Purchase. 574.39. Repr. *Ptg. & Sc.*, p. 174.

SQUIRRU, Carlos Maria Miguel. Argentine, born 1934.

CANCER. 1957. Tempera, 23⅞ x 18″ (60.7 x 45.6 cm). Inter-American Fund. 269.57. Repr. *Suppl. VII*, p. 22.

STAËL, Nicolas de. French, born Russia. 1914–1955.

345 PAINTING. 1947. Oil on canvas, 6′5″ x 38⅜″ (195.6 x 97.5 cm). Gift of Mr. and Mrs. Lee A. Ault. 28.51. Repr. *Suppl. III*, p. 18.

STAMOS, Theodoros. American, born 1922.

332 SOUNDS IN THE ROCK. 1946. Oil on composition board, 48⅛ x 28⅜″ (122.2 x 72.1 cm). Gift of Edward W. Root. 27.47. Repr. *Ptg. & Sc.*, p. 227.

SACRIFICE. 1948. Oil on composition board, 36 x 48⅛″ (91.3 x 122 cm). Gift of William Rubin. 662.70.

THE FALLEN FIG. (1949) Oil on composition board, 48 x 25⅞″ (121.9 x 65.7 cm). Given anonymously. 34.55; *Natural Paradise*, p. 34.

TAYGETOS. (1958) Oil on canvas, 60″ x 6′ (152.3 x 182.8 cm). Purchase. 24.59.

RED MOUND NUMBER 1. 1963–64. Oil on canvas, 52 x 56″ (132 x 142 cm). Gift of the artist in memory of René d'Harnoncourt. 1535.68.

STANKIEWICZ, Richard. American, born 1922.

URCHIN IN THE GRASS. (1956) Iron and steel, 23⅝ x 16½ x 13″ (59.9 x 41.7 x 32.8 cm), including steel base ¼ x 16½ x 11⅛″ (.6 x 41.7 x 28.1 cm). Gift of Philip Johnson. 797.69.

386 INSTRUCTION. (1957) Welded scrap iron and steel, 12½ x 13¼ x 8⅝″ (31.7 x 33.6 x 21.8 cm). Philip Johnson Fund. 17.58. Repr. *Suppl. VIII*, p. 16; *16 Amer.*, p. 73; *What Is Mod Sc.*, p. 97.

386 NATURAL HISTORY. (1959) Welded iron pipes and boiler within wire mesh, 14¾ x 34¼ x 19¼″ (37.3 x 87 x 48.8 cm). Elizabeth Bliss Parkinson Fund. 11.61. Repr. *Suppl. XI*, p. 41; *Amer. Art*, p. 46.

STAZEWSKI, Henryk. Polish, born 1894.

486 COLORED RELIEF. 1963. Oil on relief construction of composition board and wood strips, 19¾ x 32¾ x 2⅞″ (50 x 83.1 x 7.3 cm). Gift of Mr. and Mrs. Maurice A. Lipschultz. 114.65.

STEICHEN, Edward J. American, 1879–1973.

The seven mural decorations that follow were painted for Mr. and Mrs. Eugene Meyer, Jr., New York, between 1910 and 1913. All are the gift of the children of Eugene and Agnes E. Meyer: Elizabeth Lorentz, Eugene Meyer III, Katharine Graham, and Ruth M. Epstein. Identification of the flowers is from the catalog of the exhibition *Paintings by Eduard J. Steichen*, M. Knoedler & Co., New York, January 25–February 6, 1915.

IN EXALTATION OF FLOWERS: ROSE GERANIUM. 1910. Tempera and gold leaf on canvas, 10′ x 55″ (304.9 x 139.7 cm). 1421.74.

IN EXALTATION OF FLOWERS: CLIVIA, FUCHSIA-HILIUM, HENRYI. (c. 1910–13) Tempera and gold leaf on canvas, 10′ x 8′4″ (304.9 x 243.8 cm). 1421.74.

IN EXALTATION OF FLOWERS: COLEUS, THE FLORENCE MEYER POPPY. (c. 1910–13) Tempera and gold leaf on canvas, 10′ x 55″ (304.9 x 139.7 cm). 1415.74.

IN EXALTATION OF FLOWERS: GLOXINIA, DELPHINIUM. (c. 1910–13) Tempera and gold leaf on canvas, 10′ x 55″ (304.9 x 139.7 cm). 1418.74.

IN EXALTATION OF FLOWERS: GOLDEN-BANDED LILY, VIOLETS. (c. 1910–13) Tempera and gold leaf on canvas, 10′ x 55″ (304.9 x 139.7 cm). 1419.74.

IN EXALTATION OF FLOWERS: PETUNIA, CALADIUM, BUDLEYA.

(c. 1910–13) Tempera and gold leaf on canvas, 10′ x 8′4″ (304.9 x 243.8 cm). 1420.74.

IN EXALTATION OF FLOWERS: PETUNIA, BEGONIA REX, THE FREER BRONZE. 1913. Tempera and gold leaf on canvas, 10′ x 55″ (304.9 x 139.7 cm). 1416.74.

STELLA, Frank. American, born 1936.

366 THE MARRIAGE OF REASON AND SQUALOR. 1959. Oil on canvas, 7′6³/₄″ x 11′3/4″ (230.5 x 337.2 cm). Larry Aldrich Foundation Fund. 725.59. Repr. *16 Amer.*, p. 78; *Stella*, p. 27.

TUFTONBORO IV. (1966) Fluorescent alkyd and epoxy paint on canvas, 8′4¹/₈″ x 9′3/4″ (254.3 x 276.3 cm). Gift of David Whitney. 577.70. Repr. *Amer. Art*, p. 71.

STELLA, Joseph. American, born Italy. 1877–1946. To U.S.A. 1896.

224 BATTLE OF LIGHTS. (1913–14? Dated on painting 1914 and 1915). Oil on canvas mounted on cardboard, 20¹/₄″ (51.4 cm) diameter (irregular). Elizabeth Bliss Parkinson Fund. 143.58. Repr. *Suppl. VIII*, p. 7. *Note*: said to be a study for the large *Battle of Lights, Coney Island*, 1913, now in the Yale University Art Gallery, Société Anonyme Collection.

224 FACTORIES. (1918) Oil on burlap, 56 x 46″ (142.2 x 116.8 cm). Acquired through the Lillie P. Bliss Bequest. 756.43. Repr. *Ptg. & Sc.*, p. 111.

224 SONG OF THE NIGHTINGALE. 1918. Pastel, 18 x 23¹/₈″ (45.8 x 58.6 cm). Bertram F. and Susie Brummer Foundation Fund. 121.62. Repr. *Suppl. XII*, p. 10.

427 FIRST LIGHT [*Crépuscule premier*]. (c. 1928) Oil on canvas, 16¹/₄ x 16¹/₄″ (41.3 x 41.3 cm). Elizabeth Bliss Parkinson Fund. 203.66. *Note*: also called *Twilight*.

STEPANOVA, Varvara (Varst). Russian, 1894–1958.

TWO MEN SEATED AT A TABLE. 1921. Tempera, 11¹/₄ x 11¹/₄″ (28.5 x 28.5 cm). Given anonymously. 33.36.

STEPHAN, Gary. American, born 1942.

ALKAHEST E. 1973. Oil on canvas, 57″ x 7′8¹/₈″ (144.8 x 234.2 cm). Mr. and Mrs. John R. Jakobson Fund. 132.74.

STERN, Marina. American, born Italy 1928. To U.S.A. 1941.

464 SEVEN MINUS TWENTY-ONE EQUALS SEVEN. 1966. Oil on canvas, 50¹/₄ x 50¹/₈″ (127.5 x 127.3 cm). Gift of Alfred Schwabacher. 256.66.

STERNE, Hedda. American, born Rumania 1916. To U.S.A. 1941.

339 NEW YORK, VIII. (1954) Synthetic polymer paint on canvas, 6′1¹/₈″ x 42″ (183.2 x 106.7 cm). Mr. and Mrs. Roy R. Neuberger Fund. 558.54. Repr. *Suppl. V*, p. 25.

STERNE, Maurice. American, born Latvia. 1877–1957. To U.S.A. 1889.

219 RESTING AT THE BAZAAR. (1912) Oil on canvas, 26³/₄ x 31¹/₂″ (68 x 80 cm). Abby Aldrich Rockefeller Fund. 301.38. Repr. *Ptg. & Sc.*, p. 68.

GIRL IN BLUE CHAIR. 1928. Oil on canvas, 34¹/₂ x 24¹/₂″ (87.6 x 62.2 cm). Gift of Sam A. Lewisohn. 298.38. Repr. *Modern Works*, no. 147.

219 AFTER THE RAIN. 1948. Oil on canvas, 26¹/₂ x 34″ (67.3 x 86.4 cm). Mrs. Sam A. Lewisohn Bequest. 276.54. Repr. *Suppl. V*, p. 5.

STETTHEIMER, Florine. American, 1871–1944.

PORTRAIT OF MY MOTHER. 1925. Oil on canvas, 38³/₈ x 26⁵/₈″ (97.3 x 67.6 cm). Barbara S. Adler Bequest. 534.71. Repr. *Stettheimer*, p. 38.

237 FAMILY PORTRAIT, II. 1933. Oil on canvas, 46¹/₄ x 64⁵/₈″ (117.4 x 164 cm). Gift of Miss Ettie Stettheimer. 8.56. Repr. in color, *Stettheimer*, p. 35. *Note*: represented, from left to right, the artist, her sister Ettie, her mother, and her sister Carrie.

STILL, Clyfford. American, born 1904.

325 PAINTING. 1951. Oil on canvas, 7′10″ x 6′10″ (238.8 x 208.3 cm). Blanchette Rockefeller Fund. 277.54. Repr. *Suppl. V*, p. 20; *New Amer. Ptg.*, p. 78; *Art of the Real*, p. 16; in color, *Invitation*, p. 134; *Natural Paradise*, p. 123.

PAINTING. Oil on canvas, 8′8¹/₄″ x 7′3¹/₄″ (264.5 x 221.4 cm). Inscribed on reverse: *1944-N*. The Sidney and Harriet Janis Collection (fractional gift). 655.67. Repr. *Janis*, p. 127. *Note*: also called *Red Flash on Black Field*.

STORRS, John. American. 1885–1956.

STONE PANEL WITH BLACK MARBLE INLAY. (1920–21) Cast stone and black marble, 60¹/₂ x 15¹/₄ x 1³/₄″ (153.7 x 38.8 x 4.5 cm), with wood base 18¹/₂ x 12¹/₈ x 12¹/₈″ (46.1 x 30.8 x 30.8 cm). Purchase. 599.76.

STOUT, Myron. American, born 1908.

369 NUMBER 3. 1954. (1954) Oil on canvas, 20¹/₈ x 16″ (50.9 x 40.6 cm). Philip Johnson Fund. 25.59. Repr. *Suppl. IX*, p. 39.

STREAT, Thelma Johnson. American, born 1912.

RABBIT MAN. 1941. Gouache, 6⁵/₈ x 4⁷/₈″ (16.8 x 12.4 cm). Purchase. 216.42.

STUART, Ian. Irish, born 1926.

379 MAYO. (1960) Assemblage: two sheep jawbones and parts of cast-iron stove, 22″ (55.8 cm) high, at base 8⁷/₈ x 6¹/₂″ (23 x 16.5 cm). Gertrud A. Mellon Fund. 303.61. Repr. *Suppl. XI*, p. 39.

STUEMPFIG, Walter. American, 1914–1970.

CAPE MAY. (1943) Oil on canvas, 28 x 35″ (71.1 x 88.9 cm). Acquired through the Lillie P. Bliss Bequest. 757.43. Repr. *Ptg. & Sc.*, p. 168.

SUGAÏ, Kumi. Japanese, born 1919. Lives in Paris.

354 KABUKI. 1958. Oil and gilt paint on canvas, 57¹/₂ x 44⁵/₈″ (145.8 x 113.3 cm). Purchase. 26.59. Repr. *Suppl. IX*, p. 24.

SUGARMAN, George. American, born 1912.

TEN. (1968–69) Laminated wood, painted, in ten parts; overall, 7′7″ x 12′5″ x 71¹/₄″ (233 x 378 x 182 cm). Purchase. 289.76a–j.

SUICHIKU. See ABE.

SUIJŌ. See IKEDA.

SULLIVAN, Patrick J. American, 1894–1967.

THE FOURTH DIMENSION. (1938) Oil on canvas, 24¹/₄ x 30¹/₄″ (61.5 x 76.6 cm). The Sidney and Harriet Janis Collection (fractional gift). 656.67. Repr. *Janis*, p. 85.

A-HUNTING HE WOULD GO. (1940) Oil on canvas, 26¹/₄ x 36¹/₈″

(66.7 x 91.8 cm). Purchase. 370.41. Repr. *Bulletin*, vol. 9, no. 2, 1941, p. 9.

SURVAGE, Léopold. Russian, 1879–1968. To Paris 1908.

127 COLORED RHYTHM. Fifty-nine studies for the film. (1913) Watercolor, brush and ink, 14⅛ x 10⅜″ and 13 x 12¼″ (35.9 x 26.3 and 33 x 31.1 cm). Purchase. 661.39.1–.59. Six studies repr. *Art in Our Time*, p. 367; 661.39.58 repr. *Masters*, p. 213; single study, *Seurat to Matisse*, p. 42.

ŠUTEJ, Miroslav. Yugoslavian, born 1936.

501 BOMBARDMENT OF THE OPTIC NERVE, II. 1963. Tempera and pencil on circular canvas, 6′7″ (200.5 cm) diameter. Larry Aldrich Foundation Fund. 373.65.

SUTHERLAND, Graham. British, born 1903.

270 HORNED FORMS. 1944. Oil on composition board, 39¼ x 31⅞″ (99.7 x 80.9 cm). Acquired through the Lillie P. Bliss Bequest. 129.46. Repr. *Ptg. & Sc.*, p. 232.

270 THORN HEADS. 1946. Oil on canvas, 48 x 36″ (122 x 91.5 cm). Acquired through the Lillie P. Bliss Bequest. 345.55. Repr. *Masters of Brit. Ptg.*, p. 140.

SVAVAR GUDNASON. Icelandic, born 1909.

DEAD BIRD. 1934. Watercolor, 8½ x 11⅛″ (21.7 x 28.2 cm). Purchase. 292.61. Repr. *Suppl. XI*, p. 21.

TADASKY (Tadasuke Kuwayama). Japanese, born 1935. To U.S.A. 1961.

500 A-101. 1964. Synthetic polymer paint on canvas, 52 x 52″ (132.1 x 132.1 cm). Larry Aldrich Foundation Fund. 579.64. Repr. in color, *Responsive Eye*, p. 32.

471 B-171. 1964. Synthetic polymer paint on canvas, 15⅛ x 15⅛″ (38.4 x 38.4 cm). Given anonymously. 8.65. *Note*: study for a larger painting, *B-199*, 6 x 6′.

TAEUBER-ARP, Sophie. Swiss, 1889–1943. To France 1928.

SCHEMATIC COMPOSITION. (1933) Oil and wood on composition board, 35⅜ x 49¼″ (89.6 x 125 cm). Gift of Silvia Pizitz. 1008.69.

TAJIRI, Shinkichi G. American, born 1923. Lives in the Netherlands.

359 MUTATION. (1959–60) Brazed and welded bronze, 8′4¾″ (255.9 cm) high, at base 8¾ x 8¾″ (22.2 x 22.2 cm). Gift of G. David Thompson. 12.61. Repr. *Suppl. XI*, p. 34.

TAKESHI, Imaji (pen name: Sofu). Japanese, born 1913.

317 THE SUN. (c. 1953) Two-panel screen, brush and ink, each sheet 55 x 27½″ (139.7 x 69.8 cm). Japanese House Fund. 280.54. Repr. *Suppl. V*, p. 29.

TAKIS (Takis Vassilakis). French, born Greece 1925.

375 SIGNAL ROCKET. (1955) Painted steel and iron, 48″ (121.9 cm) high, at base 5¼ x 5″ (13.2 x 12.5 cm). Mrs. Charles V. Hickox Fund. 675.59. Repr. *Suppl. IX*, p. 34.

HEAD IN SPACE. (1956) Bronze, 9″ (22.9 cm) high. Gift of D. and J. de Menil. 368.60. Repr. *Suppl. X*, p. 59.

375 TELE-SCULPTURE. (1960–62) Three-part construction: a) an electromagnet, 10⅝″ (26.8 cm) high x 12⅝″ (31.9 cm) diameter; b) a top-shaped black-painted cork, 4″ (10.1 cm) high x 1¾″ (4.3 cm) diameter; and c) a white-painted wood sphere, 4″ (10.1 cm) diameter; both cork and sphere contain magnets. Kept in motion

by gravity and by positive and negative magnetic forces, the hanging cork and sphere swing and occasionally collide. Gift of D. and J. de Menil. 252.62a–c. Repr. *Suppl. XII*, p. 34.

TAL COAT, René Pierre. French, born 1905.

LA MARSEILLAISE. (1944) Oil on canvas, 16⅛ x 12⅞″ (41 x 32.7 cm). Mrs. Cornelius J. Sullivan Fund. 274.48.

TAM, Reuben. American, born Hawaii 1916.

MOON AND SHOALS. 1949. Oil on canvas, 30 x 34⅞″ (76.2 x 88.6 cm). Gift of Sam A. Lewisohn. 289.49. Repr. *Suppl. I*, p. 22.

TAMAYO, Rufino. Mexican, born 1899. Worked in New York 1935–48; in Paris 1949–54.

WAITING WOMAN. 1936. Watercolor, 15 x 20¾″ (38.1 x 52.7 cm). Extended loan from the United States WPA Art Program. E.L.39.1829.

207 ANIMALS. 1941. Oil on canvas, 30⅛ x 40″ (76.5 x 101.6 cm). Inter-American Fund. 165.42. Repr. *Ptg. & Sc.*, p. 233; in color, *Masters*, p. 168; in color, *Invitation*, p. 82.

207 WOMAN WITH PINEAPPLE. 1941. Oil on canvas, 40 x 30″ (101.6 x 76.2 cm). Gift of friends of the artist. 79.43.

207 GIRL ATTACKED BY A STRANGE BIRD. 1947. Oil on canvas, 70 x 50⅛″ (177.8 x 127.3 cm). Gift of Mr. and Mrs. Charles Zadok. 200.55. Repr. *Suppl. VI*, p. 28.

207 MELON SLICES. 1950. Oil on canvas, 39⅜ x 31¾″ (100 x 80.6 cm). Gift of Mrs. Sam A. Lewisohn. 27.53. Repr. *Suppl. IV*, p. 29.

TANAKA, Atsuko. Japanese, born 1932.

471 Untitled. (1964) Synthetic polymer paint on canvas, 10′11¼″ x 7′4¾″ (333.4 x 225.4 cm). John G. Powers Fund. 612.65. Repr. in color, *New Jap. Ptg. & Sc.*, p. 17.

TANCREDI. Italian, 1927–1964.

SPRINGTIME. 1952. Gouache and pastel, 27½ x 39⅜″ (69.8 x 100 cm). Gift of Peggy Guggenheim. 192.52.

TANGUY, Yves. American, born France. 1900–1955. To U.S.A. 1939.

178 RUE DE LA SANTÉ. 1925. Oil on canvas, 19¾ x 24⅛″ (50.2 x 61.1 cm). Kay Sage Tanguy Bequest. 338.63. Repr. *Tanguy*, p. 12.

178 MAMA, PAPA IS WOUNDED! [*Maman, papa est blessé!*]. 1927. Oil on canvas, 36¼ x 28¾″ (92.1 x 73 cm). Purchase. 78.36. Repr. *Ptg. & Sc.*, p. 196; in color, *Masters*, p. 144; *Tanguy*, p. 27.

178 EXTINCTION OF USELESS LIGHTS [*Extinction des lumières inutiles*]. 1927. Oil on canvas, 36¼ x 25¾″ (92.1 x 65.4 cm). Purchase. 220.36. Repr. *Tanguy*, p. 26.

178 Untitled. 1931. Gouache, 4½ x 11½″ (11.4 x 29.2 cm). Purchase. 261.35. Repr. *Tanguy*, p. 35.

Untitled. 1936. Ink transfer (decalcomania), 12¾ x 19¾″ (32.3 x 50 cm). Alva Gimbel Fund. 13.69.

179 LA GRANDE MUE. (1942) Gouache and pasted paper, 11½ x 8¾″ (29.2 x 22 cm). Kay Sage Tanguy Bequest. 272.63.

178 SLOWLY TOWARD THE NORTH [*Vers le nord lentement*]. 1942. Oil on canvas, 42 x 36″ (106.7 x 91.4 cm). Gift of Philip Johnson. 627.43. Repr. *Ptg. & Sc.*, p. 197; in color, *Tanguy*, p. 44.

Untitled. (1945) Gouache, 17½ x 11⅞″ (44.3 x 29.9 cm). Kay Sage Tanguy Bequest. 273.63.

179 MULTIPLICATION OF THE ARCS. 1954. Oil on canvas, 40 x 60″

(101.6 x 152.4 cm). Mrs. Simon Guggenheim Fund. 559.54. Repr. in color, *Tanguy*, p. 67; in color, *Invitation*, p. 92.

TÀPIES PUIG, Antoní. Spanish, born 1923.

353 SPACE. (1956) Latex paint on canvas with marble dust, 6'4⁵/₈" x 67" (194.6 x 170 cm). Gift of Mrs. Martha Jackson. 27.59. Repr. *New Spanish Ptg. & Sc.*, p. 49; *Suppl. IX*, p. 25.

353 PAINTING. 1957. Latex paint with marble dust and sand on canvas, 57³/₈ x 35" (145.7 x 88.8 cm). Gift of G. David Thompson. 28.59. Repr. *New Spanish Ptg. & Sc.*, frontispiece; *Suppl. IX*, p. 25.

353 GRAY RELIEF ON BLACK. 1959. Latex paint with marble dust on canvas, 6'4⁵/₈" x 67" (194.6 x 170 cm). Gift of G. David Thompson. 13.61. Repr. *Suppl. XI*, p. 29.

TAVERNARI, Vittorio. Italian, born 1919.

298 TORSO. (1961) Wood, 6'6" x 33¹/₈" (198.1 x 84.1 cm). Blanchette Rockefeller Fund. 82.62. Repr. *Suppl. XII*, p. 24.

TCHELITCHEW, Pavel. American, born Russia. 1898–1957. Worked in Western Europe and England from 1921. In U.S.A. 1938–52.

196 NATALIE PALEY. 1931. Oil on canvas, 32 x 21¹/₄" (81.3 x 54 cm). Acquired through the Lillie P. Bliss Bequest. 253.54. Repr. *Suppl. V*, p. 8.

196 THE MADHOUSE. 1935. Gouache, 19⁷/₈ x 25⁵/₈" (50.3 x 65.1 cm). Purchase. 26.36. Repr. *Ptg. & Sc.*, p. 184. *Note*: study for *Phenomena*.

ORPHEUS. Twenty-nine costume designs for the opera-ballet produced by the American Ballet Company, New York, 1936. Gouache, 9⁵/₈ x 7³/₄" to 18⁷/₈ x 8³/₄" (24.4 x 19.7 cm to 45.4 x 22.1 cm). Gift of the artist. 513.41.1–.29. Theatre Arts Collection.

NOBILISSIMA VISIONE or ST. FRANCIS. Forty designs for the ballet produced by the Ballets Russes de Monte Carlo, London, 1938. Gouache, thirty-six designs for costumes, 20¹/₂ x 9³/₄" (52 x 24.8 cm); four designs for scenery, 17³/₈ x 24⁷/₈" to 20³/₄ x 25³/₄" (44.4 x 63.2 cm to 52.7 x 65.4cm). Gift of the artist. 65.42.1–.40. Theatre Arts Collection.

The six works that follow are studies for *Hide-and-Seek*, 1940–42, in the Museum's collection.

AUTUMN LEAF. 1939. Gouache, 10¹/₂ x 8¹/₄" (26.7 x 21 cm). Mrs. Simon Guggenheim Fund. 598.42.

THE DANDELION. 1939. Gouache and watercolor, 11 x 8¹/₂" (27.9 x 21.6 cm). Mrs. Simon Guggenheim Fund. 351.42.

196 LEAF CHILDREN. 1939. Gouache, 25¹/₄ x 19³/₄" (64.1 x 50.2 cm). Mrs. Simon Guggenheim Fund. 219.42. Repr. *Tchelitchew*, pl. 55.

TREE INTO HAND AND FOOT. 1939. Watercolor and ink, 14 x 9³/₄" (35.6 x 24.8 cm). Mrs. Simon Guggenheim Fund. 348.42. Repr. *Masters*, p. 165.

TREE INTO HAND AND FOOT WITH CHILDREN. 1940. Watercolor and ink, 13⁷/₈ x 16³/₄" (35.3 x 42.5 cm). Mrs. Simon Guggenheim Fund. 599.42. Repr. *Tchelitchew*, p. 86.

HEAD OF AUTUMN. 1941. Watercolor and gouache, 13 x 14⁷/₈" (33 x 37.8 cm). Gift of Lincoln Kirstein. 28.47. Repr. *Tchelitchew*, p. 82.

197 HIDE-AND-SEEK [*Cache-cache*]. 1940–42. Oil on canvas, 6'6¹/₂" x 7'3³/₄" (199.3 x 215.3 cm). Mrs. Simon Guggenheim Fund. 344.42. Repr. *Ptg. & Sc.*, p.236. Details: *Tchelitchew*, pp. 83–85; in color, *Masters*, p. 165; *Tchelitchew*, frontispiece. In color, *Invitation*, p. 103. *Note*: the Museum also owns five ink studies for this painting.

BALUSTRADE. Design for costume for the ballet produced by W. de Basil's Original Ballet Russe, New York, 1941. Gouache, 16 x 8⁵/₈" (40.7 x 21.9 cm) (sight). Gift of the artist. 137.44. Theatre Arts Collection.

THE CAVE OF SLEEP. Seventeen designs for the ballet, 1941, not produced. Gouache, sixteen designs for costumes: one, 11 x 14"; seven, 11¹/₄ x 7¹/₄"; seven, 14 x 11"; one, 14⁵/₈ x 11" (27.9 x 35.6; 28.6 x 18.4; 35.6 x 27.9; 37.2 x 27.9 cm); one design for scenery, 19³/₈ x 32⁷/₈" (49.2 x 83.5 cm). Gift of the artist. 64.42.1–.17. Theatre Arts Collection.

APOLLON MUSAGÈTE. Two designs for scenery for the ballet, produced by the American Ballet Company, Buenos Aires, 1942. Gouache, 18¹/₈ x 28¹/₂; 20 x 28¹/₂" (46 x 72.3 cm; 50.7 x 72.3 cm). Gift of Lincoln Kirstein. 24.43.1–.2. Theatre Arts Collection.

PAS DE DEUX. Design for costume. 1942. Gouache, 14³/₈ x 11³/₈" (36.7 x 28.9 cm). Gift of Lincoln Kirstein. 25.43. Theatre Arts Collection.

TEBO (Angel Torres Jaramillo). Mexican, born 1916.

210 PORTRAIT OF MY MOTHER. 1937. Oil on cardboard, 9¹/₈ x 6¹/₈" (23.2 x 15.6 cm). Gift of Sam A. Lewisohn (by exchange). 796.42. Repr. *Latin-Amer. Coll.*, p. 72.

THARRATS, Joan Josep. Spanish, born 1918.

353 THAT WHICH WILL BE [*Lo que será*]. 1961. Mixed mediums on canvas, 51¹/₄ x 38¹/₈" (130 x 96.8 cm). Gift of Mr. and Mrs. Gustav P. Heller. 100.61. Repr. *Suppl. XI*, p. 30.

THIEBAUD, Wayne. American, born 1920.

392 CUT MERINGUES. 1961. Oil on canvas, 16 x 20" (40.6 x 50.6 cm). Larry Aldrich Foundation Fund. 122.62. Repr. *Suppl. XII*, p. 29.

THOMAS, Byron. American, born 1902.

PASTIME BOWLING ALLEY. 1939. Oil on canvas, 15 x 40¹/₂" (38.1 x 102.9 cm). Purchase. 575.39.

THOMPSON, Bob. American, 1937–1966.

ST. MATTHEW'S DESCRIPTION OF THE END OF THE WORLD. 1964. Oil on canvas, 6' x 60¹/₈" (182.8 x 152.8 cm). Blanchette Rockefeller Fund. 380.71.

UNTITLED (AFTER POUSSIN). (1964) Oil on printed gallery announcement, 10⁷/₈ x 18¹/₈" (27.5 x 46 cm). Gift of Lillian L. and Jack I. Poses. 143.71.

THORNTON, Leslie T. British, born 1925.

297 MEN FISHING FROM A PIER. (1955) Iron wire, 23 x 21 x 14¹/₂" (58.4 x 53.4 x 36.8 cm). Mrs. Bertram Smith Fund. 347.55. Repr. *Suppl. VI*, p. 31.

TINGUELY, Jean. Swiss, born 1925. Lives in Paris and Basel.

375 HATCHING EGG. 1958. Motor-driven relief construction of painted metal and plywood, 30¹/₂ x 32¹/₂ x 9" (77.5 x 82.4 x 22.7 cm). Gift of Erwin Burghard Steiner. 616.59. Repr. *Suppl. IX*, p. 35.

375 PUSS IN BOOTS. 1959. Motor-driven construction of painted steel and wire, 30¹/₈" (76.4 cm) high, at base 6⁷/₈ x 7⁷/₈" (17.3 x 19.9 cm). Philip Johnson Fund. 369.60. Repr. *Suppl. X*, p. 51.

476 Fragment from HOMAGE TO NEW YORK. (1960) Painted metal, 6'8¹/₄" x 29⁵/₈" x 7'3⁷/₈" (203.7 x 75.1 x 223.2 cm). Gift of the artist. 227.68. Repr. *The Machine*, p. 171; entire piece repr. in *The Machine*, frontispiece, and *Dada, Surrealism*, p. 22. *Note*: *Homage to New York*, a motorized assemblage of eighty bicycle

wheels, old motors, a piano, metal drums, an addressograph machine, a child's go-cart, and an enameled bathtub, was set in motion and destroyed, except for this fragment and a few smaller fragments, on March 17, 1960, in the Sculpture Garden of The Museum of Modern Art.

TIPPETT, Bruce. British, born 1933. In Rome 1962–66. To U.S.A. 1968.

490 ITEM 34, 1964, SPIRAL IV. 1964. Synthetic polymer paint on canvas, 67³/₄ x 67³/₄ x 4″ (172 x 172 x 10 cm). Given anonymously. 632.65.

TOBEY, Mark. American, 1890–1976. To Basel 1960.

320 THREADING LIGHT. 1942. Tempera on cardboard, 29³/₈ x 19¹/₂″ (74.6 x 49.5 cm). Purchase. 86.44. Repr. *Ptg. & Sc.*, p. 228; *Tobey*, p. 55.

431 THE VOID DEVOURING THE GADGET ERA. 1942. Tempera on cardboard, 21⁷/₈ x 30″ (55.3 x 76 cm). Gift of the artist. 264.64. Repr. *The Machine*, p. 163.

FATA MORGANA. 1944. Tempera on cardboard, 14¹/₈ x 22¹/₄″ (35.8 x 56.4 cm). The Sidney and Harriet Janis Collection (fractional gift). 657.67. Repr. *Janis*, p. 117. *Note*: also called *White Writing*.

320 REMOTE FIELD. 1944. Tempera, pencil, and crayon on cardboard, 28¹/₈ x 30¹/₈″ (71.4 x 76.5 cm). Gift of Mr. and Mrs. Jan de Graaff. 143.47. Repr. *14 Amer.*, p. 71; *Tobey*, p. 63.

HOMAGE TO THE VIRGIN. 1948. Tempera on cardboard, 9 x 15″ (22.7 x 38 cm). Gift of Mr. and Mrs. Daniel Saidenberg. 1071.69. Repr. *Tobey*, p. 69.

320 EDGE OF AUGUST. 1953. Casein on composition board, 48 x 28″ (121.9 x 71.1 cm). Purchase. 5.54. Repr. *Masters*, p. 174; in color, *Tobey*, p. 39; in color, *Invitation*, p. 136; *Natural Paradise*, p. 113.

WILD FIELD. 1959. Tempera on cardboard. 27¹/₈ x 28″ (68.9 x 71.1 cm). The Sidney and Harriet Janis Collection (fractional gift). 658.67. Repr. *Janis*, p. 117.

TOMLIN, Bradley Walker. American, 1899–1953.

NUMBER 3. (1948) Oil on canvas, 40 x 50¹/₈″ (101.3 x 127.2 cm). Fractional gift of John E. Hutchins in memory of Frances E. Marder Hutchins. 423.60. Repr. *Suppl. X*, p. 36.

335 NUMBER 20. (1949) Oil on canvas, 7′2″ x 6′8¹/₄″ (218.5 x 203.9 cm). Gift of Philip Johnson. 58.52. Repr. *15 Amer.*, p. 25; *New Amer. Ptg.*, p. 82; in color, *Masters*, p. 180; in color, *Invitation*, p. 137.

335 NUMBER 9: IN PRAISE OF GERTRUDE STEIN. (1950) Oil on canvas, 49″ x 8′6¹/₄″ (124.5 x 259.8 cm). Gift of Mrs. John D. Rockefeller 3rd. 348.55. Repr. *Suppl. VI*, p. 40; in color, *New Amer. Ptg.*, p. 81.

335 NUMBER 3. 1953. Oil on canvas, 46 x 31″ (116.6 x 78.6 cm). Gift of John E. Hutchins in memory of Frances E. Marder Hutchins. 655.59. Repr. *Suppl. IX*, p. 16.

TOOKER, George. American, born 1920.

277 SLEEPERS, II. (1959) Egg tempera on gesso panel, 16¹/₈ x 28″ (40.8 x 71.1 cm). Larry Aldrich Foundation Fund. 370.60. Repr. *Suppl. X*, p. 24.

TORRES-GARCÍA, Joaquín. Uruguayan, 1874–1949. Worked also in Spain, U.S.A., Italy, and France.

COMPOSITION. 1931. Oil on canvas, 36¹/₈ x 24″ (91.7 x 61 cm). Gift of Larry Aldrich. 281.56. Repr. *Suppl. VI*, p. 20.

CONSTRUCTIVE PAINTING [*Pintura constructiva*]. (c. 1931) Oil on

canvas, 29⁵/₈ x 21⁷/₈″ (75.2 x 55.4 cm). The Sidney and Harriet Janis Collection (fractional gift). 659.67. Repr. *Janis*, p. 47.

212 COMPOSITION. 1932. Oil on canvas, 28¹/₄ x 19³/₄″ (71.8 x 50.2 cm). Gift of Dr. Román Fresnedo Siri. 611.42. Repr. *Ptg. & Sc.*, p. 226.

212 PORTRAIT OF WAGNER. 1940. Oil on cardboard, 16¹/₈ x 14⁵/₈″ (40.9 x 37 cm). Gift of Mr. and Mrs. Louis J. Robbins. 127.61. Repr. *Suppl. X*, p. 15. *Note*: the German composer Richard Wagner is the subject.

212 THE PORT. 1942. Oil on cardboard, 31³/₈ x 39⁷/₈″ (79.7 x 101.3 cm). Inter-American Fund. 801.42. Repr. *Latin-Amer. Coll.*, p. 86.

TOULOUSE-LAUTREC, Henri de. French, 1864–1901.

29 LA GOULUE AT THE MOULIN ROUGE. (1891–92) Oil on cardboard, 31¹/₄ x 23¹/₄″ (79.4 x 59 cm). Gift of Mrs. David M. Levy. 161.57. Repr. *Toulouse-Lautrec*, p. 15; *Bulletin*, Fall 1958, p. 48; *Suppl. X*, p. 1; *Levy Collection*, p. 25; in color, *Invitation*, p. 18. *Note*: Louise Weber, nicknamed "La Goulue" ("The Glutton"), won fame during the 1890s as a dancer. She died a pauper in 1929.

TOWN, Harold (Harold Barling Town). Canadian, born 1924.

460 OPTICAL NUMBER 9. 1964. Oil and synthetic polymer paint on canvas, 60 x 60″ (152.5 x 152.5 cm). Gift of J. G. McClelland. 507.65.

TOYOFUKU, Tomonori. Japanese, born 1925. Lives in Milan.

297 ADRIFT, 3. 1960. Wood on iron supports; figure 6′3¹/₄″ (191.2 cm) high; boat 10′ (304.8 cm) long. Philip Johnson Fund. 14.61a–b. Repr. *Suppl. XI*, p. 47; *New Jap. Ptg. & Sc.*, p. 67.

TROVA, Ernest (Ernest Tino Trova). American, born 1927.

314 STUDY. 1960. Oil and mixed mediums on canvas, 20 x 16″ (50.8 x 40.6 cm). Gift of Mr. and Mrs. Morton D. May. 159.62. Repr. *Suppl. XII*, p. 22.

479 STUDY FROM FALLING MAN SERIES. (1964) Chromium figure, lying on miniature automobile chassis, in a plexiglass case, 6⁷/₈ x 15³/₄ x 6¹/₈″ (17.3 x 40 x 15.5 cm); figure and chassis, 3³/₈ x 14 x 5³/₈″ (8.4 x 35.4 x 13.4 cm). Larry Aldrich Foundation Fund. 10.65a–b.

479 STUDY FROM FALLING MAN SERIES. (1964) Sixteen plaster figures, two plaster molds, with plastic devices, string, cloth, compass, etc., in a compartmented wood box, 48 x 32³/₄ x 6³/₄″ (121.8 x 83.1 x 16.9 cm); each figure 12¹/₂″ (31.8 cm) high. John G. Powers Fund. 11.65.

479 STUDY FROM FALLING MAN SERIES: WALKING MAN. (1964) Chromium-plated bronze (cast 1965), 58⁵/₈ x 11³/₈ x 26¹/₂″ (148.7 x 28.7 x 67 cm), on chrome base recessed in marble base 4 to 6″ high x 20¹/₈ x 35¹/₈″ (10.1 to 15.2 x 50.9 x 89.1 cm). Gift of Miss Viki Laura List. 597.66.

TROWBRIDGE, David. American, born 1945.

Untitled. 1974. Powdered pigment on acetate, 23⁷/₈ x 20″ (60.7 x 50.8 cm). Acquired with matching funds from the National Endowment for the Arts and an anonymous donor. 446.74.

Untitled. 1974. Powdered pigment on acetate, 24 x 20″ (61 x 50.8 cm). Acquired with matching funds from the National Endowment for the Arts and an anonymous donor. 447.74.

TRUITT, Anne. American, born 1921.

CATAWBA. (1962) Painted wood, 42¹/₂ x 60 x 11″ (106.6 x 152.4 x 27.9 cm). Given anonymously. 115.73.

TRYGGVADOTTIR, Nina. Icelandic, 1913–1968. To U.S.A. 1942.

340　PAINTING. (1960) Oil on canvasboard, 24 x 17⁷/₈″ (60.8 x 45.3 cm). Larry Aldrich Foundation Fund. 392.61. Repr. *Suppl. XI*, p. 33.

TUCKER, Albert. Australian, born 1914.

271　LUNAR LANDSCAPE. 1957. Synthetic polymer paint on composition board, 37³/₄ x 51¹/₄″ (95.6 x 130.3 cm). Purchase. 94.58. Repr. *Suppl. VIII*, p. 15.

268　EXPLORERS, BURKE AND WILLS. 1960. Oil and sand on canvas, 48¹/₈ x 61¹/₂″ (122.1 x 156.1 cm). Philip Johnson Fund. 124.60. Repr. *Suppl. X*, p. 29.

TUCKER, William. British, born Cairo 1935.

　　Untitled. (1967) Construction of painted polyester resin, in two parts, each 47 x 59³/₈ x 68³/₄″ (119.3 x 150.7 x 175 cm). Charles Henry Coster Fund. 1312.68a–b.

TUNNARD, John. British, born 1900.

142　FUGUE. 1938. Oil and tempera on gessoed composition board, 24 x 34¹/₈″ (61 x 86.7 cm). Acquired through the Lillie P. Bliss Bequest. 19.43. Repr. *Ptg. & Sc.*, p. 121.

TUTTLE, Richard. American, born 1941.

　　CLOTH OCTAGONAL, 2. (1967) Dyed and sewn canvas, 57¹/₈ x 53³/₄″ (145.2 x 136.5 cm). Mrs. Armand P. Bartos Fund. 133.74. Repr. *Amer. Art*, p. 74.

TWARDOWICZ, Stanley. American, born 1917.

339　NUMBER 11. 1955. Enamel and oil on canvas, 6′ x 50″ (182.9 x 127 cm). Purchase. 244.56. Repr. *Suppl. VI*, p. 34.

TWOMBLY, Cy. American, born 1939.

　　THE ITALIANS. 1961. Oil, pencil, and crayon on canvas, 6′1/2″ x 8′6¹/₄″ (199.4 x 259.6 cm). Blanchette Rockefeller Fund. 504.69.

　　Untitled. 1968. Oil and crayon on canvas, 68¹/₈″ x 7′3¹/₈″ (172.8 x 216 cm). Gift of Mr. and Mrs. John R. Jakobson. 5.69. Repr. *Amer. Art*, p. 75.

TWORKOV, Jack. American, born Poland 1900. To U.S.A. 1913.

　　THE WHEEL. 1953. Oil on canvas, 54 x 50″ (137.2 x 127 cm). Gift of the Gramercy Park Foundation, Inc. 31.54. Repr. *Suppl. V*, p. 21.

330　WEST 23RD. 1963. Oil on canvas, 60¹/₈″ x 6′8″ (152.6 x 203.3 cm). Purchase. 274.63.

TYAPUSHKIN, Alexei Alexandrovich. Russian, born 1919.

469　EMOTIONAL SIGN. 1965. Oil and tempera mixed with sawdust on canvas, 51¹/₄ x 39⁵/₈″ (130 x 100.5 cm). Purchase. 2107.67.

UBAC, Raoul. Belgian, born 1911. To Paris 1929.

346　TWO PERSONS AT A TABLE. 1950. Oil on canvas, 51 x 28³/₄″ (129.5 x 73 cm). Purchase. 30.51. Repr. *Suppl. III*, p. 18.

UECKER, Günther. German, born 1930.

504　WHITE FIELD. 1964. Nails projecting from canvas-covered board, painted, 34³/₈ x 34³/₈ x 2³/₄″ (87.2 x 87.2 x 6.8 cm). Matthew T. Mellon Foundation Fund. 1244.64.

UEDA, Sokyu. Japanese, born 1900.

317　NINE COVES AND THREE BENDS IN THE RIVER. (c. 1953) Brush and ink, 26¹/₂ x 50¹/₄″ (67.3 x 127.6 cm). Japanese House Fund. 281.54. Repr. *Suppl. V*, p. 28.

URBAN, Albert. American, born Germany. 1909–1959. To U.S.A. 1940.

　　PAINTING. (1959) Oil on canvas, 68 x 71⁷/₈″ (172.6 x 182.4 cm). Purchase. 653.59. Repr. *16 Amer.*, p. 83.

URQUHART, Tony, Canadian, born 1934.

　　FOREST FLOOR, II, 1961. Oil and ink on paper, 11 x 13⁷/₈″ (27.8 x 35.3 cm). Gift of Emilio del Junco. 393.61. Repr. *Suppl. XI*, p. 53.

　　SUMMER FORMS, I. (1961) Oil and ink on paper, 11⁷/₈ x 17³/₄″ (30 x 45 cm). Gift of Emilio del Junco. 394.61.

URTEAGA, Mario (Mario Urteaga Alvarado). Peruvian, 1875–1957.

214　BURIAL OF AN ILLUSTRIOUS MAN. 1936. Oil on canvas, 23 x 32¹/₂″ (58.4 x 82.5 cm). Inter-American Fund. 806.42. Repr. *Ptg. & Sc.*, p. 179.

UTRILLO, Maurice. French, 1883–1955.

65　THE CHURCH AT BLÉVY. (Previous title: *Provincial Church.*) Oil on canvas, 25¹/₂ x 19¹/₂″ (64.8 x 49.5 cm). Given anonymously. 455.37. Repr. *Ptg. & Sc.*, p. 54.

VAGIS, Polygnotos. American, born Greece. 1894–1965. To U.S.A. 1910.

418　THE SNAKE. 1942. Stone (gneiss), 18 x 27⁵/₈ x 20⁷/₈″ (45.5 x 70 x 53 cm). Gift of the artist in memory of his wife, Sylvia Bender Vagis. 1245.64.

255　REVELATION. (1951) Stone (gneiss), 16¹/₈ x 18″ (41 x 45.7 cm) (irregular). Gift of D. and J. de Menil. 583.56. Repr. *Suppl. VI*, p. 18.

VAIL, Laurence. American, born France. 1891–1968. Lived in France.

477　BOTTLE. (1945) Glass bottle and stopper encrusted with shells, glass, barnacles, coral, and metal, 13³/₄ x 8⁷/₈ x 5⁵/₈″ (34.8 x 22.4 x 14.3 cm). Gift of Peggy Guggenheim. 51.65a–b.

VALADON, Suzanne. French, 1867–1938.

　　PORTRAIT OF MME ZAMARON. 1922. Oil on canvas, 32¹/₈ x 25⁷/₈″ (81.5 x 65.6 cm). Gift of Mr. and Mrs. Maxime L. Hermanos. 581.64.

VALTAT, Louis. French, 1869–1952.

　　THREE DOGS ON A BEACH. (c. 1898) Watercolor and ink, 9⁵/₈ x 12³/₈″ (24.4 x 31.4 cm). Mrs. Cornelius J. Sullivan Fund. 28.53; *Seurat to Matisse*, p. 31.

32　NUDE IN FOREST. (c. 1905) Oil on burlap, 24¹/₈ x 32³/₈″ (61.3 x 82.2 cm). Gift of Mr. and Mrs. Henry F. Fischbach. 291.58. Repr. *Suppl. VIII*, p. 4.

VAN BUREN, Richard. American, born 1937.

　　Untitled. (1969) Clear casting polyester resin, graphite, aluminum, and bronze powder, in 79 parts, overall, 10 x 15′ (304.9 x 456 cm). Larry Aldrich Foundation Fund. 1072.69.

VAN EVEREN, Jay. American, 1875–1947.

　　The following nine works are the gift of Henry M. Reed:

　　Untitled. (c. 1926) Gouache and pencil, 8⁷/₈ x 9″ (22.4 x 22.6 cm). 268.69.

　　Untitled. (c. 1926) Gouache, ink, and pencil, 5³/₈ x 5⁵/₈″ (13.7 x 14 cm). 269.69.

　　Untitled. (c. 1926) Gouache and pencil, 8 x 8″ (20.1 x 20.1 cm). 270.69.

　　Untitled. (c. 1926) Gouache and pencil, 7¹/₂ x 8″ (19 x 20.1 cm). 271.69.

Untitled. (c. 1926) Gouache and pencil, 7⅞ x 7⅞″ (19.9 x 20 cm). 272.69.

Untitled. (c. 1926) Gouache and pencil, 5⅝ x 5½″ (14.1 x 13.8 cm). 273.69.

Untitled. (c. 1926) Gouache and pencil, 5½ x 5½″ (13.9 x 13.8 cm). 274.69.

Untitled. (c. 1926) Gouache on cardboard, 9½ x 12⅛″ (24.1 x 30.6 cm). 275.69.

Untitled. (c. 1926) Gouache on cardboard, 9½ x 12″ (24 x 30.3 cm). 276.69.

VAN GOGH. See van GOGH.

VANTONGERLOO, Georges. Belgian, 1886–1965. To Paris 1927.

138 CONSTRUCTION WITHIN A SPHERE. (1917) Silvered plaster, 7″ (17.8 cm) high, at base 2¾″ (7 cm) diameter. Purchase. 265.37. Repr. *Ptg. & Sc.*, p. 277; *Cubism*, p. 190.

138 CONSTRUCTION OF VOLUME RELATIONS. (1921) Mahogany, 16⅛″ (41 cm) high, at base 4¾ x 4⅛″ (12.1 x 10.3 cm). Gift of Silvia Pizitz. 509.53. Repr. *Suppl. V*, p. 16.

VARAZI, Avtandil Vasilievich. Georgian, U.S.S.R., born 1926.

469 BLEEDING BUFFALO. (1963) Cloth trousers impregnated with glue, then shaped and attached to wood boards; folds highlighted with oil paint, 25⅛ x 14⅞ x 4⅜″ (63.8 x 37.7 x 11.2 cm). Purchase. 2108.67.

VARGAS, Raúl. Chilean, born 1908.

THE DANCER, INÉS PISARRO. 1941. Terra cotta, 11½″ (29.2 cm) high. Inter-American Fund. 220.42. Repr. *Latin-Amer. Coll.*, p. 42.

VARISCO, Grazia. Italian, born 1937.

512 DYNAMIC LATTICE A. (1962) Motor-driven construction with plexiglass, cardboard lattices, and light in a wood box, 20¼ x 20¼ x 5⅞″ (51.4 x 51.4 x 14.7 cm). Gift of the Olivetti Company of Italy. 1246.64.

VASARELY, Victor. French, born Hungary 1908. To Paris 1930.

370 YLLAM. 1949–52. Oil on canvas, 51⅜ x 38¼″ (130.3 x 97.2 cm). Blanchette Rockefeller Fund. 280.58. Repr. *Suppl. VIII*, p. 18.

460 YARKAND, I. 1952–53. Oil on canvas, 39½ x 28¾″ (100.1 x 73 cm). Gift of Mr. and Mrs. Allan D. Emil. 388.66.

370 ONDHO. 1956–60. Oil on canvas, 7′2⅝″ x 71″ (220 x 180.4 cm). Gift of G. David Thompson. 15.61. Repr. *Suppl. X*, p. 49.

CAPELLA 4 B. (1965) Tempera on composition board in two parts; overall, 50⅝ x 32¾″ (128.5 x 83.1 cm). The Sidney and Harriet Janis Collection (fractional gift). 660.67. Repr. *Janis*, p. 143.

498 CTA-104-E. (1965) Synthetic polymer and metallic paint on cardboard, 31⅜ x 31⅜″ (79.6 x 79.6 cm). Given in memory of G. David Thompson by his New York friends. 181.66.

VASILIEV, Yuri V. Russian, born 1925.

352 CONCERN FOR LIFE. 1962. Pastel and watercolor on cardboard, 27¾ x 30⅞″ (70.5 x 78.3 cm). Gift of Yevgeny Yevtushenko. 18.63.

VASIRI, Mohsen. Iranian, born 1924.

449 Untitled. 1962. Sand and synthetic polymer paint on canvas, 39⅜ x 71″ (99.9 x 180.1 cm). Helmuth Bartsch Fund. 52.65.

VEDOVA, Emilio. Italian, born 1919.

COSMIC VISION. (1953) Tempera on plywood, 32⅝ x 21⅞″ (82.8 x 55.5 cm). Blanchette Rockefeller Fund. 282.56. Repr. *Suppl. VI*, p. 30.

350 UNQUIET SPACE. 1957. Tempera and sand on canvas, 53⅛ x 67″ (134.9 x 170 cm). Gift of Mr. and Mrs. Kurt Berger. 281.58. Repr. *Suppl. VIII*, p. 10.

VENET, Bernar. French, born 1941. To U.S.A. 1966.

TIME SPECTRUM OF COINCIDENCES BETWEEN ELECTRONS AND GAMMA RAYS. 1967. Synthetic polymer paint on canvas, 71⅝″ x 6′ (181.9 x 182.6 cm). Gift of Paul Schupf. 1524.68.

VIANI, Alberto. Italian, born 1906.

298 TORSO. (1945) Marble, 38 x 21″ (96.5 x 53.3 cm). Purchase. 352.49. Repr. *20th-C. Italian Art*, pl. 133; *Sc. of 20th C.*, p. 198.

VICENTE, Esteban. American, born Spain 1906. To U.S.A. 1936.

NUMBER FOUR. 1956. Oil on canvas, 52⅜ x 64⅛″ (132.8 x 162.7 cm). Gift of Mrs. Esteban Vicente. 505.69.

382 BLUE, RED, BLACK, AND WHITE. 1961. Collage of painted paper on cardboard, 29⅞ x 40¼″ (75.8 x 102 cm). Larry Aldrich Foundation Fund and anonymous gift. 265.64.

VIEIRA DA SILVA, Marie Hélène. French, born Portugal, 1908. Worked in Rio de Janeiro 1940–47.

345 DANCE. 1938. Oil and wax on canvas, 19½ x 59¼″ (49.5 x 150.5 cm). Alfred Flechtheim Fund. 29.54. Repr. *Suppl. V*, p. 39.

436 THE CITY. (1950–51) Oil on canvas, 38⅜ x 51″ (97.3 x 129.4 cm). Gift of Mrs. Gilbert W. Chapman. 508.65. Repr. *New Decade*, p. 103.

VILLAMIZAR. See RAMÍREZ.

VILLON, Jacques. French, 1875–1963.

GIRL ON BALCONY. (c. 1900) Watercolor, 7⅞ x 5⅛″ (20 x 13 cm). Katherine S. Dreier Bequest. 211.53.

WOMAN WITH UMBRELLA. (c. 1900) Watercolor and pencil, 7⅞ x 4¾″ (20 x 12 cm). Katherine S. Dreier Bequest. 212.53.

103 COLOR PERSPECTIVE. 1922. Oil on canvas, 28¾ x 23⅝″ (73 x 60 cm). Katherine S. Dreier Bequest. 213.53. Repr. *Suppl. IV*, p. 9.

103 DANCE. 1932. Oil on canvas, 15⅛ x 21⅝″ (38.4 x 54.9 cm). Gift of Mrs. Arthur L. Strasser. 576.39.

VINCENT, René. Haitian, born 1911.

COCK FIGHT. 1940. Oil on canvas, 18 x 26″ (45.7 x 66 cm). Inter-American Fund. 150.44.

VIVIN, Louis. French, 1861–1936.

8 THE WEDDING. (c. 1925) Oil on canvas, 18¼ x 21⅝″ (46.3 x 54.9 cm). Gift of Mr. and Mrs. Peter A. Rübel. 512.51. Repr. *Suppl. IV*, p. 47.

THE PANTHEON. (1933) Oil on canvas, 15 x 21¾″ (38.1 x 55.1 cm). The Sidney and Harriet Janis Collection (fractional gift). 661.67. Repr. *Janis*, p. 95.

VLAMINCK, Maurice de. French, 1876–1958.

63 MONT VALÉRIEN. (1903) Oil on canvas, 22 x 30¼″ (55.9 x 76.8 cm). Acquired through the Lillie P. Bliss Bequest. 275.48.

AUTUMN LANDSCAPE. (c. 1905) Oil on canvas, 18¼ x 21¾″ (46.2 x 55.2 cm). Gift of Nate B. and Frances Spingold. 80.58.

63 STILL LIFE. (1913–14) Watercolor and gouache, 15⅝ x 18⅞″ (39.7 x 47.9 cm). Gift of Justin K. Thannhauser. 693.49.

63 WINTER LANDSCAPE. (1916–17) Oil on canvas, 21¼ x 25½″ (54 x 64.8 cm). Gift of Mr. and Mrs. Walter Hochschild. 324.39. Repr. *Ptg. & Sc.*, p. 56.

VOLLMER, Ruth. American, born Germany 1903. To U.S.A. 1935.

Untitled. (1960) Bronze, 10¼ x 9⅞″ (25.8 x 25 cm). Gift of Mr. and Mrs. Leo Rabkin. 276.63.

VUILLARD, Édouard. French, 1868–1940.

30 FAMILY OF THE ARTIST [*L'Heure du dîner*]. (1892) Oil on canvas, 28¼ x 36⅜″ (71.8 x 92.2 cm). Gift of Mr. and Mrs. Sam Salz and an anonymous donor. 101.61. Repr. *Suppl. XI*, p. 11. *Note*: from left to right, the artist's mother, Marie Michaud Vuillard, his grandmother, his sister Marie. Peering through the door in background, the artist.

30 STILL LIFE. (1892) Oil on wood, 9⅜ x 12⅞″ (23.7 x 32.6 cm). Acquired through the Lillie P. Bliss Bequest. 283.56. Repr. *Suppl. VI*, p. 6.

30 MOTHER AND SISTER OF THE ARTIST. (c. 1893) Oil on canvas, 18¼ x 22¼″ (46.3 x 56.5 cm). Gift of Mrs. Saidie A. May. 141.34. Repr. *Ptg. & Sc.*, p. 37; in color, *Masters*, p. 38; *Vuillard*, p. 25; in color, *Invitation*, p. 26. *Note*: the subjects are Marie Michaud Vuillard and Marie Vuillard.

31 THE PARK. (1894) Distemper on canvas, 6′11½″ x 62¾″ (211.8 x 159.8 cm). Fractional gift of The William B. Jaffe and Evelyn A. J. Hall Collection. 600.59. Repr. in color, *Vuillard*, p. 37; *Bulletin*, Fall 1958, p. 52.

MISIA AND THADÉE NATANSON. (c. 1897) Oil on paper mounted on canvas, 36½ x 29¼″ (92.7 x 74.2 cm). Gift of Nate B. and Frances Spingold. 270.57. Repr. in color, *Vuillard*, p. 51; *Bulletin*, Fall, 1958, p. 51.

PORTRAIT OF MISIA. (1914) Distemper and charcoal on cardboard, 17 x 14⅜″ (43.1 x 36.4 cm). Gift of Mr. and Mrs. Eli Wallach. 156.70.

WAGEMAKER, Jaap. Dutch, born 1906.

380 METALLIC GREY. 1960. Assemblage: wood panel relief with aluminum egg slicer and scrap metal, painted, 24 x 19⅝ x 2¾″ (61 x 50 x 6.9 cm). Philip Johnson Fund. 304.61. Repr. *Assemblage*, p. 122.

WALKOWITZ, Abraham. American, born Russia. 1878–1965.

222 NUDE. 1910. Watercolor, 19⅛ x 14″ (48.6 x 35.6 cm). Gift of the artist. 214.53.

222 HUDSON RIVER LANDSCAPE WITH FIGURES. (1912) Watercolor, 21¼ x 29¼″ (54 x 74.3 cm). Gift of Abby Aldrich Rockefeller. 154.35.

WALLACE, John and Fred. Haida Indians, British Columbia, Canada. John Wallace was born about 1860; Fred is his son.

11 TOTEM POLE. (1939) Red cedar, polychrome, 32′ (975 cm) high. Extended loan from the Indian Arts and Crafts Board, U.S. Department of the Interior. E.L.40.5034. Repr. *Ptg. & Sc.*, p. 295; *Indian Art*, p. 176.

WALLIS, Alfred. British, 1855–1942.

10 ST. IVES HARBOR. (Previous title: *Cornish Port*.) (c. 1932–33) Oil on cardboard, 10⅛ x 12⅜″ (25.7 x 31.4 cm). Gift of Ben Nicholson. 1646.40. Repr. *Ptg. & Sc.*, p. 16.

402 ROUGH SEA. Oil and pencil on paper, 8⅜ x 11¼″ (21 x 28.4 cm). Gift of Robert G. Osborne. 519.64.

WALSH, Bernard. American, born 1912.

256 MINER'S SON. (1940) Cast iron, 27½″ (69.8 cm) high, at base 6¼ x 6″ (15.9 x 15.2 cm). Van Gogh Purchase Fund. 372.41. Repr. *Ptg. & Sc.*, p. 262.

WALTERS, Carl. American, 1883–1955.

254 ELLA. (1927) Ceramic sculpture, 16¾″ (42.5 cm) high, at base 9⅜ x 9¾″ (23.8 x 24.8 cm). Purchase. 373.41. Repr. *Art in Our Time*, no. 301.

BABY HIPPO. 1936. Ceramic sculpture, 6 x 19 x 8″ (15.2 x 48.3 x 20.3 cm). Gift of Abby Aldrich Rockefeller. 1.38.

WARHOL, Andy. American, born 1930.

WATER HEATER. (1960) Synthetic polymer paint on canvas, 44¾ x 40″ (113.6 x 101.5 cm). Gift of Roy Lichtenstein. 706.71.

393 GOLD MARILYN MONROE. 1962. Synthetic polymer paint, silkscreened, and oil on canvas, 6′11¼″ x 57″ (211.4 x 144.7 cm). Gift of Philip Johnson. 316.62. Repr. *Suppl. XII*, p. 28.

440 CAMPBELL'S SOUP. (1965) Oil silkscreened on canvas, 36⅛ x 24⅛″ (91.7 x 61 cm). Elizabeth Bliss Parkinson Fund. 110.66.

440 CAMPBELL'S SOUP. (1965) Oil silkscreened on canvas, 36⅛ x 24″ (91.7 x 60.9 cm). Philip Johnson Fund. 111.66.

SELF-PORTRAIT. 1966. Synthetic polymer paint and enamel silkscreened on six canvases, each 22⅝ x 22⅝″ (57.5 x 57.5 cm). The Sidney and Harriet Janis Collection (fractional gift). 662.67.1–.6. Repr. *Janis*, p. 163.

SEVEN DECADES OF JANIS. (1967) Synthetic polymer paint silkscreened on eight joined canvases, each 8⅛ x 8⅛″ (20.6 x 20.5 cm); overall, 16¼ x 32⅜″ (41.1 x 82 cm). The Sidney and Harriet Janis Collection (fractional gift). 2355.67a–h. Repr. *Janis*, p. 164.

SIDNEY JANIS. (1967) Photosensitive gelatin and tinted lacquer on silkscreen on wood frame, 7′11⅛″ x 6′4⅛″ (241.6 x 193.1 cm). The Sidney and Harriet Janis Collection (fractional gift). 2354.67. Repr. *Janis*, p. 105.

WARZECHA, Marian. Polish, born 1930.

NUMBER 50. 1960. Paper collage, 13¾ x 21⅝″ (34.7 x 54.7 cm). Philip Johnson Fund. 274.61. Repr. *15 Polish Ptrs.*, p. 56.

WATKINS, Franklin Chenault. American, 1894–1972.

TRANSCENDENCE. Fourteen designs for the ballet produced by the American Ballet Company, Hartford, Connecticut, 1934. Watercolor, eleven designs for costumes, various sizes, 10¼ x 14½″ to 20½ x 12″ (26 x 36.8 cm to 52 x 30.4 cm); three designs for scenery, 4¼ x 7″; 16 x 24⅞″; 12 x 18⅞″ (10.8 x 17.8; 40.7 x 63.2; 30.5 x 47.9 cm). Acquired through the Lillie P. Bliss Bequest. 38.42.1–.14. Theatre Arts Collection.

BALLET SCHOOL. Four designs for scenery for a projected ballet, 1935. Watercolor, 16½ x 22¾″; 15¼ x 22⅝″; 16⅜ x 22⅝″; 10⅞ x 14⅛″ (40.9 x 57.8 cm; 38.5 x 57.3 cm; 41.4 x 57.3 cm; 27.6 x 35.9 cm). Gift of Lincoln Kirstein. 514.41.1–.4. Theatre Arts Collection.

240 BORIS BLAI. 1938. Oil on canvas, 40 x 35″ (101.6 x 88.9 cm). Gift of A. Conger Goodyear (by exchange). 257.39. Repr. *Ptg. & Sc.*, p. 169.

WEBER, Max. American, born Russia. 1881–1961. To U.S.A. 1891.

TWO BROODING FIGURES. 1911. Oil on cardboard, 12⅛ x 17⅛″ (30.8 x 43.5 cm). Gift of Nelson A. Rockefeller. 19.52. *Note*: study for *The Geranium*, 1911.

218 THE GERANIUM. 1911. Oil on canvas, 39⅞ x 32¼″ (101.3 x 81.9

cm). Acquired through the Lillie P. Bliss Bequest. 18.44. Repr. *Ptg. & Sc.*, p. 69; in color, *Masters*, p. 112.

218 MAINE. 1914. Pastel, 24¹/₂ x 18³/₄″ (62.2 x 47.6 cm). Richard D. Brixey Bequest. 632.43. Repr. *Weber*, no. 31.

218 AIR-LIGHT-SHADOW. 1915. Polychromed plaster, 28⁷/₈ x 12¹/₄″ (73.2 x 31.1 cm). Blanchette Rockefeller Fund. 654.59. Repr. *Suppl. IX*, p. 12.

218 THE TWO MUSICIANS. (1917) Oil on canvas, 40¹/₈ x 30¹/₈″ (101.9 x 76.5 cm). Acquired through the Richard D. Brixey Bequest. 19.44. Repr. *Ptg. & Sc.*, p. 110.

219 INTERIOR WITH FIGURES. 1918. Gouache, 4⁷/₈ x 4¹/₂″ (12.4 x 11.4 cm). Richard D. Brixey Bequest. 116.43.

218 STILL LIFE WITH CHINESE TEAPOT. (1925) Oil on canvas, 20 x 24¹/₈″ (50.8 x 61.3 cm). Gift of Abby Aldrich Rockefeller. 155.35. Repr. *Ptg. & Sc.* (*I*), p. 80.

THE RIVER. (1926) Oil on canvas, 25 x 31″ (63.5 x 78.8 cm). Richard D. Brixey Bequest. 120.43. Repr. *Weber*, no. 83.

The following fourteen small gouaches are the gifts of Abby Aldrich Rockefeller:

STILL LIFE. (1926) Gouache, 5 x 4⁵/₈″ (12.7 x 11.7 cm). 160.35.

219 HEAD. (1928) Gouache, 5 x 4⁵/₈″ (12.7 x 11.7 cm). 157.35.

SEATED NUDE. (1928) Gouache, 5 x 4⁵/₈″ (12.7 x 11.7 cm). 158.35.

WRESTLERS. (1928) Gouache, 5¹/₄ x 4¹/₂″ (13.2 x 11.4 cm) (composition). 162.35.

THE ATHLETE. 1930. Gouache, 5¹/₂ x 4¹/₈″ (14 x 10.5 cm). 220.40.

THE BLUE RIBBON. 1930. Gouache, 5¹/₈ x 3⁵/₈″ (13 x 9.2 cm). 221.40.

THE CHINESE VASE. 1930. Gouache, 4¹/₄ x 5¹/₄″ (10.8 x 13.3 cm). 222.40.

THE FLOWER POT. 1930. Gouache, 4¹/₄ x 6¹/₄″ (10.8 x 15.9 cm). 223.40.

MORNING. 1930. Gouache, 4¹/₄ x 6″ (10.8 x 15.2 cm). 224.40.

THE RABBI. 1930. Gouache, 6 x 4¹/₈″ (15.2 x 10.5 cm). 225.40.

THE SISTERS. 1930. Gouache, 7 x 4¹/₄″ (17.8 x 10.8 cm). 226.40.

SLEEP. 1930. Gouache, 4¹/₄ x 6¹/₂″ (10.8 x 16.5 cm). 227.40.

WONDERMENT. 1930. Gouache, 7 x 4¹/₈″ (17.8 x 10.5 cm). 229.40.

YOUNG WOMAN. 1930. Gouache, 5 x 4⁵/₈″ (12.7 x 11.7 cm). 228.40.

WEINBERG, Elbert. American, born 1928.

302 RITUAL FIGURE. (1953) Beechwood, 60¹/₄″ (153 cm) high, at base 12⁷/₈ x 16⁵/₈″ (32.7 x 42.2 cm). A. Conger Goodyear Fund. 35.55. Repr. *Suppl. V*, p. 30.

WEINER, Lawrence Charles. American, born 1940.

IN RELATION TO AN INCREASE IN QUANTITY REGARDLESS OF QUALITY: HAVING BEEN PLACED UPON A PLANE () UPON A PLANE HAVING BEEN PLACED (). (1973–74) Black letters on white wall, size variable. Given anonymously. 117.75.

WELLS, Luis Alberto. Argentine, born 1939.

504 Model for detail of ceiling relief in the donor's apartment, Buenos Aires. 1966. Enamel on paper over cardboard, 3¹/₄ x 18⁷/₈ x 19¹/₈″ (8.1 x 47.9 x 48.4 cm). Gift of Jorge Romero Brest. 7.67.

WELLS, Lynton. American, born 1940.

AAYH 74. (1974) Synthetic polymer paint and oil on photo-sensitized linen, three panels, each 7'¹/₈″ x 42″ (213.6 x 106.7 cm);

overall, 7'¹/₈″ x 10'6″ (213.6 x 323 cm). Purchased with the aid of funds from the National Endowment for the Arts and an anonymous donor. 380.75a–c.

WERNER, Theodor. German, born 1886.

351 VENICE. 1952. Oil and tempera on canvas, 32 x 39³/₈″ (81.3 x 100 cm). Gift of Mrs. Gertrud A. Mellon. 282.54. Repr. *New Decade*, p. 50.

WESSELMANN, Tom. American, born 1931.

393 THE GREAT AMERICAN NUDE, 2. 1961. Gesso, enamel, oil, and collage on plywood, 59⁵/₈ x 47¹/₂″ (151.5 x 120.5 cm). Larry Aldrich Foundation Fund. 79.63. Repr. *Suppl. XII*, p. 29.

STILL LIFE PAINTING, 30. 1963. Assemblage: oil, enamel, and synthetic polymer paint on composition board with collage of printed advertisements, plastic artificial flowers, refrigerator door, plastic replicas of "7-Up" bottles, glazed and framed color reproduction, and stamped metal, 48¹/₂ x 66 x 4″ (122 x 167.5 x 10 cm). Gift of Philip Johnson. 578.70. Repr. *Amer. Art*, p. 54.

MOUTH, 7. 1966. Oil on shaped canvas, 6'8¹/₄″ x 65″ (206.3 x 165.1 cm). The Sidney and Harriet Janis Collection (fractional gift). 663.67. Repr. *Janis*, p. 157.

SMOKER, 1 (MOUTH, 12). 1967. Oil on canvas, in two parts, overall, 9'⁷/₈″ x 7'1″ (276.6 x 216 cm). Susan Morse Hilles Fund. 226.68.

STILL LIFE, 57. (1969–70) Assemblage: oil and synthetic polymer paint on canvas, in seven sections, overall, 10'3¹/₈″ x 16'2⁷/₈″ x 6' (312.5 x 495 x 182.8 cm). Gift of the artist. 1253.69a–g.

VON WIEGAND, Charmion. American, born 1899.

381 NUMBER 254–1960. 1960. Collage of paper, string, bristles, 20³/₈ x 10³/₄″ (51.6 x 27.2 cm). Given anonymously in place of von Wiegand *Number 180* (585.56). 126.61. Repr. *Suppl. XI*, p. 24.

WILEY, William T. American, born 1937.

PEACOCK GAP. 1970. Watercolor, pen and ink, 29 x 21″ (73.5 x 53.2 cm). Larry Aldrich Foundation Fund. 395.70.

VICTORY GUARDIANS. 1973. Watercolor, felt-tipped pen, pen and ink, and pencil, 22³/₈ x 30″ (56.7 x 76 cm), irregular. Acquired with matching funds from the National Endowment for the Arts and the Joseph G. Mayer Foundation, Inc. 281.73.

WILFRED, Thomas. American, born Denmark. 1889–1968. To U.S.A. 1916.

261 VERTICAL SEQUENCE, OP. 137. 1941. Lumia composition (projected light on translucent screen). Form cycle 7 minutes; color cycle 7 minutes 17 seconds. The two cycles coincide every 50 hours and 59 minutes. Screen, 15¹/₄ x 15³/₈″ (38.7 x 39 cm). Purchase. 166.42.

261 ASPIRATION, OP. 145. 1955. Lumia composition (projected light on translucent screen). Duration of composition 42 hours, 14 minutes, 11 seconds. Screen, 19¹/₄ x.15″ (48.9 x 38.1 cm). Gift of Mr. and Mrs. Julius Stulman. 133.61. Repr. *Suppl. XI*, p. 4.

514 LUMIA SUITE, OP. 158. (1963–64) Lumia composition (projected light on translucent screen). Three movements, lasting 12 minutes, repeated continuously with almost endless variations. Duration of entire composition not calculated. Screen, 6 x 8' (182.8 x 243.2 cm). Commissioned by the Museum through the Mrs. Simon Guggenheim Fund. 582.64.

WILLIAMS, Hiram D. American, born 1917.

284 CHALLENGING MAN. 1958. Oil and enamel on canvas, 8'¹/₄″ x 6'¹/₈″ (244.3 x 183 cm). Fund from the Sumner Foundation for the Arts. 425.60. Repr. *Suppl. X*, p. 28.

WILLIAMS, William Thomas, Jr. American, born 1942.

ELBERT JACKSON L.A.M.F. PART II. (1969) Synthetic polymer paint and metallic paint on canvas, 9'1⁷/₈" x 9'7¹/₄" (279 x 292.6 cm). Gift of Carter Burden, Mr. and Mrs. John R. Jakobson, and Purchase. 1009.69.

WILLIAMSON, Clara McDonald. American, born 1875.

6 THE DAY THE BOSQUE FROZE OVER. 1953. Oil on composition board, 20 x 28" (50.8 x 71.1 cm). Gift of Albert Dorne. 32.54. Repr. *Suppl. V*, p. 33.

WILMARTH, Christopher. American, born 1943.

TARP. (1971) Four curved strips of glass suspended from two wire-and-nail wall configurations, overall, 26¹/₄ x 68¹/₂ x 4¹/₂" (66.5 x 174 x 11.4 cm). Purchase. 423.71a–f.

NORMAL CORNER (YARD). (1972) Steel and etched glass in four parts, overall, 30³/₈ x 60¹/₈ x 30³/₈" (77.2 x 152.5 x 77.2 cm). Given anonymously. 264.72a–d.

WILSON, Jane. American, born 1924.

339 THE OPEN SCENE. 1960. Oil on canvas, 60³/₈" x 6'8" (153.3 x 203.1 cm). Given anonymously. 110.60. Repr. *Suppl. X*, p. 27.

WINSOR, Jacqueline. American, born Canada 1941. To U.S.A. 1952.

BOUND SQUARE. (1972) Wood and twine, 6'3¹/₂" x 6'4" x 14¹/₂" (191.8 x 193 x 36.8 cm). Purchase. 426.74.

WINTER, Fritz. German, born 1905.

351 QUIET SIGN. 1953. Oil on burlap, 45 x 57¹/₂" (114.3 x 146 cm). Gertrud A. Mellon Fund. 161.55. Repr. *New Decade*, p. 55.

WOJCIECHOWSKY, Agatha. American, born Germany 1893. To U.S.A. 1923.

Untitled. 1962. Watercolor, 14³/₄ x 11" (37.3 x 27.7 cm). Larry Aldrich Foundation Fund. 406.63.

Untitled. (1962?) Watercolor, 12 x 10³/₄" (30.3 x 27.1 cm). Larry Aldrich Foundation Fund. 407.63.

WOLS (Otto Alfred Wolfgang Schulze). German, 1913–1951. To France 1932.

344 PAINTING. (1944–45) Oil on canvas, 31⁷/₈ x 32" (81 x 81.1 cm). Gift of D. and J. de Menil. 29.56. Repr. *Suppl. VI*, p. 25.

WOOD, J. Trevor. Rhodesian, born Great Britain 1930.

315 FOURTH-DIMENSIONAL PEBBLE BEACH. (1962) Oil on canvas, 36¹/₄ x 44³/₈" (92 x 112.7 cm). Gift of Mr. and Mrs. Walter Hochschild. 340.63. Repr. *Suppl. XII*, p. 32.

WOTRUBA, Fritz. Austrian, born 1907.

298 HEAD. (1954–55) Bronze, 16³/₄" (42.5 cm) high. Blanchette Rockefeller Fund. 162.57. Repr. *Suppl. VII*, p. 15; *New Images*, p. 148.

WRIGHT. See MACDONALD-WRIGHT.

WYETH, Andrew. American, born 1917.

276 CHRISTINA'S WORLD. (1948) Tempera on gesso panel, 32¹/₄ x 47³/₄" (81.9 x 121.3 cm). Purchase. 16.49. Repr. *Suppl. I*, p. 25; in color, *Invitation*, p. 120. *Note*: Christina Olson, a personal friend and Maine neighbor of the artist, is the subject.

WYNTER, Bryan. British, born 1915.

348 MEETING PLACE. (1957) Oil on canvas, 56 x 44" (142.2 x 111.7 cm). G. David Thompson Fund. 617.59. Repr. *Suppl. IX*, p. 27.

YACOUBI, Ahmed (Ahmed Ben Driss El Yacoubi). Moroccan, born 1928.

450 KING SOLOMON'S RING. 1963. Oil on canvas, 28³/₄ x 23¹/₂" (73 x 59.6 cm). Gift of Mrs. Raymond J. Braun and David Mann. 118.66.

YAGI, Kazuo. Japanese, born 1918.

475 A CLOUD REMEMBERED. (1962) Ceramic, 9 x 8 x 10" (22.9 x 20.3 x 25.4 cm). John G. Powers Fund. 613.65. Repr. *New Jap. Ptg. & Sc.*, p. 45.

YAMAGUCHI, Takeo. Korean, born 1902. Lives in Tokyo.

ENSHIN. (1961) Oil on wood, 71⁷/₈ x 71⁷/₈" (182.6 x 182.6 cm). Gift of Mr. and Mrs. Gianluigi Gabetti. 696.71. Repr. *New Jap. Ptg. & Sc.*, p. 23.

470 TAKU. 1961. Oil on canvas over wood, 35⁷/₈ x 35³/₄" (90.9 x 90.8 cm). Junior Council Fund. 614.65.

YEKTAI, Manoucher. American, born Iran 1921.

339 STILL LIFE D. 1959. Oil on canvas, 48¹/₄ x 68" (122.3 x 172.7 cm). Gift of Mr. and Mrs. Bernard J. Reis. 618.59. Repr. *Suppl. IX*, p. 28.

YOSHIMURA, Masanobu. Japanese, born 1932.

474 TWO COLUMNS. (1964) Construction of plaster on wood and composition board, recessed in wood base, one column in a plexiglass vitrine, 6'2¹/₄" x 36" x 18" (188.4 x 91.4 x 45.6 cm). Purchase. 615.65a–d. Repr. *New Jap. Ptg. & Sc.*, p. 85.

YOUNG, Peter. American, born 1940.

Untitled. (1966) Synthetic polymer paint on canvas, 42¹/₈" x 9'8⁵/₈" (107 x 296.1 cm). Gift of Philip Johnson. 118.75.

NUMBER 7. (1967) Synthetic polymer paint on canvas, 9' x 9' (274.5 x 274.5 cm). Gift of Philip Johnson. 105.76.

YOUNGERMAN, Jack. American, born 1926.

447 BLACK, RED, AND WHITE. 1962. Oil on canvas, 6'3⁵/₈" x 6'11" (191.9 x 210.7 cm). Larry Aldrich Foundation Fund (by exchange). 1134.64.

YUNKERS, Adja. American, born Latvia 1900. In Sweden 1933–47. To U.S.A. 1947.

BLACK CANDLE IN A BLUE ROOM. 1939. Gouache, 18⁷/₈ x 13³/₈" (47.9 x 34 cm). Purchase. 16.40.

341 HOUR OF THE DOG. 1961. Pastel and gouache, 69 x 47⁷/₈" (175.1 x 121.7 cm). Gift of the artist through the Ford Foundation Purchase Program. 102.62. Repr. *Suppl. XII*, p. 20. *Note*: the title refers to a Japanese name for a period in the evening.

"THE PINNED-UP WOMAN" [*"La Femme épinglée"*]. 1972. Collage of synthetic polymer paint on cut-and-pasted paper on cardboard, 40¹/₈ x 30¹/₈" (102 x 76.5 cm). Gift of James T. Wallis. 306.74. *Note*: title from a poem by Octavio Paz.

YVARAL (Jean Pierre Vasarely). French, born 1934.

370 ACCELERATION 19, SERIES B. (1962) Construction of plastic cord, plexiglass, and wood, 23⁷/₈ x 24³/₈ x 3¹/₈" (60.5 x 61.8 x 8 cm). Gift of Philip Johnson. 20.63. Repr. *Responsive Eye*, p. 40.

ZADKINE, Ossip. French, born Russia. 1890–1967. To Paris 1909. In U.S.A. 1940–45.

104 TORSO. (1928) Ebony, 36″ (91.4 cm) high. Gift of Mrs. Maurice J. Speiser in memory of her husband. 17.49. Repr. *Suppl. I*, p. 28.

ZAJAC, Jack. American, born 1929.

304 EASTER GOAT. (1957) Bronze, 19⅛ x 31¾″ (48.5 x 80.6 cm). Udo M. Reinach Estate Fund. 29.59. Repr. *Recent Sc. U.S.A.*

ZALCE, Alfredo. Mexican, born 1908.

PIRULI. 1939. Oil on wood, 15 x 21⅞″ (38.1 x 55.6 cm). Inter-American Fund. 810.42. Repr. *Latin-Amer. Coll.*, p. 76.

ZAMMITT, Norman. American, born Canada 1931. To U.S.A. 1944.

503 Untitled. (1966) Laminated synthetic polymer, 5¾ x 15¼ x 4¼″ (14.6 x 38.5 x 10.6 cm). Larry Aldrich Foundation Fund. 8.67.

ZAÑARTU, Enrique. Chilean, born Paris 1921. Works in Paris.

311 PERSONAGES. 1956. Oil on canvas, 39 x 32″ (99 x 81.3 cm). Inter-American Fund. 198.56. Repr. *Suppl. VI*, p. 32.

ZEHRINGER, Walter. German, born 1940.

504 NUMBER 2, 1964. 1964. Plexiglass with background of painted plastic over composition board, 31⅝ x 31⅝ x 1½″ (80.1 x 80.1 x 3.9 cm). Larry Aldrich Foundation Fund. 115.65.

ZENDEROUDI, Hossein (Zendh-Roudi). Iranian, born 1937. In France since 1961.

319 K + L + 32 + H + 4. 1962. Felt pen and colored ink on paper mounted on composition board, 7′5″ x 58⅝″ (225.9 x 148.7 cm), irregular. Philip Johnson Fund. 317.62. Repr. *Suppl. XII*, p. 31.

ZERBE, Karl. American, born Germany. 1903–1972. To U.S.A. 1934.

241 HARLEM. 1952. Polymer tempera on canvas over composition board, 44½ x 24″ (113 x 61 cm). Gift of Mr. and Mrs. Roy R. Neuberger. 483.53. Repr. *Suppl. V*, p. 17.

ZIEGLER, Laura. American, born 1927.

MAN WITH A PICKAX. (1954) Bronze, 11¾″ (29.9 cm) high. Blanchette Rockefeller Fund. 285.56. Repr. *Suppl. VI*, p. 32.

ZOLOTOW, Harry. American, born Ukraine. 1888–1963. To U.S.A. 1906.

PAINTING. (1946) Oil on canvas, 54¼ x 40″ (137.8 x 101.6 cm). Gift of the artist. 82.47.

ZORACH, William. American, born Lithuania. 1889–1966. To U.S.A. 1891.

254 CHILD WITH CAT. (1926) Tennessee marble, 18″ (45.7 cm) high, at base 6⅝ x 10″ (16.8 x 25.4 cm). Gift of Mr. and Mrs. Sam A. Lewisohn. 15.39. Repr. *Ptg. & Sc.*, p. 256. *Note*: the child is the artist's daughter, Dahlov Ipcar.

FISHERMAN. 1927. Watercolor, 14⅝ x 21¾″ (37.2 x 55.2 cm). Given anonymously. 171.35.

SPRING. 1927. Watercolor, 15⅛ x 22″ (38.4 x 55.9 cm). Given anonymously (by exchange). 173.35.

SETTING HEN. (1941) Cast stone (after original marble of 1935), 14¼″ (36.2 cm) high, at base 11¼ x 11″ (28.5 x 27.9 cm). Abby Aldrich Rockefeller Fund. 497.41.

254 HEAD OF CHRIST. (1940) Stone (peridotite), 14¾″ (37.5 cm) high. Abby Aldrich Rockefeller Fund. 188.42. Repr. *Ptg. & Sc.*, p. 257. *Note*: the artist's father, Aaron Zorach, served as a model for the head. The title was given after the sculpture was finished.

ZOX, Larry. American, born 1936.

PETTYS BRIGHT. (1968) Synthetic polymer paint on canvas, 6′6″ x 11′11¾″ (198.1 x 364.6 cm). Gift of Charles and Anita Blatt. 6.69.

ZVEREV, Anatoly Timofeevich. Russian, born 1931.

289 APPLES. (1955) Gouache, 10½ x 15¼″ (26.7 x 38.7 cm) (irregular). Alfred Flechtheim Fund. 278.56. Repr. *Suppl. VI*, p. 33.

SELF-PORTRAIT IN PLAID SHIRT. (1955) Watercolor, 13½ x 9¾″ (34.3 x 24.8 cm). Purchase. 19.58. Repr. *Suppl. XII*, p. 26.

SELF-PORTRAIT—HEAD. (1955) Watercolor, 10⅞ x 8⅞″ (27.8 x 22.5 cm). Purchase. 20.58. Repr. *Suppl. XII*, p. 26.

SELF-PORTRAIT. 1957. Watercolor, 23⅜ x 16½″ (59.4 x 41.8 cm). Purchase. 18.58. Repr. *Suppl. XII*, p. 26.

MUSEUM PUBLICATIONS CITED IN THE CATALOG

THE CATALOG contains abbreviated references to Museum of Modern Art publications in which works are reproduced. A key to those abbreviations follows, arranged chronologically for the first three editions of *Painting and Sculpture in The Museum of Modern Art* and its supplements, and alphabetically for all other publications. Page references to works illustrated in *Painting and Sculpture in The Museum of Modern Art, 1929–1967*, appear to the left of titles in the Catalog listing.

Ptg. & Sc. (I) Painting and Sculpture in The Museum of Modern Art. Edited by Alfred H. Barr, Jr. 1942.

Ptg. & Sc. (I) Suppl. Painting and Sculpture in The Museum of Modern Art, Supplementary List. 1945.

Ptg. & Sc. Painting and Sculpture in The Museum of Modern Art. Edited by Alfred H. Barr, Jr. 1948.

Suppl. I The Museum of Modern Art Bulletin: vol. 17, nos. 2–3, 1950.

Suppl. II The Museum of Modern Art Bulletin: vol. 18, no. 2, Winter 1950–51.

Suppl. III The Museum of Modern Art Bulletin: vol. 19, no. 3, Spring 1952.

Suppl. IV The Museum of Modern Art Bulletin: vol. 20, nos. 3–4, Summer 1953.

Suppl. V The Museum of Modern Art Bulletin: vol. 23, no. 3, 1956.

Suppl. VI The Museum of Modern Art Bulletin: vol. 24, no. 4, 1957.

Suppl. VII The Museum of Modern Art Bulletin: vol. 25, no. 4, July 1958.

Suppl. VIII The Museum of Modern Art Bulletin: vol. 26, no. 4, July 1959.

Suppl. IX The Museum of Modern Art Bulletin: vol. 27, nos. 3–4, 1960.

Suppl. X The Museum of Modern Art Bulletin: vol. 28, nos. 2–4, 1961.

Suppl. XI The Museum of Modern Art Bulletin: vol. 29, nos. 2–3, 1962.

Suppl. XII The Museum of Modern Art Bulletin: vol. 30, nos. 2–3, 1963.

Abstract Ptg. & Sc. Abstract Painting and Sculpture in America. By Andrew Carnduff Ritchie. 1951.

Amer. Art American Art since 1945 from the Collection of The Museum of Modern Art. By Alicia Legg. 1975.

Amer. 1942 Americans 1942: 18 Artists from 9 States. Edited by Dorothy C. Miller. 1942.

Amer. 1963 Americans 1963. Edited by Dorothy C. Miller. 1963.

Amer. Ptg. & Sc. American Painting and Sculpture: 1862–1932. By Holger Cahill. 1932.

Amer. Realists American Realists and Magic Realists. Edited by Dorothy C. Miller and Alfred H. Barr, Jr. 1943.

Archipenko Archipenko: The Parisian Years. By William S. Lieberman and Katharine Kuh. 1970.

Arp Arp. Edited by James Thrall Soby. 1958.

Art in Our Time Art in Our Time: An Exhibition to Celebrate the Tenth Anniversary of The Museum of Modern Art and the Opening of Its New Building. 1939.

Art in Prog. Art in Progress: A Survey Prepared for the Fifteenth Anniversary of The Museum of Modern Art. 1944.

Art Israel Art Israel: 26 Painters and Sculptors. By William C. Seitz. 1964.

Art Nouveau Art Nouveau: Art and Design at the Turn of the Century. Edited by Peter Selz and Mildred Constantine. 1959. Reissued 1975.

Art of the Real The Art of the Real: U.S.A. 1948–1968. By E. C. Goossen. 1968.

Assemblage The Art of Assemblage. By William C. Seitz. 1961.

Balthus Balthus. By James Thrall Soby. 1956.

Bearden Romare Bearden: The Prevalence of Ritual. By Carroll Greene. 1971.

Beckmann Max Beckmann. By Peter Selz. 1964.

Bliss, 1934 The Lillie P. Bliss Collection. 1934.

Bonnard (1948) Pierre Bonnard. By John Rewald. 1948. Published by The Museum of Modern Art in collaboration with the Cleveland Museum of Art.

Bonnard Bonnard and His Environment. Texts by James Thrall Soby, James Elliott, and Monroe Wheeler. 1964.

Braque Georges Braque. By Henry R. Hope. 1949.

Bulletin The Bulletin of The Museum of Modern Art.

Bulletin, Fall 1958 Two Exhibitions—Works of Art: Given or Promised; The Philip L. Goodwin Collection. The Museum of Modern Art Bulletin: vol. 26, no. 1, Fall 1958.

Burchfield Charles Burchfield: Early Watercolors. 1930.

Calder (2nd) Alexander Calder. By James Johnson Sweeney. 1951. 2nd edition, revised.

Caro Anthony Caro. By William Rubin. 1975.

Chagall Marc Chagall. By James Johnson Sweeney. 1946.

de Chirico Giorgio de Chirico. By James Thrall Soby. 1955.

Contemp. Ptrs. Contemporary Painters. By James Thrall Soby. 1948.

Cubism Cubism and Abstract Art. By Alfred H. Barr, Jr. 1936. Reissued 1974.

Dada, Surrealism Dada, Surrealism, and Their Heritage. By William S. Rubin. 1968.

Dali (2nd) Salvador Dali. By James Thrall Soby. 1946. 2nd edition, revised.

Davis Stuart Davis. By James Johnson Sweeney. 1945.

Demuth Charles Demuth. By Andrew Carnduff Ritchie. 1950.

Dubuffet The Work of Jean Dubuffet. By Peter Selz. 1962.

Duchamp Marcel Duchamp. Edited by Anne d'Harnoncourt and Kynaston McShine. 1973.

Ernst Max Ernst. Edited by William S. Lieberman. 1961.

Fantastic Art (3rd) Fantastic Art, Dada, Surrealism. Edited by Alfred H. Barr, Jr. 1947. 3rd edition.

Fauvism The "Wild Beasts": Fauvism and Its Affinities. By John Elderfield. 1976.

Feininger-Hartley Lyonel Feininger, Marsden Hartley. 1944.

Feininger-Ruin Lyonel Feininger: The Ruin by the Sea. Introduction by Eila Kokkinen, edited by William S. Lieberman. 1968.

15 Amer. 15 Americans. Edited by Dorothy C. Miller. 1952.

15 Polish Ptrs. 15 Polish Painters. By Peter Selz. 1961.

Figure U.S.A. Recent Painting U.S.A.: The Figure. Introduction by Alfred H. Barr, Jr. 1962.

Flannagan The Sculpture of John B. Flannagan. Edited by Dorothy C. Miller. 1942.

Four Amer. in Paris Four Americans in Paris: The Collections of Gertrude Stein and Her Family. 1970.

14 Amer. Fourteen Americans. Edited by Dorothy C. Miller. 1946.

Futurism Futurism. By Joshua C. Taylor. 1961.

German Art of 20th C. German Art of the Twentieth Century. By Werner Haftmann, Alfred Hentzen, and William S. Lieberman; edited by Andrew Carnduff Ritchie. 1957.

Giacometti Alberto Giacometti. By Peter Selz. 1965.

Gonzalez Julio Gonzalez. Introduction by Andrew Carnduff Ritchie. The Museum of Modern Art Bulletin: vol. 23, nos. 1–2, 1955–56.

Gorky Arshile Gorky: Paintings, Drawings, Studies. By William C. Seitz. 1962.

Gris Juan Gris. By James Thrall Soby. 1958.

Hofmann Hans Hofmann. By William C. Seitz. 1963.

Hopper Edward Hopper. By Alfred H. Barr, Jr. 1933.

Hunt The Sculpture of Richard Hunt. By William S. Lieberman and Carolyn Lanchner. 1971.

Impress. (4th) The History of Impressionism. By John Rewald. 1973. 4th edition, revised.

Indian Art (2nd) Indian Art of the United States. By Frederic H. Douglas and René d'Harnoncourt, 1949. 2nd edition.

Information Information. Edited by Kynaston McShine. 1970.

Invitation An Invitation to See 125 Paintings from The Museum of Modern Art. By Helen M. Franc. 1973.

Janis Three Generations of Twentieth-Century Art: The Sidney and Harriet Janis Collection of The Museum of Modern Art. 1972.

Kelly Ellsworth Kelly. By E. C. Goossen. 1973.

Klee, 1930 Paul Klee. By Alfred H. Barr, Jr. 1930.
Klee, 1945 Paul Klee. By Alfred H. Barr, Jr., James Johnson Sweeney, Julia and Lyonel Feininger. 1945. 2nd edition.
de Kooning Willem de Kooning. By Thomas B. Hess. 1968.
Lachaise Gaston Lachaise. By Lincoln Kirstein. 1935.
Last Wks. of Matisse The Last Works of Henri Matisse: Large Cut Gouaches. By Monroe Wheeler. 1961.
Latin-Amer. Coll. The Latin-American Collection of The Museum of Modern Art. By Lincoln Kirstein. 1943.
Léger. Léger. By Katharine Kuh. 1953. Published by the Art Institute of Chicago in collaboration with The Museum of Modern Art and the San Francisco Museum of Art.
Lehmbruck & Maillol Lehmbruck and Maillol. 1930.
Lettering Lettering by Modern Artists. By Mildred Constantine. 1964.
Levy Collection The Mrs. Adele R. Levy Collection: A Memorial Exhibition. Prefaces by Blanchette H. Rockefeller, Alfred M. Frankfurter, and Alfred H. Barr, Jr. 1961.
Lipchitz The Sculpture of Jacques Lipchitz. By Henry R. Hope. 1954.
Living Amer. Painting and Sculpture by Living Americans. Foreword by Alfred H. Barr, Jr. 1930.
The Machine The Machine as Seen at the End of the Mechanical Age. By K. G. Pontus Hultén. 1968.
Magritte René Magritte. By James Thrall Soby. 1965.
Masson André Masson. By William Rubin and Carolyn Lanchner. 1976.
Masters Masters of Modern Art. Edited by Alfred H. Barr, Jr. 1954.
Masters Brit. Ptg. Masters of British Painting: 1800–1950. By Andrew Carnduff Ritchie. 1956.
Masters Pop. Ptg. Masters of Popular Painting: Modern Primitives of Europe and America. Text by Holger Cahill et al. 1938.
Matisse Matisse: His Art and His Public. By Alfred H. Barr, Jr. 1951. Reissued 1974.
Matisse, 64 Paintings Henri Matisse: 64 Paintings. By Lawrence Gowing. 1966.
Matta Matta. By William Rubin. The Museum of Modern Art Bulletin: vol. 25, no. 1, 1957.
Miró Joan Miró. By James Thrall Soby. 1959.
Miró (1973) Miró in the Collection of The Museum of Modern Art. By William Rubin. 1973.
Mod. Art in Your Life Modern Art in Your Life. By Robert Goldwater in collaboration with René d'Harnoncourt. 1953. 2nd edition.
Modern Drwgs. (1st) Modern Drawings. Edited by Monroe Wheeler. 1944. 1st edition.
Modern Masters Modern Masters: Manet to Matisse. Edited by William S. Lieberman. 1975.
Modern Works Modern Works of Art. By Alfred H. Barr, Jr. 1934.
Modigliani (3rd) Modigliani: Paintings, Drawings, Sculpture. By James Thrall Soby. 1963. 3rd edition, revised.
Mondrian Mondrian. By James Johnson Sweeney. 1948.
Monet Claude Monet: Seasons and Moments. By William C. Seitz. 1960.
Moore Henry Moore. By James Johnson Sweeney. 1946.
Motherwell Robert Motherwell. By Frank O'Hara. 1965.
Murphy The Paintings of Gerald Murphy. By William Rubin with the collaboration of Carolyn Lanchner. 1974.
Nadelman The Sculpture of Elie Nadelman. By Lincoln Kirstein. 1948.
Nakian Nakian. By Frank O'Hara. 1966.
Natural Paradise The Natural Paradise: Painting in America 1800–1950. Edited by Kynaston McShine. 1976.
New Amer. Ptg. The New American Painting: As Shown in Eight European Countries, 1958–1959. 1959.
New Decade The New Decade: 22 European Painters and Sculptors. Edited by Andrew Carnduff Ritchie. 1955.
New Horizons New Horizons in American Art. Introduction by Holger Cahill. 1936.
New Images New Images of Man. By Peter Selz. 1959.
New Jap. Ptg. & Sc. The New Japanese Painting and Sculpture. Selected by Dorothy C. Miller and William S. Lieberman. 1966.

New Spanish Ptg. & Sc. New Spanish Painting and Sculpture. By Frank O'Hara. 1960.
Newman Barnett Newman. By Thomas B. Hess. 1971.
Nolde Emil Nolde. By Peter Selz. 1963.
Object Transformed The Object Transformed. By Mildred Constantine and Arthur Drexler. 1966.
Oldenburg Claes Oldenburg. By Barbara Rose. 1970.
Paintings from MoMA Paintings from The Museum of Modern Art, New York. Edited by Alfred H. Barr, Jr. 1963.
Picasso 50 (3rd) Picasso: Fifty Years of His Art. By Alfred H. Barr, Jr. 1955. 3rd edition. Reissued 1974.
Picasso 75th Anniv. Picasso: 75th Anniversary Exhibition. Edited by Alfred H. Barr, Jr. 1957.
Picasso in MoMA Picasso in the Collection of The Museum of Modern Art. By William Rubin. 1972.
La Pintura La Pintura Contemporánea Norteamericana. 1941.
Pollock Jackson Pollock. By Sam Hunter. The Museum of Modern Art Bulletin: vol. 24, no. 2, 1956–57.
Pollock, 1967 Jackson Pollock. By Francis V. O'Connor. 1967.
Post-Impress. (2nd) Post-Impressionism: From van Gogh to Gauguin. By John Rewald. 1962. 2nd edition.
Private Colls. Paintings from Private Collections. The Museum of Modern Art Bulletin: vol. 22, no. 4, Summer 1955.
Ptg. in Paris Painting in Paris. Foreword by Alfred H. Barr, Jr. 1930.
Rauschenberg Robert Rauschenberg. By Lawrence Alloway. 1977. Published by the National Collection of Fine Arts, Washington, D.C., for an exhibition there, at The Museum of Modern Art, and at three other Museums.
Recent Sc. U.S.A. Recent Sculpture U.S.A. By James Thrall Soby. The Museum of Modern Art Bulletin: vol. 26, no. 3, Spring 1959.
Redon Odilon Redon, Gustave Moreau, Rodolphe Bresdin. By John Rewald, Harold Joachim, and Dore Ashton. 1961.
Responsive Eye The Responsive Eye. By William C. Seitz. 1965.
Rivera Diego Rivera. Introduction by Frances Flynn Paine, notes by Jere Abbott. 1931.
Rodin Rodin. By Albert E. Elsen. 1963.
Romantic Ptg. Romantic Painting in America. By James Thrall Soby and Dorothy C. Miller. 1943.
Rosso Medardo Rosso. By Margaret Scolari Barr. 1963.
Rothko Mark Rothko. By Peter Selz. 1961.
Rouault (3rd) Georges Rouault: Paintings and Prints. By James Thrall Soby. 1947. 3rd edition.
Rousseau (2nd) Henri Rousseau. By Daniel Catton Rich. 1946. 2nd edition.
Salute to Calder A Salute to Alexander Calder. By Bernice Rose. 1969.
School of Paris The School of Paris: Paintings from the Florene May Schoenborn and Samuel A. Marx Collection. Preface by Alfred H. Barr, Jr., introduction by James Thrall Soby, notes by Lucy R. Lippard. 1965.
Sc. of Matisse The Sculpture of Matisse. By Alicia Legg. 1972.
Sc. of Picasso The Sculpture of Picasso. By Roland Penrose. 1967.
Sc. of 20th C. Sculpture of the Twentieth Century. By Andrew Carnduff Ritchie. 1952.
Seurat Seurat Paintings and Drawings. Edited by Daniel Catton Rich. 1958. Published by the Art Institute of Chicago for an exhibition at the Art Institute and The Museum of Modern Art.
Seurat to Matisse Seurat to Matisse: Drawing in France. By William S. Lieberman. 1974.
Shahn Ben Shahn. By James Thrall Soby. 1947.
16 Amer. Sixteen Americans. Edited by Dorothy C. Miller. 1959.
Smith David Smith. By Sam Hunter. The Museum of Modern Art Bulletin: vol. 25, no. 2, 1957.
Soby Collection The James Thrall Soby Collection. 1961.
Soutine Soutine. By Monroe Wheeler. 1950.
Stella Frank Stella. By William S. Rubin. 1970.
Stettheimer Florine Stettheimer. By Henry McBride. 1946.
de Stijl de Stijl. By Alfred H. Barr, Jr. The Museum of Modern Art Bulletin: vol. 20, no. 2, Winter 1952–53.

Tanguy Yves Tanguy. By James Thrall Soby. 1955.
Tchelitchew Tchelitchew: Paintings and Drawings. By James Thrall Soby. 1942.
Tobey Mark Tobey. By William C. Seitz. 1962.
Toulouse-Lautrec Toulouse-Lautrec. 1956.
12 Amer. 12 Americans. Edited by Dorothy C. Miller. 1956.
20th-C. Art from NAR Coll. Twentieth-Century Art from the Nelson Aldrich Rockefeller Collection. Essay by William S. Lieberman. 1969.

20th-C. Italian Art Twentieth-Century Italian Art. By James Thrall Soby and Alfred H. Barr, Jr. 1949.
20th-C. Portraits 20th Century Portraits. By Monroe Wheeler. 1942.
Vuillard Edouard Vuillard. By Andrew Carnduff Ritchie. 1954.
Weber Max Weber. 1930.
What Is Mod. Ptg. (9th) What Is Modern Painting? By Alfred H. Barr, Jr. 1966. 9th edition, revised. Reissued 1976. -
What Is Mod. Sc. What Is Modern Sculpture? By Robert Goldwater. 1969.

DONORS

Charles Abrams
Mrs. George Acheson
Mr. and Mrs. A. M. Adler
Theodor Ahrenberg
Mrs. Joseph James Akston
Larry Aldrich
Mr. and Mrs. E. Brooke Alexander
Mr. and Mrs. Arthur G. Altschul
Mrs. Frank Altschul
Mr. and Mrs. L. M. Angeleski
Frances Archipenko
Emil J. Arnold
Mme Jean Arp
Leigh Athearn
Mr. and Mrs. Douglas Auchincloss
Mr. and Mrs. Lee A. Ault
Mr. and Mrs. Leslie Ault
Mr. and Mrs. Lester Avnet
Dr. Frederick Baekeland
Harold W. Bangert
Mr. and Mrs. Walter Bareiss
James W. Barney
Alfred H. Barr, Jr.
Mrs. George E. Barstow
Frederic Clay Bartlett
Mr. and Mrs. Armand P. Bartos
Y. K. Bedas
Larry Bell
Albert M. Bender
Warren D. Benedek
Mrs. Robert Benjamin
W. B. Bennet
LeRay W. Berdeau
Carl Magnus Berger
Mr. and Mrs. Kurt Berger
Samuel A. Berger
Mr. and Mrs. Edwin A. Bergman
Eugene Berman
Mr. and Mrs. Herbert C. Bernard
Mrs. Marya Bernard
Ernst Beyeler
Alexander M. Bing
Charles and Anita Blatt
Mrs. Maurice Blin
The Honorable and Mrs. Robert Woods Bliss
Richard Blow
Henriette Bonnotte
Mr. and Mrs. Stephen B. Booke
Mrs. Harry Lynde Bradley
Mr. and Mrs. Warren Brandt
Mr. and Mrs. Raymond J. Braun
Francis E. Brennan
Mrs. Abner Brenner
Jorge Romero Brest
Mrs. Walter D. S. Brooks
Briggs W. Buchanan
Arthur M. Bullowa
Mr. and Mrs. Gordon Bunshaft
Carter Burden
Mr. and Mrs. William A. M. Burden
James Lee Byars
J. Frederic Byers III
Alexander Calder
Juan M. and Roderick W. Cameron
Mr. and Mrs. Joseph Cantor
Louis Carré
Carroll Carstairs
Mr. and Mrs. Victor M. Carter

Constance B. Cartwright
Dr. H. B. G. Casimir
Mrs. Gilbert W. Chapman
Mr. and Mrs. Michael Chapman
Christo (Javacheff)
Walter P. Chrysler, Jr.
Stephen C. Clark
Mr. and Mrs. Eliot C. Clarke
Mr. and Mrs. Erich Cohn
Richard A. Cohn
Mr. and Mrs. Sidney Elliott Cohn
Mr. and Mrs. Ralph F. Colin
Mr. and Mrs. Edouard Cournand
Mme Sibylle Cournand
Charles Cowles
Mrs. W. Murray Crane
Frank Crowninshield
Mrs. John de Cuevas
Mrs. Charles Suydam Cutting
Mr. and Mrs. Cuthbert Daniel
Mme Ève Daniel
Bernard Davis
Richard Davis
Albert Dorne
Mr. and Mrs. Samuel Dorsky
Mr. and Mrs. Robert W. Dowling
Donald Droll
Jean Dubuffet
Marcel Duchamp
Douglas M. Duncan
H. S. Ede
Arne Ekstrom
Craig Ellwood
Mr. and Mrs. Allan D. Emil
Judge and Mrs. Henry Epstein
Lady Kathleen Epstein
Ruth M. Epstein
R. H. Donnelley Erdman
Jimmy Ernst
Max Ernst
Armand G. Erpf
Dr. Andres J. Escoruela
Eric Estorick
Mr. and Mrs. Solomon Ethe
Mrs. Marjorie Falk
Richard L. Feigen
Julia Feininger
Mrs. Marie L. Feldhaeusser
Miss Louise Ferrari
Marshall Field
Mr. and Mrs. E. C. Kip Finch
Mr. and Mrs. Henry F. Fischbach
Mr. and Mrs. Herbert Fischbach
Mr. and Mrs. Sol Fishko
Myrtil Frank
Helen Frankenthaler
Mr. and Mrs. Clarence C. Franklin
Ruth Stephan Franklin
Mr. and Mrs. Arthur S. Freeman
Dr. Román Fresnedo Siri
Miss Rose Fried
Mr. and Mrs. Gianluigi Gabetti
Naum Gabo
Edward Joseph Gallagher 3rd Memorial Collection
A. E. Gallatin
Mr. and Mrs. Theodore S. Gary
Mr. and Mrs. Monroe Geller
Estate of George Gershwin

Mrs. Bernard F. Gimbel
Hyman N. Glickstein
Dr. Alfred Gold
Mr. and Mrs. C. Gerald Goldsmith
Mr. and Mrs. Herbert A. Goldstone
Mme Natalie Gontcharova
Philip L. Goodwin
A. Conger Goodyear
Mary A. Gordon
Adolph Gottlieb
Mr. and Mrs. Jan de Graaff
Katharine Graham
Mme Katia Granoff
Dr. and Mrs. Alex J. Gray
Wilder Green
Dr. Jack M. Greenbaum
Balcomb Greene
Peggy Guggenheim
Mrs. Simon Guggenheim
Mr. and Mrs. Nathan L. Halpern
Edith Gregor Halpert
Nancy Hanks
August Hanniball, Jr.
Ruth Gilliland Hardman
Mrs. Meredith Hare
Wallace K. Harrison
Mr. and Mrs. Ira Haupt
Mr. and Mrs. Joseph H. Hazen
Mr. and Mrs. Ben Heller
Mr. and Mrs. Gustav P. Heller
Joseph Helman
Mr. and Mrs. Maxime L. Hermanos
Mr. and Mrs. Irwin Hersey
Mr. and Mrs. Thomas B. Hess
Susan Morse Hilles
Mr. and Mrs. Alex L. Hillman
Hans Hinterreiter
Norman Hirschl
Dr. and Mrs. F. H. Hirschland
Joseph H. Hirshhorn
Mr. and Mrs. Walter Hochschild
Hans Hofmann
Vladimir Horowitz
John E. Hutchins
Alexandre Iolas
Mrs. O'Donnell Iselin
Mrs. Martha Jackson
Mr. and Mrs. William B. Jaffe
Mr. and Mrs. George M. Jaffin
Mr. and Mrs. John R. Jakobson
Edward James
Sidney Janis
Sidney and Harriet Janis
Philip Johnson
Mrs. H. Harris Jonas
Mr. and Mrs. E. Powis Jones
T. Catesby Jones
Mr. and Mrs. Samuel Josefowitz
Mr. and Mrs. Werner E. Josten
Emilio del Junco
Mr. and Mrs. Gilbert W. Kahn
Margery and Harry Kahn
Constance Kane
Mrs. Francis Douglas Kane
Mrs. Jacob M. Kaplan
Donald H. Karshan
Mr. and Mrs. Hugo Kastor
Edgar Kaufmann, Jr.

Mrs. Edgar J. Kaufmann
Mr. and Mrs. Harold Kaye
Mrs. Alexander Keiller
Ellsworth Kelly
Lincoln Kirstein
William Kistler III
S. Herman Klarsfeld
Mr. and Mrs. David Kluger
Mrs. Alfred A. Knopf
Miss Belle Kogan
Joseph H. Konigsberg
Mr. and Mrs. Edward F. Kook
Mr. and Mrs. Samuel M. Kootz
Dr. and Mrs. Leonard Kornblee
Harold Kovner
Mrs. Katharine Kuh
Dr. Kuo Yu-Shou
Mr. and Mrs. František Kupka
Michael Larionov
Mr. and Mrs. H. Irgens Larsen
Mr. and Mrs. Albert D. Lasker
Mr. and Mrs. Ronald S. Lauder
Lee Ung-No
Lucien Lefebvre-Foinet
Dr. and Mrs. Arthur Lejwa
Dr. Rosemary Lenel
Robert Lepper
Mr. and Mrs. Fernand Leval
Mrs. Fernand Leval and children
Mrs. David M. Levy
Mr. and Mrs. Albert Lewin
Mr. and Mrs. Sam A. Lewisohn
Roy Lichtenstein
Mr. and Mrs. Harry G. Liese
Colonel and Mrs. Charles A. Lindbergh
Mr. and Mrs. Leo Lionni
Jacques Lipchitz
Jean and Howard Lipman
Mr. and Mrs. Maurice A. Lipschultz
Seymour Lipton
Mr. and Mrs. Albert A. List
Miss Viki Laura List
George B. Locke
Pierre M. Loeb
Elizabeth Lorentz
Henry Luce III
Henry R. Luce
Earle Ludgin
J. G. McClelland
Thomas McCray
Mr. and Mrs. Archibald MacLeish
Mrs. Annie McMurray
Paul Magriel
Aristide Maillol
David Mann
Mr. and Mrs. Arnold H. Maremont
Marino Marini
Mrs. Reginald Marsh
Sra. Carlos Martins
Mr. and Mrs. Samuel A. Marx
André Masson
Mr. and Mrs. Edward J. Mathews
Mrs. Pierre Matisse
Mr. and Mrs. Pierre Matisse
Mr. and Mrs. Morton D. May
Mrs. Saidie A. May
Mr. and Mrs. William Mazer
Joan H. Meijer

Dr. Abraham Melamed
Mrs. Gertrud A. Mellon
Paul Mellon
The Honorable Turgut Menemencioğlu
D. and J. de Menil
Mrs. Knud Merrild
Charles E. Merrill
André Meyer
Eugene Meyer III
Mr. and Mrs. Ben Mildwoff
Mr. and Mrs. N. Richard Miller
Maximilian H. Miltzlaff
Joan Miró
Mr. and Mrs. Jan Mitchell
Mrs. Sibyl Moholy-Nagy
George L. K. Morris
Mr. and Mrs. Irving Moskovitz
Robert Motherwell
Mr. and Mrs. Gerald Murphy
Mrs. Ray Slater Murphy
Mrs. Elie Nadelman
Reuben Nakian
Dr. and Mrs. Ronald Neschis
Mr. and Mrs. Roy R. Neuberger
J. B. Neumann
Morton G. Neumann
Louise Nevelson
Albert Newall
John S. Newberry
S. I. Newhouse, Jr.
Ben Nicholson
Isamu Noguchi
Claes Oldenburg
Erik Ortvad
Robert G. Osborne
Maria del Carmen Ossaye
Mrs. Roberto Ossaye
Alfonso A. Ossorio
Mr. and Mrs. F. Taylor Ostrander
William S. Paley
Stamo Papadaki
Mrs. Bliss Parkinson
Carl-Henning Pedersen
Mr. and Mrs. Donald H. Peters
Antoine Pevsner
Mr. and Mrs. Walter Nelson Pharr
Duncan Phillips
Mr. and Mrs. Gifford Phillips
Pablo Picasso
Silvia Pizitz
Henry H. Ploch
George Poindexter
Mr. and Mrs. Jack I. Poses
Stuart Preston
Mr. and Mrs. Joseph Pulitzer, Jr.
Mr. and Mrs. Leo Rabkin
Theodore R. Racoosin
Dr. C. M. Ramírez Corría
Waldo Rasmussen
Mrs. G. P. Raymond
Mr. and Mrs. Henry M. Reed
Udo M. Reinach Estate
Ad Reinhardt
Mrs. Ad Reinhardt
Mr. and Mrs. Bernard J. Reis
Mr. and Mrs. Stanley Resor
Mr. and Mrs. John Rewald
Miss Jeanne Reynal

Victor S. Riesenfeld
Mr. and Mrs. M. Riklis
Sra. Giovanola Ripandelli
Mr. and Mrs. Louis J. Robbins
Abby Aldrich Rockefeller
Mr. and Mrs. David Rockefeller
Mrs. John D. Rockefeller 3rd
Nelson A. Rockefeller
Alexander Rodchenko
Mr. and Mrs. Richard Rodgers
Allan Roos, M.D., and B. Mathieu Roos
Edward W. Root
Barbara Rose
Dr. and Mrs. Samuel Rosen
Mr. and Mrs. Alexandre P. Rosenberg
Mr. and Mrs. Paul Rosenberg
Samuel I. Rosenman
Mark Rothko
Herbert and Nannette Rothschild
Mr. and Mrs. Peter A. Rübel
William S. Rubin
Mme Helena Rubinstein
Anthony Russo
Mr. and Mrs. A. M. Sachs
Mr. and Mrs. Daniel Saidenberg
Mr. and Mrs. Sam Salz
Mr. and Mrs. Ansley W. Sawyer
Mr. and Mrs. Norbert Schimmel
Dr. and Mrs. Daniel E. Schneider
Miss Antoinette Schulte
Mrs. Heinz Schultz
Paul Schupf
Alfred Schwabacher
Mr. and Mrs. Wolfgang S. Schwabacher
Mr. and Mrs. Eugene M. Schwartz
Mrs. Wallace M. Scudder
Mr. and Mrs. Robert C. Scull
Nelson A. Sears
William C. Seitz
Mr. and Mrs. Georges E. Seligmann
Mr. and Mrs. Richard L. Selle
John L. Senior, Jr.
Ben Shahn
Mrs. Alfred P. Shaw
Charles Sheeler
Mrs. Saul S. Sherman
Mr. and Mrs. Herman D. Shickman
Daphne Hellman Shih
Mario da Silva
Mrs. Rita Silver
Pat and Charles Simon
Mrs. Leo Simon
Mrs. Kenneth Simpson
Mrs. William Sisler
Mr. and Mrs. Leif Sjöberg
Henry Slesar
Mr. and Mrs. Joseph Slifka
Mrs. Bertram Smith
The family of Janet Sobel
James Thrall Soby
Mr. and Mrs. David M. Solinger
Mrs. Maurice J. Speiser
Miss Darthea Speyer
Nate B. and Frances Spingold
Miss Renée Spodheim
Mrs. Charles G. Stachelberg
Mrs. Emily Staempfli
Theodoros Stamos

Erwin Burghard Steiner
Miss Ettie Stettheimer
Leopold Stokowski
Allan Stone
Mrs. Maurice L. Stone
J. van Straaten
Mrs. Arthur L. Strasser
Mr. and Mrs. David Stulberg
Mr. and Mrs. Julius Stulman
Suzy Prudden Sussman
Kay Sage Tanguy
Pavel Tchelitchew
Mr. and Mrs. Justin K. Thannhauser
Mr. and Mrs. Eugene Victor Thaw
G. David Thompson
Mr. and Mrs. Murray Thompson
Jean Tinguely
Mark Tobey
Harry Torczyner
Jock Truman
Mr. and Mrs. William Unger
Polygnotos Vagis
Curt Valentin
Dr. W. R. Valentiner
Carl van der Voort
J. C. Van Rijn
Fania Marinoff Van Vechten
Mrs. Esteban Vicente
N. E. Waldman
Abraham Walkowitz
Mr. and Mrs. Eli Wallach
James T. Wallis
Miss May E. Walter
Mr. and Mrs. Edward M. M. Warburg
Mrs. Felix M. Warburg
Andy Warhol
Edna and Keith Warner
John W. Weber
Mr. and Mrs. Richard K. Weil
Mrs. Milton Weill
Mr. and Mrs. Harold X. Weinstein
Mr. and Mrs. William H. Weintraub
Mr. and Mrs. Donald Weisberger
Mr. and Mrs. Frederick R. Weisman
Mrs. Lloyd Bruce Wescott
Claire and Tom Wesselmann
Monroe Wheeler
David Whitney
Mr. and Mrs. John Hay Whitney
Mr. and Mrs. Arthur Wiesenberger
Nicholas Wilder
R. Thornton Wilson
Mr. and Mrs. Harry Lewis Winston
Lydia and Harry L. Winston Art Collection
Dr. Nathaniel S. Wolff
Mr. and Mrs. Bagley Wright
Yevgeny Yevtushenko
Mr. and Mrs. Samuel J. Zacks
Mr. and Mrs. Charles Zadok
Dr. Gregory Zilboorg
Harry Zolotow

Anonymous gift in memory of Milton Avery
Anonymous gift in memory of Holger Cahill
Anonymous gift in memory of Robert Carson
Anonymous gift in memory of Gaston Lachaise
Anonymous gift in memory of Carol Buttenwieser Loeb
Anonymous gift in memory of Jules Pascin
Anonymous gift in memory of G. David Thompson

Anonymous gift in memory of Curt Valentin
Anonymous gift in memory of Dr. Hermann Vollmer

James S. and Marvelle W. Adams Foundation
Advisory Committee of The Museum of Modern Art
American Abstract Artists
American Academy and National Institute of Arts and Letters Fund
American Art Foundation
American Iron and Steel Institute
The American Tobacco Company, Inc.
Lily Auchincloss Foundation, Inc.
B. G. Cantor Art Foundation
The Cantor, Fitzgerald Collection
Comisión Cubana de Cooperación Intelectual, Havana
Contemporary Art Society, London
Cordier & Ekstrom, Inc.
Estudio Actual
Fischbach Gallery
Ford Foundation Purchase Program
The Four Seasons
Fratelli Fabbri Editori
French Art Galleries, Inc.
Glickstein Foundation
James Graham and Sons
Gramercy Park Foundation, Inc.
Griffis Foundation
Kasmin, Ltd.
M. Knoedler & Company, Inc.
Mr. and Mrs. Stanley Marcus Foundation
Marlborough-Gerson Gallery, Inc.
Pierre Matisse Gallery
Joseph G. Mayer Foundation, Inc.
Tibor de Nagy Gallery
National Endowment for the Arts
Samuel I. Newhouse Foundation, Inc.
New York World's Fair, 1939
Olivetti Company of Italy
Organizing Committee of Homage, "Walk with Antonio Machado"
Passedoit Gallery
Henry Pearlman Foundation
PepsiCo, Inc.
The Perls Galleries
Beatrice Perry, Inc.
Radio City Music Hall Corporation
Galerie Denise René
Adelaide Ross Foundation
Galleria Schwarz
Staempfli Gallery
Jerome L. and Jane Stern Foundation
M. E. Thelen Gallery
Time Inc.
Women's Committee of the Art Gallery of Toronto

BEQUESTS

Barbara S. Adler
Alexander M. Bing
Lillie P. Bliss
Richard D. Brixey
Eve Clendenin
Mary Anderson Conroy
Katherine S. Dreier
Mary Flexner
Rose Gershwin
Philip L. Goodwin
Harriet H. Jonas
Loula D. Lasker
Anna Erickson Levene
Mrs. David M. Levy

Sam A. Lewisohn
Mrs. Sam A. Lewisohn
John S. Newberry
Abby Aldrich Rockefeller
Grace Rainey Rogers
Lee Simonson
Kay Sage Tanguy
Curt Valentin

PURCHASE FUNDS

Joachim Jean Aberbach Fund
Mr. and Mrs. Joachim Jean Aberbach Fund
Louis and Bessie Adler Foundation Fund
Advisory Committee Fund
Larry Aldrich Foundation Fund
Hedwig van Ameringen Foundation Fund
Mr. and Mrs. Simon Askin Fund
Mr. and Mrs. Walter Bareiss Fund
Mrs. Armand P. Bartos Fund
Helmuth Bartsch Fund
Alexander M. Bing Fund
Charles and Anita Blatt Fund
Funds realized through the Lillie P. Bliss Bequest
Brazil Fund
Francis E. Brennan Fund
Funds realized through the Richard D. Brixey Bequest
Bertram F. and Susie Brummer Foundation Fund
Mr. and Mrs. Gordon Bunshaft Fund
William A. M. Burden Fund
Mrs. Wendell T. Bush Fund
Katharine Cornell Fund
Charles Henry Coster Fund
Mrs. W. Murray Crane Fund
Frank Crowninshield Fund
Mrs. Ruth Dunbar Cushing Fund
Bernard Davis Fund
Katherine S. Dreier Fund
Mr. and Mrs. Samuel C. Dretzin Fund
Mrs. John C. Duncan Fund
Joseph M. and Dorothy B. Edinburg Charitable Trust Fund
Mr. and Mrs. Allan D. Emil Fund
Dr. and Mrs. Joseph A. Epstein Fund
Armand G. Erpf Fund
Alfred Flechtheim Fund
Funds realized through the Mary Flexner Bequest
Rose Gershwin Fund
The Gilman Foundation Fund
Alva Gimbel Fund
Mrs. Bernard F. Gimbel Fund
Samuel Girard Fund
van Gogh Purchase Fund
Fund given in memory of Philip L. Goodwin
A. Conger Goodyear Fund
Katia Granoff Fund
Mrs. Simon Guggenheim Fund
Mr. and Mrs. Joseph H. Hazen Fund
Mrs. Charles V. Hickox Fund
Susan Morse Hilles Fund
Mr. and Mrs. Alex. L. Hillman Fund
Hillman Periodicals Fund
Vladimir Horowitz Fund
Inter-American Fund
Mr. and Mrs. William B. Jaffe Fund
Mr. and Mrs. John R. Jakobson Fund
Edward James Fund
Japanese House Fund
Philip Johnson Fund
W. Alton Jones Foundation Fund

Mr. and Mrs. Werner E. Josten Fund
Junior Council Fund
Edgar Kaufmann, Jr., Fund
Frances Keech Fund
Mr. and Mrs. A. Atwater Kent, Jr., Fund
Loula D. Lasker Fund
Adele R. Levy Fund
Mr. and Mrs. Albert Lewin Fund
Mrs. Sam A. Lewisohn Fund
Fund given by friends of Jacques Lipchitz
Miss Janice Loeb Fund
Robert O. Lord Fund
Aristide Maillol Fund
Saidie A. May Fund
Grace M. Mayer Fund
Joseph G. Mayer Foundation Fund
Gertrud A. Mellon Fund
Matthew T. Mellon Foundation Fund
D. and J. de Menil Fund
Mr. and Mrs. Gerald Murphy Fund
Mr. and Mrs. Roy R. Neuberger Fund
John S. Newberry Fund
William P. Jones O'Connor Fund
Elizabeth Bliss Parkinson Fund
Mr. and Mrs. Milton J. Petrie Fund
John G. Powers Fund
Adriane Reggie Fund
Udo M. Reinach Estate Fund
Abby Aldrich Rockefeller Fund
Blanchette Rockefeller Fund
David Rockefeller Latin-American Fund
Mr. and Mrs. David Rockefeller Fund
Grace Rainey Rogers Fund
Mr. and Mrs. Francis F. Rosenbaum Fund
Robert Rosenblum Fund
Helena Rubinstein Fund
Harry J. Rudick Fund
Mrs. Charles H. Russell Fund
Mrs. John Barry Ryan Fund
Sir Michael Sadler Fund
Mr. and Mrs. Sam Salz Fund
Benjamin Scharps and David Scharps Fund
Mr. and Mrs. Norbert Schimmel Fund
Mrs. George Hamlin Shaw Fund
Daphne Hellman Shih Fund
Charles Simon Fund
Dorothy and Sidney Singer Foundation Fund
Mr. and Mrs. Joseph Slifka Fund
Mrs. Bertram Smith Fund
James Thrall Soby Fund
Mr. and Mrs. David M. Solinger Fund
Mr. and Mrs. Stuart M. Speiser Fund
Dr. and Mrs. Frank Stanton Fund
Mr. and Mrs. Donald B. Straus Fund
Benjamin Sturges Fund
Mrs. Cornelius J. Sullivan Fund
Sumner Foundation for the Arts
Kay Sage Tanguy Fund
G. David Thompson Fund
Treadwell Corporation Fund
William H. Weintraub Fund
Mr. and Mrs. William H. Weintraub Fund
Wildenstein Foundation Fund
Richard S. Zeisler Fund

LENDERS OF WORKS OF ART FOR AN EXTENDED PERIOD

Mr. and Mrs. Walter Bareiss
Mr. and Mrs. William A. M. Burden

Mr. and Mrs. William N. Copley
Mrs. Jefferson Dickson
Mr. and Mrs. David Kluger
Royal S. Marks
Mrs. John D. Rockefeller 3rd
Mr. and Mrs. Frank S. Wyle

United States Department of the Interior, Indian Arts and Crafts Board
United States Public Works of Art Project
United States WPA Art Program (Works Progress Administration, Federal Art Project)

GIFTS, THE DONORS RETAINING LIFE INTEREST

THE WORKS LISTED below have been given to the Museum with the proviso that the donors (or, in some cases, other individuals designated by the donors) retain possession of them during their lifetimes. All works have been assigned by deed of gift.

Biographical information is given only for artists not listed elsewhere in the Catalog. In other respects the entries conform to those in the Catalog.

ARP, Jean.
PTOLEMY. 1953. Limestone, 42″ (106.7 cm) high, on black marble base, 35 x 12 x 12″ (88.8 x 30.5 x 30.5 cm). William A. M. Burden. 494.64.

BRANCUSI, Constantin.
YOUNG BIRD. 1928. Bronze, 16″ (40.5 cm) high, on two-part pedestal of stone and wood (carved by the artist), overall 35³/₄″ (90.7 cm) high. William A. M. Burden. 498.64. *Geist* 172. *Note:* other titles: *L'Oiselet* and *Little Bird*.

BIRD IN SPACE. (1941?) Bronze, 6′ (182.9 cm) high, on three-part stone pedestal, overall 59¹/₈″ (150.2 cm) high. William A. M. Burden. 497.64. *Geist* 197. *Note:* fifteenth of sixteen variations from 1923 to 1941 and depending on *Geist* 185, 1933.

BUCHHOLZ, Erich.
WITH TWO YELLOW CIRCLES [*Mit zwei gelben Kreisem*]. 1954. Plaster relief, 25¹/₂ x 18³/₄″ (64.7 x 47.7 cm). Mr. and Mrs. William Feinberg. 563.64.

BURLIUK, David. American, born Ukraine. 1882–1967.
Untitled. 1908. Oil on burlap, 23 x 25″ (58.3 x 63.5 cm). Mr. and Mrs. William Feinberg. 564.64.

CÉZANNE, Paul.
L'ESTAQUE. (1879–83) Oil on canvas, 31¹/₂ x 39″ (80.3 x 99.4 cm). William S. Paley. 716.59. *Venturi* 492.

BOY IN A RED WAISTCOAT. (1893–95) Oil on canvas, 32 x 25⁵/₈″ (81.2 x 65 cm). David Rockefeller. 190.55. *Venturi* 680.

MONT SAINTE-VICTOIRE. (1902–06) Watercolor, 16³/₄ x 21³/₈″ (42.5 x 54.2 cm). David Rockefeller. 114.62.

GAUGUIN, Paul.
PORTRAIT OF MEYER DE HAAN. 1889. Oil on wood, 31³/₈ x 20³/₈″ (79.6 x 51.7 cm). David Rockefeller. 2.58.

GIACOMETTI, Alberto.
LARGE HEAD [*Grande tête*]. 1960. Bronze, 38″ (96.5 cm) high. David M. Solinger. 568.64.

KLEE, Paul.
MAN WITH TOP HAT [*Herr mit Cylinder*]. 1925. Gouache, pen and ink on paper, 15¹/₈ x 10³/₈″ (38.3 x 27 cm) (composition) with ¹/₂″ (1.2 cm) border on cardboard mount painted by the artist. Anonymous, in honor of Margaret Scolari Barr. 570.64.

MATISSE, Henri.
WOMAN ON A HIGH STOOL. (1913–14) Oil on canvas, 57⁷/₈ x 37⁵/₈″ (147 x 95.5 cm). Mr. and Mrs. Samuel A. Marx. 506.64.

GOLDFISH. (1915?) Oil on canvas, 57³/₄ x 44¹/₄″ (146.5 x 112.4 cm). Mr. and Mrs. Samuel A. Marx. 507.64.

VARIATION ON A STILL LIFE BY DE HEEM. (1915, 1916, or 1917) Oil on canvas, 71¹/₄″ x 7′3″ (180.9 x 220.8 cm). Mr. and Mrs. Samuel A. Marx. 508.64.

THE RED BLOUSE. (1923) Oil on canvas, 22 x 18³/₈″ (55.9 x 46.7 cm). Mr. and Mrs. Walter Hochschild. 781.63.

MONDRIAN, Piet.
TRAFALGAR SQUARE. 1939–43. Oil on canvas, 57¹/₄ x 47¹/₄″ (145.2 x 120 cm). William A. M. Burden. 510.64.

OLIVEIRA, Nathan.
HEAD OF A MAN. 1960. Watercolor, 26 x 20″ (66 x 50.7 cm). Mrs. Samuel I. Rosenman. 511.64.

PICASSO, Pablo.
BOY LEADING A HORSE. (1905–06) Oil on canvas, 7′2³/₄″ x 51¹/₂″ (220.3 x 130.6 cm). William S. Paley. 575. 64.

VASE OF FLOWERS. (1907) Oil on canvas, 36¹/₄ x 28³/₄″ (92 x 73 cm). Mr. and Mrs. Ralph F. Colin (the latter retaining a life interest). 311.62.

WOMAN AND DOG IN A GARDEN. 1961–62. Oil on canvas, 63⁷/₈ x 51¹/₈″ (162.2 x 129.8 cm). David Rockefeller. 529.64.

REDON, Odilon.
JACOB WRESTLING WITH THE ANGEL. (c. 1905) Oil on cardboard, 18¹/₂ x 16¹/₂ (47 x 41.8 cm). Matthew H. and Erna Futter. 784.63.

SCHWITTERS, Kurt.
Untitled. 1946. Collage of pasted paper on corrugated cardboard, 9³/₄ x 8³/₈″ (24.6 x 21.1 cm). Mr. and Mrs. Douglas Auchincloss. 577.64.

SEURAT, Georges-Pierre.
THE CHANNEL AT GRAVELINES, EVENING. (1890) Oil on canvas, 25³/₄ x 32¹/₄″ (65.4 x 81.9 cm). William A. M. Burden (the donor and his wife retaining life interests). 785.63.

TANGUY, Yves, and BRETON, André.
Untitled. 1941. A nineteen-page notebook with ten gouaches and pencil drawings by Tanguy and poems by Breton. Ink, gouache, collage, pencil, and chalk on white and colored paper, 11¹/₈ x 8⁵/₈″ (28 x 22 cm). Mrs. Yves Tanguy (Pierre Matisse retaining a life interest). 346.55.1a–23b.

TOBEY, Mark.
MICROCOSMS OF TIME. 1961. Tempera, 19³/₈ x 25¹/₈″ (49.2 x 63.6 cm). William A. Koshland. 580.64.

UTRILLO, Maurice.
FORT IN CORSICA. 1912. Oil on canvas, 25⁵/₈ x 19¹/₂″ (65 x 49.5 cm). Matthew H. and Erna Futter. 515.64.

SACRÉ COEUR. (c. 1916) Oil on canvas, 32 x 24″ (81.3 x 61 cm). Mr. and Mrs. Walter Hochschild. 786.63.

VUILLARD, Édouard.
THE PARK. (1894) Distemper on canvas, 6′11¹/₂″ x 62³/₄″ (211.8 x 159.8 cm). Mr. and Mrs. William B. Jaffe. 600.59.